Public Monuments and Sculpture Association
National Recording Project

Public Sculpture of Leicestershire and Rutland

PUBLIC SCULPTURE OF LEICESTERSHIRE AND RUTLAND

Terry Cavanagh

INTRODUCTION BY
ALISON YARRINGTON

LIVERPOOL UNIVERSITY PRESS

First published 2000 by LIVERPOOL UNIVERSITY PRESS,
Liverpool, L69 7ZU

HERITAGE LOTTERY FUND

The National Recording Project is supported by the
National Lottery through the Heritage Lottery Fund

Copyright © 2000
Public Monuments and Sculpture Association

The right of Terry Cavanagh and Alison Yarrington
to be identified as the authors of this work has been
asserted by them in accordance with the
Copyright, Design and Patents Act 1988

British Library Cataloguing-in-Publication Data
A British Library CIP record is available

ISBN 0-85323-645-3 (cased)
ISBN 0-85323-655-0 (paper)

Design and production, Janet Allan

Typeset in 9/11pt Stempel Garamond
by XL Publishing Services, Lurley, Tiverton, Devon
Originated, printed and bound in Great Britain by
Henry Ling Ltd, Dorchester

Preface

This is the fourth volume of a series published by the Public Monuments and Sculpture Association and intended eventually to cover the whole of Britain. The Association was founded to encourage the appreciation and conservation of public sculpture and monuments and believes that this objective can only be achieved by the publication of a richly detailed and well illustrated account of them. A computerised database including not only the sculptures in this volume but also many others of smaller importance in the two counties has also been compiled and can easily be updated to cover new sculptures and new research. This ambitious programme is being carried out by the Association's National Recording Project through partnerships with selected universities, colleges, museums and art galleries throughout the country. The Department of the History of Art at Leicester University played a major part in the Association's first volume covering Liverpool and this volume is even more closely associated with it. Terry Cavanagh, a researcher in the Department, has written both volumes and the depth and accuracy of his work and scholarship have already set a very high standard for the whole series. The Association is also deeply indebted to Alison Yarrington, Professor in the Department and an authority on British sculpture. Under her guidance the Department has long specialised in the history of sculpture and she has played a leading role both in the development of the Association's national project and in the work on both volumes. The University of Leicester has had a very distinguished record in the study of local history ever since the appointment of W.G. Hoskins as Reader in English Local History in 1948, and, although his department did not work directly on this project, it is particularly appropriate that the University should have been so deeply involved in two of the first four volumes in this series.

This volume is the first to cover an area not dominated by a metropolitan conurbation. Public sculpture may be most conspicuous in urban centres but important works may still be found by energetic cataloguers in more secluded areas. Leicester itself however offers a rich and varied historical iconography to sculptors ranging from Queen Ethelfleda (or Aethelflaed) to Ramsay Macdonald through Simon de Montfort, John Wycliffe, Richard III, Cardinal Wolsey, Hugh Latimer and Thomas Cook. The list is distinctly reformist, even Radical, in general complexion – particularly since Richard III and Wolsey are only associated with the city through dying in or near it – and Leicester had in the nineteenth and early twentieth centuries a strong Radical and Dissenting tradition well represented in its statues. It is therefore perhaps surprising that Leicester's first statue commemorates the fifth Duke of Rutland, the 'good old duke' of Disraeli's *Coningsby* and ' a firm supporter of the corn laws', standing right outside the Corn Exchange. Much closer to the city's reforming tradition was the pioneering programme established by Stewart Mason, Leicestershire's Director of Education, after the Second World War. Mason and his successors installed sculpture and other works of art by notable contemporary 'progressive' artists in many of the county's schools and colleges in order to stimulate the creativity of their pupils and to assist the artists. No other local education authority has come near to Leicestershire's achievement in the rich context of post war social and artistic idealism. The Public Monuments and Sculpture Association defines public sculpture as widely as possible – only excluding ecclesiastical sculpture which has its own cataloguing procedures – and it is right that sculpture in schools, colleges and universities should occupy a considerable section of this volume. On a sadder note the Association also includes notable sculptures planned but never executed, and in this less happy category Leicester has a notable example by Alfred Gilbert.

The Heritage Lottery Fund gave a large grant towards the research required for the whole series of volumes and the Henry Moore Foundation has provided generous publication grants for each volume. Leicester City Council and Leicestershire County Council assisted the project in many ways. Robin Bloxsidge and the Liverpool University Press have continued to support a series richer in cultural than in financial reward. Janet Allan has designed and organised the production of this volume with the same care and elegance which she devoted to the earlier volumes.

EDWARD MORRIS
Chairman of the Editorial Board

Contents

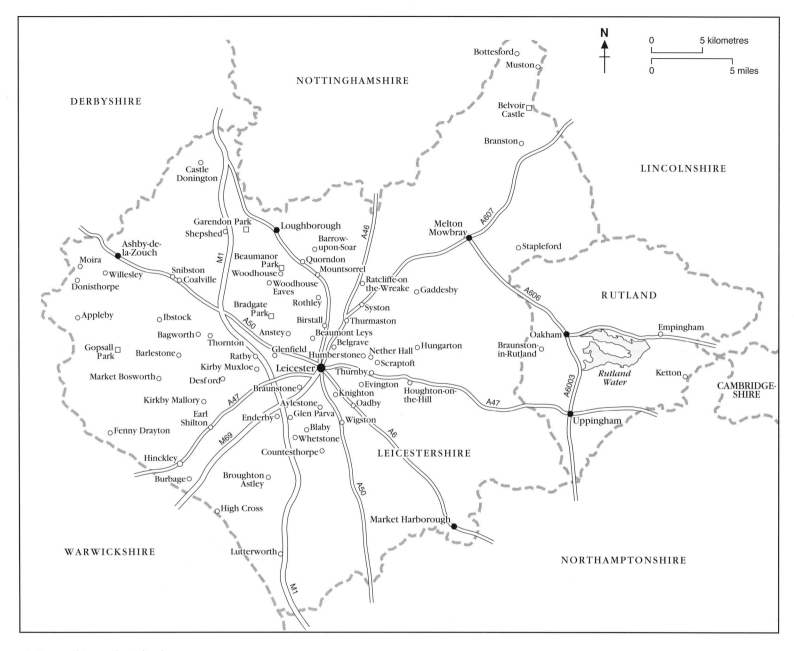

Leicestershire and Rutland

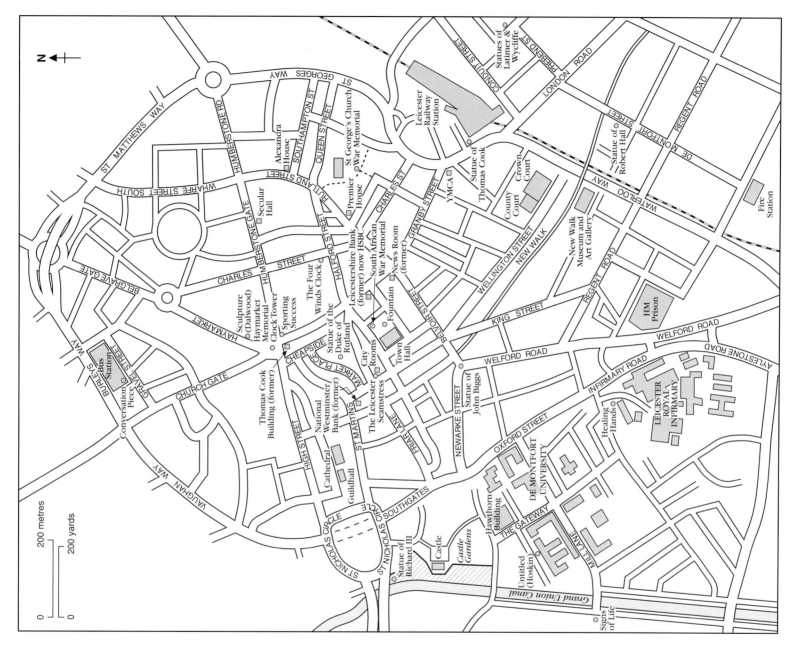

Leicester city centre

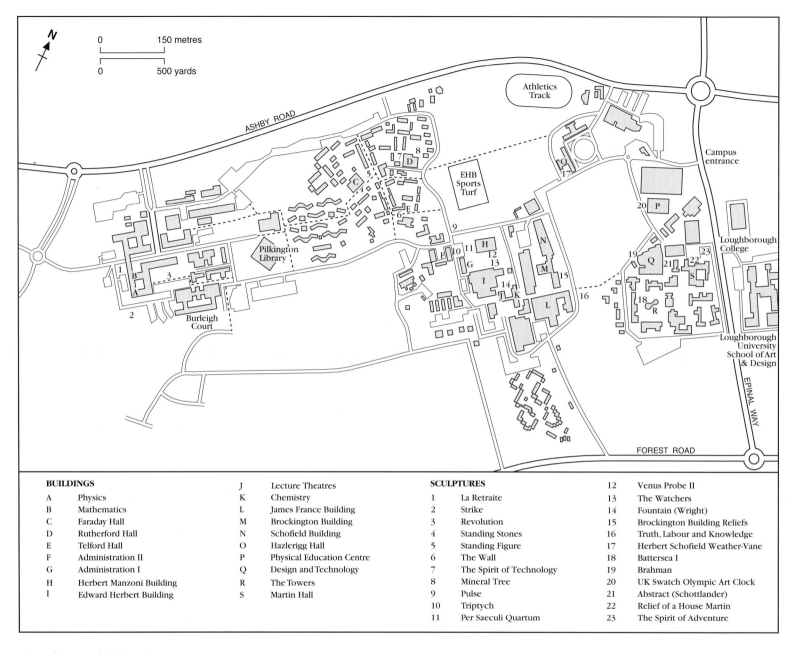

BUILDINGS				SCULPTURES			
A	Physics	J	Lecture Theatres			12	Venus Probe II
B	Mathematics	K	Chemistry	1	La Retraite	13	The Watchers
C	Faraday Hall	L	James France Building	2	Strike	14	Fountain (Wright)
D	Rutherford Hall	M	Brockington Building	3	Revolution	15	Brockington Building Reliefs
E	Telford Hall	N	Schofield Building	4	Standing Stones	16	Truth, Labour and Knowledge
F	Administration II	O	Hazlerigg Hall	5	Standing Figure	17	Herbert Schofield Weather-Vane
G	Administration I	P	Physical Education Centre	6	The Wall	18	Battersea I
H	Herbert Manzoni Building	Q	Design and Technology	7	The Spirit of Technology	19	Brahman
I	Edward Herbert Building	R	The Towers	8	Mineral Tree	20	UK Swatch Olympic Art Clock
		S	Martin Hall	9	Pulse	21	Abstract (Schottlander)
				10	Triptych	22	Relief of a House Martin
				11	Per Saeculi Quartum	23	The Spirit of Adventure

Loughborough University

Introduction [1] by ALISON YARRINGTON

As Nikolaus Pevsner pointed out in his introduction to the *Buildings of England* volume for Leicestershire and Rutland, the qualities of Leicestershire do not proclaim themselves ostentatiously to the visitor. There is, however, as he states, 'enough of positive value, at least in the fields of architecture, of sculpture, of wood work and iron work'.[2] In 1777 William Bray, travelling through Leicestershire, wrote; 'Leicestershire has not many gentlemen's houses of note in it, and not many matters of curiosity, but has much rich pasture, and feeds great numbers of cattle'.[3] Bray's comments suggest a region of undistinguished appearance, more significant for its farmland and the animals that feed on it than the built environment. Although there was coal mining to the north west of the county its appearance remained predominantly agricultural with the manufacture of hosiery the dominant industry until the mid-nineteenth century. Similar sentiments to Bray's have been expressed more recently about the city of Leicester: 'if we were asked wherein lies the charm of Leicester, it would be its very lack of size and grandeur that comes to mind'.[4] Jack Simmons calls it a 'comfortable city', one that 'is capable of inspiring affection not romantic devotion'.[5] Here the city's motto 'semper eadem' seems to indicate an unchanging (and perhaps unchallenging) environment. However, recent publications such as Michael Taylor's *The Quality of Leicester*[6] have done much to refute this idea, bringing into focus the distinctive qualities of the city expressed through its external appearance as it enters the new millennium.

A sense of the sculptural richness of the area would have been immediately apparent had it been possible to include church monuments and religious works in the context of religious buildings, but the remit of this series excludes them.[7] An enormous wealth of church monuments and religious decorative sculpture survives in the counties, of which those at Bottesford and Exton are only two of many fine examples. In more recent times the Jain Centre on Oxford Street, Leicester has introduced a different religious sculptural tradition to the city. The conversion of Shenton and Baker's Congregational Chapel (originally built in 1865) that commenced in 1983 resulted in a profusion of carved Indian white marble external sculpture, with the interior woodcarvings and fifty-four carved sandstone columns of the temple making it one of the most distinctive recent examples of a religious sculptural programme in the city, one that is indicative of its rich cultural diversity. In the context of 'private'

Christian memorials there is a vast number of Swithland slate tombstones located in churchyards throughout the area, their exquisite, incised lettering and decoration demonstrating the high quality of the local masons' craft.[8]

Despite this variety of exclusions there remains 'enough of positive value' to excite interest in this survey of public sculpture in Leicestershire and Rutland; these range from the oldest piece of sculpture, the limestone *Figure* at Braunston in Rutland, the dating of which and its meaning are still unresolved, to the many notable sculptures appearing in more modern times. The remains of twelfth-century sculpture at Oakham Castle, the figure sculptures set into the façade of Lady Abigail's Range at Stapleford Park, Roubiliac's statue of *Religion* in the grounds of Belgrave Hall, Leicester's own *Statue of Liberty* by Joseph Morcom on the skyline of the old Lennards' shoe factory, Phillip King's *Declaration* at Beaumanor Hall, the dramatic *Watchers* by Lynn Chadwick at Loughborough University and Alexander's the *Great Tower* at Empingham, overlooking Rutland Water, along with the many others explored in this catalogue, show that there are some remarkable instances of free-standing sculpture available to public view. In addition there is a wealth of architectural sculpture, including some fine Coade stone figures made for Charity schools and the elegant Leicester City Rooms. Perhaps inevitably, the greatest quantity dates from the Victorian and Edwardian periods.

In the years following the Second World War, there has been a marked growth of interest in the role of public sculpture within the urban environment and the ways in which it may function as an expression of communal and civic identities. In public parks and gardens, initially established for the benefit of the health and pleasure of city dwellers, sculpture is often used to punctuate the man-made landscape. Free-standing works and ornamental structures such as gates and fountains are often found in such environments. For example, in Leicester's Abbey Park there is the purpose-built *Redland Garden of the Senses* that opened in 1995. In Queen's Park, Loughborough, David Tarver's *Swan* forms an integral part of a design that includes a delicate wrought-iron gazebo and a brick maze completed in the early 1990s. Outside the urban areas, in the 'rich pastures' of the countryside, sculpture trails have been created for public use, notably the Leicestershire-wide East Midlands Shape

Sculpture Trail that is still under way (see for example entries under Blaby, Moira and Thornton). At Snibston, on the site of the colliery that closed in 1986, a sculpture trail has been created as part of the wider environment of the Discovery Park, a reinvigoration of man-made presence in the landscape that is now orientated towards leisure and education rather than its traditional industrial base. In many cases such works of sculpture have been funded through co-operation between different public and charitable bodies and the local people, a means of focusing upon a community's identity in a changing economic climate. In the last decade of the twentieth century the city and county councils have been particularly active in supporting the installation of public sculpture as part of planning developments working closely with, amongst others, East Midlands Arts.[9] Partnerships created between funding bodies, the people and sculptors is perhaps the most noticeable trend to emerge in recent commissions for public sculpture in the region, but arguably the most innovative, distinctive and sustained public patronage was that which formed part of the progressive educational developments initiated by Stewart Mason (1906–83) during his period of office as Director of Education for Leicestershire (1947–71). Those works that survive in schools and colleges, many of which are found in this catalogue or listed in its appendix, are evidence of Mason's original ambition, and demonstrate the ways in which sculpture was understood to be an integral and working part of the educational initiatives which he instigated. These differing and distinctive strands of the region's public sculpture are examined here.

Leicester's development and embellishment has, over the years, been necessarily dependent upon the demands of its population and developing civic, regional and national identities. As a 'service' centre for the people from town and county the viewing public for sculpture raised in this central location was regional as well as urban. The town had grown considerably during the eighteenth century from a population of 6,000 in 1700[10] to 16,953 within a total county population of 130,000 by 1801. By 1831 Leicester's population had nearly doubled in size, but the town's appearance remained undistinguished: 'The streets have been laid out without much, if any regard to task and regularity', wrote John Curtis in his topographical history of the county published that year, adding 'the new buildings are in general destitute of ornament and uniformity'.[11] In his second lecture to Leicester's Literary and Philosophical Society in 1864 Dr John Barclay was to note how the town had recently changed but felt that it 'must ever remain an enlarged country town, irregularly laid out, and with no other plan than the highways to other towns, we can never hope to have such streets as we see in Edinburgh or even Glasgow, or Liverpool, or Manchester … the best we can hope for is that the taste of builders and architects may gradually produce some congruity out of

the multifarious elements that now constitute our streets'.[12] Leicester was an important centre of commercial exchange, not least through its many, long-established, markets that serviced the county's agricultural communities and, increasingly, the coal producing areas.[13] The new, vigorous growth of the town between 1741 and 1844 when many streets were built up and laid out, was particularly noticeable in the expansion of the area to the north-east to accommodate the artisan and working population.[14] This area was not a particularly healthy environment being marshy and low lying; as one commentator observed at the proposal to create Abbey Park in 1881 it was a 'dark diptherial and febrile spot'.[15] Indeed the question of a clean water supply and effective sewerage systems was of major significance in the nineteenth century, one that may be seen to have impacted on the embellishment of the city. In 1785 'Queen's Walk' or New Walk had been formed, on the boundary between the social zones of the relatively poor St Margaret's parish and that of the more affluent St Mary. This pedestrian route into the town centre from polite society's housing to the south and to the London Road toll-gate and racecourse (now Victoria Park) was a genteel means of access to the centre with country views, which in 1805 was referred to as 'Ladies Walk'.[16] It was along this route that from 1811 housing was developed and eventually the Museum and Art Gallery established in 1849, housed in the former Nonconformist Proprietary School. Two of the three examples of free-standing full-length portrait statues raised in the town by public subscription were also placed in close proximity to this route in the early 1870s: that to the radical Baptist minister and reformer, the Reverend Robert Hall by John Birnie Philip in De Montfort Square, near to the Leicester Museum (and far removed from Harvey Street Chapel in St Margaret's, where Hall preached his fiery sermons); and that to the hosier and radical Unitarian, John Biggs, at Welford Place near to its terminus point in the town centre, and more significantly near to the New Hall (now the public lending library) which had been built as a meeting place for Liberals in the city.[17] The first statue raised by this method of funding in the town, that to the 5th Duke of Rutland, was placed in the centre of the town in the market area as discussed below.

Leicester was in many ways, according to Nash and Reeder, an 'industrial late developer',[18] although the production of hosiery was well established in the county much earlier. In his *A Tour through the Whole Island of Great Britain* (1724) Daniel Defoe had noted the 'considerable manufacture … for weaving of stockings by frames; and one would scarce think it possible so small an article of trade could employ such multitudes of people as it does; for the whole county seems to be employ'd in it'.[19]

By the mid-nineteenth century Leicester was the cradle of the hosiery industry and by 1865 it has been estimated that a comparatively high proportion (40%) of its electoral base could be understood as artisan or

'working class'.[20] However its most 'pronounced population expansion' came comparatively late in the nineteenth century, between 1871 and 1911, when it increased by 140%.[21] During this period the boot and shoe industry had become a major employer and it was also at this time that the town began to shed its earlier image of being made up of 'buildings without ornament'. The 1901 census gives Leicester's population as 211,579 in a total county population of 437,501 and by this date it was 'the undisputed capital of hosiery and footwear production'.[22] It was, despite pockets of poverty (notably in St Margaret's parish) a prosperous town, achieving city status in 1919 and becoming the seat of a bishop in 1926. In 1936 when the level of household income, rather than that of business, was taken into account it was possible for the Bureau of Statistics of the League of Nations to state that it was 'the second most prosperous city in Europe'.[23] By 1991 the population of the city was 272,133, with that of the county being 865,133.[24]

The embellishment of Leicester during the nineteenth century resulted from a desire on the part of the civic leaders to enhance its appearance and to mark its civic strength and history. This had to be accomplished alongside the pressing need to develop its public amenities, catering for the health and education of the people. One obvious indicator of this, as in so many other developing urban areas during the Victorian era, was the introduction of public parks. Currently the city has 2,700 acres of public gardens and parks, the best known of these being Abbey Park (founded 1882), Victoria Park (founded 1883), Spinney Hill Park (1886) and Western Park (1901).[25] These have continued to be maintained today with sculpture being used in Abbey Park to punctuate the landscape, and to provide points of visual and educational interest for the visitor.

Given the apparent prosperity of Leicester and Leicestershire during the reign of Queen Victoria (1837–1901) when a profusion of statues and sculpture was being raised in other expanding urban and industrial centres, there is little evidence of what the sculptor Hamo Thornycroft was to call the 'coat and trouser school' of public sculpture in the region at this time. By 1851, the year of the Great Exhibition, Leicester had a greater population than the neighbouring conurbations of Nottingham, Northampton and Derby. Nevertheless, it did not have any wealth of large-scale, public, sculptural works commensurate with its size and status that proclaimed through a celebration of local figures either its civic identity or its place within a construct of national identity. This apparent lack of public interest in promoting such forms of ostentatious display is highlighted by the fact neither Leicestershire nor Rutland raised a full-length portrait statue of Queen Victoria to celebrate her Jubilee or to mark her death. Such commemorative impulses seem to have been kept to a minimum, along with less contentious and cheaper means of marking civic status such as occasional commissions for busts of eminent Leicester citizens or historical figures. The reasons for such a low-key, local pattern of patronage were inevitably complex and to some extent still remain an enigma today; they may partly have been the result of political factionalism (a reason identified in 1873) but, more obviously, were linked to the long-standing dissenting, radical tradition in the region.[26] The fact (mentioned above) that two out of the three full-length portrait statues of contemporary local figures were to prominent, radical non-conformists, associated clearly with the hosiery industry and the welfare of its workers, supports this view. In general terms the demand for practical means of improvement of the population as a whole worked against bravura displays of expensive, decorative sculpture unrelated to any practical function. It has also been argued elsewhere that these factors and the nature of the industrial base in Leicester worked against public support for public art and its institutions.[27] In terms of men and women of national importance, who might evoke enthusiasm for commemorative and celebratory sculptural projects by linking civic standing with national status, it is certainly true that Leicester, as Jack Simmons has pointed out, had no politician of national standing other than Ramsay MacDonald (1866–1937).[28] Perhaps, more significantly, in the nineteenth century there was no local millionaire who could help fund important projects; although there were wealthy individuals, such as Sir Israel Hart (1835–1911)[29] who were benefactors to the arts, the wealth of Leicester was, as its appearance suggests, comfortable rather than outstanding. Local men, notably the photographer, radical and at one time editor of the *Leicester Mercury*, John Burton (1808–81), who were enthusiasts for public sculpture as markers of civic pride seem to have been in the minority.[30] Burton himself contributed great energy to the project to raise a Clock Tower at the commercial centre of the town and it is arguable that without his enthusiasm this focal point, increasingly the site of its most important market,[31] would have been no more than an unmarked and unremarkable traffic island. The Clock Tower (1868), designed by the architect Joseph Goddard (1840–1900) with sculpture executed by the sculptor-mason Samuel Barfield (1830–87) was the answer to a planning dilemma and, as was so often the case with such structures, acted as a nodal point in the townscape.[32] In a cultural environment where there seems to have been little interest or enthusiasm for sculpture as an art form *per se* protagonists for a decorative structure on this site cleverly appealed to the local population's sense of civic identity along with its role as an amenity. The practical function of the structure was a clock and lighting for pedestrians whilst Leicester's historical identity – the symbolic function of the tower – was marked by the inclusion of statues of famous historical figures linked with the town: Simon de Montfort, William of Wigston, Sir Thomas White and Gabriel Newton. This combination of function and decoration appealed to the public in a way

that is familiar today, as other catalogue entries in this volume reveal.

Another of the city's best-known structures, the ornamental bronze fountain (1879) in Town Hall Square designed by Francis J. Hames was a gift to the town from Sir Israel Hart. His intervention here ensured that the space in front of the newly-built town hall (the former site of a malodorous animal market) would be transformed into a public amenity for citizens, for their pleasure and their health. The introduction of a sculptural work that was dependent for its visual effect upon the display of clean water outside the town hall, was particularly apposite at this time, bringing together concerns about improvement, amenity, health and civic embellishment. In the Victorian era such means of moral and physical 'improvement' of the population through the enhancement of public amenities was widespread. In Leicester the prioritising of improvements was a focus of debate, particularly during the 1840s, when it became a 'significant political question' with the municipal elections of 1845 and 1846 being fought on this basis.[33] Quite dramatic contrasts between the furtherance of public health and the desire to embellish the town were drawn at this time, focused upon the urgent need for drainage systems and the provision of clean water, as opposed to the building of a prestigious new town hall.[34] The possibility of large-scale, decorative sculptural projects did not augur well in such an environment, and gave rise to such stark observations as 'plans founded upon humanity and for the real benefit of the town have not always originated in patriotism or philanthropy'.[35] Hart's commissioning of a fountain for the town hall square may, in this context, be viewed as a symbolic means of drawing together apparently competing and potentially divisive factions within Leicester's community at its civic 'heartland'.

In the second half of the nineteenth century the products of Leicester's industrial base were modest in scale and predominantly functional. Perhaps it was this very 'plainness' that worked against a widespread interest in modern design and overt displays of aesthetic bravura in the townscape. It would, however, be wrong to think that because there were only a few, free-standing sculptures, sculptural embellishment in its broadest sense was a rarity in the townscape. In Victorian (and then Edwardian) Leicester sculpture was predominantly used as decoration to buildings where it was an indicator of mercantile or industrial wealth (evident in architectural sculpture for banks) and the function of the building. The richness of this form of sculpture, visible for example in the terracotta reliefs found on the exterior of the former General News Rooms (1898) on Granby Street, may easily be overlooked. (It should be noted here that one of Leicester's most popular and idiosyncratic instances of public sculpture is architectural decoration – the sixteen carved heads of 'Tanky Smith' on numbers 113–119 Victoria Terrace, London Road.) This in itself may account for a general sense of

understatement to city squares and streets today.

It is perhaps significant that the first public, portrait, statue to be raised in Leicester (in that it was raised by public subscription) was erected in the vicinity of its central, and largest market place, the site of commercial exchange and the county's wealth since the thirteenth century. Initially sited at Cheapside and then moved to stand in front of the Corn Exchange (but further in advance of its site today),[36] this statue of John Henry Manners, 5th Duke of Rutland (1778–1857) by Edward Davis celebrated a powerful aristocrat and local landowner.[37] The site confirmed his social standing and his agrarian interests (initially raised above and presiding over the market traders and, from the 1870s, in relation to but essentially apart from the dealings of the Corn Exchange). The bronze statue cast by the Parisian firm of Simonet et fils was exhibited at the 1851 Great Exhibition, that great celebration of Britain's world role in industry and trade, to a muted critical response. However, its appearance at this world fair and its subsequent position in Leicester underlines the importance of landed interests and commerce on this regional stage. The history of this sculpture detailed in the catalogue below gives further credence to the argument that political and social divisions meant that it was difficult to sustain public enthusiasm (and consequently funding) for public statuary at this time, with the committee taking measures to ensure that no rivalry should arise between donors.[38] Leicester's nineteenth-century public sculpture provides an indicator of its social and economic structures just as the spectacle of sculptural display in the other areas covered by this series reveals different local and regional preoccupations and meanings, determining appearance and site. The ceremonies that surrounded their inauguration are detailed in the various catalogue entries and these should also be considered as a part of our understanding of the works' roles in their various settings. Displays of civic ritual in the streets and squares of towns focused upon public sculpture were as much an 'important feature of urban culture' in the nineteenth century as they have been demonstrated to be in the period 1660–1800.[39]

In many ways the 'coat and trouser school' of public sculpture may now be seen to be flourishing as demonstrated by the recent statue of Thomas Cook (1993) by James Butler placed outside Leicester's London Road railway station. The continuing demand for pictorial and figurative sculpture that is seen to be 'readable' by the public is a strong strain appearing in many of the region's major public commissions.[40] In the setting of a modern 'market place' Robert John Royden Thomas's *Mother and Child* (1963) at Coalville[41] was originally commissioned to stand in the social and commercial space of the town's new shopping precinct. The large number of people who would encounter the sculpture on a daily basis, combined with the use of public money, made those in control of commissioning the work anxious that it should not cause controversy or

criticism. The selection committee included both local people and representatives from the art world, a move to please both the interests of 'art' and the local community, a continuation of a long-established tradition of public commissioning.[42] When compared to the mid-nineteenth-century example of the statue of the Duke of Rutland erected in the market place in Leicester a difference is immediately visible, one that is perhaps an indicator of social change. Rather than a figure of a named individual raised above the masses, the sculpture that was chosen by the Coalville committee represents an 'anonymous' figure, representative of those who use the site on a day-to-day basis and underpin its economy – a mother and child shopping – a kind of 'Everywoman' originally placed where it formed part of the crowd. No gesture of control is found here, nor awards or honours displayed on her breast; instead her shopping bag contains references to the industry and commerce of the area. When further building took place in the precinct, instead of keeping the work on the site for which it had been intended it was moved, after the intervention of the North West Leicestershire District council to preserve it in 1989. It now stands rather forlornly out of context in front of the library where, ironically, it has become less 'readable' by the general public.

Another more recent scheme to enhance a market place in the county, like the Coalville *Mother and Child*, demonstrates the considerable efforts by planners and local representatives to make public sculpture accessible to the people through a process of elaborate public consultation. The Lutterworth Market Place Improvement Scheme launched by Leicestershire County Council in partnership with Harborough District Council and the Lutterworth Chamber of Commerce[43] instigated a project that would 'celebrate Lutterworth's past, present and future', providing a focus for the new layout to the area, a similar if less complex 'nodal point' to Leicester's Victorian Clock Tower. A process of selection, including public exhibition of maquettes and sketches selected by representatives of the County and District Planning Councils, resulted in a 'tower' decorated with carved, coloured, ceramic tiles incorporating details of Lutterworth's history designed by Martin Williams. It could be argued that a monolithic structure covered in ceramic tiles is a pictorial means of conveying the various scenes from the town's history that had been determined by the initial sub-group. Whilst this may seem to provide a very direct means of conveying significant episodes in the town's history, the fragmentation of image and text results in a complex visual reading, one that may become as obscure as any non-referencing abstract work as time moves onward. Here, as is the case with many other works explored in this catalogue, there is a need for some permanent explanation of its imagery and textual references on site.

Sculpture produced for the public is always the result of some form of partnership forged between the producer and the patron(s). Recently one of the most exciting means of creating sculpture for the public in the region has been a deliberate move to bring together the sculptor and the community within the design process as an integral part of the commission. This is meant to promote understanding of sculpture amongst those for whom it is made and a greater understanding on the part of the sculptor of the context for which the work is being carried out, a symbiotic process that is intended to be educative in the broadest sense. It is also a means whereby a community may work together, and in some cases this has meant people from a particular locality or section of a community being involved at each stage in the making of a sculptural work. It is arguable that this involvement in 'process' is as important as the final work itself, resulting in truly 'public' sculpture rather than a work selected and controlled by a small group; this is in contrast to the more traditional procedures of public commissioning where the sculptor often works at a physical distance from the intended site, and the sculpture is brought in from outside after approval by a small controlling 'patron' group. One example of this new 'insider' sculpture-making currently under way is the 'East Midlands Shape 21st Birthday Sculpture Trail'; a series of sculptures made through the process of collaboration between practising artists and people with disabilities. This project, initiated in 1997 by East Midlands Shape (founded 1978), forms part of its mission to provide 'greater access to the arts for disabled people and other disenfranchised groups'.[44] In joint partnership with Mantle Community Arts of Coalville (founded 1985) £6,434 was raised through a variety of sources including the National Lottery Charities Board, the National Forest and Leicestershire County Council. As the initial 'pilot' project Martin Heron was appointed in 1998 to work with members of local groups; work began in July of that year and is continuing. In the communities of north-west Leicestershire – for example Ellistown, Measham, Moira and Snibston[45] – that have been affected socially and economically by the closure of the mines, this kind of project has created a positive means of focusing attention upon the strengths of the community and its continuance during the most difficult times.

Arguably some of the most difficult times that the people of Leicestershire and Rutland had to face in the twentieth century were the devastation and suffering caused by the First World War. As Paul Fussell wrote in *The Great War and Modern Memory* 'The whole texture of British daily life could be said to commemorate the war still'.[46] John Sharpe in his study of the war memorials of Leicestershire and Rutland makes their significance as public art clear: 'These memorials represent the largest single display of public art ever commissioned in this country'.[47] These culturally significant structures are, as elsewhere in the United Kingdom, the most 'prominent features in numerous rural and

urban historic environments'[48] and their scale and form was determined by the community which commissioned them: 'perhaps the most striking aspect … is the diversity of design and construction. There was no agreed national pattern or standard.'[49] Their historic value has been marked by the formation of the National Inventory of War Memorials at the Imperial War Museum, London in 1989, a database that is still being added to and updated. In order not to replicate this work the PMSA national recording project has not included war memorials on its own database. In this volume, as in those for Liverpool, Birmingham and the North-East that precede it, some war memorials are included in order to provide a more complete picture of the existing range of public sculpture; however, because of the great number found in the region, many of which are purely architectural in form, the PMSA decided that only those with a predominantly sculptural content should be included here.[50] The sample is therefore not fully representative of all the different monumental types. Sharpe has pointed out 'virtually every Leicestershire town and village has at least one memorial dedicated to those who fell in battle or took part in the conflicts of the twentieth century'.[51] As he demonstrates, this reflects the fact that both Leicestershire and Rutland suffered badly in the Great War: 12,000 of those who enlisted from Leicester and the County were slain, and 525 Rutland men were killed and 479 injured.[52] Whilst it is impossible to know the depth of individual distress that such loss engendered, or the extent to which memorials engaged with private grief and memory, some sense of communal responses may be gauged by the subtle variations that occur between the monuments themselves and the ways in which the names of the fallen are recorded: 'Many memorials are similar, even in neighbouring villages, but they are never identical'.[53] Each memorial represents to a greater or lesser degree the views of the communities who met together to decide upon the appropriate form that it should take and raised funds for the commission to be put into effect. In the process much debate could occur particularly about the site:[54] that raised by the villagers of Burbage is a case in point, and incidentally the only example of a First World War memorial in the region to include a full-length figure of a British 'Tommy'. Once more the strong non-conformist tradition in the county, already discussed in the context of Leicester's public sculpture in the nineteenth century, seems to have played its part. The question of the use of consecrated ground to site a public memorial to the community's war dead was at the heart of the matter, with much dissent about the original proposal to site the memorial at the far end of the Anglican church graveyard. It is clear that there was a demand for some public and inclusive means of marking the loss of local men who came from a variety of religious denominations or non-religious backgrounds. The eventual choice of the village green resolved the question and the threat that the Burbage Co-operative

Society would withdraw their subscription of £100 was obviated.

The designs for memorials were frequently chosen from pattern books and could be made from a variety of building stone available nationally, from the deep soft-pink to silver-grey hard granite of the Aberdeenshire quarries, to the high fossil content of Portland stone which allowed the sharp carving of detail. Interestingly, as Sharpe has found, 'in the south and east of the county there is a noticeable concentration of slender war memorials constructed from local oolitic limestone'.[55] The forms memorials take range from small crosses made by local masons (an example of this is found in the small village of Grimston) to major sculptural works such as Allan G. Wyon's figure of *Peace* on the Hinckley War memorial and the reliefs on the Oakham School Memorial Chapel by Francis William Sargant. Lutyens's Memorial Arch in Victoria Park, Leicester is the most grandiose structure, but ultimately perhaps no more poignant and telling reminder of loss than the most simple ringed cross in the smallest village. The maintenance of these significant works of public art is, by and large, the responsibility of parish councils or local authorities, and our survey has shown that many are in urgent need of conservation. It is encouraging that at the time of writing there is a proposal to record these works nationwide on the basis of their state of conservation with a view to their long-term preservation.

Whilst war memorials represent the regional response to a nation-wide demand for commemoration that was shaped at local level, a later twentieth-century scheme in Leicestershire to place sculpture in schools was to achieve national recognition. Stewart Mason's scheme to remodel education throughout the county, produced the most innovative and sustained use of sculpture in educational environments of the century, with its most creative phase taking place in the quarter of a century that followed the end of the Second World War. It is, of course, traditional to decorate school buildings, like those of other institutions, with art works or sculptures to provide permanent reminders of benefactors and those historical figures who are linked with their foundation.[56] Evidence of this is found in several school buildings in the region before the twentieth century. The statue of Sir John Moore by Sir William Wilson at John Moore's School at Appleby Parva (formerly the Old Grammar School) was put in place at the school's foundation to commemorate the benefactor of the school. In the late eighteenth century we have the figures of the Charity school children at St Mary de Castro Parochial School (now located at St John the Baptist School in Clarendon Park) and at Wyggeston Hospital, all made by the Coade Stone manufactory and placed to indicate the function of the building.[57] In the nineteenth century statues of John Wycliffe and Hugh Latimer by the local stonemason-sculptor John Firn were placed in niches on the external face of the building in College Street, which housed the Wycliffe Congregational

Church and the Collegiate Girls School (now the offices of the Leicester City Council Arts and Leisure Department). These are necessarily meant to be viewed from a distance and revered by those who belong to the church or the school, acting as signs of historical association that are also indicators of the aspirations of the institution.

A very different philosophy structured Mason's scheme, one of the most remarkable examples of the sustained patronage of contemporary sculpture in Leicestershire. As a direct result of the changes in educational policies he initiated during his period of office as Leicestershire's Director of Education, and which were continued by his successor Andrew Fairbairn (retired 1984), schools and colleges were the recipients of an adventurous range of contemporary art amongst which sculpture, and in particular abstract works, featured strongly: 'visitors to the county's schools are also struck by the emphasis on contemporary arts, especially music, painting and sculpture ... every school has its share, while no new building is without its sculpture or murals as a focal point'.[58] The national importance of the collection[59] was made clear by the exhibition staged at the Whitechapel Gallery in 1967–8, *British sculpture and painting from the collection of the Leicestershire Education Authority in collaboration with Loughborough University of Technology*.[60] The sample of works on display was selected specifically for exhibition in London and included some which were sited in schools and others from the County Collection,[61] a loan collection from which schools could – and still do – borrow works. In this category the sculpture tended to be on a transportable, and therefore modest, scale; take for example Gertrude Hermes's bust of *Sir Michael Tippett* (1966, bronze, 36 × 20 × 25cm / 1'2" × 8" × 10"), a subject that had particular resonance for the county because of Tippett's involvement with the Leicestershire Schools Orchestra, another flowering of Mason's Directorship that, unlike the art collection, continues unabated to this day.[62] A later exhibition at the Whitechapel *Growing up with Art: the Leicestershire Collection for Schools and Colleges* staged during September–October, 1980 confirmed that Mason's and Fairbairn's directorships had been a period of utopianism the result of which was an unprecedented patronage of contemporary sculpture by a local education authority: 'the courage of the Authority in its purchasing policy has proved a great encouragement to many young artists of talent'[63] wrote Henry Moore in the 'Preface' to the exhibition. The exhibitions where sculpture was separated from context inevitably gave the impression of art created for gallery spaces, despite the photographs in the 1980 catalogue showing the works 'in use'. The reality, as set out below, was somewhat different and to a great extent explains the 'well-thumbed' appearance of many of the surviving works which were never intended as museum pieces.

Any perusal of the inventory of the LEA's collection shows an astonishing variety of sculptural works. Many of the larger pieces, purchased when new schools or buildings were commissioned as part of the capital grant, are still *in situ* although in varying states of repair. Some notable examples are Willi Soukop's *Signs of the Zodiac* at Guthlaxton College, the Martin High School and Burleigh Community College, Loughborough, William Pye's *Broken Curve* and Phillip King's *Dunstable Reel*, both at Countesthorpe College. Many of the new schools built by T.A. Collins, the County Architect during the period 1948–67, have sculptures commissioned in this way, including works by R.E. Clatworthy, Georg Ehrlich, Penelope Ellis, Ben Franklin, Antony Hollaway, Alwen Hughes, Peter Peri and Ronald Pope. Another important piece, Barbara Hepworth's *Coré* at Bosworth Community College is indicative of the distinctive purchasing policy. Mason noted in the 1980 exhibition catalogue that purchasing took place: 'from time to time with the aid of the Arts Council, or by virtue of our membership of the Contemporary Arts Society, or through the generosity of the artist we can acquire works from those who have climbed several rungs up the ladder'.[64]

Mason believed, refreshingly, that 'schools which placed value on the arts and encouraged individual creativity in them were almost invariably schools where you would find interesting and original work going on in ... academic subjects'.[65] In this he was in tune with the ideas formulated by the Society for Education through Art, established at the end of the Second World War by Herbert Read.[66] Alongside Mason's move towards the liberation of children from what he considered to be a repressive, stultifying and ultimately damaging selection system at the age of 11 (the 11 plus examination) – put into effect in the 'Leicestershire Plan' (1957)[67] – came the need to provide opportunities to develop their individual creativity to the maximum. In many ways Mason may be seen to have been following closely in the footsteps of Henry Morris, Chief Education Officer for Cambridgeshire, who had commissioned Walter Gropius to build Impington Community College and had planned to include sculpture by Henry Moore, although the latter was never completed. Mason had worked with Morris prior to his appointment as Leicestershire's Director of Education. His implementation of a similar, but more ambitious, scheme to purchase contemporary art for Leicestershire schools and colleges was undertaken to facilitate an 'open' interaction between art works, children and teachers. In this he was initially aided by his appointment of Alec Clifton-Taylor as the County Art Adviser and then by Bryan Robertson, Director of the Whitechapel Gallery, London. However the choice of works became increasingly his own domain. After his retirement from the Directorship he continued as Art Adviser under his successor Fairbairn, with whose retirement in 1984 we see the end of an era. With political changes in the eighties the

possibility of expanding and developing the scheme through further commissions waned, the schools to house the baby-boomers had been built and the constraints of the financial systems within which education authorities had to work allowed little room for the particular artistic entrepreneurial flair of the kind demonstrated by Mason.

Today the very fact that Mason as Director of Education could afford to commission such a range of art seems quite extraordinary. In part it was the 'baby-boom' necessitating the increased provision of more schools and colleges nationally that allowed him to incorporate sculpture as part of the educational environment on an unprecedented scale.[68] There was also the reorganisation of county secondary schools that he had masterminded, which impacted upon their spatial organisation. Mason's genius was his ability to seize the moment by a creative use of funds, and thus a small percentage [69] of the building capital fund appears to have been earmarked for a sculpture commission when each new school or major extension was approved by the authorities. Here he was carrying out a similar policy to his counterpart, John Newsom in Hertfordshire who during the period 1949–53, ensured that three per cent of the total cost of each new school in his county was set aside for the purchase of works of art for embellishment.[70] Mason also had at his disposal a fund, known as the 'director's grant', with which he could help in the purchase of works of art for schools and colleges, as well as the occasional help, mentioned above, from bodies such as the Arts Council and the Contemporary Arts Society. There are also instances of works purchased as a joint effort between the school (governors, head teacher, parents) and the LEA.[71]

In 1967, responding to questions posed by Bryan Robertson who had undoubtedly fuelled Mason's developing passion for abstract art, he outlined the three ways in which funding was found for the purchase of contemporary art by the LEA. Firstly there was the special fund which allowed c. £800–1,000 per annum to be spent on a loan collection for schools and colleges (the County Collection). Secondly, schools were able to purchase for themselves out of their general fund inexpensive works at an annual 'art fair', an event that was only discontinued in 1999. Thirdly work was commissioned for new schools or those where 'extensive additions' were being made when 'we always try to set aside a small sum out of the building contract for a piece of sculpture,[72] and out of the initial equipment vote[73] we start them off with two or three pictures and pots'.[74] Inevitably, because this volume is about public sculpture we have been most concerned with those works that remain in situ and are visible to the public, rather than small moveable works that are in teaching rooms. William Tucker's abstract sculpture Untitled (1974), exhibited as part of the 1980 Whitechapel exhibition, had been purchased by the LEA with assistance from the Arts Council for Brookvale High School, Groby,

where it remained until 1985 when it was relocated to Limehurst High School, Loughborough.[75] Quite clearly, large-scale works set into the fabric of the building funded under the buildings' capital scheme could not be moved around easily, but as the catalogue here demonstrates other works from the various schemes could be moved and indeed were. The works in the County Collection continue their peripatetic existence, whilst those listed under Beaumanor Hall in the catalogue are, in the main, currently 'resting'. Mason's idea was that works should circulate between schools in order that familiarity did not breed contempt, but this of course was dependent upon many factors, not least the extent to which the work was an integral or fixed part of the fabric and the enthusiasm of busy head teachers to enable such exchanges.

Some notable examples of works commissioned for new buildings remain in situ; for example Peter Peri's Man's Mastery of the Atom = Self Mastery at Longslade Community College. Here Mason's scheme may be seen to have born fruit, a detailed description of its making appeared in the Longslade School Magazine with the design being adopted both for the school's badge and its logo. In the context of Peter Peri's work it is interesting to note that Leicestershire was not the only county where schools were being decorated with sculpture. Peri also produced works for Derbyshire, Northamptonshire, Staffordshire, Warwickshire and Yorkshire. At Greenhead High School in Huddersfield which was being upgraded he made the dramatic figure Welcome (1961) for the new science building.[76] It was, however, the scale of Mason's enterprise with its national publicity through the Whitechapel exhibitions that made it so memorable.

Mason, initially with the help of Clifton-Taylor and Robertson, but increasingly exercising his own independent judgement, managed to persuade London galleries, notably the Redfern and Piccadilly galleries to sell him good quality sculptural works at affordable (and often uncommercial) prices.[77] This process was not without its difficulties and, as Davies points out, Mason's increasing interest in abstract works particularly visible at the Whitechapel exhibition, caused a rift between Clifton-Taylor and himself that was never fully resolved.[78] Of significance was his patronage of emergent artists; not only did this provide works for the County that were inexpensive compared with commercial rates required for sculpture by more established artists, but it also keyed-in to his encouragement of young talent. How this process took place in one instance during the late 1950s is explored in the catalogue entry for Brockington College, with the sculpture Badger (1957–8) commissioned from Penelope Ellis as a consequence of Clifton-Taylor approaching F.E. McWilliam, Head of Sculpture at the Slade to recommend a young sculptor to carry out a commission for the external face of Brockington Church of England Secondary School. Of course many local sculptors

from both Leicester and Loughborough colleges were given the opportunity to carry out public commissions as an outcome of Mason's scheme. Teachers were also able to attend workshops at Loughborough College, notably those given by Willi Soukop who had carried out several commissions for works to enhance new school and college buildings in the region.[79]

A controversial scheme which had its detractors as well as its protagonists nevertheless meant that works by artists such as Barbara Hepworth, Henry Moore, Phillip King and Lynn Chadwick were sited in schools and colleges across the county. It is a collection that still has enormous strengths in terms of its variety, but inevitably with increasing constraints of education budgets and with schools and colleges hard-pressed to provide teaching resources, the scheme has sadly faded from view. For Mason, writing just before his retirement:

> an outward and visible sign to children and teachers of a positive attitude on the part of the authority has been its acquisition for schools of a wide variety of contemporary works of art, especially by young artists of national repute or promise. … History shows that the arts in their own right are a necessity to civilised man, but possibly their greatest advantage is that they act as a catalyst in the general life of the school. So long as they are treated not as an academic exercise but with vitality they appear to release energy and add sparkle and inventiveness to the general life of the school. They pay for themselves by quickening the whole tempo.[80]

The significance of this seems to be confirmed in the photograph on the cover of the book *In Our Experience* edited by Mason that shows a group of children experiencing an Antony Hollaway sculpture in Thringstone Primary School. The interactive nature of the sculpture was stressed by teachers reporting on their 'experience' of the Mason system: 'More sophisticated pictures grow in popularity the more they are seen, while *The Clown* – a piece of sculpture in the playground is fondled and loved and climbed upon and sometimes even given clothing'.[81] Sometimes the idea that these were physical objects to be explored and touched inevitably resulted in their damage, or sometimes total destruction. This was certainly the case at Warren Hill Primary School where a fibreglass sculpture placed on the outside of the building was destroyed by the children 'not by vandalism, but by playing in it, curling up in it and generally adoring it. It was part of their school life.'[82] The problems of conserving sculptural works, often made in modern and inexpensive materials, when used in such a pro-active way are clear; some literally fell apart, some were 'played out', others were forgotten or displaced when building extensions were made. Time has wreaked damage upon these works as has their continuing attractiveness as playthings. One work

exhibited at the 1967/8 Whitechapel exhibition, David Annesley's *Big Ring* (1965) sited at Lutterworth High School is a case in point. It no longer retains its circular form but has, over time, been pushed into an ellipse. This is just one instance from many where schools are faced with problems (namely those of conservation and the increasing historical significance of the works themselves) that were never envisaged by Mason with his vision of sculptures in schools as essentially 'working' pieces.

The 'Mason project' was very much a product of its time and as such needed to be constantly updated and reviewed to maintain its impact. A work that seemed so contemporary at the moment of installation could just as quickly lose its 'vitality', 'energy' and 'sparkle' as new ideas about artistic form came into circulation and fashions changed. As this catalogue reveals there are many examples of the works fading from memory and losing their impact. One instance of this is found in the entry for *Calendula* by Wendy Taylor made for a specific site of the William Bradford Community College.[83] Some of the finest examples of Mason's initiative are found in the collection of Loughborough University (formerly Loughborough College), now arguably the major site of post-Second-World-War British sculpture in Leicestershire; a situation undoubtedly brought about through the influence of staff at the College of Art and Design which formed part of the institution. Here Lynn Chadwick's *The Watchers* (1966) should be noted as Mason's grandiose tribute to his predecessor Sir William Brockington, to Sir Robert Martin, Chairman of Leicestershire County Council, and to Herbert Schofield, first Principal of Loughborough College. This cast after the original was thought by Mason to be a particularly appropriate tribute to the three men most responsible for initiating technical education in the region.

As the history of Mason's project indicates, locally based colleges of art were, in a variety of ways, important providers of designers and makers of public sculpture. Both Loughborough College of Art and Design, now part of Loughborough University,[84] and Leicester School of Art, now within De Montfort University, played their part. The Loughborough campus is an important site for modern and contemporary sculpture; De Montfort University also has several sculptural works embellishing its buildings and public spaces created by staff: these include the early metal relief panels of the entrance doors (1937) made by Percy Brown for the Hawthorn Building designed by Everard and Pick (1896–7) which are of particular interest. As the first purpose-built housing for the Art and Technical Colleges, these doors pick up the theme of art and industry that lay at the heart of this hard-won educational development in the city. In 1895, one Councillor T.F. Richards debating the issue of whether colleges of art and technology should be established in Leicester took it upon himself to pronounce: 'before they went for science and literature … they wanted to see starving

people fed'.[85] His argument failed to win the day and the new Technical and Art Schools were opened on 9 October 1897. Staff and students from these Leicester and Loughborough institutions have been commissioned for works over the years. Both Joseph Morcom and Crosland McClure taught at Leicester College of Art; indeed it was probably because of this connection that the latter was employed on one of the city's most accomplished examples of the 'New Sculpture', the *South African War Memorial.* The committee had been left in an untenable position because of the failure of the internationally renowned Alfred Gilbert to complete the commission, and the idea of employing a 'local' man had obvious advantages over a London-based sculptor.

In more recent times staff of De Montfort University (as a College of Art and then Polytechnic) including Percy Brown, Ken Ford, John Hoskin and Albert Pountney have all made sculpture for the city. Similarly David Tarver, Head of Sculpture at Loughborough College of Art and Design (1957–1989) is responsible for several sculptures in the region, including the relief that is placed at the entrance to the institution (1968). There have also been opportunities for young local sculptors to participate in making public sculpture. Carole Kirsopp, at the time a final year student at the College of Art and Design was commissioned by Leicester City Council to make the *Tower of Silence* (1995) for the *Redland Garden of the Senses*, Abbey Park, Leicester. The University of Leicester was not able to participate in the same way as those other institutions in the region that included practical art and design as part of the curriculum. Nevertheless, as the catalogue shows, it still commissioned and received gifts of sculpture to decorate its buildings and grounds. Amongst these was a cherished Henry Moore sculpture, *Oval with Points,* that originally stood outside the Fielding Johnson Building. Unfortunately it is listed in the catalogue under 'removed and lost works', a particularly sad loss given that Moore was an Honorary Graduate of the university.[86] Nevertheless, it is an institution where the study of the history of sculpture is an integral part of the history of art curriculum and of several individual research programmes; it is also the regional centre for the East Midlands as part of the PMSA's National Recording Project.

The present catalogue highlights both the positive and the negative aspects of public sculpture in the region and the ways in which it is indicative of its social, political structures and its civic identities. The continuing promotion of public sculpture through the city, district and local councils in partnership with other public and charitable bodies is to be applauded and is contributing to the quality of public life in villages, towns, city and country. Stewart Mason's utopian scheme has brought into schools and colleges a wide range of sculpture, but in several instances the initial qualities have often faded from view, either through misunderstandings about how the works were intended to be viewed or

because of lack of funds available for their upkeep. Although the idea is that these should be living works of art functioning in a quite different way to gallery pieces, it would be a shame for Leicestershire to lose any more works because they fade from view or public interest. This is of course true of a wide range of public sculpture, and one of the very simple remedies for ensuring the continuing vivacity of pieces and a means of promoting an understanding of their meaning would be the introduction of labels or information panels to keep in the viewer's mind the intention of the work. This is certainly true of some pieces placed in parks: for example the symbolic function of the *Three Orchids* in Abbey Park, Leicester would have far more meaning if the viewer knew that these represent three different kinds of orchid located in different parts of the globe. Recent works, such as the Lutterworth market place sculpture cited above, may be quite complex in their imagery but this, too, needs to be conveyed to the public so that they may share in an understanding of the iconography. The move towards the involvement of the community in the design and making of sculpture may well ensure their upkeep in the short term, but further measures need to be taken to make them lasting works of historic value. It should however be noted that at the time of writing there is no sustained evidence of malicious or vandalous damage to works of sculpture, perhaps with the exception of the *Statue of Liberty* which has suffered badly at the hands of graffitists. The Rutland *Figure's* recent damage is a different matter, one that has occurred as a result of its very public site. Nevertheless, there is indeed 'enough of positive value' in the public sculpture of Leicestershire and Rutland to encourage further and different kinds of study of this important aspect of the region's material culture.

Notes

1. I am most grateful to Professor Charles Phythian-Adams for his guidance on aspects of local and regional history during the writing of this introduction.
2. Pevsner, N., *Leicestershire and Rutland* (Buildings of England series), rev. edn Williamson, E. and Brandwood, G.K., Harmondsworth, Penguin, 1984, p.17.
3. Bray, W., *Sketch of a tour into Derbyshire and Yorkshire including part of Buckingham, Warwick, Leicester...* White, B., 1778 quoted by J.D. Welding (ed.) *Leicestershire in 1777: An edition of John Prior's Map of Leicestershire with an introduction and commentary by members of the Leicestershire Industrial History Society, Leicester,* Leicestershire Libraries and Information Service, 1984, p.7. For the number of distinguished country houses in the region see the Victoria County History; also Cantor, L., *The Historic Country Houses of Leicestershire and Rutland,* Leicester, Kairos Press, 1998.
4. Elliot, M., *Victorian Leicester,* London and Chichester, Phillimore & Co., 1979, p.17. This is a view echoed elsewhere, see for example the introduction to Nash, L. and Reeder, D. (eds) *Leicester in the Twentieth Century,* Stroud, Alan Sutton Publishers and Leicester City Council, 1993.
5. Simmons, J., *Leicester Past and Present,* 2 vols, vol. 2 *Modern City,* Eyre Methuen, London, 1974, p.143.

6. Leicester City Council, *The Quality of Leicester*, Leicester, Leicester City Council, rev. edn 1998.

7. The PMSA national survey upon which this volume is based excludes church monuments and religious works in religious buildings. Pevsner's *Buildings of England* series provides a very full listing of religious works found in churches, chapels and cathedrals.

8. There is little published material on this form of churchyard memorial, although they are included in Burgess, F., *English Churchyard Memorials*, 1963, 1979, and Davies, J.C., 'The "tulip slates" of south Leicestershire and north-west Northamptonshire', *The Leicestershire Historian*, 4: 1, 1993.

9. *East Midlands Arts Operational Plan 1998/99*, p.7. EMA maintains a network of sixteen local arts and community arts development agencies in partnership with local authorities including North-West Leicestershire, Harborough, Charnwood, Melton, Blaby, Hinkley and Bosworth.

10. Chinnery, G.A., 'Eighteenth-Century Leicester', *The Growth of Leicester*, ed. A.E. Brown, Leicester, Leicester University Press, 1972, p.47. For a full account of population changes see Strachan, A.J., 'Patterns of population change', *Leicester and its Regions*, ed. N.J. Pye, Leicester, Leicester University Press, 1972, pp.424–54.

11. Curtis, J., *Topographical History of the County of Leicester*, Leicester 1831.

12. Barclay, J., 'Modern Leicester, Part II', lecture delivered to the Leicester Literary and Philosophical Society, 22 February 1864, reprinted from *The Leicester Advertiser*, in Ellis, C.D.B., *History in Leicester 55 B.C. – A.D. 1900*, Leicester, City of Leicester Publicity Department, 1948, p.126.

13. Temple Patterson, A., *Radical Leicester a History, 1780–1850*, Leicester, Pitman Press for University College Leicester, 1954, pp.4–7 who discusses these markets; for an account of the earlier development of the markets, see Everitt, A.M., 'Leicester and its Markets: the seventeenth century', *The Growth of Leicester*, ed. A.E. Brown, Leicester, Leicester University Press, 1972, pp.39–46.

14. Gill, R., *The Book of Leicester*, Buckingham, Barracuda Books Limited, 1985 provides an architectural history of housing in Leicester. For the growth of Leicester in the context of social and economic change see Pritchard, R.M., *Housing and the Spatial Structure of the City: residential mobility and the housing market in an English city since the Industrial Revolution*, Cambridge, Cambridge University Press, 1976. A brief survey using old photographs is provided by Clarke, D.T. –D. and Simmons, J., 'Old Leicester An Illustrated Record of Change in the City', *The Leicestershire Archaeological and Historical Society Transactions*, vol. xxxvi, 1960, pp.45–8.

15. Ellis, R. Jnr., *Modern Leicester*, 1881, cited in Ellis (1948) p.105, n.1.

16. For the importance of 'walks', 'promenades' and public gardens see Borsay, P., *The English Urban Renaissance: Culture and Society in the Provincial Town, 1660–1770*, (Oxford Studies in Social History, Gen. Ed. K. Thomas) Oxford, Oxford University Press, 1989, pp.162–72. Gill, R. (1985), p.37 refers to it as a 'rural promenade' and that it was to be confirmed as a footpath by the Corporation in 1824 and has remained pedestrianised ever since.

17. It is interesting to note the temporary removal of Biggs's statue to De Montfort Square recorded in the catalogue entry below, one which would appear to provide an opportunity to decorate the area with further sculptures indicative of civic identity but which was never taken forward.

18. Nash, L. and Reeder, D. (1993), p.2.

19. Defoe, D., *A Tour through the Whole Island of Great Britain*, London, J.M. Dent and Sons, 1962, pp.88–9; Pritchard, R.M. (1976), p.32, 'Leicester was, with Nottingham, the administrative and commercial heart of the national hosiery trade'. Pritchard provides a summary of the development of the industry – its apparent decline in its 'proto-industrial phase' in the early nineteenth century with unemployment in the post-Waterloo years through the hungry forties to its resurgence in the 1850s with the use of new industrial processes.

20. Fraser, D., *Urban Politics in Victorian England: The structure of politics in Victorian cities*, Leicester, Leicester University Press,1976, p.223. This compares with Birmingham's 19% and Nottingham's 39% and shows the enfranchisement of skilled operatives and artisans. Lancaster, B., *Radical Cooperation and Socialism: Leicester working class politics 1860–1906*, Leicester, Leicester University Press, 1987, p.1 states that by 1851 the hosiery industry was the largest single source of employment, and it was upon this that 'the pattern of industrial organisation' for the new, incoming industry of mass-produced footwear was based.

21. *Ibid*. The census of population of 1871 gave the population of the town as over 95,000. At the turn of the century it was over 200,000 (see Simmons, J., 'The Power of the Railway', *The Victorian City Images and Realities*, vol. II, *Shapes on the Ground/A change of Accent*, eds H.J. Dyos and M. Wolff, London, Routledge & Kegan Paul, 1973, p.299).

22. *Ibid*.

23. *Ibid*., p.54.

24. Figures from the official census returns for 1991.

25. Cantor, L. and Squires, A., *The Historic Parks and Gardens of Leicestershire and Rutland*, Leicester, Kairos Press, 1997, p.65. Simmons, J., *Mid-Victorian Leicester*, reprinted from the *Transactions of the Leicestershire Archaeological and Historical Society*, vol. XLI, 1965–6, Society of the Guildhall, Leicester 1967, p.49: Simmons notes that Leicester was somewhat 'tardy' in public improvements and this included a reluctance to the creation of public parks where it 'lagged behind' Derby and Nottingham.

26. For the standard account of this tradition see Temple Patterson, A. (1954). See also Simmons, J. (1967) pp.52–3 where he summarises briefly the political and non-conformist nature of the town in the mid-Victorian period.

27. See Beaumont, L. de, *The History of Leicester School of Art 1869–1839*, M.Phil. Thesis, Leicester Polytechnic (De Montfort University), 1987.

28. Simmons, J. (1974), 2, p.144.

29. Sir Israel Hart was a prominent member of the Jewish community who was mayor in 1884, 1885, 1886 and 1893. For a history of Hart's role in the Jewish community see Newman, A. and Lidiker, P., *Portrait of a community: a history of the Leicester Hebrew Congregation*, Leicester, Lithigo Press, 1998.

30. Burton was also a key figure in the projects to raise statues to John Biggs, Robert Hall, John Wycliffe and Hugh Latimer.

31. Everitt, A.M. (1972), pp.43–4. The market on this site had been of great local and regional significance in the seventeenth century and was originally the site for the Barrel Cross.

32. The project as the catalogue entry below indicates was pushed forward by the East Gates Committee to which Burton was Honorary Secretary.

33. Fraser, D. (1978) p.169. Evans, R.H., 'The local government of Leicester in the nineteenth century', *The Growth of Leicester*, ed. A.E. Brown, Leicester, Leicester University Press, 1972, makes it clear that as a result of the 1848 Public Health Act (applied in Leicester in 1849) the Corporation acted as the Board of Health, and a waterworks company was established in 1851. By 1855 £40,000 had been spent on main sewers with the first sewage works being established. Three reservoirs were built to provide water for the region: Thornton (1851), Cropston (1866) and Swithland (1899).

34. In 1849 Angus Reach in *The Morning Chronicle* noted the 'miserably defective drainage' and the incidence of fever in the lower lying areas of the town which meant that whilst the mean duration of life in England was 29.11 years, in Leicester it was only 25 years.

35. *Payne's Leicester Advertiser*, 12 July 1845 quoted by Fraser (1978) p.168, n.57.

36. Simmons, J., *Mid-Victorian Leicester*, reprinted from the *Transactions of the Leicestershire Archaeological and Historical Society*, vol. XLI, 1965–6, Society of the Guildhall, Leicester 1967, plate I (a, b), plate II (a) shows the market place in 1847, 1881 and 1852 respectively; those of 1852 and 1881 showing the statue *in situ*. The Corn Exchange had been raised in 1851 initially as a market hall to replace two former municipal halls, with the upper storey – the corn exchange – and external staircase added in 1855.

37. For a survey of landholding in Leicestershire and Rutland between 1873 and 1941 and after the 5th Duke's death and the importance of the Rutland estate in the county, see Reeder, D., *Landowners and Landholdings in Leicestershire and Rutland 1873–1941*, Leicester, University of Leicester Centre for Urban History, 1994.

38. See below entry for statue of John Henry Manners, 5th Duke of Rutland, Market Place, note 4.

39. Borsay, P., '"All the town's a stage": urban ritual and ceremony 1660–1800', *The Transformation of English Provincial Towns*, P. Clarke (ed.), London, Hutchinson University Library, 1984, pp.228–58.

40. See for example the entry for Coalville, High Street in the catalogue below and the view expressed by the Vice-Chairman of the Coalville Urban Council arguing against abstract forms because they would not be understood.

41. See below entry for Coalville, High Street. Coalville was created in the nineteenth century as a result of the need to house coal industry workers.

42. *Ibid*.

43. Leicestershire County Council, Department of Planning and Transportation, fundraising letter from Tony Lockley to local firms in Lutterworth, 14 June 1996.

44. Public Art in North-West Leicestershire. *A sculpture for the National Forest (report)* as cited under the catalogue entry for Moira.

45. Moira was formed in 1811 to provide housing for miners working in the Ashby Wolds collieries, Ellistown was built for similar purposes in the mid nineteenth century and Snibston was similarly enlarged.

46. Fussell, P., *The Great War and Modern Memory*, Oxford, Oxford University Press, 1977, p.315. For a study of the ways in which British and European memorials and art functioned as a means of coming to terms with the war, see Winter, J., *Sites of Memory, Sites of Mourning: the Great War in European Cultural History*, Cambridge, Cambridge University Press, 1995.

47. Sharpe, J., *The War Memorials of Leicestershire and Rutland*, unpublished MA thesis, De Montfort University, 1992, p.1.

48. *Ibid*. For a broader-based study see Borg, A., *War Memorials from Antiquity to the Present*, London, Leo Cooper, 1991.

49. Borg, A. (1991) p.75. See also Moriarty, C., 'Private Grief and Public Remembrance: British First World War Memorials', Evans, M. and Lunn, K. (eds) *War and Memory in the Twentieth Century*, Oxford and New York, Berg, 1997, pp.125–42. Catherine Moriarty has pointed to the fact that 'the sheer speed of memorialising activity towards the end of the war and in the immediate post-war period thwarted the possibility of control by legislative or other means ... Choices were made locally rather than determined from above, yet it is important to emphasize that memorials rarely challenged official interpretations of the war' (p.126).

50. All the memorials in the two counties were surveyed and the information passed to the National Inventory of War Memorials for inclusion on their database. The paper archive will be held by the Leicestershire Record Office with the rest of the archive for the region.

51. Sharpe, J. (1992) p.5.

52. Figures from Sharpe, J. (1992) p.65, n.4. Here Sharpe cites Phillips, G., *Rutland and the Great War*, Salford, J. Pastfield & Co, 1920 where it is claimed that the loss of 14% of the population was two per cent above the national average.

53. Sharpe, J. (1992) p.9, p.23, who reveals the significance of the debate over how the names were to be recorded on the memorial found in the minutes of the Dunton Bassett War Memorial Committee. The decision to do so was not unanimous.

54. Moriarty, C., (1997) pp.126–30 summarises the processes usually followed in the choice of memorials by communities.

55. Sharpe, J., (1992) p.61.

56. See for example Leicester's Secular Hall with its busts of *Christ, Owen, Paine, Socrates*, and *Voltaire*.

57. See entries for Leicester, East Avenue and Hinkley Road.

58. Simon, B., 'Education in Leicestershire', *Leicester and its region*, ed. N. Pye, Leicester, Leicester University Press, 1972, p.506.

59. *Ibid*. Here Simon refers to a 'collection of paintings, sculpture and mobiles by contemporary artists that is nationally known'.

60. The sculptors included (although works by some were not on display) were Maurice Agis, Anthea Alley, David Annesley, Brian Bishop, Michael Bolus, Antanas Brazdys, Ralph Brown, Laurence Burt, Shirley Cameron, Lynn Chadwick, Michael Chilton, Geoffrey Clarke, Alfred Dunn, Georg Ehrlich, Jacob Epstein, Garth Evans, Stephen Gilbert, Gerald Gladstone, David Hall, Barbara Hepworth, Gertrude Hermes, Antony Hollaway, John Hoskin, Maurice Jadot, Douglas Jeal, Michael Kenny, Phillip King, Bryan Kneale, Kim Lim, Denis Mitchell, Henry Moore [n.b., this was a printed fabric panel], Tony Morgan, Francis Morland, Victor Newsome, Ezra Orion, David Partridge, Ron Robertson-Swann, Matt Rugg, Neil Rutherford, Christopher Sanderson, Michael Sandle, Bernard Schottlander, Tim Scott, Shinchiki Tajiri, William Tucker, Brian Wall, Isaac Witkin, Derrick Woodham, Austin Wright.

61. This is now entitled 'Artworks' and is administered by the County Museum Service.

62. It should be noted that because many of these works are sited inside schools, and as part of 'Artworks' have no permanent fixed site, only a small number are included in this catalogue. An inventory of the collection is held by the Leicestershire Museum Service, based at the Sherrier Centre, Lutterworth; an inventory of the works purchased by the LEA is held at Beaumanor Hall.

63. *Growing up with Art: the Leicestershire Collection for Schools and Colleges*, Whitechapel Art Gallery, London, 1980, p.3.

64. *Ibid*., p.9.

65. Mason, S., in *British Sculpture and Painting from the Collection of the Leicestershire Education Authority in collaboration with the Loughborough University of Technology*, Whitechapel Gallery, London, 1967, p.30.

66. See Robertson, B., 'Introduction', in *ibid*., p.11.

67. For a discussion of Mason's part in the formation of the Leicestershire plan see Jones, D. (1988) pp.167–9. For the situation in the city, see Rimington, G.T., *The Comprehensive School Issue in Leicester 1943–1974, and other essays*, Peterborough, IOTA Press, 1984. For an outline of the development of

education in Leicestershire up to the early 1970s see Simon, B. (1972), pp.493–514.

68. With regard to the 'bulge' in population see *Circular 145* issued by the Ministry of Education on 6 June 1947. This asked local LEAs 'to make an assessment of problems of catering for the coming "bulge" – with particular reference to school accommodation, the supply of teachers and the supply of furniture'. See Mander, J., *Leicester Schools 1944–1947*, Leicester, Leicester City Council, 1980, p.62 who analyses school building in the city during the period. For a broader view giving the national perspective in relation to the Ministry of Education (but one which makes only passing reference to Mason and Leicestershire) see Saint, A., *Towards a Social Architecture: the role of school-building in Post-War England*, New Haven and London, Yale University Press, 1987. Saint (pp.118–23) discusses the impact of the baby-boom and the funding of the school-building programme that ensued in the 1950s.

69. This seems to have been in the region of a quarter of 1 per cent. See Mason, S., in *British Sculpture and Painting from the Collection of the Leicestershire Education Authority in collaboration with the Loughborough University of Technology*, Whitechapel Gallery, London, 1967, p.34.

70. Nairne and Serota, pp.149, 150–1. Newsom had, for example, approached Henry Moore to make a sculpture for the Barclay School, Stevenage, see James, P.(ed.), *Henry Moore on Sculpture*, 1966, p.225.

71. See for example the entry for Langmore, Langmore Primary School.

72. Referred to in the catalogue below as the 'building capital grant'.

73. Referred to in the catalogue below as the 'initial stocking grant'.

74. Mason, S. in *British Sculpture and Painting from the Collection of the Leicestershire Education Authority in collaboration with the Loughborough University of Technology*, Whitechapel Gallery, London, 1967/8, p.27.

75. See entry for Loughborough, Bridge Street, Limehurst High School.

76. Kay, J., 'Sculpture, Schools and People – The work of Peter Peri', *Peter Peri*, Leicester, Leicestershire Museums, 1991, pp.9–10.

77. Davies, D., *Stewart Mason: The Art of Education*, London, Lawrence and Wishart, 1983, p.87, n. 12 quotes Phillip King's observation that Mason managed to get the 'most knock-down prices' of all concessions given to public bodies purchasing works.

78. *Ibid.*, pp.90–2.

79. *Ibid.*, p.105.

80. Mason, S.C., 'Introduction', *In our Experience*, (Education Today Series) London, Longman, 1970, p.xv.

81. Stanley, A. [Headmaster of Albert Road School, Hinckley] and Stanley, V. [teacher], 'A Primary School in a vintage Victorian Building', *In Our Experience* (ed. S.C. Mason), London, Longman, 1970, p.57.

82. Hazel Sibley, Headteacher in conversation with Donald Jones, July 1983, in Jones, D. (1983) p.85.

83. See entry for Earl Shilton, William Bradford Community College.

84. Loughborough College was awarded University status in 1966.

85. Elliott, M. (1979) p.16.

86. He received the degree of Doctor of Letters in 1971.

Abbreviations

1. Newspapers and periodicals

C. Times: Coalville Times
E. Echo: Evington Echo
H. Echo: Hinckley Echo
H. Guardian: Hinckley Guardian
H. Times: Hinckley Times
L. Advertiser: Leicester Advertiser
*L. Chronicle: Leicester Chronicle, Leicester
 Chronicle and Leicestershire Mercury,
 Illustrated Leicester Chronicle*[1]
L. Daily Post: Leicester Daily Post
L. Evening Mail: Leicester Evening Mail
L. Guardian: Leicester Guardian
L. Herald and Post: Leicester Herald and Post
L. Journal: Leicester Journal
L. Link: Leicester Link
L. Mail: Leicester Mail
*L. Mercury: Leicestershire Mercury, Leicester
 Daily Mercury, Leicester Mercury*
L. & R. Topic: Leicester and Rutland Topic
*L, R & S Mercury: Lincoln, Rutland and
 Stamford Mercury*
*Lo. and C. Trader: Loughborough and
 Coalville Trader*
Lo. Advertiser: Loughborough Advertiser
Lo. Echo: Loughborough Echo
Lo. Monitor: Loughborough Monitor
Lo. News: Loughborough News
M. Free Press: Midland Free Press
*M.H. Advertiser: Market Harborough
 Advertiser*

M.M. Times: Melton Mowbray Times
R. Times: Rutland Times

2. Transactions...

*Transactions of the Leicestershire Architectural
and Archaeological Society*, so-called from
1854 (vol. i) to 1913–14 (vol. xi); afterwards
entitled:
*Transactions of the Leicestershire Archaeological
Society*, from 1921–2 (vol. xii) to 1954 (vol.
xxx); afterwards entitled:
*The Leicestershire Archaeological and Historical
Society. Transactions*, from 1955 (vol. xxxi)
to the present day

3. Organisations

DCMS: Department of Culture, Media and
 Sport; previously DNH: Department of
 National Heritage; previously DOE:
 Department of the Environment
EMA: East Midlands Arts
LRO: Leicestershire Record Office
PMSA NRP East Midlands Archive: Public
 Monuments and Sculpture Association
 National Recording Project East Midlands
 Regional Archive Centre (these archives are
 stored at the Leicestershire Record Office)
RBS: Royal Society of British Sculptors
RA: Royal Academy of Arts, Royal
 Academician; ARA: Associate of the Royal
 Academy; PRA: President of the Royal
 Academy
RIBA: Royal Institute of British Architects

4. Exhibitions

1955, London, O'Hana Gallery: 'Georg

Ehrlich', 5–24 May
1958, London, Royal Academy of Arts:
 Summer Exhibition
1960, London, Battersea Park: 5th LCC
 'Sculpture in the Open-Air',
 May–September
1960, London, Redfern Gallery: 'Kneale', 1–25
 November
1961, London, Waddington Galleries: 'Denis
 Mitchell. Sculpture', 2–26 May
1963, London, Battersea Park: 6th LCC
 'Sculpture in the Open Air', May–September
1963, London, Royal Academy: Summer
 Exhibition
1964, London, Hamilton Galleries:
 'Werthmann', December
1965, Arts Council of Great Britain, 'Towards
 Art II. Sculptors from the Royal College of
 Art' (touring exhibition)
1965, London, Redfern Gallery: 'Geoffrey
 Clarke. Recent Sculptures 1965'
1965, London, Tate Gallery, 'British Sculpture
 in the Sixties' (organised by the
 Contemporary Art Society in association
 with The Peter Stuyvesant Foundation), 25
 February – 4 April
1965, London, Whitechapel Art Gallery: 'The
 New Generation: 1965', March – April
1965–6, London, Hamilton Galleries: 'Antanas
 Brazdys', 15 December 1965 – 15 January
 1966
1966, London, Battersea Park: 'Sculpture in the
 Open Air', 20 May – 30 September
1966, London, Redfern Gallery: 'Alfred Dunn',
 1–26 November
1966, London, Rowan Gallery: 'Garth Evans',
 9–29 September

1. These titles ran consecutively. In the present
volume, 1849–64 dates are the *Leicester Chronicle*;
1865–1909 the *Leicester Chronicle and Leicestershire
Mercury and 1918 on the Illustrated Leicester
Chronicle.*[1]

1966, London, Whitechapel Art Gallery: 'Bryan Kneale. Sculpture: 1959 – 1966', February – March

1967, London, Hamilton Galleries: 'David Partridge', 14 March – 8 April

1967–8, London, Whitechapel Art Gallery: 'British Sculpture and Painting from the collection of the Leicestershire Education Authority in collaboration with the Loughborough University of Technology', December 1967 – January 1968, January – February 1968

1968, Arts Council of Great Britain: 'Sculpture in a City', touring exhibition: Birmingham, 24 May – 16 June; Liverpool, 23 June – 13 July; Southampton, 20 July – 10 August

1968, Camden Arts Centre: 'Survey '68: Abstract Sculpture', 20 June – 21 July

1968, Coventry, Cathedral ruins: 'Exhibition of British Sculpture', June–August

1969, Blenheim Palace Garden Centre, Woodstock, Oxfordshire: Open-air sculpture exhibition, 19 July – 13 September

1969, London, Redfern Gallery: 'Kenneth Draper', 7–31 October

1969, London, Redfern Gallery: 'Alfred Dunn. New Works 1969', 27 March – 18 April

1969, Nottingham, Midland Group Gallery: 'Sculpture in Nottingham', 21 June – 8 July

1970, Colchester, The Minories: 'Peri's People', June–July

1971, London, Annely Juda Fine Art: 'Antanas Brazdys. Sculpture', 27 October – 4 December

1971, Northampton, City Art Gallery: Robert Adams retrospective exhibition, January–February; toured by the Arts Council of Great Britain to Sheffield, March–April; Newcastle upon Tyne, May; and the Camden Arts Centre, London, June–July

1972, London, Royal Academy: 'British Sculptors '72', 8 January – 5 March

1974, Otterloo, Kröller-Müller National Museum: 'Phillip King', 7 April – 9 June

1975, London, Taranman: 'Geoffrey Clarke', 19 May – 30 June

1975–6, London, Hayward Gallery: 'New Work 2' (various artists), 6 December – 4 January

1978, London, Serpentine Gallery: 'Bryan Kneale. Sculpture. Work in Progress' (Arts Council of Great Britain), 20 May – 11 June

1978–9, Yorkshire Sculpture Park: 'William Pye', 24 September 1978 – 22 April 1979

1979, London, Victoria and Albert Museum: 'The Doulton Story', 30 May – 12 August

1980, Aberystwyth, Arts Centre, University College of Wales: 'William Pye. Sculpture for Public Places', 26 April – 17 May

1980, London, Whitechapel Art Gallery: 'Growing up with Art. The Leicestershire Collection for Schools and Colleges', 17 September – 26 October 1980 (then touring to Carmarthen, Henry Thomas Gallery, 17 November – 12 December 1980; Nottingham, Midland Group, 20 December 1980 – 26 January 1981; Barnsley, Cooper Gallery, 7 February – 8 March 1981; Kirkcaldy Art Gallery, 14 March – 12 April 1981; Durham, D.L.I. Museum and Arts Centre, 25 April – 17 May 1981; Southport, Atkinson Art Gallery, 8 June – 4 July 1981)

1981, London, Hayward Gallery: 'Phillip King', 24 April – 14 June

1981, London, Warwick Arts Trust: 'Kenneth Draper. Sculpture and Drawings 1962–81', 22 April – 23 May

1981, London, Whitechapel Art Gallery: 'British Sculpture in the Twentieth Century. Part 1: Image and Form 1901–1950', 11 September – 1 November

1981–2, London, Whitechapel Art Gallery: 'British Sculpture in the Twentieth Century. Part 2: Symbol and Imagination 1951–1980', 27 November – 24 January

1982, Colchester, The Minories: 'Kenneth Draper Sculpture, Paintings and Drawings 1962–82', 20 February – 21 March (then to Cardiff, 27 March – 24 April)

1983, London, Hayward Gallery: 'Anthony Hill. A Retrospective Exhibition', 20 May – 10 July

1987, London, Benjamin Rhodes Gallery: 'Zadok Ben-David', November

1987, London, Camden Arts Centre: 'Fighting Spirits: Peter Peri and Cliff Rowe'

1990, London, Gillian Jason Gallery: 'Denis Mitchell. A Retrospective. Sculptures 1951–1990', 11 July – 10 August

1994–5, Ipswich Borough Council Museums and Galleries touring exhibition: 'Geoffrey Clarke. Symbols for Man. Sculpture and Graphic Work', The Wolsey Art Gallery, Christchurch Museum, Ipswich, 17 December 1994 – 29 January 1995; The Herbert Art Gallery and Museum, Coventry, 11 February – 26 March 1995; Pallant House, Chichester, 15 April – 20 May 1995

1996, 'Chelsea Harbour Sculpture' (RBS exhibition)

1997, Florence, Forte di Belvedere: 'Phillip King', 8 June – 30 September (sponsored by the British Council and the Henry Moore Foundation)

Acknowledgements

We would firstly like to thank those people who gave up many hours of their own time to serve as members of the East Midlands Regional Archive Steering Committee (Chair, Professor Alison Yarrington) and whose advice, particularly on local matters, proved to be invaluable: Dr Chris Brooke (leader, Heritage and Resources Team Leicestershire County Council), Dr Richard Gill (Victorian Society), Ms Eleanor Harper (Senior Clerk, Research Office, University of Leicester), Dr Timothy Hobbs (University of Leicester Librarian), Mr Robin Jenkins (Keeper of Archives, Leicestershire Record Office), Mr T.H. McK. Clough (Curator, Rutland County Museum), Professor Charles Phythian-Adams (Emeritus Professor of English Local History, University of Leicester), Mr John Sharpe (Senior Historic Buildings Officer, Leicestershire County Council), Mr Mike Taylor (Conservation Officer, Leicester City Council), and Mr Peter Townsend (formerly Research Projects Administrator, University of Leicester).

We also owe a very great debt of gratitude to all those volunteers who helped by making site visits. These included Jean Baxter, John Bonehill, Jenny Booker, Pat Buckham, Kathy Charles, Paula Dobrowolski, Dorothy Fox, Emily Grycuk, Mike Hagiioannu, Barbara and David Harrison, Christopher Hearnden, Nicholas James, Robin Jenkins, Ann and Phillip Lindley, Anita Linsell, Barbara Musetti, Mark Richards, Joan Skinner, Mike Taylor, and Amber, Naomi and Nigel Wood.

Especial thanks go to Leicester City Council for making available the photographic skills of George Thomas Wilson, who provided us with many excellent photographs in the City of Leicester, and also to Colin Brooks, University of Leicester, who took many equally excellent photographs throughout Leicestershire and Rutland.

Others who should be thanked for their advice and help in a variety of ways include Sue Anderson (National Forest); John Aston; Geoff Brandwood; Carol Charles (University of Leicester); Zuleika Dobson; Karen Durham (formerly Leicester City Council); Roy Evans (Leicestershire County Council Education Dept.); Anne Fletcher (Loughborough University); Ken Ford; Bruce Fruin; Miriam Gill; Rachael Green (Leicestershire Education Authority); Dr Steve Gurman (University of Leicester); Professor Luke Herrmann (University of Leicester); Antony Hollaway; John Hutchinson; Richard King (Charnwood Borough Council); Tony Lockley (Leicestershire County Council); Ken Long; Jasia McArdle (Leicester City Council); Alan McWhirr (University of Leicester); Tessa Massey (North West Leicestershire District Council); J.P. Warwick Metcalfe (Uppingham School); Martin Minshall (Oakham School); Richard Mobbs (University of Leicester); David Parsons (University of Leicester); Kathryn Paterson; Marjorie Pickard; Pat Reid; Paul Roberts (ADW Partnership); Rowan Roenisch (De Montfort University); Adeline van Roon (The Centre for the Study of Sculpture, Leeds); Jerry Rudman (Uppingham School); Mrs Cecilia Slack; Dr Keith Snell (University of Leicester); Wendy Taylor; Professor Susan Tebby (De Montfort University); Karen Wilby (Hinckley and Bosworth Borough Council); and Rosalind Willatts (Harborough District Council).

Thanks are also due to Jo Darke, Ian Leith, Edward Morris and Benedict Read of the PMSA for reading and criticising the typescript, to Robin Bloxsidge, Liverpool University Press, for his continuing belief in the project of which this volume is a part, to Janet Allan, production editor, Michael Sherratt, copy-editor, Gwynn-fyl M. Lowe, proof-reader, Grant Shipcott, typesetter at XL Publishing Services, and finally to the Department of the History of Art and the Faculty of Arts of the University of Leicester for their unstinting support throughout this project.

Sources of Illustrations

Grateful acknowledgement is made to the following for the supply of photographs and for permission, where it has been possible to contact the source, to reproduce them: The Centre for the Study of Sculpture, Leeds: pp.192 (left), 312 (right), 314, 327 (left); The Conway Library: p.309; Ken Ford: p.321; John Goldblatt and the Whitechapel Art Gallery: p.313 (right); Iris Hannaford: p.263: John Cleveland College, Hinckley: p.59; Jeff Johnson, Bagworth Residents' Association: p.6; Eric Keeton: pp.310 (left), 324 (left); Leicester City Council, Arts and Cultural Services Section: p.190; Leicester City Libraries: p.184; Leicestershire County Council: p.252; Leicestershire Education Authority: pp.307, 308, 328; Leicestershire Record Office: pp.96 (both), 161 (right), 162, 312 (left), 316, 317, 319, 324 (right); Phillip Lindley: pp.276 (top right). 277; Loughborough University: p.327 (right); Phillips Fine Art Auctioneers: p.329; Jane Pountney: pp.315, 318; Mark Richards: pp.99, 148; Rutland County Museum: p.297; *Studio International*: p.310 (right); Wendy Taylor: p.313; University of Leicester Central Photographic Unit: pp.2, 4, 7, 8, 25, 26, 27 (both), 28 (both), 29, 38 (left), 40, 41 (both), 46, 51, 52, 62, 65, 67, 68, 69, 105 (right), 108, 112, 121 (both), 122, 140, 147 (top), 166, 167, 168, 169, 173, 174, 175 (left), 177, 193, 196 (right). 199 (left), 201 (all), 202 (right), 203, 204, 205 (left), 206, 207, 208 (both), 211 (left), 214, 215, 217 (both), 218, 219, 221 (both), 222 (left), 225, 235, 236, 241 (both), 242 (both), 243, 254, 257 (both), 258 (all), 259 (both), 260, 261, 264, 265 (both), 266 (both), 267, 268, 270 (right), 271 (all), 272 (all), 282, 294 (bottom), 295 (right), 298, 299, 300 (right), 304 (right), 322, 323; Uppingham School: p.304 (left); George Wilson, Leicester City Council: pp.79, 83, 84, 85, 87 (both), 89, 92 (both), 93 (both), 94, 98, 100 (all), 102 106, 107, 109 (both), 111, 113, 114, 117, 119, 123 (both), 124, 125, 126, 127, 128 (both), 129 (both), 130, 131, 132 (both), 133 (all), 135, 136, 137 (left), 138, 141, 149, 150 (both), 151 (both), 152, 155 (both), 156, 158 (both), 159, 179, 183, 192 (right); Alison Yarrington: pp.61 (left), 255 (both). All other photographs are by the author.

Organisation of the Catalogue

TERRY CAVANAGH

The following catalogue has been arranged by county, and within the two counties by town, village or rural location (e.g., Rutland Water, Saltersford Valley Picnic Area, etc.).

The length of each catalogue entry does not reflect the relative importance of its subject but rather the amount of information available; it has been the policy of the author to include all relevant information where known. The 'Literature' section at the end of each catalogue entry assembles all sources known to the author even where those sources have not contributed materially to the text of the entry.

The Leicestershire Education Authority has been without doubt Leicestershire's most important patron of contemporary sculpture. Many of the pieces are, however, small-scale and moveable and are by their nature outside the scope of this survey. Only those sculptures which are permanently-sited, either in the grounds or in a main circulation area are, therefore, the subjects of catalogue entries. Even this selection is not comprehensive, but it has been the aim of the author to include all the more significant pieces. An appendix (see p.333) gives a list by artist of all known LEA sculptures not included in the main catalogue.

Another important category that has had to be limited is war memorials. The original intention was to include all free-standing memorials, but it became clear that they would, by sheer weight of numbers, create an imbalance (and also double the size of the volume). Consequently it was with much regret that the decision had to be taken to include only those examples that incorporate figurative sculpture. All known free-standing war memorials in Leicestershire and Rutland which are not the subject of a catalogue entry are, however, listed in an appendix (see p.339).

Finally, and in common with PMSA guidelines for the series as a whole, two categories are excluded entirely, sculptures and monuments in ecclesiastical settings, and funerary monuments in cemeteries.

Leicestershire

ANSTEY
Civil Parish: Anstey
Borough Council: Charnwood

Link Road

The Martin High School (access only by prior arrangement), 1956, by T.A. Collins, County Architect

1. On the wall to the left of the main entrance:

Martins in Flight

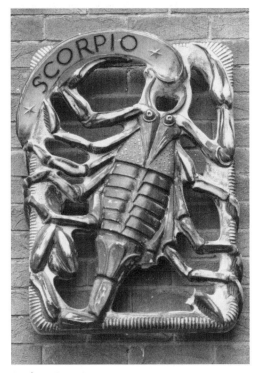

Soukop, *Scorpio*

Sculptor: Willi Soukop

Bird sculptures in sheet copper
Each bird: h. 26.25cm (10"); w. 45cm (1'6")
Executed: 1957
Status: not listed
Owner: Leicestershire Education Authority

Description: A flock of six martins in aluminium, flying left to right, each individually fixed to the exterior brick wall to the left of the main entrance of the school.

Condition: In addition to the six surviving martins, there are a further three pairs of small holes in the wall indicating the positions of lost birds. Of the remaining birds, the uppermost five are missing their right wings.

History: *Martins in Flight* was purchased by the Leicestershire Education Authority in 1957.[1]

Note
[1]LEA inventory.

2. Mounted at intervals on the exterior walls of the school buildings:

Signs of the Zodiac (series of relief panels)

Sculptor: Willi Soukop

Reliefs in polychrome tin-glazed earthenware
Portrait format reliefs: h. 78.75cm (2'7"); w. 56.25cm (1'10"); d. 7.5cm (3")
Landscape format reliefs: h. 56.25cm (1'10"); w. 78.75cm (2'7"); d. 7.5cm (3")
Inscriptions: each relief has a scroll with the name of the relevant sign inscribed on it, viz.:
AQUARIUS, PISCES, ARIES, TAURUS, GEMINI, CANCER, LEO, VIRGO, LIBRA, SCORPIO, SAGITTARIUS, CAPRICORN.
Executed: *c*.1957
Status: not listed
Owner: Leicestershire Education Authority

Description: The *Signs of the Zodiac* relief panels are fixed to the exterior elevations of the school buildings, and appear in the correct order if followed in a clockwise direction.

Condition: Most are in good condition. *Taurus*, however, is missing almost the whole of the right horn and the tip of the left, and *Scorpio* is missing the right back leg.

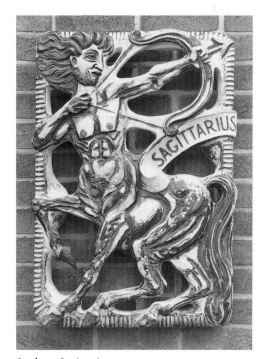

Soukop, *Sagittarius*

History: Although there appears to be no documentation relating to this series of reliefs they would in all likelihood have been installed as part of the original decoration of the building in 1956.

Related works: Other identical sets are at Burleigh Community College, Loughborough (incomplete; see p.277) and Guthlaxton Community College, Wigston (complete; see p.284).

Literature
Berger, J., 1957; Pevsner, N. and Williamson, E., 1992, p.72.

APPLEBY MAGNA
Civil Parish: Appleby Magna
District Council: North West Leicestershire

Top Street

Sir John Moore's Church of England Primary School, 1693–7. Building was begun by Thomas Woodstock to designs by Christopher Wren. Following Woodstock's death in 1694, Sir William Wilson took over, modifying with Wren's approval (as he later claimed) the original designs.[1]

Inside the school (access only by prior arrangement), on the east wall of the assembly hall, is an aedicule containing:

Statue of Sir John Moore

Sir John Moore (1620–1702), lead merchant, alderman and benefactor, was born in Norton-juxta-Twycross, Leicestershire, a son of Charles Moore who, in 1599, had purchased the manor of Appleby Parva. John Moore moved to London, entered the East India trade, was elected an alderman in 1671, Sheriff of London in 1672 (and was knighted the same year), and Lord Mayor of London, 1681–2. In 1683, in recognition of his loyalty to the crown during the difficult times of his mayoralty, King Charles II granted him an augmentation to his arms of 'a canton, gules, charged with a lion of England'. Moore was MP for the City of London in 1685. Having no direct heir, he devoted much of his wealth in later years to charitable causes. He was President of Christ's Hospital in 1681 and funded the building of its writing and mathematical schools in 1693. He also rebuilt the Grocers' Company Hall, London, 1682, of which company he had been a member since 1649 and master in 1671–2. Sources: *DNB*; Dunmore, R., 1992.

Sculptor: Sir William Wilson

Mason (decorative carving of the aedicule): Thomas Sabin[2]

Statue in stone, painted white
Statue h. (est.): 1.68m (5'6")
Aedicule h. (est.): 4.27m (14'); w. 1.86m (6'1")
Inscription on a tablet set into the wall beneath the niche:
TO the Memory / of SʀR. IOHN MOORE Knight & ALDERMAN of the / CITY of LONDON who Erected this SCHOOLE / A°Dˉ 1697 And Endowed yᵉ same for yᵉ Education / of yᵉ Male Childern [sic] of the Parishes & Towns of APPLEBY / NORTON, AUSTERY, NEWTON in ye THISTLES, STRETTON in yᵉ FIELD, / MESHAM, SNARSTON, CHILCOT. And by yᵉ STATUTES / made A:D: 1706 it was made FREE for all ENGLAND.
Executed: 1700
Status of building: Grade I
Owner: Sir John Moore's Church of England Primary School

Description: A standing statue of Sir John Moore set within an aedicule. The aedicule comprises a round-headed niche under a segmental pediment bearing the Moore coat of arms, the details picked out in colour. The

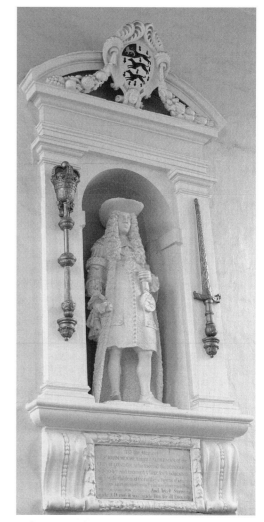

Wilson, *Sir John Moore*

pilasters are decorated with gilded reliefs: that on the left representing the Lord Mayor's mace and that on the right, the ceremonial sword. Moore is portrayed wearing a long wig under a wide-brimmed hat and a floor-length fur cloak over a knee-length coat. Beneath the niche,

between scroll brackets, is a tablet bearing the dedicatory inscription (see above).

Condition: There are small losses to the forward parts of the statue: Moore's nose is damaged and the brim of his hat and the hem of his coat are chipped.

History: Sir John Moore's reasons for building the school at Appleby Magna are set out in a letter dated 15 June 1695 to his nephews George and Thomas Moore, who still lived in Leicestershire and to whom Sir John had entrusted supervision of the building works:

> Lett Norton[3] Gentlemen know from me. I do put my selfe upon 4: to five thousands [pounds] charge at least for the benefit of the present: and future generations to come. because there I drew my first breath, And do it as an acknowledge[ment] of my thankfulness to God, for his goodness to me. to make me able to returne this acknowledgement, of my thankfulness to him: which may prove with Gods blessing to their posterity better than all their estates are worth: for what are men without education and learning. I praise God. I have found the benefitt of it: for without learning men are not prepaired for preferment. you may informe them what I write: from experience.[4]

Although Sir John had already consulted Sir Christopher Wren on the designs for the school at Appleby, he also instructed his nephews to engage the services of a local man as on-site architectural advisor. The man they selected was Sir William Wilson, a Leicester-born architect, mason and sculptor then living at Castle Bromwich[5] who would not only build the school but also execute Sir John's portrait statue.

The earliest documentary reference to the statue seems to be in a note from Wilson to John Moore (another of Sir John's nephews, acting from about 1697 as his London agent),

dated 10 June 1700, stating his intention to have the statue in place 'this Summer'.[6] Wilson eventually delivered it to the school on 6 September of that year.[7]

Meanwhile arrangements had been made relating to the inscription beneath the niche which had been created at the east end of what was then the principal schoolroom. Although Sir John was clearly willing to countenance a statue of himself, he initially resisted approving an inscription 'while he lives, because it looks like ostentation, or vain glory'. At last, however, he yielded to his nephews' wishes that the basic facts of his donation of the school be inscribed. Consequently, on 3 September 1700 John Moore wrote to Wilson with the approved wording, stressing 'And nothing else must be writt'.[8] Indeed, the only alterations to this wording were the insertion of the word 'male' before the word 'Childern' and, after Sir John's death, the addition by the trustees of the final phrase beginning 'And by ye Statutes …'.[9]

The surviving documents relating to the building of the school give, in the recurrent and long-running disputes over payment that form a great part of their content, clear evidence of a significant level of mismanagement of Sir John's enterprise by his nephews in Appleby. Undoubtedly Wilson's elaborations of Wren's original design (which were insufficiently controlled by the Appleby Moores) were partly the cause of the exorbitant bills but, one suspects, there was also more than a little opportunism on the part of the workmen who, from Wilson downwards, appear to have been trying to make financial capital out of the situation. Thomas Sabin, the principal mason, was in dispute with John Moore from October 1697 until the matter was resolved in the latter's favour in March 1698. He had originally submitted bills to a total of £595 but Moore had shown them to 'a workman and mason [in London]' who reckoned them to be too high:[10] ultimately Sabin accepted £532. 5s. 0d.[11]

Wilson for his part attempted to charge £125 for the statue. John Moore again sought out professional advice. He asked '2 or 3 masons, one belonging to St Paul's Church, and another that hath made severall Statues in the Company's Halls' what such a statue should cost and, as he points out in his letter to the sculptor:

> … some value it at £70, and some more, one £5 more, but I assure you none above £90. And I would not give you 2d. less than the value, but had rather give you £5 more to gratify anything done for Sir John Moore …[12]

The above-mentioned £90 is the amount the far better known Grinling Gibbons had charged for his *Statue of Sir John Moore* for Christ's Hospital in 1695.[13]

Evidently Wilson's fee of £125 for 'Surveying the work at ye Schoole' was also deemed to be excessive and towards the end of March 1702 Wilson decided to travel to London to discuss the matter with Sir John Moore himself.[14] Sir John was by now in a poor state of health (he was to die on 2 June of that year) and, if Wilson's account is to be believed, aggravated his condition by insisting that he and Wilson drink a couple of glasses of wine each during their meeting. The drink, according to Wilson, went straight to Sir John's head and made it impossible to do business with him. Wilson writes that Sir John had begun by agreeing that his prices were fair but:

> … I observe ye wine makes him ten times worse than with out it, for, tell him what you will, hee [forgets] as fast as hee hears. Soe I see it is to noe purpose to reason with him, or have his worde for any thing.[15]

Sir John later denied agreeing to Wilson's prices and the latter, in apparent exasperation, agreed in settlement of both his architectural and sculptural work, a sum of just £100 over and above the £26 already paid to him.[16]

Literature
Dunmore, R., 1992, pp.21–2, **23**; Gunnis, R., [1964], pp.339, 434; Nichols, J., 1811, vol. 4, pt ii, p.441; Pevsner, N. and Williamson, E., 1992, pp.75–6; Wren Society, 1934, pp.85, 100–2, 104, 105–7, 123, pl. **lv**.

Notes
[1] Dunmore, R., 1992, p.13. [2] Gunnis, R., [1964], p.339. [3] Norton-juxta-Twycross, Sir John Moore's birthplace, just south of Appleby. [4] As quoted in Dunmore, R., 1992, p.8. [5] *Ibid.*, 1992, p.9. [6] Wren Society, 1934, p.105. [7] Note from Thomas Moore, George Moore and G. Wait to John Moore, dated 7 September 1700, transcribed in *ibid.*, p.105. [8] Letter from John Moore to Thomas Moore, dated 3 September 1700, transcribed in *ibid.*, p.105. [9] Dunmore, R., 1992, p.21–2. [10] Wren Society, 1934, pp.100–1. [11] Dunmore, R., 1992, p.19. [12] Letter from John Moore to Sir William Wilson, dated 12 March 1701/2, transcribed in Wren Society, 1934, p.106. [13] *Ibid.* (introduction, n. pag.). [14] *Ibid.*, 1934, p.106. [15] Letter from Sir William Wilson to John Moore, dated 25 April 1702, transcribed in *ibid.*, p.107. [16] *Ibid.*

ASHBY-DE-LA-ZOUCH
Civil Parish: Ashby-de-la-Zouch
District Council: North West Leicestershire

Bath Street

At the junction of Bath Street, Station Road and South Street:

Memorial to Edith, Lady Maud Hastings, Countess of Loudoun

Edith Maud Hastings, (1833–74), married Charles Frederick Clifton in 1853. In 1859, by Act of Parliament, Edith and her husband assumed the surname and arms of Abney-Hastings. She died at Ventnor, Isle of Wight, on 23 January 1874.

Architect: Sir George Gilbert Scott
Contractors: Farmer and Brindley[1]

Memorial in Hopton Wood stone[2]
h. 21.34m (70')

Inscriptions on shields on the lower part of the memorial:
– on the west face: IN MEMORY OF / EDITH MAUD. / COUNTESS OF LOUDOUN; / IN HER OWN RIGHT; / BARONESS BOTREAUX, / HUNGERFORD, DE MOLEYNS, / AND HASTINGS; / WHO, / SPRUNG FROM / AN ILLUSTRIOUS ANCESTRY, / HERSELF POSSESSED / THEIR NOBLEST QUALITIES. / THE PEOPLE OF / ASHBY-DE-LA-ZOUCH / AND ITS NEIGHBOURHOOD / HAVE RAISED THIS CROSS, /

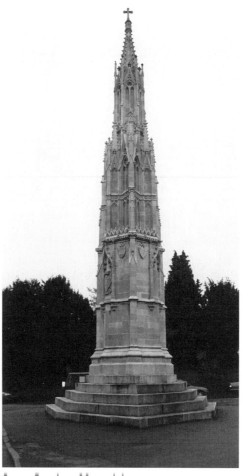

Scott, *Loudoun Memorial*

A TRIBUTE OF ADMIRATION / AND OF LOVE. / 1874.
– on the north-east face below the Countess of Loudoun's arms: TRUST WINNETH TROTH
– on the south face below the Abney-Hastings arms: IN VERITATE VICTO[RIA]
Unveiled: Thursday 24 July 1879, by W.E. Smith, Chairman of the Loudoun Memorial Committee
Status: Grade II*
Owner / custodian: Ashby-de-la-Zouch Town Council

Description: Modelled on the type of an 'Eleanor' cross, the memorial is a hexagonal neo-Gothic tower surmounted by a cross. The memorial's heraldry and inscriptions are described by W. Scott as follows:

> … on the lower part of the structure are three niches, containing the arms of the Countess, those of her husband, and the inscription. Between the niches and the corners of the monument, are six shields, carved in stone, and suspended by sprays of foliage, copied from the tomb of Aylmer de Valence, Earl of Pembroke, (d.1316), in Westminster Abbey, an ancestor of the Countess. These shields contain respectively the arms of – (1) Hastings, Baron Hastings, which dates back to 1441; (2) Rawdon, Earl of Moira; (3) Hungerford, Baron Hungerford, created 1426, and Botreaux, Baron Botreaux, created 1368; (4) Pole, Baron Montagu; (5) Plantagenet, Countess of Salisbury; (6) Neville, Earl of Warwick. All these arms were borne by the Countess in right of her descent from the heirs of those families. The first of the three niches contains the arms of the Countess of Loudoun on a lozenge, surmounted by her coronet, and beneath, her motto, 'Trust Winneth Troth.' Besides the arms already named, it bears in the first quarter the arms of Abney-Hastings quarterly, and in

addition the arms of de Moleyns 1445, Montacute, Monthermer, and Loudoun, created in 1601. The next niche bears the arms of Mr. Abney-Hastings, surmounted by two helmets, bearing the crests of Hastings and Abney, and beneath, the motto, 'In Veritate Victoria'. These arms are (1st) quarterly Hastings and Abney, (2nd) Clifton of Clifton and Lytham, (3rd) Molyneux of Sefton, (4th) Lucy of Charlecote; and in the middle, on an "escutcheon of pretence," the arms of the Countess, which are similar to those on the shield. The third niche contains the inscription [see above] composed by Lord Beaconsfield …[3]

Condition: Fair, although there is some weathering to the stonework – most notably the end of the scroll bearing the Abney-Hastings motto is now missing. The memorial was restored in 1999.

History: The *Loudoun Memorial*, one of Sir George Gilbert Scott's last designs, was completed in 1879, the year after his death. The project originated at a public meeting at Ashby-de-la-Zouch in February 1875.[4] The meeting having decided that a public memorial to the Countess should be erected in the town in recognition of her many acts of charity, a committee was duly formed to supervise a public subscription. In all, £3,000 was collected.[5] In his speech at the unveiling ceremony, the Chairman of the memorial committee, W.E. Smith, alluded to those qualities for which the Countess was most admired and which fuelled the public subscription:

She may be described as one in whom the poor ever found a true friend, the sorrowing a comforter; no one ever went to her in distress and returned unrelieved from her doors. Kind and open-hearted, of great intellect and acuteness, she lived beloved and

died regretted by all …[6]

The dedicatory inscription on the memorial was composed by Benjamin Disraeli, 1st Earl of Beaconsfield, a close and long-term friend of the Countess,[7] then enjoying his second term as Prime Minister (1874–80).

Related works: (i) (Sir) George Gilbert Scott (architect) and Henry Weekes (sculptor), *Martyrs' Memorial* (based on the Waltham Eleanor Cross), 1841–3, Oxford; (ii) E.M. Barry (architect) and Thomas Earp (sculptor) *Eleanor Cross*, 1863, London, Charing Cross; (iii) *The Countess's Cross*, 1874, another memorial to the Countess of Loudoun, on her estate at Donington Park, Castle Donington.

Literature
Art Journal, vol.xviii (n.s.), 1879, p.235; Ashby-de-la-Zouch Civic Society, n.d., pp.4, 15, **4**; *Ashby-de-la-Zouch Gazette*, 2 August 1879, p.5; *Builder*, vol. xxxvii, no. 1905, 9 August 1879, p.900; Hillier, K., 1984, p.99, **99**; *L. Advertiser*, 26 July 1879, p.5; *L. Chronicle*, 26 July 1879, p.5; *L. Daily Post*, 25 July 1879, p.3; *L. Journal*, 1 August 1879, p.3; *L. Mercury (Weekly edn)*, 26 July 1879, p.6; Pevsner, N. and Williamson, E., 1992, p.85; Scott, W., 1907, pp.172–81.

Notes
[1] Scott, W., 1907, pp.178–9. [2] Ashby-de-la-Zouch Civic Society, n.d., p.4. [3] Scott, W., 1907, pp.179–80 [4] Ibid., p.178 [5] Ibid., p.179 [6] Ibid., p.180 [7] *Ashby-de-la-Zouch Gazette*, 2 August 1879, p.5

Lower Church Street

In the western part of St Helen's Parish Churchyard:

War Memorial

Architect: unknown

Sculptor: unknown

Memorial in limestone, lead and red brick
h. 3.98m (13'1')
Inscriptions:
– running around the base of the shaft of the

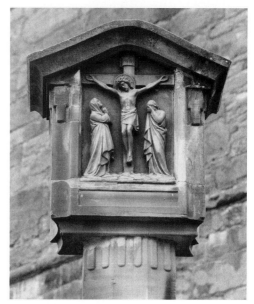

St Helen's Churchyard War Memorial

cross in raised letters:
GRANT THEM O LORD ETERNAL REST
– running around the pedestal in raised interlaced letters: IN GLORIOUS MEMORY OF ALL THOSE WHO FROM THIS TOWN GAVE THEIR LIVES FOR ENGLAND AND FOR US 1914 – 1919
Unveiled and dedicated: Thursday 13 November 1919, by Mrs R. Abney-Hastings and the Rt Revd Dr Norman Lang, Bishop of Leicester
Status: Grade II
Owner / custodian: Ashby-de-la-Zouch Town Council

Description: The war memorial is in the form of a pedimented tabernacle framing a lead relief of Christ on the Cross flanked by standing figures of the Virgin Mary and St John the Evangelist. The tabernacle is raised upon an octagonal, concave-faced shaft, elliptical in plan, with a moulded base bearing one of the two

inscriptions. This in turn is mounted on an octagonal pedestal bearing the second inscription, this being notable for the way individual letters are folded round the corners to indicate the continuity of the wording around the pedestal. The pedestal is mounted on a low base of stone on three courses of red bricks.

Condition: Generally good, although the stone is now rather weathered.

History: The memorial was presumably erected by the parishioners of St Helen's Church (no contemporary records have yet been found) as their own tribute to the 123 men of Ashby-de-la-Zouch who gave their lives in the First World War. The main memorial to Ashby's war dead stands in Market Street: it was designed by T.H. Fosbrooke and was unveiled and dedicated by Lady Hood and the Rt Revd Dr Frank Theodore Woods, Bishop of Peterborough, on Thursday 8 June 1922.

Literature
Kelly's Directory . . . of Leicester and Rutland, 1922, p.25; *L. Chronicle*, 7 February 1920, p.14; *L. Daily Post*: – [i] 26 September 1919, p.6 [ii] 14 November 1919, p.6; *L. Mercury*, 14 November 1919, p.8; Sharpe, J.M., 1992, pp.24, 48, fig. **3.17**.

SEE ALSO Thornton Reservoir p.279

SEE ALSO Thornton Reservoir p.279

BAGWORTH
Civil Parish: Bagworth
Borough Council: Hinckley and Bosworth

Station Road

Temporarily sited outside Bagworth Community Centre (ultimately to be erected on the site of the former Bagworth Colliery):
Bagworth Miners' Memorial
Sculptor: Paul Williams

Sculpture in bronze

Founders: Accrite Aluminium
Unveiled: Saturday 6 November 1999, by former pitmen George Farmer, Derek Smith, and Derrick Holmes
Status: unlisted
Owner: Bagworth Residents' Association

History: The closure of the coal mine at the centre of Bagworth in the 1980s effectively split the village into two parts. In 1991, the Residents' Association agreed that in order to generate the much needed redevelopment of the village centre they should take the initiative and commission a memorial to Bagworth's mining heritage.[1] Jeff Johnson, spokesman for the Association, contacted East Midlands Arts who recommended sculptor Paul Williams. Having already decided that the memorial should take the form of a naturalistic representation of a miner working at a coalface, the Residents' Association offered the brief to Williams who came up with an acceptable wax model.[2]

There was then an eight-year delay while the Residents' Association raised the necessary £12,625, an initial application to the National Lottery for funding having been turned down on the grounds that the memorial had already been commissioned. Johnson attributes the attainment of the target largely to the energetic support the Association received from Hinckley and Bosworth Borough Council's Strategic Arts Officer, Karen Wilby. The Residents' Association ultimately raised about £5,000, while the remainder was obtained in the form of various grants: £1,525 from Hinckley and Bosworth Borough Council's Policy and Resources Committee, £1,000 from the Coalfields Rural Initiative Fund and £2,500 from Leicestershire County Council, this last consisting of £1,000 from its Leicestershire and South Derbyshire Coalfields Rural Development Fund, plus a £1,500 Local Landmark Grant

There was also an initial problem with the site for the memorial, which the Residents' Association insisted had to be on the site of the former coal mine. The Coal Board, then in the process of negotiating the sale of the land, was naturally reluctant in the meantime to grant permission to erect a memorial on it. Ultimately the land was bought by property developers Strawson Holdings who readily gave permission to erect the memorial in the centre of what was to be a new housing development. At this point yet another complication arose owing to the fact that whereas the various grants had to be taken up before the end of the Council's financial year it would obviously be somewhat reckless to put up a memorial on a building site. Fortunately the Parish Council stepped in and granted the Residents' Association permission to erect the memorial temporarily outside Bagworth Community Centre pending completion of the former Coal Board site.

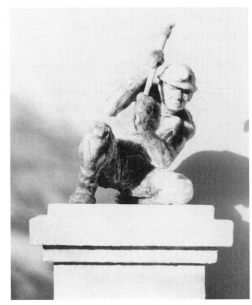

Williams, *Bagworth Miners' Memorial (model)*

The foundry, Accrite Aluminium, was chosen by the Residents' Association.[3]

Literature
C. Times: – [i] 11 June 1999, p.6, **6** [ii] 12 November 1999, p.11, 11; *L. Mercury*, 8 November 1999, p.3, **3**.

Notes
[1] *C. Times*, 11 June 1999, p.6. [2] *Ibid.*, illustration, p.6. [3] Information for this entry is largely from Jeff Johnson, Spokesman for Bagworth Residents' Association and Karen Wilby, Hinckley and Bosworth Borough Council Strategic Arts Officer.

BARLESTONE
Civil Parish: Barlestone
Borough Council: Hinckley and Bosworth

Barton Road

In Barlestone Memorial Gardens, to the left of the entrance from Barton Road:

The Circle of Time
Sculptor: Andrew Stonyer

Sculpture in Corten steel
h. 2.14m (7'0"); w. 1.65m (5'5"); d. 73cm (2'5")
Inscription printed on a plaque mounted on a nearby boulder:
'CIRCLE OF TIME' SCULPTURE. / SCULPTOR – A.A. STONYER / [beneath which is a diagram of the sculpture with the relevant dates symbolised by the segments and wedges of the circle, followed by the following verbal explanation:]
This sculpture celebrates and emphasises the last fifty years of peace by / contrasting it to the previous forty six years which were marked by two world / wars and considerable social and political upheaval in Europe. This cycle of / events is described in the detail of the sculpture. / [*space*] / Commencing from the top in a clockwise direction one proceeds from 1900 to / 1918 as defined by the first segment of the circle. Subsequently 1914 to 1918 is / defined by a wedge which breaks the circle and suggests violence and / destruction (First World War). The second segment proceeds from 1918 to 1939 / when it is

defined by a second wedge (Second World War). Moving to the / largest and most dominant segment, with its ascendant rotation to the top of the / circle, symbolises the last fifty years of peace. [*sic*] / [*space*] / The sculpture is in Corten Steel. / [*space*] / This sculpture was officially unveiled on August 10th 1996 by / T.G.M. Brooks JP, Lord Lieutenant of Leicestershire.
Unveiled and dedicated: Saturday 10 August 1996, by T.G.M. Brooks, JP, Lord Lieutenant of Leicestershire, and the Revd Len Carpenter, Vicar of Barlestone
Status: not listed
Owner / custodian: Barlestone Parish Council
Condition: Good

History: Barlestone Memorial Gardens, paid for by public subscription, were originally laid out in the 1950s as a setting for the village's memorial obelisk, commemorating its dead of two world wars. By early 1993, Barlestone Parish Council agreed that it was time for a major campaign of renovation and improvement and, after consultation with the parishioners, decided that a suitable enhancement might be provided by a specifically-commissioned sculpture. All agreed that it was essential that the sculpture should be 'sympathetic to the original purpose of the gardens as a place of remembrance' and that it should, in addition, both complement the existing war memorial in scale and colour and be of durable materials. No preference was expressed either way for figuration or abstraction.[1]

Although it had been hoped that the sculpture would be installed by March 1994, gathering the requisite funds took rather longer.[2] Ultimately the target was reached only with considerable financial assistance: the Parish Council managed to contribute £1,000, with the remainder of the cost covered by Leicestershire County Council (£1,000), Hinckley and Bosworth Borough Council (£500), the Caterpillar Tractor Company (£100)

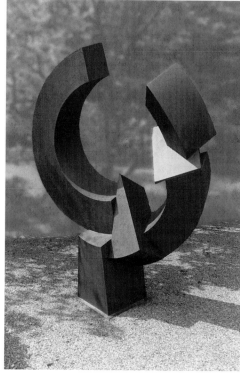

Stonyer, *The Circle of Time*

and Orbit Housing Trust (£25). Most important of all, however, was the £6,500 of National Lottery money awarded via the Arts Council of Great Britain.[3]

On 21 August 1995 a number of sculptors, selected by the Parish Council in consultation with East Midlands Arts, were invited to compete for the commission. Each sculptor was required to submit a full CV along with photographs of his or her previous work by 11 September. From the responses, a shortlist of four sculptors was drawn up comprising Hilary Cartmel, Polly Ionides, Judith Holmes Drewry and Andrew Stonyer. Each of the four was invited to submit drawings and maquettes of

their proposed sculptures by 2 November, payment for which was £250. The four sets of drawings and maquettes were then exhibited in Barlestone Primary School and Community College from 10–22 November so that local people could see the designs and express their preferences. Final selection, however, was entrusted to a six-person selection panel consisting of two members of the Parish Council, a sculptor, a civil engineer, Leicestershire County Council's senior landscape architect and a museum professional. Towards the end of November each of the sculptors was interviewed by the panel and on 30 November 1995, Andrew Stonyer was selected.[4] Stonyer's maquette, at the time of its submission to the exhibition, was still untitled. *Circle of Time* was in fact coined by a pupil of Barlestone Primary School and Community College.[5]

The full-size sculpture was fabricated by Stonyer in his workshop and brought to Barlestone Memorial Gardens on 31 May 1996 where it was installed to the left of the gate, thereby balancing the village war memorial, already sited to the right.[6] In designing the sculpture, Stonyer had taken into account both its immediate surroundings and its socio-historical context. As he explained:

> I have attempted to feature important issues concerning the life of Barlestone. The fact that this sculpture will be situated in close proximity to the memorial to the dead of Barlestone of the First and Second World Wars is an issue that I also wished to include in the sculpture and it is for this reason that the tapering base of the sculpture is designed to reflect the form of the War Memorial, and echo the pathos which the proportions of the latter seem to signify.
>
> Another important issue in the life of Barlestone, particularly over the last fifty years, concerns the mining industry.

Certainly this is apparent in the centre of the village where the presence of the wheel from the now disused colliery is all pervasive. One might take this as a symbol for a bygone industry, as indeed it is, nevertheless, it can also be read as the symbol for renewal and regeneration of life as defined by the circle. Hence, I see this wheel as such a potent visual element within the context of Barlestone because it prescribes the inevitability of a cycle of events; because it underlies the form and so much of the thinking behind this sculpture.[7]

Stonyer also gave careful thought to the material of the sculpture. He chose Corten steel for two main reasons: the first was practical, for the rust which naturally forms over the surface acts as a protective layer, thereby considerably reducing the amount of maintenance necessary and rendering graffiti difficult to apply; the second, directly related to this process, was aesthetic, for the resultant red-brown of the metal provides a strong complementary contrast to the green of the surrounding foliage.[8]

Literature
Leicestershire County Council archives. *Barlestone Memorial Gardens draft sculpture brief; Unveiling & Dedication of 'Circle of Time' Sculpture* (unveiling ceremony programme).
General: *C. Times*: – [i] 23 August 1996, p.14, **14** [ii] 10 October 1997, p.35, **35**; *L. Mercury (Harborough edn)*: – [i] 9 November 1995, p.4 [ii] 21 November 1995, p.4.

Notes
[1] Barlestone Memorial Gardens draft sculpture brief, August 1993, Leicestershire County Hall. [2] *Ibid*. [3] *Unveiling and Dedication of 'Circle of Time' Sculpture* (official programme). [4] Information from various documents at Leicestershire County Hall. [5] *Unveiling and Dedication of 'Circle of Time' Sculpture* (official programme). [6] Information from various documents at Leicestershire County Hall. [7] *Unveiling and Dedication of 'Circle of Time' Sculpture* (official programme). [8] *Ibid*.

BARROW-UPON-SOAR
Civil Parish: Barrow upon Soar
Borough Council: Charnwood

North Street to South Street

Fossil Sculpture Trail

Sculptors: 2nd year students of Loughborough College of Art and Design Sculpture Department

Date trail inaugurated: June 1998
Status of sculptures: not listed
Owner / custodian: Barrow-upon-Soar Community Association

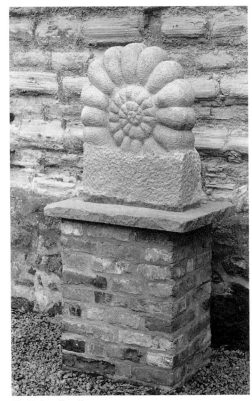

McCabe, *Fossil*

The area around Barrow-upon-Soar is rich in palaeontological deposits. To celebrate Barrow's 'important position in the world of palaeontology',[1] students of Loughborough College of Art and Design were invited by Barrow-upon-Soar Community Association to create a fossil sculpture trail through the village. The trail begins outside the Three Crowns Inn at the corner of Cotes Road and North Street. Moving along North Street, on the left one sees *Trilobite* (bronze resin plaque) by Nick Bartrum and *Shell Forms* (bronze forms in cement) by Emma Evans and, on the right, *Skeletal Relief* (bronze plaque) by Jamie Frost. Taking the next turning on the right into Breadcroft Lane, one finds *Three Ammonites* (bronze plaque) by Conal McCabe. A footpath on the right, immediately after Bryan Close, leads to Church Street. At the far end of the footpath is *Jurassic Amber* (bronze dragonfly set in clear resin) by Sara Spencer. The trail continues along Church Street and turns into Beveridge Street. On the right, near the corner, is *Broken Arc* (Ancaster weatherbed stone) by Michael Thacker. Further along Beveridge Street on the same side is *Fossil* (Cadeby stone) by Conal McCabe and opposite, on the left, *Trilobite II* (bronzed resin) by Sara Spencer and *Kuehneusaurus* (bronze) by Lorna Grossner. A left turn into Melton Road and one finds *Organic Forms* (cement and resin) by Glenn Webb. Another left turn into South Street and along to the traffic roundabout, Jerusalem Island, leads to the end of the trail, the village sign with its relief representation of a Plesiosaur skeleton.

Related works: (i) Mark Thacker, *Arc II*, Quorn (see p.262); (ii) Sara Spencer, *Trilobite*, Quorn (see p.256)

Literature
Barrow Community Association, *Fossil Trail. Barrow Upon Soar* (trail guide), n.d.

Note
[1] Barrow Community Association, *Fossil Trail*, n.d.

Cotes Road

Humphrey Perkins School (access only by prior arrangement), 1955, by T.A. Collins.

On the south-east facing exterior wall of Orchard Block:

Watching the Birds Flying by

Sculptor: Peter Peri

Mural relief in yellow concrete
h. 2.59m (8'6"); w. 6.38m (20'11")
Signed, in cement, at the extreme right of the ledge upon which the group of figures stands:
Peri
Executed: *c*.1955
Status: not listed
Owner: Leicestershire Education Authority

Description: The relief comprises two discrete groups, set high up on the exterior brick wall of Orchard Block, and bounded on the left by a corner of the building and on the right by a buttress flanking a doorway. At the lower left, on a narrow corbelled ledge, is a group of three figures: a standing youth and girl and a girl seated on the ground. The two standing figures look up towards a flock of six birds at the top right. The seated girl is drawing on a sketching block resting on her knees.

Condition: Generally good, although there is a long, fine, horizontal crack running across the thighs of the standing youth and the skirt of the standing girl. There is also, between the standing and seated girl, a vertical sequence of cracks, beginning in the mortar between the bricks and continuing through the ledge.

History: *Watching the Birds Flying By* was commissioned by Stewart Mason, then Director of the Leicestershire Education Authority, to complement County Architect T.A. Collins's extension to the school, completed in 1955. Mason seems to have maintained a close involvement with these commissions, selecting the themes to be represented (for example, see p.191) and suggesting amendments where he thought necessary. A letter dated 3 June 1955, from Collins to Peri, informing him of two required amendments, makes illuminating reading. The architect writes that the sculptor should alter the composition:

> … so that the girl sitting down on the right of the group would not appear to be perched

Peri, *Watching the Birds Flying By*

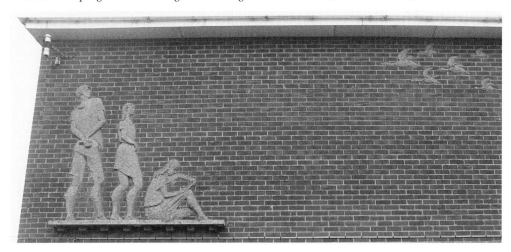

on the end of a spring-board. Also ... it might be better if the boy on the left of the group did not have his hand resting on the girl's shoulder.[1]

Whereas the first alteration was a straightforward matter of compositional adjustment (and may well have been an improvement), the second – which Collins clearly seemed embarrassed to add – gives an illuminating insight into the kind of details to which Mason, as guardian of the moral welfare of the young people in his schools, had to be sensitive and to which Peri presumably, in all innocence, had not given the slightest thought. Peri obviously complied with Mason's request, but one wonders whether there was not just a touch of impish humour in the over-compensation of his solution: the boy's stance is almost exaggeratedly drawn back from the girl, his right hand very emphatically holding his left wrist behind his back.

Peri executed the work, as was his usual practice, *in situ*, first applying the concrete mixture with a small trowel and then finishing off by carving the finer details. The colour he considered an essential element, it being not merely applied to the surface but forming an integral part of the mixture.[2]

Literature
The Centre for the Study of Sculpture, Leeds.
Kenny, S., 1980, pp.33–4.
General. Berger, J., 1957; Camden Arts Centre, 1987, p.43; Leicestershire Museum and Art Gallery, 1991, p.16; The Minories, 1970, n. pag; Pevsner, N. and Williamson, E., 1992, pp.44, 92.

Notes
[1] Letter dated 3 June 1955 from T.A. Collins to Peter Peri; quoted in Kenny, S., 1980, p.33.
[2] Camden Arts Centre, 1987, pp.25, 30.

Melton Road
In a memorial garden at the corner of Melton Road and Beveridge Road:

Barrow-upon-Soar War Memorial
Architect: William Douglas Caröe
Sculptor: unknown
Contractors: James and Robert Agar[1]

Memorial in Clipsham stone
h. 5.79m (19')
Inscriptions:
– repeated on the left and right faces of the pedestal: 1914 / 1918
– below this, running the whole way round the pedestal, in raised Gothic capital letters, starting on the front face:
GREATER LOVE HATH NO MAN THAN THIS THAT A MAN LAY DOWN HIS LIFE FOR HIS FRIENDS + + +
[on the risers of the upper two hextagonal steps are the names of the dead, in blackened Roman capital letters; the whole of the upper step and the top course of the lower step bearing the names of the 71 First World War dead; the bottom course of the lower step, with 1939–1945 carved in raised numbers in a blackened recessed panel on the forward corner, bearing the names of the 19 Second World War dead]
Unveiled and dedicated: Sunday 22 May (Trinity Sunday) 1921, by Lieutenant-Colonel R.E. Martin, CMG, and the Revd T. Stone, MA., Vicar of Barrow-upon-Soar
Status: not listed
Owner / custodian: Barrow-upon-Soar Parish Council

Description: The memorial is in the form of a cross on a tall shaft, raised on a square pedestal and a stepped hexagonal base, oriented diagonally to the front. A niche near the foot of the shaft contains a carved figure of St George.
Condition: Fair. The old repairs following the storm damage (see below) are visible but sound. The carving, especially of the figure of St

George, is very weathered, the face of the saint being virtually lost.

History: In the period immediately following the end of the First World War, the people of Barrow-upon-Soar installed a temporary war shrine at the corner of North Street and Church Street.[2] The first meeting to consider a more permanent memorial was held on 18 June 1919.[3] On 19 January 1920, the parish selected the present site.[4] The architect W.D. Caröe would have already been known to the people of Barrow-upon-Soar through his restoration work for the parish church of the Holy Trinity[5] and it was to him they turned for their war memorial. On 24 April 1920 Caröe's approved drawing for the stone monument and memorial gardens was published in the *Leicester Chronicle*.[6] The final cost of the whole scheme was £500.[7]

During a gale on Sunday 4 January 1925, the upper 10-foot portion of the memorial's column was blown down, the stonework and carving at the top sustaining considerable damage, while the figure of St George below the break was loosened but evidently undamaged.[8] The memorial was re-erected at a cost of £30, 'subscribed by parishioners and friends'.[9]

Literature
Bennett, R.H., 1938, pp.55–6; *L. Advertiser*, 28 May 1921, p.3; *L. Chronicle*: – [i] 21 June 1919, p.14 [ii] 24 April 1920, p.9 [iii] 28 May 1921, pp.8–9 [iv] 10 January 1925, p.16; *L. Daily Post*: – [i] 8 January 1920, p.6 [ii] 21 January 1920, p.6; *L. Mail*, 24 May 1921, p.3; *L. Mercury*, 5 January 1925, p.5; *Lo. Echo*, 27 May 1921, p.5; *M.M. Times*, 23 January 1920, p.3; Sharpe, J.M., 1992, pp.24, 48, 49, figs. **2.2, 3.17**; Wilford, B. and J., 1981, pp.29, **28**.

Notes
[1] *Lo. Echo*, 27 May 1921, p.3. [2] Wilford, B. and J., 1981, p.29; illus. p.28. [3] *L. Chronicle*, 21 June 1919, p.14. [4] *L. Daily Post*, 21 January 1920, p.6. [5] See Freeman, J.M., 1990, pp.117–18. [6] *L. Chronicle*, 24 April 1920, p.9. [7] *L. Mercury*, 5 January 1925, p.5. [8] *Ibid.*; for a photograph of the fallen monument, see *L. Chronicle*, 10 January 1925, p.16. [9] Bennett, R.H., 1938, pp.55–6.

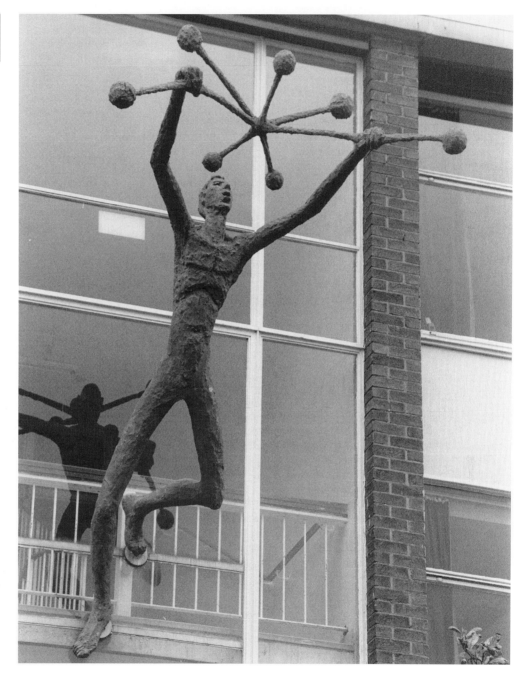

BIRSTALL Civil Parish: Birstall
Borough Council: Charnwood

Wanlip Lane

Longslade Community College, opened 1960 (access only by prior arrangement):

Projecting from the window to the right of the entrance to the school's main block:

Man's Mastery of the Atom = Self Mastery (also known as *Atom Boy*)

Sculptor: Peter Peri

Projecting figure in turquoise concrete and polyester resin on a mild steel armature
h. (est.) 2.74m (9')
Executed: 1960[1]
Status: not listed
Owner: Leicestershire Education Authority

Description: An elongated male nude, projecting diagonally up and away from the exterior of the building, the windows of the staircase to the right of the main entrance serving as its backdrop. The figure is so positioned as to appear to be running down the vertical face of the building. The right foot is secured to a concrete projection of the first-floor landing, while the left foot (higher up the window pane) is secured to a cylindrical metal support which passes through the window transom and is fixed to the railings of the first-floor landing. The figure holds in its upraised hands a model of a molecular structure.

Condition: Poor. Cracks are noticeable in both legs: a deep crack on the right thigh has windblown vegetation sprouting from it; and on the left leg, two cracks are visible, one on the back of the calf muscle and the other on the back of the knee. In addition, the surface of the

Peri, *Man's Mastery of the Atom...*

figure appears somewhat friable.

History: Peri's projecting figure was commissioned in 1959 by Stewart Mason, Leicestershire's then Director of Education. The earliest surviving document relating to it is a letter, dated 23 February 1959, from the school architect, T.A. Collins, to Peri advising him that Mason had seen the maquette and was very pleased with it.[2] By June Peri had executed the sculpture – in situ, as was his usual practice for this type of sculpture – and Collins wrote to him congratulating him on the result.[3]

Even more so than with Peri's other projecting figures, this is very much a part of the fabric of the building, designed whilst the school was still under construction and with a base that begins as an extrusion of the landing of the main interior staircase, situated to the right of the main entrance. A former pupil of Longslade Community College, writing in 1961 for the school magazine, has given a useful account of the particular process employed by Peri for this sculpture. The lower end of the metal armature which was to support the projecting figure was secured into a base in the staircase landing (the edge of which lies just behind the window) before the window panes themselves were put in. Once this was done the sculptor then built up his figure in a polyester resin and concrete mixture around that part of the armature which projected into space. (This mixture, of Peri's own devising, the sculptor dubbed 'Pericrete'.)[4] Finally, the staircase window was fitted into the frame behind the figure 'to create the impression that [the figure] was actually mounted on a glass panel'.[5]

Very much a part of the school's identity, the 'Atom Boy', as the figure is more popularly known,[6] was immediately adopted as the school badge and to this day appears as a logo on school publicity material. As the then headmaster wrote to Peri in September 1960:

The figure already has a firm place in all our affections, and if the ideal of self-mastery to which you refer can become a reality for the boys and girls who pass through the school, I shall be very happy.[7]

Literature
The Centre for the Study of Sculpture, Leeds. Kenny, S., 1980, pp.16, 26, 38, 39; László, H., 1990, pp.87, 95.
General. Berger, J., 1957; Camden Arts Centre, 1987, pp.36, 37, 44; Leicestershire Museum and Art Gallery, 1991, p.16; Longslade School Magazine, 1960–1, p.11; The Minories, 1970, n. pag.

Notes
[1] This is the date given in the LEA inventory. Camden Arts Centre (1987, p.44) and Leicestershire Museum and Art Gallery (1991, p.16), however, give 1959. [2] Kenny, S., 1980, p.38. [3] Ibid., p.39. [4] Leicestershire Museum and Art Gallery, 1991, pp.9–10. [5] Suzanne Burden, Longslade School Magazine, 1960–1, p.11. [6] It is listed as 'Atom Boy' in the LEA inventory. [7] As quoted in Kenny, S., 1980, p.39.

Wall-mounted in the library:
Overhang
Sculptor: Kenneth Draper

Sculpture in wood, acrylic paint and oil paint
h. 65.5cm (2'2"); w. 2.475m (8'2"); d. 68.5cm (2'3")
Status: not listed
Owner: Leicestershire Education Authority
Executed: 1969
Exhibited: 1969, London, Redfern Gallery (no.10); 1981, London, Warwick Arts Trust (no.5); 1982, Colchester, The Minories (no.5)

Description: An abstract sculpture fixed to the right-hand interior wall of the school library, above the level of the bookshelves, and comprising two main elements: a rectangular frame flush with the wall containing smaller horizontal elements (two against the upper edge, two against the lower) and a solid overhanging rectangular element. The colours are principally yellow and black.

Condition: Fair, though there is some scuffing to the paint surface on the forward edge of the overhanging element and the paint surface in general appears grimy.

History: Overhang was purchased by the Leicestershire Education Authority in 1969 with funds made available through the buildings capital scheme.[1]

Related works: Overhang III – Counterpoint, 1971; Overhang VI – Ellora, 1981; Overhang VII – Imminent Eclipse, 1981; Overhang VIII – Distant Monument, 1982.[2]

Literature
The Minories, 1982; Redfern Gallery, 1969a; Warwick Arts Trust, 1981.

Notes
[1] LEA inventory. [2] All shown with Overhang at The Minories, Colchester, 1982.

Wall-mounted in a corridor:
Saxophone
Sculptor: Hilary Cartmel

Sculpture in stainless steel and smalt glass
max. l. 98cm (3'3"); max. w. 62cm (2'1"); d. 3cm (1")
Status: not listed
Owner: Leicestershire Education Authority

Description: Fixed to a corridor wall, the sculpture is a decorative relief in the shape of a saxophone, in bent and soldered stainless steel rods with infills of cement inlaid with pieces of coloured glass.

Condition: Good.

History: Saxophone was purchased by the Leicestershire Education Authority from the artist in 1992.[1]

Note
[1] LEA inventory.

Watermead Park

On a platform on King Lear's Lake, close to the western shoreline:

King Lear sculpture
Sculptors: David Hunter and others

Group in concrete painted white on a chicken wire armature
h. (est.) of tallest figure: 2.74m (9')
dimensions (est.) of platform: 5.48m (18') × 5.48m (18')
Inscription incised on a wooden plaque on the shore near the sculpture:
KING LEAR'S LAKE / Legend has it that sometime in the 8th century B.C., / Britain was ruled by a king called Leir. It is told that on / his death, Leir was buried in a chamber beneath the / River Soar, downstream from Leicester – perhaps close / to this point! / Shakespeare based his tragedy – "King Lear" on the legend / and the sculpture portrays the final scene from / the play. / King Lear (kneeling) mourns his daughter, Cordelia, / who has been killed after fighting in battle on / his behalf. Lear's courtiers, the Earl of Kent and the / Duke of Albany, look on in pity at the grieving king.
Executed: *c.* 1987
Status: not listed
Owner / custodian: Leicestershire County Council

Description: Erected on a raft in King Lear's Lake, the sculpture is a four-figure group comprising two male figures standing while a third kneels over a prone female figure.

Condition: The paint is blistering and peeling and there are some losses. The concrete is deteriorating, with losses to the right elbow of the left-hand hooded courtier and to the upper part of his staff (in this latter, the metal armature is revealed). The courtier in oratorical pose on the right has lost the little finger of his right hand while the little finger of his left hand

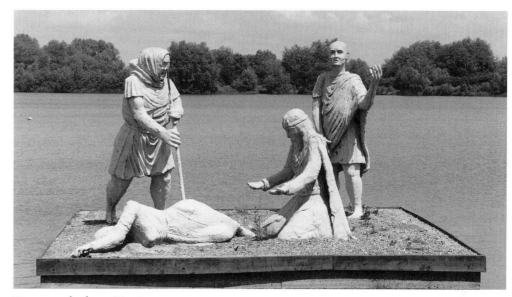

Hunter and others, *King Lear*

is deeply cracked across the knuckle.

History: The raft upon which *King Lear* stands pre-dates the sculpture and had for some time been a potential hazard to windsurfers, etc., posing the problem of whether to remove it or make it more noticeable. Deciding on the latter approach, Leicestershire County Council commissioned sculptor David Hunter to design and execute a sculpture to reflect the area's association with the legend of King Lear. The Council also hoped that it could thereby change the name of the lake from Marina Lake (a name bestowed on it by a former owner whose plans to build a marina on the site had come to nothing) to King Lear's Lake.

Hunter designed a model that was approved by the Council, but he evidently emigrated to Nicaragua during the course of work on the sculpture and the Council was thus compelled to commission another sculptor or sculptors to complete it. The group was created *in situ* in

summer 1987.[1]

Although located on a raft some distance from the shore of the lake, the sculpture was nonetheless not safe from vandals. When first erected, it was regularly used for target practice. However, following the installation of an interpretative plaque – part of a programme of restoration carried out by Loughborough College of Art and Design – the vandalism seems thereafter to have reduced significantly.[2]

Literature
Birstall Post, no.72, July 1989, p.1; *Lo. Echo*, 25 July 1997, p.2.

Notes
[1] Unfortunately Leicestershire County Council is unable to locate any records relating to this commission and so it is not possible to identify the replacement sculptor(s). The Council does, however, have a set of colour transparencies, dated June 1987, of the work in progress. [2] The above account of the *King Lear sculpture* commission is based on information from Peter Williams, Leicestershire County Hall.

On the shore a short distance north of the King Lear Sculpture:

Serpentine Bench
Designer: Mark Oakden

Sculptural bench in laminated wood and stone
h. 42cm (1'5"); w. 4.48m (14'9"); d. 50cm (1'8")
Status: not listed
Executed: *c.* 1997
Owner / custodian: Leicestershire County
Council

Description: As the title suggests, a long
serpentine bench of laminated wood on two
stone feet.
Condition: Good
History: Costing £3,000, the *Serpentine
Bench* was purchased for Watermead Park by
Charnwood Borough Council at
Loughborough College of Art and Design's
annual degree show, June 1997 and
subsequently gifted to Leicestershire County
Council.

Oakden, *Serpentine Bench*

| BLABY | Civil Parish: Blaby |
| | District Council: Blaby |

Welford Road

*In Bouskell Park, close to the gate on
Welford Road:*

The Aviary Tower
Sculptors: Martin Heron and members of the Blaby Access Group

Sculpture in limewood
h. 2.13m (7'); dia. 40.5cm (1'4")
Unveiled: Saturday 26 June 1999, by Councillor
White, Chair of the Heritage, Leisure and Arts
Committee
Status: not listed
Owner / custodian: East Midlands Shape /
Blaby District Council

Description: The sculpture is in the form of a
cylindrical castellated tower with a single
round-arched doorway carved at its foot.
Carved around the tower at various heights are
birds including an owl and a swallow,
butterflies, a squirrel and a snail. Around the
foot of the tower are grasses and flowers, a
rabbit and a mouse.
Condition: Good. As a general policy for all
sculptures on the trail, however, it has been
decided by East Midlands Shape that natural
disintegration should not be inhibited and that
any biological accretions should be allowed to
grow.[1]
History: The present sculpture is part of a
county-wide sculpture trail initiated by East
Midlands Shape, comprising one sculpture or
group of sculptures in each borough or district.
As with all the other completed or projected
sculptures on the trail, *The Aviary Tower* was
designed and executed by disabled people from
a local group – in this case the Blaby Access
Group – under the supervision of professional

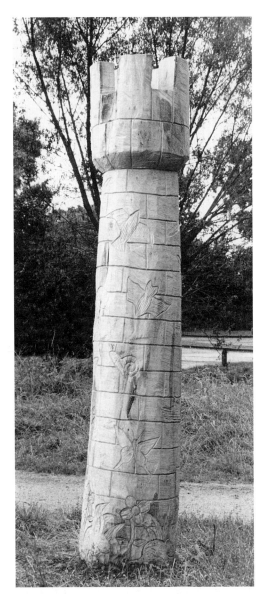

Heron and others, *The Aviary Tower*

sculptor Martin Heron.[2] The group members carried out every step of the process including digging the hole for the tower, mixing the concrete for the foundations and planting the tower itself.

The motif of the castellated tower was chosen to reflect the fact that Bouskell Park is on the site of a medieval village, while the door at the bottom of the tower is loosely modelled on that of the nineteenth-century ice house on the far side of the park.[3]

Related works: Other sculptures in the East Midlands Shape 21st Birthday Sculpture Trail are: *Untitled*, National Forest Visitor Centre (see pp.246–7); *The Bird Totems*, Thornton Reservoir (see pp.279–80) and *The Kingfisher*, Stonebow Washlands Community Wildlife Area, Loughborough (see p.218). At the time of writing (summer 1999), further sculptures are planned for Melton, Harborough, Oadby and Wigston, and Hinckley and Bosworth.

Literature
East Midlands Shape, *Leicestershire Sculpture Trail. Map and Guide*, 1999; *L. Mercury*, 29 June 1999, p.16, 16.

Notes
[1] As stated in the report on the pilot sculpture set up at the National Forest Visitor Centre. See p.244. [2] For an account of the project as a whole see p.246–7. [3] Information from Lucy Banwell, Project Co-ordinator, East Midlands Shape.

BOTTESFORD
Civil Parish: Bottesford
Borough Council: Melton

Barkestone Lane

Belvoir High School and Community Centre (access only by prior arrangement), 1959, by T.A. Collins.

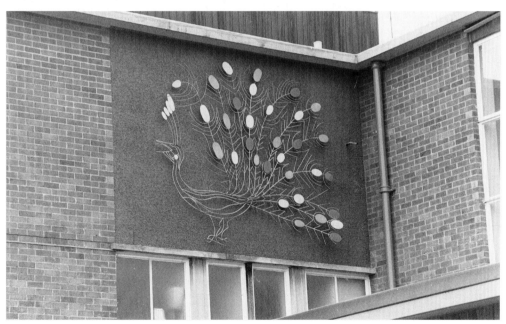

Hollaway, *Peacock*

1. On an exterior wall:

Peacock
Sculptor: Antony Hollaway

Sculpture in anodised aluminium
Dimensions (est.): h. 2.55m (8'4"); w. 3.05m (10')
Executed: *c*.1959
Status: not listed
Owner: Leicestershire Education Authority

Description: A peacock in aluminium rods, the tail-feather eyes formed by oval pieces of sheet aluminium painted terracotta, pale green and blue.

Condition: Generally good, although the lower part of the peacock's tail has been accidentally bent outwards.

History: *Peacock* was commissioned by Stewart Mason, then Director of Leicestershire Education Authority, from Antony Hollaway in 1959.[1] The peacock is still used as the school's logo and derives from the coat of arms of the Manners family (the Dukes of Rutland) whose seat is nearby Belvoir Castle.

Note
[1] LEA inventory; confirmed by the sculptor.

2. On the lawns to the rear of the main block:

Pivot II
Sculptor: Bryan Kneale

Sculpture in galvanised steel and slate on a wooden base
h. (excluding base): 2.57m (8'5"); w. 1.37m (4'6"); d. 48cm (1'7")
Executed: 1963
Exhibited: 1963, London, Royal Academy, as *Pivot* (no. 1291);[1] 1966, London, Whitechapel Art Gallery (no. 16); 1967–8, London, Whitechapel Art Gallery (no. 32)
Status: not listed
Owner: Leicestershire Education Authority

Condition: Generally good, although there are some areas of rust.

History: *Pivot II* was purchased by the Leicestershire Education Authority in 1967 specifically for Loughborough Technical College, with funds provided through the buildings capital scheme. It was later transferred to the LEA float and on 7 September 1998 relocated to the present school.[2]

Related work: *Pivot I* (present location unknown).[3]

Kneale, *Pivot II*

Literature
L. Chronicle, 19 January 1968, p.**22**; Robertson, B., 1967, p.152; Spencer, C.S., 1966b, p.67; Whitechapel Art Gallery, 1966, no. **16**; Whitechapel Art Gallery, 1967, p.17, illus. betw. pp.18/19.

Notes
[1] It is not clear whether this is *Pivot I* or *Pivot II* (i.e., the present sculpture). [2] LEA inventory. [3] Referred to in Robertson, B., 1967, p.152.

Witness
Sculptor: Bryan Kneale

Sculpture in steel

Kneale, *Witness*

h. 1.45m (4'9"); w. 1.7m (5'7"); d. 1m (3'3")
Executed: 1963–4
Exhibited: 1965, London, Tate Gallery (no. 58); 1966, London, Whitechapel Art Gallery (no. 17)
Status: not listed
Owner: Leicestershire Education Authority

Condition: All surfaces are heavily rusted.

History: *Witness* was purchased by the Leicestershire Education Authority in 1968 specifically for Bishop Ellis Roman Catholic Primary School, Thurmaston, with funds provided through the buildings capital scheme. The sculpture was transferred to the LEA float in March 1985 and relocated to Belvoir High School on 7 September 1998.[1]

Literature
Tate Gallery, 1965, no. 58; Whitechapel Art Gallery, 1966, no. **17**; Whitechapel Art Gallery, 1967, p.17, illus. betw. pp.18/19.

Note
[1] LEA inventory.

BRANSTON
Civil Parish: Croxton Kerrial
Borough Council: Melton

Main Street

In a semi-circular recess of St Guthlac parish churchyard wall:

Branston War Memorial
Designer: unknown

Memorial in wood and limestone
h. 2.46m (8'1")
Inscriptions, in incised and blackened Roman capital letters:
– on the front face of the pedestal: "LORD REMEMBER WHEN THOU COMEST / IN THY KINGDOM THOSE WHO GAVE LIFE / FOR US IN

THE GREAT WAR 1914–1918." [underneath
which is a list of six names with ranks and
regiments]
– on the front face of the upper tier of the base:
R.I.P.
– on the front face of the lower tier of the base:
SONS OF THIS PLACE, LET THIS OF YOU BE SAID, /
THAT YOU WHO LIVE ARE WORTHY OF YOUR
DEAD. / THESE GAVE THEIR LIVES, THAT YOU
WHO LIVE MAY REAP / A RICHER HARVEST, ERE
YOU FALL ASLEEP.
– on wooden plaques to either side of the
memorial (the dedicatory inscription being the
same on both): IN THANKFUL REMEMBRANCE OF
/ THE MEN OF BRANSTON WHO WENT / TO SERVE
THEIR COUNTRY IN / THE GREAT WAR 1914 . 18 /
AND RETURNED IN SAFETY / WE THANK THEE O
GOD [underneath which on each plaque are 16
names]
Unveiled: c.1920
Status: not listed
Owner / custodian: Croxton Kerrial and
Branston Parish Council[1]

Description: A First World War memorial in
the form of a figure of Christ on the Cross, in
carved wood, raised on a pedestal and a two-
tiered base, in stone; sheltered by a pitched
wooden roof. Mounted on the walls of the
semi-circular recess to either side of the
memorial are gabled name plaques listing those
who returned from the war.

Condition: Generally good, although there is
some biological growth on the stone. The
wooden name plaques appear to be relatively
recent.

Literature
Sharpe, J.M., 1992, p.25, figs. 2.6, 3.16.

Note
[1] Name of owner / custodian as suggested by the
Clerk to Croxton Kerrial Parish Council.

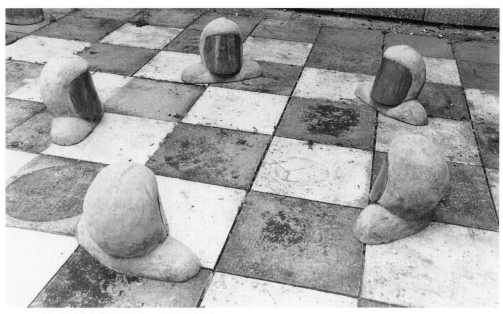

Taylor, *Circle of Power*

BRAUNSTONE
Civil Parish: Braunstone
District Council: Blaby

Hamelin Road

*Wycliffe Community College (set for closure in
summer 1999).* The sculptures were allocated to
the college by the Leicestershire Education
Authority; following local government re-
organisation in 1997, ownership of the
sculptures passed to Leicester City Council.

In the Friendship Garden:
Circle of Power
Sculptor: Mark Taylor

Five busts in concrete and brass
Each bust: h. 43cm (1'5"); w. 62cm (2'1"); d.
32cm (1'1")
Executed: 1990
Status: not listed
Owner: Leicester City Council

Description: Five-piece group of busts in
concrete, the mask-like faces formed by plain
screwed-on sheets of brass.
Condition: Good.
History: *Circle of Power* was purchased by
the Leicestershire Education Authority from
the sculptor in 1991.[1]

Note
[1] LEA inventory.

Rocket Tree
Sculptor: Alfred Dunn

Kinetic sculpture in mild steel, painted
h. 9m (29'6")[1]
Executed: 1970
Status: not listed
Owner: Leicester City Council

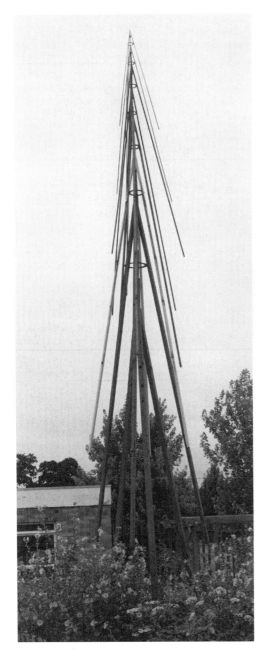

Dunn, *Rocket Tree*

Condition: The lower part of the sculpture was, at the time of viewing (July 1999), obscured within an overgrown mallow bush rendering a detailed examination difficult.

History: *Rocket Tree* was purchased by the Leicestershire Education Authority in 1970. Originally sited at Leicester Ashfield School for the Physically Handicapped, North Evington, the funds were made available through the LEA's buildings capital scheme. In April 1986 *Rocket Tree* was returned to the LEA float and subsequently relocated to its present site.

In 1980, when the sculpture was still at Ashfield School, the then Headmaster, Vernon Parfitt, spoke appreciatively of its effect on the physically handicapped pupils at the school:

> ... it has an aural attraction to the children. When the wind blows ... the movements of the branches [the downward-pointing rods] on the main trunk of the Rocket Tree cause quite delightful sounds which trigger off quite a lot of excitement among the children. There are several kinds of movement all the way up the main trunk as it were, which I think excites the children who really are deprived of a lot of movement. They can see something which is moving according to the elements. It is an excellent piece of work.[2]

Related works: *Rocket Tree*, mild steel, painted, h. 2.74m (9'); w. 61cm (2'); d. 61cm (2');[3] *Rocket Tree II*, steel and cellulose enamel, 3.96m (13') × 81cm (2'8").[4]

Literature
Arts Council of Great Britain, 1980, p.17, **17**; Redfern Gallery, 1966a; Redfern Gallery, 1969b; Strachan, W.J., 1984, p.148, **148**.

Notes
[1] Strachan, W.J., 1984, p.148. [2] Arts Council of Great Britain, 1980, p.17. [3] Although the title is the same as for the present work, this *Rocket Tree*, shown at the Redfern Gallery in 1966 (no. 2), was evidently a smaller version. [4] Shown at the Redfern Gallery, 27 March – 18 April 1969 (no. 10).

Kingsway North

Winstanley Community College (access only by prior arrangement).

On an exterior wall to the left of main reception:

Dragon relief
Sculptors: pupils of Winstanley Community College

Relief in concrete with inlaid ceramic pieces, pebbles and stones
h. 61cm (2'); w. 1.37m (4'6"); d. 15cm (6")
Status: not listed
Owner: Leicestershire Education Authority

Description: Concrete relief of a dragon with its head turned around to look back over its shoulder.

Condition: Fair. Some of the inlaid material is lost and some of the remaining ceramic pieces are broken.

History: The *Dragon relief* was designed and executed 'some years ago' by pupils of Winstanley Community College as part of a design course.[1]

For Ben Franklin's *Fellowship*, formerly sited in the school playground, see 'Lost Works', pp.307–8.

Note
[1] Information from staff at Winstanley Community College (September 1999). Unfortunately the member of staff who organised the project has since left the school and no further information is currently available.

BROUGHTON ASTLEY
Civil Parish: Broughton Astley
District Council: Harborough

Station Road

Thomas Estley Community College (access only by prior arrangement).

On a brick platform in the centre of a shrubbery outside Reception:

Versus

Sculptor: Wendy Taylor

Sculpture in stainless steel and forged steel
h. 84.5cm (2'9"); w. 2.05m (6'9"); d. 96.5cm
(3'2")
Executed: 1973
Status: not listed
Owner: Leicestershire Education Authority

Condition: Fair. The stainless steel beam is in relatively good condition with just a few scratches to the surfaces; the forged steel chain, however, has areas of rust.

History: *Versus* was purchased from the sculptor in 1977 by Leicestershire's then Director of Education, Stewart Mason. It had been specifically chosen for the present school by the then headmaster, its price being covered by funds made available through the buildings capital scheme. The brick plinth upon which the sculpture remains mounted to this day was designed by the headmaster and the school's architect.[1]

Versus is one of a series of sculptures by Wendy Taylor dating from the early 1970s in which she has combined industrial chains and metal beams or tubes in relationships that are intended to contradict one's expectations. As Edward Lucie-Smith explains in his monograph on the sculptor, the themes explored in this series are central to the sculptor's abiding fascination with visual paradox and illusion.[2] In the early 1970s, Taylor was renting a studio in St Katherine Docks, London, where there were still to be seen lengths of heavy-duty chain lying around from the days when the docks were active. She had for some time been experimenting with sculptures in which certain combinations of two or more abstract elements resting one upon the other were made to appear to be defying gravity and retaining a balance where there should be none (e.g., *Recoil*, 1970[3]).

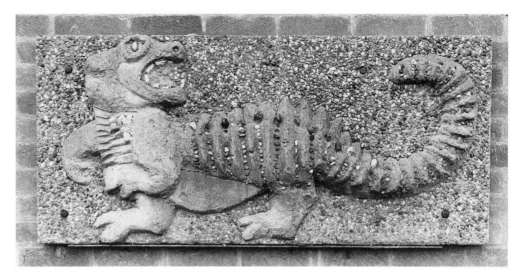

Pupils of Winstanley Community College,
Dragon

Taylor, *Versus*

She eventually became concerned, however, that the tensions she was creating in these combinations of abstract forms might only be fully appreciated by an observer with a trained eye. To make the point more forcefully, she felt it would be more effective to combine familiar objects in a way that inverted their accepted relationships: 'I looked around my own patch of the docks for something that was universally known and taken for granted in its role, and then reversed it.'[4]

Although the chain elements were inspired by actual chains, these could not have served the purpose to which Taylor now put their sculptural counterparts. It was necessary to convince the viewer that the chains were restraining the steel beam or tube whilst in fact supporting it and thus they had to be of exactly the correct proportions and meticulously welded. This was a difficult process whose early attempts, she recalled, sometimes ended in disaster.[5]

In the daily life of the docks the chains had been used for lifting heavy objects. In the series of sculptures Taylor now began to make the steel beams appear to have lost their assumed weight and have become lighter than air, restrained from floating away only by the chains which hold them to the ground:

For me it's all about not taking things for granted without wondering about them – gravity, materials, etc. – plus about using forms which are in appearance heavy and making them light … Another side is humour: I've come to accept and enjoy this and now enjoy others' pleasure in it.[6]

Nonetheless, there will inevitably be some who even when they get the point, fail to realise that they have. A 'senior citizen', interviewed for the catalogue of the second Whitechapel Art Gallery exhibition of Leicestershire schools' art in 1980, said of Versus (presumably with no irony intended):

There's a peculiar chunk of metal outside. Now, some people might say it's art. Well if it's art, then the man [sic] who designed it doesn't know the laws of gravity. I mean he's got it tilted upright with a chain.[7]

Related works: (i) *Versus Maquette* (edition of six), 1979, 41 × 41 × 21cm (16" × 16" × 8");[8] (ii) *Inspan*, 1971, 2.74m × 20.5cm × 61cm (9' × 8" × 2'), formerly at Heathfield High School, Earl Shilton (currently in store – see pp.312–13).

Literature
Arts Council of Great Britain, 1980, p.10, 10; Lucie-Smith, E., 1992b, pp.24–8, 117, 119, **117, 119**; Strachan, W.J., 1984, p.148, **148**.

Notes
[1] Information from the sculptor and the LEA inventory. [2] Lucie-Smith, E., 1992b, pp.24–8. [3] See photograph in *ibid.*, p.22. [4] *Ibid.*, p.24. [5] *Ibid.*, p.27. [6] *Ibid.* [7] Arts Council of Great Britain, 1980, p.10. [8] Illustrated in Lucie-Smith, E., 1992b, p.119.

BURBAGE Civil Parish: Hinckley
Borough Council: Hinckley and Bosworth

Church Street

In a triangular, gated memorial garden in the centre of the road (the former village green):
Burbage War Memorial
Architect: unknown
Sculptor: unknown

Statue in white Carrara marble; pedestal and steps in limestone; base in concrete
Dimensions:
– statue (including integral base): h. (est.) 1.77m (5'10")
– pedestal: h. 2.14m (7'); w. 91cm (3'); d. 91cm (3')
– steps (two): h. 35cm (1'2"); w. 1.37m (4'6"); d. 1.37m (4'6")
Inscriptions on the pedestal:
– on the front (south) face: TO THE MEMORY OF / THE BURBAGE MEN, / WHO GAVE THEIR LIVES FOR THEIR COUNTRY / 1914 – 1919. [then follows the list of the 54 dead, officers before non-commissioned ranks, then in alphabetical order. Beneath this the words:] "GREATER LOVE HATH NO MAN THAN THIS, THAT / A MAN LAY DOWN HIS LIFE FOR HIS FRIENDS".
– on the left (east) face, a list of six names, below which are the words: THE MEN NAMED ABOVE DIED LATER / FROM THE EFFECTS OF THE WAR / 1914 – 1918.[1]
– on the rear (north) face: IN HONOURED MEMORY OF / THE MEN OF BURBAGE / WHO DIED WHERE DUTY CALLED / 1939 – 1945. [then follows a list of 31 names in straight alphabetical order with rank, initials, surname and regiment]
Unveiled and dedicated: Saturday 26 February 1921, by Lieutenant-Colonel C.H. Jones, CMG, TD, and the Revd R.D.H. Pughe, Rector of Burbage
Status: not listed
Owner / custodian: Burbage Parish Council

Description: On a tall pedestal, a representative, anonymous British 'Tommy' stands in mourning pose with head bowed and rifle reversed, the muzzle resting on top of his left boot (a precaution against dirt entering the barrel).

Condition: The carving of the statue appears softened by weathering and there are areas of biological growth and black encrustation. The tip of the nose, lips, chin and ears are all damaged, presumably by frost.

History: A Burbage war memorial committee seems to have been formed fairly soon after the close of the First World War and by the middle of 1920 had collected enough publicly-subscribed money to allow it to procure a site and have the memorial's foundations dug. Unfortunately, the committee's choice of site, 'the extreme end of the local churchyard', was evidently 'contrary to the wishes of the general public'.[2] The local

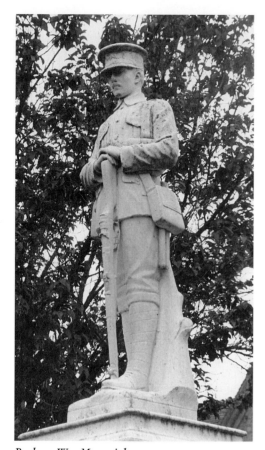

Burbage War Memorial

press reports of the furore provoked by such an apparently high-handed action make no mention of why the site was found inappropriate by a large section of the village. However, as the more popular site was the village green it would strongly suggest that a site in what was after all an Anglican churchyard would have implicitly marginalised those of the fallen and their grieving relatives who were from the non-conformist communities.[3] Such was the feeling against the

churchyard that the Burbage Co-operative Society, whose members had contributed £100 towards the memorial, advised the committee that it would recall its subscription unless the site were relocated to the village green. The matter was finally resolved in favour of the village green after the committee had agreed to augment its numbers, presumably with those members of the Co-operative Society who had been at the forefront of the protest.[4]

If the campaign to erect the memorial had had its moments of controversy, there was none about the memorial itself. The local press pronounced it 'strikingly beautiful', enthusiastically proclaiming that 'a more exquisite piece of work than the figure is probably not to be found in the whole of Leicestershire'.[5] And yet, notwithstanding the unanimous acclaim with which the 'exquisite piece' was greeted, not one of the local papers reporting the unveiling ceremony made any mention of the sculptor who carved it. The Burbage War Memorial Committee minutes, which perhaps would have mentioned the sculptor's name, do not seem to have survived, although according to a local man the statue was ordered at cost price from Italy by his grandmother.[6] There is, however, an extremely similar marble statue on the war memorial at Metheringham, Lincolnshire, which is attributed in the National Inventory of War Memorials – though unfortunately no documentary source is given for the attribution – to a local monumental mason, Frederick William Baldock. The two statues are almost certainly by the same person but unless some hitherto unlocated documentary evidence relating to the *Burbage War Memorial* is found (or contemporary documents confirm authorship of the Metherington memorial), the identity of the sculptor will have to remain unknown.

In 1996 the memorial enclosure was replanted in commemoration of the seventy-fifth anniversary of the foundation of the

British Legion and the tenth anniversary of the reconstituted Burbage Parish Council, and in late 1999 there was a major refurbishment of both the memorial and its enclosure by the Parish Council with assistance from Leicestershire County Council's Department of Planning and Transportation.

Literature
H. Echo: – [i] 15 September 1920, p.1 [ii] 2 March 1921, p.1; Hinckley Times, 1996, p.**72**; *L. Daily Post*: – [i] 31 July 1920, p.6 [ii] 15 September 1920, p.5 [iii] 15 November 1920, p.6 [iv] 28 February 1921, p.2; *L. Mail*: – [i] 31 July 1920, p.2 [ii] 15 November 1920, p.6 [iii] 28 February 1921, p.4; *L. Mercury*, 28 February 1921, p.4; McNaughton, J.D., 1980, n. pag. [photograph of unveiling]; Sharpe, J.M., 1992, pp.28, 35, 41, fig. **2.1**.

Notes
[1] This date, 1918, refers to the cessation of hostilities, that is, the signing of the armistice, on 11 November 1918. The date 1919 on the front inscription refers to the signing of the peace treaty with Germany, the Treaty of Versailles, on 28 June 1919. [2] *L. Mail*, 31 July 1920, p.2. [3] It is perhaps worth noting in this context that the service at the unveiling and dedication ceremony was, like so many others, performed jointly by the Anglican Rector and a Wesleyan minister (see *L. Mercury*, 28 February 1921, p.4). [4] *L. Daily Post*, 15 September 1920, p.5. [5] *L. Mail*, 28 February 1921, p.2; *L. Mercury*, 28 February 1921, p.4. [6] Information from George Lord, a former director of T.S. Lord & Sons, a Burbage firm of painters, decorators and plumbers, etc. His grandmother was herself director of the firm at the time of the *Burbage War Memorial* commission.

St Catherine's Close

Hastings High School (access only by prior arrangement), 1956, by T.A. Collins.

Located in the left-hand corner of the playground, facing the sports fields:

Boy and Girl with Puppy
(also known as *Family Group*)[1]

Sculptor: Georg Ehrlich

Sculpture in bronze on a concrete pedestal

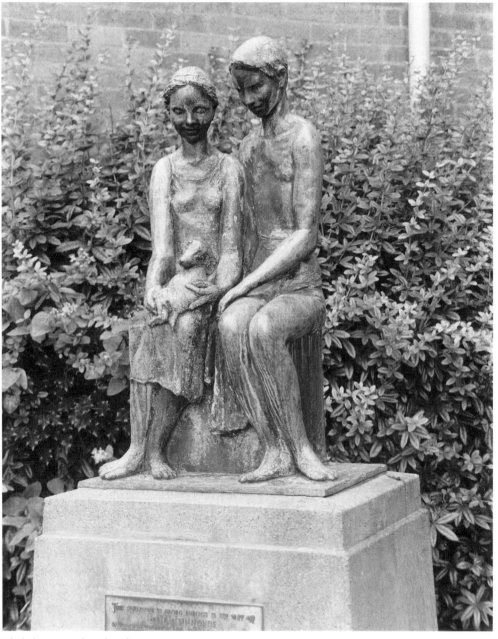

Ehrlich, *Boy and Girl with Puppy*

Sculpture: h. 84cm (2'9"); w. 49cm (1'7"); d. 35.5cm (1'2")
Pedestal: h. 77.5cm (2'7"); w. 63.5cm (2'1"); d. 50.5cm (1'8")
Inscription on a bronze plaque fixed to the pedestal: THIS SCULPTURE BY GEORG EHRLICH IS THE GIFT OF / MRS F.A. SIMMONDS / IN COMMEMORATION OF THE NOTABLE SERVICES / TO EDUCATION IN LEICESTERSHIRE AND IN / HINCKLEY RENDERED BY HER HUSBAND, THE LATE / ALDERMAN RICHARD HENRY SIMMONDS / MEMBER OF THE COUNTY EDUCATION COMMITTEE, / CHAIRMAN OF ITS BUILDINGS AND SITES / COMMITTEE, CHAIRMAN OF THE GOVERNORS OF / THE HINCKLEY GRAMMAR SCHOOL, CHAIRMAN OF / THE MANAGERS OF THE BURBAGE COUNTY JUNIOR / SCHOOL, AND CHAIRMAN OF THE GOVERNORS OF / THE HINCKLEY COLLEGE OF FURTHER EDUCATION.
Executed: 1955
Exhibited: 1955, London, O'Hana Gallery. The full catalogue entry reads: 'No. 25. *Boy and Girl with Puppy*, bronze, 1955. Commissioned by Mrs F.A. Simmonds for Burbage Secondary School, Leicestershire'.
Status: not listed
Owner: Leicestershire Education Authority

Description: The sculpture represents a young man and woman seated side-by-side on a bench. The woman holds a puppy in her lap.

Condition: Good, although there is some loss of patination from the bronze sculpture, particularly on the dog's head, and the pedestal has green run-off below the bronze inscription plaque.

For Ben Franklin's *Girl Releasing Dove*, see 'Lost and Removed Works', p.307.

Literature
O'Hana Gallery, 1955; Pevsner, N. and Williamson, E., 1992, pp.44, 117.

Note
[1] The former is the title given in Ehrlich's 1955 one-man exhibition at the O'Hana Gallery; the latter is the title under which it is listed in the LEA inventory.

CASTLE DONINGTON
Civil Parish: Castle Donington
District Council: North West Leicestershire

High Street

Castle Donington War Memorial
Architect: Cecil G. Hare
Sculptor: unknown

Monument, coping and terminal pillars of bounding wall in Guiting limestone; bounding wall and risers of steps of forecourt in Breedon limestone; gable over Crucifix in oak; name plaques in bronze; main inscription tablet in Portland stone
h. (est.) 5.49m (18')
Inscriptions:
– on the gableboard above the Crucifix, in raised letters:
THEY LOVED NOT THEIR LIVES UNTO THE DEATH
– on the front face of the pedestal, on a slab of Portland stone: YE WHO PASS BY, REMEMBER BEFORE GOD THE / GALLANT DEAD WHOSE NAMES ARE WRITTEN / HERE, THOUGH MANY LIE IN OTHER LANDS / THEY FELL IN THE GREAT WAR OF 1914–1919. / "THE MEN WERE VERY GOOD UNTO US, AND WE WERE NOT HURT. / THEY WERE A WALL UNTO US BOTH BY NIGHT AND DAY."[1]
– on a bronze plaque fixed to the plinth, in raised letters: ALSO THESE WHO ADDED THE GIFT OF THEIR LIVES 1939–1945 [underneath which are 14 names in alphabetical order, in raised letters]
– on the forward faces of the terminal pillars of the bounding walls, two bronze plaques bearing the names of the 70 First World War dead in raised letters, in alphabetical order, with one name added at the end, followed by the words, in parenthesis: KILLED IN A MUNITIONS EXPLOSION.
Unveiled and dedicated: Wednesday 12 January

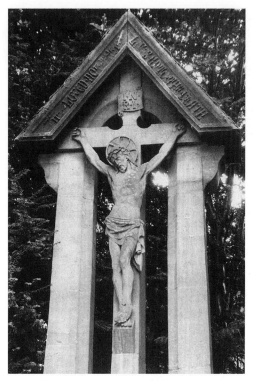

Castle Donington War Memorial

1921, by Lady Donington and the Rt Revd Dr Frank Theodore Woods, Bishop of Peterborough
Status: not listed
Owner / custodian: The Royal British Legion

Description: A war memorial comprising a figure of Christ on the Cross carved in limestone, under a wooden gable, set before an arch. To either side curving walls with terminal pillars bearing the bronze name plaques form a stepped semi-circular forecourt.

Condition: Fair. The figure is somewhat weathered and the dangling end of the loin cloth on the figure's left side is slightly chipped. Also the wood of the gable has deteriorated and

most of the raised lettering has been lost.

History: The site for the memorial was given by Miss Eaton, a member of the war memorial committee, and the Breedon limestone was donated by John Gillies Shields, JP. According to a contemporary account of the unveiling ceremony, the limestone from Guiting in Gloucestershire was selected because not only does it harden by exposure to the weather, it also 'assumes a beautiful colour with the passing of the years'.[2]

Literature
L. Chronicle, 22 January 1921, pp.8–9; L. Daily Post, 13 January 1921, p.6; L. Mail, 13 January 1921, p.2; Sharpe, J.M., 1992, p.25, figs. **2.6**, **3.16**.

Notes
[1] The quotation is adapted from 1 Samuel 25: 15, 16.
[2] L. Daily Post, 13 January 1921, p.1.

COALVILLE
District Council: North West Leicestershire

Ashby Road

Snibston Discovery Park (Leicestershire Museums, Arts and Records Service), opened in June 1992. The site comprises exhibition galleries exploring the social and industrial history of the area and one hundred acres of grounds laid out as parkland on the site of the former NCB Snibston Colliery. In the grounds is a sculpture trail, the first in the East Midlands, initiated in 1991 by officers of Leicestershire County Council's Museums, Arts and Record Services. As part of their initial research, members of the project team visited the Yorkshire Sculpture Park and Grizedale Forest, to investigate some of the ways in which a sculpture trail might be made to relate both to the area and to the community in which it is located.

The aims of the trail, according to a 'Vision

Statement' issued by the Council, are: '... to demonstrate in an exciting and accessible way that sculpture is an integral part of the unique Snibston experience and that the Trail is the main focus for contemporary commissioned public art in the East Midlands.'[1]

It was intended that sculptors selected to produce work for the Trail should: '... demonstrate the relationship between art, science, technology and local industry. Sculptors are also encouraged to explore the use of local materials; particularly from extractive industries.'[2]

Essential to the original Snibston Sculpture Trail scheme was the idea that the sculptures should not be solely the result of commissions awarded to professional sculptors. There was also the Community Outreach initiative, offering opportunities to local people to produce sculpture. Thus, the first piece for the trail was *The Last Shift*, designed and executed by GCSE students at the nearby King Edward VII Community College. The earliest sculptures commissioned from professional sculptors were created for specific sites along the trail during forty-day residencies. To demonstrate further its commitment to community involvement, Snibston made it a requirement of the residencies that each sculptor conduct workshops in the community for a minimum of eight days. Also, all sculptors were encouraged to be accessible to the public whilst working on their sculptures so that those who wished to could discuss the work-in-progress. Submissions for the first three residencies were invited in August and September 1992.

From the beginning the project has been managed by Leicestershire County Council in close collaboration with East Midlands Arts who also contribute financially towards the sculpture trail. Their work has been supported by an advisory committee comprising representatives from local government,

community arts groups, access groups, educational institutions and artistic advisors.[3]

Literature
Snibston Discovery Park archives. Leicestershire County Council, *Snibston Sculpture Trail. Annual Review 1992/93*.
General. *L. Mercury*, 24 February 1994, p.27; Leicestershire Museums Arts and Records Service, *The Snibston Sculpture Trail* (leaflet and map), n.d.

Notes
[1] Leicestershire County Council, *Snibston Sculpture Trail. Annual Review 1992/93*. [2] *Ibid*. [3] *Ibid*.

The following sculptures are listed in the order in which they occur on the trail. The first is inside the foyer of the exhibition hall, the rest are sited in the grounds:

1. *The Last Shift*

Sculptors: 5 GCSE students at King Edward VII Community College, Coalville

Sculpture in brick and mortar
h. 2.4m (7'11")
Installed: June 1992
Status: not listed
Owner: Leicestershire County Council (Museums Arts and Records Service)

Description: Standing in the entrance hall of Snibston Discovery Park museum, the sculpture takes the form of four over-life-size miners standing back-to-back in a tight circle, arms linked, thumbs tucked into belts.

Condition: Good.

History: In April 1991, King Edward VII Community College, Coalville, organised 'Into Partnership', an event to which were invited 18 companies and 97 visitors, to celebrate with staff and students 'the benefits of industry and education working together'. One of the companies was Butterley Brick from Ripley, Derbyshire. Following an initial donation of some bricks for use in solving problems in

The Last Shift

GCSE mathematics classes, the company donated one thousand unfired Class A Engineering bricks for a sculpture project the College was then planning with Snibston Discovery Park. The result, *The Last Shift*, was designed and created as part of their GCSE Art and Design course by Jane Bailiss, Sophie Beardsmore, Faye Birde, Emma Glover and Amanda Peers, under the supervision of Hugh Madden, Head of Art.

For the first stage of the process of making the sculpture the students stacked the wet bricks to ensure a bond. They then enlarged their working drawing to full size and pricked the design through onto the stack. Next, with assistance from a number of other students from both the College and from Forest Way (Special) School, they cut away the surplus bricks to reveal the design. It was necessary to complete this stage within three weeks before the bricks dried out and became unworkable. Once the stack had been cut to shape it was taken apart and each brick numbered and drilled in preparation for firing. After firing, common mortar was used to cement the bodies and a high-tech adhesive to cement the heads.[1]

The grandfathers of all five of the female students had worked in the local coal mines. Said Emma Glover: 'It's given us something that we can be proud of, to show our kids and for them to show their kids.'[2]

This, the first sculpture in the trail, was erected at the time of Snibston Discovery Park's opening in June 1992.[3] Symbolising 'the pride of a community and its heritage' through an image of the solidarity of its miners, the sculpture also commemorates the end of deep mining in Leicestershire.[4]

Literature
Snibston Discovery Park archives. Leicestershire County Council, *Snibston Sculpture Trail. Annual Review 1992/93.*
L. Mercury archives. Press cutting – *L. Mercury*, 23 May 1992.
General. *L. Mercury (NW Leics edn)*, 22 November 1995, p.5; Leicestershire Museums Arts and Records Service, *Sculpture at Snibston* (sculpture trail guide), 1994.

Notes
[1] Information from Snibston Discovery Park.
[2] *L. Mercury*, 23 May 1992. [3] Leicestershire County Council, *Snibston Sculpture Trail. Annual Review 1992/93.* [4] *L. Mercury*, 23 May 1992.

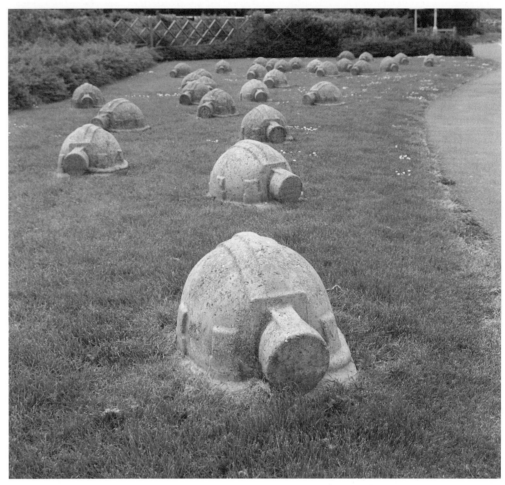

Fletcher, *Undermined*

2. *Undermined*
Sculptor: Yan Fletcher

31 over-life-size miner's helmets in cast concrete
Group (est.): 23m (75'6") × 9m (29'6")
Installed: Spring 1993
Status: not listed
Owner: Leicestershire County Council (Museums Arts and Records Service)

Description: 31 over-life-size miner's helmets in cast concrete arranged in a triangular configuration on the grass verge of the roadway in front of the Snibston Discovery Park exhibition hall. Onto the rear of each helmet is fixed a metal plaque labelled: WESTOE (a mining equipment manufacturer).

Condition: There is some biological growth and some guano. Cracks in some of the helmets appear to be faults in the casting.

History: Yan Fletcher, Snibston's second sculptor-in-residence, executed *Undermined* between February and May 1993. According to the sculptor, 'The helmets represent the thirty-one collieries earmarked for closure in 1993.'[1] The sculpture cost £2,000.

Literature
Snibston Discovery Park archives. Leicestershire County Council, *Snibston Sculpture Trail. Annual Review 1992/93.*
General. Leicestershire Museums Arts and Records Service, *Sculpture at Snibston* (sculpture trail guide), 1994.

Note
[1] Leicestershire Museums Arts and Records Service, *Sculpture at Snibston* (sculpture trail guide), 1994, n. pag.

3. *Seam-stress*
Sculptor: Pauline Wittka-Jezewski (née Holmes)

Sculpture in brick and slate
l. 20m (65'6"); w. 7.5m (24'6")
Sited: April 1994
Inscriptions on two brick tiles at the lower right (north-east) corner of the sculpture:
(i) left-hand tile: SEAM-STRESS / BY / PAULINE HOLMES / 1994 / SNIBSTON SCULPTURE TRAIL
(ii) right-hand tile: SNIBSTON DISCOVERY PARK THANKS / THE FOLLOWING SPONSORS: / IBSTOCK BUILDING PRODUCTS LTD / DAVID WILSON HOMES LTD / STEVEN BROOKS / TILCON LTD
Status: not listed
Owner: Leicestershire County Council (Museums Arts and Records Service)

Description: The whole of the sculpture lies virtually flush with the grassy slope of the rising ground overlooking the event arena. It comprises a long narrow paved strip with wedge-shaped ends overlaid along its middle section by two x-shapes, either side of which, and in line with their ends, are six circles. The

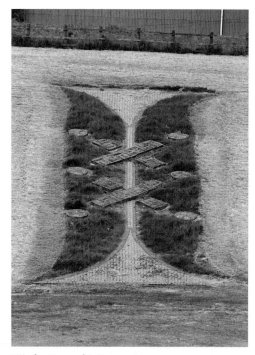

Wittka-Jezewski, *Seam-stress*

x-shapes and circles are made from embedded blocks of vertically-packed roofing slates (there are about 550 slates in the two x-shapes and about 30 in each circle). The sculpture is intended to be viewed from a distance (presumably from the high ground opposite). From here it can be seen that the sculpture is suggestive of the cross stitches of a corset. As the *Sculpture at Snibston* trail guide explains: 'The theme of the sculpture is inspired by the fashion and textiles [in the exhibition hall], especially the corsets'.[1]

Condition: Fair, although some of the slates are crumbling and some loose.

History: Pauline Wittka-Jezewski, Snibston's fifth sculptor-in-residence, began her residency in February 1994 and, with the

assistance of a bricklayer, completed and sited *Seam-stress* two months later. The inscription plaques were installed in July 1995. The final cost of the sculpture was £2,000.

Literature
Snibston Discovery Park archives. Leicestershire Museums Arts and Records Service, *Snibston Discovery Park. Resume ... 1995/96.*
General. *L. Mercury*, 9 December 1994, p.21; Leicestershire Museums Arts and Records Service, *Sculpture at Snibston* (sculpture trail guide), 1994.

Note
[1] Leicestershire Museums Arts and Records Service, *Sculpture at Snibston* (sculpture trail guide), 1994, n. pag.

4. *Time Passages*
Sculptor: Kevin Blackwell

Sculpture in wood (railway sleepers) treated with creosote, stone and brick
h. 3m (9'10"); w. 9m (29'6"); d. 4.75m (15'7")
Erected: August 1993
Status: not listed
Owner: Leicestershire County Council (Museums Arts and Records Service)

Description: *Time Passages* is located on the summit of the old pit bank, now a part of the Discovery Park. It comprises 17 railway sleepers set upright into the ground in two lines, planted close at the ends and diverging towards the middle where there are breaks in both lines. The two lines lean together, the tallest towards the middle, their tops touching, forming a kind of cave, the floor of which is lined with pebble-sized stones, except at the sharp ends where there are bricks, each inscribed with a name or slogan. At the south-east end are six bricks, inscribed: WILLY FOWKES; Alex☆ COAL / NOT / DOLE; A. LAVERICK; BUTLER; FRED RUSH; BOB YORK. At the south-west end are two inscribed: J. WARDLE; JOHN ELMES, while a third, half underlying the first

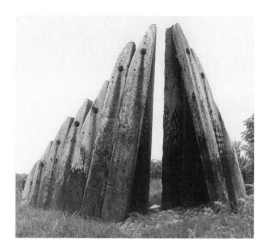

Blackwell, *Time Passages*

two reads: SID M[...?]. Outside, extending from each end of the sleeper-structure are long heaps of boulders diminishing in height towards the extremities. According to the *Sculpture at Snibston* trail guide:

> The sculpture is a large tactile structure which loosely resembles a huge ribcage or cave, and visitors can stand inside it. It is also intended to signify change and development of the landscape which is in keeping with the environmental theme of the Discovery Park.

Condition: Good.
History: Kevin Blackwell, Snibston's third sculptor-in-residence, executed *Time Passages* between June and August 1993. The sculpture cost £2,000.

Literature
Snibston Discovery Park archives. Leicestershire County Council, *Snibston Sculpture Trail. Annual Review 1992/93.*
L. Mercury archives. Press cutting – *L. Mercury*, 9 July 1993.
General. Leicestershire Museums Arts and Records Service, *Sculpture at Snibston* (sculpture trail guide), 1994.

5. *Give Us This Day Our Daily Bread*
Sculptor: Stuart Bastick

Sculpture in coal, galvanised steel, wood and thick wire mesh
h. 2.9m (9'6"); w. 2.28m (7'6"); d. 1.88m (6'2")
Sited: Spring 1994
Status: not listed
Owner: Leicestershire County Council (Museums Arts and Records Service)

Description: Located on the old pit bank, *Give Us This Day Our Daily Bread* takes the form of an over-sized toast rack in galvanised steel holding three elements suggestive of toast – the crusts in rusted steel, the surface of the bread in thick wire mesh. Each 'piece of toast' is filled with coal and has a hole cut out of the centre. A correspondingly-shaped 'charm' dangles below. The sculptor described his work as follows: 'Here toast made from caged coal is cooling in a giant rack high on the pit bank above the former Snibston Mine ... This sculpture is a meditation on the relationship between "our daily bread" and the labour which pays for it.'[1]
Condition: Good.
History: Stuart Bastick, appointed Snibston's fourth sculptor-in-residence in November 1993, completed *Give Us This Day Our Daily Bread* in spring 1994. The sculpture cost £2,000.

Literature
Snibston Discovery Park archives. Bastick, S., *Report on Sculpture Park Residency 1994*; Leicestershire County Council, *Snibston Sculpture Trail. Annual Review 1992/93.*
General. *L. Mercury*, 24 February 1994, p.27; Leicestershire Museums Arts and Records Service, *Sculpture at Snibston* (sculpture trail guide), 1994.

Note
[1] Bastick, S., *Report on Sculpture Park Residency 1994*.

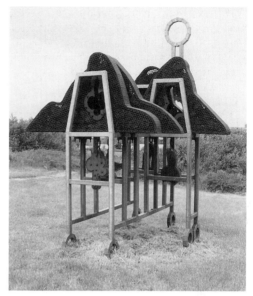

Bastick, *Give Us This Day...*

6. *Glowing Red in the Darkness*
Sculptor: Michael Farrell

Sculpture in two pieces of Ketton limestone mounted on wooden platforms
Larger piece: h. 75cm (2'6"); w. 1.23m (4'1"); d. 1.12m (3'8")
Smaller piece: h. 44cm (1'5"); w. 1.62m (5'4"); d. 76cm (2'6")
Sited: January 1993
Inscription on the upper surface of the smaller piece:
GLOWING RED IN / THE DARKNESS
Status: not listed
Owner: Leicestershire County Council (Museums Arts and Records Service)

Description: The sculpture takes the form of two wedge-shaped blocks of Ketton limestone with carved repeat patterns on the upper surfaces, mounted on low wooden platforms

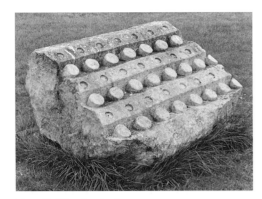

Farrell, *Glowing Red...*

made from railway sleepers, sited at opposite ends of the picnic area. Some of the carving was originally finished with metallic paint[1] but this is now lost.

Condition: The stone appears to have weathered somewhat; the inscription in particular is now rather faint.

History: Farrell was the first professional sculptor to work at Snibston Discovery Park, in a residency lasting from November 1992 to January 1993. He had hoped to use stone from the immediate area, but finding this unsuitable for carving he settled for Ketton stone, a stone from neighbouring Rutland. For his theme he turned to the mining industry. The wedge-shaped forms of the stones were intended to echo the shapes of mining derricks. His principal theme, however, was not the machinery but the human involvement:

I wanted to make a piece of work that recognised the individual within this anonymous and massive industry and, at the same time, could be optimistic ... The main theme for the sculpture is based on the lamp room, as it is in this space that miners would collect their self rescuer and lamps which were stored in a pigeon hole system and

charging racks, these two more personal objects which could potentially save life and give light were the optimistic symbols I was looking for.[2]

Farrell chose the picnic area site partly because his work would be seen by the maximum amount of people and partly because the eminence of the site which was once a slag heap, gave good views over a surrounding landscape itself formed by the mining industry. The two pieces of Ketton stone were mounted on wooden platforms made from old railway sleepers set into chippings: '... in the manner of a railway line as it was through ... the development of the railway line that Coalville's growth was enabled'.[3]

Farrell borrowed the title from an evocative line from local author Kathleen M. Donaldson: 'Whitwick pit bank always seemed to be on fire, glowing red in the darkness'.[4] *Glowing Red in the Darkness* cost £2,000.

Literature
Snibston Discovery Park archives. Farrell, M., *Report on Sculpture Park Residency November 1992 –*

February 1993; Leicestershire County Council, *Snibston Sculpture Trail. Annual Review 1992/93*. **General**. *L. Mercury (NW edn)*, 15 December 1992, p.5; Leicestershire Museums Arts and Records Service, *Sculpture at Snibston* (sculpture trail guide), 1994, n. pag.

Notes
[1] Farrell, M., *Report on Sculpture Park Residency November 1992 – February 1993*. [2] *Ibid*. [3] *Ibid*. [4] As quoted in *ibid*.

In Snibston Discovery Park's Grange Nature Reserve and Fishery:

Near the south-east end of Match Lake:

7. *Ultrasound*
Sculptor: Jez Noond

Sculpture in steel and iron
h. 71cm (2'4"); w. 5.18m (17'); d. 1.19m (3'11")
Installed: September 1994
Status: not listed
Owner: Leicestershire County Council (Museums Arts and Records Service)

Description: Abstract sculpture based on the

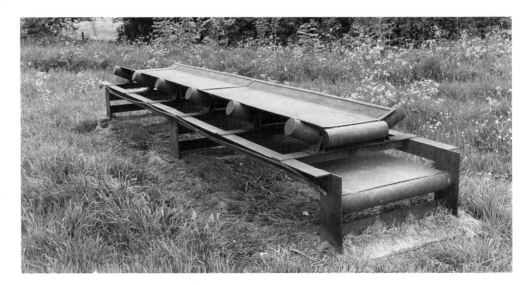

form of a mining conveyor belt.

Condition: All surfaces are completely oxydised, presumably intentionally.

History: In echoing the form of a coal conveyor in *Ultrasound*, Noond was making reference to the former principal industry of the area around Snibston. Both the materials used, steel and iron, and the method of construction, welding, were intended to be sympathetic to the methods of fabrication used in the coal mining industry.

The Grange was chosen by the sculptor for two main reasons. From a personal point of view, he felt that the area closer to the exhibition hall was already well-populated with sculptures, but more importantly, from the point of view of the sculpture's meaning, he wanted to reflect the fact that the subterranean mine workings extended even to this distance. Thus, one of Noond's chief aims in *Ultrasound* was to highlight 'the essential invisibility of the mine workings that lie 1000ft below the surface of the Discovery Park'.[1] It was also important to him that The Grange was 'an area of protected and nurtured beauty' for he felt that the sculpture, which played 'upon notions of industrial restoration and heritage' would convey its meanings best in such a context.

He also gave careful consideration to the siting within the area. Firstly, he perceived a metaphorical link between the sculpture and the gravel path which runs by it, in as much as the latter seemed to be 'a kind of conveyor [that] transports visitors around the nature trail from their entrance to their point of exit'. Secondly, he valued the possibility of the disparate messages the visitor might experience when viewing *Ultrasound* from different sides. From the path side, there was an intended contrast

between the rigid steel horizontality of the sculpture and the natural majesty of the backdrop of tall trees, suggesting 'the conflict between nature as an idealised, romantic experience and culture as a harsh industrial reality' – from this vantage the sculpture 'as an intrusion into the landscape' was a vital part of the sculptor's theme. On the other hand, from the opposite side, the backdrop would be the distant horizon marked by the colliery's slag heap. From here the sculpture could be seen instead as an integrated part of a landscape formed by the mining industry.

The title, *Ultrasound*, alludes to ultrasonic technology, evoked here as representative of the new technologies which have displaced the traditional ones:

> ... the most important point about Ultrasound in this context is its relationship to the physicality of sculpture and the industry that this work refers to. It is [the] contrast between an intangible technology and a tangible but obsolete industry, a

relationship full of tension and uncertainty as many traditional work patterns are eroded by the newer technologies.[2]

Literature
Snibston Discovery Park archives. Noond, J., *Report on 'Ultrasound'*, Snibston Discovery Park, 1994.
General. *L. Mercury*, 9 December 1991, p.21, **21**.

Notes
[1] Noond, J., *Report on 'Ultrasound'*, Snibston Discovery Park, 1994. [2] *Ibid*.

Near the north-east bank of Match Lake:
8. *Like a Fish Out of Water*
Sculptor: Dawn Beresford

Sculpture in recycled metal
h. 2.13m (7'); w. 2.65m (8'8"); d. 83cm (2'9")
Installed: April 1995
Status: not listed
Owner: Leicestershire County Council
(Museums Arts and Records Service)

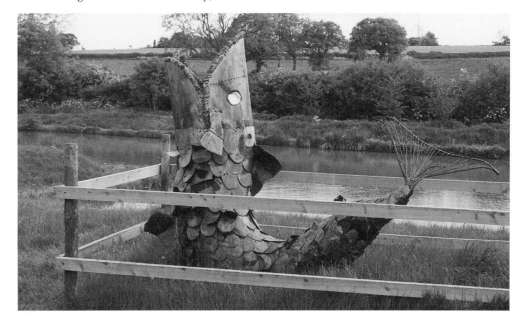

(opposite) Noond, *Ultrasound*

Beresford, *Like a Fish Out of Water*

Description: A giant leaping fish made from recycled metal, fenced around with a wooden railing (a later measure following health and safety fears over the sculpture's jagged metal edges).

Condition: Fair, though some of the scales are bent outwards and a few are missing.

Literature
Snibston Discovery Park archives. Leicestershire Museums Arts and Records Service, *Snibston Discovery Park. Resume ... 1995/96.*
General. *C. Times*, 10 October 1997, p.35, 35.

High Street, Coalville

Belvoir Shopping Centre – for the two abstract sculptures formerly at the entrances to the shopping precinct, see 'Lost Works', p.309; for R.J.R. Thomas's *Mother and Child*, formerly in the centre of the shopping precinct, see below.

Coalville Public Library, to the right of the entrance:

Mother and Child

Sculptor: Robert John Royden Thomas
Founder: Corinthian Bronze Foundry

Group in bronze
Dimensions:
group: h. 2.25m (7'5"); w. 97cm (3'2"); d. 45cm (1'6")
base (upper step): h. 7.5cm (3"); w. 1.2m (4'); d. 53.5cm (1'9")
base (lower step): h. 5.5cm (2"); w. 1.32m (4'4"); d. 66cm (2'2")
Executed: 1962–3
Unveiled: Friday 11 October 1963, by Colonel P.H. Lloyd, Chairman of Leicestershire County Council
Inscription on a plaque fixed to the library wall to the rear of the sculpture:[1]
MOTHER AND CHILD / THIS SCULPTURE BY R.J.R. THOMAS OF / "MOTHER AND CHILD" WAS AWARDED / THE SIR OTTO BEIT PRIZE FOR 1963 /

[space] / THE SCULPTURE USED TO BE SITED IN / THE PRECINCT SHOPPING CENTRE AND / WAS PROVIDED WITH A NEW HOME IN / 1992 WHEN THE NEW LIBRARY / FRONTAGE WAS IMPROVED
Status: not listed
Owner / custodian: North West Leicestershire District Council

Description: the sculpture, located amongst some shrubbery, facing the road, to the right of Coalville Public Library's entrance, is a standing group of a mother with a small boy at her left side. The mother, her feet planted firmly apart, looks up to her left. She rests her left hand on her son's head, her right hand behind her back holding his right hand. The boy leans against his mother's left leg, his head turned to the rear to look at something behind her as he clasps the front of the hem of her skirt with his left hand. From the mother's right wrist hangs a string shopping bag with a few lumps of coal at the bottom, some books, a bobbin, a baby doll, and an (unidentified) object bearing the sculptor's monogram. The contents of the shopping bag are intended to be representative of local commercial and industrial life: the lumps of coal reflect the then main industry of the area, the cotton bobbin refers to Coalville's history as a centre for the manufacture of elastic webbing, and the doll refers to Palitoy (toy manufacturers).

Condition: Good.

History: In 1962, property developers Triland (Coalville) Ltd, a subsidiary of Costain Property Investments, decided to commission a sculpture as centre-piece for their new shopping precinct in Coalville.[2] Following an invitation to an open competition to which 200 sculptors responded, an eight-man selection panel was appointed with R. Bentley Claughton, vice-president of the Royal Society of British Sculptors, called in as independent assessor;

representatives from Coalville were included on the panel to reflect local taste. As the vice-chairman of Coalville Urban Council explained: 'We wanted to please the local people ... We were not in favour of abstract figures because we didn't think the local people would understand them.'[3]

For the first stage, the sculptors were

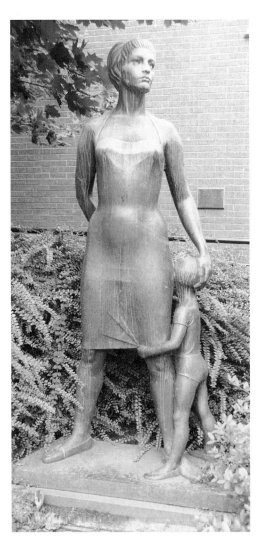

Thomas, *Mother and Child*

required to submit photographs of their designs; from the 200 submitted, the panel drew up a shortlist of twelve sculptors who were then invited to submit models. On 19 October 1962, the panel assessed the shortlisted entries. After four hours of consideration, it awarded third prize (£50) to David Tarver of Loughborough College of Art and Design and second prize (£100) to Raymond Arnatt. The first prize of £200, plus a fee of £2,500 to carry out the work, was awarded to R.J.R. Thomas.[4]

The panel had found Thomas's design of a mother with a child clutching her skirts as she rests a comforting hand on his head particularly appealing in that it 'represents a mother and child and safety'.[5] Thomas had visited Coalville during the summer to survey the site and to get a feel for the town and its people and the type of sculpture to which they would most relate, a task made simpler, he said in an interview with the local press, by his own upbringing in a mining community in South Wales. He continued:

> Further reading of Coalville's other industrial activities enabled me to plan for the contents of the string shopping bag, used in a sculptural manner, in symbolising the products of these industries or works ... The statue would be of figures standing. Yes! I felt the town stood on its own two feet, and the strong, upright figure would best illustrate and represent the energy and vigour of the place. The boy would certainly symbolise the future of the town. What better for a square in the shopping centre than the figure of a young mother, a string bag round her wrist, and with her young son.[6]

At the end of August 1963, the *Coalville Times* published a photograph of the sculptor taking his first look at the newly-cast figure in the foundry in London. In the same week that the commissioners released the picture to the press,

however, came the frustrating news that the opening of the precinct – originally scheduled for the previous May – was to be postponed (and evidently not for the first time) because of a building strike.[7] The £1 million shopping precinct was finally opened and the sculptural centre-piece unveiled on 11 October 1963.

Contrary to Thomas's hope that he would create something the people of Coalville would appreciate, initial popular reaction seems not to have been entirely positive.[8] Nonetheless, the sculpture remained *in situ* for another 26 years, becoming, as the *Leicester Mercury* referred to it in 1991, 'one of Coalville's most famous landmarks'.[9] And yet this celebrity did not save it from nearly being consigned for scrap. In August 1989, the new owners of the precinct decided to install four more units, one of which was to occupy the space taken up by the sculpture. The owners were on the point of sending the sculpture to the scrapyard when North West Leicestershire District Council intervened. *Mother and Child* then spent 18 months in storage before Ian Stemp, a freelance landscape architect working for the Council on improvements to the approach to Coalville's public library, suggested siting it amidst the shrubbery in front of the wheelchair access ramp to the main entrance.[10]

Although some of the people of Coalville may not have taken to the sculpture when it was first unveiled, the Royal Society of British Sculptors gave it their ultimate accolade. At the meeting of the RBS Council on 28 November 1963, from a total of 18 eligible entries, R.J.R. Thomas's *Mother and Child* was awarded the Sir Otto Beit Medal for the best sculpture of the year.[11]

Literature
Royal Society of British Sculptors archives. Minutes of a meeting of the Council held on 28 November 1963.
General. *C. Times:* – [i] 26 October 1962, p.5 [ii] 30 August 1963, p.6, **6** [iii] 6 September 1963, p.9[12] [iv] 4 October 1963, p.1 [v] 18 October 1963, p.3 [vi] 10

October 1997, p.22, **22**; *L. & R. Topic*, June 1971, pp.5, 6, **6**; *L. Mercury:* – [i] 20 October 1962, p.9, **9** [ii] 5 November 1962, p.9, **9**; *L. Mercury (NW Leics edn)*, 15 February 1991, p.13; Pevsner, N. and Williamson, E., 1992, p.133.

Notes
[1] The plaque that was fixed to the front of the statue's original plinth is in store. The inscription reads: THIS SCULPTURE WAS COMMISSIONED / BY TRILAND (COALVILLE) LIMITED, A / SUBSIDIARY OF COSTAIN PROPERTY INVESTMENTS, / EXECUTED BY ROBERT THOMAS, SCULPTOR AND / AWARDED THE SIR OTTO BEIT MEDAL 1963 / BY THE ROYAL SOCIETY OF BRITISH SCULPTORS [2] *L. & R. Topic*, June 1971, p.6. [3] *L. Mercury*, 20 October 1962, p.9. [4] *C. Times*, 26 October 1962, p.5. [5] The words of the Chairman of the selection panel (Philip Sherling, Director of Triland), as reported in *L. Mercury*, 20 October 1962, p.9. [6] *Ibid.*, 5 November 1962, p.9. [7] *C. Times*, 30 August 1963, p.6. [8] H. Martin, writing for *Leicester and Rutland Topic* (June 1971, p.5) reckoned that Thomas's *Mother and Child* 'aroused as much public ire as any incomprehensible abstract', although he does not explain what had caused such hostility. [9] *L. Mercury (NW Leics edn)*, 15 February 1991, p.13. [10] Information from Tessa Massey and Clark Robinson, North West Leicestershire District Council; see also *L. Mercury (NW Leics edn)*, 15 February 1991, p.13. [11] Royal Society of British Sculptors, minutes of a meeting of the Council on 28 November 1963. [12] Reference as given on a typed transcript supplied by the *Coalville Times*; original article not found on LRO microfilm of the newspaper for that date.

On the north side of High Street, opposite the entrance to the Belvoir Shopping Centre:
Miners' Memorial
Sculptor: Judith Holmes Drewry
Founder: Le Blanc Fine Arts, Saxby

Statue in silicon bronze
h. 1.8m (5'11"); w. 1.26m (4'2"); d. 67cm (2'3")
Inscription on the left face of a 'chunk of coal' beneath the miner's right foot (in script):
This memorial is dedicated to all / miners of Leicestershire who gave their / lives winning the coal / [*space*] / Unveiled on the 19th of April 1998 / by David Taylor MP

Signed beneath the dedicatory inscription:
– towards the left: J. Holmes Drewry
– towards the right: LE BLANC FINE ART
Unveiled and dedicated: Sunday 19 April 1998, by David Taylor, MP, North West Leicestershire, and the Rt Revd William Down, Assistant Bishop of Leicester
Status: not listed
Owner / custodian: North West Leicestershire District Council

Description: Standing figure of a miner, his right foot on a chunk of coal, wielding a pick-axe. Behind his left foot is a cast of an Eccles Protector Lamp, inscribed 'Type 6 MEQ Safety Lamps'. On the miner's back is an Oldham

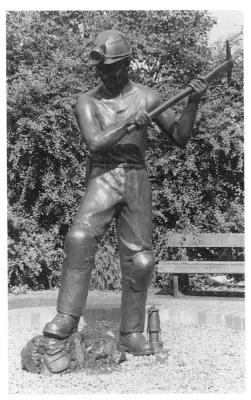

Holmes Drewry, *Miners' Memorial*

battery pack. The figure's base is flush with the gravel of its circular setting, which is bounded by a low brick wall.

Condition: Good.

History: On 8 March 1996 the *Coalville Times* published a front page article proposing a memorial to mark the hundredth anniversary of the 1898 Whitwick pit fire, Leicestershire's worst ever mining disaster in which 35 miners were killed. To this end it announced the launch of the Whitwick Mining Disaster Memorial Fund, an idea seemingly generated by local businessman Phil Holland, who set the ball rolling with a £100 donation. The plan at this point was to erect a statue outside Snibston Discovery Park, a location the paper considered appropriate partly because it is on the site of Snibston Colliery and partly because it was hoped that a statue there would provide a focus and impart a sense of identity to 'one of the untidiest areas of the town'.[1]

By July 1996 the Leicester area NUM and Leicestershire branch of NACODS had expressed interest but suggested that it might be more fitting if the proposed memorial were a commemoration of all miners who had lost their lives over the years in the Leicestershire mining industry. Consequently, a public meeting was convened for 2 August and there the suggestion was endorsed and the Mining Memorial Committee elected.[2]

In order to gauge public expectations, the Committee, through the pages of the *Coalville Times*, asked its readers for their suggestions as to the appearance of the memorial – although the paper wisely made it clear that the ultimate decision would rest with the Committee. By now the Committee was considering several other central sites in addition to Snibston Discovery Park.[3]

The Committee sought advice on the choice of sculptor from local arts organisations and from Loughborough College of Art and Design. Having expressed a preference for

keeping the commission within Leicestershire if possible, the Committee was advised to contact, among others, Le Blanc Fine Art of Saxby. The Committee reviewed its options and, following a satisfactory presentation from the husband and wife team of Judith Holmes Drewry (sculptor/founder) and Lloyd Le Blanc (founder), awarded them the commission.[4]

In all the Committee managed to raise about £24,000 both from private and corporate contributors.[5] The statue, costing £20,000, was eventually unveiled in the High Street on 19 April 1998, exactly 100 years to the day after the Whitwick pit disaster.

Literature
PMSA NRP East Midlands Archive. Letter, dated 26 June 1998, from P. Smith, Leicester Area NUM, to the author.
General. *C. Times*: – [i] 8 March 1996, p.1 [ii] 15 March 1996, p.1 [iii] 23 August 1996, p.2 [iv] 17 April 1998, pp.1, 21–2, 35, **35** [v] 24 April 1998, pp.21, 22, 35, **35**; *L. Mercury*: – [i] 13 November 1997, p.12 [ii] 12 March 1998, p.2 [iii] 31 March 1998, p.19, **19** [iv] 4 April 1998, p.17, **17** [v] 17 April 1998, p.5 [vi] 20 April 1998, p.3, **3**.

Notes
[1] *C. Times*, 8 March 1996, p.1. [2] Letter, dated 26 June 1998, from Pete Smith, Chairman of the Miners' Memorial Fund, to the author. [3] *C. Times*, 23 August 1996, p.2. [4] Letter, dated 26 June 1998, from Pete Smith, Chairman of the Miners' Memorial Fund, to the author. [5] *Ibid.*

Warren Hills Road (B587)

King Edward VII Community College (access only by prior arrangement), 1958–62, by Dennis Clarke Hall.

On a raised walkway linking the Main Hall to the Science Block:

Sculptural Screen Wall
Sculptor: Antony Hollaway

Screen wall in reinforced concrete, ceramic tiles

and glass
Screen wall: h. 2.22m (7'4"); w. 9.14m (30'); d. 22.75cm (9")
Raised on two feet, each one: h. 30.5cm (1'); w. 1.97m (6'6"); d. 51cm (1'8")
Status: not listed
Owner: Leicestershire Education Authority

Condition: The armature has become exposed on the bottom edge towards the left and is now rusty. Without treatment, the metal will expand and eventually burst the concrete.[1] Apart from this the sculpture is in fair condition with just two of the cones from the group at lower left and some of the blue tesserae missing.

History: The screen wall was commissioned in 1961 from sculptor Antony Hollaway by Stewart Mason, the then Director of Education for Leicestershire.[2] After agreeing financial terms – which had to be kept, as always with Education Authority commissions, within tight constraints – Mason arranged a meeting between the sculptor and Clarke Hall, the architect of the new school, so that the details of the project could be discussed. Basically the raised walkway connecting the Main Hall to the Science Block needed a screen wall to provide pedestrians with protection against the wind channelling between the two buildings and it was thought by Mason that this would be an ideal opportunity for an 'integral piece of sculpture'.[3]

The screen wall relief was produced following a method Hollaway evolved for working in concrete during the period of his consultancy (1959–68) with the then London County Council. Negative moulds were produced by cutting the design into sheets of expanded polystyrene. These were then inserted into shuttering (the arrangement of wooden boards used to shape reinforced concrete while it is setting). The concrete was then poured into the negative moulds. For the last

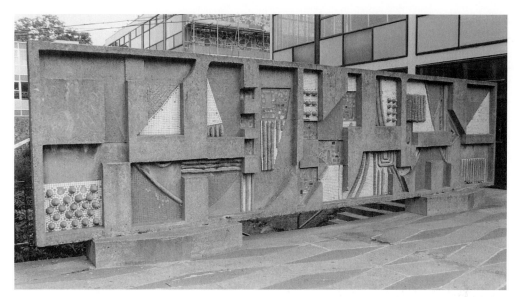

Hollaway, *Sculptural Screen Wall*

part of the process, the removal of the polystyrene moulds from the set concrete, Hollaway had the assistance of volunteer sixth form schoolgirls who, in addition to the time allocated to the project during their art lessons, elected to work on through their lunch hours. The volunteers – suitably kitted out with protective masks, goggles and rubber gloves – removed the polystyrene with paint and wallpaper stripping knives, wire brushes and small nail bars. For the final traces – the 'fuzz', as the sculptor calls it – a solution of carbon tetrachloride was brushed on and the semi-dissolved polystyrene scraped away with wire brushes.

The design of the screen wall, based on the Golden Section, or Mean, is explained by the sculptor as follows:

The main lines correspond with a subdivision of two dimensional space starting with the root 2 rectangle. This is the so-called Golden Mean. This Golden Mean rectangle is contained within the icosahedron and hence the major design lines forming the basis of the relief are all related to space-filling objects ... Put simply, if one asks an observer to divide a rectangle into two visually satisfactory parts, not through the centre, most will instinctively choose a close approximation to the Golden Mean. This has an accurate geometric calculation ... All this has obvious implications for architecture and engineering structures. Buckminster Fuller's geodesic domes are an example and hyperbolic paraboloid roofs too. Plant structures, crystallography and the proportion and symmetry of music are all related. The relief is [intended to be] a basis for discussion and project development by virtue of its design.[4]

Although the Golden Section design is restricted to the side facing the walkway, the

wall is cut through in various places and glazed with one-inch thick coloured slab glass, thus providing the reverse side also with visual interest.

Literature
PMSA NRP East Midlands Archive. Letter, dated 30 August 1999, from Antony Hollaway to the author. **General**. Orna, B., 1964, p.60; Pevsner, N. and Williamson, E., 1992, p.128.

Notes
[1] On being advised of the current condition of the screen wall by the author (August 1999), the sculptor stated that the best course of action would be to expose the affected area of armature by cutting away the surrounding section of concrete, then remove the rust from the metal with acid, and finally re-cover the restored section of armature with fresh concrete. [2] LEA inventory. [3] From a letter, dated 30 August 1999, from the sculptor to the author. [4] *Ibid*.

COUNTESTHORPE
Civil Parish: Countesthorpe
District Council: Blaby

Winchester Road

Countesthorpe College (access only by prior arrangement), 1967–70, by Farmer & Dark.

In the reception area:
Broken Curve

Sculptor: William Pye

Sculpture in nickel-plated steel on a concrete plinth
Sculpture: h. 1.97m (6'6"); w. 58.5cm (1'11"); d. 50cm (1'8")
Plinth: h. 14.5cm (6"); w. 68.5cm (2'3"); d. 57.5cm (1'11")
Executed: 1966[1]
Exhibited: 1968, Coventry, Cathedral ruins (no.27); 1969, London, Redfern Gallery (no. 1); 1980, London, Whitechapel Art Gallery (no. 80)

Status: not listed
Owner: Leicestershire Education Authority

Condition: Several screws are missing from the joints: one at the top of the left-hand upright tube and both from the right-hand upright tube. There are some very small areas of loss to the nickel plating at the joints. Patches of dried adhesive show where paper stickers have

Pye, *Broken Curve*

been removed from the sculpture; three stickers remained at the time of viewing (August 1998). The surface overall is rather dulled with grime.

History: *Broken Curve* was purchased by the Leicestershire Education Authority in 1970 with funds made available through the buildings capital scheme.[2] It is one of a series of sculptures executed by Pye in the late 1960s and early 1970s using as his basic material industrial steel tubing (see also *Ganglion*, 1969, Loughborough College, pp.219–20).

In the catalogue of his 1969 exhibition at the Redfern Gallery, Pye discusses the various techniques and methods he employs and the expressive possibilities of his chosen medium. One of the salient features of the present sculpture is the contrast between the flowing curve of the upper looping section as it descends to the left-hand upright and the abrupt 90° change of direction (the 'broken curve') as it meets the right-hand upright. Pye writes:

> The simple act of cutting a straight tube at 45°, and turning one of the pieces through 180°, and placing the two eliptical facets together to produce a 90° mitred corner I still find curiously intriguing, and it surprises me that such a simple act should have such a transforming and complicating effect ...[3]

The polished surface of the steel is also considered by Pye to be a 'valuable quality', reflecting as it does its immediate environment.[4] As Kenneth Coutts-Smith observed in 1970:

> This results not merely in a kinetic effect of light and form constantly moving across the sculpture to the spectator's eye, or the distorted incorporation of a spectator himself, but in a curious effect as if space actually penetrates and cuts across the sculpture ...[5]

Broken Curve is an example of Pye's fascination with the transformation of what

were basically functional industrial elements into sculpture capable of exerting an emotional or sensuous impact on the viewer. For Pye, an important quality of the final effect is that none of the effort that went into making the piece should be visible; thus the welding of the individual sections that make up the serpentine upper part has been cleaned up to render the seams virtually invisible.[6]

Literature
Art and Artists, vol. 3, no. 5, August 1968, p.**45**; Arts Council of Great Britain, 1980, p.32; Coutts-Smith, K., 1970, p.20; Redfern Gallery, 1969c.

Notes
[1] The catalogue of the 1968 Coventry Cathedral sculpture exhibition gives the date as 1966 (as does the coverage of that exhibition in *Art and Artists*, vol. 3, no. 5, August 1968, p.45). The catalogue of Pye's 1969 Redfern Gallery exhibition, however, gives the date as 1967. The catalogue of the 1980 LEA Whitechapel Art Gallery exhibition (p.32) gives 1970 but this may be a confusion with the LEA's date of acquisition. [2] LEA inventory. [3] Redfern Gallery, 1969c, n. pag. [4] *Ibid.* [5] Coutts-Smith, K., 1970, p.20. [6] Redfern Gallery, 1969c, n. pag.

In the quadrangle:
Dunstable Reel
Sculptor: Phillip King

Sculpture in steel, painted yellow and red-purple
h. 1.97m (6'6"); w. 5.46m (17'11"); d. 5.74m (18'10")
Executed: 1970
Exhibited: 1997, Florence, Forte di Belvedere
Status: not listed
Owner: Leicestershire Education Authority

Description: Abstract sculpture with six elements, three in yellow and three in red-purple, cut from sheet metal. The six elements, combining sharp rectilinearity and swinging curves, touch at points to form an unbroken ring around an open space.
Condition: Good. The paint was retouched

in August 1998 following its return from exhibition in Florence.

History: *Dunstable Reel* was purchased by the Leicestershire Education Authority in 1970 with funds provided through the buildings capital scheme[1] and, according to the sculptor (though not recorded in the LEA inventory), an Arts Council grant. The sculptor commented: 'With the aid of an Arts Council grant, Leicestershire acquired "Dunstable Reel" in 1970 for one of its schools. Its siting there is one of the most successful settings of any of my works.'[2]

According to Strachan, 'Dunstable' appears in the title because King wanted to celebrate the fact that he had just moved to a new studio near Dunstable in Bedfordshire and 'Reel' because he wanted to convey 'the image of a spool with a suggestion of connected threads'.[3]

All too often, abstract sculptures purchased

by the LEA have been ignored, misunderstood and in some cases ultimately rejected by the host schools. For John Watts, former principal of Countesthorpe College, however, *Dunstable Reel* evidently had a deep and appropriate significance:

There you have, in hard edged sheet metal, the symbolising of the dance and *that* seems to me to be what education is essentially about. People joining together in doing something which is tough but enjoyable. And as I go past that work of art day in, day out, it's never quite the same twice over. It changes with the light, the shade, the shadows, the position of the onlooker. It is this changing, shifting view of it – which at the same time is always there and always the same – which I find very fascinating and very satisfying, and I wouldn't like to think

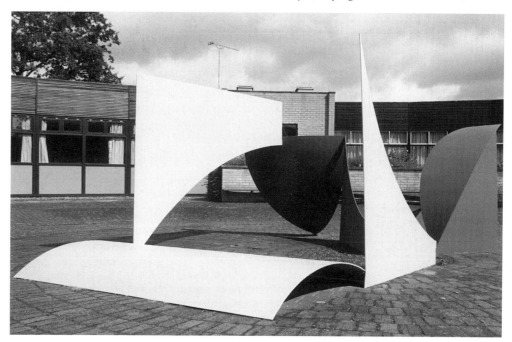

King, *Dunstable Reel*

of anything else now at the centre of Countesthorpe other than the Dunstable Reel.

I think that it's important perhaps that it has simply been there and been taken for granted. People walk past it every day, look at it, stare at it, smack it with their hands as they go by, and simply allow it to become part of their view of the place. To ask anybody for their reaction to it might possibly produce false responses. You might get a very good and significant reaction from people if it suddenly one day wasn't there ... and I think that it would be felt then, somehow, that symbolically, its heart had been torn out.[4]

Following its showing at Florence in 1997, *Dunstable Reel* was, after some time in store, finally resited in August 1998 in its former position in the quadrangle at Countesthorpe College.[5]

Related works: The present sculpture is one of an edition of three, the other two being at the Tate Gallery, London, and at the National Gallery of Australia, Canberra. *Dunstable Reel*

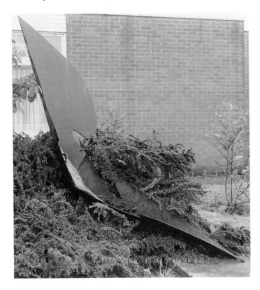

Kneale, *Slip*

was preceded by *Reel*, 1969, stainless steel, aluminium and plastic, edition of two, at the Kröller-Müller National Museum, Otterloo, Netherlands, and Musées Royaux des Beaux-Arts de Belgique, Brussels.

Literature
Whitechapel Art Gallery archives. Press cuttings: *Building*, 3 October 1980; *Times Educational Supplement*, 3 October 1980; *Tribune*, 3 October 1980.
General. Arts Council of Great Britain, 1980, p.21, **21**; Arts Council of Great Britain, 1981, p.24; Firenze, Comune di, 1997, pp.29, **59**; Hilton, T., 1992, pp.57, 58, 112, **28**, col. pl. **12**; Jones, D.K., 1988, p.87; Kröller-Müller National Museum, 1974, p.**38**; Strachan, W.J., 1984, pp.148–9, **149**.

Notes
[1] LEA inventory. [2] As quoted in Whitechapel Art Gallery, 1980, p.21. [3] Strachan, W.J., 1984, pp.148–9. [4] As quoted in Whitechapel Art Gallery, 1980, p.21. [5] Information from Pat Ellson, Countesthorpe College secretary, 21 August 1998.

Kirkby Road

Desford County Primary School (access only by prior arrangement).

1. Outside Reception:

Slip

Sculptor: Bryan Kneale

Sculpture in steel, painted black
h. 1.88m (6'2"); w. 1.8m (5'11");[1] d. 52cm (1'9")
Executed: 1965
Exhibited: 1966, London, Whitechapel Art Gallery (no. 45)
Status: not listed
Owner: Leicestershire Education Authority

Condition: Generally good, although the lower part of the sculpture was completely engulfed within a cotoneaster shrub at the time of viewing (June 1999).

History: *Slip* was purchased by the Leicestershire Education Authority in 1968/9 with funds provided through the buildings capital scheme.[2]

Literature
Whitechapel Art Gallery, 1966.

Notes
[1] The catalogue for Bryan Kneale's 1966 exhibition at the Whitechapel Art Gallery gives different dimensions for this sculpture. While the height at 6'2" (i.e., 1.88m) agrees exactly, the length (designated here as 'width') is given as 9' (i.e., 2.74m). Although the lower part of the present sculpture was difficult to locate within the cotoneaster at the time of viewing, it is not possible to account for such a discrepancy.
[2] LEA inventory. 1968 is the date of acquisition given on the artist's index card; 1969 on the school card.

2. In a small yard within the school buildings:

Child and Bird

Sculptor: Ron Florenz

Sculpture in cold cast bronze and steel
h. 2.92m (9'7"); w. 1.02m (3'4"); d. 1.12m (3'8")
Inscription on a plaque fixed to the nearby wall:
THIS SCULPTURE BY RON FLORENZ / WAS COMMISSIONED BY CATHERINE AND / KENNETH BYRON AND PRESENTED / IN RECOGNITION OF THE WORK OF / DESFORD PRIMARY SCHOOL. / 3RD MARCH 1983
Status: not listed
Owner: Desford County Primary School

Description: The sculpture is located in an extremely small inner yard and takes the form of a three-quarter length representation of a young girl, her body twisting as she reaches her arms up to release a dove. From her swirling skirts descend the three curved legs of a tripod stand, continuing the spiralling movement of

her body.

Condition: Good.

History: As indicated in the above inscription, *Child and Bird* was commissioned by a local couple, Catherine and Kenneth Byron. Early in 1982, Catherine Byron advised the County Council's Education Department of their scheme and requested financial assistance which the Council duly made available on the understanding that the sculpture would be both durable and appropriate for the school. By July 1982 Florenz, a Nottingham-based sculptor whose work the Byrons had seen in an exhibition at Hinckley public library, had produced his first maquette.

The present site is that for which the sculpture was originally intended. It is a small enclosed play area overlooked on all sides by windows. Florenz raised the child's body on three arching legs, high enough so that the children in the play area could move freely between them but not so high that children indoors could not see the child and bird. As Mrs Byron stated in her letter to the Council, Florenz had been asked to design the sculpture not as a showpiece, not for staff and visitors, but essentially for the children.

Florenz modelled the head of the child at the school using one of the then pupils, Alison Peasgood, as his model. The advantage of carrying out this stage of the work at the school was that it showed the children – in something of a workshop situation – how such sculptures were made and gave them, it was hoped, more of a bond with the finished piece.

The whole sculpture was later cast by the sculptor in his studio. For economy and lightness, Florenz used cold cast bronze, a type of polyester resin naturally transparent but made opaque through the addition of a powder filler (and capable of being made to look like bronze, hence the name). The legs were made from steel rods. These two materially disparate parts were lastly given visual unity by the weatherproofing finish applied to both.[1]

Note
[1] From a letter dated 1 July 1982 from Mrs Catherine Byron to Rosemary Drury, Administrative Assistant, Leicestershire County Council Education Department; the name of the pupil whom Florenz used as a model for the head was supplied by the staff of Desford County Primary School.

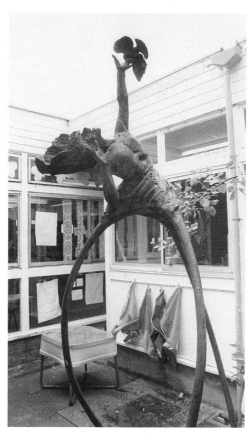

Florenz, *Child and Bird*

Leicester Lane

Bosworth Community College (access only by prior arrangement), by Gollins, Melvin, Ward & Partners, completed 1970.

In front of the Youth Wing:
Avila

Sculptor: Bryan Kneale

Sculpture in steel, painted
h. 2.32m (7'7"); w. 2.66m (8'9"); d. 1.14m (3'9")
Executed: 1975[1]
Exhibited: 1975–6, London, Hayward Gallery; 1978, London, Serpentine Gallery (no. 9)
Status: not listed
Owner: Leicestershire Education Authority

Condition: The sculpture is embedded to a depth of a couple of inches in the asphalt surface upon which it is sited. As a photograph of *c*.1980 shows,[2] the sculpture was originally bolted to what was then a paved surface. When the area was resurfaced, the sculpture was left *in situ* and the asphalt laid around it.

The sculpture appears to have suffered no structural damage over the years, but the paint surface is in poor condition, with losses due to scratching, scuffing and general wear and tear; rust has formed on all areas where the metal has been exposed. Stickers have been partially removed from the upper part of the crescent-shaped element leaving behind their adhesive backing.[3]

History: *Avila* was purchased by the Leicestershire Education Authority in 1976 with funds provided through the buildings capital scheme.[4]

Literature
Arts Council of Great Britain, 1975; Arts Council of Great Britain, 1978; Arts Council of Great Britain, 1980, pp.19, **18**.

Notes
[1] Date as given in Arts Council of Great Britain, 1975 (Hayward Gallery 'New Work 2' exhibition

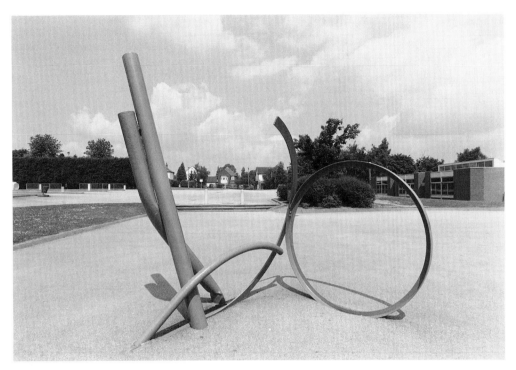

Kneale, *Avila*

catalogue); however, Arts Council of Great Britain, 1978 (Serpentine Gallery Bryan Kneale exhibition catalogue) gives the date as 1973. [2] Arts Council of Great Britain, 1980, p.18. [3] Between the date of the survey (22 October 1998) and a return visit to take photographs (1 June 1999), the sculpture had been repainted in red (previously blue-green), matching the nearby railings. [4] LEA inventory.

In front of Reception, to the right of the entrance:

Coré

Sculptor: Barbara Hepworth

Sculpture in bronze on a base in black slate and a plinth in concrete
Sculpture: h. 74cm (2'5"); w. 40cm (1'4"); d. 31.5cm (1'1")
Base: h. 5cm (2"); w. 46cm (1'6"); d. 35.5cm (1'2")
Plinth: h. 91.5cm (3'); w. 51cm (1'8"); d. 51cm (1'8")
Executed: 1959 (plaster taken from an earlier marble sculpture); 1960 (bronze edition of seven)
Exhibited (this cast only): 1967–8, London,

Whitechapel Art Gallery (no. 24); 1980, London, Whitechapel Art Gallery (no. 74)[1]
Status: not listed
Owner: Leicestershire Education Authority

Condition: The sculpture itself appears to be in good condition, although it is spattered with guano. The polished black slate base, however, is slightly chipped along the front and rear upper edges and has some biological growth on its sides. The cream-painted surface of the plinth is in poor condition: there is much blistering and flaking and some losses, exposing the concrete; the front face has extensive biological growth.

History: *Coré* was originally loaned by the sculptor to Dixie Grammar School, Market Bosworth;[2] by 1980, however, it had been purchased by the Leicestershire Education Authority with assistance from the Arts Council of Great Britain.[3]

Hepworth began casting in bronze in 1956 in response to a growing demand for her work, both for sale and for international exhibitions. As she explained to Herbert Read in 1961, 'the travelling circus [of biennales and British Council tours] shriek [sic] for more and more bronzes [because] the transporters smash all carvings'.[4] In the same letter she expressed her fears that such demands on sculptors would inevitably lead to over-production and a corresponding drop in the quality of casts. The present cast of *Coré*, however, appears to be of fine quality. Casts from the edition of seven were shown soon after casting at Zurich (Galerie Charles Lienhard, October 1960) and in an Arts Council touring exhibition of English public galleries (July-December 1961), and frequently over the next few years at venues both at home and abroad. The edition was sold out by 1968.[5]

Marble Form (Coré), 1955–6, the marble sculpture of which the present bronze is a cast, was produced shortly after the sculptor's return

from her first visit to Greece and the Greek islands in August 1954 and reflects both in its title and in its material, her response to the culture of ancient Greece. It was not merely Greek sculpture that made such a strong impression on her, but also the architectural sites within their landscape settings and the rugged landscape itself. These influences informed a whole group of sculptures in wood (she having recently been given a large consignment) that she executed on her return: *Corinthos*, 1954–5; *Curved Form (Delphi)*, 1955; *Configuration (Phira)*, 1955; and *Oval Sculpture (Delos)*, 1955.[6] With *Marble Form (Coré)*, however, Hepworth used the actual

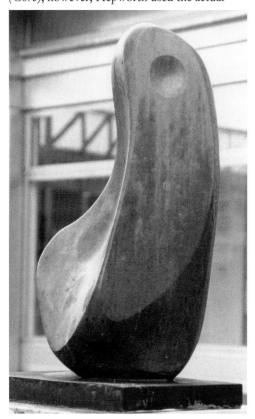

Hepworth, *Coré*

material more commonly associated with the surviving sculpture of ancient Greece.

'Core', or more usually 'kore', is Greek for maiden and is the term used for statues of standing draped female figures, characterised by a rigidly frontal pose and typical of the Archaic Greek period (*c*.620 – *c*.500 BC). However, as Chris Stephens has pointed out, despite Hepworth's reference to the Archaic Greek kore in her title, hers is an essentially individual response, her *Coré* being conceived as a sensuously organic form with just a vestigial suggestion of the human face in its upper part, in the crescent on the left-hand side and the circular concavity on the right.[7]

Related works: (i) *Marble Form (Coré)*, marble, 1955–6, Coll. Mr Pierre Schlumberg, Houston, Texas; (ii) *Coré*, bronze edition of seven, 1960: casts in public collections include London, Tate Gallery (inscribed 1/7, cat. no. T03135) and Manchester, Whitworth Art Gallery (unnumbered cast, cat. no. S.1968.1).

Literature
Gale, M. and Stephens, C., 1999, pp.143, 145–7, 287, **146**; *L. Chronicle*, 19 January 1968, p.**23**; Tate Gallery, 1968, p.57; Tate Gallery, 1982, pp.47, **29**; Whitechapel Art Gallery, 1967, p.16, illus. betw. pp.18/19; Arts Council of Great Britain, 1980, pp.18, 32, **18**.

Notes
[1] The many exhibitions in which the other casts have been shown are listed in Gale, M. and Stephens, C., 1999, p.145. [2] Whitechapel Art Gallery, 1967, p.16 (no. 24). [3] Arts Council of Great Britain, 1980, p.32 (no. 74). The LEA inventory, however, lists *Coré* as 'gift of artist'. It has not been possible to verify which statement is correct. Nor is it clear from either the Arts Council catalogue or the LEA inventory whether *Coré* had by this time been relocated to Bosworth Community College – the catalogue gives its location merely as 'Bosworth' which could either refer to the Community College at Desford or to Dixie Grammar School at Market Bosworth. [4] As quoted in Gale, M. and Stephens, C., 1999, p.145. [5] *Ibid.* [6] Tate Gallery, 1968, p.25; Tate Gallery, 1982, p.16. [7] Gale, M. and Stephens, C., 1999, p.145.

In the quadrangle to the rear of the main reception area:

3B Series No. 2
Sculptor: Bernard Schottlander

Sculpture in mild steel, painted black
h. 3.36m (11'); w. 8.1m (26'7"); d. 3.34m (11')
Monogram and date in raised characters on the north face of the upright element supporting the ring:
BS / – / 68
Executed: 1968
Exhibited: (?)1968, 'Exhibition of British Sculpture', Coventry Cathedral[1]
Status: not listed
Owner: Leicestershire Education Authority

Condition: Although the sculpture appears to be structurally sound, much of the black paint surface is in poor condition on the lower, more accessible surfaces. The paint has been scratched and scuffed, exposing the green undercoat and in places even the metal. Where the metal is exposed, rust has formed.

History: *3B Series No. 2* was purchased by the Leicestershire Education Authority in 1969 with funds made available through the buildings capital scheme.[2]

Related works: *3B Series No. 1*, 1968, steel, painted scarlet, Warwick University;[3] *3B Series No. 3*, mild steel, painted black, Shepshed High School (see pp.272–3).

Literature
Arts Council of Great Britain, 1980, p.19, **19**; Strachan, W.J., 1984, p.149, **149**.

Notes
[1] In an article 'How to see Sculpture' by Charles Spencer (*Sculpture International*, vol. 2, no. 3, October 1968, p.35) there is a colour photograph showing what looks like the present work (in red); a brief reference on p.34 does not give the sculpture's title. The catalogue, Coventry Cathedral, *Exhibition of British Sculpture*, June-August 1968, however, lists only one work by Schottlander, *Box Section*, 1968 (no. 35, not illustrated). [2] LEA inventory. [3] Strachan, W.J., 1984, p.163.

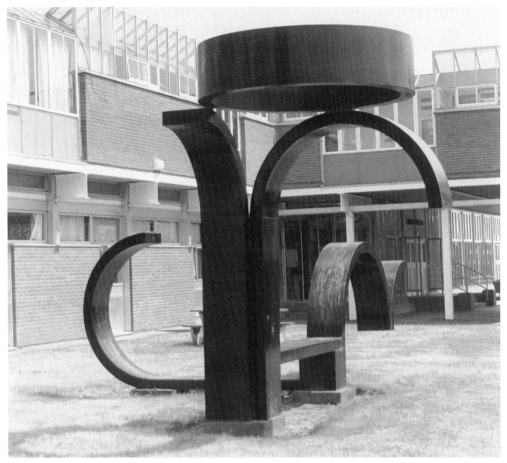

Schottlander, 3B Series No. 2

Condition: Good.

History: This cast of *Four Rings* was, as the inscription states, presented to Bosworth College by Timothy and Eva Rogers in memory of their son.

Related work: A further cast is at the University of Sheffield, presented in 1982 by the Sheffield Fine Art Society to commemorate the centenary of Firth College.[1]

Literature
Hamilton, J., 1994, p.104 (S246).

Note
[1] Hamilton, J., 1994, p.104.

Desford Hall (now MTM Marketing), 2 miles S.E. of Desford.
Neither the date of construction nor the architect's name are known.

Status of the building: not listed
Owner of building: privately owned

On the exterior side walls are two portrait roundels:
1. West-facing side wall:

King Henry VII

Sculptor: unknown

Portrait roundel in [?]terracotta
Dia. (est.): 89cm (2'11")
Inscriptions either side of the head:
– to the left: HENRIC. VII
– to the right: REX. ANG

Description: A head and shoulders portrait of *Henry VII* modelled in high relief, within a roundel with a heavily moulded frame. Depicted looking to his left, he wears a cap and holds a sceptre in his hand.

Condition: Generally good, though with some biological growth.

In the corridor outside the Vice-Principal's office:

Four Rings

Sculptor: Austin Wright

Sculpture in aluminium on a pedestal in wood
Sculpture: h. 44cm (1'5"); w. 78cm (2'7"); d. 41cm (1'4")
Pedestal: h. 81.5cm (2'8"); w. 78cm (2'7"); d. 35.5cm (1'2")
Inscription on a metal plaque affixed to the front face of the pedestal:
AUSTIN WRIGHT / FOUR RINGS / GIVEN BY HIS PARENTS IN MEMORY OF / JONATHAN OLE WALES ROGERS / 1954 – 1982
Executed: 1966
Exhibited: 1968, 'Austin Wright', Goosewell Gallery, Menston, Ilkley

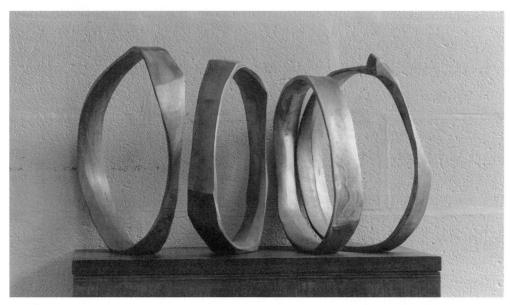

Wright, *Four Rings*

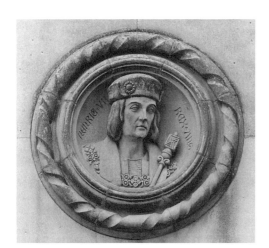

King Henry VII

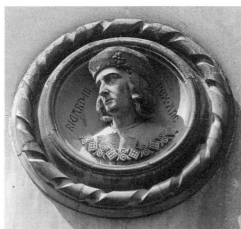

King Richard III

2. East-facing side wall:

King Richard III

Sculptor: unknown

Portrait roundel in [?]terracotta
Diam. (est.): 89cm (2'11")
Inscriptions either side of the head:
– to the left: RICARD. III
– to the right: REX. ANG

 Description: A head and shoulders portrait
of *Richard III* in high relief set within a roundel
with a heavily moulded frame. He is depicted
wearing a cap, looking to his right.
 Condition: Generally good, though with
some biological growth.

EARL SHILTON
Civil Parish: Hinckley
Borough Council: Hinckley and Bosworth

Alexander Avenue

*Weaver's Close Primary School (access only
by prior arrangement), 1955, by T.A.
Collins.*

Mounted on an exterior wall:

Relief sculpture

Sculptor: Ronald Pope

Sculpture in Hadene stone
h. 1.54m (5'); w. 47cm (1'7"); d. 8cm (3")
Executed: 1956
Status: not listed
Owner: Leicestershire Education Authority

 Description: The relief sculpture represents a
seated woman looking upwards against a
background of stylised vegetal forms. Her right
hand rests palm upwards in her lap supporting
her left hand which she holds in a perpendicular
position.

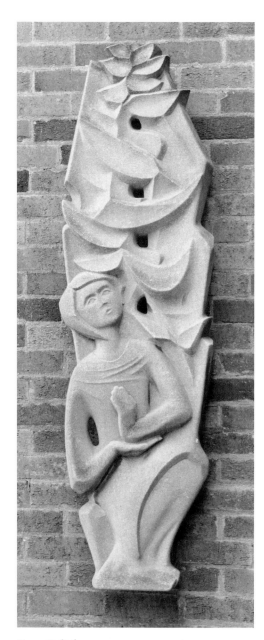

Pope, *Relief*

Condition: Good.

History: The present relief sculpture was commissioned by the Leicestershire Education Authority in 1956.[1]

Note

[1] Information from Derby Museum and Art Gallery.

Heath Lane

William Bradford Community College (access only by prior arrangement).

On an exterior wall to the left of Reception:

Calendula

Sculptor: Wendy Taylor

Sculpture in fibreglass and metal
Each circle dia. 76.2cm (2'6"); depth: 18cm (7")
Overall dia. 3m (9'10")
Executed: 1966–7; remade 1977[1]
Exhibited: 1968, Camden Arts Centre (no. 1)
Status: not listed
Owner: Leicestershire Education Authority

Description: The sculpture comprises seven identically-sized discs arranged in a circular formation, fixed to, and standing slightly away from, an exterior brick wall. Edward Lucie-Smith has written of the piece as follows:

> The point here is not so much the forms themselves, taken in isolation, but the pattern of shadows they cast on the brickwork according to the time of day and the conditions of light. The discs seem to float against their background because they are semi-circular in profile – that is, each one is a slice cut from a sphere.[2]

The original colouring was bright orange for the fronts and dark green for the sides facing the wall – this, however, has recently been drastically altered (see 'Condition', below).

Condition: The sculpture was repainted in green during the 1998 summer vacation to

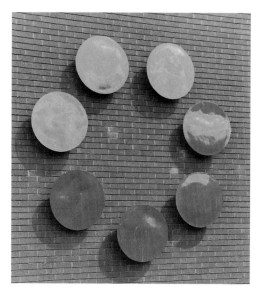

Taylor, *Calendula*

match the school's new colours. The original colour of the front faces, orange, had been specifically selected by the sculptor to give the illusion that the discs were floating. Sadly the repainting has effectively neutralised the intended effect.

History: *Calendula* was purchased by the Leicestershire Education Authority in 1977.[3] It is closely related to Taylor's contemporary piece, *Calthae* (1967), although in the latter piece the considerably larger discs – they are over twice as large as those in *Calendula* – are designed to float on water, each anchored to the bottom in a circular configuration. Where *Calendula* is rigidly fixed to its wall, changing only as the movement of the sun modifies the light and shade across its surfaces, *Calthae* actually does move: its discs are blown by the wind out of their circular configuration, only to float back again into a perfect circle when the wind dies down and the surface of the water calms. Both sculptures were inspired by

flowers. Taylor was at this time earning money as a gardener in a public park and she had been struck by the way the flower heads in a densely planted bed of marigolds moved out of and then back into their original pattern under the influence of the wind.[4]

Of the link between her sculpture and nature, Taylor said in 1968:

> A coloured shape that has the same impression upon our mind as, for example, the sight of a bed of Calendulas (Giant Marigolds) at 7.30 on an autumn morning, walking out when it is crisp and cold, and seeing the sheer brilliance and warmth of several hundred glowing orange circles and sensing that to be amongst them it would be warm and bright – this is the feeling that I want to create in a single collection of shapes; to be able to retain that emotion.[5]

Literature
Camden Arts Centre, 1968, pp.6, **7**; Lucie-Smith, E., 1992b, pp.17, 18, 19, 115, **17**, **115**; Strachan, W.J., 1984, p.149, **149**.

Notes
[1] Strachan, W.J., 1984, p.149. [2] Lucie-Smith, E., 1992b, p.17. [3] LEA inventory. [4] Lucie-Smith, E., 1992b, p.18. *Calthae* is not, however, nor has it ever been, at Earl Shilton Community Centre, as Lucie-Smith states. According to the sculptor the piece has not survived. [5] As quoted in Camden Arts Centre, 1968, p.6.

Inside the school:
Sculpture for the Side of a Mountain
Sculptor: Paul Williams

Sculpture in pine, carved
h. 88cm (2'11"); w. 1.59m (5'3"); d. 1.14m (3'9")
Status: not listed
Owner: Leicestershire Education Authority

Description: Located in the waiting area behind Reception, the sculpture represents a

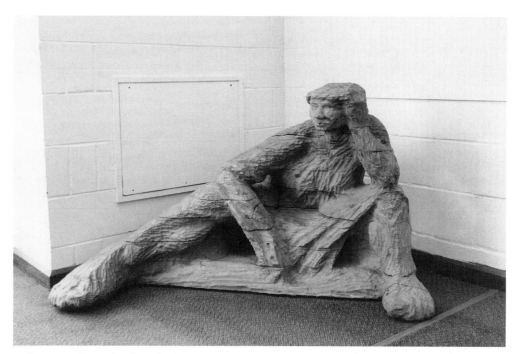

Williams, *Sculpture for the Side of a Mountain*

female figure seated on the ground, gazing off into the distance, her head supported on her left hand.

Condition: Good, although the sculpture is now without the plinth upon which it was mounted when originally sited in the entrance hall of the school.

History: *Sculpture for the Side of a Mountain* was purchased by the Leicestershire Education Authority from the artist in 1992.[1]

Note
[1] LEA inventory.

Wood Street

On the south side of Wood Street:
Earl Shilton War Memorial

Architect: Edward John Williams
Sculptor: Anthony Smith

Memorial in Portland stone on a base of Mountsorrel granite
h. 5.49m (18')
Inscriptions, incised into the pedestal and gilded:
– front face: 1939 / 1945 [within a laurel wreath carved in high relief] / TO COMMEMORATE / THE MEN OF THIS PARISH / WHO GAVE THEIR LIVES / IN THE WARS / 1914.1919 – 1939.1945 [below which is a list of 30 names in two columns, initials only of forenames, surnames in alphabetical order; and then, in italic script] *"They shall grow not old, / As we that are left grow old, / Age shall not weary them / Nor the years condemn, / At the going down of the sun /*

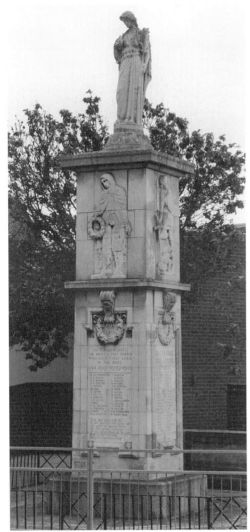

Earl Shilton War Memorial

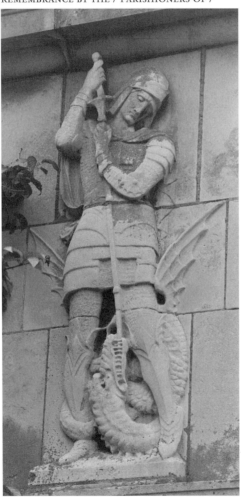

Earl Shilton War Memorial: St George

And in the morning, / We will remember them"
– left face: 1914 / 1919 [within a laurel wreath carved in high relief] / LEST WE FORGET [below which is a list of 52 names in alphabetical order, from A–H, in two columns]
– right face: 1914 / 1919 [within a laurel wreath carved in high relief] / LEST WE FORGET [below which is a list of 52 names, from H onwards, plus added names, in two columns]
– rear face: ERECTED IN GRATEFUL / REMEMBRANCE BY THE / PARISHIONERS OF /

EARL SHILTON / 1920 / RESTORED / 1948
In a recessed panel on the rear face of the pedestal:
E.J. WILLIAMS […?] / A. SMITH SCULPTOR / J.W. WORTH R.I.B.A.
Unveiled and dedicated: Monday 11 October 1920, by Lieutenant-Colonel C.H. Jones, CMG, TD, and Canon Hurrell, Vicar of Hinckley and Rural Dean.
Status: Grade II
Owner / custodian: Earl Shilton Parish Council

Description: The war memorial is in the form of a tall cenotaph in Portland stone on a base of Mountsorrel granite. The lower portion of the cenotaph bears the inscriptions. On the front, left and right faces each inscription is set within a moulded frame at the top of which is a bracket decorated with a cherub face. From the lower end of each bracket hangs a laurel wreath carved in high relief. Above the brackets is an architrave, wide frieze and cornice. The frieze has high relief carvings of, on the front face, a classically-draped widowed mother holding a laurel wreath in her right hand, and with a child – 'in whom all her future hope is centred'[1] – standing at her left side; on the left face, St George killing the dragon; and on the right face, St Michael vanquishing Satan. Surmounting the whole is *Peace*, a free-standing classically-draped female figure. She gazes down mournfully on a dove (for peace) which she holds tenderly in her right hand, while in her left hand she holds a palm branch (for self-sacrifice).

Condition: Fair, although the carving is now weathered, especially the makers' names, which are incised in a recessed panel on the rear face of the memorial. The three names are still relatively readable, but the letters following 'E.J. Williams' are totally illegible and the word 'Sculptor' following 'A. Smith' only just readable. The whole memorial was restored in 1948.

History: The *Earl Shilton War Memorial*

cost nearly £800, raised by a combination of public subscription and various fund-raising events.

The weathering of the small recessed panel on the rear of the memorial listing the names of the three makers has resulted in a degree of confusion. The only one about whom we can be certain is 'A. Smith Sculptor'. This is Anthony Smith, listed in contemporary trade directories as a Leicester-based carver in wood and stone. E.J. Williams is, however, the only one of the three to be mentioned in contemporary newspaper accounts of the unveiling and dedication ceremony where he is referred to as the 'honorary architect' and is congratulated 'on the excellence of the cenotaph'.[2] That Smith is not mentioned may indicate that he merely executed the sculptures to the architect's design, a not uncommon practice. It is with the last name, 'J.W. Worth R.I.B.A.' (Royal Institute of British Architects), that a problem arises. Whereas E.J. Williams is listed in *Kelly's Directory of Leicester*, 1922, as a partner in the Leicester architectural practice, Harding and Williams, J.W. Worth cannot be found. Nor does there appear to be any record of his membership of the RIBA. And yet the DCMS lists attribute the design of the memorial to Worth, relegating Williams unaccountably to carver of inscriptions (no source for these attributions is stated). Given the evidence of the contemporary press, it is probable that Williams was indeed responsible for the design. However, as he did not start independent practice until 1921, the year after the memorial was unveiled, perhaps Worth was a more experienced architect from whom Williams received technical advice.

Literature
H. Echo, 13 October 1920, p.4; Hinckley Times, 1996, p.**71**; *L. Chronicle*: – [i] 15 November 1919, p.2 [ii] 2 October 1920, p.1 [iii] 16 October 1920, pp.2, 1; *L. Daily Post*: – [i] 13 November 1919, p.4 [ii] 12 October 1920, p.5; *L. Mail*: – [i] 30 June 1920, p.4 [ii] 12 October 1920, p.3; Sharpe, J.M., 1992, pp.20, 26, 27, 51, figs. **2.8**, **2.10**, **4.3**; Shaw, F., 1987, fig. **58**.

Notes
[1] *L. Chronicle*, 16 October 1920, p.2. [2] *L. Mail*, 12 October 1920, p.3.

ENDERBY

Blaby Road

In the forecourt of Diamond Wood Partnership (consulting engineers), formerly the National School, by Millican and Smith, 1860:[1]

Memorial to Charles Brook

Charles Brook (1813–72), philanthropist, was born in Huddersfield, Yorkshire, and in 1840 became a partner in Jonas Brook Brothers, his father's banking and cotton-spinning firm. In addition to introducing improvements to the machinery, he not only made strenuous efforts to promote the welfare of his two thousand employees but also taught their children at Sunday School. He laid out an estate for his employees at Melpham and equipped it with a dining hall, concert room and swimming bath. At a personal expense of £40,000 he built a convalescent home at Huddersfield, designing the landscaped grounds himself. Throughout the area he erected or enlarged churches, schools, infirmaries and cottages. In 1865 he purchased Enderby Hall and adjoining estates for £150,000. Once at Enderby, Brook started philanthropic works there too. He donated land for a new cemetery (in which he was ultimately buried); separated the livings of Enderby and Whetstone to increase the number of those who ministered to Enderby's spiritual needs; funded, in 1868, the rebuilding of the Church of St John the Baptist (£7,000); erected the parish vicarage; rebuilt the local stocking weavers' cottages; paid for a cistern for the village water supply;

enlarged the parish school (£500); and established a public library and reading room (completed after his death). Though a devout member of the Church of England, his beneficence extended to Christians of all denominations. As his friend, the Revd Ince, said at the unveiling ceremony: 'for a man to be Christian was a sufficient passport to his affection and esteem.'[2] Brook married in 1860. He died at Enderby Hall of pleurisy and bronchitis on 10 July 1872.
Sources: *DNB*; *L. Chronicle*, 8 August 1874, p.7; *L. Daily Post*, 6 August 1874, p.3.

Designer: John Breedon Everard
Sculptor: Mark Hessey
Monumental masons: Thrall and Vann

Memorial in Sicilian marble, Shap granite and limestone
h. (overall) 4.6m (15'1")
Inscriptions:
(a) on the cylindrical pedestal
– incised into the front: CHARLES BROOK / BORN NOVEMBER 18 / 1813 / DIED JULY 10 / 1872
– incised into the rear: ERECTED / BY / SUBSCRIPTION / 1874
(b) on the front of the base of the clustered columns, beneath the medallion portrait, in metal letters: RICH IN GOOD WORKS. I. TIMOTHY. VI. 18.
Unveiled: Wednesday 5 August 1874, by the Revd E.C. Ince, a friend of the subject
Status: Grade II
Owners: Mr and Mrs P.D.M. Diamond of Poplar House, The Cross, Enderby

Description: A Gothic-style monument comprising a square stone base and sub-base oriented diagonally to the front, supporting two octagonal steps leading up to a cylindrical pedestal of polished granite with a moulded cornice and base, bearing on the front and rear of the drum the main inscriptions. On top of the pedestal, in white marble, is a stumpy pier

of four clustered columns crowned by capitals with conventionalised foliage and various naturalistically-carved flowers, each one symbolic. According to the designer, J.B. Everard, they are:

> The rose and jasmine representing love and amiability; the white lily and crocus representing purity and cheerfulness, the water lily and white bell flowers representing purity of heart and gratitude, the poppy and chrysanthemum representing consolation and truth.[3]

The shaft of the front column bears a carved portrait head of Charles Brook in a projecting oval frame. Around the base of the clustered columns runs an inscription in metal letters: 'Rich in good works ...' Crowning all is a winged Angel of Charity, also in white marble, kneeling on one knee with small children sheltering under its wings. The sculptor provided the following explanation:

> The figures are intended to personify a characteristic of Mr. Brook's nature, charity, care and thought for others, and the two most prominent objects of his kindliness the sick and untaught. The group represents no particular incident in Mr. Brook's life, rather the ideal form his goodness would take in the minds of people when told of Mr. Brook's disposition and deeds; hence the clouds on which all creations float mental or material. The wings of the central figure are typical of power, shelter, and upholding presence in another form than that of the body, as a memory, an influence, comforting, sustaining, encouraging. The dove symbolising love enveloped in light which never faileth, the light of friendliness, intelligence, sympathy, flowing out of the better nature of the man, now, if you will, living on the name and fame he made and won, and the spirit of his good works.[4]

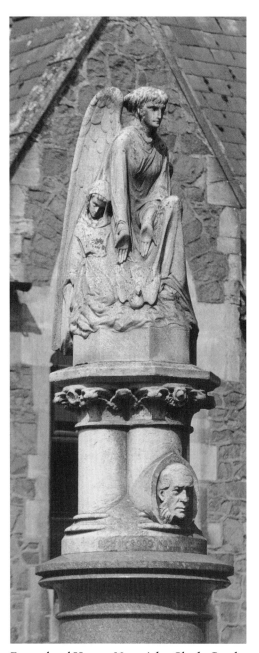

Everard and Hessey, *Memorial to Charles Brook*

The monument is surrounded by a low chain link fence.

Condition: Generally fair, although the carving of those parts in Sicilian marble – the clustered columns and surmounting group – is very weathered with a consequent blurring of detail. The marble is also grimy with some areas of black accretions and lichen. The base and steps have patches of moss and a considerable covering of ivy, particularly at the rear. The uppermost step is cracked across on the right rear face.

History: Following Brook's death in July 1872, a group of the leading citizens of Enderby met to discuss how to commemorate a man who in such a short time had done so much for their village. In early 1874, a committee was elected to supervise a public subscription for a monument. The make-up of the committee reflected Brook's non-sectarian beneficence, with the local vicar, the Revd G. Edwards, as chairman and a dissenting minister, the Revd G.H. Dickinson as secretary. Another member of the committee was a local farmer, William Everard. It was his nephew, John Breedon Everard, a Leicester-based civil engineer, who designed the memorial free of charge and supervised its erection by Thrall and Vann, a firm of monumental masons also based in Leicester. Only the figurative sculpture was executed by a non-local, Mark Hessey, from York.[5]

According to the Revd Dickinson, speaking at the unveiling ceremony, the design of the memorial was wholly Everard's: the people of Enderby, he said, 'were not indebted to the committee for the very chaste and elegant memorial', it being 'an emanation from the mind of Mr. Everard himself'.[6] The architect was not able to attend the ceremony but had supplied the Committee with the following explanation of his design: 'The leading object has been the use of rich and lasting materials, and by substantial construction without

excessive ornamentation to typify the sterling qualities of Mr. Brook, which it is intended to memorialize.'[7]

The unveiling ceremony clearly reflected the esteem in which Brook was held by the village. About five hundred children from both the Parish and Dissenting schools assembled at their respective schools, marched to The Cross, sang a hymn, formed into twos and, preceded by the Revds Edwards and Dickinson, processed through the streets of Enderby to the memorial. At the unveiling ceremony, Brook's friend from Huddersfield, the Revd Ince, explained to the assembled crowds the greater purpose of the memorial:

> ... to remind the rising generation of one who was good, humble, always spoke the truth, unselfish, simple in character, lived to do others good, and lived to show himself a true disciple of Jesus Christ – an example which ought to inspire all present with an emulation to 'go and do likewise'.[8]

Literature
Crofts, J. and Moreton, N., 1998, p.22; *Kelly's Directory of ... Leicester and Rutland*, 1922, p.79; *L. Chronicle*: – [i] 28 December 1872, p.3 [ii] 8 August 1874, p.7; *L. Daily Post*, 6 August 1874, [p.3]; *L. Journal*, 7 August 1874, [p.3].

Notes
[1] Pevsner, N. and Williamson, E., 1992, p.151. [2] *L. Chronicle*, 8 August 1874, p.7. [3] From J.B. Everard's prepared statement for the unveiling ceremony, as transcribed in *L. Journal*, 7 August 1874, p.3. [4] M. Hessey's prepared statement for the unveiling ceremony, as transcribed in *L. Journal*, 7 August 1874, p.3. [5] *L. Chronicle*, 8 August 1874, p.7. [6] *Ibid*. [7] *L. Journal*, 7 August 1874, p.3. [8] *L. Chronicle*, 8 August 1874, p.7.

Mill Lane

Brockington College (access only by prior arrangement), 1957, by T.A. Collins, officially opened by Sir William Brockington, 23 June 1958

On the right-hand exterior rear wall beyond the reception area:

Badger

Sculptor: Penelope Ellis

Relief sculpture in ciment fondu, marble pebbles, ceramic pieces and slate
h. 1.04m (3'5"); w. 1.87m (6'2"); d. 22.5cm (9")
Designed and executed: August 1957 – April 1958
Status: not listed
Owner: Leicestershire Education Authority

Description: A relief representation of a badger, mounted directly onto the exterior elevation of a brick wall, above head height, to the right of the steps leading down from the rear entrance of the reception area. The badger is shown walking from right to left, snout down, head turned towards the viewer. Its natural markings are suggested by small inlaid pieces of slate, dark stones, and white stones.

Condition: Good.

History: In early 1957 Alec Clifton-Taylor, artistic advisor to Stewart Mason, then Director of Education for Leicestershire, contacted F.E. McWilliam, then Head of Sculpture at the Slade School of Fine Art, to see whether he knew of any young sculptors who might be interested in producing a sculpture to decorate an exterior wall of a Leicestershire school.[1] McWilliam wrote to Penelope Ellis, one of his former students, who was then living in Paris. In his letter he states that the fee is to be £90 and suggests that the most appropriate material would, in his opinion, be concrete. In pragmatic fashion, he ends his letter recommending that the sculptor, if interested, should 'be thinking

Ellis, *Badger*

of solid animals which could be cast easily (no one-leg storks)'.[2]

On her return to England in July 1957, Ellis wrote to Clifton-Taylor expressing her interest and on 17 July received a reply in which are quite apparent the financial restraints within which LEA commissions were always conducted and the need to show value for money: Clifton-Taylor writes that the relief should be 'as large as possible within a price limit of £90' and raises a concern (presumably in the end surmounted) about the potentially high carriage costs of transporting any finished work from the sculptor's studio in Corsham. However, before any agreement could be finalised, he advises her, he would first need to see her drawings. A few days later Ellis visited Clifton-Taylor in London to show him examples of her work and to discuss possible approaches to the commission. On 31 July she received a postcard informing her that she had been selected for one of the jobs then on offer (Mason and Clifton-Taylor were looking for sculptures for two of their schools, one at Castle Rock, near Coalville, the other the present school, Brockington Church of England Secondary School and Community College, then in the course of construction). The sculptor was taken to view both potential sites in August.

The Enderby school had been named after

Sir William Brockington, Mason's predecessor, referred to affectionately as Brocky. From this it was but a short step to deciding that the most suitable subject for the relief would be a brock or badger. It would seem that Ellis had little enthusiasm for the badger idea at first,[3] but after spending some time observing and drawing them she warmed to the subject, confirmed that she wanted the Enderby commission and, on 9 September, received the go-ahead from Mason who, according to the sculptor, gave her complete artistic freedom. By mid-November, the relief was almost finished and Ellis turned her attention to the method of fixing it to the wall. She calculated that it would need five or six support bars projecting seven inches from the back of the relief, at first suggesting copper rods but later securing agreement from the County Architect (i.e., T.A. Collins) that more weather-resistant phosphor-bronze rods should be used.

The relief was transported to Enderby on 5 May 1958 and fixed to the wall shortly afterwards. The agreed sum of £90, paid on 8 August 1958, covered all costs – the sculptor's fee, materials, casting and travelling expenses, etc. – except for transportation of the completed relief from the sculptor's studio to the school.

Of *Badger*, the sculptor writes:

I liked the colour of ciment fondu, it was well suited to Badger although perhaps unadulterated its matt finish over a large expanse was a bit dull. I wanted to enjoy the distinctive badger markings – to do this I adapted mosaic techniques to cast into the finished work un-cut chunks of slate, Carrara marble pebbles, some halved and some quartered (I had picked these pebbles up on the beach at Carrara on a family holiday some years previously – there were just enough for Badger) and ceramic pieces with a shiny black glaze (made specially by PE) to add variety and incident.[4]

Literature
PMSA NRP East Midlands Archive. Letter from Penelope Ellis to the author, dated 19 July 1999, with photocopied correspondence from Alec Clifton-Taylor; *Opening of the Brockington C.E. Secondary School and Community College, Enderby* (official programme), 1958.
General. *L. Evening Mail*, 24 June 1958, p.2, 2; Pevsner, N. and Williamson, E., 1992, pp.44, 151.

Notes
[1] All of the information forming this account is contained in a letter from Penelope Ellis to the author, dated 19 July 1999, along with accompanying photocopies of correspondence between the sculptor and her patrons. [2] As transcribed by Penelope Ellis. [3] Clifton-Taylor writes in his postcard, dated 31 July 1957: 'It's a pity you are not drawn to badgers!' [4] Letter from Penelope Ellis to the author, dated 19 July 1999.

In Danemill County Primary School (access only by prior arrangement):
Sun

Sculptor: Bernard Schottlander

Sculpture in steel, painted purple
h. 2.35m (7'9"); w. 1.07m (3'6"); d. 20.25cm (8")
Executed: *c.*1965
Status: not listed
Owner: Leicestershire Education Authority

Condition: According to the school, the sculpture has been repainted on the premises in recent years. The paint surface of the 'head' and 'stem' is sound, but the base is in poor condition, the paint being variously blistered, peeling, flaking and lost; where the metal is exposed rust has formed. Following the sculpture's removal from its original location immediately to the right of the entrance, the bolts securing the base to the ground were left proud of the surface: three are now rusted in position, the fourth may be broken. The sculpture is not fixed in its present location.

History: *Sun* was acquired by the Leicestershire Education Authority in 1965.[90]

Schottlander, *Sun*

Until recently it stood at the rear of a little flower bed to the immediate right of the entrance to Reception. When this was converted into a memorial flower bed for a former headmaster, the sculpture was removed and is now somewhat less sympathetically located in a corner outside one of the classrooms.

Note
[1] LEA inventory.

George Fox Lane

On the east side of George Fox Lane, at the corner with Old Forge Road:

Monument to George Fox

George Fox (1624–91), founder of the Society of Friends, was born at Fenny Drayton, the son of a Puritan weaver. In 1643, he left home, disassociating himself for a while from his friends and family in order to find religious truth. He began preaching in the years 1647–8, firstly at Dukinfield in Cheshire, then at Manchester and then Broughton Astley in Leicestershire, where he evidently experienced a trance-like state. In 1648, disillusioned with contemporary religious practice, he founded the society of the 'Friends of the Truth' (nicknamed the Quakers by Gervase Bennet in 1650), recruiting mostly from the lower middle classes. The first of the annual meetings of the society was held in 1669. Fox made missionary journeys to Scotland, 1657, Ireland, 1669, North America and the West Indies, 1671–2, and Holland twice, in 1677 and 1684. He was imprisoned eight times for his beliefs, notably at Lancaster and Scarborough, 1663–6, and at Worcester, 1673–4. He died in London on 13 January 1691. His *Journal* was published posthumously in 1694.
Source: *DNB*.

Designer: unknown

Obelisk in Mansfield stone
h. 4.57m (15')
Inscription in incised, blackened Roman capital letters, on the front face of the pedestal:

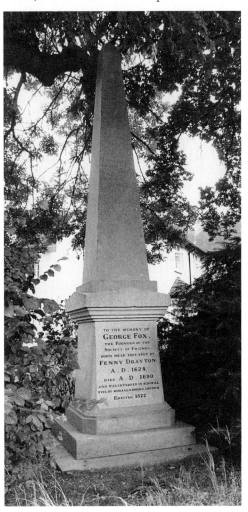

Memorial to George Fox

TO THE MEMORY OF / GEORGE FOX, / THE FOUNDER OF THE / SOCIETY OF FRIENDS. / BORN NEAR THIS SPOT AT / FENNY DRAYTON / A.D. 1624, / DIED A.D. 1690 / AND WAS INTERRED IN BUNHILL / FIELDS BURIAL GROUND LONDON / ERECTED 1872
Status: Grade II
Owner / custodian: Hinckley and Bosworth Borough Council

Description: The memorial is in the form of a simple obelisk, mounted on a pedestal bearing the inscription, raised on two steps.
Condition: Good, although there are cracks – perhaps superficial – all around the upper step. The memorial appears to have been recently cleaned and the letters recut and blackened.
History: The *Monument to George Fox* was erected in 1872 on the initiative of Charles Holte Bracebridge of Atherstone Hall, Warwickshire, in co-operation with George Dymond of Birmingham, and was funded by public subscription.[1] The erroneous date of 1690 given in the inscription for Fox's death (he actually died in 1691) is due to a failure by the memorialists to take into account the continued use in Britain until 1752 of the old-style Julian calendar. Contemporary records would have given Fox's death as 1690 because until 1752 New Year's Day was reckoned to fall on 25 March, the Feast of the Annunciation, or Lady Day.

Literature
H. Echo, 2 March 1921, p.3; Lee, J. and Dean, J., 1995, p.57, 57; *L. Mail*, 1 December 1920, p.3.

Note
[1] *H. Echo*, 2 March 1921, p.3.

FOSSE PARK

Civil Parish: Enderby
District Council: Blaby

Everard Way, Fosse Park Shopping Centre

Set into a free-standing display wall on the north side of the road by a security lodge:

King Lear roundel

Designer: Steve Field
Sculptor: John McKenna
Founders: Castle Fine Art Foundry

Relief roundel in bronze
Diam. 1.2m (3'11")
Inscriptions on the circular frame, incised:
(a) at the top in Roman capital letters: KING LEAR
(b) at the bottom in cursive script: *Legendary King of 'Leir' cester*
Signed and dated in the bottom right-hand segment of the relief in incised Roman capital letters: JOHN MCKENNA STUDIO / WORCESTER 1997

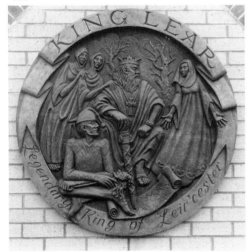

Field and McKenna, *King Lear*

Description: The roundel depicts King Lear enthroned, with his jester at his feet and, standing either side of him, his three daughters Goneril, Regan and Cordelia. Goneril and Regan stand close behind their father's throne. Lear points with his sword to a map of the British Isles and glares at Cordelia who, standing to the right, is shown reacting to his words with a gesture of open-handed innocence. It is the moment from Shakespeare's play following Lear's demand that his daughters tell him how much they love him so that he can judge what portion of his kingdom to pass on to each of them. Regan and Goneril have flattered him but Cordelia has responded honestly with the words: 'I love your majesty according to my bond – no more no less' (*King Lear*, 1.1.92–3).
Condition: Good
History: The *King Lear roundel* was commissioned by Castlemore Securities, the then owners of the Fosse Park site. The company was familiar with the work of Steve Field, concept designer with Art for Architecture, and it was to him they turned when the management decided to commission some sculptures for Fosse Park (see also the following entry).

Grove Way

Set into a wall on the west side of the road:

Fosse Plaza: Fosse Way roundel

Designer: Steve Field
Sculptor: John McKenna
Founders: Castle Fine Art Foundry

Relief roundel in bronze
Diam. 2.1m (6'11")
Inscriptions on the circular frame, incised in Roman capital letters:

(a) at the top: FOSSE PLAZA
(b) at the bottom: FOSSE WAY LEICESTER
Signed in the bottom right segment of the relief in incised 'handwritten' script:
John McKenna
Executed: 1997
Status: not listed
Owner: The Retail Park Unit Trust

Description: A relief roundel with inscriptions on the upper and lower segments of its circular frame. The relief depicts a charioteer in the costume of an ancient Roman soldier driving a two-horse chariot along a cobbled street. In the background are three poplars and a building with two arched windows.
Condition: Good.
History: *Fosse Plaza: Fosse Way* was commissioned by Castlemore Securities, the then owners of the site which they had intended to call 'Fosse Plaza'. The subject of the relief, the Roman charioteer, refers to the fact that the shopping centre is close to the site of the Fosse Way, a major Roman road that ran from Lincoln to Exeter. As with the *King Lear roundel* above, Steve Field designed the relief

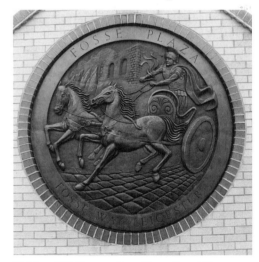

Field and McKenna, *Fosse Plaza: Fosse Way*

and John McKenna modelled his design in clay ready for casting in bronze by the lost wax process at Castle Fine Art Foundry.

<div style="background:gray">

GADDESBY
Civil Parish: Gaddesby
Borough Council: Melton
</div>

Church Lane

In the chancel of St Luke's Parish Church (Grade I listed):

Monument to Colonel Edward Hawkins Cheney

Edward Hawkins Cheney (1778–1848), born in Derbyshire into a military family, received the commission of Lieutenant in the 2nd Dragoons (Scots Greys) in 1794 and served with the regiment on the continent throughout the Napoleonic wars. He was promoted to brevet Major on 1 January 1812 and to brevet Lieutenant-Colonel on 18 June 1815 and Major 2nd Dragoons on 20 July 1815; finally, on 10 January 1837 he was promoted to brevet Colonel. In 1812 Cheney had married Eliza Ayre whose family had owned Gaddesby Hall Estate since the early eighteenth century. Eliza was the younger of two sisters – her sister never married and a brother who would have inherited the estate had died in infancy. Thus, the estate eventually devolved to Edward Henshaw Cheney, the eldest son of Colonel Edward Hawkins and Eliza Cheney.
Source: *The Gentleman's Magazine*, May 1848, p.548 [obituary].

Sculptor: Joseph Gott

Monument in marble
Sculptural group: h. 1.6m (5'3"); w. 2.4m (7'11"); d. 96cm (3'2")
Pedestal: h. 1.13m (3'9"); w. 2.5m (8'3"); d. 1.18m (3'11")

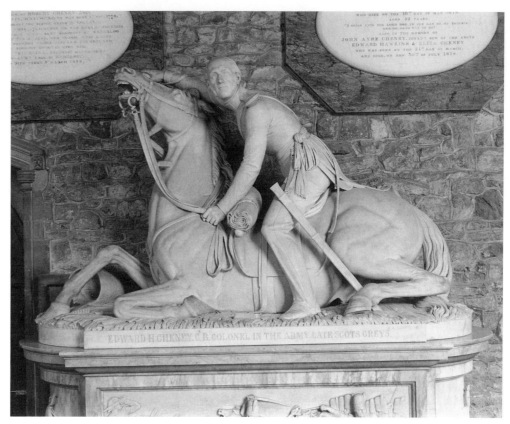

Gott, *Cheney Monument*

Base: h. 17cm (7"); w. 2.82m (9'3"); d. 1.28m (4'2")
Relief on the front of the pedestal: h. 69.5cm (2'3"); w. 1.56m (5'2")
Inscriptions, all incised:
– on the front of the base of the sculpture:
EDWARD. H. CHENEY. C.B. COLONEL IN THE ARMY. LATE SCOTS GREYS.
– on the rear of the base of the sculpture:
"TANNAR" ONE OF FOUR HORSES KILLED UNDER HIM JUNE 18TH 1815
– in a central panel on the rear of the pedestal:

WATERLOO
Signed on the front of the base of the sculpture towards the right: J. GOTT. FT
Status: not separately listed
Owner / custodian: unknown

Description: Cheney is depicted astride one of the five horses he rode at Waterloo on 18 June 1815. The first four had been killed under him, and the fifth was injured. The depicted horse has sunk to the ground, a blood-gouting bullet wound explicitly carved in bold relief on

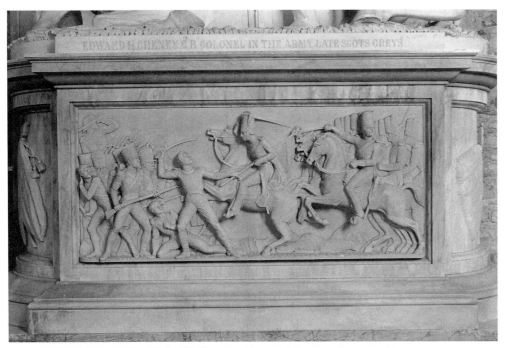

Gott, *Cheney Monument (pedestal relief)*

its chest. Cheney leans forward, his left hand still gripping the horse's reins, his right hand thrust out ahead of him, the index finger pointing forward, while he nonetheless manages to keep a grip on his sword which is now reversed and pointing backwards past his right side. Cheney is bare-headed, his shako, with broken strap, having fallen to the ground by the horse's front right hoof. The base around the collapsed horse is a mass of flattened wheat. On the front of the pedestal is a battle scene in relief. According to the Revd F.G. Clark:

> Above [the monument] is a plaque which describes the scene [the relief] depicts, viz. the wresting of the Standard (French Eagle) by Standard bearer Sergeant Ewart, Royal Scots Greys, from the enemy at the battle of Waterloo.[1]

At the semi-circular ends of the pedestal are crossed standards carved in relief: at the left end are Cheney's regimental standards and at the right, the captured French eagle standards.

Condition: Generally fairly good considering the monument's vulnerable position in the chancel, although there are some minor losses and small areas of damage:

1. The equestrian group: the lower of the two slings holding the scabbard to Cheney's waist on his left side is missing the last few inches closest to the scabbard and there is what appears to be a hairline crack running across the horse's rump and tail. The horse's teeth are blackened through years of having an apple stuck into its

mouth each Harvest Festival, according to an explanatory plaque in the church.

2. The relief: the more projecting parts of the front plane are the most damaged: the left ear of the 'nearest' horse at the right of the relief is partly lost while the left foot of the horse's rider has been broken off and cemented back, the cement now being discoloured; the right ear and part of the rifle mechanism of the standing French infantryman, second from the left, are slightly chipped; and the nose and upper lip of the semi-cumbent French infantryman are slightly chipped.[2]

History: The event for which Cheney was most renowned and which this sculpture celebrates occurred at the Battle of Waterloo on 18 June 1815, when the command of the regiment had devolved to him. During the fighting he famously had five successive horses shot from under him.

Very little is known about the present monument. It is signed but not dated and there appears to be no documentary material relating to it. There does exist, however, an indirect link between the Cheney family and the sculptor. Edward Hawkins Cheney was the only son of Robert Cheney's second wife, Bridget Leacroft. Robert Cheney's first wife, Dorothy Cheshire, had born him five children, two of whom, Robert Henry and Edward Cheney, were patrons of the watercolour painter Thomas Hartley Cromek. Cromek was in Rome from 1830 to 1849 and was a frequent visitor to Gott's Roman studio.[3] It is therefore possible that Gott obtained the commission through these associations.

Gunnis assumes that the subject himself commissioned the work:

> The whole work gives the impression of being correct in every detail, and one feels that the Colonel himself must have directed every stroke of the chisel. The result is interesting from a documentary point of

view, although artistically it leaves much to be desired. Nevertheless it has the almost fatal attraction which a second-class work sometimes exercises on the beholder, though he is forced to admit later that the whole effect was fairly comic.[4]

An alternative theory is that the son, Edward Henshaw Cheney, commissioned the monument in memory of his father following his inheritance of Gaddesby Hall Estate in 1856, a move inspired by the announcement of the scheme for the *Wellington Monument* for St Paul's Cathedral (begun 1857).[5] The problem with this suggestion is that Gott would have been over 70 years of age by this time and hardly likely to have embarked on such a grandiose scheme as the *Cheney Monument* turned out to be. One thing that is certain is that the *Cheney Monument* was not intended for its present location. Most local historians are in agreement that it originally stood in Gaddesby Hall but was relocated to the chancel of the parish church, most likely in 1917 when the estate was sold following the demise of the Cheney family.[6]

An information board in the church points out that the sculptor has omitted to give the horse a tongue and repeats a story which the writer admits is apocryphal, that the sculptor, on hearing of this embarrassing news, committed suicide. Gott died at the age of 75 in January 1860 in Rome and is buried in the Protestant Cemetery;[7] there is no evidence to suggest that his death was from anything other than natural causes.

Literature
LRO. Gaddesby Historical Society (unpublished essay), 1978, p.4.
General. Baker, A.K., 1999, pp.11–13; Clark, Revd F.G., n.d., pp.13, **12**; Gerrard, D., 1996, p.44, **44**; Gunnis, R, [1964], p.177; Lee, J., 1991, pp.30–1, **31**; Pevsner, N. and Williamson, E., 1992, p.158; Smith, E.D, 1968, pp.22, **21**; Temple Newsham House, 1972, pp.11, 34, 3⁸, pl. **33**.

Notes
[1] Clark, Revd F.G., n.d., p.13. [2] As the monument is placed very close to the north wall of the chancel it has not been possible to check the condition of the rear side. [3] Leeds, Temple Newsham House, 1972, p.38. [4] Gunnis, R., [1964], p.177. [5] Baker, A.K., 1999, p.12. [6] Clark, Revd F.G., n.d., p.13, and Gaddesby Historical Society (unpublished essay), p.4. Baker, however, seems to suggest that the transfer was effected earlier, perhaps in the 1890s when the Hall was let out by Edward Henshaw Cheney's widow following her husband's death without issue (Baker, A.K., 1999, p.13). [7] Gunnis, R., [1964], p.177.

Hillsborough Road
Rolleston Infant School (access only by prior arrangement).

In the playground:
Crocodile Play Sculpture
Sculptor: Austin Wright

Sculpture in concrete
h. 40cm (1'4"); l. 6.83m (22')
Executed: 1961
Status: not listed
Owner: Leicester City Council

Description: Originally this was a three-piece sculpture consisting of a crocodile on the ground and two reliefs mounted on the wall to the rear. The crocodile is composed of a curving line of 15 shaped concrete blocks, each standing on three iron legs. The head has an aperture which, according to the school premises officer, held a glass ball for an eye until stolen by vandals some years ago. The reliefs were removed by the school some time ago as they had become unsafe. Each was formed of lines of small concrete blocks which, typically for Wright, derived from bone formations, in this case a spinal column.

Condition: The two reliefs which once formed part of this sculpture are no longer extant (see above). Two of the blocks making up the crocodile, the fifth from the front and the third from the rear, have been patched with cement. The patched block fifth from the front is now also cracked, as is the head block. A glass ball once standing for the eye of the crocodile in the head block is now missing (see above).

History: Commissioned for the school in 1961 by Stewart Mason, Leicestershire's then Director of Education, the sculpture has suffered considerable wear and tear over its almost 40-year life. However, it must be stressed that most of the damage to the sculpture has been caused by exactly the innocent but boisterous play that both the commissioner and the sculptor fully anticipated and indeed hoped for. The sculpture was never intended as a museum piece, not to be touched: although arguably a successful piece if judged as 'art' sculpture, it has also more importantly fulfilled its function as 'play' sculpture. Mason

Wright, *Crocodile Play Sculpture*

made no secret of his view that some sculptures, even by relatively well-known sculptors such as Wright, had a particular role to play:

> Sculpture must be touched to be enjoyed ... And anyway, I prefer to think of some works of art as expendable. There ought to be a certain amount of wear and tear on objects like this which cannot be understood or enjoyed to the full unless they are played with.[1]

It was, furthermore, hoped that the sculpture would act as a stimulus to the children's imaginations; in this role too it appears early on to have been highly successful. Two years after its installation, Mervyn Levy wrote of Wright's *Crocodile Play Sculpture*:

> It is in no sense a naturalistic beast, leaving ample scope for the child's imagination to

play a part in its enjoyment. Some children thought of it as a train, while to others it was a convoy of ships, and even to one child, a column of soldiers on the march. Wright's 'crocodile' is one of the most popular of the play facilities at Rolleston ...[2]

Literature
Hamilton, J., 1994, p.98 (no. S192); Levy, M., 1963, pp.93–4, **97**.

Notes
[1] Levy, M., 1963, p.93. Although Mason was at the time referring to a sculpture by Willi Soukop, the same sentiments would have applied to the present sculpture. [2] Levy, M., 1963, p.93–4.

Hollaway, *Abstract relief*

Leicester Road

Leicestershire County Hall, built 1958–65 by T.A. Collins, completed by Thomas Locke (successive County Architects)

1. Running continuously along the east wall of the east courtyard:

Abstract relief

Sculptor: Antony Hollaway

Relief sculpture in concrete
h. 4.1m (13'6"); w. 20.5m (67'3")
Signed and dated at the bottom right of the relief:

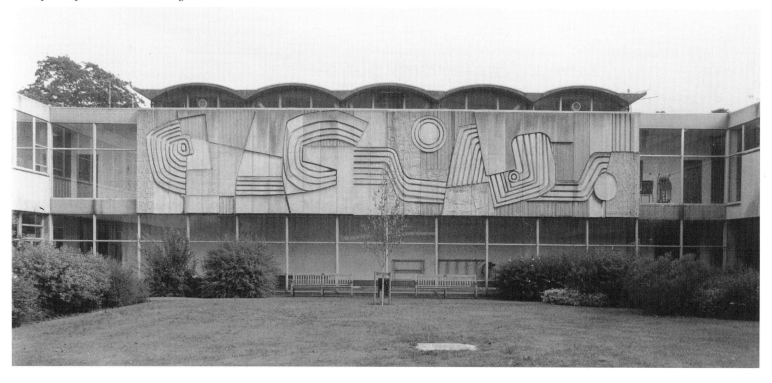

Antony Hollaway 1966
Status: not listed
Owner: Leicestershire County Council

Condition: Good

History: The concrete panels which make up the relief were pre-fabricated by Ellis & Co. (Leicestershire), the firm that produced the cladding panels for London County Council's Queen Elizabeth Hall (opened 1967) on London's South Bank. The present relief design, which is based on the meanderings of the River Soar as it moves through the Leicestershire landscape, was cast in a method devised by the sculptor. First, sheets of expanded polystyrene were applied to the face of the shuttering and a negative of the design cut into them, in some places with a hot soldering iron (where an irregular line was wanted) and in others with a small diameter cup brush in the end of a power drill (where a clean line was wanted). The concrete was then poured onto this negative mould and allowed to set. Next, the shuttering was removed leaving the concrete faced with the sculpted polystyrene sheets. Finally, the panels were applied to the walls and the polystyrene sheets removed on site by the sculptor using wire brushes and a grit blaster.[1]

Literature
PMSA NRP East Midlands Archive. Note on the Leicestershire County Hall relief from the sculptor to the author (accompanying a letter dated 13 August 1999).
General. *Architects' Journal Information Library*, 14 August 1968, pp.301, **295**; Cox, O. and Millett, F., 1961, p.99; Pevsner, N. and Williamson, E., 1992, p.162.

Note
[1] Cox, O. and Millett, F., 1961, p.99; and information supplied by the sculptor in a note to the author (accompanying a letter dated 13 August 1999).

Crampton, *Simon de Montfort*

2. In the foyer:
Statue of Simon de Montfort
Sculptor: Seán Crampton

Sculpture in metal
h. (est.) 4.88m (16')
Inscriptions incised into the wall to either side of the sculpture:
– at the lower left: SIMON DE MONTFORT
– at the lower right: SEÁN CRAMPTON / SCULPTOR 1967
Status: not listed
Owner: Leicestershire County Council

Description: A relief in openwork metal, bolted to the wall, representing Simon de Montfort. He is is depicted standing, wearing thirteenth-century armour and holding a banner in his right hand.
Condition: Good.

Literature
Architects' Journal Information Library, 14 August 1968, p.301; Pevsner, N. and Williamson, E., 1992, p.162.

HIGH CROSS
Civil Parish: Sharnford
District Council: Blaby

A5 (Watling Street)

At the point where the old Roman roads, Watling Street and Fosse Way, cross:
High Cross Monument
Mason: Samuel Dunckley

Monument in ashlar patched with brick
h. of remains (est.) 4.57m (15'); w. 1.47m (4'10"); d. 1.45m (4'9")
Erected: 1712
Inscriptions. Although largely illegible, they are recorded by Nichols as follows:
– South face: 'Vicinarum Provinciarum

VERVICENSIS / scilicet & LEICESTRENSIS ornamenta, / Proceres Patriciique, / Auspiciis illustrissimi BASILII / Comitis de Denbigh, / Hane Columnam statuendam / curaverunt in gratam pariter / et perpetuam memoriam JANI tandem / à Serenissima ANNA clausi / A.D. MDCCXII.' ['The Noblemen and Gentry, ornaments of the neighbouring counties of Warwick and Leicester, at the instances of the Right Honourable Basil Earl of Denbigh, have caused this pillar to be erected, in grateful, as well as perpetual remembrance of Peace, at length restored by her Majesty Queen Anne, A.D. 1712']
– West face: 'Si veterum Romanorum vestigia / quæras, hic cernas, Viator. Hic enim / celeberrimæ illorum Viæ Militares / sese mutuò secantes, ad extremos usque / BRITANNIÆ limites procurrunt. Hic / Stativa sua habuerunt VENNONES, & ad / Primum abhinc Lapidem Castra sua; / Ad STRATAM & ad Fossam Tumulum / CLAUDIUS quidem Cohortis Præfectus / habuisse videtur.' ['If, Traveller, you search for the footsteps of the ancient Romans, here you may behold them; for here their most celebrated ways, crossing each other, extend to the utmost boundaries of Britain. Here the *Venones* had their quarters; and at the distance of one mile from hence Claudius, a certain Commander of a Cohort, seems to have had a camp towards the street, and towards the fosse a tomb']¹
Status: Grade II
Owner / custodian: as for High Cross House nearby

Description: The monument is in the form of a corniced square pedestal with coved corners and, around the base, four square blocks for corner columns (Tuscan order; now missing). On each face of the pedestal is a square moulded recess containing a bolection moulded panel, those to the south and west bearing the defaced and largely illegible Latin

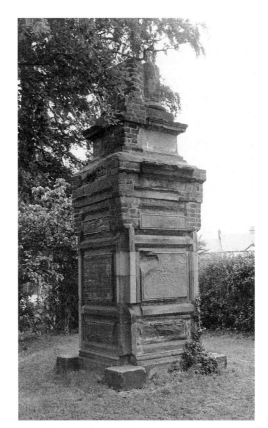

Dunckley, *High Cross Monument*

inscriptions (see transcriptions above), while those to the north and east are blank. Above and below these panels are smaller rectangular blank panels. Above the pedestal, a moulded and corniced square plinth carries the remains of a cluster of four columns with moulded round bases.

According to Nichols, the four columns were of the Doric order, one for each of the four roads (i.e., those formed by the intersection of Watling Street and Fosse Way), and these were surmounted by a sundial and a

globe and cross. The arms of the subscribers – the Earls of Denbigh and of Coventry and the Lords Brook, Willoughby, Leigh, Compton and Conway – were also formerly represented on the monument.²

Condition: Very poor (see 'Description' above); the remains of the monument are extremely weathered.

History: The *High Cross Monument* was erected, according to Nichols, on the suggestion of the Earl of Denbigh, at his and other local gentlemen's expense in 1712. It was intended to celebrate, as the inscription states, the end of the war with France, and to mark the site of the Roman settlement, Venonae, at the crossing of two major Roman roads: Fosse Way, stretching from Exeter to Lincoln, and Watling Street from London to Wroxeter, Shropshire. It replaced a simple post which in turn had replaced an older Cross. Nichols says the *Monument* was of 'handsome design', but even in his time (he was researching his volumes on Leicestershire in the late eighteenth and early nineteenth centuries) it was in poor condition, it is said, 'through the villainy ... of the architect, one Dunkley', who had used 'mouldering stone'.³

Throughout the eighteenth century the monument suffered defacement at the hands of travellers carving their initials into the stone; the nuisance having been temporarily halted by the enclosure of the monument by a garden and hedge. Then, in 1791 the monument was struck by lightning and reduced virtually to its present condition – but with the Tuscan corner columns still intact.⁴ The surviving part was later dismantled and re-erected where it now stands, a short distance from its original position.⁵

Literature
Colvin, H., 1978, p.277; Lee, J. and Dean, J., 1995, p.58, **58**; Nichols, J., 1810, vol. iv, pt i, p.127, pls. **xxi**, **xxii**; Nichols, J., 1811, vol. iv, pt ii, p.915; Pevsner, N. and Williamson, E., 1992, p.176.

Notes
[1] Nichols, J., 1811, vol. iv, pt i, p.127, and pt ii, p.915. [2] *Ibid.*, pt i, p.127 (the monument in its original state is shown in an engraved illustration on plate xxii). According to the DCMS list, the sundial, globe and cross are now in the Leicester City Museums. [3] The antiquary William Stukeley (1687–1765), as quoted in Nichols, J., 1811, vol. iv, pt i, p.127. [4] *Ibid.*, p.127, n. 7, and pl. xxi. [5] Lee, J. and Dean, J., 1995, p.58.

HINCKLEY
District Council: Hinckley and Bosworth

Argent's Mead

On the north side of Argent's Mead:
Hinckley and District War Memorial

Architect: John Alfred Gotch (of Gotch and Saunders)
Sculptor: Allan Gairdner Wyon

Contractors: Messrs Morris and Sons

Pillar in stone, painted, surmounted by a figure in bronze; screen wall and steps in stone with tablets in bronze
Statue: h. (est.) 1.19m (3'11"); pillar: h. (est.) 4.26m (14'); steps: h. 69cm (2'3") – overall h. (est.) 6.14m (20'2")
Screen wall (excluding balustraded wing walls): h. 3.15m (10'4"); w. 6.61m (21'8")
Inscriptions:
(a) on the pillar, running around the octagonal neck of its base, starting from the front (north) facet, in raised letters:
TO KEEP IN MIND THOSE FROM THIS PLACE WHO GAVE THEIR LIVES IN THE GREAT WAR 1914 – 1919
(b) on the screen wall
– across the upper part of the wall, above the First World War name tablets, in raised letters:
THEIR NAME LIVETH FOR EVERMORE

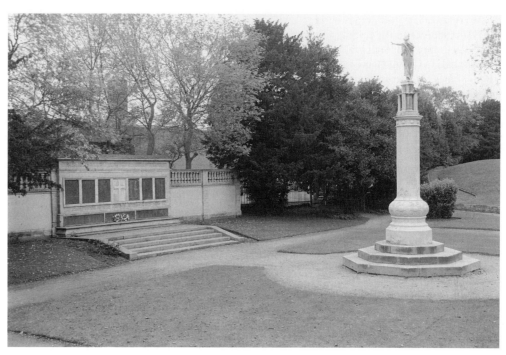

Gotch and Wyon, *Hinckley and District War Memorial*

[underneath which are six tablets, each tablet comprising two columns of names in alphabetical order, initials only of forenames, family members bracketed together, 387 names in all]
– running across the wall below the First World War name tablets, in raised letters: THE NAMES OF THOSE WHO GAVE THEIR LIVES IN THE GREAT WAR
– below this, three bronze plaques, the centre one bearing the following inscription in three lines running either side of the Hinckley coat of arms (the scroll of which bears the motto: ANGLIAE COR):
THESE PLATES WERE ADDED IN GRATEFUL MEMORY / OF THOSE WHO GAVE THEIR LIVES IN THE SECOND WORLD WAR / 1939 1945 [the

bronze plaques either side listing the names of the 166 Second World War dead, including 13 civilians]
Statue signed on the right-hand (west) face of the bronze base: A.G. WYON
Unveiled and dedicated: Saturday 20 May 1922, by Colonel R.E. Martin, CMG, and the Rt Revd Dr Frank Theodore Woods, Bishop of Peterborough
Exhibited: 1922, Royal Academy of Arts, *Pax – figure for War Memorial to be erected at Hinckley*, no. 1266 (plaster cast of Wyon's figure)
Status of wall and statue (listed separately): Grade II
Owner / custodian: Hinckley and Bosworth Borough Council

Description: The memorial is set in its own part of the gardens and comprises a bronze statue of a draped, standing female figure surmounting an octagonal pillar. The figure, representing Peace, wears a laurel wreath around her head and holds out both arms towards the screen wall opposite, 'as if in the act of blessing' the bronze tablets bearing the names of the dead of both world wars.[1] The octagonal pillar is raised on three octagonal steps. Its base comprises a plinth, a neck bearing an inscription (for which, see above) and an over-sized torus. At the top, the octagonal shaft terminates in a strapwork frieze surmounted by a cornice. Above this, the tall base of the statue is surrounded, up to about two-thirds of its height, by four square piers carrying a diagonally-oriented canopy.

The dado course of the screen wall bears seven panels, six for the names of the 387 Hinckley and District men who died in the First World War, and a central panel modelled with a cross in relief. The plinth course bears three panels, two for the 166 dead of the Second World War, and a central panel with the Hinckley and District coat of arms. The screen wall is appoached by a flight of five steps and is flanked by balustraded wing walls.

Condition: Poor, although most damage seems superficial. There are two chunks out of the octagonal steps around the pillar, at the NNW corner of the top step and along the W edge of the lowest step. The more projecting parts of the pillar – the plinth and torus of the base, and, at the top, the cornice and string course above and below the strapwork frieze – are battered. The cornice has in addition a clearly visible vertical crack on two of its opposite faces (NE and SW). The four small piers around the statue's base are also battered. The green patination of the statue appears very worn and there are traces of what appears to be gilding. The statue is furthermore grimy and spattered with guano, as is the pillar beneath it, especially the over-sized torus of the base. The pillar has been crudely repainted and the paint surface now appears blistered and worn. The upper parts of the pillar are stained with green run-off from the bronze statue. The lower part of the pillar is covered in graffiti applied with a felt-tip marker or pen. The stonework of the screen wall is similarly weathered and stained with biological growth. There are bolts missing from the upper and lower right-hand bronze panels. The central shield is missing from the coat of arms.

History: The first meeting to discuss how best to commemorate those men from Hinckley and District who had died in the First World War was convened under the auspices of Hinckley Urban Council on 27 January 1919. Various proposals were put forward and a committee was appointed to investigate the respective costs.[2] By May the Committee had decided to erect a memorial cross on a part of Castle Hill which it intended to lay out as a memorial garden. One portion of the land had been bought and donated by a local man, and committee-member Canon Hurrell, the Vicar of Hinckley, had agreed to give up that part of his garden adjoining the donated land.[3] A final piece of land was purchased by the Committee in December 1920. By this time the memorial itself had undergone changes, for the architect (Gotch) is recorded as submitting a fresh design with an estimated cost of £1,650.[4]

By February 1921, the Committee had collected £1,872 and, being sufficiently confident of raising another £1,000 to reach the amount it had estimated for the whole scheme, accepted a tender of £1,225 for the erection of the memorial, exclusive of the bronze figure which was estimated at £300.[5] At its meeting on 9 September 1921 the Committee, which was becoming anxious to set a date for the unveiling, heard from the sculptor (Wyon) that although the clay model would be completed by the end of October it would be another eight weeks

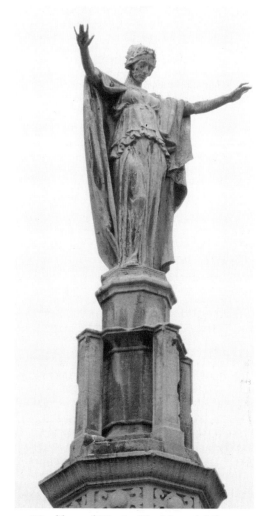

Hinckley and District War Memorial: Peace

before the statue could be cast in bronze. Given that there was still work to be done on the garden, the Committee speculated that a spring, possibly Easter, unveiling would be most likely. Unfortunately, subscriptions had virtually dried up: the Committee was still £1,000 short of its

£3,000 estimate. It was at this point that Canon Hurrell came up with the idea of a foundation stone laying ceremony to revive interest in the scheme, which could be immediately followed by an appeal for further funds.[6]

The ceremony took place on Saturday 12 November 1921, the actual laying of the foundation stone being performed by three of the most heavily-bereaved mothers: Mrs Attenborough and Mrs Dixon had each lost three sons in the war, and Mrs Orton had lost two (two other mothers had lost three sons each but one, Mrs Dalby, was unable to attend and the other, Mrs Sharpe, had herself since died).[7] The week after the ceremony (designated War Memorial Week), saw renewed collecting activity followed towards the end of November by members from the ladies' committee calling on those who had failed to respond the first time. In addition, there was in December a benefit performance of Elgar's 'For the Fallen' from his patriotic choral work, 'The Spirit of England' (1915–17).[8]

By the end of March 1922 sufficient progress had been made in creating the memorial and grounds for the Committee to be able to agree on 20 May as the date for the unveiling ceremony. The Committee was to have little luck, however, in its choice of dignitary for the unveiling itself: the Duke of York was unavailable, Earl Haig and then General Horne declined and ultimately it had to invite a local man, Colonel Martin.[9] The Committee still had a £750 shortfall by the time the memorial was unveiled and various fund-raising events continued for some time afterwards to enable the garden to be completed.[10] The final statement of accounts, presented at the last meeting of the Committee on 16 January 1924, showed a small balance in hand, the total costs amounting to £3,438. 17s. 10d. as against the £3,610. 11s. 4d. collected. The memorial (including the statue) represented £1,597. 6s. 0d. of the overall outlay.[11]

Literature
LRO. *Hinckley and District War Memorial Committee ... Minute Book*
General. *Architects' Journal*, 1 September 1920, p.250; Beavin, H.A., 1983, p.97; *H. Echo*: – [i] 29 January 1919, p.1 [ii] 26 May 1920, p.3 [iii] 18 August 1920, p.1 [iv] 23 February 1921, p.1 [v] 16 September 1921, p.5 [vi] 18 November 1921, p.5 [vii] 30 December 1921, p.2 [viii] 26 May 1922, p.8 [ix] 18 January 1924, p.8; *H. Guardian*, 18 January 1924, p.15; Hinckley Times, 1996, pp.**71**, **95**; *L. Chronicle*: – [i] 14 August 1920, p.2 [ii] 27 May 1922, pp.3, 8–9, **8–9**; *L. Daily Post*, 15 September 1919, p.6; *L. Mail*: – [i] 22 May 1920, p.5 [ii] 21 August 1920, p.3 [iii] 23 December 1920, p.5 [iv] 23 February 1921, p.6 [v] 30 March 1922, p.5 [vi] 22 May 1922, p.2; *L. Mercury*: – [i] 9 November 1921, p.10 [ii] 14 November 1921, p.7 [iii] 22 May 1922, p.7; Sharpe, J.M., 1992, pp.14, 24, 29, 35, 45, 51, figs. **3.13**, **4.2**.

Notes
[1] *H. Echo*, 26 May 1922, p.8. [2] *Ibid.*, 29 January 1919, p.1. [3] *L. Mail*, 22 May 1920, p.5. [4] *Ibid.*, 23 December 1920, p.5. [5] *Ibid.*, 23 February 1921, p.6. [6] *H. Echo*, 16 September 1921, p.5. [7] *Ibid.*, 18 November 1921, p.5. [8] *Hinckley and District War Memorial Committee ... Minute Book*, meetings of 8 November and 13 December 1921. [9] *Ibid.*, meetings of 29 March, 12 April and 20 April 1922. [10] *L. Mercury*, 22 May 1922, p.7. [11] *Hinckley and District War Memorial Committee ... Minute Book*, meeting of 16 January 1924.

Butt Lane

John Cleveland College (access only by prior arrangement).

Sited in the grounds:

Cirrus

Sculptor: Bryan Kneale

Sculpture in mild steel and stainless steel
h. 4.57m (15'); w. 2.69m (8'10"); d. 6.1m (20')[1]
Executed: 1971
Exhibited: 1972, Royal Academy of Arts (no. 36)
Status: not listed

Kneale, *Cirrus (original state)*

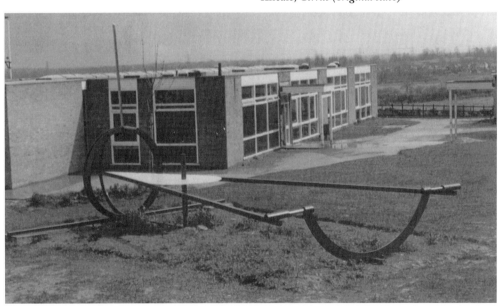

Owner: Leicestershire Education Authority

Condition: Poor. The various parts of this construction have fallen apart and collapsed to the ground. There is some rust to the mild steel elements and one or two of the smaller pieces seem to be missing.

History: *Cirrus* was purchased by the Leicestershire Education Authority in 1972 with funds provided through the buildings capital scheme.[2]

Literature
Royal Academy, 1972, n. pag. (no. 36).

Note
[1] As recorded in Royal Academy, 1972, n. pag. (no. 36). [2] LEA inventory.

Leicester Road

In the forecourt of St Peter's Roman Catholic Church:

St Peter's Roman Catholic Church War Memorial

Designer / sculptor: unknown

Memorial in Portland stone
Overall h. 4m (13'2")
Steps: w. 2.07m (6'10"); d. 2.05m (6'9")
Inscriptions (incised and painted black):
– on the front face of the pedestal: PRAY FOR THE REPOSE / OF THESE MEMBERS OF / Sᵀ PETER'S CONGREGATION HINCKLEY / WHO LAID DOWN THEIR LIVES / 1914 – FOR GOD AND THEIR COUNTRY – 1918 [then follow the 36 names in two columns, listed by rank, initials only of forenames, underneath which is] REQUIESCANT IN PACE
– on the right-hand face of the pedestal: PRAY FOR THE REPOSE / OF THESE MEMBERS OF / Sᵀ PETER'S CONGREGATION HINCKLEY / WHO LAID DOWN THEIR LIVES / 1939 – FOR GOD AND THEIR COUNTRY – 1945 [then follows a single list of 11 names in alphabetical order, initial only of

forenames, ranks not indicated, underneath which is] REQUIESCANT IN PACE [and beneath this one more name has been added]
Unveiled and dedicated: Saturday 30 September 1922, by the 9th Earl of Denbigh, CVO, and the Revd Joseph Mundy, OP
Status: not listed
Owner / custodian: St Peter's Roman Catholic Church

St Peter's Roman Catholic Church War Memorial

Description: The memorial takes the form of a figure of Christ on the Cross raised on a square pedestal on two steps.

Condition: All surfaces of the figure of Christ appear very weathered and the big toes from both feet are lost.

History: This is the third location for the memorial. It was first sited in the graveyard of St Peter's Church. When this was demolished in 1976, the memorial was resited to accommodate the new church building. This was in turn demolished and the memorial moved to its present site.

Literature
H. Echo, 6 October 1922, pp.5, 7; *L. Mail*, 30 September 1922, p.5; *L. Mercury*, 30 September 1922, p.10; Sharpe, J.M., 1992, fig. 2.6.

On the green at the rear of the car park is a bronze figure, **Christ the Mediator** by Arthur Fleischmann, formerly on the gable of the old Hinckley St Peter's Roman Catholic Church.[1]

Note
[1] Fleischman also executed the Stations of the Cross now in the present church. Information from Pat Reid, St Peter's Roman Catholic Church.

The Priory, to the left of the above war memorial. The front of the building is decorated with two reliefs:

1. Over the door to the house itself:

Relief of St Peter

Sculptor: Father Aelred Whitacre, OP

Relief in stone
h. 1.12m (3'8"); w. 60cm (2')
Executed: 1931
Inscription:
– incised across the lower part of the relief: S. PETRVS / JANITOR COELI ['St Peter – doorkeeper of Heaven']
– on the bases of the columns flanking the

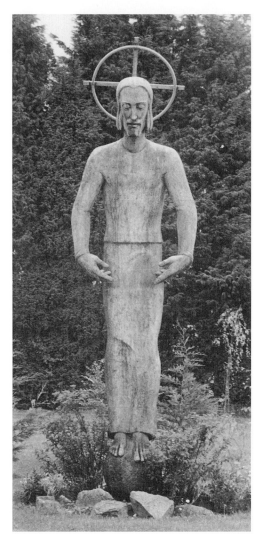

Fleischmann, *Christ the Mediator*

image of St Peter, the date:
19 [left column]; 31 [right column]
Signed in monogram at the bottom right of the
relief, an 'A' within a 'W'
Status: not listed
Owner: St Peter's Roman Catholic Church

Description: A frontal half-length relief
carving of St Peter, a key held in his left hand,
his right making the sign of benediction. The
figure is framed in a round-arched tabernacle.

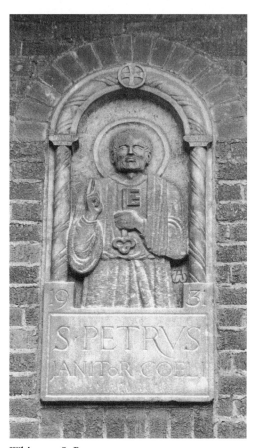

Whitacre, *St Peter*

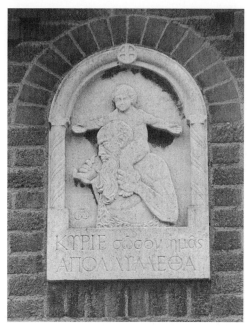

Whitacre, *St Christopher*

2. Over the garage:

Relief of St Christopher carrying the Christchild

Sculptor: Father Aelred Whitacre, OP

Relief in stone
h. 82cm (2'9"); w. 60cm (2')
Executed: *c.*1931
Inscription, in incised letters, across the lower
part of the relief:
ΚΥΡΙΕ σωσον ημας / ΑΠΟΛΛΥΜΕΘΑ ['Lord
save us – we perish']
Signed in monogram to the left of the figure, an
'A' within a 'W'
Status: not listed
Owner: St Peter's Roman Catholic Church

Description: A relief of St Christopher,
portrayed as bald and with a long beard,
bearing the Christchild on his shoulders. The

Christchild looks towards the viewer, his arms extended. The relief is framed in a round-arched tabernacle similar to that of the relief of *St Peter* (see previous entry).

Main Street

On a traffic island at the intersection of Main Street and Scotland Road:

Houghton-on-the-Hill War Memorial

Architect: William Henry Bidlake
Sculptor: unknown

Memorial cross in Portland stone
h. (est.) 4.78m (15'8")
Inscriptions on the pedestal:
(i) running in a continuous band around the upper part, starting on the south face: WE LOOK FOR A NEW EARTH WHEREIN DWELLETH RIGHTEOUSNESS
(ii) below the above inscription:
– on the south face: IN MEMORIAM [beneath which is a list of the names of the 12 men of the parish who died in the First World War]
– on the east face: AD / 1914 / 19 [framed within a lozenge]
– on the north face: DEO GRATIAS. / IN HONOUR & PRAISE / OF ALL WHO SERVED / THEIR KING & COUNTRY / IN THE GREAT WAR
Unveiled and dedicated: Tuesday 15 February 1921, by Mrs C.F. Oliver (wife of Lieutenant-Colonel C.F. Oliver, TD, DL) and the Venerable F.B. Macnutt, Archdeacon of Leicester
Status: Grade II
Owner / custodian: Houghton-on-the-Hill Parish Council

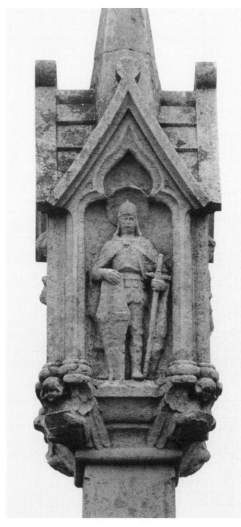

Houghton-on-the-Hill War Memorial: St George

Description: The memorial is surmounted by a tabernacle crowned by a short-armed ringed cross. Within niches on each face of the tabernacle are carved reliefs depicting *The Crucifixion* (east face), symbolic of the sacrifice made by the men here commemorated; *St George* (south face), patron saint of England; *St Catherine* (north face), patron saint of Houghton's parish church; and *Peace* (west face). At each corner of the base of the tabernacle is an angel holding a shield. The tabernacle is raised on a square tapering shaft mounted on a pedestal bearing the inscriptions, on three steps, the lowest of which has a semicircular platform extending in each direction.

Condition: Generally in fair condition, although the relief carvings are now somewhat weathered.

Related work: Also by W.H. Bidlake, in Houghton-on-the-Hill's parish church (St Catherine's), another First World War memorial, in the form of a triptych in painted and gilded carved oak, opened and dedicated on the same day as the above civic memorial, by Mrs Winckley (the Rector's wife) and the Venerable F.B. Macnutt, Archdeacon of Leicester.

Literature
Kelly's Directory of . . . Leicester and Rutland, 1922, p.103; *L. Chronicle*, 19 February 1921, pp.2, 1; *L. Daily Post*, 16 February 1921, p.3; *L. Mail*, 16 February 1921, p.4; *L. Mercury*, 16 February 1921, p.4.

Church Lane

Located on a high bank in front of The Old Rectory:

Hungarton War Memorial

Designer / sculptor: unknown

Memorial in Clipsham stone
h. 5.33m (17'6")

Inscriptions:
(i) inscribed into the front face of the pillar's base:
GREATER LOVE / HATH NO MAN / THAN THIS
(ii) inscribed into the front face of the upper pedestal:
+ IN . MEMORY . OF . THOSE . WHO . LAID . DOWN / THEIR . LIVES . IN . THE . GREAT . WARS + / 1914 . 1918 AND 1939 . 1945
[inscribed into the front face of the lower pedestal are the names in full of the five men who died in the First World War, followed by the four men who died in the Second World War, listed in the order of their deaths, the dates of which are shown]

Unveiled and dedicated: Saturday 19 November 1921, by George Warrington, ex-serviceman of the village, and the Venerable F.B. Macnutt, Archdeacon of Leicester
Status: not listed
Owner / custodian: Hungarton Parish Council

Description: A Calvary on an elevated bank within a gravelled area enclosed on three sides by privet hedges. The site is approached by two steep stairways to left and right. Christ is represented with a crown of thorns and cruciform halo. The cross and supporting pillar are both octagonal in plan and tapered; and the junctions of the arms of the cross and the capital of the pillar are decorated with foliate carving. The pillar is broached and stands on a two-tiered base raised on a two-tiered pedestal.

Condition: Generally fair, although the figure of Christ has lost its feet and the carving in general has lost some of its sharpness. There is some biological growth on the lower parts of the memorial and some guano. There is a small loss to the right-hand front corner of the cornice of the lower pedestal.

Literature
L. Chronicle, 26 November 1921, pp.8–9; *L. Mail*, 23 November 1921, p.6; *L. Mercury*, 23 November 1921, p.7; *M.M. Times*, 25 November 1921, p.5.

IBSTOCK — Civil Parish: Ibstock
District Council: North West Leicestershire

High Street

At the corner with Hinckley Road:
Ibstock Landmark Sculpture
Sculptor: Ailsa Magnus

Sculpture in glazed stoneware on a brick plinth
Dimensions:
– ceramic sculpture and base: h. 1.22m (4'); w. 66cm (2'2"); d. 64cm (2'1")
– brick pedestal: h. 80cm (2'8"); w. 81cm (2'8"); d. 81cm (2'8")
Inscription on a plaque on the front face of the pedestal:
The Ibstock Landmark Sculpture celebrates the history, / industrial heritage and environment of Ibstock. / It has been created by artist Ailsa Magnus in association / with the community of Ibstock / [*space*] / The project has been supported by:– / North West Leicestershire District Council's Ibstock Housing Renewal Panel / Leicestershire County Council's Local Landmark Grants / The National Forest Company / The Rural Development Commission / Ibstock Parish Council / Ibstock Building Products / Ibstock Community Enterprises / [*space*] / This is also the site of the Ibstock Time Capsule, a project co-ordinated by / Mantle Community Arts. / This was created during 1997 and will be opened in 2020.

Unveiled: Wednesday 11 March 1998 by Councillor Cliff Stanley, Chairman of North West Leicestershire District Council
Status: not listed
Owner / custodian: Ibstock Parish Council

Description: The sculpture is made from five pieces of glazed stoneware bonded to a core of concrete reinforced with a steel bar. One piece of stoneware forms the square, battered-sided base, three make up the roughly pot-shaped main part and a fifth, modelled into the shape of a tree, surmounts the whole. The glazed surface is decorated with brightly coloured scenes associated with Ibstock and environs.

According to the artist, in her report to the District Council, the tree at the top represents the National Forest, the rural development area in which Ibstock is situated. As a deciduous tree, however, it is also intended as 'a symbol of constant renewal and regeneration ... a fitting symbol for Ibstock's Renewal Project'. The roots of the tree descend the whole way down the outside of the sculpture and are designed to lead the viewer's eye around the representations of Ibstock life. First are the landmarks of the built environment: the parish church of St Denys, Ibstock's war memorial,[1] and the Palace Cinema. Rural life is suggested by ears of corn and green pastures with cows. Present-day local industry is represented by a man making a brick and that of the past by an underground scene of a miner digging for coal. At the bottom of the sculpture the roots of the tree finally sink into the clay 'where the roots of Ibstock lie, within the clay which brought the Roman settlers to the area'. A large tendril of ivy almost encircles the sculpture, a motif intended 'to bring together the elements which make up Ibstock and also [to serve] as a symbol of the community's symbiotic relationship with the environment ... The dominant feature of the sculpture is the renewal and preservation of natural features and resources'.[2]

The clay for the sculpture and bricks for the plinth were donated by Ibstock Building Products Ltd.
Condition: Good.
History: The *Ibstock Landmark Sculpture* was commissioned by North West Leicestershire District Council from Ailsa Magnus during her term as artist-in-residence at Ibstock, March-June 1997. The sculpture, made entirely of local materials, was intended 'to reflect the history and heritage of the village'.[3]

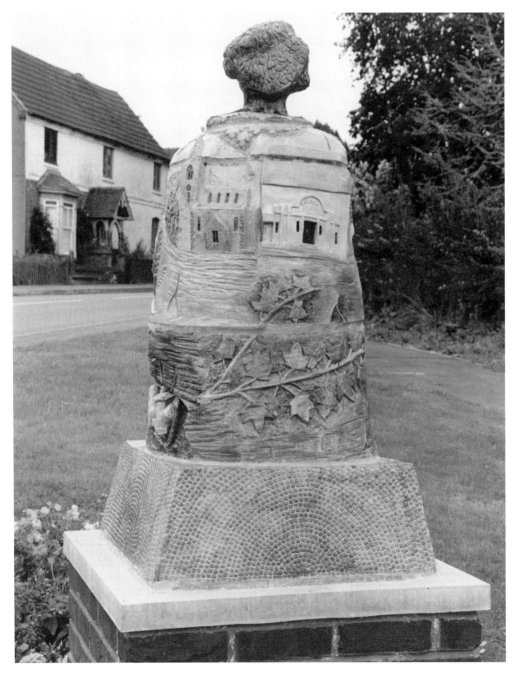

In November 1996, North West Leicestershire District Council placed an advertisement in *Artists Newsletter*, inviting professional artists to apply, by 16 December, for the post of artist-in-residence at Ibstock and to create a landmark sculpture for siting in the village. From the responses to the advertisement a shortlist of five artists was drawn up, Ailsa Magnus being selected following interviews with each of the five. Keen to involve the people of Ibstock from the outset, the District Council arranged an introductory meeting in the village on 4 March 1997 so that local people could meet the sculptor. Before starting work on her sculpture, Magnus ran a series of workshops at three Ibstock schools and, on the evening of 17 April, led a public meeting at Ibstock Community College. The workshops and public meeting were doubly important to the sculptor in that they gave her an opportunity both to form a closer working relationship with the people for whom she was going to create her sculpture and to discuss the ideas she had started to formulate.[4] The first workshop was run during the Easter holidays at the Community College. Here Magnus worked with groups of local children aged from five to eighteen years, helping them to design and make decorative tiles to be incorporated into the new Youth Centre.[5] With the beginning of the summer term, she returned to the school to work with its pupils to create a ceramic welcome sign, now prominently sited at the school entrance.[6] Further welcome signs were created at workshops at Ibstock Infant and Junior Schools.[7] Magnus also acquainted herself with the village itself, looking particularly at existing landmarks: the Palace Cinema, the Ibstock War Memorial, St Denys Parish Church 'and an attractive corner on High Street

Magnus, *Ibstock Landmark Sculpture*

... I felt they should all be included in the final design'.[8]

By the end of April 1997, she had completed her initial design in the form of a maquette. During early May the maquette was displayed at a series of venues around Ibstock, with the sculptor in attendance to explain her design and listen to local people's comments.[9] On 7 June, the District Council approved the final design and Magnus began work on the full-scale sculpture. This was completed by August in five glazed stoneware sections. These were then delivered to Ibstock where they were put in store, before being transported to the site and, on 14 January 1998, bonded together around the concrete core.[10] The selection of the site had also been a collaborative decision, arrived at as a result of discussions between the Ibstock Housing Renewal Panel, members of the local community, and the sculptor.[11]

The unveiling ceremony, on 11 March 1998, was also the occasion for the burial next to the *Ibstock Landmark Sculpture* of the Ibstock time capsule, the result of a project funded by Leicestershire County Council Art Development and Leicestershire and South Derbyshire Rural Initiatives Fund, and co-ordinated by Mantle Community Arts. The capsule, due to disinterred in 2020, contains items 'representative of life today', including photographs, newspapers, a book of Ibstock people's memories of the village, and a video of Ibstock life in 1997.[12]

Literature
NW Leics District Council archives. *A Landmark for Ibstock* (sculptor's report).
General. *C. Times*: – [i] 10 October 1997, p.22 [ii] 20 March 1998, p.1, 1; *L. Mercury*, 14 March 1998, p.13, 13; *National Forest News*, Spring 1998, p.8, 8.

Notes
[1] The *Ibstock War Memorial* stands in the middle of Central Avenue, Ibstock, and was designed by T.B. Wain of Goddard and Wain. It was unveiled and dedicated on Saturday 19 February 1921. As an architectural structure, it is outside the scope of this volume. [2] *A Landmark for Ibstock* (sculptor's report). [3] *Ibid*. [4] *Ibid*.: press cuttings – *L. Mercury*, 25 June 1997; *Coalville and Ashby Echo*, 16 April 1997. [5] *A Landmark for Ibstock* (sculptor's report): press cuttings – *C. Times*, 4 April 1997; *Coalville and Ashby Echo*, 2 April 1997; *L. Mercury*, 20 March 1997. [6] *A Landmark for Ibstock* (sculptor's report). [7] *Ibid*. : press cuttings – *L. Mercury*, 26 June 1997; *Coalville and Ashby Echo*, 25 June 1997. [8] *A Landmark for Ibstock* (sculptor's report). [9] *Ibid*. [10] *Ibid*. [11] *Ibid*. [12] *C. Times*, 20 March 1998, p.1; *L. Mercury*, 14 March 1998, p.13.

KIRKBY MALLORY
Civil Parish: Peckleton
Borough Council: Hinckley and Bosworth

At Mallory Park race track, in the car park, either side of the circuit entrance, are four statues of racing heroes. They are, in the order in which they were commissioned:

1. To the immediate right of the circuit entrance:

Statue of Jim Clark

Jim Clark (1936–68), racing driver, born at Kilmany, Fife, had become interested in motor racing as a young man in Scotland, but it was when his friend, Ian Scott-Watson, revived the Border Reivers racing team that he got involved on a full-time basis. In 1958 at Full Sutton he became, at the age of 22, the first post-war sports-car driver to lap a British circuit at over 100 mph. In 1960 he joined Colin Chapman's Team Lotus, scoring his first Grand Prix win (and the Team's first continental win) at Pau in 1961. He became close friends with Chapman, staying with Lotus for the rest of his career. In 1963, Clark became World Champion Racing Driver, achieving a record total of seven Grand Prix wins. He was again world champion in 1965, achieving a new record speed at the Indianapolis 500, race and lap records at Nürburgring, and a record five consecutive

Annand, *Jim Clark*

Grand Prix wins. He was killed in a racing accident at Hockenheim, Germany, on 7 April 1968. Five-times world champion Juan Manuel Fangio described Clark as 'the greatest driver in the world'. Clark was appointed OBE in 1964. Sources: *DNB 1961–1970*; *The Times*, 8 April 1968, p.10 (obituary); *Who Was Who 1961–1970*.

Sculptor: David Annand
Founder: Powderhall Bronze Foundry, Edinburgh

Statue and plinth in bronze on a granite base
Statue: h. 1.69m (5'7")
Plinth: h. 10cm (4"); w. 75.5cm (2'6"); d. 1.52m (5')
Base: 29cm (1'); w. 1.73m (5'8"); d. 2.03m (6'8")
Inscriptions in raised letters on the upper surface of the plinth:
– in front of the statue: Jim Clark / (1936 – 1968)
– to the rear of the statue: COMMISSIONED BY / CHRIS MEEK / FOR MALLORY PARK
Unveiled: Tuesday 25 March 1997, jointly by Roy Salvadori and Ian Scott-Watson
Status: not listed
Owner: Mallory Park Motor Sport Ltd

Description: Clark is portrayed in mid-step, marching briskly, hands plunged into the pockets of his racing suit. On his left breast is the Lotus Team badge and a Firestone logo and on his right an Esso logo over his name.
Condition: Good.
History: The present statue is a second cast from the model commissioned to provide a statue of Jim Clark for his birthplace, Kilmany, in Fife. The Kilmany statue had been proposed in the early 1980s; a memorial committee had been formed and local sculptor David Annand commissioned to carry out the work. As with all his portrait work, Annand worked from photographs, supplemented with details of height and clothing sizes to secure a physical likeness, with biographical and anecdotal

research providing the basis for his attempt to create a livelier, more characteristic portrayal.[1]

Annand produced a maquette and the committee launched its subscription but found it impossible to raise sufficient funds. The scheme fell into abeyance until the early 1990s when Ian Thomson was elected to the committee in the role of secretary and made efforts to restart the subscription. The breakthrough came when Thomson managed to persuade the Ford Motor Company to bear the bulk of the £20,000 cost of having the life-size statue and plinth cast in bronze.[2]

Chris Meek, the owner of Mallory Park Circuit in Leicestershire, had been not just a fellow competitor, but also a friend of Clark's. Furthermore, he had driven in the very race in which Clark had had his fatal accident at Hockenheim in 1965. When Meek heard about the Kilmany commission, he contacted the sculptor and commissioned a second cast for Mallory Park. Although the present statue was the second to be cast, it was the first to be unveiled owing to delays in the erection of the Kilmany statue.

Related work: David Annand, *Statue of Jim Clark*, life-size bronze, 1997, Kilmany, Fife, Scotland.

Literature
H. Times. Review, 17 April 1997, p.3; *L. Mercury*: – [i] 27 March 1997, p.11 [ii] 21 October 1997, p.16.

Notes
[1] Information from the sculptor. [2] *Ibid*.

2. To the immediate left of the circuit entrance:
Statue of Mike Hailwood

Mike Hailwood (1940–81), world champion motor cyclist and car driver, began as a motor cycle racer in 1957. By the end of the following year he was British champion in the 125, 250, and 350cc classes and had won 74 races. In 1959, Hailwood won the first of his 76 Grand Prix victories and in 1961 he won the first of his

ten world championship titles. In this latter year he also entered the record books by becoming the first rider to win three TT races in a single week. In 1966 he joined Honda, winning the 250 and 350cc world titles in both 1966 and 1967. When in the following year Honda quit Grand Prix racing, Hailwood switched to car racing. In 1972 he won the European Formula Two Championship, but was never to achieve the same level of success with cars as he had with motor cycles. In 1974 Hailwood's car racing career was abruptly terminated after he broke his right leg in three places during the German Grand Prix. He retired to New Zealand, but in 1978 he made a remarkable come-back, returning to the Isle of Man and winning the Formula One TT race for Ducati. In recognition of his triumphant return, he was awarded the Segrave Trophy (1979). After winning the Senior TT Race in 1979 he retired permanently. Tragically, he died on 23 March 1981 as a result of a car crash (in which his daughter was also killed) two days earlier. His honours include an MBE (1968) and the George Medal (1973) for rescuing fellow competitor, Clay Regazzoni, from a burning car at the South African Grand Prix.
Sources: *DNB 1981–1985*; *The Times*, 24 March 1981, p.14 (obituary).

Sculptor: David Annand
Founder: Powderhall Bronze Foundry, Edinburgh

Statue and plinth in bronze on a granite base
Statue: h. 1.73m (5'8")
Plinth: h. 10cm (4"); w. 75.5cm (2'6"); d. 88.5cm (2'11")
Base: h. 28cm (11"); w. 1.07m (3'6"); d. 2m (6'7")
Inscriptions in raised letters on the upper surface of the plinth:
– in front of the statue: MIKE HAILWOOD M.B.E., GEORGE MEDAL. / 1940 – 81 [dates are within a bronze laurel wreath]

Annand, *Mike Hailwood*

– at the rear of the statue: COMMISSIONED BY CHRIS MEEK ESQ., / FOR MALLORY PARK

Unveiled: Saturday 26 July 1997, jointly by Geoff Duke, Phil Read, and the subject's widow, Pauline Hailwood

Status: not listed

Owner: Mallory Park Motor Sport Ltd

Description: Hailwood, wearing racing overalls, is portrayed standing with his hands on his hips, his weight on his left leg, his right knee flexed.

Condition: Good.

History: When motor cycle fans heard that Chris Meek had commissioned a statue of racing car driver Jim Clark for Mallory Park (see previous entry), a group of them formed a deputation to ask Meek if he would consider doing the same for a motor cycle racer. Meek was enthusiastic about the idea and, taking into consideration the names the deputation had suggested, organised a phone-in poll through *Motor Cycle News* (26 March 1997).[1] Readers were given three telephone numbers with which to register their choice, one for Mike Hailwood (Meek's personal favourite), one for John Surtees, and a third for any other rider of their choice. On 9 April 1997 the magazine announced that 97 per cent of the readers who had telephoned in had voted for Hailwood.[2]

Pleased with sculptor David Annand's success with the *Statue of Jim Clark*, Meek commissioned him to carry out the companion statue of Hailwood. For the earlier statue, Annand had first made a small maquette, but, in retrospect, he decided that this was, for him, an unnecessary and potentially misleading complication of the process and so for this statue he went straight to work on the full-size clay model.[3]

The *Statue of Mike Hailwood* cost Meek £20,000. He explained, 'I wanted to give something back, this is the perfect tribute to an old friend'.[4] An executive from Honda had been invited to participate in the joint unveiling but, having other commitments, promised instead to have a sign erected at Mallory Park detailing all Hailwood's achievements[5] (this now stands next to Hailwood's statue). Ultimately, the ceremony was performed by Hailwood's widow and motor cycling champions Geoff Duke and Phil Read. Among the other invited guests was Roger Clark, who would himself be dead within one year and, within two, commemorated alongside his former friend (see below, pp.68–9).

Literature

Mallory Park Estate. Press cuttings – *The Advertiser* [local newspaper], 18 July 1997, p.78; *Motor Cycle News*, 26 March 1997.

General. *H. Times*, 31 July 1997, pp.67, 68; *H. Times. Review*, 17 April 1997, p.3; *L. Mercury*: – [i] 2 August 1997, p.54 [ii] 21 October 1997, p.16; *Motor Cycle News*: – [i] 9 April 1997, p.27 [ii] 30 July 1997, p.39, **39**.

Notes

[1] See also *H. Times. Review*, 17 April 1997, p.3. [2] *Motor Cycle News*, 9 April 1997, p.27. [3] Information from the sculptor. [4] *Motor Cycle News*, 30 July 1997, p.39. [5] *H. Times*, 31 July 1997, pp.68, 67.

3. To the far right of the circuit entrance:

Statue of (Anthony) Colin (Bruce) Chapman

Colin Chapman(1928–82), racing car designer and driver, was founder and Chairman of the Lotus Group of Companies, and owner of the Lotus Grand Prix racing team. Born at Richmond, Surrey, he attended Stationers' Company's School, Hornsey, before going on to University College, London, where he gained a BSc in engineering. By 1948 he had designed his first car, the Lotus Mark 1. Over the ensuing years he immersed himself in designing ever more refined cars for circuit racing, forming his own company, Lotus Cars, in 1955. Chapman's first Grand Prix victory

was at Monaco in 1960 with a Lotus-Climax driven by Stirling Moss, but it was Jim Clark who established Lotus as leader in its class before his tragic death in 1968. Clark was a great loss to Chapman and not until he teamed up with Mario Andretti did he again have such rapport with a driver. In 1978, Chapman's last world-beating year, Andretti raced the Lotus 78 to eight victories. Chapman's last years were soured by the scandal surrounding the De Lorean project. On 16 December 1982 he died at home of a heart attack. His honours include FRSA (1968), CBE (1970), Fellow, University College, London (1972), RDI (1979), and honorary Dr RCA (1980).

Sources: *DNB 1981–1985*; *The Times*, 17 December 1982, p.12 (obituary); *Who Was Who 1981–1990*.

Sculptor: David Annand
Founder: Powderhall Bronze Foundry, Edinburgh

Statue and plinth in bronze on granite base
Statue: h. 2m (6'7")
Plinth: h. 10cm (4"); w. 89cm (2'11"); d. 76cm (2'6")
Base: h. 22.5cm (9"); w. 1.44m (4'9"); d. 1.1m (3'7")
Inscriptions in raised letters on the upper surface of the plinth:
– in front of the statue: ANTHONY COLIN BRUCE CHAPMAN / 1928 – 1982
– at the rear of the statue: COMMISSIONED BY CHRIS MEEK ESQ., / FOR MALLORY PARK
Unveiled: Saturday 18 July 1998, by Hazel Chapman, the subject's widow
Status: not listed
Owner: Mallory Park Motor Sport Ltd

Description: Chapman, in short-sleeved polo shirt and belted trousers, is represented in celebratory stance, standing with legs wide apart and arms outstretched above his head.
Condition: Good.
History: The present statue was

Annand, *Colin Chapman*

commissioned by Chris Meek, owner of Mallory Park, with financial assistance from Hazel Chapman and Lotus,[1] to mark the fiftieth anniversary of Lotus. Meek was particularly keen to erect a statue to Chapman, both to honour their friendship and to stand as a tribute to the man who had designed the Lotus cars in which Meek had achieved his own greatest successes as a racing driver, successes for which he was awarded the Chapman Trophy on a record three occasions.[2]

Again Meek called on David Annand, the sculptor responsible for the previous two statues at Mallory Park, of Jim Clark and Mike Hailwood (see above). By spring 1998, Annand had completed the full-size clay model and duly sent a photograph to Hazel Chapman, the subject's widow. Having made a few modifications to her satisfaction, the sculptor sent the model to the founders for casting.[3]

Following the statue's unveiling at Mallory Park, Chris Meek acclaimed Chapman as the man who 'inspired all modern Formula One racing'. He explained: 'Colin was never honoured by the industry or the government in his lifetime . . . so we felt it entirely appropriate to pay a permanent tribute to him [at Mallory Park].'[4]

Literature
Mallory Park Estate. Press cuttings – *The Advertiser* [local newspaper], 12 September 1997, p.82; *H. Times*, 30 July 1998.
General. *Autosport*, 23 July 1998, p.96.

Notes
[1] Mallory Park Estate: press cutting – *H. Times*, 30 July 1998. [2] Information from Mallory Park Estate (letter to the author, dated 4 March 1999). [3] Information from the sculptor. [4] *Autosport*, 23 July 1998, p.96.

4. To the far left of the circuit entrance:
Statue of Roger Albert Clark

Roger Clark (1939–98), international rally driver, was born in Narborough, Leicestershire. He joined the family bus business in the 1950s and took up motor-sport, teaming up with Jim Porter who was to remain his regular co-driver for 20 years. In 1964 he won the Scottish Rally for the first time and in 1965, driving a Rover 2000, he won the standard car category in the Monte Carlo Rally. He afterwards joined Ford, staying with them for 15 years. From 1968 until the 1980s he drove a variety of Ford Escorts, becoming the most successful British rally

driver of all time: he was double winner of the RAC International Rally (1972, 1976), four times British champion and winner of 25 other major international rallies. In 1980 he was appointed MBE. He died from a stroke at home in Desford, Leicestershire, on 12 January 1998. Source: *The Times*, 14 January 1998, p.21 (obituary).

Sculptor: David Annand
Founder: Powderhall Bronze Foundry, Edinburgh

Statue and plinth in bronze on a granite base
Statue: h. 1.86m (6'1")
Plinth: h. 10cm (4"); w. 89cm (2'11"); d. 75.5cm (2'6")
Base: h. 24cm (10"); w. 1.66m (5'5"); d. 97cm (3'2")
Inscriptions in raised letters on the upper surface of the plinth:
– in front of the statue: ROGER ALBERT CLARK M.B.E. / 1939 – 1997 [*sic*]
– at the rear of the statue: COMMISSIONED BY CHRIS MEEK ESQ., / FOR MALLORY PARK
Unveiled: Monday 11 January 1999, by Judith (Goo) Clark and Oliver Clark, the subject's widow and younger son
Status: not listed
Owner: Mallory Park Motor Sport Ltd

Description: Clark, wearing leather jacket and trousers, is portrayed walking, with his hands in his jacket pockets. On his left breast pocket is a Ford logo and above it, a BRDC (British Racing Drivers' Club) badge.

Condition: Good.

History: As with the three statues of racing heroes at Mallory Park that preceded the present statue, this was commissioned by Chris Meek, the race circuit's owner. Again, Meek was erecting a tribute to someone who was both a friend and someone who had made a significant contribution to his sport. Moreover, there were close local connections: as a professional rally driver Clark had achieved

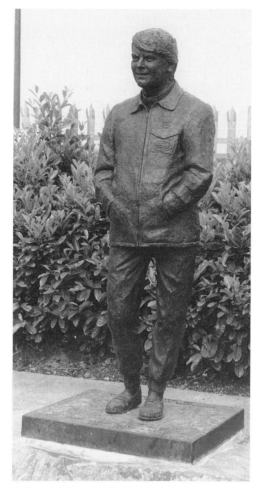

Annand, *Roger Clark*

many of his successes at Mallory Park, while in his leisure he had raced a speedboat on Mallory's lake. Furthermore, his home had been in a nearby village (Desford), and his ashes laid at Peckleton Church.[1]

Of all David Annand's statues at Mallory Park, this is the only one where the sculptor had met the subject, having been introduced to

him at the celebrations following the unveiling of the *Statue of Colin Chapman* only the previous July.[2] The granite for the plinth was chosen by Mrs Clark and the statue was unveiled on the eve of the first anniversary of her husband's death.[3]

Speaking at the unveiling ceremony, Martin Whitaker, European Director of Ford Racing, said: 'Roger was a fine sportsman, a great ambassador for Ford and for motor sport ... To have this memorial at Mallory, so close to Roger's home is a fitting tribute to an outstanding British talent.'[4]

Literature
Autosport, 14 January 1999, p.22; *L. Mercury*, 16 January 1999, p.52.

Notes
[1] Information from Mallory Park Estate (letter to the author, dated 4 March 1999). [2] Information from the sculptor. [3] Unlabelled press cutting supplied by Mallory Park Estates. [4] *L. Mercury*, 16 January 1999, p.52.

1. CITY CENTRE

Abbey Park

1. On the site of the former Abbey:

Memorial to Cardinal Thomas Wolsey

Thomas Wolsey (c.1475–1530), a butcher's son, was born at Ipswich. He entered the church, becoming archbishop of Canterbury in c.1501, and of York in 1514. In 1515 he was created Cardinal by Pope Leo X and appointed Lord Chancellor by Henry VIII. Wolsey became immensely powerful but in 1527 his inability to secure papal sanction for the King's divorce from his first wife, Catherine of Aragon, resulted in his fall from power. Wolsey retired to Cawood but was arrested for high treason on 4 November 1530. He died at Leicester, having stopped there on the journey back to London. Source: *DNB*.

Designers: Bedingfield and Grundy

Memorial in brick and concrete
Memorial: h. (max.) 28cm (11"); w. (max.) 91cm (3'); d. 2.53m (8'4")
Base: h. 28.5cm (11"); w. (max) 1.06m (3'6"); d. 2.7m (8'10")
Inscriptions on the upper face of the slab:
– in the middle: CARDINAL / WOLSEY / OBIT A.D. 1530
– towards the foot: GIVE HIM A LITTLE EARTH / FOR CHARITY
Unveiled: Wednesday 24 October 1934, by Lord Cromwell
Status: not listed
Owner / custodian: Leicester City Council

Description: The memorial is designed to look like a tomb. The low base, of concrete with brick and concrete corner blocks, supports a wedge-shaped superstructure bearing Wolsey's coat of arms and the inscriptions.

Condition: Generally good, though the colouring of Wolsey's coat of arms has faded.

History: The memorial was erected on the site of the Lady Chapel of Leicester Abbey, where Cardinal Wolsey died and, according to tradition, was buried in 1530.[1]

Literature
LRO. *Order of Proceedings at the Unveiling of a Memorial to Cardinal Wolsey, October 24th, 1934*.
General. *L. Chronicle*, 27 October 1934, pp.4, 1; Leicester City Council, *Public Art Trail* (leaflet), n.d.; *L. Mail*, 24 October 1934, p.1; *L. Mercury*, 24 October 1934, pp.11, 1.

Note
[1] *L. Chronicle*, 27 October 1934, p.4.

2. In the Café garden:

Statue of Cardinal Wolsey

Sculptor: unknown

Restorers: Mark Thompson (replacement head), Paul Wood (replacement right hand)

Statue in York stone (body) and Portland stone (replacement head and right hand)
Statue: h. 2.35m (7'8"); w. 1m (3'3"); d. 81cm (2'8")
Base: h. 17cm (7")
Inscription on a plaque set into the pavement before the statue:
CARDINAL / WOLSEY / CHANCELLOR TO HENRY VIII / DIED AT LEICESTER ABBEY, 1530 / BURIED IN ABBEY GROUNDS. / THE STATUE WAS DONATED / TO THE CITY BY WOLSEY / THE INTERNATIONAL / KNITWEAR FIRM.
Executed: 1920
Status: not listed
Owner / custodian: Leicester City Council

Description: A standing statue of Wolsey in his Cardinal's robes and hat. He points with his

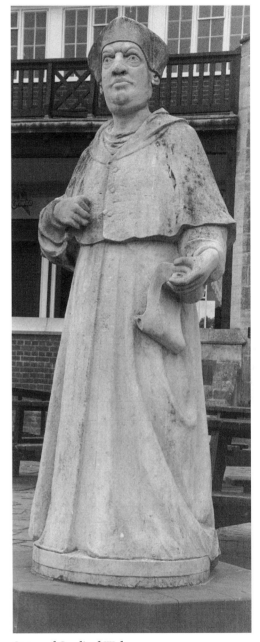

Statue of Cardinal Wolsey

right hand to a scroll held in his left hand. The statue is raised on a low octagonal base.

Condition: The head and right hand are replacements; the carving of the original stone is much weathered and there appears to be a crack running across the front of the cape at elbow height. The statue is generally grimy, with some guano and areas of biological growth.

History: The present statue, carved in 1920, was commissioned by hosiery firm Wolsey Ltd for its head office in King Street, Leicester.[1] It was originally sited indoors, at the end of a short corridor beyond the ground floor showrooms in front of a shallow niche at the head of a flight of four stairs.[2] In 1971 it was relocated out-of-doors, to a courtyard of the company's Abbey Meadow premises[3] and in 1979, following the sale of the building, donated by Wolsey Ltd to Leicester City Council who re-erected it outside the café at Abbey Park.[4]

At some time over the weekend of 18/19 January 1992 vandals decapitated the statue, inflicting irreparable damage to the head.[5] The statue had, moreover, lost a hand at some time before this and so the Council engaged craftsmen to carve replacements of both the head and the hand. The commission for the head was given to Bristol-based Mark Thompson while that for the hand was given to Leicester-based Paul Wood. Thompson travelled up to Leicester to view the statue but carried out the carving of the replacement head at his workshop in Bristol.[6] Working from old photographs of the statue in its undamaged state, photographs of a faience relief of Wolsey from the old Wolsey Ltd factory in Belgrave Road (see p.76), and a reproduction of a painted portrait of Wolsey in the National Portrait Gallery, Thompson took two weeks to fashion the replacement head from Portland stone.[7]

The statue had meanwhile been kept in store in the yard behind the lodge in Abbey Park.[8] By February 1993, the new head and hand had

been fixed to the statue[9] and during the summer of that year the restored statue was re-sited in the Café garden.[10] Unfortunately, the replacement head is over-large; furthermore, it has been put on at a wrong angle. As photographs of the statue in its original condition show, Wolsey's head was turned to his left, his eyes directed as if towards somebody standing on his left.[11] The original turn of the head countered the raising of the left shoulder, imparting not only a balance to the figure but also a certain dignity to the action, whereas the present reconstruction merely renders the figure grotesque.

Literature
LRO. *Wolsey Ltd photograph album*, n.d., n. pag. **Leicester City Council, Arts and Leisure Department**. Various correspondence, internal memoranda, etc.
General. Banner, J.W., 1991, pp.68–9; Burton, D.R., 1994, p.**39**; Darke, J., 1991, pp.177, 178; *L. Link*, September 1993, p.3; *L. Mercury*: – [i] 20 May 1988, p.8 [ii] 22 January 1992, p.13, **13** [iii] 13 February 1993, p.4, **4** [iv] 13 August 1993, p.27, **27**; *L. Topic*: – [i] January 1986, pp.34–5, **35** [ii] March 1990, p.45.

Notes
[1] *L. Mercury*, 22 January 1992, p.13. [2] As shown in a photograph in *Wolsey Ltd Photograph Album* (LRO). [3] See photograph in Burton, D.R., 1994, p.39. [4] *L. Mercury*, 13 February 1993, p.4. [5] *Ibid.*, 22 January 1992, p.13; *Ibid.*, 13 February 1993, p.4. [6] Information from Pete Bryan, former Public Arts Officer, Leicester City Council Arts and Leisure Dept. [7] Documents in Leicester City Council Arts and Leisure Dept; and *L. Mercury*, 13 February 1993, p.4. [8] Information from Pete Bryan, former Public Arts Officer, Leicester City Council Arts and Leisure Dept. [9] *L. Mercury*, 13 February 1993, p.4. [10] *Ibid.*, 13 August 1993, p.27. [11] See notes 2 and 3.

3. In the main area of the park: a sculpture trail, launched in 1987 by Leicester City Council's Arts Development Unit
The earliest pieces were the results of sculptors' residencies. Each sculptor was required to create a sculpture in the park, for siting in the park, using natural materials. At the time of

writing (autumn 1999), the sculpture trail is inactive, there having been no pieces commissioned since 1995.

Near the south-western edge of Abbey Park's pond:
Islands and Insulators
Sculptor: Steve Geliot

Sculpture in painted ash on a concrete base
Sculpture: h. 2.1m (6'11"); w. of archway with inset relief: 1m (3'3"); w. of open archway: 1.25m (4'1")
Base: h. 3cm (1"); w. 1.8m (5'11"); d. 1.8m (5'11")
Executed: 1989
Status: not listed
Owner / custodian: Leicester City Council

Description: The sculpture comprises two uprights panels joined at right-angles. The left-hand panel is an archway with an inset carved and painted relief and the right-hand panel is an open archway. The relief on the inner face of the left-hand archway is a sunny seascape with two islands in the distance beneath a few puffy clouds. In complete contrast that on the outer face is a murky underwater scene with a young boy and his books sinking to the bottom where can be seen the conning tower of a nuclear submarine.

Condition: There are splits in the panel with the inset relief and the paint on all surfaces is faded and peeling; the wood is damp towards the base.

History: Steve Geliot's *Islands and Insulators* was the second sculpture to be commissioned by Leicester City Council for the Abbey Park sculpture trail.[1] The scheme, begun in 1987, stated specifically that each sculptor should use natural materials to harmonise with the parkland setting. Geliot created his sculpture during a seven week residence in the park from 8 August to 25 September 1989, the public being invited to

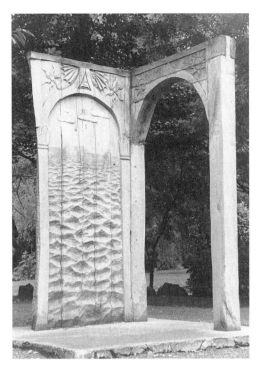

Geliot, *Islands and Insulators*

view him at work each day between 10 a.m. and 4 p.m.[2] During his time in the park he also conducted a series of workshops of two to three hours' duration with various school parties and community groups.

For his sculpture, Geliot used ash wood from storm-damaged trees, stained with coloured pigments. He explained his work as follows:

What I have tried to do is like a kind of psychological portrait of the place – a response to the feelings of Abbey Park and what goes on there now. There are two sides to the sculpture – a very positive celebratory one which is the main view you get and a darker more critical one. My portrait is a

warts and all job as I felt I could not ignore some of the really terrible things I saw happen in the park, and the warning signs of things that may happen in the future if we don't learn to protect and nurture our public places. However, the overall message of the piece is a positive one.

I have now given the piece an overall title ISLANDS AND INSULATORS but each side has its own separate title. The positive side is called Islands of Consciousness and it can be read on a number of levels. On one level it is an interpretation of a park as a green island in an urban ocean. It is also to do with the multi-cultural nature of the park being like a window to other places and cultures far away from the U.K. The arch is something you walk through, a triumphal act of transformation. In the park and the city you can witness the beginnings of new activities and attitudes – a number of positive social initiatives, ranging from equal opportunities to ecological awareness and bringing the arts into the public arena. It is these aspects of the park and the City of Leicester which I want to celebrate.

The darker side which is called The Insulators can be interpreted as a kind of warning about the forces and attitudes which threaten the positive things which the first side is concerned with. It is the negative sense of 'island' – the ignorance and closed mindedness that causes an insular attitude, a closing of doors and the arrogance and violence that would be the result if we were to loose our wisdom and culture.[3]

Geliot's fee, covering his residency and the production and purchase of the sculpture was £1,500.[4]

Literature
Leicester City Council, Arts and Leisure Department. *Steve Geliot. Sculpture* (artist's statement)
General. *Abbey Park sculpture trail*, n.d.; Leicester

City Council, 1997, 1993 edn, p.105; Leicester City Council, 1997, pp.104, 105; *L. Mail*, 5 October 1989, p.1; *L. Mercury*: – [i] 10 August 1989, p.22 [ii] 17 November 1989, p.16.

Notes
[1] *L. Mercury*, 17 November 1989, p.16. [2] *Ibid.*, 10 August 1989, p.22. [3] *Steve Geliot. Sculpture* (artist's statement). [4] Letter dated 28 July 1989, from Jasia McArdle, Arts Development Officer, to Steve Geliot (Leicester City Council, Arts and Leisure Dept. archives).

On the north-east side of Abbey Park pond:
Traffic Jam
Sculptor: Julie Edwards

Sculpture in various woods, painted and varnished
Inscription plaque in front of the sculpture:
TRAFFIC JAM / by / Julie Edwards
Executed: 1990
Status: not listed
Owner / custodian: Leicester City Council

Description: The sculpture, before extensive vandalization, appears to have consisted of a numbers of cars, crudely carved out of wood and painted in bright colours, arranged around the base of a tree.

Condition: Poor. Some of the pieces are missing and one of the two pieces remaining is badly broken.

History: Julie Edwards created *Traffic Jam* for the Abbey Park sculpture trail during her summer residence in the park in 1990, during which time the public were invited to come along and view her at work. The trail had been launched in 1987, each selected sculptor being required to make his or her sculpture out of natural materials. Edwards selected various types of wood, cutting the pieces to shape with bow saws and a chain saw.

The sculpture is described as a 'monument to the traffic jam, to an invention that has changed our lives, and is, at the same time, destroying

the balance of nature'. The sculptor explained:

> Inspiration for my sculpture comes from various sources. Over population, exploitation of the land, the balance of land, nature and the man-made object. The fact that there are very few open spaces, everything has been consumed or is being consumed by the developing world.[1]

Literature
Abbey Park sculpture trail, n.d.; Leicester City Council, 1997, 1993 edn, p.105; *L. Mercury*: – [i] 3 September 1990, p.5 [ii] 10 September 1990, p.13.

Note
[1] As quoted in *Abbey Park sculpture trail*, n.d., n. pag.

Next to the Abbey Park Bowls Club green:
Three Orchids
Sculptor: Kerry Morrison

Sculpture in oak
h. (est.) 3m (9'10")
base area: 4.29 × 4 × 3.5m (14'1" × 13'2" × 11'6")
Inscription plaque:
THREE ORCHIDS / BY KERRY MORRISON 1995 / [*space*] / THE WORK COMMISSIONED BY / LEICESTER CITY COUNCILS / LEISURE SERVICES DEPARTMENT / WAS UNVEILED BY / COUNCILLOR E. CASSIDY / (CHAIR OF PUBLIC ARTS WORKING / PARTY & PLANNING COMMITTEES) / ON / SATURDAY 30TH SEPTEMBER 1995
Executed: 1995
Unveiled: Saturday 30 September 1995, by Councillor E. Cassidy, Chair of Leicester City Council Public Arts Working Party and Planning Committees
Status: not listed
Owner / custodian: Leicester City Council

Condition: Good.
History: *Three Orchids* stands on the site previously occupied by *Family Group*. This latter had been conceived as an ephemeral piece

(see pp.314–15), but following its removal, Pete Bryan, then Public Arts Officer for Leicester City Council, proposed a more permanent piece whose theme would allude to the diversity of cultures that make up the local community. He approached sculptor Kerry Morrison with the idea and, during a residency in Abbey Park in summer 1995, the sculptor created the present piece, *Three Orchids*, representing species from, respectively, the European, African and Asian continents.[1]
Three Orchids was unveiled as part of a joint ceremony with Richard Janes's *Steps into Nature* at Evington Park, Leicester (see p.189), officials and guests being conveyed by mini-bus between the two centres.[2]

Literature
L. Mercury: [i] 1 June 1995, p.14 [ii] 28 September 1995, p.5 [iii] 9 October 1995, p.4.

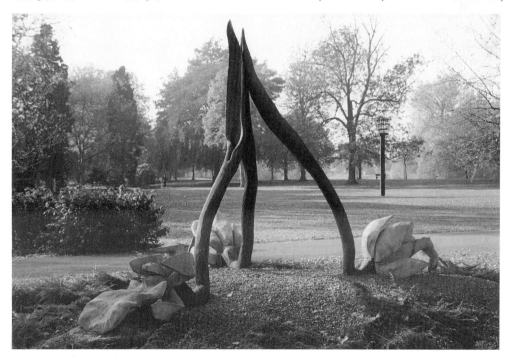

Morrison, *Three Orchids*

Notes
[1] Information from Pete Bryan, former Leicester City Council Public Arts Officer. [2] *L. Mercury*, 28 September 1995, p.5.

Outside the Redland Garden of the Senses:
Tower of Silence
Sculptor: Carole Kirsopp

Sculpture in reconstituted stone
h. 2.58m (8'6"); dia 2.34m (7'8")
Inaugurated: Tuesday 20 June 1995, by Councillor Robert Wann, Chair of Leicester City Council Leisure Services
Status: not listed
Owner / custodian: Leicester City Council

Description: The sculpture is in the form of a circle of 18 tall, square posts in reconstituted stone with, at its centre, a circle of three shorter,

wedge-shaped stones, in the midst of which nestles a bronze plumb bob secured by a chain to the concrete base.

Condition: There is a line of spray paint across seven of the posts. More importantly, the plumb bob in the centre is a much smaller replacement for a large bob that sat on top of the inner circle of wedge-shaped stones, until it was stolen shortly after the sculpture was erected.

History: *Tower of Silence* was commissioned by Leicester City Council from Carole Kirsopp, a final-year student at Loughborough College of Art and Design. The cost of the sculpture was covered by sponsorship from Redland Aggregates, Handi-Hire, Sprint Lifting Equipment, Leicester City Council's Leisure Services Department, City Landscapes, and the sculptor herself. The work was ceremonially inaugurated by Councillor Robert Wann, Chair

of Leicester City Council's Leisure Services Department, who lowered the original, larger, plumb bob into position from the controls of a crane.[1]

Literature
L. Mercury, 21 June 1995, p.17.

Note
[1] *L. Mercury*, 21 June 1995, p.17.

4. *The Redland Garden of the Senses (the principal sponsor for which was Redland Aggregates), officially opened by David Blunkett, MP, on 22 April 1995*
The garden was designed to combine features 'that appeal to all the senses with good access' for the disabled and was intended to be 'particularly enjoyable to people with a sensory or physical disability'. Plants have been chosen for scent, colour and texture, there is a sound garden with wind chimes, and also a number of sculptures whose 'unusual textures and shapes' were a specific requirement of the commission.[1] The sculptures are as follows:

Note
[1] Leicester City Council, Redland Garden of the Senses, publicity material.

Feely Fish

Sculptors: Kerry Morrison, with eight children and young people from The Netherhall and Rushey Mead Integration Link

Sculpture in oak
h. 1.82m (6'); w. 1.51m (5'); d. 1.28m (4'3")
Inscription plaque standing next to the sculpture:
"FEELY FISH" / CREATED BY STUDENTS FROM / THE NETHER HALL – RUSHEY MEAD / INTEGRATION LINK / AND KERRY MORRISON / DECEMBER 1995 / LEICESTER CITY COUNCIL / LEISURE SERVICES [this being also set out in Braille]

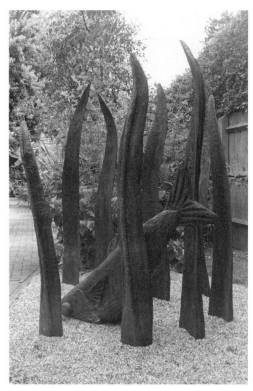

Morrison, *Feely Fish*

Executed: September / October 1995
Unveiled: Monday 15 December 1995, by Councillor Ted Cassidy
Status: not listed
Owner / custodian: Leicester City Council

Condition: Fair, although a piece of wood from the fish's side (close to the head) has been lost.

History: *Feely Fish* was commissioned from Kerry Morrison by Leicester City Council during her summer residency at Abbey Park. The sculptor's brief was to work with eight pupils from special needs schools in late summer / autumn 1995. The result was a design

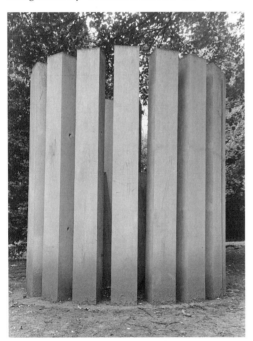

Kirsopp, *Tower of Silence*

based on a fish swimming through eight reeds.[1] The eight reeds represent the eight pupils, the various heights of the reeds corresponding to those of the pupils at the time of the commission.[2]

Related work: see also *A Touch of Nature*, below.

Literature
L. Mercury: – [i] 1 June 1995, p.14 [ii] 28 September 1995, p.5 [iii] 16 December 1995, p.5, **5**.

Notes
[1] *L. Mercury*, 16 December 1995, p.5.
[2] Information from Jasia McArdle, Leicester City Council.

A Touch of Nature
Sculptors: Kerry Morrison, with pupils from Ellesmere College, Leicester

Sculpture in oak
h. 2.06m (6'9"); w. 85cm (2'10"); d. 41cm (1'4")
Inscription on a plaque standing next to the sculpture:
"A TOUCH OF NATURE" / CREATED BY STUDENTS FROM / ELLESMERE COLLEGE / AND KERRY MORRISON / DECEMBER 1995 / LEICESTER CITY COUNCIL / LEISURE SERVICES [this being also set out in Braille]
Unveiled: Monday 15 December 1995, by Councillor Ted Cassidy
Status: not listed
Owner / custodian: Leicester City Council

Description: The sculpture takes the form of two (smoker's) pipe shapes with hollow bowls. Each of the stems transforms as it rises into a spiky fifteen-pointed leaf shape pierced along its length with a long aperture.

Condition: The bowl shapes are split and cracked in places and there is some biological growth on the lower parts. Each of the bowls is pierced with a drilled hole at its bottom (for drainage) and is used to contain seeds and nuts

for squirrels and birds. Originally only one was holed, the other having been intended to hold water for use as a birdbath. When, however, this bowl split and began to leak it too was drilled through for use as a seed and nut container.[1]

History: Kerry Morrison produced this

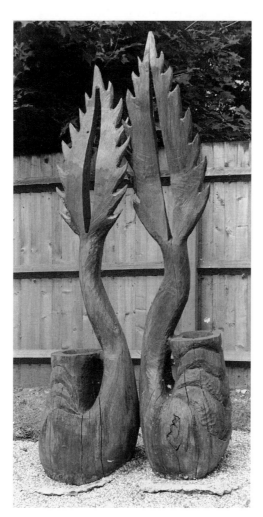

Morrison, *A Touch of Nature*

piece during her residency at Abbey Park in late summer / autumn 1995, with assistance from a group of pupils from Ellesmere College, Leicester.[2]

Related work: see also *Feely Fish*, above.

Literature
L. Mercury: – [i] 28 September 1995, p.5 [ii] 16 December 1995, p.5, **5**.

Notes
[1] Information from Dave Pick, Leicester City Council. [2] *L. Mercury*: [i] 28 September 1995, p.5 [ii] 16 December 1995, p.5.

Note: there are a number of other sculptures in the Redland Garden of the Senses, but it has not been possible to obtain precise information about them. They include (?)*Quecha*, granite and marble, h. 42cm (1'5"), w. 1.76m (5'9"), d. 46cm (1'6") (sculptor unrecorded) and (?)*Fertility God*, wood, h. 1.6m (5'3"), w. 22cm (9"), d. 29cm (11") (sculptor unrecorded).

Abbey Park Street

The Sangra Building (former Wolsey Ltd warehouse), 1922–3, by W. Riley[1]

Over the entrance on the building's splayed corner at the junction of Abbey Park Street and Ross Walk:

Relief Portrait of Cardinal Wolsey
Artist: unknown

Relief portrait in faience
h. 2.12m (7'); w. 1.83m (6')
Executed: *c*.1923
Status: not listed
Owner: unknown

Description: Relief portrait of Cardinal Wolsey wearing a brown cardinal's cap and cloak, set against a circular blue background within a yellow rectangular setting slightly higher than wide, all in faience. The rectangular

Relief Portrait of Cardinal Wolsey

setting is in turn framed at top and sides by fasces carved in stone in high relief.

Condition: Good.

Note
[1] Information from Dr Joan Skinner.

Applegate

Wygston's House Museum of Costume, 12 Applegate

In the garden, set into the garden wall:

Relief Portrait of William Carey

William Carey (1761–1834), Baptist preacher, missionary and orientalist, was born in Northamptonshire, the son of an Anglican schoolmaster. At first he worked as a shoemaker, but in 1783 he joined the Baptists and was pastor from 1786–89 at Moulton, Northamptonshire, and from 1789–93 at Leicester. Carey founded the Baptist Missionary Society in 1792 and sailed for India in 1793. He moved to Máldah where he worked as a foreman in an indigo factory. He learnt several Indian languages, becoming sufficiently fluent to be able to preach in Bengali, 1795–9. In 1801 he published his own translation of the New Testament into Bengali and when Fort William College was opened in Calcutta he was appointed first professor of Sanskrit, Bengali and Marathi. In 1805 he opened a mission chapel at Calcutta. He translated the entire Bible into Bengali in 1809 and all or part into 24 other languages or dialects.
Sources: *DNB*; Livingstone, E.A., 1977.

Sculptor: unknown

Relief plaque in limestone
h. 63cm (2'1"); w. 47cm (1'7")
Inscription on a tablet set into the wall beneath the relief, in raised Roman capital letters in recessed panels:
IN THIS HOUSE LIVED / WILLIAM CAREY / MISSIONARY / 1780 – 1793
Unveiled over the doorway of William Carey's cottage, Harvey Lane, Leicester, Saturday 20 March 1943, by Councillor S.J. Perry
Status: not listed
Owner / custodian: Leicester City Council

Description: The relief tablet is set into the north part of the garden wall of Wygston's House Museum of Costume, above an inscription tablet; it is almost completely obscured by shrubbery. The relief tablet is round-arched and is carved with a bust-length portrayal of Carey, his head turned towards his left.

Condition: Extremely poor. The surface is almost completely lost with the consequent obliteration of most details of the carving, this deteriorated state presumably being a result of its long exposure to urban atmospheric conditions.

History: The *Relief Portrait of William Carey* is believed to have been originally carved for the Carey Memorial Hall, built on the site of the old Harvey Lane Baptist Chapel and destroyed by fire in 1921. The relief was salvaged and included in an auction of relics from the Hall, whereupon it was purchased, presented to William Carey's cottage in Harvey Lane and, as part of the 1943 celebrations marking the 150th anniversary of Carey's departure for India as a missionary, set up over

Relief Portrait of William Carey

the doorway and unveiled by Councillor S.J. Perry, a relative of the donor.[1]

The relief itself was simply inscribed across the bottom 'WILLIAM CAREY'. Beneath it, however, was an inscription plaque with the following words:

WILLIAM CAREY 1761–1834 / PIONEER OF MODERN MISSIONS / THROUGH WHOSE INFLUENCE THE / BAPTIST MISSIONARY SOCIETY / WAS FOUNDED IN 1792. / HE LIVED IN THIS COTTAGE FROM 1789 TO 1793 / FROM WHENCE HE SAILED TO INDIA, LABOURING / THERE CONTINUOUSLY FOR 40 YEARS AS / MISSIONARY, TRANSLATOR, BOTANIST AND REFORMER.[2]

Part of the cottage had been converted to a museum in the early 1900s and part was used as a Baptist Chapel, the final act of worship taking place on 27 March 1968. The building was demolished soon afterwards to make way for major redevelopment of the area (the site now being occupied by the Holiday Inn). At some time after this, the relief was relocated to Wygston's House Museum of Costume where it was installed in the garden wall.[3] It is now under the custodianship of Leicester City Council.

Literature
L. Chronicle, 27 March 1943, p.1; *L. Mail*, 20 March 1943, p.4; *L. Mercury*, 22 March 1943, p.5; Leicester Mercury, 1995, p.141; Williams, Revd E., n.d.

Notes
[1] *L. Mail*, 20 March 1943, p.4. [2] Photograph in Leicester Mercury, 1995, p.141. [3] The relief is here installed above a rather confusing inscription stating simply that 'in this house lived William Carey' (to which house it refers is not clear). To make matters worse, the museum has no information relating to the relief.

Bede Island
At the main entrance to International Youth House:
Sculptural Gates, Railings and Entrance Canopy
Sculptor: Anuradha Patel

Gates and canopy in aluminium, railings in mild steel, all in a polyurethane finish
Installed: Tuesday 19 January 1999
Status: not listed
Owner / custodian: Leicester City Council

Condition: Good.
History: As is usual practice with Leicester City Council commissions, Patel was required to discuss her ideas with staff at International Youth House and also with local youth groups, incorporating some of their suggestions into her designs. Her principal sources of inspiration, however, were the proximity of Bede Park and the River Soar, the newness of the building, and the fact that its users were young people. In her report to the Council following completion of her work, the artist explained the designs as follows:

The theme of a 'Magical Garden' evolved reflecting both the natural setting of the location and the symbolism of new growth, young life and optimism. Other aspects of the design such as images of the lotus flower, the elephant, and the peacock are there as symbols of purity, generosity, pride and self respect. The human figure at the heart of the design symbolizes togetherness, and the configurations in which the figures are represented suggest nurture and support.

The Main Gate uses the symbol of the eye as its centre, look within, look out. Within this is represented the globe. As a disk it has other associations of navigation and new technology. The physical nature of the figures represents dynamism and energy and its association with youth and creativity. The sun and moon represent the world and its time zones. Those are the ultimate symbols of unity.

Literature
Leicester City Council, Arts and Leisure Department. International Youth House Project: artist's final report and maintenance schedule.

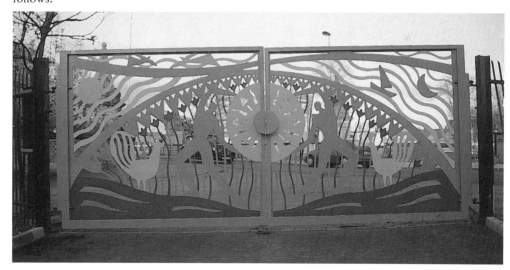

Patel, *Sculptural Gates*

Bede Island North

On The Plaza, Western Boulevard, opposite Mill Lane:
Signs of Life
Designers: Gary Drostle and Rob Turner of Wallscapes

Sculpture in Kerridge sandstone and vitreous glass
h. (max.) 1.88m (6'2"); w. 7m (23'); d. 6.15m (20'2")
Erected: Autumn 1998
Status: not listed
Owner / custodian: Leicester City Council

Drostle and Turner, *Signs of Life*

Description: Located in the centre of a sunken paved area, the sculpture is in the form of a circle of five roughly-shaped standing stones decorated with brightly-coloured, pictographic drawings. Each is titled by the artists according to the theme of the drawings: 'Castle' shows a castle with a flag flying; 'Music', musical notation with sun motifs and smiling figures; 'Home', a house, cars, a ladder and a star; 'Children', two smiling children holding hands; and 'Tree', a tree motif and a boy kicking a ball at a goal.

Condition: Good.

History: *Signs of Life* was commissioned by Leicester City Challenge for the newly laid-out plaza on Bede Island North. In August 1997 Leicester City Challenge placed an advertisement in *Artists Newsletter* asking for interested artists to submit designs. As has been usual practice in Leicestershire in recent years, the Council stipulated that the winning designer(s) be prepared to discuss their work at a public meeting and also that they agree to run a programme of design workshops with local children and various community groups and to incorporate some of the ideas arising from those sessions.

In December 1997, ten short-listed artists were asked to make maquettes and submit estimates of the cost of their schemes. In March 1998, the design submitted by Gary Drostle and Rob Turner of Wallscapes was selected. On 21 April, Drostle and Turner discussed their scheme at a public meeting at the West End Centre, Andrewes Street, Leicester, and throughout May ran a series of design workshops: daytime sessions at Shaftesbury Junior School, Hazel Primary School, and King Richard Infant School, and evening sessions at the West End Neighbourhood Centre (one drop-in evening for young people and another for adults with learning difficulties) and at the Bhagini Centre (for the Bhagini Girls Group).

Meanwhile, the artists went to Bridge Quarry at Kerridge, Macclesfield, and selected five pieces of sandstone and also agreed the final design and layout of the surrounding paving with the landscape architects for The Plaza, Brown Associates of Sheffield. During summer 1998, the site contractors, Brofeys, sited and bedded the stone circle (a third of the height of each stone is below ground) under Turner's supervision, and in autumn Drostle and Turner returned to execute the carving and mosaic work *in situ*. Finally, each stone was treated by Beech Restoration of Nottingham with a water repellent and anti-graffiti sealant, Funcasil SML.[1] By October, the work was complete and in February 1999 *Signs of Life* was handed over to Leicester City Council.

Drostle and Turner describe *Signs of Life* as follows:

> A circle of five standing stones approximately 7m in diameter. Each stone has been inlaid with glass smalti mosaic in designs drawn up with a cross section of local people. The inspiration for the work came from our seemingly primeval need to mark the landscape, to leave behind evidence of ourselves. This need can be seen from the earliest cave paintings to today's 'tagging'. We ran workshops with the various community groups to try and design our own mark. The workshops aimed to produce designs using simple pictographic style to develop personal symbols, reflecting identity and environment. A selection of these [were] then ... transferred onto the stones by Wallscapes.[2]

The total cost of the project was just over £22,000, comprising £5,000 for the commissioning process, £2,115 for site preparation and

£15,000 to the artists to cover their involvement in the programme of community workshops and their design and execution of the sculpture.[3]

Literature
Wallscapes, *Signs of Life. Technical and Maintenance Specifications*, 1999.

Notes
[1] Information from Gary Drostle of Wallscapes.
[2] From Wallscapes, *Signs of Life. Technical and Maintenance Specifications*, 1999. [3] Letter, dated 19 May 1999, from Richard Payne, Leicester City Council, to Patrick Davis, Sustrans (Leicester City Council, Arts and Leisure Dept. archives).

Bishop Street

Former Liberal Club, now Alliance House, No. 6 Bishop Street (a Grade II listed building).

In the entrance hall:

Bust of William Ewart Gladstone

William Ewart Gladstone (1809–98), statesman, renowned political orator and author. The son of a Liverpool merchant, he intended first becoming an Anglican priest, but instead entered politics in 1832 as Tory member for Newark. By 1845 he was Sir Robert Peel's Colonial Secretary and took his premier's side in the Corn Law dispute. A mistrust of aristocratic government, exacerbated by a visit to Naples in 1851 when he witnessed the horrific reprisals exacted by King Ferdinand against the rebels, led ultimately to his transferring to the Liberal party. From 1859–66 he was Palmerston's Chancellor of the Exchequer and was Liberal Prime Minister in 1868–74, 1880–5, 1886 and 1892–4.
Source: *DNB*.

Sculptor: George H. Saul

Bust in marble
Bust: h. 69.5cm (2'3"); w. 65cm (2'2"); d. 32cm (1'1")

Socle: h. 15cm (6")
Pedestal: h. 1.24m (4'1")
Inscriptions (in cursive script) on two brass plaques fixed to pedestal:
– upper plaque: *The Right Hon: W.E. Gladstone, M.P. / – / Presented to / The Leicester & County Liberal Club / by / Edwin Clephan Esq: J.P. / 1898*
– lower plaque: *This Building, / formerly known as / "Gladstone Buildings" / was occupied by / The Leicester and County Liberal Club / From 1888 until 1936.*
Signed and dated on the rear of the bust on a *trompe-l'œil* label with a down-turned top left corner: *G.H. Saul 1881* (in cursive script)
Status: not listed
Owner: Leicester City Council

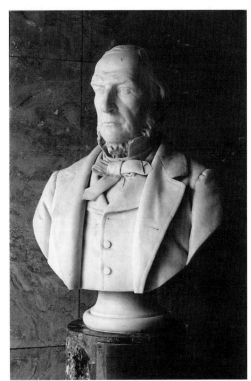

Saul, *W.E. Gladstone*

Description: Portrait bust of Gladstone in his later years, wearing a frock coat, waistcoat, wing-collared shirt and tie. The head is turned slightly to the subject's right, the eyes, which are incised, look straight ahead.

Condition: The points of the wing collar are missing, there are small (?recent) chips out of the forward part of the left shoulder, a loss to the lower end of the right lapel and a rough edge to the lower end of the left lapel. Also there are superficial scratches on the rear of the bust. The surfaces are generally grimy and an unidentified material has been stuffed into the right nostril and between the lips. The lettering on the upper of the two brass plaques on the pedestal is very faint, presumably from polishing.

History: Edwin Clephan, the donor of the present bust, had been vice-president, president and then – voluntarily making way for a younger man – vice-president once more of the Leicester Liberal Club. He had moved to Leicester from Stockton-on-Tees in 1834, working firstly as a silversmith. In 1840, however, Thomas Paget (Liberal MP for Leicestershire, 1831–2, and Mayor of Leicester, 1836–7) had found him a position in his bank. Clephan was later to rise to manager and finally partner. He was also evidently an art lover, serving for a time on the Art Gallery and School of Art committees as well as being president both of the local Society of Artists and of the Kyrle Society.[1]

Literature
Banner, J., 1994, p.47; *The Wyvern*, 3 March 1893, p.295.

Note
[1] *The Wyvern*, 3 March 1893, p.295.

Britannia Street

The Victoria Model Lodging House by Thomas Hind, 1887 (located just off Belgrave Road, nearly opposite St Mark's Church)

On the exterior wall:

Two relief panels showing the four British nationalities

Sculptor: unknown

Relief panels in brick
Each panel: h. 1.04m (3'5"); w. 2.21m (7'3")
Executed: c.1887
Status: not listed
Owner of building: unknown

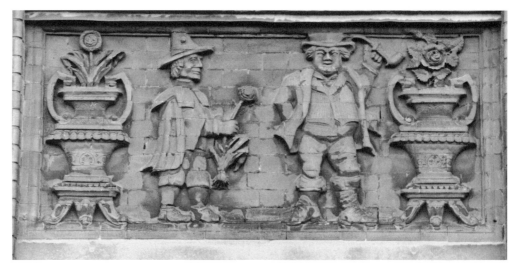

(above) *British nationalities: Welsh and English* (below) *British nationalities: Scots and Irish*

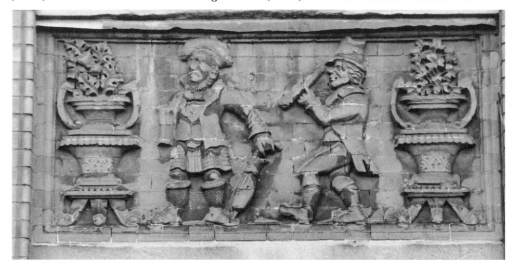

Description: The two panels, on the frontage between the ground and first-floor levels, represent stock caricatures of British nationalities. Each panel shows two men flanked by ornate vases containing their national flowers. The left-hand panel shows, on the left, a man in traditional Welsh costume carrying a leek and, on the right, a corpulent English John Bull figure waving a pipe; the Welsh vase contains a leek and the English vase a rose. The right-hand panel shows, on the left, a kilted Scotsman with a furled umbrella and, on the right, a shillelagh-wielding Irishman. The Scottish vase contains a thistle and the Irish a shamrock.

Condition: Fair. The carved brickwork of both reliefs is, however, weathered and blackened in places and the mortar appears to need repointing.

History: Lodging houses in the nineteenth century were generally older premises, many of them overcrowded and insanitary, converted for the accommodation of the poor.[1] The Victoria Model Lodging House was, however, specifically designed for the purpose and represented an attempt to give a better standard of accommodation. The proprietor, Harry Wilkinson, evidently kept strict order in the house with a framed set of rules hung upon the wall – alcohol was banned altogether and smoking prohibited upstairs. A bed for the night ranged from 4d. to 8d. and, according to a contemporary observer, there were 'enamelled-brick-lined lavatories and laundries' and 'cooking ranges [that] would not shame a Stoneygate mansion'.[2]

The Belgrave Gate area, in which Britannia Street is situated, had the highest density of Irish immigrants in Leicester, the biggest influx following the potato famine of 1845–6. The 1851 census tells us that although the Irish

population was one in 71 of the overall population of Leicester, it was one in four for Abbey Street, off Belgrave Gate.[3] Inevitably these immigrants were poor. Many were without permanent homes and consequently would have formed a large percentage of those having to resort to lodging houses. This presumably explains the presence of the Irishman at least on the relief panel, although the fact that he appears to be approaching the Scotsman from behind brandishing a dangerous-looking shillelagh would appear to be a somewhat tactless reference to the petty crime and violence for which Irish immigrant areas were notorious[4] (the smiling Welshman by contrast appears to be engaged in a much friendlier exchange as he proffers his leek to a bluff John Bull).

Literature
Banner, J.W., 1991, p.117; Elliott, M., 1979, p.121, pls **26, 27, 28**; *The Wyvern*, vol. viii, no. 193, 5 July 1895, p.165.

Notes
[1] Elliott, M., pp.119–21. [2] Armer Teufel, writing in *The Wyvern*, 5 July 1895, p.165. [3] Elliott, M., pp.118–19. [4] *Ibid.*, p.119.

Castle Gardens

In the gardens, close to the St Nicholas Circle gateway:

Statue of King Richard III

Sculptor: James Walter Butler
Bronze founders: Meridian Sculpture Foundry
Contractors for the pedestal: McAlpine & Sons Ltd

Statue in bronze on a roughly-hewn granite base surmounting a plinth in concrete
Statue: h. 1.83m (6')
Base ('rocky promontory'): h. 1.08m (3'7"); w. 1.22m (4'); d. 1.23m (4'1")
Upper plinth: h. 40cm (1'4"); w. 1.36m (4'6"); d.

1.36m (4'6")
Lower plinth: h. 95cm (3'2"); w. 1.95m (6'5"); d. 1.96m (6'5")
Inscriptions, all in raised letters:
(i) on a metal plaque on the front face of the statue base:
RICHARD III / KING OF ENGLAND / 1483 1485
(ii) on a metal plaque on the right face of the statue base:
BORN FOTHERINGAY / 2 OCTOBER 1452
– and between the above two lines, on a raised green block:
A GOOD LAWMAKER FOR THE EASE AND / SOLACE OF THE COMMON PEOPLE
(iii) on a metal plaque on the left face of the statue base:
KILLED BOSWORTH / 22 AUGUST 1485 / BURIED LEICESTER
– and between the second and third of the above three lines, on a raised green block:
PITEOUSLY SLAIN FIGHTING MANFULLY / IN THE THICKEST PRESS OF HIS ENEMIES
(iv) on a metal plaque on the rear face of the statue base:
THIS STATUE BY JAMES BUTLER RA / IS A GIFT TO THE CITY OF LEICESTER / FROM MEMBERS OF THE RICHARD III SOCIETY / AND OTHERS THROUGHOUT THE WORLD / – / PATRON OF THE APPEAL FUND / HIS GRACE THE DUKE OF RUTLAND / – / UNVEILED 31 JULY 1980 BY / HRH PRINCESS ALICE / DUCHESS OF GLOUCESTER / ON BEHALF OF / HRH THE DUKE OF GLOUCESTER
Unveiled: Thursday 31 July 1980, by Princess Alice, Duchess of Gloucester
Status: not listed
Owner / custodian: Leicester City Council

Description: Richard III is shown standing on a granite base suggestive of a rocky promontory in the battlefield. He is bare-headed and dressed in armour, his torn right sleeve indicating the battle he has fought and the spurs he wears on his heels, his lost horse. With his right foot planted firmly on the

highest part of the promontory and his lowered right hand grasping a dagger, he looks up to the crown he holds aloft in his left hand.

Condition: Good. The dagger and crown are, however, replacements. The dagger replaces a sword which had to be replaced so often the Council commissioned the sculptor to make a dagger instead. This so far remains untouched. The crown has not had to be replaced since the statue was relocated to the edge of the park.

History: In 1977, Jeremy Potter, the then Chairman of the Richard III Society, proposed commissioning a statue as the principal memorial in Leicester to King Richard III.[1] As Potter explained: 'We felt that Leicester was the best place as a focal point for the Richard memorial, because he really is Leicester's own king.'[2]

Richard had stayed in Leicester on the eve of his fatal defeat at Bosworth Field on 22 August 1485. His corpse was afterwards carried back to Leicester and publicly displayed for several days before being handed over, as many historians believe, to the Grey Friars for interment in their church in what is now the St Martins district of the city. An unsubstantiated but popular story relates how, following the dissolution of the monasteries, Richard's remains were disinterred and thrown into the River Soar from Bow Bridge (the very bridge he would have passed over on his way to and from Bosworth); one variant of this story being that the remains were secretly fished out of the water and re-interred on the west side of Bow Bridge. Whatever the truth, Leicester, in addition to its role as the burial place of the King, which alone would merit its selection as the site of his statue, also had several specific locations relating to his posthumous story – and the Richard III Society also wanted to mark these sites with memorial plaques.[3]

It was Potter who suggested James Butler as sculptor of the statue, having seen and liked his sculpture, the *Burton Cooper* (1977) at Burton-

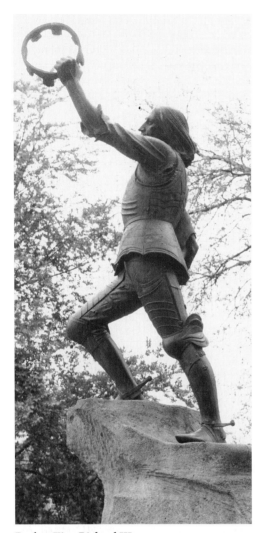

Butler, *King Richard III*

on-Trent.[4] The Society launched a public appeal for donations, forming an Appeals Committee under the patronage of the Duke of Rutland. At the Society's request, Butler produced a sketch model and in January 1978, Potter travelled to Leicester to promote the appeals and show the model. This first model was rather different from that ultimately selected. The *Leicester Mercury* describes it as 'a lean young man ... wielding a death axe',[5] a description which tallies with the photograph used in an undated appeal leaflet produced by the Richard III Society.[6] At this point the Society was aiming to commission an eight-foot high statue at an estimated cost of £25,000.[7]

In February 1978, Butler's model for the statue formed the centre-piece of a three-month-long exhibition of his work held in Leicester's Grand Hotel.[8] Over the next seven or eight months the Society attempted to raise the required sum. It soon became clear, however, that donations were unlikely to reach £25,000 and so the proposed height of the figure was reduced to six feet and a granite base substituted for the original bronze base allowing the appeal target to be lowered to £19,000.[9]

The Society also asked the sculptor to consider various alternative designs for the statue. Among its principal concerns were that the statue should not show the King in an aggressive light nor should it portray him as physically deformed. The popular image of Richard III as a murderous hunch-backed tyrant – fuelled principally by Shakespeare's eponymous play – meant that the Society had to be more than usually careful to eliminate any design which could be open to such a negative reading: one idea, with the King standing four-square over a dead body, presumably intended to suggest valiant deeds on the battlefield, was consequently dropped as being rather too easily evocative of foul deeds in the Tower.[10] A delegation from the Society visited Butler's studio to review his alternative designs and, at its annual general meeting on 29 September 1979, approved the model for the present statue showing the King with a crown in one hand and a sword in the other.[11] The chosen design was, according to the sculptor, intended 'to show [Richard] as if he were in battle, fighting for his life'.[12]

Although Castle Gardens was the site originally agreed for the statue, there was another – at once more central and, to the Society, more prestigious – that had subsequently become available: the piazza outside the Crown Courts then under construction at Wellington Street. This latter site appeared particularly attractive to the Society in that the proximity of the Courts would serve to enhance the image it was trying to restore of Richard as a legal reformer.[13] Unfortunately for the Society, the Council ultimately decided to approve instead a kinetic sculpture, which it had been considering for some time (see pp.325–6).

By 22 July 1980, the lowest stage of the plinth had been erected in Castle Gardens and the bronze figure cast. On 24 July the sculptor arrived in Leicester with the statue to supervise its installation on the plinth.[14] Richard, Duke of Gloucester, had accepted an invitation to unveil the statue on 31 July, but ultimately had a more pressing appointment (representing the Queen at independence celebrations in the former New Hebrides) and was deputised by his mother, Princess Alice.[15]

The statue, sited originally in the centre of Castle Gardens, almost immediately fell prey to vandals. By 13 September 1980, the figure's sword had been broken off.[16] In the following July the sword and arm were bent out of shape. Over the ensuing years so many replacement swords were stolen[17] that in 1990 the Council decided to substitute a (less attractive and, it was hoped, less vulnerable) dagger (also designed by the sculptor). The crown proved no less a target: it too was stolen, as were a number of replacements.[18] By 1991, in an effort to combat the incessant acts of vandalism, the Council was considering a number of alternative, less secluded sites for the statue.[19] At last, in November 1995, the statue was

removed to store and in July 1996 relocated to its present, 'more visible' site close to the gates facing St Nicholas Circle.[20]

Related works: Other Ricardian memorials in Leicestershire: tablet commemorating Richard III and those who fell at Bosworth, Sutton Cheney Church, 1967; memorial tablet to Richard III in Leicester Cathedral, dedicated August 1982; plaque on an exterior wall of the National Westminster Bank, St Martins, Leicester, marking the site of Richard III's supposed burial place in the long-demolished Church of the Grey Friars, inaugurated October 1990.

Literature
Leicester City Council, Arts and Leisure Department. Various correspondence, internal memoranda, etc.
Richard III Society. Letter, dated 27 May 1998, from the Secretary to the author.
General. Banner, J.W., 1991, p.20; Banner, J.W., 1994, pp.33, **32**; Darke, J., 1991, pp.177–8; *L. Mercury*: – [i] 19 January 1978, p.24 [ii] 18 February 1978, p.5 [iii] 6 June 1978, p.19 [iv] 12 October 1979, p.30 [v] 22 July 1980, p.7 [vi] 1 August 1980, pp.1, 25, **1** [vii] 13 September 1980, p.1 [viii] 9 May 1983, p.1 [ix] 24 January 1991, p.5 [x] 22 November 1995, p.13, **13** [xi] 27 November 1995, p.17 [xii] 11 July 1996, p.8, **8**; Pevsner, N. and Williamson, E., 1992, p.219; Stevenson, J., 1995, pp.31, **32**; Tyler-Bennett, D., 1990, pp.44–5.

Notes
[1] Letter, dated 27 May 1998, from Elizabeth Nokes, Richard III Society, to the author. [2] *L. Mercury*, 19 January 1978, p.24. [3] See 'Related Works', below. [4] Letter, dated 27 May 1998, from Elizabeth Nokes, Richard III Society, to the author. [5] *L. Mercury*, 19 January 1978, p.24. [6] *A Statue for Leicester and the Whole English-Speaking World* (Richard III Society), n.d. [7] *Ibid.*; *L. Mercury*, 18 February 1978, p.5. [8] *L. Mercury*, 18 February 1978, p.5. [9] The statue was now going to cost £15,000 plus VAT at 15% (i.e., £17,250) with a further £2,000 estimated for the cost of the base and plinth (see Leicester City Council internal memorandum, dated 29 August 1979, from the City Planning Officer to the Director of Recreation and Cultural Services; Letter, dated 4 October 1979, from James Butler to Jeremy Potter; and also *L. Mercury*, 12 October 1979, p.30). On the subject of the substitute base, the sculptor advised: '... we should require either a block [of granite] that roughly corresponds to the size of the original bronze base or a slab that can be tilted to the appropriate angle. The bronze base had a forward thrusting movement and I should like to reserve this in the granite block.' (Letter from James Butler to Leicester City Council's Director of Recreation and Arts, dated 18 October 1980.) [10] Letter, dated 3 September 1979, from Jeremy Potter to Leicester City Council's Director of Recreation and Cultural Services; letter, dated 27 May 1998, from Elizabeth Nokes, Richard III Society, to the author. [11] Letter, dated 15 October 1979, from Jeremy Potter to James Butler. [12] *L. Mercury*, 22 July 1980, p.7. [13] Leicester City Council internal memorandum, dated 17 August 1979, from the City Planning Officer to the Director of Recreation and Cultural Services; letter to the same from Jeremy Potter, dated 3 September 1979. [14] *L. Mercury*, 22 July 1980, p.7. [15] *Ibid.*, 1 August 1980, p.1. [16] *Ibid.*, 13 September 1980, p.1. [17] See *Ibid.*, 9 May 1983, p.1. [18] Letter from James Butler, dated 30 December 1988, to Leicester City Council's Assistant Director, Arts and Community, detailing proposed repairs to the sword and crown. [19] *L. Mercury*, 24 January 1991, p.5. [20] *Ibid.*: – [i] 22 November 1995, p.13 [ii] 27 November 1995, p.17 [iii] 11 July 1996, p.8.

Charles Street

No. 193 Charles Street

Mounted high on the south end of the exterior wall:

Seahorse

Sculptor: Percy Brown

Sculpture in limestone
h. 1.5m (4'11"); w. 45cm (1'6")
Executed: *c.*1930s
Status: not listed
Owner of building: Terry Ryan

Description: The sculpture, carved into a block of limestone, represents a seahorse surrounded with decorative flower and wave shapes.

Condition: Good.

History: The *Seahorse* was executed for the offices of the Leicester and County Saturday Hospital Society.

Related work: Eric Gill, *Two Seahorses*, stone, executed 1933, Midland Hotel, Morecambe, Morecambe Bay, Lancashire (high up on the façade).[1]

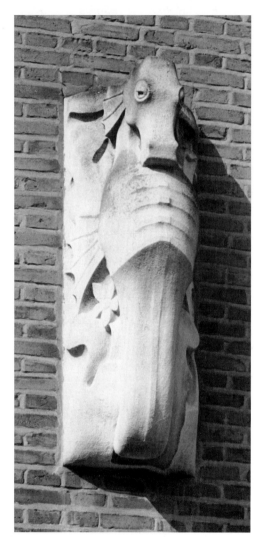

Brown, *Seahorse*

Literature
Charles, B., n.d., plate (n. pag.).

Note
[1] See Collins, J., 1998, p.183 (no. 222; illus.).

*Halford House, No. 90 Charles Street.
Built for the Leicester Temperance
Building Society by Pick Everard Keay and
Gimson, 1955–9*

Above the main entrance, on the central tower,
is:

The Four Winds Clock
Sculptor: Albert Pountney

h. 3.62m (11'11"); w. 3.24m (10'8")
Carved clock frame in Portland stone
Executed: *c.*1955–9[1]
Status: not listed
Owner of building: Alliance and Leicester Plc

 Description: The clock is situated on the
central tower high over the main entrance to the
building. The carved clock frame is slightly
higher than it is wide and has a gabled upper
edge. The winds are represented by four heads,
one at each corner of the frame, their arms
reaching out to each other.
 Condition: Good.

Literature
Leicester City Council, 1997, p.156, **156**; *L. Mercury*,
19 September 1992, p.15, **15**.

Note
[1] Leicester City Council, 1997, p.156.

Cheapside

Leicester Market Column
Designer: Peter Parkinson

Column in steel, painted black
h. 4.57m (15')
Inaugurated: Monday 2 June 1997, in the

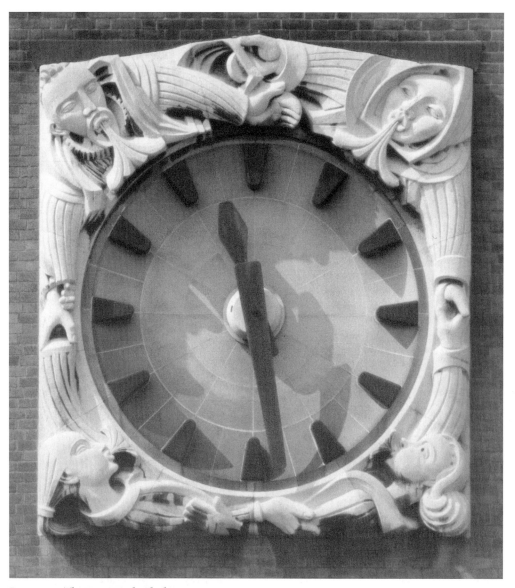

Pountney, *The Four Winds Clock*

presence of Councillor Ray Flint, Lord Mayor of Leicester
Status: not listed
Owner / custodian: Leicester City Council

Description: A free-standing column in black-painted steel, its height decorated with cut-out symbols of market produce and the word 'Market', spelt out vertically in giant letters.
Condition: Good, although there are scuff marks to the paint surface in the lower parts of the column as well as stickers and traces of removed stickers.
History: The *Leicester Market Column* and *Leicester Market Archway* were commissioned jointly by Leicester City Council and the Market Traders Association, the final selection, from a short list of six, having taken into account preferences expressed by market traders and public. The *Leicester Market Column* cost £15,000.[1]
Related work: John Clinch, *Leicester Market Archway*, Market Approach (see pp.145–6).

Literature
L. Mercury, 5 June 1997, p.4.

Note
[1] Information from Karen Durham, Public Arts Officer, Arts and Leisure Department, Leicester City Council; see also *L. Mercury*, 5 June 1997, p.4.

Conversation Piece, by Kevin Atherton

A group of three bronze heads on Plexiglas pedestals, formerly displayed in Cheapside, but now in store. This was actually one of three sets of three heads each, sited at Cheapside, Market Street and Gallowtree Gate. In 1992 one set was relocated to St Margaret's Bus Station (see pp.110–11).

Clarendon Park Road

In the 'Garden of Remembrance', opposite the east end of the Church of St John the Baptist with St Michael and All Angels:

Untitled
Sculptor: George Pickard

Sculpture in glass on a rough stone base
Sculpture: h. 74cm (2'5"); w. 66cm (2'2"); d. 16.5cm (7")
Base: h. 70cm (2'4"); w. 67cm (2'2"); d. 83cm (2'9")

Pickard, *Untitled*

Executed: 1994
Installed: Wednesday 2 November 1994
Status: not listed
Owner / custodian: Church of St John the Baptist with St Michael and All Angels

Condition: Good.
History: The present sculpture was commissioned by Mrs C. Lancaster in memory of her late husband.[1]

Note
[1] Letter dated 8 June 1998 from Marjorie Pickard to the author.

College Street
The Rowans

The building, erected to the design of John Grey Weightman of Sheffield in 1835–6[1] originally housed the Leicester and Leicestershire Collegiate School (for boys). The school closed in 1866 at which point the building was purchased by a property speculator for £4,525. He fairly quickly resold part of the property to a Mrs Islip for her Collegiate Girls' School and, some time after, sold the hall to the trustees of a Congregationalist church.[2] The Collegiate Independent Church, as the hall became known, did not prosper however and in 1872 the trustees sold the hall for £5,000 to another group of Congregationalists who had split from their church at Oxford Street and who had in the interim been worshipping on a temporary basis at the Corn Exchange. This second group opened as the Wycliffe Congregational Church on 15 May 1872.[3] In 1922, following the closure of the Collegiate Girls' School, the Leicester Education Committee purchased that part of the building and in 1954 purchased the hall,[4] though the church continued to function until 1957. For a number of years thereafter the building served as home to the Leicester College of Music, before being converted to its

current use as offices of Leicester City Council's Arts and Leisure Department.

Notes
[1] Leicester City Council, 1975, p.31; Pevsner, N. and Williamson, E., 1992, p.260. [2] Freebody, N.K., 1967, pp.16, 19. [3] *M. Free Press*, 18 May 1873, p.5. [4] McKinley, R.A., 1958, pp.334, 394.

In niches flanking a five-light Perpendicular Gothic style window:

Statues of John Wycliffe and Hugh Latimer

Wycliffe (*c*.1330–84) was a philosopher, religious reformer and theologian. He was Master of Balliol College, Oxford, *c*.1360–1; Warden of Canterbury Hall, Oxford, 1365–7; and Rector of Fillingham, 1361–8, Ludgershall, 1368–84, and Lutterworth, 1374–84. He condemned what he saw as the corruption of the established church, denied the authority of the pope and the validity of monasticism, and attacked the doctrine of transubstantiation, being saved from ecclesiastical censure only through the protection of his patrons, John of Gaunt and Edward, the Black Prince. Believing that the Bible was the only source of religious truth and that all people should have access to it in their own language, Wycliffe instituted and supervised its first translation into English. His followers were known as Lollards.

Latimer (*c*.1485 – 1555) was a religious reformer, born at Thurcaston, Leicestershire. Licensed to preach in 1522 by the University of Cambridge, his extreme Protestant teaching led to his censure by Convocation in 1532. Following Henry VIII's break with Rome in 1534, however, Latimer became one of his chief advisors and, in 1535, was appointed Bishop of Worcester. In 1539 he resigned his see in opposition to Henry's Act of Six Articles, but came back into favour in the reign of Edward VI. Finally, on the accession of the Catholic Mary Tudor, Latimer was confined to the Tower and in 1555 burnt at the stake.
Sources: *DNB*; Livingstone, E.A, (ed.), 1977.

Stonemason-sculptor: John Firn

Statues in limestone
Wycliffe: h. 2.13m (7'); base: h. 8.5cm (3")
Latimer: h. 2.04m (6'8"); base: h. 8.5cm (3")
Inscriptions carved into the fronts of the statue bases:
– left base: WYCLIFFE.
– right base: LATIMER.
Unveiled: Monday 7 October 1872, by J. Stafford, Mayor of Leicester
Status of building: Grade II
Owner of building: Leicester City Council

Description of statues: Standing figures in Gothic-style niches dressed in period costume. *Wycliffe* holds a staff in his right hand, his left hand extended slightly to explain a point; *Latimer*, a rather more animated figure, holds a book in his left hand, its pages angled downwards towards the viewer. He points with the index finger of his right hand to the all-important words on the pages.

Condition: *Wycliffe* has green biological growth on both hands and cuffs and the surfaces of both feet are spalling and crumbling. There is a diagonal crack on the base beneath the right foot and a crack in the drapery above the inner side of the left foot. All surfaces of the *Latimer* figure appear weathered and there is green biological growth on the cuff of the right sleeve and down the side of the book on the viewer's right. The back of the crown of the hat appears to be missing. Both forearms of *Wycliffe* and the forward half of the book held by *Latimer*, plus his right forearm, are modern replacements in Bath limestone.[1]

History: Shortly after their purchase of the present building, the Revd Joseph Wood and his congregation elected to name their church after John Wycliffe. Wood explained the reasons for their choice:

It was concluded that they should take as their name the English morning star of the Reformation – he who first gave English people an English bible – he who laboured so ardently for truth and freedom – he who worked so zealously in one of their villages [i.e., Lutterworth].[2]

It was this designation that inspired John Burton (1808–81) to suggest that a statue of Wycliffe should be commissioned as one of a pair to fill the niches flanking the great window. Burton had by this time earned a reputation as a man committed to the improvement of the town of Leicester through his campaigns for public sculpture, having initiated or been involved in every one of the handful of schemes carried out up to that date. He had already seen through to completion the *Haymarket Memorial Clock Tower* (see pp.112–18) and *Robert Hall Statue* (see pp.89–91) and was currently involved in promoting the cause of the *John Biggs Statue* (see pp.177–81) and the radical repairs and 'improvements' to the *Duke of Rutland Statue* (see pp.144–5). According to Burton's own testimony, the sight of the empty niches on the present building had bothered him as long ago as its construction as a school – he had felt that to leave the building thus was to leave it incomplete. It was only when the building became a church, however, that he saw his opportunity and only when the present congregation gave it its new name that he realised the form in which that opportunity might be realised.[3] For the companion niche, Burton suggested a statue of Hugh Latimer. Latimer was doubly appropriate for, in addition to his fame as a sixteenth-century reformer, he had been a Leicestershire man, born at Thurcaston. Notwithstanding the Congregationalists' own claim that they represented the Puritan element of Dissent[4] and might therefore have been expected to reject images, they agreed to his suggestion with

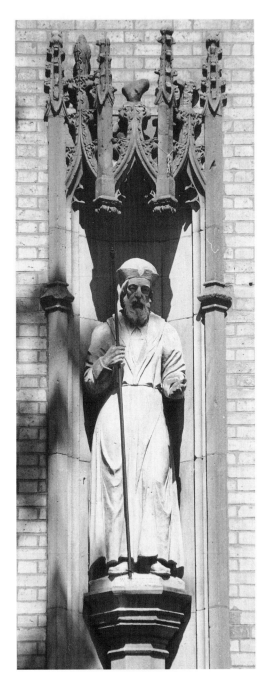

Firn, *John Wycliffe*

enthusiasm. The statues would not, after all, be mere adornments: they would be first and foremost didactic. As the Revd Mackennal, guest speaker from the Gallowtree Gate Congregational Chapel, explained to the congregation in the church after the unveiling ceremony:

> It was a good thing for the parents of the congregation that these statues were erected, for the thoughtful child would wonder what they were, and would ask the parents, who would then have an opportunity of imparting to them a lesson on the principles of the Reformation.[5]

To both Wood and Mackennal the presence of the statues on Wood's church was a potent symbol of the Congregationalists' sense of their own continuity with the aims of Wycliffe and Latimer. Wood was careful to emphasise, however, that this did not mean that the Congregationalists had exactly the same 'doctrinal principles and ecclesiastical opinions as these men'. It was their 'passion for the truth', their devotion to the cause of freedom and their determination 'to acknowledge no other authority in religion than Christ and conscience' that the Congregationalists espoused. Wood insisted moreover that had Wycliffe and Latimer been living in the present time they would have held similar opinions to those of the congregation before him. Lest there be anyone still unconvinced, Mackennal – presumably with an eye as much to the press reporters amongst the congregation as to the congregation itself – gave the clearest possible statement of the Congregationalists' position:

> It was to assert that they were sons of the Reformation as much as the members of the

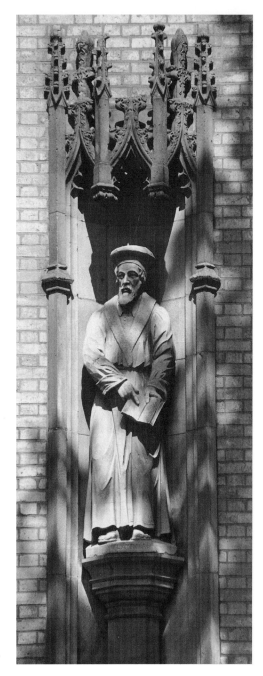

Firn, *Hugh Latimer*

Established Church of this country that the statues had been erected. They claimed that they, as Dissenters, and especially as Independents,[6] had not been cut off from the religious history of this country. The reformation of this country, at its conception, divided itself into two parts. There were those who were root and branch reformers, and those who stuck up for the old system of compromise. They, however, confessed themselves to be representatives of the old root and branch reformers of the age ... They [the congregation] claimed that in the revolt against tradition, of which Wickliffe [*sic*] and Latimer ... were the great representatives, they were their successors ... They owned no authority but the authority of Christ and God, and they held that there was no interpreter of that authority except human reason and conscience. That was the position Wickliffe assumed, and that was the position they assumed that day. In the application of this ... they had been led to cast away many things Wickliffe and Latimer did not feel themselves called upon to cast away, but they held that this was their absolute principle. When they started the Reformation, their forefathers only endeavoured to carry out what their own time permitted being carried out. They set men thinking, and their consciences and reasons at work in relation to Christian truth and Christian organisation ...[7]

If Wood and Mackennal's speeches appear rather embattled, there was good reason. Wood's new church represented an attempt to create a modified, more liberal form of Congregationalism.[8] A series of articles on Congregationalism, one of which had singled out a recent paper by Wood for harsh and, according to both men, inaccurate criticism, had recently been published in the *Christian Penny Magazine*.[9] Consequently, both men made

direct reference to the magazine, using the presence of the press at the unveiling ceremony to rebut publicly what they considered to be a total misrepresentation of the Wycliffe Church's experiment. The statues of Wycliffe and Latimer, therefore gave Wood's Congregationalists an opportunity to assert publicly their direct line of descent from the English Reformation.

The ministers' emphasis on the didactic function of the statues did not preclude their appreciation of them as works of art, however. Yet even here both ministers' remarks appear defensive, as if criticism had been levelled at the quality of the work. Wood explained that:

> ... the statues were the work of a local artist. Some people might feel inclined to correct him, and say they were the work of an artisan. Truly, they were so, but they revealed true artistic faculty. In execution they were the work of one of the most intelligent workmen with whom he had had the pleasure to be acquainted, and he was sure the meeting would join with him in saying that he had imparted to these figures an amount of beauty and feeling which was lacking very often in much more pretentious works.[10]

Mackennal commended 'the artistic feeling and beauty of execution' of the statues, but then added the telling reassurance that 'the expression of the features would grow upon them the more accustomed they were to look upon them', strongly suggesting a degree of disappointment from some of the congregation. He also opined that they would be improved by the passage of time 'when they [the statues] became toned down to the tone of the niches in which they had been placed' (presumably the freshly carved limestone had presented too stark a contrast with the building stone for some).[11] At any rate, Wood in particular must have been much relieved by the press coverage

which gave what appear to be full accounts of the speeches and generous tributes to John Firn, the mason-sculptor. Firn – whether or not he was a Congregationalist is not known – was evidently also much gratified by the reception accorded to his work for he donated the models of the statues, to be sold at £10 each at the bazaar organised to help fund the building's purchase.[12]

By the early 1990s both statues were in poor condition, *Wycliffe* having lost both its forearms and *Latimer* its forearms and book. They were restored by Herberts (Masonry Contractors) Ltd, Market Harborough, in the mid-1990s.[13]

Literature
Freebody, N.K., 1967, pp.21–2; *Herberts stone masons* (publicity brochure); *L. Advertiser*, 19 April 1873, p.7; *L. Chronicle*, 12 October 1872, p.6; Leicester City Council, 1975, p.31, **31**; Leicester City Council, 1997, pp.90, **87**; *L. Daily Post*, 8 October 1872, p.3; *L. Journal*: – [i] 17 May 1872, p.6 [ii] 11 October 1872, p.8; McKinley, R.A., 1958, pp.334, 394; *M. Free Press*, 18 May 1872, p.5; *Modern Memorials*, 1875, p.42; Pevsner, N. and Williamson, E., 1992, p.260.

Notes
[1] Information from Alfred Herbert.
[2] *L. Chronicle*, 12 October 1872, p.6. [3] *Ibid.*, 12 October 1872, p.6. [4] As reported in *ibid*. [5] *Ibid.*; *L. Daily Post*, 8 October 1872, p.3. [6] Another term for Congregationalists. [7] *L. Chronicle*, 12 October 1872, p.6. [8] Mackennal had referred to this new 'modified congregational order' in his letter to Wood on the occasion of the official opening of the Wycliffe Church on 15 May 1872, which he had been unable to attend. He had wished Wood and his congregation well with their 'experiment', while at the same time assuring them that they would 'be welcomed back to the older paths' should they fail (*M. Free Press*, 18 May 1873, p.5). [9] See the *L. Chronicle*, 12 October 1872, p.6, and the *L. Daily Post*, 8 October 1872, p.3. [10] *L. Chronicle*, 12 October 1872, p.6; *L. Daily Post*, 8 October 1872, p.3. [11] *L. Chronicle*, 12 October 1872, p.6. [12] *L. Chronicle*, 12 October 1872, p.6; *L. Daily Post*, 8 October 1872, p.3. [13] *Herberts stone masons* (publicity brochure).

De Montfort Square

Statue of the Revd Robert Hall

The Revd Robert Hall (1764–1831), Baptist divine, was born at Arnesby, Leicestershire, the son of a Baptist minister. A precocious child, he is said to have taught himself the alphabet from inscriptions on gravestones, to have composed hymns before his ninth birthday, and to have been allowed to preach at a Baptist meeting at the age of eleven. In 1778, he received adult baptism. He was educated at the Baptist Academy, Bristol, and King's College, Aberdeen (MA 1784). He soon became an influential preacher, drawing vast crowds, firstly as assistant at Broadmead Chapel, Bristol, 1785–90, then as minister at Cambridge, 1791–1806. His mental health had always been delicate, and in 1804–5 and 1805–6 he suffered breakdowns. Initially he had been recommended tobacco as a sedative, but later he turned to increasingly large doses of laudanum and opium. By 1807, however, he seems to have recovered and in that year was appointed minister at Harvey Lane Baptist Chapel, Leicester, a post which he held until 1825. In 1826, he returned to Broadmead Chapel, Bristol, this time as minister. In 1830, he contracted heart disease, preached his last sermon in January 1831 and died in the following month, on 21 February. Hall was renowned for his eloquence as a preacher, delivering an impromptu sermon, much celebrated at the time, on the death of Princess Charlotte in 1817. His sermon, 'Modern Infidelity considered with respect to its Influence on Society', caused a sensation when it was published in 1800. Of his other publications, the most important are the collected 'Works' in six volumes, published in 1832, and 'Fifty Sermons', published posthumously in 1843.
Source: *DNB*.

Sculptor: John Birnie Philip[1]
Contractors for the pedestal:
J. Freeman and Sons

Statue in Sicilian marble on a pedestal in Cornish granite
h. of statue: 2.74m (9')
h. of circular pedestal: 2.58m (8'6")
h. of octagonal base: 56cm (1'10")
Inscribed in gilt letters on the cylindrical pedestal:
– front: ROBERT HALL
– rear: BORN 1764. – DIED 1831.
Signed and dated on the left rear diagonal face of the octagonal marble base of the statue: J.B. PHILIP / LONDON. 1871
Unveiled: Thursday 2 November 1871, by the sculptor, John Birnie Philip
Status: Grade II
Owner / custodian: Leicester City Council

Description: Hall is portrayed bareheaded, standing with his weight on his left leg, his right leg bent slightly at the knee, his right heel raised. He rests his left hand on the upper edge of a book standing on a pedestal by his side, his forefinger inserted between the pages. On the cover of the book is inscribed: THE WORD. Hall's right hand is upraised as if in the act of speaking. Over his left shoulder is slung a full-length, fur-collared cloak. He also wears a morning coat, waistcoat, knee breeches and silk hose.

The base of the cylindrical pedestal is encircled by low stone posts linked by a spiked chain, part of the original scheme approved by Leicester Corporation Estate Committee on 15 November 1871.[2]

Condition: The statue, much worn and eroded, is in poor condition. It has green biological growth on all exposed surfaces, with black encrustation on undersides and in

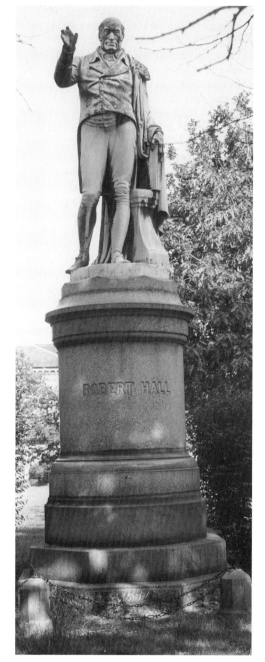

Birnie Philip, *Robert Hall*

hollows. The marble surface is pitted, especially on the rear (north-west facing) side. All digits of the raised right hand are lost.

History: The idea that Robert Hall should be commemorated by a public statue had for some time exercised the imagination of his successor at Harvey Lane Baptist Chapel, the Revd James Philippo Mursell (1799–1885). It was not until 1868, however, that moves were made to turn the dream into reality. One day during the latter part of this year, Mursell and his son, the Revd Arthur Mursell, were walking along New Walk with their friend, John Burton, a keen promoter of memorials in Leicester,[3] when the latter is said to have exclaimed: 'Well, the Memorial Tower being accomplished, what think ye of the idea of placing in the centre of that oval a fine, colossal, marble statue of the great ROBERT HALL!'[4]

The men agreed to send out circulars inviting a select group to a meeting at the town library in February 1869 to discuss the matter.[5] Some of those at the meeting seem to have initially resisted the idea of erecting a statue, evidently on the grounds of expense, but Mursell eventually won over the majority both with his enthusiasm and, more importantly, his unshakeable conviction that the requisite funds could easily be raised for a monument to such 'a great and good man'.[6] A committee of about 30 men was appointed to supervise the project, including the then Mayor, John Baines, as Chairman, Mursell as Honorary Secretary and Burton as Secretary. Promotion of the scheme included public lectures on Hall by Mursell and his son, although subscriptions were chiefly raised through the secretaries' correspondence with about 600 people, supposedly representing 'all shades of opinion, both religious and political, throughout Her Majesty's British realm'.[7] At some time during the early part of the campaign, the Committee secured the services of John Birnie Philip,[8] by then one of the most successful sculptors in the country.[9]

On 13 December 1870, with the statue well under way and about £1,000 collected,[10] the Committee met and agreed to petition the Corporation for a specific site for the statue on the south side of De Montfort Square, just off New Walk. After some discussion, and with the approval of the full Council, the Corporation Estate Committee agreed on 18 July 1871 to the memorial committee's request to erect the statue some 35 feet back from the railing (which at that time bounded the square).[11]

In the estimation of those few surviving men who had known Hall (who had died nearly forty years earlier) Philip's portrayal of the man was excellent. One such person, the Revd Thomas Stevenson, when asked by a local reporter whether he considered it a good likeness had answered: 'Sir ... I should have known the statue to be that of Robert Hall, had I seen it in any part of the world.'[12]

Not only did those who spoke at the unveiling ceremony and subsequent banquet deem it an accurate portrait, they also praised it as a 'beautiful and commanding statue' (Mursell)[13] and a 'beautiful ... work of art' (John Baines).[14] Philip's sole guides to Hall's appearance had been what Mursell referred to as 'existing but most imperfect resemblances',[15] along with corrections and modifications suggested by Mursell and Burton on their regular visits to the sculptor's studio throughout the course of the work, for which guidance Philip thanked them in his speech at the banquet.[16]

Another of those invited to speak at the banquet, the Revd Dr Haycroft, admitted that he had initally considered a statue an unsuitable commemoration for a 'religious teacher', but had later come to appreciate the beneficent influence that such a thing might exert and continue to exert on the spiritual improvement of the populace:

... a statue of the kind they had was, on the whole, the most appropriate monument. Any other public monument would cease to awaken attention when a generation or two had passed away, whereas a statue of such artistic merit would remain for generations, and by the attention which it would excite would direct the minds of the beholders to the works of the man whom it was intended to honour. Leicester was indeed to be congratulated on having such a statue of the most illustrious man she ever had the honour of calling one of her citizens ...[17]

The total cost of the *Statue of Robert Hall* was £1,077.[18]

Literature

LRO. *Council Minutes*: – [i] 29 June 1869 – 20 February 1872, pp.289–90, 400–1 [ii] 31 March 1874 – 4 January 1876, pp.493–4; *Estate Committee Minutes*: – [i] 30 November 1870 – 28 June 1875, n. pag. [ii] 19 July 1875 – 20 October 1881, n. pag.
General. Banner, J.W., 1991, pp.63–4; Banner, J.W., 1994, p.77; Bennett, J.D., 1968, pp.38–9; Darke, J., 1991, p.177; *L. Advertiser*, 4 November 1871, p.8; *L. Chronicle*: – [i] 13 June 1868, p.3 [ii] 28 October 1871, p.5 [iii] 4 November 1871, p.8 [iv] 23 January 1875, p.7; *L. Guardian*, 8 November 1871, p.6; *L. Journal*, 3 November 1871, p.8; *L. Mercury*: – [i] 2 November 1921, p.9 [ii] 9 November 1921, p.9 [iii] 17 June 1988, p.14; *Modern Memorials. Leicester...*, 1875, pp.26–32; Pevsner, N. and Williamson, E., 1992, p.236; *Spencers'...Guide to Leicester*, 1878, pp.189–90; *Spencers' New Guide...*, 1888, pp.56–7.

Notes

[1] Unpublished documents in the possession of Professor Susan Tebby evidently demonstrate that Philip did not himself execute this work – even though he signed it. It has not been possible to glean any further information relating to this matter.
[2] *Estate Committee Minutes*, 30 November 1870 – 28 June 1875. [3] Burton took a leading part in the Haymarket improvement scheme (see p.114ff.), the erection of the statues of Wycliffe and Latimer on the Wycliffe Congregational Church, College Street (see p.86ff.), and the erection of the *Statue of John Biggs* (see p.178ff.). [4] *Modern Memorials. Leicester...*, 1875, p.26. [5] *Ibid.* [6] *L. Chronicle*, 4 November 1871, p.8. [7] According to the Revd J.P. Mursell, quoted in *L. Chronicle*, 4 November 1871, p.8.

[8] *Modern Memorials. Leicester...*, 1875, p.26. [9] He was, from 1864 to 1872, one of the principal sculptors working on Sir George Gilbert Scott's national memorial to Prince Albert at Hyde Park, London. [10] *Modern Memorials. Leicester...*, 1875, p.27. [11] *Council Minutes*, 29 June 1869 – 20 February 1872, p.400, and *Estate Committee Minutes*, 30 November 1870 – 28 June 1875, n. pag. [12] *L. Chronicle*, 4 November 1871, p.8. [13] *Ibid.* [14] *Ibid.* [15] *Ibid.* [16] *L. Guardian*, 8 November 1871, p.6. [17] *Ibid* [18] *Modern Memorials. Leicester...*, 1875, p.32.

De Montfort University

The origins of De Montfort University lay in Leicester's Municipal Technical and Art Schools, completed in 1897. The Schools expanded over the next half century until they were redesignated the City of Leicester Polytechnic in 1969. The Polytechnic ultimately became De Montfort University in 1992 as a result of the Further and Higher Education Act.

The Gateway

The Portland Building, 1888,[1] flanking the doorway:

Crouching female figures

Sculptor: unknown

Figure carvings in stone
Each figure (est.): h. 76cm (2'6"); w. 42cm (1'5"); d. 42cm (1'5")
Executed: *c.*1888
Status of building: not listed
Owner of building: De Montfort University

Description: The doorway is framed by a broken bed pediment supported on Ionic columns. Crouched into the spaces between the architrave returns over the column capitals and the broken bed of the pediment – and either side of a window – are draped female figures

The Portland Building: doorway sculptures

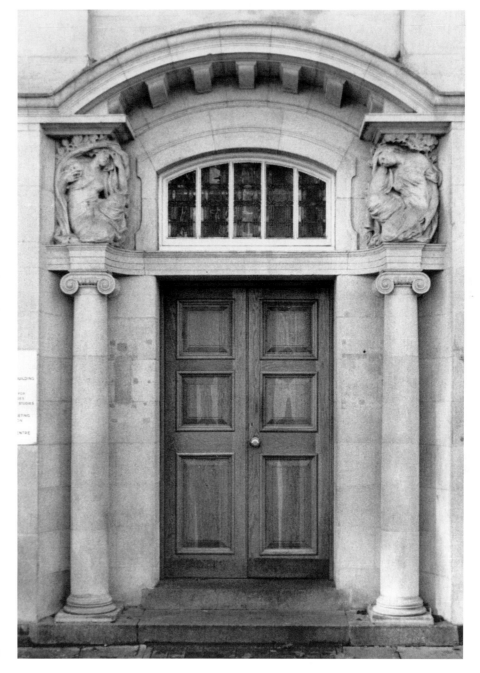

with foliage backgrounds. The figure on the left crouches with her right knee raised, her right hand at her shoulder and her left hand to her forehead. She is framed by a swathe of drapery running up her right side and over her head. The figure on the right rests her head on her right hand, her right elbow supported on her raised right knee. Her left hand is lowered to her left hip. Above her drooping head is a leafing branch.

Condition: Both reliefs are somewhat weathered but there is no evidence of any losses.

Literature
Leicester City Council, 1997, p.200.

Note
[1] Date according to Leicester City Council, 1997, p.200. The identity of the architect remains unknown.

The Newarke

The Hawthorn Building, built by Everard and Pick, 1896–7. The building was expanded in several stages, the north wing being completed in 1937.

1. Entrance doors opening on to The Newarke:
Four relief panels
Sculptor: Percy Brown

Relief panels in metal, painted bronze
Each relief: h. 88cm (2'11"); w. 43cm (1'5")
Signed and dated, in script, top right on the left relief, top left on the right relief:
Percy Brown / 37
Executed: 1937
Status of building: not listed
Owner: De Montfort University

Description: The panels, mounted on the doors of the main entrance to the Hawthorn Building, have low-relief representations of art and design tools and equipment.
Condition: Good.

Brown, *Hawthorn Building: main doors, relief panels (detail)*

Literature
Charles, B., n.d., n. pag.; Leicester City Council, 1997, p.**198**.

2. Either side of the ground floor window, fourth to the right of The Newarke entrance:
Figurative relief panels
Sculptor: Percy Brown

Relief panels in white limestone
h. 91.5cm (3'); w. 84cm (2'9"); d. 30.5cm (1')
Executed: c.1937
Status of building: not listed
Owner of building: De Montfort University

Description: The two sculptures are carved in high relief on thick blocks of white limestone inserted beneath the bases of the first-floor pilasters, either side of the lintel of the westernmost ground-floor window on The Newarke elevation. The left-hand relief has a half-length figure of a nude female rising from stylised waves, a fish by her left elbow, a star to the left of her head. That on the right has a half-length male figure rising from stylised flowing leaf shapes, his head in profile facing left, his right hand holding a bow. He looks towards a bird at the top left of the relief. The carving of both reliefs carries round on to the sides of the blocks.

It has been suggested that the two reliefs, clearly intended as pendants, may represent Venus and Adonis.[1] Certainly the female nude rising from the waves could be Venus, whom

Brown, *Hawthorn Building: carved relief (?Venus)*

Hesiod says was born of the sea; whilst the male figure with the bow could indeed be Adonis, the beautiful young hunter with whom Venus had fallen hopelessly in love.

Condition: Good, though the block on the left has a generally duller surface and has drip stains on the lower projecting parts of the carving.

History: Although the reliefs are not signed and there appears to be no documentary evidence for an attribution to Percy Brown – the sculptor of the signed bronze doors of the present building (see previous entry) – the style of carving in these limestone reliefs is similar to that on his *Seahorse* in the same stone on the exterior wall of No. 193 Charles Street (see p.83). This is particularly apparent in the stylised flowers and the fluid curves of the vegetal and wave patterns of the Hawthorn

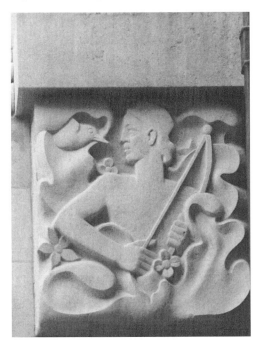

Brown, *Hawthorn Building: carved relief (?Adonis)*

Building reliefs and the similar flower and wave shapes of the *Seahorse* relief.

There is, in fact, a general consensus amongst local experts that these two reliefs are by Percy Brown.[2] In addition, Professor Susan Tebby has closely studied the limestone coat of arms (dated 1937) over the Hawthorn Building entrance, which she also considers to be by Brown. She writes:

The three carvings are all mounted at a similar height, but the balance is odd, and the western (male) capital almost disappears into the end projection of the West Wing in an extraordinary manner. Perhaps more were intended for the north elevation at the eastern end ... The three carvings are all carried out in the same white limestone. No other sculpture staff were known to have been employed by the College at that time.[3]

Literature
Leicester City Council, 1997, pp.198, 200.

Notes
[1] As proposed by Susan Tebby. [2] Ken Ford, Jane Pountney and Susan Tebby all assume Brown to be the sculptor of the Hawthorn reliefs. [3] From a typed account of the sculpture by Susan Tebby, dated June 1999.

Newarke Close

To the left of the entrance to the Fletcher Building:
Untitled

Sculptor: John Hoskin

Sculpture in mild steel, finished in red oxide paint
h. 4.62m (15'2"); w. 1.52m (5'); d. 3.24m (10'8")
Installed: 1984
Status: not listed
Owner / custodian: The sculpture is on semi-permanent loan to De Montfort University from the sculptor's widow

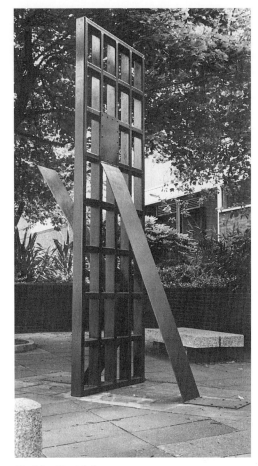

Hoskin, *Untitled*

Condition: Good, the sculpture having been repainted and the two Norwegian Maples that formerly overhung its top with their branches, cut back in June 1999.

History: Hoskin's *Untitled* relates to a series of small sculptures he made in 1983 and 1984 while he was Leicester Polytechnic's first Professor of Fine Art. The maquette for *Untitled* was first made in wood in 1983, although its rectangular grid was cast in bronze

later the same year in the School of Sculpture and exhibited with different attachments in several versions.

Untitled originally stood near Leicester Polytechnic's Eric Wood building and was specifically designed to relate to its context. Professor Susan Tebby, De Montfort University, explains:

> Hoskin had carefully located the sculpture at an angle between the two red-brick buildings to which it related, such that the sculpture acted as a visual link between the two and gave meaning to the space. At the very least this provided a focus to the otherwise empty space, but from Mill Lane, the primary viewing route, the sculpture appeared to change the perspectives sensed between the two buildings as one travelled past, acting as a pivot between [them] and "bending" the space. The sculpture's main proportions and form emphasized the vertical brick piers that characterized the two buildings, while the diagonal stee tes were imitative of the vertical strip wii rs of the Kimberlin Exhibition Hall, directly behind.[1]

In 1992, construction of the Polytechnic's new Engineering School building necessitated the sculpture's removal and relocation to the present Newarke Close site outside the Fletcher Building (which houses the Faculty of Art and Design). The new site and alignment were selected with advice from Tebby, according to whom several options were considered, the present location being chosen as the most suitable. Here, *Untitled* is sited between three buildings: one, the Fletcher Building, in blue brick, and the other two – the Hawthorn and Portland Buildings – as before, in red brick. The sculpture has been 'precisely aligned' between the 'corner of the entrance of the Fletcher Building' and the corner of the Portland Building (and is thus set diagonally to the road).

Tebby also perceived a visual relation between the Hawthorn Building and the sculpture in as much as the former 'has windows almost identically proportioned to the rectangular grid of the sculpture'. Then there were the 1970s-style concrete benches already in the space which seemed 'both visually and physically [to] suit the sculpture' and lastly, there were the surrounding trees and shrubs with their variegated greens and the Fletcher Building with its blue brick, both of which would, it was felt, provide an attractive contrast to the red-oxide of the sculpture.[2]

The main, grid-like element of the sculpture gives it its popular name, 'The Waffle'.

Related work: *Bronze Grid with Red (Maquette)*, 1984–5, 46 × 12.7 × 10.2cm (1'6" × 5" × 4"), The Centre for the Study of Sculpture, Leeds.

Related work exhibited: Maquette (horizontal version) entitled *JH/235/82*, bronze, *c.*30 × 10 × 0.15cm (1' × 4" × ⅛"): Royal College of Art, 1984.[3]

Notes
[1] From a typed account of the sculpture by Susan Tebby, dated June 1999. [2] *Ibid*. [3] This was cast in the Sculpture School, Leicester Polytechnic, 1982. It may also have been exhibited at a London Group exhibition and at the Gulbenkian Gallery in 1984 (information from Susan Tebby).

Oxford Street

The Clephan Building; in the entrance archway to the courtyard, on the right-hand wall:

Untitled

Sculptor: George Pickard

Sculpture in mild steel
h. 3.78m (12'5"); w. 1.11m (3'8"); d. 14cm (6")
Inscription on a brass wall plaque to the left of the sculpture:

GEORGE PICKARD 1929 – 1993 / ARCHITECT, ARTIST AND SCULPTOR / UNTITLED MILD STEEL WALL SCULPTURE 1970 / DONATED BY JUSTIN PARKER OF OAKLAND ELEVATORS OADBY LEICESTER / UNVEILED / 20 JUNE 1996 / BY / MARJORIE PICKARD
Executed: 1970
Unveiled: Thursday 20 June 1996, by Marjorie

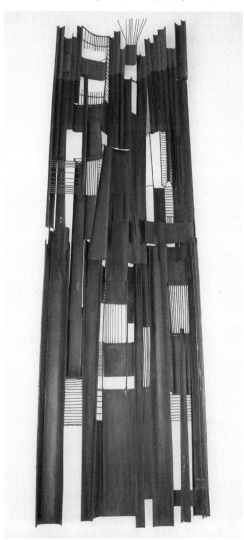

Pickard, *Untitled*

Pickard
Status: not listed
Owner: De Montfort University

Condition: The surface has considerable amounts of rust.

History: George Pickard's untitled sculpture was commissioned in 1969 by Justin Parker for the reception area of his company, Oakland Elevators. In 1996 the business was taken over by an American company who considered the sculpture unsuitable and so the piece was donated by the original patron to De Montfort University and installed in its present location.[1]

Note
[1] Letter dated 12 June 1998 from Marjorie Pickard to the author.

Dolphin Square

Memorial Fountain to Edith Gittins

This fountain, which was originally sited in Victoria Park, was re-erected in Dolphin Square in August 1980. Repeated vandalization, however, led to its being dismantled shortly afterwards. For an account of the fountain, see pp.324–5; for the replica statuette retained after the fountain was dismantled, see pp.129–30.

East Avenue

St John the Baptist Church of England Primary School (access only by prior arrangement), 1971–4, by Douglas Smith Stimson Partnership

To the right of the main entrance:
Development
Sculptor: Geoffrey Clarke

Sculpture in cast aluminium
h. 1.65m (5'5"); w. 1.35m (4'5"); d. 61cm (2')
Status: not listed
Owner: Leicester City Council

Condition: Good. Although, regrettably *Development* is half-obscured by the shrubs that have been planted around it.

History: The sculpture was installed shortly before the official opening of the school on Monday 24 June 1974. The official opening day programme explains:

The philosophy behind this piece of sculpture is one of the developing child gaining support and guidance by entwining itself around the established structure of education, which is represented by the three sides of the square firmly implanted into the ground.

From the growing plant breaks the first bloom, which rises above the framework and can be accepted as a Christian symbol.[1]

Literature
Saint John the Baptist Church of England Schools. Official Opening ... , 1974, n. pag.

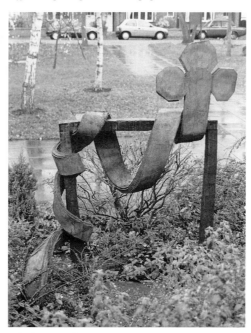

Clarke, *Development (rear view)*

Note
[1] *Saint John the Baptist Church of England Schools. Official Opening ...* , 1974, n. pag.

In the school grounds:
Abstract Sculpture
Sculptor: Derek Carruthers

Three-piece group in fibreglass with a matt black finish
h. (max.) 2.12m (7')
Status: not listed
Owner: Leicester City Council

Description: An abstract group which 'depicts humanoid forms in a conversational relationship',[1] originally erected on a circular brick platform outside the assembly hall.

Condition: All three pieces have been taken off their platform. One piece has a poorly-repaired break near the top and is without its base.

History: *Abstract Sculpture* was donated by the sculptor to Douglas Smith, the architect, for installation in the school grounds in 1973.[2]

Literature
PMSA NRP East Midlands Archive. Letter, dated 22 March 1998, from the sculptor to the author. **University of Leicester library,** Local History collection – *Saint John the Baptist Church of England Schools. Official Opening ...* , 1974, n. pag.

Notes
[1] *Saint John the Baptist Church of England Schools. Official Opening ...* , 1974, n. pag. [2] Letter, dated 22 March 1998, from the sculptor to the author.

Inside the entrance foyer:
Statues of Two Charity School Children
Sculptor: unknown
Manufacturer: Coade of Lambeth

Two statues in Coade stone
Boy: h. 1.46m (4'10"); w. 50cm (1'8"); d. 32cm (1'1")

Girl: h. 1.24m (4'1"); w. 41cm (1'4"); d. 36cm (1'2")
Inscriptions on the front faces of the bases towards the right:
Boy: *COADE*. LONDON
Girl: *COADE*. LAMBETH
Executed: 1787[1]
Status: not listed
Owner: Leicester City Council

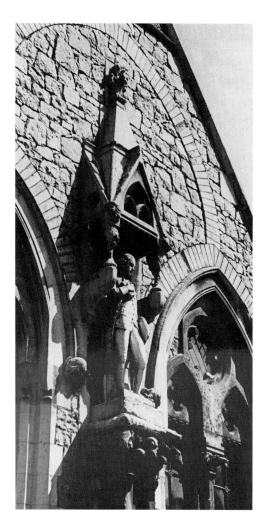

Charity School Boy (in former location on Castle Street frontage)

Description: Two children in eighteenth-century charity school uniforms. The *Boy* stands with his weight on his right leg, his left leg bent at the knee, holding a book in his right hand and a hat in his left. He wears a long outer coat, waistcoat and cravat, breeches and buckled shoes. The *Girl* stands with her weight on both legs, feet slightly apart. She holds an open book in both hands, angled downwards so that the viewer can see the pages (faintly incised with lines suggestive of columns of type). She wears a cap, a close-fitting tunic decorated at the front with a large bow, and a full-length skirt and apron.

Condition: Fair. Both have uneven surface coloration, perhaps the darker areas being the remains of soot from nearly two hundred years' exposure to a polluted urban atmosphere. The *Boy* has areas of black encrustation, notably on the rim of his hat, the collar of his coat, the cuff of his left sleeve, and the rear of his upper right arm. The *Girl* is not so badly affected. Both figures have suffered minor losses. The forward edge of the *Boy*'s hat rim is chipped, as is the forward edge of his right coat tail and right sleeve cuff. The *Girl* has suffered damage to the little finger of her right hand – it appears to have been broken off at some time and poorly restored. The pages of the lowered corner of her book are very slightly chipped, her cap and the left side of her collar edge also have minor chips missing. However, considering their age, the figures are in fair condition, the only significant damage being, as is stated above, to the *Girl*'s little finger.

History: These two figures, of a boy and a girl, are probably the works referred to briefly as being in a 'Leicester School-house' in *Coade's Gallery*, a catalogue published in 1799 by Eleanor Coade's artificial stone

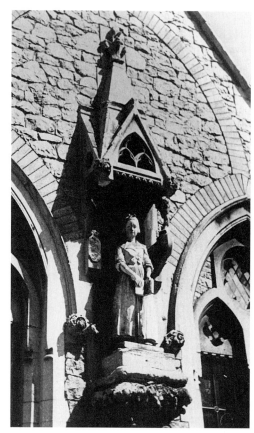

Charity School Girl (in former location on Castle Street frontage)

manufactory,[2] established by her in 1769 in Lambeth.[3] The statues, which would have cost about 16 guineas each,[4] were presented to St Mary de Castro charity school by two of the trustees and originally bore the following inscription beneath them:

> The figures were erected at the joint expense of John Johnson and John Horton, esquires, of London; both natives of Leicester. By the kindness of our benefactors we were

instructed in the Holy Scriptures, which are able to make us wise unto salvation.[5]

Interestingly, one of the benefactors, John Johnson, was the architect of the Assembly Rooms (now City Rooms, see pp.124–9), the frontage and ballroom of which he had decorated with other sculptures manufactured by Coade's of Lambeth.

St Mary de Castro charity school was founded in 1785. Its origins lay in an earlier initiative of 1747 when Alderman Gabriel Newton established at his own cost, a school for 35 boys in St Martin's Church. Unfortunately the venture was short-lived, chiefly, it would seem, because of Newton's quarrelsome nature. In 1760 he made a second attempt, establishing a trust under the care of the Corporation to educate, clothe and apprentice boys whose families were poor and were members of the Established Church. Newton died in 1762, adding a substantial amount to the original fund in his will. There were, however, problems in the will, not resolved until 1785 at which time the school, the first charity school in Leicester, was finally opened.[6] At some time after this date, the two *Charity School Children* were installed, presumably on the exterior of the school building.

In 1869, the school, by now affiliated to the National Society, was rebuilt in Castle Street and the two statues were re-housed in canopied niches at either end of the new school's frontage.[7] This building was demolished in the early 1960s but Canon Robert Symonds, appreciating the high quality of the figures, had them placed in store until they could be appropriately relocated, which they were in 1974 in the present school.[8]

Related works (from the same model): *Statues of Two Charity School Children*, Wyggeston's Hospital, Hinckley Road, Leicester (see p.122–3).

Literature
Burton, D.R., 1994, p.**152**; *Coade's Gallery ...*, 1799, p.ix; Dove, C. and Gill, R., 1986, p.**64**; Elliott, M., 1983, figs **123**, **124**; Gunnis, R. [1964], p.106; Kelly. A., 1990, pp.83, 361; Leicester City Council, 1975, p.29, **29**; McKinley, R.A., 1958, p.329; Pevsner, N. and Williamson, E., 1992, p.261; *Saint John the Baptist Church of England Schools. Official Opening ...*, 1974, n. pag.

Notes
[1] Another pair from the same model, at Wyggeston's Hospital, is dated 1787 (see p.122). [2] *Coade's Gallery, or, Exhibition in Artificial Stone ...*, 1799, p.ix. [3] For an account of the firm, see p.361. [4] According to Gunnis, R., [1964], p.106. [5] *Saint John the Baptist Church of England Schools. Official Opening ...*, 1974, n. pag. [6] Simmons, J., 1974, vol. 1, pp.123–4, 127, 130. [7] McKinley, R.A., 1958, p.329. For an illustration of the Castle Street frontage, showing both statues *in situ*, see Elliott, M., 1983, fig 123. [8] *Saint John the Baptist Church of England Schools. Official Opening ...*, 1974, n. pag.

Eastern Boulevard

Liberty Buildings, designed by Howard Henry Thomson, 1919, at the corner of Walnut Street

The corner tower is surmounted by:

The Liberty Statue

Sculptors: Joseph Herbert Morcom and workshop

Statue in stone, white-painted
h. (est.) 4.57m (15′)
Executed: *c*.1926–7[1]
Status of building: Grade II
Owner: privately owned

Condition: The statue is extremely weathered and heavily covered in graffiti, with areas of paint peeling away, and the torch has been removed at some time.

History: The building was erected for Lennards Shoes in 1919. Morcom's statue, surmounting the corner tower, was intended as a free adaptation of Auguste Bartholdi's *Statue of Liberty*, 1875–84, in New York Harbour. The directors of Lennards Shoes had seen and been impressed with the original statue during their trip to New York in 1920 and on their return commissioned a considerably reduced version from Morcom. Following the erection of the statue on its building, the firm, which has since ceased trading, became known as 'Liberty Shoes'.[2] Morcom's *Liberty Statue* is carved from three pieces of stone, as can be seen in a photograph of the statue before it left Morcom's yard in The Newarke.[3]

By the early 1980s, the statue had deteriorated to the extent that 'during a heavy frost' one winter its torch fell to the pavement below.[4] In 1985–6, the building's new owners, LCV International, paid for a campaign of restoration of the building and statue, although the torch was never replaced.[5] By 1991, the building was again empty and both it and the statue which was by this time covered in graffiti, were suffering attacks by vandals. Throughout the 1990s a succession of owners have failed to find a use for the rapidly-deteriorating building, although at the time of writing (1999) the present owner is in discussion with Leicester City Council over a range of possibilities.

Literature
Banner, J.W., 1991, p.97; Darke, J., 1991, p.178; Lee, J. and Dean, J., 1995, p.74, **74**; Leicester City Council, 1997, p.**126**; *L. Mercury*: – [i] 6 February 1985, p.8 [ii] 17 May 1986, p.39 [iii] 4 July 1986, pp.29, 1 [iv] 5 September 1986, p.6 [v] 31 January 1994, p.4 [vi] 23 September 1995, p.5 [vii] 28 August 1997, p.42 [viii] 23 March 1998, p.10 [ix] 27 April 1998, p.10.

Notes
[1] A local woman, Mrs Emma Norris, had been a pupil at St Mary de Castro School in Castle Street in *c*.1926–7, and remembered seeing the statue under execution in Morcom's yard as she passed on her way to school in the mornings (*L. Mercury*, 27 April 1998, p.10). [2] *L. Mercury*, 5 September 1986, p.6. [3] *Ibid.*, 23 March 1998, p.10. The original photograph is in the possession of stonemason David Simpson who inherited it from Bill Briggs, the man who taught him

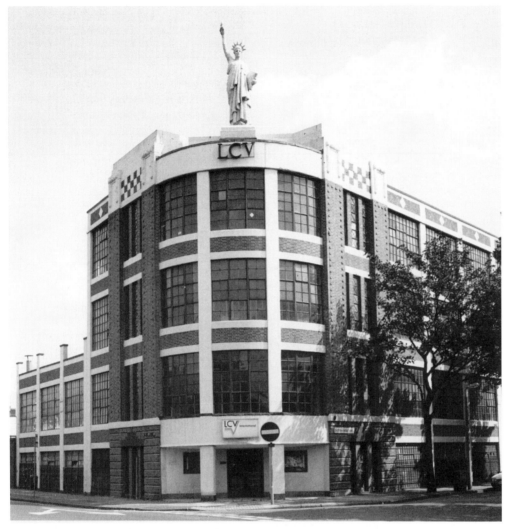

Morcom, *The Liberty Statue*

his trade. Briggs was one of the stonemasons who worked on the *Liberty Statue*, as can be seen in another of Simpson's photographs, published in the same article. Yet another photograph of the statue in the yard, still surrounded by scaffolding and with one of the stonemasons working on it, is in the *Leicester Mercury* photographic library (reproduced in *L. Mercury*, 6 February 1985, p.8). [4] *L. Mercury*, 5 September 1986, p.6. [5] *Ibid.*: – [i] 6 February 1985, p.8 [ii] 17 May 1986, p.39 [iii] 5 September 1986, p.6.

Evesham Road

At the entrance to Aylestone Meadows Local Nature Reserve:

Gateway and fence

Designer: Alan Potter

Gateway and fence in steel, painted blue, black and gold
Executed and installed: 1998
Status: not listed
Owner / custodian: Leicester City Council

Description: According to an information sheet produced by Leicester City Council before completion of the gateway:

> The Gateway signals the entrance to Aylestone Meadows Local Nature Reserve and incorporates images of woodland, waterways, fauna and flora.
>
> The woodlands are represented by two stylised tree forms. They act as gateposts and clearly mark the entrance, providing a distinct and memorable visual image.
>
> Within the tree tops, bird mobiles (designed by local children and young people), will be suspended.
>
> The waterways are depicted in the form of the fence and gate bars.
>
> Flora and fauna are incorporated through the use of silhouettes that depict stylised plants and animals such as voles, rabbits, fishes and dragonflies.
>
> A gilded sun is positioned to the right of the entranceway as a symbol of life, happiness and energy.

Condition: The bird mobiles have been stolen from the tree sculptures and the fish on the gate has been daubed with paint.

(opposite) Potter, *Gateway*

Francis Street

Between 61 and 63 Francis Street, on the exterior elevation, at first floor level:

Commemorative plaque with relief bust of Queen Victoria

Designers: Stanley Bros of Nuneaton

Plaque in terracotta
h. 67.5cm (2'3"); w. 52.5cm (1'9")
Inscriptions:
– around the head a circular inscription reads:
VICTORIA 60 YEARS QUEEN OF GREAT BRITAIN & IRELAND
– to left and right of the head: EMPRESS OF INDIA.
– around the outer, square border are listed various parts of the then British Empire. Across the top: CANADA AUSTRALIA; across the bottom: GIBRAL[R] MALTA CYPRUS EGYPT; on the left: AFRICA W. INDIES; on the right: N. ZEALAND BURMAH
Status: not listed
Owners: various

Description: Victoria is shown in profile facing right, within a circular border inside a square frame, both of which bear inscriptions. At the top is a crest bearing the date 1897 supported by C-scrolls.

History: These plaques were made in relatively large numbers, firstly for the 50th anniversary of Queen Victoria's accession in 1887. Evidently they were not as popular as the makers had hoped and unsold stock was later adapted for the Diamond Jubilee in 1897. These appear to have sold in greater numbers and examples are to be found throughout central and southern England. Other examples of the 1897 plaque are to be found in Leicester at St Saviours Road and Spa Place, off Humberstone Road; an example in the county is to be found at Witherly.[1] The Spa Place plaque is on the former head office of Broadbent's, a builder's merchant who, it has been suggested, may have been the Leicestershire handler for Stanley Bros (i.e., the designers).[2] In 1987 Arthur Sadler recorded a total of five of the rarer 1887 plaques (none in Leicestershire) and 44 of the 1897 plaques.[3]

Literature
Lee, J. and Dean, J., 1995, p.70, 70; Sadler, A., 1999, pp.1–2.

Notes
[1] Lee, J. and Dean, J., 1995, p.70; Sadler, A., 1999, p.2. [2] Sadler, A., 1999, pp.1, 2. [3] *Ibid.*, p.1.

Gallowtree Gate

Former Thomas Cook Building, 1894, by Goddard, Paget & Goddard

At the first floor level:

Relief panels

Sculptor: unknown

Reliefs in bronzed terracotta[1]
Each relief (est.): h. 76cm (2'6"); w. 1.73m (5'8")
Status of building: Grade II
Owner of building: BG Pension Schemes

Description: The four reliefs, depicting milestones in Thomas Cook's career as a pioneer tour operator, run across the frontage at first-floor level, above the round-headed windows. That on the extreme left shows Thomas Cook's first excursion in 1841, when he hired a train to transport 500 passengers to a temperance rally in Loughborough. The second from the left shows the trip in 1851 to the Great Exhibition at Hyde Park, London, with, on the left, the Crystal Palace; advances in train design after 1841 are suggested by the more robust-looking engine and the closed-in cars of the 1851 train. The third panel shows a steamer on the Nile (note the dhow on the left of the panel and, on the far shore, pyramids). In 1873, the firm had opened an office in Cairo and instituted tours by steamer up the Nile. By 1884, the year indicated on the panel, the Mahdi had roused the Sudan against Egyptian rule, and Thomas Cook's firm was commissioned by the British government firstly to transport General Gordon up the Nile as far as Korosko and, later the same year, to convey troops and supplies to

Thomas Cook Building: Loughborough excursion

Thomas Cook Building: London excursion

Thomas Cook Building: The Nile

Thomas Cook Building: The Forth Railway Bridge

relieve him at Khartoum. The panel at the extreme right, dated 1891, the year of the firm's Golden Jubilee, shows a train steaming towards the Forth Railway Bridge, opened the previous year.[2]

Condition of panels: Good.

Literature

Banner, J.W., 1991, pp.128–32; Banner, J.W., 1994, pp.54–6, **54–5**; Brandwood, G. and Cherry, M., 1990, pp.39–40, 89, **91**; Darke, J., 1991, p.178; Gerrard, D., 1996, p.54, **54**; Leicester City Council, 1975, p.38, **38**; Pevsner, N. and Williamson, E., 1992, p.233.

Notes

[1] Pevsner, N. and Williamson, E., 1992, p.233.
[2] Banner, J.W., 1994, pp.54–6; *DNB*; Pevsner, N. and Williamson, E., 1992, p.233.

Nos 10–12 Gallowtree Gate. Originally built for the Stamford, Spalding and Boston Banking Co., by Stockdale Harrison, 1907; now Dorothy Perkins

On the frontage:

Architectural sculpture

Sculptor: Joseph Crosland McClure[1]

Carvings in silver-grey Aberdeen granite
Heads representing *Night* and *Day*; each head: h. 98cm (3'3"); w. 48cm (1'7"); d. 30cm (1')
Executed: *c.*1907
Status: not listed
Owner of building: Arcadia Group Plc

Description: The frontage has a centrally-placed entrance flanked by display windows. Each window has two keystones: over the left-hand window is, on the left, a child's head, and on the right a female head with open eyes symbolising Day; over the right-hand window is another child's head and a female with closed eyes symbolising Night. Over the entrance, above the Tuscan columns flanking the doorway and supporting a balcony, are consoles again carved with children's heads. The present frontage has been considerably

McClure, *Day*

altered to accommodate the two large display windows. Originally it was of five bays: to the left of the main entrance were a side door and a window and to the right two windows. Each of the keystones was thus originally over a single element.[2]

Condition: Good.

History: Joseph Crosland McClure is first recorded in Leicester working as an assistant to sculptor C.J. Allen on Everard & Pick's Pares's Bank, 1900–1 (see p.153). McClure's first commission in Leicester as an independent sculptor was the stone figures of *Truth* and *Wisdom* for H.H. Thomson's St Alban's Church, c.1905–6.[3] In 1908, the year after he completed the present work, he was to receive his most important commission in Leicester – perhaps on the recommendation of J.B. Everard – designing and modelling the bronze groups on the *Leicestershire South African War Memorial* (see pp.164–5). He was employed again by the present architect, Stockdale Harrison, on the sculptural decoration of the Usher Hall, Edinburgh.[4]

Related works: full-size plaster models of *Night* and *Day*, A.D.W. Partnership, De Montfort Square, Leicester.

Literature
Banner, J.W., 1994, p.54; *Examples of Modern Architecture. Series No. 6. J. Stockdale Harrison. Shirley Harrison*, n.d., p.4; Gill, R., 1994, p.11.

Notes
[1] *Examples of Modern Architecture. Series No. 6...*, n.d., p.4. [2] The frontage in its original state is illustrated in *Ibid.*, pl. opp. p.4. [3] *Transactions ...*, vol. x, 1911–12, p.14. [4] See illus. in *Architects' Journal*, 8 September 1920, p.261.

Conversation Piece, by Kevin Atherton

A group of three bronze heads on Plexiglas pedestals, formerly displayed in Gallowtree Gate, but now in store. This was actually one of three sets of three heads each, sited at Gallowtree Gate, Market Street and Cheapside. In 1992 one set was relocated to St Margaret's Bus Station (see pp.110–11).

On the east side of Gallowtree Gate, at the corner with Humberstone Gate:

Sporting Success
Sculptor: Martin Williams
Founder: M.B. Fine Arts Foundry

Sculpture in bronze on a plinth in concrete clad in York stone
Bronze group: h. 1.72m (5'8")
Plinth: h. 78cm (2'7"); each side w. 2.81m (9'3")
Inscriptions in raised capital letters on bronze strips running along the upper part of each face of the plinth:
1. (facing north towards Humberstone Gate) SPORTING SUCCESS BY MARTIN WILLIAMS. THIS SCULPTURE WAS PAID FOR WITH CONTRIBUTIONS FROM LEICESTER MERCURY READERS AND PRIVATE / COMPANIES TO CELEBRATE THE ACHIEVEMENTS OF OUR SOCCER, RUGBY AND CRICKET CLUBS – AND TO INSPIRE FUTURE SPORTING SUCCESS.
2. (facing west across Gallowtree Gate): LEICESTER CITY FOOTBALL CLUB – COCA-COLA CUP WINNERS 1996/7. LEICESTER TIGERS RUGBY CLUB – PILKINGTON CUP WINNERS 1996/7 / LEICESTERSHIRE COUNTY CRICKET CLUB – BRITANNIC ASSURANCE COUNTY CHAMPIONS 1996 AND 1998
3. (facing south-east along Gallowtree Gate): SPONSORED BY: DIAMOND CABLE COMMUNICATIONS (UK) LTD NEXT PLC, KIRBY & WEST LTD, DAVID SAMWORTH CBE DL, HIGH SHERIFF OF LEICESTERSHIRE, LEICESTER MERCURY / COMMISSIONED BY THE LEICESTER MERCURY AND LEICESTER CITY COUNCIL AND UNVEILED BY HAROLD WHITE AND MATTHEW BAKER ON 16TH NOVEMBER 1998.
Unveiled: Monday 16 November 1998, by Harold White and Matthew Baker
Status: not listed
Owner / custodian: Leicester City Council

Description: Group of three figures of sportsmen in action, namely a cricketer, a footballer and a rugby player, in bronze on a triangular stone-clad plinth. The sculptor explains:

> As the aim of the commission is to celebrate the success of three clubs, the figures are locked into a strongly triangular

composition. Triangular arrangements predominate on all sides of the figure group intending to subtly suggest the notion of an apex or peak of achievement. It is a tightly worked and controlled composition further emphasised by the base, a large triangular concrete block dressed in York stone.[1]

Condition: Good; some slight metallic staining on the plinth beneath the bronze figures.

History: On 21 May 1997, the *Leicester Mercury* reported that Leicester East MP Keith Vaz had submitted a motion to Parliament congratulating Leicestershire on its triple sporting successes over a single twelve-month period: Leicestershire County Cricket Club had won the 1996 Britannic Assurance County Championship, Leicester City Football Club had won the 1996–7 Coca-Cola Cup and Leicester Tigers Rugby Club had won the 1996–7 Pilkington Cup. As no county had hitherto won championships in all three sports in a single season, the *Mercury* asked its readers to suggest how this unique achievement might be marked.[2]

Having established that there was considerable enthusiasm for a permanent memorial of some sort, on 28 May 1997 the newspaper gave over the whole of its front page to the launch of a £40,000 appeal for a publicly-subscribed sculpture.[3] From this time until the target was reached, the *Mercury* featured the appeal in virtually every issue with editorials, news updates and scores of letters, both in favour (the majority) and against (usually recommending more utilitarian schemes). Realising that if the appeal were to succeed the public should be involved in every way possible, on 30 May the newspaper began a series of articles inviting its readers to suggest how the sculpture should look.[4]

On 3 June 1997 came the announcement of the first of the corporate donations, £5,000 from

Williams, *Sporting Success*

Diamond Cable Communications (Leicester) Ltd,[5] followed in quick succession by £2,500 from Alliance and Leicester Plc,[6] £5,000 from Next Retail Ltd,[7] and £5,000 from Kirby and West Ltd.[8] By 12 June, the *Mercury* had received the backing of Leicester City Council whose public arts officer made herself available to advise the newspaper on how to commission a sculpture and how to select an appropriate site.[9]

In addition to organising the public subscription, the *Mercury* launched a series of fund-raising schemes, including the sale of 'Champions' t-shirts,[10] an 850 limited edition of prints depicting Leicestershire's sporting heroes,[11] a 150 limited edition of prints entitled

'Year of the Fox',[12] and 'Sporting Capital' lapel badges.[13] Independent initiatives included a fund-raising dance and variety show at Scraptoft Working Men's Club[14] and 'Triple Glory' ale, brewed by a local brewery who contributed 20p to the appeal from the price of each pint sold.[15]

On 2 July 1997, the *Mercury* announced on its front page that the appeal had, after a single month, reached £20,660, the halfway mark. Two days later it was able to report that a Hindu saint, Param Puyja Swami Shree Satyamitranand Giriji Maharaj, on a visit to Leicester, had earnestly enjoined Leicestershire Hindus to support the appeal, advocating participation in sport and local affairs as fundamental both to healthy living and to a cohesive and tolerant society.[16] The combined effects of the *Mercury*'s unrelenting publicity, public endorsements from celebrities, various fund-raising schemes and, on 26 July, a donation of £5,000 from Leicestershire's High Sheriff, brought the appeal to within £5,000 of the £40,000 target. This was finally reached with the *Mercury*'s own donation of £5,000 on 18 September 1997.[17]

Although readers had come up with some interesting designs it was obvious that a major piece of publicly-subscribed sculpture in the city centre would need a professional artist, experienced in outdoor sculpture, to design and execute it. In early July 1997, Leicester City Council's Public Arts Officer began discussing potential sites with the *Mercury*, and in August placed an advertisement in *Artists Newsletter* inviting professional artists to apply for a brief.[18] Over 200 responded and all were sent information packs asking them to send in preliminary ideas by September. From the total of submitted designs, 30 were selected for review by a judging panel comprising the chairmen of the three sports clubs, the editor of the *Leicester Mercury*, and the City Council's Public Arts Officer, Urban Design Manager,

and Arts, Libraries and Museums Committee Chairman.[19] From these 30 designs a short list of five was drawn up, being those submitted by John Clinch, Malcolm Robertson, David Annand, Martin Williams, and Andy Ray. From Saturday 18 October, for five consecutive issues, the *Mercury*, maintaining its intensive coverage of the scheme, treated each of the five short-listed artists to a profile, complete with colour photographs of the man and his work.[20]

On 23 October 1997, at the selection panel's invitation, the five artists visited Leicester to view and evaluate the site, to be apprised of the Council's forthcoming pedestrianization of the area and to meet the sports clubs' chairmen.[21] They were then given two weeks to finalise their designs[22] after which, for one week from 1 December, all five designs were exhibited at the City Rooms.[23] More than a thousand people attended the exhibition, many completing feedback forms recording their preferences.[24] On 26 December 1997, the *Mercury* announced on its front page that Martin Williams's design – the favourite of both the public and the selection panel – had won, and on 2 March 1998, Leicester City Council's Planning Sub-Committee gave its approval for the sculpture's erection at the corner of Gallowtree Gate and Humberstone Gate.[25]

By 25 July 1998, Williams had completed the three figures in plaster. It was at this point that an error in the cricketer's pose was brought to Williams's attention. His approved model had shown the ball at its moment of impact with the bat, whereas in fact the ball would have been at least twenty yards away by the time the cricketer had reached the position represented – so for the final sculpture, the ball was removed completely.[26]

The full-size figures were then cut into sections for casting and taken to Martin Bellwood's Carmarthenshire foundry (M.B. Fine Arts Foundry). The sculptor has described the casting process as follows: firstly negative

rubber moulds were made of the sections and from these hollow wax replicas were cast. The wax replicas were then encased in cristobalite investiture moulds, the wax melted out in the furnace and molten bronze poured into the resultant cavity. Lastly, the pieces were welded back together, the welds ground off and cleaned up, and the overall surface patinated and waxed.[27] Casting of two of the figures was completed by 1 October 1998[28] and the final figure shortly after.[29] The sculpture arrived at its site in Leicester at 10 a.m. on Sunday 15 November 1998, the day before the unveiling. With the sculptor supervising the operation, the sculpture was then lowered and bolted on to the plinth, which had been in place since 26 October (installed in advance so that it would settle properly before taking the sculpture's 600-kilogram weight).[30]

As a final touch to reinforce the point that this was the people of Leicestershire's sculpture, the *Mercury* asked its readers to nominate the two people most deserving of the honour of unveiling the sculpture.[31] The two eventually chosen were 93-year-old Harold White, who as a young man had played football and cricket and who, well into his seventies, had been a rugby linesman, and 10-year-old football fan Matthew Baker, who had overcome two major operations on brain tumours.[32]

The unveiling was a suitably festive occasion attended by many of the sportsmen who had achieved the triple success. Proceedings started with a performance by the Enderby Youth Band in Town Hall Square followed by a parade along Gallowtree Gate to the sculpture site where 800 balloons in the clubs' colours were released before the unveiling of the sculpture itself. Later in the evening replicas of the sculpture were presented to winners of the Mercury Sports Awards at Leicester's Guildhall.

Related works: miniature replicas were presented to winners of the 1998 'Leicester

Mercury Sports Award' in a ceremony at Leicester's Guildhall following the unveiling of the *Sporting Success* sculpture.[33]

Literature
PMSA NRP East Midlands Archive. Written statements by Martin Williams on the commission and casting process.
General. *Artists Newsletter*, August 1997; *L. Mercury*: – [i] 21 May 1997, p.12 [ii] 28 May 1997, pp.1, 12, 22 [iii] 29 May 1997, pp.8, 9 [iv] 30 May 1997, pp.16, 17 [v] 3 June 1997, p.1 [vi] 4 June 1997, p.8 [vii] 10 June 1997, pp.1, 20 [viii] 12 June 1997, pp.1, 3, 8, 26, 55 [ix] 18 June 1997, pp.18, 19, 28 [x] 19 June 1997, pp.30, 35 [xi] 23 June 1997, pp.6, 8 [xii] 24 June 1997, p.17 [xiii] 25 June 1997, p.12, and supplement [xiv] 26 June 1997, p.22 [xv] 27 June 1997, pp.50, 51 [xvi] 28 June 1997, p.13 [xvii] 30 June 1997, p.8 [xviii] 2 July 1997, pp.1, 24, 29 [xix] 3 July 1997, p.18 [xx] 4 July 1997, pp.3, 8 [xxi] 5 July 1997, p.18 [xxii] 7 July 1997, p.8 [xxiii] 9 July 1997, p.8 [xxiv] 11 July 1997, p.14 [xxv] 14 July 1997, p.18 [xxvi] 16 July 1997, p.16 [xxvii] 18 July 1997, p.20 [xxviii] 24 July 1997, pp.1, 12 [xxix] 28 July 1997, p.19 [xxx] 1 August 1997, pp.20, 21 [xxxi] 14 August 1997, p.8 [xxxii] 18 August 1997, p.21 [xxxiii] 20 August 1997, p.24 [xxxiv] 21 August 1997, p.22 [xxxv] 23 August 1997, p.8 [xxxvi] 16 October 1997, p.3 [xxxvii] 18 October 1997, p.11 [xxxviii] 20 October 1997, pp.20, 21 [xxxix] 21 October 1997, p.16 [xl] 22 October 1997, p.23 [xli] 23 October 1997, p.20 [xlii] 24 October 1997, pp.30, 31 [xliii] 29 November 1997, pp.26, 31 [xliv] 8 December 1997, p.23 [xlv] 26 December 1997, pp.1, 2, **1** [xlvi] 2 March 1998, p.17 [xlvii] 3 March 1998, p.3 [xlviii] 14 April 1998, pp.16–17 [xlix] 25 July 1998, pp.32, 37, **32**, **37** [l] 16 September 1998, p.20 [li] 17 September 1998, p.20 [lii] 30 September 1998, p.13 [liii] 1 October 1998, p.12, **12** [liv] 12 November 1998, p.13 [lv] 16 November 1998, pp.1, 3, **1**, **3**, and supplement [lvi] 17 November 1998, pp.1, 3, 22, 27, **1**, **3**, **22**, **27** [lvii] 18 November 1998, p.17.

Notes
[1] Typed statement from Martin Williams (n.d.) [2] *L. Mercury*, 21 May 1997, p.12. [3] *Ibid.*, 28 May 1997, p.1. [4] *Ibid.*, 30 May 1997, p.16. The first designs to be published were from the pupils of Measham Primary School (18 June 1997, pp.18–19). Readers' designs were published in several issues during June 1997, including 10 June, p.20; 23 June, p.8; 24 June, p.17; 26 June, p.22; 27 June, p.51; and 28 June, p.13. [5] *Ibid.*, 3 June 1997, p.1. [6] *Ibid.*, 10 June 1997, p.1. [7] *Ibid.*, 12 June 1997, p.1. [8] *Ibid.*, 18 June 1997, p.28. [9] *Ibid.*, 12 June 1997, p.3.

[10] *Ibid.*, 19 June 1997, pp.30, 35. [11] From a watercolour by *Leicester Mercury* artist, Kelvin Adams. (See 'We are the Champions', supplement, pp.iv, v, in *L. Mercury*, 25 June 1997; and *L. Mercury*, 9 July 1997, p.8.) [12] The fox is a symbol of the county. The prints are from a painting by Leicestershire artist, Mark Postlethwaite. (See *L. Mercury*: – [i] 2 July 1997, pp.24, 29 [ii] 18 July 1997, p.20.) [13] *L. Mercury*: – [i] 1 August 1997, p.21 [ii] 14 August 1997, p.8 [iii] 18 August 1997, p.21 [iv] 20 August 1997, p.24. [14] *Ibid.*: – 4 July 1997, p.8 [i] 5 July 1997, p.18 [ii] 14 August 1997, p.8. [15] *Ibid.*, 28 July 1997, p.19. [16] *Ibid.*, 4 July 1997, p.3. [17] *Ibid.*, 16 November 1998, p.14. The 'Scroll of Honour' listing those individuals and businesses who made contributions to the appeal is reproduced on p.16 of the above edition and is permanently displayed in the *Leicester Mercury* offices in George Street, Leicester. [18] *Ibid.*: – [i] 14 July 1997, p.18 [ii] 16 July 1997, p.16. [19] *Ibid.*: – [i] 16 October 1997, p.3 [ii] 16 November 1998, p.5. [20] The profiles were – John Clinch: *L. Mercury*, 18 October 1997, p.11; Malcolm Robertson: *L. Mercury*, 20 October 1997, pp.20–1; David Annand: *L. Mercury*, 21 October 1997, p.16; Martin Williams: *L. Mercury*, 22 October 1997, p.23; and Andy Ray: *L. Mercury*, 23 October 1997, p.20. [21] *Ibid.*, 24 October 1997, p.31. [22] *Ibid.*, 16 October 1997, p.3. [23] All five submitted designs are illustrated in *L. Mercury*, 16 November 1998, p.5. [24] *Ibid.*, 16 November 1998, p.5. [25] *Ibid.*, 3 March 1998, p.3. [26] The report also revealed that the figure was based on a photograph of Surrey and England batsman Graham Thorpe. The fact that Thorpe is left-handed helped Williams place the cricket bat in what he considered to be the best position for the composition (*L. Mercury*, 30 September 1998, p.13). The next day the newspaper revealed that the footballer was based on an action shot of David Perry of Swansea Football Club and that of the rugby player, of South African international centre, Pieter Muller (*L. Mercury*, 1 October 1998, p.12). In response to letters of disapproval from fans who thought that the models should have been Leicestershire sportsmen, Williams explained: 'It was just the poses I was looking at. They could have been anyone. I was just looking for three figures that would work in the composition' (*L. Mercury*, 16 November 1998, p.9). [27] From a written description supplied to the author by the sculptor. [28] *L. Mercury*, 1 October 1998, p.12. [29] A selection of photographs of the process of making the sculpture is in *L. Mercury*, 16 November 1998, pp.8–9, 13. [30] *L. Mercury*: – [i] 25 July 1998, p.37 [ii] 16 November 1998, pp.3, 14. [31] *Ibid.*, 16 September

1998, p.20. [32] *Ibid.*: – [i] 12 November 1998, p.13 [ii] 16 November 1998, p.7. [33] *Ibid.*, 18 November 1998, p.17.

Gateway Street

No. 52 Gateway Street; former Harrison and Hayes hosiery factory, 1913, by S.H. Langley

Around the main entrance, near the corner of Henshaw Street:
Architectural sculpture
Stonemason-sculptor: unknown

Sculpture in sandstone
Entrance keystone and spandrels: h. (est.) 91cm (3'); w. 2.19m (7'2")
Flanking stonework: h. (est.) 1.95m (6'5"); w. 43cm (1'5")
Executed: *c*.1913
Status: not listed
Owner of building: unknown

Description: The arched doorway has a keystone with a carved cherub head flanked by garlands of fruit and foliage in high relief. The entablatures on the buttresses to left and right of the entrance are broken by blocks supported on scroll brackets with carved female heads. That on the left looks downwards (the eyes are not quite closed), that on the right straight ahead. Surmounting each block is a decoration in the form of a lamp issuing flames from its top, with a fruit motif beneath.

Condition: Fair, though the stone is now rather weathered and there is some black encrustation. There is some minor damage to the right-hand edge of the right-hand lamp.

Literature
Leicester City Council, 1997, pp.78–9, **79**.

(opposite) *Harrison and Hayes factory: architectural sculpture*

Granby Street

The Leicestershire Bank (now HSBC), No. 31 Granby Street, 1872–4, by Joseph Goddard

Located at the corner with Bishop Street, built of red brick and Portland stone, it is a striking mixture of Venetian and northern Gothic. The corner entrance porch, with arches onto both Granby and Bishop Streets, is emphasised by a tower and French pavilion roof. Three tall pointed-arch windows on the Granby Street frontage have stained glass designed by the architect. Both frontages (and the rear wall towards Town Hall Square) are decorated with:

Architectural sculpture

Sculptor: Samuel Barfield

Architectural sculpture in Portland stone and terracotta

Status of building: Grade II
Owner of building: HSBC

Description: Barfield's sculptural decoration consists of a series of panels in terracotta and numerous small dragons carved in Portland stone. The dragons decorate the main horizontal and vertical divisions of the building, for example corners, string courses, window piers, etc. There are 15 on the Granby Street frontage, 19 on Bishop Street and just one on the rear elevation overlooking Town Hall Square – some singly, others, on the corners, in pairs; some with wings, others wingless; but each one individualised.

The terracotta panels on Bishop Street are floral repeat patterns, but those on Granby Street include figurative reliefs, stressing the importance of this as the main frontage. Below

Barfield, *Leicestershire Bank: relief sculpture*

each of the three tall stained-glass windows are paired panels each decorated with three flying doves, while at the tops of the two piers between the windows, at the level of the springing of the window arches, are rather more intriguing reliefs. Each panel has three 'medieval' heads: two women flanking a 'wild man' poking out his tongue. It has not been possible to identify the details of the woman on the left, although the woman on the right clearly has closed eyes and a veil over her mouth. It has been suggested that the woman on the left has raised gloved hands to her ears and that this represents therefore the motto: 'Hear no evil, see no evil, speak no evil'.

Condition: Generally good, although some of the dragons are damaged: note especially one of the dragons on the Bishop Street side of the corner entrance which has lost part of its head and one on the Granby Street frontage, on the left-hand corner of the projecting window bay, which has lost its hind quarters. In addition, the dragons on the Bishop Street and Town Hall Square elevations are grimier than those on Granby Street. The terracotta decoration is in good condition throughout.

Literature
Banner, J.W., 1991, p.110; Banner, J. W., 1994, p.52; Brandwood, G. and Cherry, M., 1990, pp.59–60, col. pl. IV; Leicester City Council, 1975, p.41, **41**; Leicester City Council, 1997, pp.93–4, **75, 94**; *L. Mercury*: – [i] 11 July 1994, p.4 [ii] 15 March 1997, p.10; Pevsner, N. and Williamson, E., 1992, p.233.

News Room (former), No. 59 Granby Street and Nos 1 & 3 Belvoir Street, 1898, by Goddard & Co.

The frontages in Granby Street and Belvoir Street are decorated with:
Architectural sculpture
Designer and modeller: E. Caldwell Spruce[1]
Manufacturers: Burmantofts Works, Leeds Fireclay Company[2]

Architectural sculpture in Burmantofts terracotta
Each niche figure (est.): h. 1.22m (4')
Each spandrel (est.): h. 91.5cm (3'); w. 1.07m (3'6")
Status of building: Grade II
Owner of building: Derek Robinson Ltd

Description: The former News Room stands

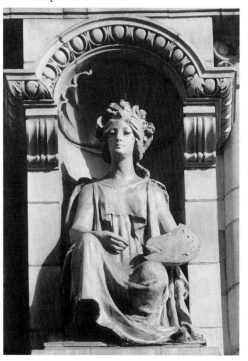

Spruce (for Burmantofts), *The Arts*

at the corner of Belvoir Street and Granby Street. Each frontage comprises three bays plus, at the west end of the Belvoir Street frontage, an entrance bay surmounted by a cupola. There are five zones of sculpture:

1. Four statues of seated female allegories in shell-headed niches between the second-floor windows, duplicated on each frontage. From left to right they are: *Astronomy*, or *Urania, Muse of Astronomy*, crowned with a star, holding a pair of compasses in her right hand and a globe in her left; *The Arts* holding an artist's palette in her left hand and in her right hand a brush (the brush now missing on both frontages);[3] *Literature*, crowned with a laurel wreath, holding a quill pen in her right hand and resting her left hand on the top edge of a book (hand and book now missing on both frontages) placed upright on her knee;[4] and *Commerce*, wearing a castellated crown, holding a caduceus in her right hand, and pointing downwards with her left hand to a model of a sailing ship.

2. Spandrels either side of the arches of the central lights of the first-floor Palladian windows. The spandrels, unlike the niche statues, are not duplicated across the two frontages. Each has a relief of a female figure either kneeling or seated on the ground. Eight of them, identified by inscribed scrolls, represent Muses and two of them, identifiable by their attributes, Fates; all have floral backgrounds.

The Belvoir Street spandrels are: left-hand bay, left-hand spandrel – *Euterpe*, Muse of music and lyric poetry, holding a flute with both hands, an eagle perching in the upper right part of the spandrel (below the scroll bearing her name); right-hand spandrel – *Thalia*, Muse of comedy, holding a mask in her right hand and a staff in her left, looking at a grapevine; central bay, left-hand spandrel – *Melpomene*, Muse of tragedy, holding a dagger in her right hand and a crown in her left; right-hand

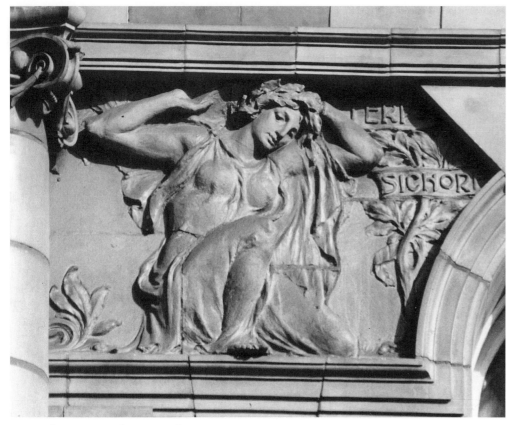

Spruce (for Burmantofts), *Terpsichore*

with, at her right elbow, a burning oil lamp. The central bay, left-hand spandrel, inscribed *Calliope*, shows the Muse of epic poetry reading from a book held in her left hand, the cover of which is inscribed with the word POEMS. She rests her right wrist on a book standing upright on a pile of three more and holds in her right hand a laurel wreath. The right-hand spandrel, inscribed *Polyphymnia* [*sic*], shows Polyhymnia, the Muse of sacred music, a veil over her face, a crown on her head, holding a sceptre in her left hand, her right hand extended, the index finger pointing upwards. The right-hand bay, left-hand spandrel, shows a woman at a spinning wheel; presumably this is Clotho, the first of the Three Fates, spinning the thread of life.[5] The right-hand spandrel shows a female figure resting her left hand on a globe, her right arm raised behind her head. Although not named, the globe suggests that this is *Urania*, Muse of astronomy and the only one of the traditional nine muses not otherwise represented in the spandrels.

3. Between the bases of the coupled Ionic columns of the first floor, heraldic beasts with lions' heads and eagles' wings, bodies and talons.

4. The segmental pediment over the Belvoir Street entrance. The pediment contains a relief of two male figures, the upper parts of their bodies nude, the lower halves draped, seated on the ground, back-to-back, either side of a shield bearing in raised letters the inscription: NEWS / ROOM / A 1898 D. The left-hand figure is a bearded, elderly man, reading from a scroll. The right-hand figure, a younger man, reads from a book held in his left hand, the book resting on his knee. He rests his chin on his right hand, his index finger extended over his cheek. At the top of the shield between them is an oil lamp from which radiate rays of light (which is presumably intended not merely as natural light, but specifically the light of learning).

5. On the cupola of the entrance bay, winged

spandrel – *Clio*, Muse of history, reading from a book held in her right hand and holding in her left hand, above a pile of three more books, a trumpet; right-hand bay, left-hand spandrel – *Terpsichore*, Muse of dancing, crowned with a laurel wreath, appearing to be on the point of rising up, her arms raised above and behind her head; right-hand spandrel – *Erato*, Muse of love poetry, resting her chin on her right hand looking longingly at a flower, her left arm resting on her lyre.

Of the Granby Street spandrels only those in

the central bay have identifying inscriptions. The left-hand bay, left-hand spandrel, shows an old woman, a veil over her head, cutting a thread with shears; this must be Atropos, one of the Three Fates of Greek and Roman mythology. Together the Fates determined the events and duration of a person's life at birth: Clotho spun the thread of life, Lachesis measured it out, and Atropos cut it. The right-hand spandrel, the subject of which is not clear, shows a young woman with her right hand raised above her shoulder adjusting her mantle

cherubs, one above each of the columns of the supporting drum.

Condition:

1. Niche figures – (i) *Astronomy / Urania*: The figures on both frontages are spattered with guano. The Granby Street figure is missing the right hand and globe and there is a big crack under the fold of drapery hanging from the right knee. (ii) *The Arts*: The figures on both frontages have lost the paint brushes originally held in their right hands.[6] The Granby Street figure has damage to the fingers of the left hand and there is a crack running from the left knee to the base. What appears to be a slightly more superficial crack runs down her right side. (iii) *Literature*: The Belvoir Street figure has an apparently deep vertical crack in the drapery below the right leg. The left hand and part of the forearm are missing and there are cracks around the left knee. The Granby Street figure is missing the left hand. The left foot (protruding over the edge of the base) appears to be rather weathered and there is cracking above it. There are superficial cracks to the drapery over the right upper arm. (iv) *Commerce*: The Belvoir Street figure is missing the last joint of the index finger of the right hand. The Granby Street figure has a damaged tip to the little finger of the left hand. The caducei held by both figures are missing the bodies of the snakes; the wings of the snakes remain, but appear damaged.

2. Spandrels – All are rather grimy, but apparently are otherwise in good condition.

3. Pediment – There is a deep crack running through the bottom right-hand corner of the relief. In addition, the surfaces are rather grimy.

4. The heraldic lion/eagle beasts appear to be in good condition.

5. The cherubim on the cupola appear to be slightly weathered.

History: Goddard's plans are dated 18 April 1898.[7] As has been observed by Brandwood and Cherry, the building is influenced by Belcher

and Pite's Institute of Chartered Accountants (1888–93) in the City of London, with its integrated sculptural decoration, use of blocked columns and its treatment of the corner with its first-floor oriel and recessed cornice.[8] Goddard's News Room was erected to replace William Flint's 1837 building (see pp.316–17). The News Room was a rather exclusive institution patronised by subscription-paying members. The membership would largely have consisted of businessmen and so the sculptural decoration, with its flattering allusions to culture and learning combined with commerce, would have been considered particularly appropriate. The News Room ceased to operate as such in 1902.[9]

Literature
LRO. Leicester News Room building plans (no. 5732).
General. Brandwood, G. and Cherry, M., 1990, pp.92, **93**; Leicester City Council, 1975, p.40, **40**; Leicester City Council, 1997, p.94, **94**; Pevsner, N. and Williamson, E., 1992, p.234.

Notes
[1] Information from Scott Anderson. E. Caldwell Spruce, principal modeller for Burmantofts in the 1880s and '90s, definitely designed and modelled the seated figures, as his signature appears on the model for *Literature* – as can be seen in a photograph in Mr Anderson's collection. The author assumes that Spruce was responsible for the design of the spandrel reliefs as well. [2] Two pages from a Burmantofts catalogue show (i) a general view of the exterior of the building and (ii) two of the statues and a section of the frieze (date and details unknown; photocopies of the two pages supplied by Dr Alan McWhirr, University of Leicester). [3] As is shown in an illustration on a photocopied page from a Burmantofts' catalogue (supplied by Dr A. McWhirr, University of Leicester). The caption beneath the illustration reads: 'Reproductions of photos. of ornament as submitted for architects' approval. Modelled and Executed by the Burmantofts Works, Leeds, for the General News Room, Leicester'. [4] A photograph of the plaster model for *Literature* is in the collection of Scott Anderson. [5] Curiously, Lachesis is not represented. [6] See footnote 3 [7] Building plan no. 5732 (LRO). [8] Brandwood, G. and Cherry, M., 1990, p.92. [9] Leicester City Council, 1975, p.40.

Victoria Coffee House (former), Nos 38 & 40 Granby Street, 1887, by Edward Burgess

The building is surmounted by a central octagonal drum faced with a three-storeyed pedimented frontispiece, and flanking turrets. The second-storey window of the drum and the equivalent windows of the right-hand turret are decorated with *Atlantes* on tapering pedestals.

Sculptor: unknown

Status of building: Grade II
Building in private ownership

History: The Leicester Coffee and Cocoa House Company was founded in 1877 by Edward Shipley Ellis, a Quaker and strong advocate of the temperance movement. The company established 14 coffee houses, the purpose of which was to provide non-alcoholic beverages in an attempt to combat what the proponents of temperance saw as the evils of intoxicating drinks. Three former coffee houses survive in Leicester: the present building, plus Eastgates and High Cross, all designed by Burgess, who was also a Quaker and related to

Victoria Coffee House: architectural sculpture

Ellis by marriage.[1] The Victoria Coffee House was so-called because it was built in 1887, the 50th anniversary of Queen Victoria's accession.[2]

Literature
Banner, J.W., 1994, pp.51, 50; Leicester City Council, 1975, p.55; *L. Mercury*, 14 March 1998, p.10.

Notes
[1] *L. Mercury*, 14 March 1998, p.10. [2] Leicester City Council, 1975, p.55.

The YMCA building, at the corner of East Street, designed by A.E. Sawday in collaboration with Draper and Tudor Walters, and officially opened by the Marquess of Northampton, 5 December 1901

The Granby Street frontage runs roughly east to west and is three storeys high and eight bays long, its bays articulated in the two upper storeys by colossal engaged Composite columns, blocked in their lower halves. The columns support a heavy entablature and cornice and are doubled at the (former) main entrance bay (fourth from the left). The bays of the upper storey have paired windows and the lower, single. This frontage is decorated with *architectural sculpture* in three zones. Beneath the entablature, between the paired windows of the upper storey, is a series of six *winged beasts* and *grotesque figures*; in the upper corners of the large first-floor window surrounds are seven pairs of *crouching figures*; and beneath the bases of the columns are *cherub terms*.

Sculptor(s): unknown

Architectural sculpture in stone
Status: not listed
Owner of building: Leicester YMCA

Description: The principal sculptural programme is the series of crouching figures in the upper corners of the first-floor window recesses on Granby Street. All are winged and

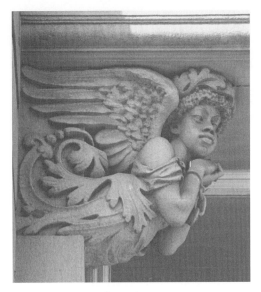

YMCA building: African boy

YMCA building: Arab

are either half-length figures emerging from the jamb or full-length figures crouching or kneeling against it. The following descriptions begin at the corner with East Street, moving left to right across the frontage. Bay one: on the left a bearded male figure holding unidentified objects in each of his hands; on the right a figure with a Pan-like face holding panpipes. Bay two: on the left a female figure with a bare torso, a fillet around her head; on the right a black African male figure with a plumed head-dress, his chin resting contemplatively on his right hand as he gazes upwards. Bay three: on the left a semi-naked male figure with acanthus leaves curling around his arm; on the right a mermaid-like creature, her hands on her hips. (Bay four, the entrance bay, has no sculptural decoration.) Bay five: on the left a figure with her hair in plaits, pulling her garment up to cover herself with her right hand, grasping a knife in her left hand; on the right a satyr-like,

half-naked male figure, his left hand grasping at his draperies. Bay six: on the left a male half-figure with curling horns; on the right a female figure clutching her drapery, her left breast revealed. Bay seven: on the left a black African boy with manacled wrists; on the right a bearded male wearing Arab headgear and robes, a pistol in his right hand. Bay eight (canted to follow the curve in the road): on the left, a bearded male figure, crowned with a laurel wreath, crouching, his right foot braced against the left-hand jamb. In his right hand is a mallet and on his knee a bust on a pedestal. He presumably represents *Sculpture*; on the right, a beardless male figure, crowned with a laurel wreath, kneeling against the right-hand jamb. In his left hand he holds a Greek Doric column and in his right a scroll. He presumably represents *Architecture*, in which case the scroll would be his building plans.

The figures make up a very odd bunch and if

there is a unified theme, it has not yet been possible to detect exactly what it is.

Condition: Good.

Literature
Banner, J.W., 1994, p.88; *L. Chronicle*, 7 December 1901, p.5; *L. Daily Post*, 6 December 1901, p.5.

Gravel Street

St Margaret's Bus Station

Just inside the entrance at the corner of Gravel Street and New Road:

Conversation Piece

Sculptor: Kevin Atherton
Foundry: A & A Sculpture Casting Ltd

Three busts in bronze on 14mm Plexiglas pedestals
James Welsh bust: h. 36cm (1'2"); w. 49cm (1'7"); d. 31cm (1')
– pedestal for the above: h. 1.45m (4'9")
Phil Leach bust: h. 35cm (1'2"); w. 41.5cm (1'4"); d. 23cm (9")
– pedestal for the above: h. 1.43m (4'9")
Cleo Craig bust: h. 39cm (1'3"); w. 39cm (1'3"); d. 20.5cm (8")
– pedestal for the above: h. 1.27m (4"2")
Inscription:
JAMES WELSH / PHIL LEACH / CLEO CRAIG / "CONVERSATION PIECE" / by KEVIN ATHERTON / COMMISSIONED BY LEICESTER CITY COUNCIL / THROUGH PUBLIC ART DEVELOPMENT TRUST / 1990
Founder's mark on the right-hand part of the upper surface of the *Cleo Craig* stand (arranged into a monogram): A A LONDON
Installed at their original sites, Market Street, Cheapside and Gallowtree Gate: Friday 27 July 1990
One set relocated to St Margaret's Bus Station: January 1992
Status: not listed
Owner / custodian: Leicester City Council

Description: Three portrait busts on tall stands of varying height arranged into a group facing inwards towards each other as if having a conversation.

Condition: Good.

History: *Conversation Piece* is actually one of a set of three inter-related groups originally located in Market Street, Cheapside and Gallowtree Gate. Unfortunately bronze heads on Plexiglas pedestals proved particularly vulnerable in such open locations. Within days of their installation several had been vandalized. Ultimately all three groups were removed and placed in storage until January 1992 when one set was relocated in the more secure surroundings of St Mary's Bus Station.

The three *Conversation Pieces* were commissioned by Leicester City Council's Planning Committee, along with James Butler's *Leicester Seamstress* (see p.130), as part of the Council's £30,000 City Centre Action Programme.[1] The ten-year programme, a joint venture of Leicester City and Leicestershire County Councils, included proposals 'to upgrade traffic management, tourism, shopping and conservation in the city centre'.[2] Recognising the role of public art in contributing to the city's identity, the Council viewed it as an important element in the programme from the outset. The two commissions were intended to complement each other, one representing 'a part of the heritage of the City' (the role fulfilled by the *Seamstress*) and the other, the present sculpture, 'a work which could be enjoyed on its own terms and yet would also be relevant to Leicester'.[3]

The organisation of the commission was entrusted by the Council to the Public Art Development Trust (PADT), a national non-profit-making body established to encourage the siting of works of art in public places. PADT thus dealt with all stages of the commission from the selection of the artist to the installation of the sculpture on site.[4]

The first stage opened in April 1989 with a competition to which artists were invited to submit their ideas. From the responses a short list of five sculptors was drawn up from which Kevin Atherton's was ultimately selected. Atherton's idea was to erect three groups of three busts each, mounted on Plexiglas pedestals, in three different shopping areas of the city. Although there were to be nine heads in all, two were to be repeated, making seven different heads. These seven were to be formed from casts of local people, selected to reflect Leicester's multi-cultural community. One head from each group would be talking while the other two listened. The idea was that a listening head from the first group would re-appear as a talker in the second, a listener from the second would re-appear talking to the third, and a listener in the third would be the talker in the first, so conveying the idea of gossip passing around the city. As the sculptor explained: 'The idea is for people to imagine what the story [being passed on] might be.' The Plexiglas pedestals were intended to involve the viewer by reflecting his or her body, thus 'giving each bronze head a fleeting new body'.[5]

On 10 August 1989, the *Leicester Mercury* featured an article inviting aspiring models for the busts to send a photograph, address and telephone number to the City Engineer's Department. Evidently the response did not provide an ideal cross-section, so on 13 September the sculptor himself went out into the streets to see if he could recruit potential models.[6] Once Atherton had found all seven models, he began the casting process at the City's Fosse Neighbourhood Centre. According to Atherton's own account of the process, he took piece moulds directly from each model's head and from these negative moulds he made a plaster cast of the whole head. As the plaster cast would by necessity have impressions of closed eyes, he drilled holes

into the plaster to make eye sockets and filled them with clay from which he modelled the eyeballs. For the clothes, he added pieces of material stiffened with resin to make them hold to the desired shape until cast. Finally, he cast the plaster, clay and fabric models in bronze, using the lost wax process (see glossary).

Immediately following their installation at the three sites in the City centre, the *Leicester Mercury* reported on the public's reaction. Inevitably it was mixed, with some finding the sculptures an enhancement of the urban environment, whereas others voiced the inevitable complaint that the money should have been spent 'where it's needed'. One couple, however, perceptively pointed out the apparent vulnerability of the sculptures.[7] Within days their reservations were seen to have been justified when the *Leicester Mercury* reported that two of the plinths for the

Cheapside busts had been removed by the Council after being badly damaged.[8] Then, in early September, one of the plinths in the Market Street group was smashed. By this time the Council was considering a number of possible measures to combat the problem, including making replacements for the Plexiglas pedestals in stainless steel and even removing the sculptures to storage each night and at weekends. Both suggestions were rejected by the sculptor – the former because, as explained above, he considered the Plexiglas an integral part of the work and the latter presumably because his sculptures were after all intended to be permanently sited in a public place.[9] By December, all six of the sculptures in Cheapside and Market Street had been damaged and removed to store, though the group in Gallowtree Gate – the only ones protected by bollards – had thus far escaped damage, leading

the Council and sculptor to the optimistic conclusion that the damage had not been sustained by vandalism but by cars accidentally hitting them.[10] Sadly, this optimism proved to be misplaced as, before arrangements could be made to erect a cordon of bollards around each group, the Gallowtree Gate group was also vandalized. By January 1992, the Council had finally accepted that the only safe locations for such breakable sculptures would be those where there was 'an element of supervision'.[11] Consequently, one group was re-erected in St Margaret's Bus Station, while sites in the railway station and in one of the shopping malls were considered for the others. Up to the time of writing, however, only the first group has been re-sited. It is a point worth remembering, however, that until all three groups are re-sited (and ideally with interpretative plaques), the sculptor's principal idea of verbal information being passed from group to group around the city is lost.

Literature
Leicester City Council, Arts and Leisure Department. *Conversation Piece* draft press release, dated 4 August 1989.
General. *L. Mercury:* – [i] 22 April 1989, p.13 [ii] 10 August 1989, p.11 [iii] 13 September 1989, p.11 [iv] 14 September 1989, p.55 [v] 19 October 1989, p.14 [vi] 6 November 1989, p.4 [vii] 30 June 1990, p.3 [viii] 28 July 1990, p.10 [ix] 30 July 1990, p.9 [x] 8 August 1990, p.5 [xi] 13 August 1990, p.13 [xii] 7 September 1990, p.11 [xiii] 27 December 1990, p.33 [xiv] 24 January 1991, p.5 [xv] 28 January 1991, p.25 [xvi] 18 January 1992, p.50.

Notes
[1] *L. Mercury*, 22 April 1989, p.13. [2] *Ibid.*, 30 June 1990, p.3. [3] From an explanatory display board of the *Conversation Pieces* at Leicester City Council's Arts and Leisure Department. [4] *Ibid.* [5] *L. Mercury*, 28 July 1990, p.10. [6] *Ibid.:* – [i] 10 August 1989, p.11 [ii] 13 September 1989, p.11 [iii] 14 September 1989, p.55. [7] *Ibid.*, 30 July 1990, p.9. [8] *Ibid.*, 8 August 1990, p.5. [9] *Ibid.*, 7 September 1990, p.11. [10] *Ibid.*, 27 December 1990, p.3. [11] *Ibid.*, 18 January 1992, p.15.

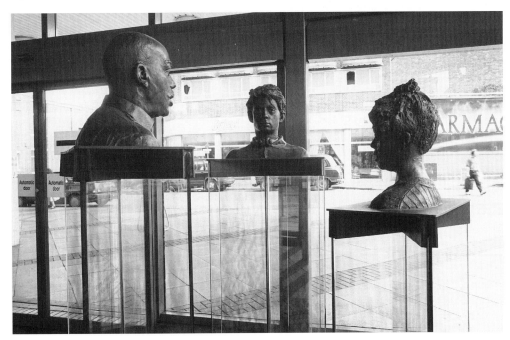

Atherton, *Conversation Piece*

Guildhall Lane

The Guildhall

In the library (upper floor):

Bust of Alderman Sir Jonathan North Kt, DL, JP

Sir Jonathan North (1855–1939), benefactor, businessman and politician, was born 11 January 1855 at Rothley, Leicestershire. A partner in the firm of Leavesley and North, boot and shoe manufacturers, and later Chairman of Freeman, Hardy and Willis, he began political life as a member of the Belgrave (Leicester) School Board. He was a Liberal

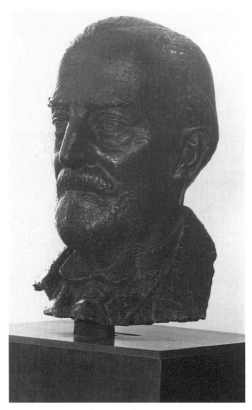

Brown, *Sir Jonathan North*

member of Leicester City Council from 1889, was elected alderman in 1909, and served as Mayor of Leicester from 1914 to 1918. He was also Chairman of the Education Committee from 1906–37 and was a member of the Leicester Board of Guardians for nine years (two as Chairman). In 1919 he received the Freedom of the Borough and was knighted by King George V in De Montfort Hall. He was also a founder of Leicester University College. In 1931 North presented the Victoria Park war memorial gates to the city in memory of his wife who had died the previous year. He died at 'Glebe Mount', his house at Glebe Road, Oadby, on 12 November 1939.
Sources: Hartopp, H., 1935; Pike, W.T., 1902; Wade-Matthews, M., 1995; *Who Was Who 1929–1940*.

Sculptor: Percy Brown

Bust in bronze
Bust: h. 32cm (1'1"); w. 21.5cm (9"); d. 22cm (9")
Pedestal: h. 1.25m (4'2")
Inscription on a brass plaque on the front face of the pedestal:
ALDERMAN SIR JONATHAN NORTH. KT.D.L. J.P. / CHAIRMAN OF THE EDUCATION COMMITTEE / 1906 – 1937 / PERCY BROWN SCULPTOR
Status: not listed
Owner: Leicester City Council

Condition: Good.

Literature
Charles, B., n.d., b/w plate (n. pag.).

Halford Street

Wholesale Fish, Fruit and Vegetable Market building (demolished)

The main entrance was decorated with *Mermaid* reliefs – these have been relocated to the West Bridge (for which, see pp.182–3).

Haymarket

Haymarket Memorial Clock Tower

with statues of four historical benefactors of Leicester: *Simon de Montfort, William Wyggeston, Sir Thomas White*, and *Alderman Gabriel Newton*

Simon de Montfort (*c.*1208–65), was born in Normandy, but came to England in 1229. In 1238 he married King Henry III's sister and in 1239 was formally invested with the earldom of Leicester (inherited from his English grandmother). By 1261, the King was in dispute with his barons over his right to rule as he saw fit. De Montfort, who by this time had withdrawn to his lands in Gascony following his own disagreement with the King, was summoned back by the barons to be their leader. The royalist cause was defeated by de Montfort at Lewes in 1264 and the King captured. In January 1265 de Montfort summoned what is generally viewed as the first Parliament. He was by now virtual dictator of England. Following a subsequent dispute with his barons he was killed in battle at Evesham. He spent very little time at Leicester, his only real connection being his title.

William Wyggeston (or William of Wigston) (1456–1536), wool merchant, was Mayor of Leicester in 1499 and 1510, and MP for Leicester in 1504. It is as a benefactor that he is chiefly remembered, however. As neither of his two marriages produced an heir, he devoted his wealth to charitable works, the chief one being the foundation, in 1513, of Wyggeston's Hospital. Originally erected in the centre of Leicester to the west of St Martin's Church (now the Cathedral), it housed 12 poor men and 12 poor women and provided a chaplain and confrator. The hospital moved to its present site on Hinckley Road in 1869.

Sir Thomas White (1492–1567), Lord Mayor of London and knighted, 1553, was the founder

of St John's College, Oxford, 1555. His right to be considered a benefactor of Leicester resides in the loan scheme he inaugurated in 1551. The scheme consists of interest-free loans made available to certain midland towns in rotation – namely Coventry, Northampton, Leicester, Warwick, and Nottingham – the intention being to assist young men in setting themselves up in business.

Alderman Gabriel Newton (1683–1762). Leicester-born, he was made a Freeman in 1702, a Councillor in 1710, an Alderman in 1726 and Mayor of Leicester in 1732. He had begun adult life as a wool comber, later becoming landlord of the Horse and Trumpet Inn, near the High Cross. He was married three times, in each case to a woman of considerable wealth. By the time of his third marriage he had amassed a sufficient fortune to allow him to retire from business altogether. As his only child from the three marriages, a son, died before reaching adulthood, Newton decided to establish a trust, to be supervised by the Corporation, to found a school for 35 boys 'of indigent necessitous parents of the established church of England in this town without any regard to a particular parish'. The school, St Mary de Castro charity school, was eventually opened in 1785.
Sources: *The East-Gates Improvement ...*; Wilshere, J.E.O., [1968].

Architect: Joseph Goddard
Contractor and stonemason-
sculptor: Samuel Barfield

Tower of Ketton stone with a base of Mountsorrel granite; column shafts of polished Peterhead granite (large) and serpentine (small); statues in Portland stone.
h. 21.3m (70'); w. of base 3.35m (11')[1]
Inscriptions:
1. Incised into the stone in Roman capital letters (illegible or lost letters indicated in square brackets)
– within the south-facing blind arch, beneath the corporation's incised crest: ERECTED / BY / PUBLIC SUBSCRIPTION, / AIDED / BY THE CORPORATION OF / THIS BOROUGH, / A.D. 1868, / IN MEMORY OF / FOUR BENEFACTORS OF / LEICESTER. / T.W. HODGES, MAYO[R] / S. STONE, TOWN CLE[RK] / J. ALLEN [...?] / J. BURTO[N] [SECRETAR]Y. / OF THE SUBSCRIBERS' COMMITTEE. / [*space; then at bottom left:*] J. GODDARD [*bottom right:*] [S] BARFIELD
– on the crowning voussoir of each pointed arch: (i) south towards Gallowtree Gate: DE MONTFORT (ii) east towards Humberstone Gate: NEWTON (iii) north towards Haymarket: WHITE (iv) west towards High Street: WIGSTON
– at the corners of the tower, on the bases of the colonettes supporting the statue bases: (i) south-east corner: SIMON DEMONTFORT [*sic*] (s. face) EARL OF LEICESTER (e. face); (ii) north-east corner: ALD[N] GABRIEL NEWTON (e. face) 1760 (n. face); (iii) north-west corner: SIR THOMAS WHITE (n. face) 1546 (w. face); (iv) south-west corner: WILLIAM WIGSTON (w. face) 1500 (s. face)[2]
2. On a blue circular plaque, in silver lettering, within the blind arch facing west towards High Street: CLEANING AND / REFURBISHMENT / 1992 / [*space*] / FINANCED BY / LEICESTER CITY COUNCIL / AND PICK EVERARD / ON THE OCCASION OF THEIR / 125 YEAR ANNIVERSARY
Corner stone laid: Monday 16 March 1868, by John Burton
Top stone placed: Monday 8 June 1868, by George Ernest Barfield, youngest son of Samuel Barfield[3]
Statues installed: *Simon de Montfort*, 13 August 1868;[4] *Sir Thomas White*, before December 1868; *William Wyggeston*, 4 December 1868;[5] *Alderman Gabriel Newton*, late 1868 / early 1869
Refurbishment unveiled: Friday 16 October 1992, by Councillor Bob Wigglesworth, Lord Mayor of Leicester[6]
Status: Grade II
Owner / custodian: Leicester City Council

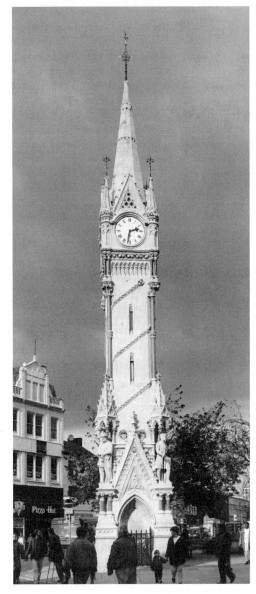

Goddard, *Haymarket Memorial Clock Tower*

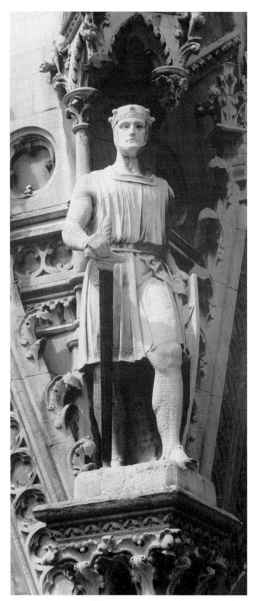

Barfield, *Simon de Montfort*

Description: Gothic-style structure on a square ground-plan with, at the base, pointed-arch doorways with iron gates and corner piers supporting statues under canopies. The statues represent four of the City's leading historical benefactors, Simon de Montfort, William Wyggeston, Sir Thomas White, and Alderman Gabriel Newton. Above, on the angles of the tower, are polished granite shafts with carved capitals. Spiral mouldings around the tower indicate the interior staircase. On each face, towards the summit, is a clock with flanking pinnacles and gable. The whole is crowned with a tall spire and weather-vane.

Condition: Restored in 1992. Although much of the stonework is weathered, there appear to be no major losses to the four portrait statues.

History: The *Haymarket Memorial Clock Tower* stands on the site of the old Assembly Rooms (built in 1750), a little to the east of the former East Gates of the medieval walls of Leicester. The gates were demolished in 1774 as part of the Corporation's attempt to relieve Leicester's increasingly congested streets. Following the opening of the new Assembly Rooms in Hotel Street in 1801 (see p.124), the old, increasingly dilapidated buildings were put to a variety of uses including a hay and straw market, they and their users proving a major impediment to traffic.[7] In 1859 the buildings were advertised for sale and purchased by the Corporation 'for improvement' – although, to the exasperation of local property owners, no immediate attempt was made to clear the site.[8]

In 1861, John Burton, a printer and photographer whose premises overlooked the Haymarket eyesore,[9] organised a meeting, comprised largely of his neighbours, to discuss the matter. This meeting saw the formation of the East Gates Improvement Committee whose first executive action was to elect a deputation to petition the Corporation's Highway Committee. The Highway Committee initially insisted that the petitioners, as the interested parties, should raise a £1,000 contribution towards the improvements.[10] They were able to raise only £400, but managed to put their case so compellingly that in early 1862 the Corporation agreed to begin clearing the site.[11] However, although the clearance was accomplished, the hay and straw market was allowed to remain, looking even more 'conspicuous and offensive' than before.[12] The market was eventually removed to Humberstone Gate, but by 1867 discontent was mounting over the danger caused by the chaotic tangle of horse traffic attempting to negotiate its way across what was now a wide open space – it was clearly imperative both to regulate the traffic and to give pedestrians who needed to cross the area a central refuge.

In September 1867 a rumour began to spread that there were plans to erect an illuminated clock on the London Road at its corner with Belvoir Street. On 4 September 1867, somebody designating himself 'Observer' wrote to the *Midland Free Press* complaining that whereas the intended site was ill-advised 'a more eligible and central place [than East Gates] does not exist, or one better adapted for a clock, with a cluster of lamps, and, if you will, a fine colossal statue of that unparalelled [*sic*] benefactor, Sir Thomas White'.[13]

The writer advised that a petition campaigning for the above scheme was currently being circulated for presentation to the Corporation. By the time it was submitted on 1 October 1867 it contained the signatures of 193 ratepayers of the Borough. The petitioners stressed the need for an island to regulate the traffic at the East Gates while also promoting the usefulness of a clock there, advocating

a sort of Gothic square tower ... on the four sides of which there should be in high relief, medallions in stone of the men whom they had selected to honour – Simon de Montfort,

William Wigston [sic], Sir Thomas White, and Alderman Newton.[14]

The petitioners urged the Corporation to take immediate action so that the structure, which they were confident would demonstrate the town's 'artistic taste in the adoption of the subject', could be erected in time for the Royal Agricultural Show due to be held in Leicester in July 1868.[15] Some Councillors, however, were not quite so sure of Leicester's capacity for good taste, evidently because the town's only venture into public art thus far – the *Statue of the Duke of Rutland* – had been viewed by many as something less than an artistic triumph (see pp.142, 144). Alderman Burgess alluded to this when he expressed his concern that the people of Leicester 'were not very celebrated in matters of taste, and he should be sorry to see another mistake made'.[16] Councillor Johnson, though equally damning of Leicester's one previous attempt at public art, was nevertheless willing at least to consider the scheme – subject to the Council first seeing rather more definite plans:

> At present [the petitioners, he said,] had only an amateur sketch to show them. They had not been very fortunate hitherto in works of art, as any one looking up the Market-place from Cheapside would see, and he hoped that no mistake of the same character would be made again.[17]

Councillor Holmes was against the scheme, fearing that such a structure would prove as great an obstruction as the recently demolished buildings, and that it 'would very soon become a lounging place for idlers'.[18] A number of councillors, however, did recognise that something was needed in the middle of the site to serve, as Alderman Viccars put it, 'as a safeguard both to pedestrians and to persons driving'.[19] Ultimately the petitioners won the day – the fact that they undertook to raise the money by public subscription, thus incurring no drain on public funds, being a major factor in their success.[20]

The petitioners next sent out circulars inviting a select group of men to a meeting at the Temperance Hall on 25 October 1867. The meeting, though by all accounts poorly attended, resulted in the formation of the Haymarket Structure Committee (again with John Burton as Honorary Secretary), as well as the beginnings of the subscription, with several of the scheme's wealthier supporters donating a substantial twenty guineas each.[21] On 30 October, John Burton drew up two public notices, one listing the committee members and appealing for subscriptions, the other requesting designs for the structure:

> It is proposed to Erect an Ornamental Structure on the Old Haymarket Site, in height from 35 to 40 feet, to contain four Illuminated Dials, four Statuettes or Medallion Busts of ancient benefactors to the town, with a Platform around about 18 feet square, and Lamps as a safeguard to passing pedestrians.
>
> The Committee appointed to prosecute the above will be happy to receive Designs from Architects for the contemplated structure, the cost of which to be about £750, exclusive of the Clock, Lamps and Lighting arrangements. Designs to be sent into [sic] the Committee not later than the 30th of November next.[22]

Within a month the Committee had raised £488. 5s. 0d., including £43 from a concert organised by the celebrated Leicester flautist, Henry Nicholson.[23]

By 30 November 1867, 106 designs had been received and were exhibited for seven days during December in Messrs Vice and Moon's gallery in the Market Place. In order to assist the Committee in its choice, subscribers were invited to vote for their favourite design, the winner by a majority of 24 being that submitted by Leicester architects Millican and Smith. The Committee then drew up its own short list, similarly placing Millican and Smith's design first.[24] By now, however, the Corporation had 'consented to supply the clock, lamps, foundations, and lighting'[25] and as its permission would, in any event, have to be obtained for the structure's erection, the Committee felt obliged to let the Corporation decide on the final choice of design. Consequently, the Committee selected three alternative designs and duly submitted them to the Corporation.[26]

At its meeting on 17 December 1867, the Council formally agreed to pay all costs over and above the £700 that the Haymarket Structure Committee had undertaken to raise, and assumed responsibility for the erection and completion of the work. The three short-listed designs consisted of the subscribers' choice by Millican and Smith, one from Joseph Goddard and Son, also of Leicester, and one from Giles and Bevan of London. A vote taken on the designs immediately eliminated the London firm but produced a tie for the two from Leicester, while a second vote still produced no clear majority, Goddard and Son gaining just one vote more than Millican and Smith. The Council had in any case insisted that certain modifications be made to both designs before a final decision could be reached so it appointed a committee to liaise with the architects and report back with the amended designs to the next meeting of the Council.[27]

The two principal changes required were that the statues should be at least six feet in height and that the various projections, seats and recesses that both designs featured at ground level – 'which may be made use of for committing nuisances' – be removed.[28] The Corporation was to provide another £50 to meet the added cost of the increased height of the statues and the architects were to guarantee

carrying out their modified designs for £800; it was also clearly laid down by the Council that apart from these modifications the designs should 'be substantially the same as those [originally] submitted'.[29] Both architects agreed to the revisions and their amended designs were reviewed by the Council on 1 January 1868. The Mayor evidently hoped to move straight to a vote, but some councillors alleged that certain members of the committee had given Goddard unfair assistance and were not prepared to let the matter pass without debate. Councillor Holmes pointed out that rather than being modified, 'Goddard's design had been altered altogether' and that some of the alterations had been 'stolen from Mr. Millican's design'. In the face of angry objections to his accusation, Holmes went on to denounce the 'secret work' that had been going on: confidential discussions within the committee on the shortfalls of Goddard's design had, he alleged, been conveyed back to the architect who had then altered his design accordingly. In short, Millican had been 'robbed' both of his ideas and of the commission, a view shared by Councillor Warner.[30]

Regardless of the merit of the individual elements in Millican's original design, however, there was a much more persuasive argument to be made for Goddard from the point of view of contemporary taste. As Councillor Kempson ('He did not profess to any knowledge of architecture himself') pointed out, Millican had chosen the Perpendicular or, as it 'was held by all true Gothic artists [the] debased style of Gothic', whereas Goddard had adopted the Decorated Gothic style, the 'pure and beautiful' style. Even more crucially, he argued, Decorated Gothic had been the prevailing style in the period of Simon de Montfort 'who had always been connected with Leicester, and a great feature in the monument would be to bring out Simon de Montfort, and give him a monument worthy of his renown'.[31]

Kempson's argument was supported by Councillor Thompson ('For 30 years' – as he assured them – 'Gothic Architecture had been his favourite study; but he had not studied it as the builders studied it, merely technically, but as a matter of taste and improvement'). His studies, he went on,

had brought him to the conclusion that the great period of Gothic art was that in which Simon de Montfort was living in that town, as Earl of Leicester ... in erecting [the monument to Goddard's design], it would be identified with a period perhaps the most prosperous and renowned in the annals of this town – a period when Simon de Montfort dwelt in the place – the founder of the system of Parliamentary representation; so that, through Simon de Montfort, the town of Leicester was identified with the introduction of that Parliamentary system to which they owed the political liberties they enjoyed at the present time ... in erecting that monument, they were not simply erecting a monument to please the eye, but one which would evoke associations the grandest and most inspiring, not only in the history of the town, but of this country.[32]

Thompson clinched his argument by reminding the Council that in July some of the most 'educated intellects of the day' would be visiting Leicester for the meeting of the Royal Agri-cultural Society and that it was Leicester's duty to 'erect a monument that should commend itself to their refined and cultivated taste, and be an honour to the town and county'. Thus had Goddard judiciously, or maybe fortuitously, chosen a style in which some very relevant and auspicious connotations could be invested and which helped his supporters on the Council win the commission for him. Goddard's design won by 30 votes to 14.[33]

Millican and Smith's extreme displeasure at this sudden reversal was published a few days

later in a letter to the *Builder*, the leading national architectural journal of the day. They claimed that in handing over the choice of design to the Corporation after the subscribers had already made their choice 'the Committee *broke faith* with *all the competitors*' [their italics]. They felt that their design was entitled to first place not only by virtue of the votes both of the subscribers and of the Haymarket Structure Committee, but also because their design had necessitated only two minor revisions whereas Goddard's had required numerous (which they cited in detail).[34] But their protest counted for nothing and Leicester Corporation maintained its selection.

Goddard, in his letter to the Corporation dated 31 December 1867, accompanying his winning design, had made a statement regarding the statues which was either wilfully misleading or an example of provincial naïvety. He had undertaken to have the statues 'sculptured by an eminent sculptor residing in London' and made of Portland stone 'the same material used in the Albert Memorial now being erected in Hyde Park'.[35] Apart from the fact that the Albert Memorial sculptures are not in Portland stone but in rather more expensive marble and bronze, Goddard would have been extremely lucky to have attracted an 'eminent' London sculptor with the small amount of money at Leicester Corporation's disposal. By 14 February 1868, Goddard had modified his position somewhat, stating his intention to the Highway and Sewerage Committee that he proposed 'to have halfsize models of the four statues ... made by an eminent artist, and to have the sculptor's work executed by a competent person'.[36] Ultimately Leicester-based monumental mason and architectural sculptor Samuel Barfield was employed both to supervise erection of the structure and to execute the statues under Goddard's supervision. Goddard's call for tenders for the building work (deadline 25 January 1868),[37] had

elicited three responses, Barfield's at £546 considerably undercutting Osborne Bros at £940 and William Neale at £880.[38] These estimates were stated to be exclusive of statues and ornamental stonework.

Meanwhile, subscriptions had been proving more difficult to raise than had been hoped. By 2 January 1868, just over £657 had been promised, which meant that the Committee still needed another £120 to cover the £700 it had agreed to hand over to the Corporation, plus incidental expenses.[39] Furthermore, an extra £50 was needed following the decision to use polished Peterhead granite instead of the red Mansfield stone that had originally been planned for the columns.[40] This resulted in the launch of a new appeal for additional subscriptions in February 1868.[41]

Excavation of the foundations began in the same month. The first brick of the foundations was laid on 3 March,[42] the corner stone on 16 March[43] and the top stone was set in place a mere twelve weeks later, on 8 June 1868.[44] It seems to have been at some time in May that it was finally confirmed that Barfield should be awarded the contract to execute the statues to Goddard's design.[45] In the absence of any documentary evidence relating to this decision, one must assume that the reality of the memorial committee's financial situation was the principal determining factor. Barfield may have been cheap but he was hardly the 'competent person' Goddard had earlier assured the Council he would find to execute such prominently-placed statues of Leicester's four chief benefactors.

Yet even if he was not the most skilled of sculptors, Barfield was certainly diligent. In mid-June, the editor of the *Leicester Chronicle* visited his workshop at Welford Road to find him hard at work on the statues. His detailed descriptions of the models for the statues show that these at least were completed. *Simon de Montfort* he described as 'the great baron ...

standing erect in his chain armour, with noble countenance and majestic port', *William Wyggeston*, 'the Leicester merchant of Henry VIII's reign ... with homely, benevolent, honest face, and burly form', *Sir Thomas White*, 'the London Alderman ... more delicate in lineament, but expressive ... habited in the graceful costume of his age', and *Gabriel Newton*, 'the Leicester Alderman, with venerable mien and countenance, in Georgian costume'.[46] Three of the likenesses, he was later to explain, were 'the ideal of the designer' (presumably Goddard), while that of Sir Thomas White was based on a painted portrait in Leicester's Guild Hall.[47]

The first of the statues to be completed was the *Simon de Montfort*. It had been hoped that this in particular, for all the reasons given above, would be in place by the time of the Royal Agricultural Show in July 1868, but it was not installed until 13 August.[48] The next to be completed was the *Sir Thomas White*, installed at some unrecorded date over the next few months. And yet despite this remarkably quick progress, the sight of the two empty niches prompted a subscriber to write to the local press on 19 November to convey his disgust that the Clock Tower had 'been allowed to remain in an unfinished condition now for nearly half a year.'[49] Though Barfield had not been directly criticised by the correspondent, it was obvious that it was the absence of the full complement of statues that was the chief cause of his complaint. With the installation of the third statue, the *William Wyggeston*, shortly afterwards on 4 December,[50] the editor of the *Leicester Chronicle* felt justified in devoting some considerable column inches to a defence and appreciation of Barfield. He pointed out that the sculptor had, despite what had been implied, made 'speedy progress'. In the short period of seven months that he had been at work on the statues he had completed and installed three and was likely to have the fourth

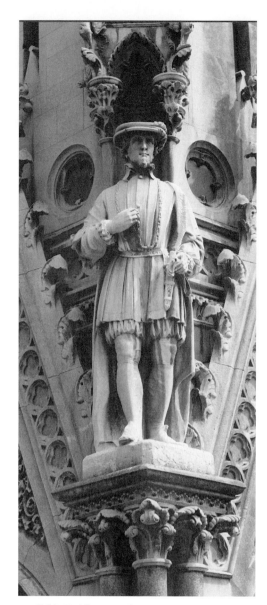

Barfield, *Sir Thomas White*

installed within a few weeks. The editor also pointed out that the £37. 10s. 0d. Barfield had charged for each was 'certainly not a large sum for statues of that size and elaborate workmanship'.[51]

Although the exact date is not known for the installation of the *Alderman Newton*, the last remaining statue, it would seem likely that it was installed in either December 1868 or January 1869.[52] The last non-sculptural parts of the Clock Tower to be completed, the ironwork and the clocks, were in place by December 1868 and early 1869 respectively. In all, 472 subscribers had contributed £872. 2s. 9d, the balance of the £1,000, plus about £200 for the clocks, being supplied by the Corporation.[53]

In 1992 the *Haymarket Memorial Clock Tower* was restored by Leicester-based architects and engineers Pick Everard. They chose the restoration of the Clock Tower as a project to mark the 125th anniversary of their practice and made substantial contributions towards the costs of the work.[54] The contractors for the restoration were Herberts (Masonry Contractors) Ltd.

Literature
Leicester City Council. Various documents relating to the 1992 refurbishment of the *Haymarket Memorial Clock Tower*; press cuttings: *L. Mercury*: – [i] 15 January 1992 [ii] 17 October 1992.
LRO. *Council Minutes*, 1 January 1866 – 11 May 1869, pp.300–2, 316–19; *Four Benefactors of Leicester and their Memorial ...*, 1868; *Highway ... Committee Minutes*, 16 August 1867 – 25 June 1868, pp.269, 329, 364–5, 373, 416, 423, 432–3, 443, 454; *Special Committees Minutes*, 21 February 1855 – 4 November 1874, p.297.
General. Banner, J.W., 1991, pp.71–80; Banner, J.W., 1994, pp.56–7, 60, **56**; Brandwood, G. and Cherry, M., 1990, pp.28, 59, 60, **60**; *Builder*: – [i] vol. xxvi, no. 1301, 11 January 1868, p.35 [ii] vol. xxvi, no. 1352, 2 January 1869, p.8 [iii] vol. lxxii, no. 2835, 5 June 1897, p.498; Darke, J., 1991, p.177; *The East-Gates Improvement and the Haymarket Memorial Clock Tower, Leicester. A Sketch ...*, 1871; Gerrard, D., 1996, p.61, **61**; *L. Chronicle*: – [i] 4 January 1868, p.8

[ii] 18 January 1868, p.1 [iii] 8 February 1868, pp.1, 5 [iv] 21 March 1868, p.5 [v] 18 April 1868, p.3 [vi] 25 April 1868, pp.6, 8 [vii] 2 May 1868, p.6 [viii] 6 June 1868, p.6 [ix] 13 June 1868, pp.5, 8 [x] 20 June 1868, p.6 [xi] 5 December 1868, p.8 [xii] 26 December 1868, p.3; Leicester City Council, 1997, pp.136–7, **137**; *L. Journal*, 20 March 1868, p.8; *L. Mercury*: – [i] 10 November 1921, p.9 [ii] 16 March 1998, p.10; McKinley, R.A., 1958, p.351; *M. Free Press*: – [i] 7 September 1867, p.4 [ii] 2 November 1867, p.4 [iii] 4 January 1868, pp.4, 5, 8 [iv] 13 June 1868, p.7 [v] 21 November 1868, p.5 [vi] 28 November 1868, p.5 [vii] 12 December 1868, p.5; *Modern Memorials. Leicester ...*, 1875, pp.3–25; Pevsner, N. and Williamson, E., 1992, pp.229–30; Read, R., 1881, p.16; Simmons, J., 1965–6, pp.47–9; Simmons, J., 1974, vol. ii, pp.48–9, 69, 79, 83, 149–50; *Spencers' ...Guide to Leicester*, 1878, p.148 (engr. opp. p.146); Wilshere, J.E.O., 1974.

Notes
[1] *Spencers' ...Guide to Leicester*, 1878, p.148.
[2] The dates associated with Newton, White and Wigston are supposed to be the dates of their donations; all, however, are inaccurate. [3] *Ibid.*, 13 June 1868, p.5. [4] *Ibid.*, 26 December 1868, p.3. [5] *L. Chronicle*, 26 December 1868, p.3. [6] *L. Mercury*, 17 October 1992. [7] For the Haymarket site in 1862, i.e., before the demolition of the old buildings, see photographs Nos 1 and 2 in Broadfield, A., 1978. [8] Wilshere, J.E.O., 1968, p.2. [9] Note Burton's premises opposite the Clock Tower in the frontispiece engraving in *The East-Gates Improvement ...*, 1871. [10] *Ibid.*, p.18. [11] *Ibid.*, pp.12–13, 14–15. [12] *Ibid.*, p.24. [13] *M. Free Press*, 7 September 1867, p.4. 'Observer' is presumably none other than John Burton; the same sobriquet being adopted by the writer of a letter to the *Leicester Chronicle* on February 6 1868 (p.5), advising the readership of the latest development in the 'Haymarket Structure' subscription. [14] *The East-Gates Improvement ...*, 1871, p.34. [15] *Ibid.*, p.33. [16] *Ibid.*, p.36. [17] *Ibid.*, p.37. [18] *Ibid.*, p.35. [19] *Ibid.*, p.36. [20] *Ibid.*, pp.35–6. [21] *M. Free Press*, 2 November 1867, p.4; *The East-Gates Improvement ...*, 1871, p.38. [22] *M. Free Press*, 2 November 1867, p.4. As, no doubt, an incentive to potential subscribers, Burton also listed the generous subscriptions already promised – 'though no formal application for Subscriptions has as yet been made'. [23] *The East-Gates Improvement ...*, 1871, p.38. [24] *Builder*, 11 January 1868, p.35. [25] *Ibid.*, 2 January 1869, p.8. [26] *The East-Gates Improvement ...*, 1871, p.38. [27] *Council Minutes*, 1 January 1866 – 11 May 1869, pp.300–2. [28] *Ibid.*, p.316. [29] *Ibid.*

[30] *L. Chronicle*, 4 January 1868, p.8. [31] Councillor Kempson, as reported in the *L. Chronicle*, 4 January 1868, p.8. [32] Councillor Thompson, as reported in *ibid.* [33] *Council Minutes*, 1 January 1866 – 11 May 1869, pp.316–19. [34] *Builder*, 11 January 1868, p.35. Interestingly, they made no capital out of the fact that Goddard was not just a competing architect, but also a member of the Haymarket Structure Committee (for the complete list of committee members, see *M. Free Press*, 2 November 1867, p.4). [35] 'Clock Tower Committee' minutes in *Special Committees Minutes*, 21 February 1855 – 4 November 1874, letter inserted between pp.298/299; copy in *Council Minutes*, 1 January 1866 – 11 May 1869, p.317. [36] *Highway ... Committee Minutes*, 16 August 1867 – 25 June 1868, p.269. [37] *L. Chronicle*, 18 January 1868, p.1. [38] *Ibid.*, 8 February 1868, p.5. [39] *M. Free Press*, 4 January 1868, p.4. [40] The smaller columns at the angles of the tower were eventually made from polished serpentine (*Builder*, 2 January 1869, p.8). [41] *L. Chronicle*, 8 February 1868, p.5. The cost was even further increased when the Corporation Highway Committee approved the Memorial Committee's request to have the height of the spire increased by five feet in April 1868. In his letter to the Highway Committee, dated 24 April 1868, Burton explained that though the architect's model had looked perfectly satisfactory, the foreshortening of the actual structure made the spire as planned look 'disappointing' (*Highway ... Committee Minutes*, 16 August 1867 – 25 June 1868, pp.364–5). [42] *The East-Gates Improvement ...*, 1871, p.39. [43] *L. Journal*, 20 March 1868, p.8. [44] *L. Chronicle*, 13 June 1868, p.5. [45] The editor of the *L. Chronicle* (5 December 1868, p.8) pointed out that Barfield had 'only received the final order for the figures seven months ago'. [46] *L. Chronicle*, 20 June 1868, p.6. [47] *Ibid.*, 5 December 1868, p.8. The painted portrait of Sir Thomas White is by an unknown painter of the British School and is dated on the frame, 1616. [48] *Ibid.*, 26 December 1868, p.3. [49] *M. Free Press*, 21 November 1868, p.5. [50] *L. Chronicle*, 26 December 1868, p.3. [51] *Ibid.*, 5 December 1868, p.8. See also Wilshere, J.E.O., 1968, p.9. [52] The dates of installation of the *Simon de Montfort* and *William Wyggeston* statues were given in the *Leicester Chronicle*, in its 'Local Chronology' for 1868, included in its edition for 26 December 1868 (p.3). The *Sir Thomas White* was not mentioned, although the same paper for 5 December 1868 (p.8) had reported that three statues were by then installed with *Alderman Newton's* expected to be shortly. [53] Wilshere, J.E.O., 1968, p.9. [54] Leicester City Council, 1997, p.137.

Beneath the steps to the Haymarket Theatre, outside the Haymarket Shopping centre:

Sculpture

Sculptor: Hubert Dalwood

Sculpture in stainless steel
h. 4.04m (13'3"); w. 3.2m (10'6"); d. 2.39m (7'10")
Unveiled: Wednesday 24 July 1974, by Mrs Irene Pollard, Lord Mayor of Leicester
Status: not listed
Owner / custodian: Leicester City Council

Description: Abstract sculpture, the form of which, in the words of the sculptor,

> echoes the horizontal and vertical structure of the architecture [of the Haymarket complex] ... the plane elements in the sculpture, although their general configuration is rectangular, produce a very strong diagonal in the composition which contrasts with the structure of the building and helps to focus attention at the principal entrance [to the Haymarket] ... the structure of the sculpture is analogous to the structure of the tree [under which it is to stand]: although it embodies in its composition the geometric structure of the architecture the total effect is more organic than architectonic ...[1]

Condition: The surfaces are rather grimy. The 'sleeve' section at the base of the sculpture bows out slightly producing a crevice between its top edge and the shaft of the sculpture. This may or may not be intended, but dirt and other small debris have collected in the gap thus formed. There are, in addition, scratch marks and some sprayed green pigment at a height of *c.*5ft on the side facing the road, and remains of stickers adhere to all sides.

History: In early 1972, Leicester consultant surgeon Paul Hickinbotham and his wife Catherine, offered £3,000 to the City of

Dalwood, *Sculpture*

Leicester towards the cost of erecting a contemporary sculpture in the Haymarket, then under development. In recommending acceptance of this offer to the Corporation's Haymarket (Special) Committee, the City Architect suggested that the most appropriate site would be in front of the entrance to the Haymarket Theatre.[2]

Although the benefactors did not expect the Corporation to contribute to the cost of the piece, the offer was made on condition that it find at least one more contributor and to this

end, in December 1972, Leicester City Council's Museums and Libraries Committee made a successful appeal to the Arts Council of Great Britain.[3] The Arts Council offered an immediate sum of £500 to fund a limited competition. Four sculptors were to be invited to submit maquettes and, should agreement be reached between the Arts Council, Leicester City Council and Mr and Mrs Hickinbotham over which sculpture should be selected, the Arts Council pledged to contribute a further £1,500 from its Sculpture for Public Places Fund.[4] In addition to this, the Museums and Libraries Committee, being fully supportive of the scheme, agreed to allocate up to £250 from its budgets to cover such expenses as the incidental costs of the competition and site preparation.[5]

By March 1973, the Museum and Libraries Committee had commissioned four sculptors to prepare models and had formed a small selection committee to judge the results.[6] The selection committee's choice of Hubert Dalwood's model was endorsed by the Museums and Libraries Committee at its meeting of 18 May 1973[7] and at its meeting on 26 June 1973, the Haymarket (Special) Committee, in consultation with the City Planning Officer and the Haymarket architect and developer, gave its approval for the erection of the sculpture 'adjacent to the entrance to the Haymarket Theatre ... subject to the precise siting being agreed and to a tree or trees being planted'.[8]

Dalwood's proposal, dated March 1973, pays meticulous attention to his sculpture's immediate surroundings, with the architectonic lines of the Haymarket complex behind and the organic form of the tree beside it:

> Although the major dimension of the whole Haymarket complex is horizontal, there are very important vertical elements, such as the exposed columns, that act as a counterpoint

to the mass of the building, emphasise its structure and give it tension and delicacy.

The angling of the facade, besides taking advantage of the site, helps to relate the scale of the building to its environment and give it more interest and variety.

In the general composition the proposed planting of a large tree plays a very important part and I have taken the architect's proposal very seriously ...[9]

He also explained that he had chosen stainless steel because of its 'high degree of corrosion resistance', its 'hardness [that] makes it virtually vandal-proof' and its surface from which 'graffiti is easily removed'. Furthermore, it had aesthetic appeal: '[Steel] is an intrinsically beautiful material which would contrast well with the surrounding brick-work'.

In addition to his written proposal, the sculptor submitted a drawing of the sculpture in its proposed situation along with two maquettes. He also undertook to construct as a preliminary measure a full-scale wooden model of the sculpture so that he and the architect could judge it *in situ* and make any necessary adjustments.[10] It was probably at this point that the height of the sculpture was increased when it was realised that the diagonal elements in the upper part would pose a potential hazard to the heads of taller passers-by.[11] That the height was increased is borne out by surviving photographs of the sculptor's model, one of which has a scale cut-out figure of a man standing beneath it.[12] Not only does the model's upright appear very much shorter, it lacks the 'sleeve' around the base of the sculpture as erected.

In her speech at the unveiling, Leicester's Lord Mayor, Mrs Irene Pollard, suspected that the sculpture would be 'controversial and stimulating' but hoped the people of Leicester would 'above all ... appreciate it'.[13] Her suspicion was certainly confirmed, but it is

difficult to assess whether her hope was ever realised. Almost a year later, Dalwood's sculpture was the subject of an editorial article in the *Leicester Mercury*, the writer endorsing the continuing popular bemusement over the piece while at the same time, with the sardonic tenor of his presentation, deliberately undermining an attempted explanation of the sculpture's relevance to the present time from the East Midlands Arts Association's Visual Arts Officer. Ironically, given the almost universal opprobrium that has been heaped on the *Statue of the Duke of Rutland* (see pp. 142, 144) from the moment of its completion, it was this that both the editorial writer and a correspondent to the newspaper put forward as a paradigm for public sculpture. The editorial writer complained, 'We ... have never understood [the Haymarket sculpture] in the way that we have ... the statue of the Duke of Rutland', while the correspondent suggested, 'Scrap the Haymarket sculpture and put the good old duke in its place'.[14] Such protests were not, however, heeded and Dalwood's sculpture remains in place as the only major piece of abstract sculpture in Leicester's city centre.

Literature
LRO. *Museums and Libraries Committee Minutes*, June 1967 – February 1974, pp. 339, 365, 377; *Special Committees Minutes*, May 1970 – February 1974, pp. 61, 109–10.
Leicester City Council archives. Artist's statement; photograph of artist's maquette.
General. *L. Mercury*: – [i] 21 May 1973, p. 9 [ii] 25 July 1974, p. 10 [iii] 12 March 1975, p. 16 [iv] 19 March 1975, p. 4; Strachan, W.J., 1984, p. 150, **150**.

Notes
[1] From Dalwood's proposal to Leicester City Council, 'Designs proposed by Hubert Dalwood', dated March 1973 (Leicester City Council archives). [2] *Special Committees Minutes*, May 1970 – February 1974, p. 61 (meeting of the Haymarket [Special] Committee, 10 February 1972). [3] *Ibid.*, p. 109 (meeting of the Haymarket [Special] Committee, 26 June 1973). [4] *Museums and Libraries Committee Minutes*, June 1967 – February 1974, p. 339 (meeting

of 17 November 1972); *Special Committees Minutes*, May 1970 – February 1974, p. 110 (meeting of the Haymarket [Special] Committee, 26 June 1973). [5] *Special Committees Minutes*, May 1970 – February 1974, p. 110 (meeting of the Haymarket [Special] Committee, 26 June 1973). [6] *Museums and Libraries Committee Minutes*, June 1967 – February 1974, p. 365 (meeting of 16 March 1972). [7] *Ibid.*, p. 377. [8] *Special Committees Minutes*, May 1970 – February 1974, p. 110 (meeting of the Haymarket [Special] Committee, 26 June 1973). [9] 'Designs proposed by Hubert Dalwood', dated March 1973 (Leicester City Council archives). [10] *Ibid.* [11] Information from Michael Parr. [12] Leicester City Council archives. [13] *L. Mercury*, 25 July 1974, p. 10. [14] *Ibid.*, 12 March 1975, p. 16.

High Street

Shop premises, No. 12 High Street (currently occupied by Irish Menswear Ltd), at the junction of High Street and Silver Street, built in 1896 by Goddard and Company for Paget Trustees

The pilasters between the three-light windows of the upper storey are decorated with **winged caryatids** supporting the cornice.

Sculptor: unknown

Status of building: not listed
Owner of building: Irish Clothing Co. Ltd.

Literature
Brandwood, G. and Cherry, M., 1990, pp. 91–2, 112, **93**; Leicester City Council, 1997, p. 136, **136**.

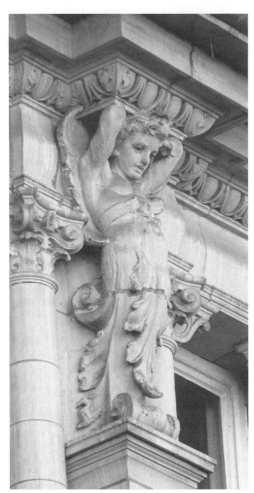

No. 12 High Street: architectural sculpture

On a shelf in the main hall, to the right of the entrance:

Bust of Thomas Paget

Thomas Paget (1778–1862), founder of Messrs Paget & Co's bank, was born 30 December 1778 at Ibstock, Leicestershire. Early in life he espoused a keen interest in radical politics and in 1831 became MP for Leicestershire South (having been defeated the previous year), resigning, however, in 1832 once he had seen the achievement of the two principal objectives of his political life: the enfranchisement of the upper middle classes and the successful passing of the Parliamentary Reform Act of 1832. In 1836, Paget was appointed JP and elected Mayor by Leicester's new corporation (instituted following the passing of the Municipal Corporation Act of 1835). He was re-elected for a second term in 1837, elected alderman in 1841 and was elected Borough Treasurer in 1854–62. He died 25 November 1862 and was buried at Ibstock.

Sources: *Gentleman's Magazine*, March 1836 (obituary); Hartopp, H., 1935; *MEB*, vol. vi.

Sculptor: Samuel Barfield

Bust in Carrara marble
Bust: h. 49cm (1'7"); w. 52cm (1'9"); d. 29cm (1')
Socle: h. 13cm (5")
Inscription on a wooden plaque beneath the bust, in gold lettering in an ornate 'Gothic' style:
The Late THOˢ PAGET Eˢᑫ / FOUNDER of the BANK / of Mᴱˢˢᴿˢ PAGET & CO / * * * ESTABLISED 1825.
Signed on the rear of the bust: S. Barfield Sculpʳ
Executed: (?)after 1862
Status: not listed
Owner: Lloyds Bank Plc

Description: Portrait bust mounted on a circular socle. Paget looks straight ahead with un-incised eyes. He wears a frock coat, waist-coat, wing-collared shirt and tie. In the button-hole of his left lapel is a flower with two leaves.

Condition: The points of both wings of the collar are lost. The left rear segment of the lower rim of the socle has, at some time, been broken off and re-fixed.

History: The bank founded by Thomas Paget (alluded to in the inscription on the present bust) was Pagets and Kirby. It opened for business on 19 February 1825 in Friar Lane, moving shortly afterwards to premises on the site of the present building. Following Thomas Paget's death in 1862 his son, Thomas Tertius Paget, succeeded him as principal partner. Shortly before the son's death in 1892 he entered negotiations with Lloyds of Birmingham. In 1895 Lloyds took over, erecting a new classically-styled building on the same site in 1903–6.[1]

Note
[1] Information from Valerie Jacques, Lloyds TSB, 28 July 1999.

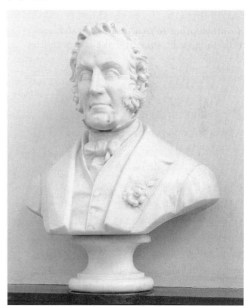

Barfield, *Thomas Paget*

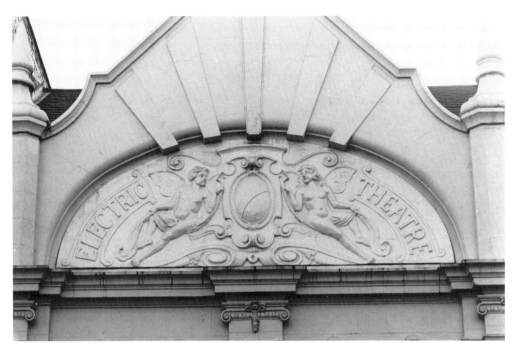

Electric Theatre: tympanum sculpture

Former Electric Theatre, 1910, by Ward and Bell

The entrance elevation is surmounted by a pediment containing a *sculptural relief*.

Modeller / sculptor: unknown

Status: not listed
Owner of building: Canada Life Ltd

Literature
Leicester City Council, 1975, p.54, **54**; Williams, D.R., 1993, pp.55–8, **56**.

Hinckley Road

Wyggeston's Hospital

In the entrance foyer:

Statues of Two Charity School Children

Sculptor: unknown
Manufacturer: Coade of Lambeth

Two statues in Coade stone
Boy: h. 1.46m (4'10"); w. 50cm (1'8"); d. 32cm (1'1")
Girl: h. 1.24m (4'1"); w. 41cm (1'4"); d. 36cm (1'2")
Inscriptions on the front faces of the bases:
Schoolboy: COADE'S *LITHODIPYRA* 1787.
Schoolgirl: COADE'S *LITHODIPYRA* 1787.
Status: not listed
Owner: Wyggeston's Hospital

Description: Two children in eighteenth-century charity school uniforms. The *Boy* stands with his weight on his right leg, his left leg bent at the knee, holding a book in his right hand and a hat in his left. He is bare-headed and wears a long outer coat, waistcoat and cravat, breeches and buckled shoes. The *Girl* stands with her weight on both legs, feet slightly apart. She holds an open book in both hands, angled downwards so that the viewer can see the pages (faintly incised with lines suggestive of columns of type). She wears a cap, a close-fitting tunic decorated at the front with a large bow, and a full-length skirt and apron.

Condition: The surfaces of both figures are considerably blackened. Although they are in relatively good condition considering their age, the figure of the schoolboy has suffered more than that of the girl: the lowest 7cm of the left end of his cravat is lost, his left foot is cracked right across the instep (perhaps an old repair), the rim of his hat is chipped at the rear, and there is a small chip out of the hem of his jacket (below the buttons on the right side near the bottom). The schoolgirl has some superficial chips out of her left cheek and jaw.

History: The *Two Charity School Children* were originally on the frontage of St Martin's Church of England School in Friar Lane where they occupied adjacent niches under a single gable.[1] The school was closed in the late 1950s and the figures were relocated to Wyggeston's Hospital, although it is not known when, by whom or by what means the transfer was made.

These are from the same model as the figures at St John the Baptist Church of England Primary School (see pp.95–7) and are identical to them with the exception of the inscriptions which here give the date of manufacture, 1787, and state the material as 'Lithodipyra', a term, according to Alison Kelly, used by Mrs Coade in the late 1780s and 1790s. The term comes from three Greek words, *litho* (stone), *di* (twice) and *pyra* (fire) and is broadly descriptive

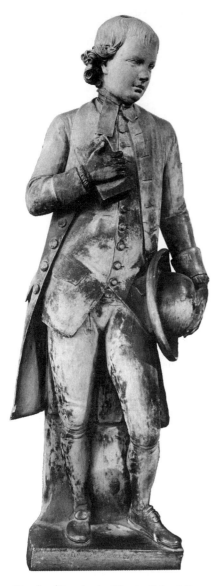

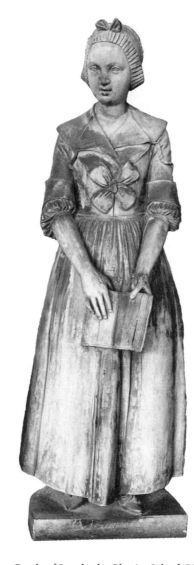

of the process of manufacture (the specific nature of which was, however, a well-kept secret). Coade stone (or 'Lithodipyra') is a form of stoneware. Two of its constituent parts are pre-fired clay ground to a powder (otherwise known as 'grog') and crushed glass. These are then mixed by the addition of water with other materials to form a kind of clay, which is then modelled and fired – thus the clay and glass are the twice-fired elements referred to in the term. The benefit of using pre-fired clay is that it does not shrink when fired again, thereby reducing considerably the overall shrinkage of the clay mixture.[2] The ultimate benefit of Coade stone, however, as is attested by the relatively good state of both sets of *Charity School Children*, is its durability – it being unsusceptible to frost and virtually impervious to weathering.

Related works (from the same model): *Statues of Two Charity School Children*, St John the Baptist Church of England Primary School, East Avenue, Leicester (see pp.95–7).

Literature
Burton, D.R., 1994, p.**152**; Kelly, A., 190, pp.56–7; Thawley, J., 1997, p.93.

Notes
[1] See photograph in Burton, D.R., 1994, p.152.
[2] Kelly, A., 190, pp.56–7.

Note: also in the foyer is a large relief panel illustrating the main events of the hospital's history, commissioned from George Wagstaffe in 1965.

Coade of Lambeth, *Charity School Boy*

Coade of Lambeth, *Charity School Girl*

Horsefair Street

No. 10 Horsefair Street, at the corner with Every Street, Barclays Bank, by A.E. Sawday, 1900

Over the main entrance, within a double-curved pediment:

Carved tympanum

Sculptor: unknown

Tympanum relief in stone
h. 1.93m (6'4"); w. 2.35m (7'9") (est.)
Status: Grade II
Owner of building: Barclays Bank Plc

Description of sculpture: Two figures seated back-to-back either side of the keystone of the main entrance archway, their upper torsos turned towards the viewer. On the left a male figure raises his right arm to adjust a ribbon of drapery fluttering across his upper chest. His left arm is lowered to his side. On the right a female figure rests her right hand on some scroll-like decoration upon which she sits, her left arm above her head, handling another ribbon of drapery. Her long hair flows in decorative swirls around her shoulders. The plaster frieze decorating the interior of the bank continues this classically-derived theme with putti and decorative scrolls and ribbons, etc.

Condition: The mortar cementing the masonry blocks that make up the tympanum appears to be crumbling. All surfaces of the relief are very weathered. The toes of the right foot of the male figure, carved on one of the voussoirs, are becoming detached, the join between the voussoir and the block with the rest of the foot cracking somewhat. The toes of the right foot of the female figure, also on a separate voussoir, are missing.

Literature
Gill, R., 1994, p.7.

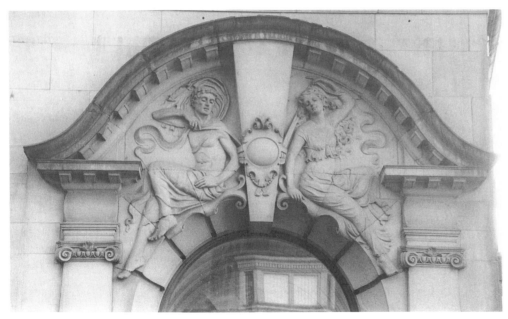

Barclays Bank: tympanum sculpture

Hotel Street

City Rooms (firstly Assembly Rooms then, until 1987, County Rooms), 1792–1800, by John Johnson

Status of building: Grade I
Owner of building: Leicester City Council

Originally intended as a hotel (hence the name of the street), the promoters ran out of money even before construction was completed and had to sell the building to a company that opened it as a public assembly rooms. In 1817 the company sold the building to the county justices after which it was used as lodging for visiting judges and perhaps also as an archive repository.[1] In 1888 ownership passed to Leicestershire County Council, generating a further change of name to the County Rooms. Finally, in 1986, the building was transferred to the City Council, and in the following year, re-opened as the City Rooms.

Literature
LRO. *Letter, John Johnson to Sir Edmund Cradock Hartopp, Bt., 1799; Hotel and Assembly Rooms, Leicester, letter and subscription list, 1800.*
General. Briggs, N., 1991, pp.51, 105, 136; *The Hotel that never was*, n.d.; Leicester City Council, 1975, p.13, **13**; Leicester City Council, 1997, pp.59–60, **58**, **60**; McKinley, R.A., 1958, p.363; Nichols, J., 1815, vol. I, pt ii, pp.533, 534, **528**; Pevsner, N. and Williamson, E., 1992, p.222; Simmons, J., 1949, pp.155–6; Simmons, J., 1974, vol. i, p.140; *Spencers'...Guide to Leicester*, 1878, p.72; *Spencers' New Guide ...*, 1888, p.137.

Note
[1] McKinley, R.A., 1958, p.362.

1. Exterior
On the façade, at first-floor level, in niches either side of the entrance bay:

Music and Dancing (also known as the *Comic Muse* and *Lyric Muse*)

Sculptors: John Charles Felix Rossi and John Bingley

Statues in artificial stone[1]
h. (est) 1.68m (5'6")
Executed: 1796[2]
Inscribed on the front of the oval base to the
figure in the left-hand niche:
ROSSI & BINGLEY

Description: Female figures, dressed
all'antica, in first-floor niches, to the left and
right of the entrance bay. The figure in the left-
hand niche plays a tambourine, while that in the
right plays a lyre. The identities of the figures
are not certain. Nichols, writing in 1815,
identifies them as the 'Comic and Lyric Muses',
that is, Thalia and Erato.[3] Unfortunately, Erato,
the Muse of lyric and love poetry, is
traditionally represented with both tambourine
and lyre, whereas Thalia, the Muse of comedy
and pastoral poetry is commonly identified
with neither – her chief attribute being the viol.[4]
Although Nichols was writing soon after the
execution of the figures and might be expected
to be closer to the truth, it is probably safer to
go with a more recent authority, Rupert
Gunnis, who referred to them simply as Music
and Dancing.[5]
Condition: The figure on the left has a
noticeable horizontal crack (or perhaps a join
between two sections) below the tunic, while
that on the right is missing the last joint of the
third finger of the left hand. Both figures have
been coated at some time in white paint or
whitewash, now flaking and worn. Both figures
have areas of black encrustation.
History: Rossi and Bingley entered into
partnership *c.*1790, specialising in works in
terracotta. The partnership seems not to have
been a success, however, and was later
dissolved.[6] As Rossi was later to tell his friend
Joseph Farington (a painter now better known
for his diaries): 'He [i.e., Rossi] was ... induced
to become a partner with a *Mason Sculptor* [i.e.,
Bingley] in John St. by which He lost much
money'.[7]

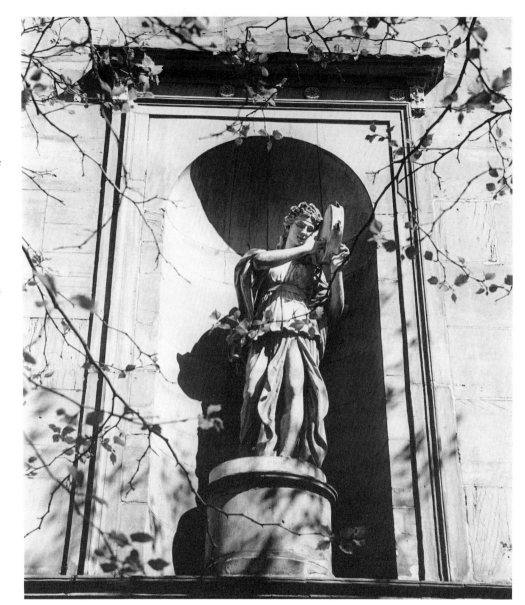

Rossi and Bingley, *Dancing*

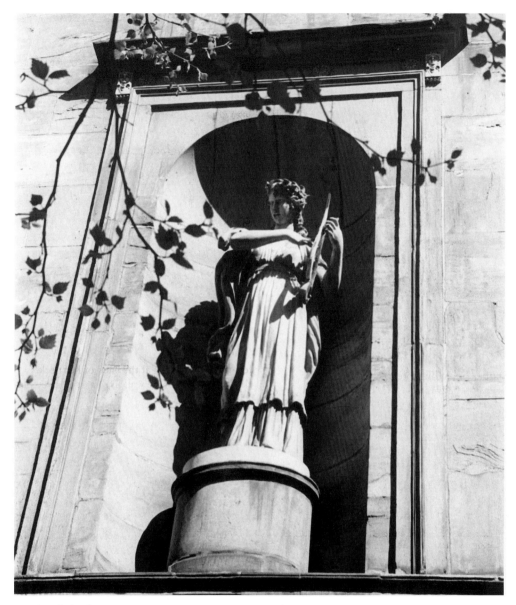

Rossi and Bingley, *Music*

Literature
Briggs, N., 1991, p.136; Darke, J., 1991, p.178; Cave,
K. (ed.), 1984, vol. xiv, p.4913; Gunnis, R., [1964],
pp.53, 326; Kelly, A., 1990, p.83; Leicester City
Council, 1975, p.13, **13**; Leicester City Council, 1997,
pp.58, **59**; *L. Mercury*, 30 September 1921, p.9;
McKinley, R.A., 1958, p.362; Nichols, J., 1815, vol. I,
pt ii, pp.533, **528**; Pevsner, N. and Williamson, E.,
1992, p.222; Simmons, J., 1949, pp.155–6.

Notes
[1] There is some disagreement as to the material.
Gunnis ([1964], p.326) states that they are of
terracotta, whereas Kelly (1990, p.83) states that they
'for once, are in natural stone'. The crisp condition of
the carving would, however, suggest that they are of
artificial stone, even if not Coade stone. [2] Gunnis,
R., [1964], p.326. [3] Nichols, J. 1815, pt. ii, p.533.
[4] See Hall, J., 1979, p.217. [5] Gunnis, R. [1964],
p.326. [6] *Ibid.*, pp.53, 326. [7] Cave, K. (ed.), 1984,
vol. xiv, p.4913; quoted in Gunnis, R., [1964], p.326.

Above the statue niches:
Reliefs after 'The Borghese Dancers'
Makers: Coade and Sealy

Reliefs in Coade stone
Dimensions: h. 53cm (1'9"); w. 1.12m (3'8")

Description: Two identical relief panels
representing five female figures dressed
all'antica, dancing in a line with hands linked.
These are free copies of the once-celebrated
Borghese Dancers, a classical antique relief panel
in marble, now rather less well-regarded and
relegated to the reserve collection of the
Louvre, Paris.[1] Haskell and Penny have
described the original as 'poor quality neo-Attic
work'.[2] The principal difference between the
original and the present reliefs is that the latter
have plain backgrounds, the figures in the
original being framed by a Corinthian
colonnade.

Condition: The left-hand panel has cracks
halfway down the right edge.

History: The present panels are listed in
Coade's Gallery, the 1799 catalogue published

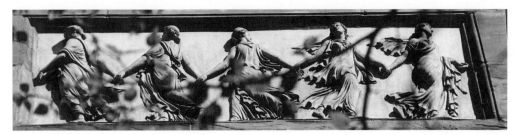

Coade and Sealy, *relief after 'The Borghese Dancers'*

by the Coade Artificial Stone Manufactory at Lambeth, as: '[No.] 85. A Pannel of the Hours, or dancing Nymphs – from the Villa Borghese – length 3ft. 8in. – wide 1ft. 9in.'

Coade's free copies after the antique panel, known from its provenance as the *Borghese Dancers*, were among their most popular designs.[3] John Nichols, writing in 1815, attributed the two panels on the City Rooms frontage to Rossi (i.e., J.C.F. Rossi, who, with J. Bingley, executed the niche figures below them).[4] Although this is plausible, given that Rossi did much work for Coade, it has not been possible to substantiate the attribution with documentary evidence.

Related works: According to Alison Kelly, other copies by Coade and Sealy were once at Moor Park, Badminton and Rokeby. A variant with four figures was made for architect James Wyatt, for the Orangery at Heveningham, Suffolk (still extant).[5]

Literature
Briggs, N., 1991, p.51; *Coade's Gallery…*, 1799, p.30; Haskell, F. and Penny, N., 1981, pp.195–6; *The Hotel that never was,* n.d., n. pag.; Kelly, A., 1990, pp.83, 96; Leicester City Council, 1975, p.13, **13**; Nichols, J., 1815, vol. I, pt ii, pp.533, **528**; Pevsner, N. and Williamson, E., 1992, p.222; Simmons, J., 1949, p.156.

Notes
[1] See Haskell, F. and Penny, N., 1981, pp.195–6.
[2] *Ibid.,* p.196. [3] Briggs, N., 1991, p.51. [4] Nichols, J., 1815, vol. I, pt ii, p.533. Pevsner, N. and Williamson, E., 1992, p.222, give the same attribution,

citing as their source Gunnis. However, Gunnis (1964, p.326) refers only to the statues, making no mention of the bas-reliefs. [5] Kelly, A., 1990, p.96.

2. Interior
(a) In the ballroom:
Statues in niches: Spring, Summer, Autumn, and Winter
Designer: John Bacon the Elder
Makers: Coade and Sealy

Statues in Coade stone
Statues (including integral bases)
Spring: h. 1.31m (4'4"); w. 53cm (1'9"); d. 30cm (1')
Summer: h. 1.28m (4'2"); w. 52cm (1'9"); d. 32cm (1'1")
Autumn: h. 1.32m (4'4"); w. 33cm (1'1"); d. 33cm (1'1")
Winter: h. 1.29m (4'3"); w. 35cm (1'2"); d. 35cm (1'2")
Pedestals: h. 45.5cm (1'6"); diam. 45cm (1'6")

Description: The statues are located in niches on the end walls of the ballroom, either side of a matching pair of carved chimney-pieces. They are all idealised standing figures of women, draped *all'antica* and holding lamps designed to resemble flaming torches; in each case the figure shields her hand with the drapery of her cloak. Each figure is secured to the back of its niche by a short chain fixed to the small of the back

and is mounted on a circular pedestal decorated with garlands and female heads modelled in relief and picked out in gold paint. The series begins with *Spring*, on the right-hand wall in the niche further from the window. *Spring* is personified as a young woman wearing sandals, her right foot forward. She holds the lamp aloft in her right hand. In her left hand, lowered by her side, she holds what appears to be a scroll (that part to the rear of her hand being complete, that to the fore seemingly broken off). She looks downwards, her hair styled with a fringe of ringlets over her forehead. Opposite, in the niche further from the window on the left wall, is *Summer*. She is a slightly more mature and altogether more active figure, barefoot and with her left heel raised as if stepping forward, her weight moving on to her right foot. Her right breast is exposed and her draperies flutter as if blown by a soft breeze. She holds the torch in her left hand. The drapery of her cloak flows across her in a loose swathe and is held in a bunch in her right hand. Her hair is parted in the centre and swept back into a bun with just a few ringlets hanging at the back of her neck. *Autumn*, on the same wall in the niche near the window, has a somewhat more matronly figure. Where the two preceding figures are bareheaded, she has her cloak pinned to the crown of her head. She too is barefoot, her right heel raised, but not as high as *Summer*, and appearing to move with a slower motion on to her left foot. Her right arm is folded across her stomach holding her drapery to her, while her left arm is folded in the opposite direction to hold the torch to her right (all torches being thus directed towards the centre of the room). *Autumn* presents a more closed composition than the two preceding figures. The series ends with *Winter*, in the window-side niche on the opposite wall. Again, this is a closed composition, with the figure's right arm folded across the upper torso to hold the torch at her left side and her left arm folded across to wrap

her drapery close around her. Her implied movement is altogether slower, the weight moving from the raised left heel to the right leg. Her cloak appears to be thicker, completely covering the top of her head and ending in a roll of doubled material over the forehead.

Condition: Overall, the condition is fair. All statues are coated in cream-coloured paint, applied thickly enough to have formed dried drips on the projecting parts of the draperies (see, for example, the right side of *Spring*). The join between *Spring*'s base and pedestal is flaking and deeply cracked (perhaps the result of a move at some time?); and the forward part of the 'scroll' held in her left hand appears to be lost. *Summer* has several small losses to the paint surface (and perhaps superficially to the stone itself): on the underside of the right breast, on the swathe of drapery across the upper thighs, and on the end of the drapery behind her left leg. There is some scuffing and cracking between the statue base and the pedestal, and some small losses to the cornice of the pedestal. *Autumn* also has some small paint losses: to the front of the right thigh and to the first joint of the big toe of the left foot. There are various superficial losses to the statue base and pedestal. The figure of *Winter* appears to have sustained no damage but there is some cracking where the statue base meets the pedestal. The 'torches' are modern electric lamps.

History: Figures representing the Four Seasons were advertised in *Coade's Gallery*, the 1799 catalogue published by the Coade Artificial Stone Manufactory at Lambeth. Each figure, 'from a model of the late Mr. Bacon' (i.e., John Bacon the Elder, Coade's chief modeller for about thirty years up to his death in 1799), is accompanied by an appropriate verse in Italian and is described as being 4 feet 3 inches in height.[1] The present figures are not signed and it seems to have been John Nichols who, in 1815, first stated that they were 'from

the designs of Bacon'.[2] Although Nichols did not give his source for this attribution, the correspondence between the heights of the figures of the Seasons in the catalogue and the measured heights of the present figures which clearly also represent the Seasons, would support that attribution. Furthermore, Bacon and the architect of the City Rooms, John Johnson, had been close friends, the sculptor carving, to the architect's design, the memorial to the latter's parents in Leicester Cathedral (1786).[3]

Literature
Briggs, N., 1991, pp.105, 136; *Coade's Gallery …*, 1799, pp.16, 17; McKinley, R.A., 1958, p.363; Nichols, J., 1815, vol. I, pt ii, p.533; Simmons, J., 1949, pp.155, 156, pl. opp. 156; Simmons, J., 1974, vol. i, p.140.

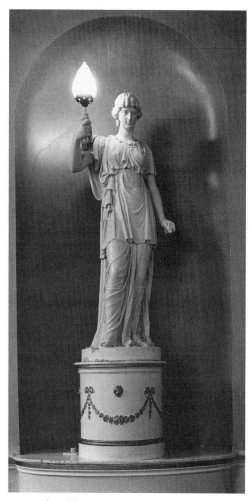

Bacon the Elder, *Spring*

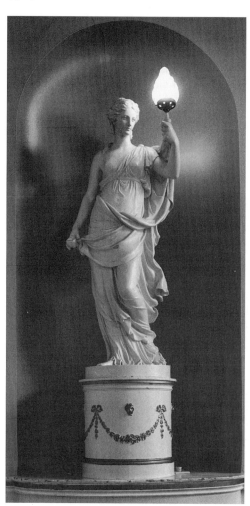

Bacon the Elder, *Summer*

Notes

[1] *Coade's Gallery...*, 1799, pp.16, 17. [2] Nichols, J., 1815, vol. I, pt ii, p.533. Both the 1878 (p.72) and 1888 (p.137) editions of *Spencers' Guide to Leicester*, in their descriptions of the ballroom, state: 'the statues and bas-reliefs were by Rossi, R.A.' This would appear to be a misreading of Nichols's description of the frontage where Rossi and Bingley's *Comic* and *Lyric Muses* stand in niches below bas-reliefs after *The Borghese Dancers* (the latter also attributed by Nichols to Rossi). The attribution of the ballroom figures to Rossi is followed by McKinley (1958, p.363). [3] *L. Mercury*, 18 March 1977, p.30; Pevsner, N. and Williamson, E., 1992, p.209.

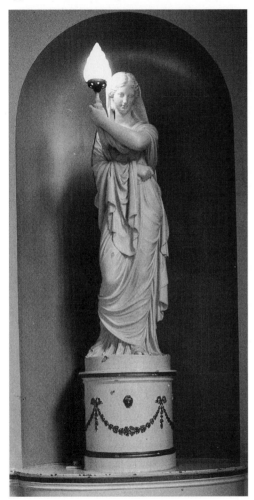

Bacon the Elder, *Autumn*

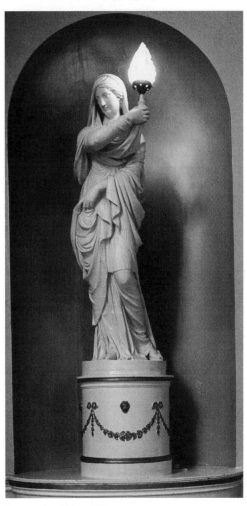

Bacon the Elder, *Winter*

(b) In the entrance hall, to the right of the staircase:

Ethelfloeda, Queen of the Mercians

Sculptor: Jack Newport, after B.J. Fletcher

Statuette in bronze on a pedestal in stone and concrete
Statuette, including socle: h. 61cm (2'); w. 15.5cm (6"); d. 12cm (5")
Pedestal: h. 1.03m (3'5"); dia. 54cm (1'9")
Inscription around the upper zone of the cylindrical pedestal:
(a) front: ETHELFLOEDA; (b) rear: EDITH GITTINS 1845 – 1910
Inscription on a brass plaque affixed to the wall to the left of the statuette:
ETHELFLEDA [*sic*] WAS THE DAUGHTER / OF KING ALFRED THE GREAT AND AS / A LEADER OF MERCIA SHE REPELLED / THE DANES FROM LEICESTER IN 918 A.D. / THIS BRONZE STATUETTE IS A REPLICA / OF THE FORMER ETHELFLEDA DRINKING / FOUNTAIN ERECTED ON VICTORIA PARK / IN 1922 AND PAID FOR FROM / MONEY LEFT BY EDITH GITTINS / 1845 – 1910 WHO WAS WELL KNOWN / LOCALLY FOR HER GENEROUS PUBLIC SERVICE.
Statuette signed and dated on the base at the feet of the figure, in cursive script: *Jack Newport 1979*, and around towards the front left, the letters: *L O*
Installed: March 1990
Status: not listed
Owner / custodian: Leicester City Council

Description: An imaginary portrait of Ethelfloeda, standing, dressed in period costume, holding a sceptre in both hands and wearing a crown. The lion's heads now attached to the pedestal are presumably those from the original fountain.
Condition: Good.
History: The present statuette is a replica of an earlier one that surmounted the *Ethelfloeda*

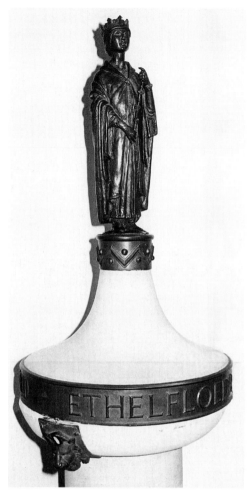

Newport (after Fletcher), *Ethelfloeda*

Fountain (The Edith Gittins Memorial Drinking Fountain) in Victoria Park, unveiled 3 August 1922 (see pp.324–5). The original bronze statuette was stolen in 1978. The decision was then taken to relocate the fountain, equipped with a replica statuette, to the newly-created Dolphin Square, at the rear of the Horsefair Street branch of the Trustees Savings Bank, next to the Market Place.

Jack Newport, a sculptor based in Cosby, Leicestershire, was commissioned to create a replica of the statuette, although given that he had no more than a small photograph to work from, his statuette is perhaps less a replica than an approximation. The replacement statuette cost £350 with funds provided by the Hickinbotham Trust.[1] The relocated fountain was unveiled on 20 August 1980 and, notwithstanding the statuette being fitted by the Council 'with a special anti-vandal device which should have made it burglar proof', it was stolen ten days later. This time, however, the theft was a practical joke and, following an anonymous telephone call to the *Leicester Mercury* the statuette was retrieved, having been left wrapped in a dustbin liner in the St George's Street car park opposite the newspaper's offices.[2] The statuette was replaced on the fountain but, after being twice more vandalised, the fountain was dismantled and the statuette placed in store until a safer location could be found for it. The City Council first proposed installing it in the foyer of their recently-acquired offices at New Walk (built speculatively in 1971–5 by Newman, Levinson and Partners).[3] It was felt, however, that the statuette was not in keeping with the starkly utilitarian design of the building and finally, in 1990, the decision was made to install the statuette and its original pedestal in the entrance hall of the City Rooms.[4]

Literature
Banner, J.W., 1991, p.96; Banner, J.W., 1994, pp.67, 95–6; *L. Mercury*: – [i] 3 August 1922, p.1 [ii] 4 February 1978, p.12 [iii] 21 August 1980, p.5 [iv] 1 September 1980, p.1 [v] 5 September 1980, p.1 [vi] 25 November 1987, p.8 [vii] 30 March 1990, p.3; *Leicester Trader*, 16 May 1984, p.4; *Sunday Extra*, 8 January 1984, p.1.

Notes
[1] *L. Mercury*, 21 August 1980, p.5. [2] *Ibid.*, 1 September 1980, p.1. [3] *Sunday Extra*, 8 January 1984, p.1. [4] *L. Mercury*, 30 March 1990, p.3.

On the pavement in front of the City Rooms:
The Leicester Seamstress
Sculptor: James Walter Butler
Founders: The Bronze Foundry (a.k.a. The Mike Davis Foundry)

Statue in bronze on a pedestal in concrete
Statue: h. 1.24m (4'1"); w. 1.06m (3'6"); d. 60cm (2')
Pedestal: h. 48cm (1'7"); w. 1.26m (4'2"); d. 81cm (2'8")
Inscription on the left long face of the pedestal:
THE LEICESTER SEAMSTRESS / JAMES BUTLER R.A. / 1990 / LEICESTER CITY COUNCIL
Signed and dated on the upper surface of the bronze base towards the rear:
The Leicester Seamstress / James Butler RA. 1990 [*followed by a monogram composed of the initials 'JWB'*]
Unveiled: Friday 29 June 1990, by the then Chair of Leicester City Council's Planning Committee
Status: not listed
Owner / custodian: Leicester City Council

Description: *The Leicester Seamstress* represents a life-size seated eighteenth-century hosiery worker sewing the seam of a stocking.

Condition: Good, apart from some small areas of loss at the corners of the pedestal.

History: *The Seamstress* was commissioned by Leicester City Council's Planning Committee, along with Kevin Atherton's *Conversation Piece* (see pp.110–11), as part of the Council's £30,000 City Centre Action Programme.[1] As a spokesman for the City Council explained to the local press at the time of the unveiling:

The statue is the first public work of art provided as part of Leicester's City Centre Action Programme ... the joint venture of the City and [County] Councils is a 10-year programme, which includes proposals to upgrade traffic management, tourism,

shopping and conservation in the city centre.[2]

The idea for the statue was formulated at a City Council sub-group meeting. Various ideas were floated, but it became clear that the majority favoured a statue that would reflect the early industry of Leicester. Michael Parr, then Assistant Director (Arts and Community), favoured a piece that would reflect the frequently overlooked female contribution, a suggestion that met with the committee's general approval.[3] Hosiery was Leicester's first and, until the second half of the nineteenth century, its sole industry of any significance. By far the greater number of people employed in the trade were women, most of them working in small workshops or at home. Thus it was agreed that the statue would be of a female hosiery worker.

A number of possible sculptors were considered, but the committee finally decided that James Butler, a sculptor who had already proved his ability with the *Statue of Richard III* at Castle Gardens (see pp.81–3), should be approached again. Michael Parr contacted Butler who accepted the £15,000 commission (this comprised a £10,000 artist's fee plus £5,000 to cover materials, manufacturing costs, assistants and transport).[4] Butler's first move was to begin researching Leicester's hosiery industry. It was initially proposed that the statue should be of a framework knitter. The sculptor, however, did not favour this idea as he considered that the machine's complex form would not work well as part of a public sculpture. Anyway, as he discovered (presumably much to his relief), the majority of framework knitters had been men. Women had for the most part been employed stitching seams – and this, Butler realised, provided a

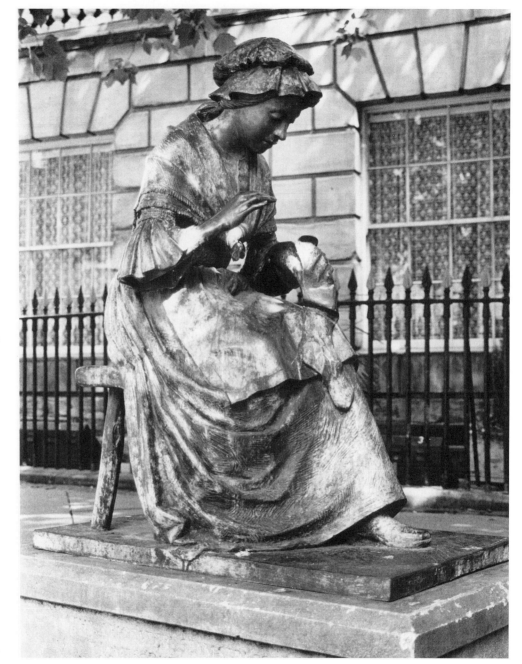

Butler, *The Leicester Seamstress*

subject much more suited to sculptural treatment. He first made some rough sketches using contemporary prints as preliminary guides. His wife, Angie, volunteered to sit for the more detailed maquette dressed in hired period costume. To ensure the costume was completely accurate for the finished bronze, Butler sought advice from the University of Leicester's history department.[5]

Unlike the contemporaneous groups forming *Conversation Piece*, which received a mixed reaction at their unveiling and were thereafter vandalised frequently until they were removed from the open streets (see p.111), *The Seamstress* found immediate favour with the public and remains to this day unvandalized.

Literature
Leicester City Council, Arts and Leisure Department. *The Leicester Seamstress* draft press release, dated 4 August 1989.
General. Leicester City Council, 1997, pp.61, **59**; *L. Mercury*: – [i] 22 April 1989, p.13 [ii] 10 August 1989, p.11 [iii] 6 November 1989, p.4 [iv] 30 June 1990, p.3.

Notes
[1] *L. Mercury*, 22 April 1989, p.13. [2] *Ibid.*, 30 June 1990, p.3. [3] Information from James Butler. [4] As recorded in an undated copy of the contract between Leicester City Council and James Butler (Leicester City Council, Arts and Leisure Department archives). [5] Information from James Butler.

Humberstone Gate

The Secular Hall, No. 75 Humberstone Gate, 1881, by W. Larner Sugden

Along the façade in aedicules set above the ground floor pier capitals are:

Busts of free-thinkers

Robert Owen (1771–1858), socialist and philanthropist, born in Montgomeryshire, Wales. He used his position as manager and later owner of New Lanark Mills to put his philanthropic schemes into practice. He was instrumental in bringing about the 1819 Factory

Vago, *Robert Owen*

Vago, *Thomas Paine*

Act and inaugurated socialism and the co-operative movement.

Thomas Paine (1737–1809), political writer, born in Norfolk, the son of a Quaker. He spent 1774–87 in America supporting the revolutionary cause, establishing his reputation with his pamphlet, 'Common Sense' (1776), on the causes of the war of independence. On his return to England he wrote 'The Rights of Man' (1790), in which his expressed sympathies with the French Revolution necessitated his flight to France to avoid prosecution. Here he entered French politics and wrote 'The Age of Reason' (1793). His opposition to the execution of

Louis XVI led to his arrest, although with the fall of Robespierre he was released and he returned to America where he spent his last years.

Voltaire (pseudonym of François-Marie Arouet, 1694–1778), French philosopher and writer whose challenge to accepted beliefs and traditions prepared the way for the French Revolution. His early writings offended the French authorities and he spent the years 1726–9 in England. On his return to France he published 'Philosophical Letters' which this time offended the priesthood. He was given asylum by the Marquise du Châtelet, spending

Vago, *Voltaire*

Vago, *Jesus Christ*

Vago, *Socrates*

the next 15 years at her castle at Cirey where he wrote 'Discourses of Man', 'Essay on the Morals and Spirit of Nations', and 'Age of Louis XIV', etc.

Jesus Christ (*c*.4 BC – *c*. AD 30), founder of Christianity, living mostly in Galilee, north Palestine. The main themes of his teaching were the imminence of the Kingdom of God and the fundamental importance of charity, sincerity, and humility, principles that received their most eloquent expression in his Sermon on the Mount. It is these latter principles, rather than a belief in his divine nature, that account for his importance to the Secular Society.

Socrates (469 – 399 BC), Greek philosopher. Although he himself wrote nothing, his teachings are known through the writings of his followers, e.g., Xenophon and Plato. He is supposed to have been compelled by the Athenian authorities to take his own life by drinking hemlock, having been found guilty of impiety and of corrupting the young.

Sculptor: Ambrose Louis Vago[1]

Busts in terracotta[2]
h. of each bust (est.):
Robert Owen: 54cm (1'9"); *Thomas Paine*: 60cm (2'); *Voltaire*: 65cm (2'2"); *Jesus*: 68cm

(2'3"); *Socrates*: 68cm (2'3")
Inscriptions: (i) on the front of *Robert Owen*'s bust, in incised Gothic letters:
R. Owen
(ii) in raised Roman letters on cartouches in the carved foliated decoration of the pier capitals below the aedicules containing the busts:
– extreme left pier capital: ROBERT OWEN
– second left pier capital: THOMAS PAINE
– third left pier capital: VOLTAIRE [the return of this capital, in the main entrance archway, is inscribed, in the same style:] FRANCOIS MICHEL / AROVET [*sic*]
– return and front face of the pier capital to the

right of the entrance archway: JESUS
– extreme right pier capital: SOCRATES
Status of building: Grade II
Owner of building: The Rationalist Trust

Description: Each bust is framed within an aedicule over a pier capital bearing the subject's name. All are represented with incised eyes, except for *Socrates*. *Robert Owen*, at extreme left, differs from the other four busts in that it is in pink terracotta (the rest being in orange), it is significantly smaller, and it is the only one inscribed with the subject's name on the front of the bust. The *Owen* bust is neo-classical in format, nude and cut away, term-like at the shoulders, the head turned slightly to the viewer's right. *Thomas Paine* is represented in period costume, with head turned slightly to the viewer's left. *Voltaire*, his head turned to the viewer's right, is portrayed with his hair encircled by a riband and wearing, around his shoulders, loose drapery. The head appears to be based on Houdon's celebrated statue of 1780.[3] *Jesus* is full-face, eyes gazing slightly upwards and to the viewer's left. The *Socrates* – bearded, snub-nosed, with one piece of drapery hanging over the right shoulder – appears to derive from one of the many antique Roman copies of a Greek original believed to be of the fourth century BC.[4]

Condition: The *Owen* bust has two deep cracks, one running across the left upper cheek and the bridge of the nose; another running vertically down the left side of the jaw and neck. The surface is blackened down the left side of the head, under the jaw and over the shoulders and throat. The *Paine* bust has a deep crack across the left upper part of the head and numerous hairline cracks; there is some blackening in the hollows and crevices. *Voltaire* has superficial cracks to the left upper shoulder, with some blackening in the hollows and crevices. The *Jesus* and *Socrates* busts are slightly blackened in the hollows and crevices.

History: The chief advocate of Secularism in nineteenth-century Leicester was Josiah Gimson (1818–83), the owner, with his brother Benjamin, of Leicester's largest engineering firm and, from 1878, of the Vulcan Works next to the Midland Railway Station. He was brought up as a member of the Unitarian Great Meeting but early on began to have serious doubts about the existence of God. It was the expression of these doubts that was the direct cause of his being debarred from speaking at the Temperance Hall and which, in turn, led to him and like-minded associates establishing the Secular Hall at Humberstone Gate.[5]

The opening of the Secular Hall (on 6 March 1881) was unsettling enough to some of the people of Leicester, but when they saw that Jesus had been appropriated to the Secularists' cause by virtue of his inclusion amongst the busts of exemplary secular freethinkers on the frontage of the new building, it caused a veritable scandal, condemned both from the pulpit and in letters to the local press. As one bewildered correspondent to the local press expressed it: 'I was considerably surprised and shocked ... to see the name of Jesus in such a position, and I am altogether at a loss to find how the Secularists can claim him as a teacher and expounder of their views of life.'[6]

Indeed, some Secularists were doubtful over the inclusion of Jesus among the ranks of secular freethinkers. Early in 1878, Josiah Gimson, a strong proponent of the view that Secularists could learn from Jesus, delivered a lecture entitled 'The Ethical Teachings of Christ testify to the all-sufficiency of Secular Conduct'. Evidently not everybody was convinced and later in the same year the Society held a debate, 'How Secularists may sit and learn at the feet of Jesus', in which Gimson asserted that Jesus 'was wholly and simply a Secular teacher' while J.H. Smith rejected Jesus as 'a mythical personage, and his doctrine as essentially supernatural'. Though Jesus

nevertheless got his place among the busts on the frontage of the hall, the matter was clearly still not settled among the Secularists for in January 1882 Gimson felt compelled to write a series of letters to the *Secular Review* defending the decision and maintaining his contention that 'Jesus enjoined the performance of right actions towards our fellowmen as our first duty, and that his gospel was moral rather than theological, and therefore Secularistic.'[7]

Taken as a whole the group was intended to 'stand in a general way for wholesome criticism, for revolt against priestly pretensions, and for endeavours after a happier social environment. They are types of great moral and intellectual activities.'[8]

Literature
Banner, J.W., 1991, p.67; Banner, J.W., 1994, p.58; *Builder*, vol. xl, no. 1991, 2 April 1881, p.418; Darke, J., 1991, p.178; Elliott, M., 1979, p.30; Elliott, M., 1983, figs **138**, **139**, **140**; Gould, F.J., 1900, pp.19, 20, 21, 24; Leicester City Council, 1975, p.15, **15**; *L. Mercury*, 6 April 1998, p.16; Pevsner, N. and Williamson, E., 1992, p.238; Simmons, J., 1974, vol. ii, pp.34–5; Stevenson, J., 1995, p.95.

Notes
[1] *Builder*, 2 April 1881, p.418. [2] *Ibid*. [3] A plaster, perhaps the original, is in the Bibliothèque Nationale, Paris, and there are two marbles, one in the Comédie Française, Paris, and the other in the Hermitage, St Petersburg (see Arnason, H.H., 1975, pp.51–2, fig 111, pls 54, 55, 56). [4] Examples are at Rome (Vatican Museums) and Naples (Museo Nazionale), etc. [5] Elliott, M., 1979, p.30. [6] As quoted in Gould, F.J., 1900, p.21. [7] *Ibid*. [8] *Ibid*.

Infirmary Close
Leicester Royal Infirmary

1. On the right side of the approach to the main entrance to the infirmary, high up on the end wall of the Department of Genito-Urinary Medicine (designed as the new casualty and X-ray department, 1954–6, by T.W. Haird of Pick Everard Keay and Gimson):

Healing Hands
Sculptor: Albert Pountney

Relief in Portland stone
h. 2.45m (8'1"); w. 1.85m (6'1"); d. 35cm (1'2")
Executed: *c*.1954
Status: not listed
Owner: Leicester Royal Infirmary NHS Trust

Description: High-relief sculpture of a woman in a hooded gown reclining across a colossal pair of open hands. The sculptor has unified his composition with the woman's gown, the hem of which he passes around behind the thumb of the colossal right hand, across the fronts of the wrists (thereby also concealing their truncated ends) and behind the wrist of the left hand. The relief consists of nine blocks of Portland stone, the blackened joins being clearly visible.

Below the relief, the foundation stone of the building, also in Portland stone, is inscribed: THIS STONE WAS LAID BY / J. REGINALD CORAH ESQ., M.B.E. / PRESIDENT OF THE LEICESTER / AND COUNTY CONVALESCENT / HOMES SOCIETY. 10TH. APRIL 1954

Condition: The stone is blackened in places with much green biological growth.

History: *Healing Hands* was commissioned by Leicester Royal Infirmary through the architects of the new wing of the hospital, Pick Everard Keay and Gimson. An undated photograph from the *Leicester Evening Mail*[1] shows Pountney, who was at the time of this commission Head of Leicester School of Art's sculpture department, modelling a one-third actual size maquette, in what is probably the school's sculpture studios in Richmond Street. Next to him is the foundation stone (see above), standing upright on two modelling stands, which, it has been suggested, he is using to provide him 'with the exact size against which to scale the sculpture in his mind's eye'.[2] The carving on the actual stone was probably carried out at a local stonemason's yard and

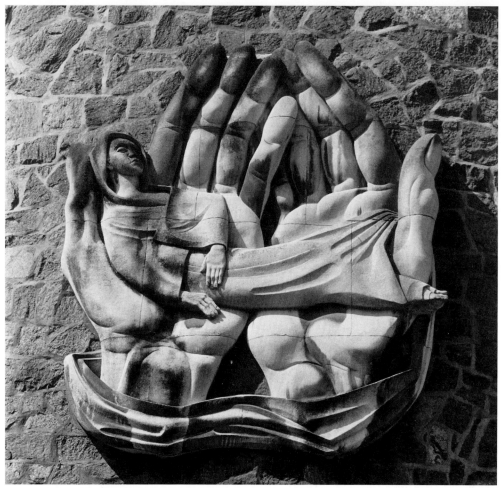

Pountney, *Healing Hands*

would, because of its size, have necessitated using assistants, although there are no known records of who these were. The lettering of the foundation stone may have been executed by the stonemason who supplied the stone or perhaps by Alec T. White, the art master at Gateway School, Leicester, who executed the lettering on Pountney's *Bond Memorial Plaque* (early 1950s), also in the Infirmary (see pp.318–19).[3]

The new building was opened by Princess Margaret on 29 October 1956.[4]

Literature
Banner, J.W., 1991, p.121; Frizelle, E.R. and Martin, J.D., 1971, p.217; *L. Mercury*, 19 September 1992, p.15; Pevsner, N. and Williamson, E., 1992, p.228.

Notes
[1] The photograph, in the possession of Jane Pountney, is stamped 'Proof from Leicester Evening Mail'. [2] Susan Tebby, De Montfort University. [3] I am indebted to Susan Tebby, De Montfort University, for the information regarding this sculpture and to Jane Pountney for the suggestion that the lettering may be by A.T. White. [4] Frizelle, E.R. and Martin, J.D., 1971, p.217.

2. In the Balmoral Building, Level O, courtyard:

Scales and Horizons

Sculptor: Peter Randall-Page

Sculptural group in Weldon stone
Max. h: 2.07m (6'10"); overall length of group: 9.14m (30')
Executed: 1982
Installed: Wednesday 20 April 1983[1]
Status: not listed
Owner: Leicester Royal Infirmary NHS Trust

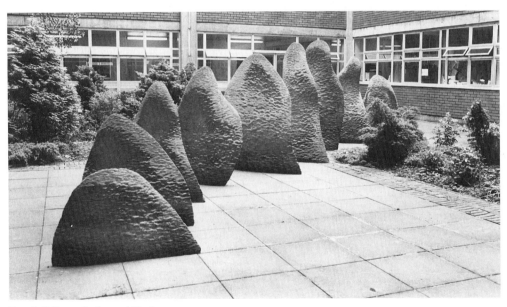

Randall-Page, *Scales and Horizons*

Description: *Scales and Horizons* is a sculpture in Weldon stone, comprising a line of twelve pieces, the smallest at the ends, the highest in the middle, 'representing the daylight hours in the months of the year'.[2]

Condition: Good.

History: *Scales and Horizons* was commissioned by Leicestershire Area Health Authority, through Edna Read of the City Gallery, Milton Keynes, with the assistance of East Midlands Arts and the Arts Council of Great Britain's Art for Public Places Scheme.[3] Randall-Page was appointed artist-in-residence to the hospital in 1982 and from April to June of that year lived-in to produce this, his first large-scale commission, specifically for the courtyard. The sculpture was commissioned as 'part of an arts project aimed at producing a better environment, both to make [the hospital] a pleasanter place and to discourage vandalism'.[4]

Literature
Financial Times, 14 August 1982, p.10, 10; Hamilton, J. and Warner, M., 1992, pp.25, 78, **25**, **78**; *L. Mercury*, 21 April 1983, p.20; Pevsner, N. and Williamson, E., 1992, p.228; Strachan, W.J., 1984, p.150, *150*.

Notes
[1] *L. Mercury*, 21 April 1983, p.20. [2] Information from Helen Stokes at Leicester Royal Infirmary, 2 July 1998. [3] *Financial Times*, 14 August 1982, p.10; Hamilton, J. and Warner, M., 1992, p.78. [4] *L. Mercury*, 21 April 1983, p.20; see also Hamilton, J. and Warner, M., 1992, p.25.

3. Balmoral Building, Level O, at the foot of the main concourse stairway:

Voyages of Discovery

Sculptor: Jim Robison

Sculptural group in stoneware with bronze lustre details
h. of tallest piece in group: 2.63m (8'10")
dimensions of enclosure: w. 4.49m (14'9"); d. 3.56m (11'9")
Executed: 1980
Status: not listed
Owner: Leicester Royal Infirmary NHS Trust

Description (from a printed sheet mounted in a clip-frame, fixed to the front face of the pillar at the right of the gravelled enclosure containing the group):

... 'Voyages of Discovery' is made from clay. It has been fired to stoneware temperature (1280° C) and refired (800°) to fuse the metallic bronze lustre glaze onto the small details. It is both strong and weather resistant with colour permanent and unaffected by sunlight. It does however retain the characteristics of stoneware pottery and should be treated as such.

The concepts behind the piece were inspired by standing stone circles such as those found at Avebury and Stonehenge. The bronze details suggest recorded wisdom and experience.

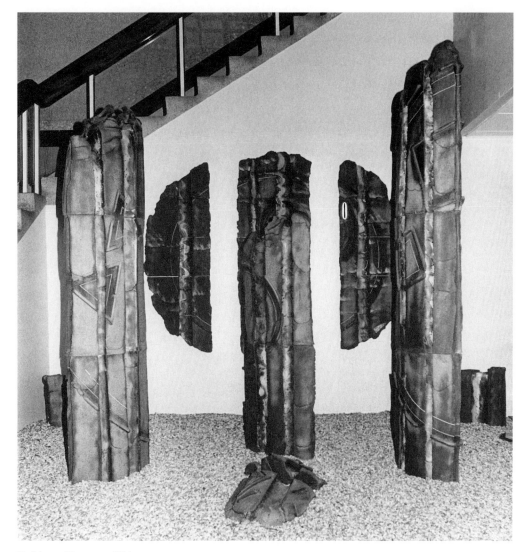

Robison, *Voyages of Discovery*

Some of the images are derived from everyday life, others suggest a 'creation' story and written messages. 'Voyages of Discovery' is about travel through life, and as with Egyptian hieroglyphs, Sumerian cuneiform inscriptions on clay tablets or drawings on prehistoric pottery the marks may be indecipherable but human and enjoyable to ponder ...

Condition: Good.
History: *Voyages of Discovery* was commissioned by Leicestershire Area Health Authority in 1980,[1] with financial assistance from East Midlands Arts.[2]

Literature
Pevsner, N. and Williamson, W., 1992, p.228.

Notes
[1] Information from Helen Stokes at Leicester Royal Infirmary, 2 July 1998. [2] As recorded on the clip-frame mounted information sheet on the pillar to the right of the sculpture's gravelled enclosure.

Lancaster Road

Fire Station, 1927, by A.E. & T. Sawday

On the skyline over the main entrance is a:

Wyvern

Sculptor: Joseph Herbert Morcom

Sculpture in cast metal, painted white
h. (est.) 1.07m (3'6"); w. (est) 1.37m (4'6")
Status of building: Grade II
Owner of building: Leicester Fire Authority

Morcom, *Wyvern*

Description: The wyvern is here represented crouching, in traditional heraldic form with a dragon's head with open mouth and darting tongue, two legs, raised wings and a coiling serpent's tail. It is coated in thickly applied paint, all white except for the red inside of the mouth and its long tongue. The wyvern is the heraldic beast on the crest of the City and County Borough of Leicester's armorial bearings.

Condition: Good.

Literature
L. Mercury: – [i] 4 December 1981, p.18 [ii] 27 June 1997, p.5.

London Road

Outside Leicester Railway Station, near the corner with Station Street:

Statue of Thomas Cook

Thomas Cook (1808–92), tourist agent, born at Melbourne, Derbyshire, was first apprenticed as a wood-turner but then went to Loughborough to work for a firm printing and publishing books for the General Baptist Association. He subsequently joined the Association, became an active member and, in 1828–9, was appointed bible reader and missionary in Rutland. He married in 1832 and moved to Market Harborough where he began business as a wood-turner, intending at the same time to continue working as a missionary. He became a zealous advocate of temperance, in consequence of which he was appointed secretary to the Market Harborough branch of the South Midland Temperance Association. When a gathering of temperance members was arranged in 1841, it occurred to Cook that he might utilise the Midland railway by commissioning a special train to convey members from Leicester to the meeting and back. Thus, on 5 July 1841, the first publicly-advertised train in England carried 570 passengers from Leicester to Loughborough at a return fare of a shilling per person. The success of this and subsequent excursions persuaded Cook in 1845 to turn his efforts in this field into a full-time business. He had by now moved to Leicester and here, in addition to organising excursions in partnership with the Midland railway, he published handbooks for tourists (based on his own researches of the stopover points) and later came up with the idea of issuing his customers with coupons for hotel expenses. From *c.*1846 he published the monthly magazine, 'Excursionist'. The business flourished, now including trips abroad. With expansion, however, Cook and his son (who had become his partner in 1864) moved their head office to London. In 1872 Cook retired to Leicester, dying on 18 July 1892 in his house, Thorncroft, in the suburb of Stoneygate. He is buried in Leicester's Welford Road Cemetery.
Source: *DNB.*

Sculptor: James Walter Butler
Bronze founders: Morris Singer

Statue in bronze on a plinth in concrete
Statue: h. 1.8m (5'11"); w. 84cm (2'9"); d. 79cm (2'7")
Plinth: h. 73cm (2'5"); w. 92.5cm (3'1"); d. 66cm (2'2")
Plinth reliefs: h. 13.5cm (5"); w. 49cm (1'7")
Inscriptions (all in raised letters on bronze plaques):
– on the front face of the plinth: THOMAS COOK / 1808 – 1892
– on the rear face of the plinth (upper plaque): THE STATUE WAS COMMISSIONED / BY LEICESTER CITY COUNCIL / WITH ASSISTANCE FROM / BRITISH RAILWAYS COMMUNITY UNIT / AND THOMAS COOK (INTERNATIONAL) LTD
– on the rear face of the plinth (lower plaque): NEAR TO THIS SITE IN / LEICESTER'S CAMPBELL ST STATION / THOMAS COOK ORGANISED THE FIRST / KNOWN MAJOR EXCURSION FROM / LEICESTER TO LOUGHBOROUGH IN 1841

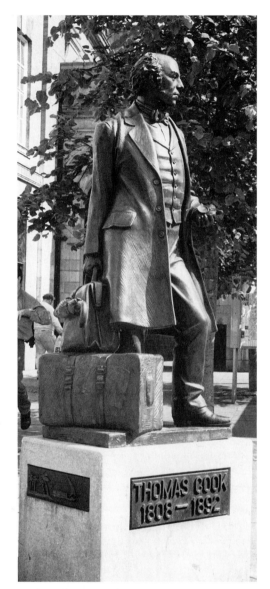

Butler, *Thomas Cook*

Signed by the sculptor in 'handwritten' style on the right of the upper surface of the base, towards the rear: Butler '93
Founder's mark stamped on the right face of the base towards the rear:
MORRIS / SINGER / FOUNDRY / ENGLAND
Unveiled: Friday 14 January 1994, by Thomas Cook, great great grandson of the subject
Status: not listed
Owner / custodian: Leicester City Council

Description: Cook is portrayed wearing an overcoat but not a hat, standing with his weight on his right leg, his left foot forward. In his left hand he holds a pocket watch, in his right hand a briefcase bearing the initials 'T C' either side of the clasp. A furled umbrella is secured to the case by straps. Cook rests his briefcase on a suitcase secured with two straps, under the right one of which is a label, the visible part of the 'handwritten' inscription reading: 'Th[...] Cook / L[...]ster'. A relief on the left face of the plinth shows a scene of the Nile with a dhow, palm tree and pyramids, while that on the right face shows a steam train excursion.

Condition: The statue is in good condition, but the top rear corner of the plinth is damaged.

History: The commissioning of a statue of Thomas Cook outside Leicester's railway station in 1992, the anniversary of his death, was originated, with the full support of the Leicester Victorian Society, by Councillor Henry Dunphy in late 1991.[1] Leicester City Council's Director of Leisure Services enthusiastically lent his support to Dunphy's proposal[2] and he and his department managed to secure financial assistance from the British Rail Community Unit (£3,000) and Thomas Cook (International) Ltd (£3,000).

James Butler, whose statues of *King Richard III* (see pp.81–3) and *The Leicester Seamstress* (see pp.130–2) were already familiar to the people of Leicester, was selected as sculptor and the contract was signed on 17 July 1992. Butler

was to be paid the sum of £20,000 'inclusive of artist's fee and artist's manufacture, assistants, materials and transport'. In the traditional manner, the sculptor was to be paid one third of the money at the signing of the contract, another following approval by the City Council of the full-sized clay model and the final third on satisfactory completion of the work and installation on site, the deadline for completion being 31 March 1993.[3] The Council was to provide the plinth (to Butler's design) and to arrange its installation as well as the actual erection of the sculpture (at a cost of a further £2,550).[4]

Butler's first step was to arrange a visit to the archives at Thomas Cook Ltd's London office to 'get a further insight into the character of Thomas Cook' and to seek out some useful photographic sources.[5] Work on the statue itself was delayed until the end of the summer owing to the sculptor's prior commitment to complete his *Jester* for Stratford-upon-Avon. He reckoned that he and his assistant welder would have the armature for the clay model erected by the end of September and undertook to have the model itself in a photographable state by mid-November.[6]

By 25 January 1993, Butler had submitted his sketch drawing of the plinth and by 25 March, the Council's Leisure Services Department had been granted a certificate of planning permission. By now the scheme was running well behind schedule. Butler had already advised the Council that the statue would not be ready before April 1993 and difficulties in reaching agreement with the Property Board of British Rail on the specific siting of the statue outside the station resulted in lengthy delays to starting work on the plinth.[7]

Casting of the statue was eventually completed in July 1993,[8] but further disagreements over the siting meant that the statue was not placed on its plinth until 12

January 1994.[9] Nevertheless, though a full ten months behind schedule, Butler's statue met with the same level of approval his previous work had received in Leicester, its unveiling being treated to very positive coverage by the *Leicester Mercury* which considered it an 'impressive' addition to Leicester's streets.[10]

Literature
Leicester City Council, Arts and Leisure Department. 'Thomas Cook Statue' file (memos, correspondence, press releases, press cuttings, etc.). **General.** Banner, J.W., 1994, p.90, **90**; Leicester City Council, 1997, pp.82, **83**; *L. Herald and Post*, 12 January 1994, p.6; *L. Mercury*: – [i] 18 July 1992, p.7, **7** [ii] 3 March 1993, p.13, **13** [iii] 10 January 1994, p.13, **13** [iv] 13 January 1994, p.7, **7** [v] 15 January 1994, p.2, **2**; *Leicester University Bulletin*, February 1994, p.7, **7**.

Notes
[1] Memo, dated 6 November 1991, from Councillor Henry Dunphy to Leicester City Council's Director of Leisure Services. [2] Letter, dated 12 November 1991, from the Director of Leisure Services to Councillor Henry Dunphy. [3] From the contract, dated 17 July 1992, between Leicester City Council and James Butler. [4] Memo, dated 20 October 1993, from Mayur Pankhania, Leicester City Council Environment and Development Department, to the Director of Leisure Services. [5] Letter, dated 31 July 1992, from James Butler to Pete Bryan, Arts Advisory Officer, Leicester City Council. [6] Letter, dated 18 September 1992, from James Butler to Pete Bryan, Arts Advisory Officer, Leicester City Council. [7] Report, dated 31 March 1993, Leicester City Council Leisure Services Committee. [8] Memo, dated 30 July 1993, from Pete Bryan, Arts Advisory Officer, to the Acting Principal Engineer – Highways. [9] 'Leicester celebrates Thomas Cook', press release, Leisure Services Department, Leicester City Council. For a photograph of the statue being lowered into position, see *L. Mercury*, 13 January 1994, p.7. [10] *L. Mercury*, 15 January 1994, p.2.

Victoria Terrace, Nos 113–19 London Road (opposite Saxby Street)

Familiarly known as 'Top Hat' Terrace, it was built by James Francis Smith in honour of his father, the detective, Francis 'Tanky' Smith, in 1864. The frontage incorporates:

16 carved heads of 'Tanky' Smith in some of his many disguises

Francis 'Tanky' Smith (d. 1888) was one of the first detectives to be appointed to Leicester's newly-created police force in 1836. A master of disguise, he seems to have been remarkably adept at infiltrating the town's criminal gangs. Following his retirement in 1864, he set himself up as a private detective. His fame and fortune were made almost immediately when he was hired to locate the High Sheriff of Leicestershire, James Beaumont Winstanley, who had gone missing on a European tour. Smith tracked Winstanley to Koblenz where he found his corpse in the River Moselle. He invested some of his considerable fee in building Victoria Terrace, employing his son, James Francis Smith, as architect. His nickname 'Tanky', evidently refers to his practice of tapping or 'tanking' disorderly people over the head with his stick.

Sources: Banner, J.W., 1994, pp.92–3; Gerrard, D., 1996, p.63; Lee, J. and Dean, J., 1995, p.65.

Sculptor: unknown

16 heads in stone, painted
Status: not listed
Owners of terrace: various

Description and condition: The frontage has been considerably altered over the years, although the heads themselves seem to be relatively untouched. An early photograph of the building in its original state shows a terrace of four houses with front gardens.[1] Bay windows in the first, third, fourth and sixth bays flank paired entrances in the second and fifth. The bay windows are surmounted at first-floor level by three-light arched windows and the paired entrances by four-light arched windows. Fourteen of the carved heads are in the spandrels above the first-floor windows and two in the spandrels between the ground-floor entrances. The most drastically altered part of the frontage is the ground floor where only the left-hand paired entrance and the right-hand bay window survive unchanged (the right-hand paired entrance has been converted into

'Top Hat' Terrace

windows, although the head remains unharmed). Each of the 16 heads is painted white with black headgear.

History: As a tribute to his father's talent for disguise, the architect of the building, James Francis Smith, had the spandrels above the arched windows and doors of the London Road frontage decorated with 16 carved heads portraying his father wearing various hats, wigs and beards. Whereas the 14 first-floor heads show 'Tanky' Smith in some of his many disguises, the two ground-floor heads show him wearing the regulation top hat of the police force of the time, and it is this that gives the terrace its more familiar name. Top Hat Terrace was restored in 1987 with a £7,700 City Council grant.[2]

Literature
Banner, J.W., 1991, pp.80–1; Banner, J.W., 1994, pp.92–3, **92**; Gerrard, D., 1996, p.63, **63**; Gill, R., 1985, p.55, **55**; Gill, R., 1994, p.**31**; Lee, J. and Dean, J., 1995, p.65, **65**; Leicester City Council, 1975, p.48, **48**; *L. Mercury*, 15 July 1994, p.14, **14**.

Notes
[1] Reproduced in Gill, R., 1985, p.55. [2] Banner, J.W., 1994, pp.92–3; Gerrard, D., 1996, p.63; Lee, J. and Dean, J., 1995, p.65.

Market Place

Corn Exchange

The ground floor is by William Flint, 1850, and the upper floor and external two-flight staircase by Frederick William Ordish, 1855. The staircase is decorated with a 'curious little figure carved in stone, which ... obviously has connections with brewing for he is standing on a tun and until recently, before it was vandalised, was holding a sheaf of barley'.[1]

Literature
Banner, J.W., 1991, p.33; Banner, J.W., 1994, p.65.

Note
[1] Banner, J.W., 1991, p.33.

In the market place, before the Corn Exchange building:

Statue of John Henry Manners, 5th Duke of Rutland

The 5th Duke (1778–1857) was born at Belvoir Castle, succeeding to the dukedom on the death of his father in 1787. In 1799 he was appointed Lord Lieutenant of Leicestershire and in the same year married Lady Elizabeth Howard (d. 1825), daughter of the Earl of Carlisle. The Duke's other appointments included Recorder of Grantham, of Cambridge and of Scarborough, and High Steward of Cambridge. From 1801–13 the Duke and Duchess employed the architect James Wyatt to rebuild Belvoir Castle. The Duke was made Knight of the Garter in 1803 and a trustee of the British Museum in 1815. In 1805 he published *Travels in Great Britain*, with engravings after drawings by the Duchess. The Duke and Duchess together published *Journal of a Trip to Paris in 1814*, and *Tour through Belgium and the Rhenish Provinces in 1822*, again with illustrations by the Duchess. He endeared himself to the people of the county as 'the good old Duke' through his support for the Infirmary and various charities, famously donating one hundred guineas towards the relief of the unemployed poor of Leicester in 1840. He was buried in the Mausoleum at Belvoir Castle in 1857.
Sources: *Gentleman's Magazine*, February 1857 [obituary]; *Leicester Chronicle*, 1 May 1852; *MEB*; Pevsner, N. and Williamson, E., 1992.

Sculptor: Edward Davis
Founders: Simonet et fils, Paris
Stonemason: Samuel Hull, Leicester

Statue in bronze on pedestal in sandstone
Statue – h: 2.78m (9'2")
Pedestal – h. 1.92m (6'4"); w. 1.37m (4'6"); d. 1.37m (4'6")

Signed and dated by the sculptor on the left-hand face of the bronze base of the statue:
E^DW DAVIS / London 1850.
Signed by the bronze foundry on the right-hand face of the bronze base of the statue:
Simonet & fils / Fondeurs, Paris. 1851.
Inscriptions:
– incised into the front face of the dado of the pedestal:
JOHN HENRY / DUKE OF RUTLAND, K.G / LORD LIEUTENANT / OF LEICESTERSHIRE. / THE INHABITANTS / OF THE COUNTY & TOWN / OF LEICESTER / DURING / THE FIFTIETH ANNIVERSARY / OF HIS HIGH OFFICE / WITH UNIVERSAL CONSENT / CAUSED THIS STATUE / TO BE ERECTED / M.DCCC.LII. / PRÆSENTI TIBI MATUROS LARGIMUR HONORES
Executed: 1849–51
Unveiled: Wednesday 28 April 1852 by Sir Frederick Gustavus Fowke, Provincial Grand Master of Freemasons for the Province of Leicestershire
Exhibited: Great Exhibition of 1851
Status: Grade II
Owner / custodian: Leicester City Council

Description: The Duke is portrayed as he appeared during his acceptance of the testimonial presented to him by the town and county on the occasion of the fiftieth anniversary of his Lord-Lieutenancy of Leicestershire on 21 September 1849. He wears a long ceremonial cloak, a jacket decorated on the left breast with the Star with St George's Cross and, below his left knee, the Garter, both insignia of the Order of the Garter. He stands with his left foot forward, his left hand, which holds the address, leaning on a small pedestal and his right hand extended before him.
Condition: Fair, although the patination of the statue is worn and the pedestal is chipped and battered at the corners, especially in the lower parts.
History: The *Statue of the 5th Duke of*

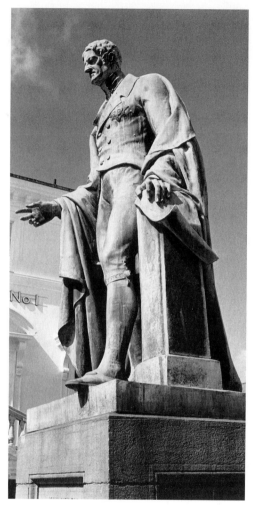

Davis, *5th Duke of Rutland*

Rutland was the first public statue ever to be erected in Leicester. Its origins lay in the determination of a group of the Duke's friends and admirers to honour the fiftieth anniversary (1849), of his lord-lieutenancy of Leicestershire. These men, among them the leading citizens of

the town and county, met on 2 April 1849 and resolved:

> That a subscription be entered into, of any sum not exceeding Five Guineas ... That after such subscription shall have been entered into, the High Sheriff be requested to convene a Public Meeting of the County to consider the best means of carrying the above object into effect.[1]

The reason for restricting individual contributions to five guineas was, as usual with such public subscriptions, so that the widest possible cross-section of the populace could contribute. The memorial, in whatever form it took, would therefore stand as an expression of civic unity. As the advertisement the Committee placed with the local press explained:

> ... the Committee would again urge upon the County that it is wished that the esteem and attachment in which his Grace is held by all classes, should be shown rather by the number of Subscribers than by the amount of Individual Subscriptions ...[2]

From the ranks of the General Committee a sub-committee was formed to debate the various options for the memorial. A new wing for the Infirmary, to be called the 'Rutland Wing' was at first proposed, although the very act of limiting individual subscriptions militated against this solution and the sub-committee was restricted to deciding between either a presentation of plate or the erection of a portrait statue. At a meeting on 2 June 1849, the General Committee voted twenty-two to eight in favour of the statue on the grounds that the testimonial to the Duke should be 'of a public nature'.[3] The question of site, however, occasioned some considerable debate. The Committee was in favour of the Market Place, but at least one of those present feared that placing a statue in such a location would render it vulnerable to attack by less civic-minded persons. In a letter to the local press, signed simply 'A Subscriber', he warned:

> The statue ... would be constantly exposed to the rude and wanton attacks of the thoughtless and mischievous, and would afford an admirable mark for the boys to throw stones at; and would doubtless soon become a receptacle of missiles and filth of every description – such for instance, was the Cross in the Belgravegate, before it was taken down ...[4]

The suggestion from some subscribers that the statue should be erected in a parkland setting outside the town centre was vehemently opposed by the then Mayor who insisted that the very centre of the town was the only fitting location.[5] He managed to persuade the Committee and at a meeting of the subscribers on 16 June 1849, those present agreed that 'a Bronze Statue of the Duke of Rutland, on a granite pedestal, be erected in the Market-place, Leicester, provided a site can be procured for the same'.[6]

On 21 September 1849, the Duke was invited to attend a meeting of the nobility and gentry of the town and county. A testimonial address was read out to him and it is reported that he was so moved by the warmth of the praise that he had to stop several times during his acceptance speech to control the excess of his emotions.[7] This event is chiefly of interest in the present context because of the presence of an (unnamed) artist who sketched the Duke's 'diffident and dignified' acknowledgement and it was these sketches that the sculptor, Edward Davis, was instructed to use for his statue.[8]

Davis's model for the statue was approved by the Committee at its meeting on 24 October 1849,[9] and the contract drawn up during the following month. The statue was cast by Simonet et fils of Paris in early 1851 and had arrived by steamer at the Port of London by 5 April,[10] in time for Davis to show it at the Great Exhibition of 1851 (opened 1 May). It was displayed in the west nave of the Crystal Palace on a pedestal considerably lower – it was apparently about 3 feet high[11] – than the 11 feet 3 inches of the base and pedestal planned for Leicester's Market Place.[12] Unfortunately the statue's closer proximity to the viewer drew attention to some rather severe defects. The *Builder* responded with what is perhaps the most memorable and oft-quoted criticism of the statue:

> Most of our readers will remember the strange, loose figure of the Duke in the Great Exhibition: it stood in the west nave. His grace is made to appear positively intoxicated; and we may expect, if it be put up without alteration, to find the old proverb of "as drunk as a lord" giving place in Leicester to "as drunk as the Duke".[13]

It is not known whether any members of the Leicester Committee felt misgivings of a similar nature.[14] One must assume that if any did, Davis was able to persuade them that his statue had been designed specifically to be seen at a greater altitude, that is, with pose and features exaggerated so that they would read clearly from below, and that once on a pedestal of the intended height, foreshortening would come into play and make the proportions appear correct.

In early September 1851 the Committee, having received a letter from the sculptor advising it that the statue would shortly be available for removal to Leicester, made its formal request to the Council for a site in the Market Place.[15] The statue arrived in Leicester in November 1851 and a local stonemason, Samuel Hull, was appointed by the Committee to prepare designs for the pedestal.[16] Hull's design and building specifications were approved by the Corporation Estate Committee on 24 February 1852 and the Market Place site approved by the Council in

the following month.

The specific site approved by the Council is not that now occupied by the statue. The original site was, in fact, Cheapside, at the north-east edge of the Market Place, close to where the High Cross pillar now stands.[17]

It had by this time been decided by the Council that the statue's pedestal should incorporate a tap for the town's conduit. The conduit had been built in 1612 in the form of a lead cistern enclosed within an octagonal brick structure. From 1841 the conduit and its tap were housed in a pedestal surmounted by a tall iron lamp post.[18] It was this latter structure that was taken down in 1852 to make way for the present statue, which, like the lamp post before it, was to incorporate the conduit outlet within its pedestal.[19] Even though there was a precedent for such an arrangement in Chelmsford where the pedestal of E.H. Baily's *Statue of Chief Justice Tindall* (1847) also incorporated a tap, the *Builder* considered the idea risible,[20] a view that was to be echoed by at least some local commentators.[21]

On Monday 12 April 1852 work on the foundations for the statue's pedestal was started close to the lamp post.[22] On Wednesday 21 April, construction of the pedestal was completed, the lamp post and its pedestal removed, and the conduit re-routed to the statue's pedestal.[23] On the following day Hull and his men raised the statue onto its pedestal with the sculptor in attendance to ensure that it was 'properly adjusted'.[24] The statue was then kept covered pending the official unveiling ceremony.

Clearly inexperienced at staging such an event, the Committee had only begun making arrangements for it on the day of the pedestal's completion – a mere seven days in advance. There was, however, unanimous agreement that the inauguration would be incomplete unless the Freemasons were called in to officiate, and the Committee resolved to request formally the Provincial Grand Master of Masons for Leicestershire, Sir Frederick Gustavus Fowke, 'to conduct the ceremony in accordance with ancient and established Masonic usages'.[25] Despite the short notice, which the Freemasons feared would not give them time to do things as meticulously as they would have hoped, they agreed and the two Leicestershire lodges (St John's and John of Gaunt's) met on 26 April to discuss the arrangements.[26]

The unveiling ceremony, set for 2 p.m. on Wednesday 28 April 1852, was made the occasion for a general holiday. Shops, warehouses and factories closed at 1 p.m., and all the participating schools – about 2,000 children had been invited, comprising 500 from dissenting congregations and 1,500 from the established church[27] – spent most of the morning in preparation.[28] Pending its unveiling, the statue remained concealed within 'a structure composed of a light square frame of wood-work, covered with red and white drapery, surmounted with banners and evergreens'.[29] Flags were flying from many of the surrounding windows and balconies, all of which were crowded with onlookers. The Freemasons processed from the Assembly Rooms through the streets to the Market Place in full regalia much to the delight and wonderment of the crowd, which contemporary sources agree was something in excess of fifty thousand.[30]

The Committee chairman being absent through ill health, his deputy, Sir Arthur Grey Hazlerigg, invited Fowke in his role as Provincial Grand Master to open proceedings. At a given sign the covers were raised just high enough to allow sight of the pedestal and the Provincial Grand Chaplain 'offered up a brief prayer for the blessing of the "Great Architect of the Universe" on the work before him'.[31] After a few more words from Fowke, the sculptor 'then delivered to the Provincial Grand Master the implements of his profession (chisel and mallet) with a suitable address'.[32] Then followed a ritual confirming the craftsmanship of the pedestal. Fowke successively requested the Junior Grand Warden, Senior Grand Warden and Deputy Grand Master to apply the 'jewels of their offices', respectively the plumb rule, level, and square, to the pedestal to confirm that the craftsmen had done their duty. Fowke then announced: 'Having full confidence in your skill in the Royal Art, it now remains with me to finish the work', and directed first the Worshipful Master of the John of Gaunt Lodge to strew grains of wheat on the pedestal 'as the emblem of plenty', then the Worshipful Master of the St John's Lodge to sprinkle it with wine 'as the emblem of cheerfulness and joy' and then the Acting Deputy Provincial Grand Master to pour oil on it 'as the emblem of prosperity and happiness'. Lastly Fowke himself scattered salt upon it:

> ... as the emblem of wisdom, fidelity, and perpetuity; and may the All-bounteous Author of Nature bless this ancient town, the county and the kingdom at large, with abundance of corn, and wine, and oil, and all the necessaries, comforts, and conveniences of life. And may the same Almighty power preserve the inhabitants in peace and unity and brotherly love.[33]

With the blessing ritual completed, the statue was delivered by Committee Deputy-Chairman Hazlerigg to the keeping of the Mayor and Corporation, and Fowke knocked three times upon the stone of the pedestal, thereby declaring the statue inaugurated. Several more speeches followed and the statue itself was unveiled.

The correspondent for the *Leicester Journal* enthusiastically refuted the bad press the statue had received at the Great Exhibition:

> ... the likeness was absolutely electrifying – it was the *Duke of Rutland* – face! attitude!

figure! Those who saw the Statue in the Exhibition, with a dark background, and on a pedestal a yard high, can form no idea of what it is, – they must see it now; now, in its proper place; now, on its fitting pedestal. With the clear sky behind it, and the bright sun in front of it, it is a noble Statue![34]

Fowke expressed similar sentiments at the official dinner that evening, redressing his admitted earlier disappointment with the heartfelt accolade that the statue, now fixed at the correct height 'was the very man they had seen moving amongst them';[35] to which the sculptor replied that:

... With regard to the differences of opinion, he might say, that it was impossible to please everybody; and like the man with the ass in the fable, in trying to please everybody one might please nobody. He might say that he had pleased some with his work, and when he reflected that the statue had been considered worthy to represent so illustrious a character as the Duke of Rutland ... he had reason to be proud.[36]

Within a few short years, however, some were suggesting that the pedestal was still not high enough. Furthermore, the siting at Cheapside was proving to be an obstacle to traffic.[37] In 1868, John Burton, a local photographer, wrote to the 6th Duke of Rutland suggesting that his father's statue would be greatly improved if it were removed from the pump, mounted on a higher pedestal and gilded. Having secured the Duke's approval, Burton assembled a small committee to prosecute the campaign. After a four-year delay due to unavoidable 'circumstances',[38] on 2 July 1872 Leicester Town Council approved the move on condition that Burton's committee pay all costs relating not just to the new site but also to rehousing the conduit.[39] Local architects Millican and Smith designed the new pedestal in Millstone grit,[40] local stonemason John Firn carried out

the work of construction,[41] the gilding was carried out as planned, and the statue was re-erected in the centre of the Market Place, in front of, and facing away from, the Corn Exchange.[42] It was unveiled 'without any public ceremony', on 30 September 1872.[43] The *Leicester Journal* observed approvingly:

The elongation of the pedestal ... has accomplished all the projector of the alterations had in view, viz., the reduction of the peculiarity in the pose of the figure which some persons might be disposed to construe into an approach to deformity. It is now perfectly right and thoroughly characteristic, as all who were accustomed to observe his Grace will bear testimony. The substitution of gold for the heavy dull surface of the bronze is very striking indeed, and will, when somewhat sobered in tone by exposure and the accumulation of dust in the interstices, be most satisfactory.[44]

The *Leicester Journal* editor's prognostication seems to be borne out by an (uncredited) writer for the *Builder* who in 1897 gave the statue a rather more favourable assessment than had his predecessor in 1852: '... a fair piece of work, and now that the gilding is weather-stained, it is rather pleasant looking than otherwise'.[45]

By 1931, however, the *Rutland Statue* had been virtually obscured by recently-erected market stalls. The Chairman of the Markets Committee petitioned the Corporation Estates Committee to have the statue relocated. Several options were considered, the choice eventually falling to the recently-laid-out Everard Place Gardens, off Castle Street, near West Bridge. Approval having been obtained from the 9th Duke of Rutland, the statue was relocated to the Gardens in the second half of 1931.[46] As an indication presumably of changed tastes, the Corporation took this opportunity to remove 'the heavy gilt' and its painted undercoat and to repolish and refinish the metal 'giving the Statue

a patina to make it a dark bronze colour', employing the local Dryad Metal Works to carry out the work.[47]

In 1967, Everard Place Gardens were swept away to make way for the St Nicholas gyratory system and the *Rutland Statue* was removed to store, where it was cleaned and renovated in the hope that it could eventually be re-erected in the Market Place.[48] By 10 September 1971, the move had been effected and the Duke was back in front of the Corn Exchange, but now standing parallel to it.[49] As the *Leicester Chronicle* explained at the time:

The Duke's figure has been installed to one side, so that he is always facing the newly created square ... [The City Planning Officer, Konrad Smigielski] likes (and we like) the contrast in colour between the statue and the steps of the bridge [i.e., that fronting the Corn Exchange] forming its background. The statue has the lovely greenish patina which bronze acquires as it ages ... Mr. Smigielski prefers the profile view of the Duke, with arm extended. But his asymmetrical placing permits a variety of impressions, and the statue's "enormous dignity" can be enjoyed from many angles ...[50]

Ironically – in the light of the consensus in Leicester in 1872 that the original eleven-foot high pedestal was not high enough – the statue now stands on a pedestal only a little over six feet in height. The unfortunate result is that the gangling figure with its stooping back, overlong arms and fingers and exaggerated physiognomy again appears as deformed as the editor of the *Leicester Journal* found it to be before its elevation in 1872.

Related works: *Statuette of the Duke of Rutland*, a variant of the present work (present location unknown);[51] *Bust of the Duke of Rutland* (unsigned, undated) marble, Belvoir Castle, Leicestershire.

Related works exhibited: Royal Academy of Arts 1850 (cat. 1380): *Marble bust of the Duke of Rutland*; Royal Academy of Arts 1852 (cat. 1365): *Statuette of the Duke of Rutland*.

Literature

LRO. *Council Minutes*: – [i] 2 May 1850 – 25 March 1852, pp.339–40, 435 [ii] 26 March 1872 – 10 March 1874, pp.78–9; *Estate Committee Minutes*: – [i] 26 May 1845 – 13 December 1854, pp.167–8 [ii] 16 November 1927 – 21 October 1931, pp.348, 356, 361–2, 367, 409, 452 [iii] 2 June 1969 – 1 May 1972, p.490; *Highway ... Committee Minutes*: – [i] 19 April – 8 November 1872, pp.121, 123, 156, 366 [ii] 15 November 1872 – 18 July 1873, p.251; *Museums and Libraries Committee Minutes*, June 1967 – February 1974, pp.9, 276.
University of Leicester library, Local History collection – *Council Minutes*, 1930–1, pp.183–4, 187, 256.
General. *Art-Journal*, vol. xii, 1850, p.329; Banner, J. W., 1991, p.34; Banner, J.W., 1994, pp.12, 33, 64; *Builder*: – [i] vol. ix, no. 458, 15 November 1851, p.715 [ii] vol. lxxii, no. 2835, 5 June 1897, p.500; Burton, D.R., 1993, pp.108, 109; Darke, J., 1991, pp.176–7, 177; Gunnis, R. [1964], p.122; *L. Advertiser*, 1 May 1852, pp.1–2; *L. Chronicle*: – [i] 7 April 1849, p.2 [ii] 21 April 1849, p.2 [iii] 9 June 1849, pp.2, 3 [iv] 16 June 1849, p.3 [v] 23 June 1849, pp.1, 3 [vi] 30 June 1849, p.2 [vii] 22 September 1849, p.3 [viii] 27 October 1849, p.3 [ix] 5 April 1851, p.3 [x] 26 April 1851, p.1 [xi] 17 April 1852, p.3 [xii] 24 April 1852, pp.2, 3 [xiii] 1 May 1852, pp.1–2 [xiv] 5 October 1872, p.5 [xv] 28 December 1872, p.3 [xvi] 10 September 1971, pp.14–15; Leicester City Council, 1975, p.12; Leicester City Council, 1997, p.35; *L. Journal*: – [i] 30 April 1852, p.3 [ii] 4 October 1872, pp.5, 8; *L. Mercury*: – [i] 1 May 1852, p.3 [ii] 5 October 1978, p.12 [iii] 21 August 1981, p.17, 17; McKinley, R.A., 1958, p.364; *Modern Memorials. Leicester ...*, 1875, pp.33–5; Nuttall, G.C., 1905, pp.32–3; Pevsner, N. and Williamson, E., 1992, pp.223–4; Read, R., 1881, pp.8, 17–18; Simmons, J., 1965–6, plate IIa; *Spencers' ... Guide to Leicester*, 1878, p.171; *Spencers' New Guide to ... Leicester*, 1888, p.56; *The Times*, 18 April 1851, p.5; *Transactions ...* 1899, pp.66–7; Tyler-Bennett, D., 1990, p.45.

Notes

[1] *L. Chronicle*, 7 April 1849, p.2. [2] *Ibid.*, 21 April 1849, p.2. [3] *Ibid.*, 23 June 1849, p.1. [4] *Ibid.*, 16 June 1849, p.3. Indeed, the subscriber's fears were not without foundation for, on 4 April 1873, Leicester Corporation's Highway and Sewerage Committee issued a reward of £5 for information leading to the detection of the person or persons who had recently thrown mortar at the *Rutland Statue*, thereby defacing it (*Minute Book of the Highway and Sewerage Committee*, 15 November 1872 – 18 July 1873). [5] *L. Chronicle*, 9 June 1849, p.3. [6] *Ibid.*, 23 June 1849, p.1. [7] *Ibid.*, 22 September 1849, p.3. [8] *Ibid.*, 1 May 1852, p.1. [9] *Ibid.*, 27 October 1849, p.3. [10] *Ibid.*, 5 April 1851, p.3. [11] *L. Journal*, 30 April 1852, p.3. [12] Full dimensions given in the caption to an engraved illustration of the statue in *L. Chronicle*, 1 May 1852, p.2. [13] *Builder*, vol. ix, no. 458, 15 November 1851, p.715. Quoted in Gunnis, R. [1964], p.122, and Leicester City Council, 1997, p.35. [14] Sir Frederick Gustavus Fowke, one of the trustees of the statue appointed in March 1851, evidently felt a certain disappointment on seeing the statue at the Crystal Palace (see p.144). [15] Meeting of Leicester Town Council, 25 September 1851, in *Council Minutes*, 2 May 1850 – 25 March 1852. [16] *L. Chronicle*, 1 May 1852, p.1. [17] An 1852 lithograph of the statue in its original location is reproduced in Simmons, J., 1965–6, plate IIa. There is also an undated photograph in the Crompton Collection, Department of the History of Art Library, University of Leicester. [18] See 1847 engraving reproduced as fig. 82 in Elliott, M., 1983. [19] McKinley, R.A., 1958, p.64. [20] *Builder*, vol. ix, no. 458, 15 November 1851, p.715. [21] *Modern Memorials. Leicester ...*, 1875, p.33. The uncredited writer comments that 'its position over the conduit was suggestive of a huge ornament upon a pump!' [22] *L. Chronicle*, 17 April 1852, p.3. [23] *Ibid.*, 24 April 1852, p.3. [24] *L. Advertiser*, 1 May 1852, p.1; *L. Chronicle*, 24 April 1852, p.3. [25] *L. Chronicle*, 1 May 1852, p.1. [26] *Ibid.* [27] *Ibid.* [28] *L. Mercury*, 1 May 1852, p.3. [29] *L. Advertiser*, 1 May 1852, p.1. [30] *Ibid.* and *L. Mercury*, 1 May 1852, p.3. [31] *L. Chronicle*, 1 May 1852, p.2. [32] *Ibid.* [33] *Ibid.* [34] *L. Journal*, 30 April 1852, p.3. [35] *L. Chronicle*, 1 May 1852, p.2. [36] *Ibid.* [37] Nuttall, G.C., 1905, p.33. [38] *Modern Memorials. Leicester ...*, 1875, p.33. [39] Approved at Leicester Corporation's Highway & Sewerage Committee meetings of 14 June, 20 June, and 28 June 1872 in *Highway ... Committee Minutes*, 19 April 1872 – 8 November 1872. Ratified by Leicester Town Council at its quarterly meeting on 2 July 1872, in *Council Minutes*, 26 March 1872 – 10 March 1874. [40] *Modern Memorials. Leicester ...*, 1875, p.35, and *Spencers' ... Guide to Leicester*, 1878, p.171.
[41] *L. Journal*, 4 October 1872, p.8. [42] At least two photographs of this second location are extant, one from the south-east side of Market Place (Leicester City Council, 1975, p.12) and one from the north-west (Burton, D.R., 1993, p.108). [43] *L. Chronicle*, 5 October 1872, p.5. [44] *L. Journal*, 4 October 1872, p.8. [45] *Builder*, vol. lxxii, no. 2835, 5 June 1897, p.500. [46] The matter was raised and approval given in Leicester Corporation's Estate Committee meetings of 28 January, 11 February, 25 February, 11 March 1931 (*Estate Committee Minutes*, 16 November 1927 – 21 October 1931). Relocation was ratified and the removal contract agreed in Leicester City Council meetings of 31 March and 2 June 1931 (*Council Minutes*, 1930–1). [47] Leicester Corporation Estate Committee meeting of 24 June 1931 (*Estate Committee Minutes*, 16 November 1927 – 21 October 1931). [48] Meeting of Leicester Corporation's Museums, Libraries and Publicity Committee, 6 June 1967 (*Museums and Libraries Committee Minutes*, June 1967 – February 1974). See also Leicester Corporation Estate Committee meeting, 6 September 1971 (*Estate Committee Minutes*, 2 June 1969 – 1 May 1972). [49] Leicester Corporation Estate Committee meeting, 6 September 1971 (*Estate Committee Minutes*, 2 June 1969 – 1 May 1972); see also *L. Chronicle*, 10 September 1971, pp.14–15. [50] *L. Chronicle*, 10 September 1971, p.15. [51] Referred to in the article covering the inauguration of the statue in the *Leicester Mercury*, 1 May 1852, p.3.

Market Place Approach

Leicester Market Archway

Designer: John Clinch

Archway in steel, painted black
h. (est) 6.1m (20')
Erected week beginning 30 June 1997
Inscription in free-standing capital letters crowning the arch: LEICESTER MARKET
Status: not listed
Owner / custodian: Leicester City Council

Condition: Generally good, although the paint surface on the reachable parts (the plinths, the lower parts of the piers) is scuffed, scratched and covered with the remains of removed posters.

Clinch, *Leicester Market Archway*

History: The *Leicester Market Archway* and *Leicester Market Column* were commissioned jointly by Leicester City Council and the Market Traders Association, the final selections, from a short list of six, having taken into account preferences expressed by market traders and public.[1] The contract between Leicester City Council and John Clinch, dated 12 March 1997, states that the cost of the *Archway* was £15,000, plus a further £500 to cover the production of plan and elevation drawings.[2]

Related work: Peter Parkinson, *Leicester Market Column*, Cheapside (see pp.84–5).

Notes
[1] Information from Karen Durham, Public Arts Officer, Arts and Leisure Department, Leicester City Council; see also *L. Mercury*, 5 June 1997, p.4.
[2] Contract in Leicester City Council, Arts and Leisure Department archives.

Market Street

Conversation Piece, by Kevin Atherton

A group of three bronze heads on Plexiglas pedestals, formerly displayed in Market Street, but now in store. This was actually one of three sets of three heads each, sited at Cheapside, Market Street and Gallowtree Gate. In 1992 one set was relocated to St Margaret's Bus Station (see pp.10–11).

Former Midland Auction Mart building, 1876, by Millican and Smith

On the upper part of the frontage is sculptural decoration including:

Roundel relief bust of Mercury

Sculptor: unknown

Roundel relief bust in stone
Status: not listed
Building in private ownership

Description: The architectural sculpture, in addition to the *relief bust of Mercury*, comprises clumps of foliage decoration and ribbon patterns. Mercury, appearing here in his role as the Roman god of commerce, is identifiable by his winged helmet and caduceus.
Condition: Fair.

Literature
Leicester City Council, 1975, p.38.

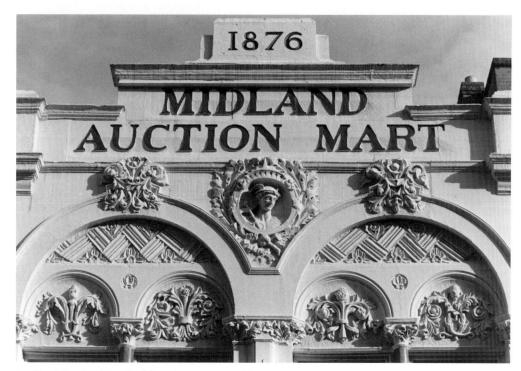

Midland Auction Mart Building: Mercury roundel

Pountney, *Wyvern*

Painter Street

Charles Keene College of Further Education

On the wall to the left of the entrance to A Block:

Wyvern

Sculptor: Albert Pountney

Sculpture in aluminium
h. 1m (3'3"); w. 1.28m (4'3"); d. 24cm (10")
Executed: *c.*1960
Status: not listed
Owner: Charles Keene College of Further Education

Description: A wyvern constructed from four cut sheets of aluminium, bolted to the wall on three metal brackets. The wyvern – a heraldic beast with a serpent's tail, a dragon's head and a body with wings and two legs – is from the crest of the City and County Borough of Leicester's armorial bearings.

Condition: Generally good, but grimy.

Rutland Street

Alexandra House, No. 47 Rutland Street, at the corner of Southampton Street, 1897, by Edward Burgess; built as a bootlace warehouse for Faire Bros & Co.[1]

The frontage is decorated with:

Architectural sculpture

Designers and Makers: Burmantofts Works, Leeds Fireclay Company[2]

All decorative sculpture in Burmantofts terracotta
Status of building: Grade II
Building in private ownership

Description: A large former warehouse at the junction of Rutland Street and Southampton Street. The main entrance, located on a sliced corner, was strongly emphasised by a crowning cupola (destroyed during the Second World War) flanked by turrets, while the ends of the frontages are emphatically marked by pavilion bays. The entire building above the six-foot high polished larvikite plinth is faced in warm-buff terracotta, stretching for nine bays along Rutland Street and five along Southampton Street; its three main storeys topped by a heavy cornice and balustrade and, above that, a top storey with arcaded windows. The decoration becomes increasingly elaborate towards the upper storeys; whereas the ground-floor windows have plain jambs and fairly restrained centre mullions with just a small amount of decoration on the capitals, the windows of the two storeys above are

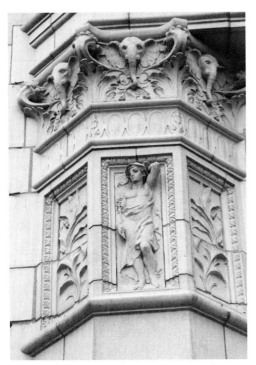

Alexandra House (Mercury panel)

articulated by centre columns and side pilasters, their shafts heavily decorated with floral designs and their capitals with foliation and grotesque masks. In Rutland Street, in the first bay to the left of the main entrance, is a subsidiary entrance with a column whose capital is decorated with the heads of two barking dogs.

The window bays between the main entrance bay and end pavilions are divided by massive piers, at the top of each one of which is a niche over a projecting corbel on which stands an atlas figure appearing to support the cornice – seven along Rutland Street and three along Southampton Street. Above the cornice at these points, the balustrade is interrupted by panels with 'F' motifs (for Faire Bros) surrounded by floral decoration.

The greatest concentration of sculptural decoration, however, is around the main entrance. The engaged piers flanking the doorway are topped with capitals decorated with elephant heads, alluding to the Jumbo and Elephant trademarks carried by some of the goods produced by Faire Bros.[3] Beneath the capitals on each of the piers' three faces are panels, the flanking ones carrying floral decoration and the central ones, classical figures. On the left is Mercury, the Roman god of commerce, identifiable by his caduceus and his winged cap and sandals. The figure on the right is less obvious. He carries a small hammer and what may be a piece of hide; if so, this could be the Roman god Vulcan, protector of craftsmen.

The date of the building, 1897, appears on a metal disc mounted on an ironwork tympanum set within the arch over the door. On the architrave above is a motto on a scroll: 'SAPIT QUI LABORAT' ['He is wise who exerts himself'] and in the centre of the frieze above this, an escutcheon decorated with five fleur-de-lys on a chevron, a (?)laurel wreath beneath, a cinquefoil at top left and (?)another wreath at top right. To either side of the escutcheon is floral decoration with, on the left, an encircled female head and, on the right, a male head. In the centre of the cornice, above the escutcheon, is a wheat sheaf encircled with what looks like a bootlace(!). The first-floor two-light window has a floral frieze and a grotesque head while the second-floor three-light window, the most elaborately decorated of all, is surmounted by a convex moulding with three blank oval shields, the two outer ones held by female supporters.

Pevsner and Williamson have commended this as 'the finest warehouse in Leicester and one of the finest in the country'.[4]

Condition: Good.

Literature
Leicester City Council, 1975, p.45, **45**; Leicester City Council, 1997, pp.119, **118, 120**; Pevsner, N. and Williamson, E., 1992, p.239.

Notes
[1] Leicester City Council, 1997, p.118. [2] A general view of the exterior of the building appears in a Burmantofts catalogue (date and details unknown; photocopy of the page supplied by Dr Alan McWhirr, University of Leicester). [3] As pointed out to the author by Dr Joan Skinner. [4] Pevsner, N. and Williamson, E., 1992, p.239.

Nos 78–80 Rutland Street, a former warehouse built for Pfister and Vogel in 1923 by Fosbrooke and Bedingfield

In the upper corners of the entrance recesses:

Decorative half-figures

Sculptor: unknown

Half-figures in stone, coated in white paint
Status: Grade II
Building in private ownership

Description: The sculptural decoration consists of half-figures in the upper corners of the entrance recesses. To either side of the main entrance recess are angels holding open books in front of them, their folded wings arching above their heads, while in the corners of the goods entrance to the right are winged animals holding open books, on the left a bull or ox and on the right a lion.

Condition: The angels are heavily coated in cream paint but appear to be in fair condition while the animals are black-encrusted and in very poor condition with some losses.

Pfister and Vogel was an American firm of leather importers.

Literature
Leicester City Council, 1997, pp.119, **120**

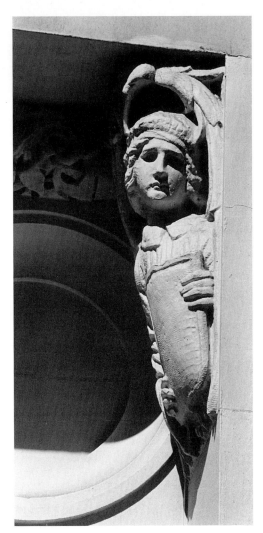

Nos. 78–80 Rutland Street: Decorative half-figure

In St George's Churchyard (now a Serbian Orthodox church), by the (liturgical) south-east corner of the church, opposite the gateway from Church Street:

St George's Church War Memorial

Architect: William Douglas Caröe
Sculptor: Anthony Smith

Contractors: W. Thrall and Sons

Crucifixion in teak on a stepped base in stone
h. (est.) 6.1m (20')
Inscriptions:
– on the front face of the stepped base, incised on a tablet: DEDICATED / BY THE REV NOEL MELLISH. V.C.M.C. / WITH PRAYER AND THANKS- / -GIVING FOR THOSE WHO / FROM THIS CHURCH AND PAR- / -ISH OF S. GEORGE THE SOL^DIER / MARTYR LAID DOWN THEIR / LIVES IN THE GREAT WAR 1914–1918 / LORD ALL PITYING JESU BLEST / GRANT THEM THINE ETERNAL REST
[on the left and right faces of the pedestal, in incised capital letters within arched recesses, the names of the First World War dead]
Dedicated: Tuesday 7 September 1920, by the Revd Noel Mellish, VC, MC, of St Mark's, Lewisham.
Status: not listed
Owner / custodian: unknown

Description: War memorial in the form of a representation of Christ crucified, mounted on a stepped base.

Condition: Fair. The wooden parts, however, have long vertical cracks along the grain and the surfaces are somewhat weathered, while the stonework of the base is slightly battered at the corners. There is biological growth on both the wood and stonework.

History: St George's Church had been erected in 1823–7 to the design of William Parsons, but in 1912–13, following a fire of 1911, the nave was completely restored by architect W.D. Caröe.[1] It was to Caröe that the church turned when, following the First World War, a memorial was needed to commemorate the fallen of the church and parish. Anthony Smith, the woodcarver employed to execute the Crucifixion, had a workshop close to the church at St George's Cottages, Colton Street.[2]

Literature
L. Advertiser, 11 September 1920, p.5; *L. Chronicle*: – [i] 11 September 1920, p.2 [ii] 23 October 1920, p.11; *L. Daily Post*, 8 September 1920, p.2; *L. Mercury*, 8 September 1920, p.3; Pevsner, N. and Williamson, E., 1992, pp.210–11.

Notes
[1] Pevsner, N. and Williamson, E., 1992, p.211.
[2] *Kelly's Directory of ... Leicester and Rutland*, 1922, p.758.

No. 29, Premier House, at the corner with Colton Street; originally built for Tyler Brothers as a wholesale shoe and leather factory, 1875

The main entrance is on a bowed corner; in the spandrels between the arched doorway and the flanking windows are:

Roundels with busts of Minerva and Mercury

Sculptor: Samuel Barfield

Busts in stone
dia. of each roundel: 84cm (2'9")
Status of building: Grade II
Building in private ownership

Description: The busts are in high relief. On the Rutland Street side is *Minerva*, crowned with an oak leaf wreath, holding a railway engine in her right hand. On the Colton Street side is *Mercury*, wearing a winged helmet, holding a caduceus in his right hand and a sailing ship in his left. In ancient Roman mythology, Mercury and Minerva are the protectors of, respectively, commerce and the crafts. The doorway and flanking windows are arched with hood moulds; the stops of the hood

Barfield, *Minerva*

Barfield, *Mercury*

No. 2 St Martins

Built for Pares's Bank, 1900–1, by J.B. Everard & S. Perkins Pick, it passed to Parr's Bank (of London) in 1902, and is now a branch of the National Westminster Bank. The sculptural decoration comprises *figurative relief panels* representing *Commerce* and *Agriculture* on the St Martins frontage, and *female console figures and cherub terms* framing the window on the Hotel Street frontage.

Sculptor: Charles John Allen

Sculpture in Portland stone
Each relief panel: h. 1.52m (5'); w. 2.9m (9'6")[1]
Winged female window frame decoration: h. (est.) 1.56m (5'2")
Agriculture panel signed on ledge towards right: C.J. ALLEN
Exhibited: Royal Academy of Arts 1901, Everard and Pick's drawing, 'New Bank at Leicester' (no. 1650), showing the elevation to St Martins with relief panels sketched in.
Status of building: Grade II* (upgraded 8 July 1999)
Building for sale at time of writing (autumn 1999)

moulds are carved in the form of fabulous beasts, also by Barfield.

 Condition: *Minerva*: some of the leaves on the front of the oak leaf wreath are broken and a chunk is missing from the back part of the model railway engine. *Mercury*: the top of the crest of the helmet is lost and the uppermost parts of the helmet's wings are damaged. The front sails of the ship are slightly damaged.

Literature

Leicester City Council, 1975, p.46, **46**; Leicester City Council, 1997, p.120, **121**; *L. Mercury*, 24 October 1997, p.48; Pevsner, N. and Williamson, E., 1992, p.239.

Description:
(i) St Martins frontage reliefs,[2] located at the first-floor level, either side of the main entrance, framed by giant coupled Ionic columns:

 1. *Agriculture*. The personification of agriculture stands in the centre, crowned with wheat, a shepherd's crook in her outstretched right hand, an apple branch in her left. Within the span of her arms, two boys play pastoral music, that on the left on a flute, that on the right, on cymbals. The four female figures to the sides typify, from left to right, the corn harvest, sheep-raising, fruit-growing, and dairy-farming.[3]
 2. *Commerce*. In a pendant composition to

the above, Commerce personified stands in the centre, a castellated crown on her head; in her right outstretched hand, a cornucopia, in her left a sailing ship. The two boys beneath her arms are her offspring: Enlightenment with a lighted torch and laurel wreath, and Peace, with a palm. To the left of Commerce, receiving her cornucopia, are two women representing British Crafts and Manufacture; to the right (those to whom Commerce's sailing ship is directed), two women bearing raw materials, representing the two hemispheres, East and West.[4]

(ii) Hotel Street frontage. To either side of the rusticated Ionic columns of the pedimented upper-floor window are nude winged female console figures. The brackets beneath the columns are crowned with cherubs whose inner wings reach out to frame a cartouche beneath the window.

Condition: Fair, although all surfaces are somewhat weathered. The mortar between the blocks appears to have crumbled in places and on the left-hand winged female of the window frame decoration the second block from the bottom has an area of crude refilling. The face of the right-hand winged female is streaked with dark drip marks.

History: The design of the architectural sculpture on No. 2 St Martins owes much to that on John Belcher and A. Beresford Pite's highly-influential Institute of Chartered Accountants, 1888–93, in the City of London. The present sculptor, C.J. Allen, had worked on the friezes of the latter building as assistant to sculptor William Hamo Thornycroft. After leaving Thornycroft's studio in 1894, Allen moved to Liverpool to teach sculpture and

(top) Allen, *Agriculture*

(left) Allen, *Commerce*

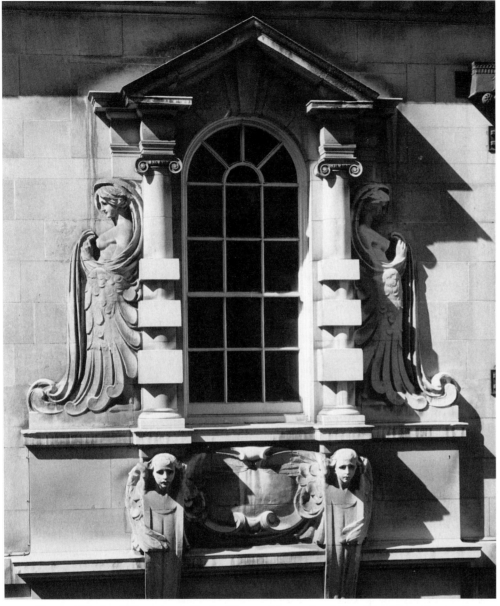

(Former) National Westminster Bank: Allen, *architectural sculpture (Hotel Street frontage)*

modelling at the School of Architecture and Applied Art, transferring in the following year to the School of Art as Vice-Principal. Over the next few years, Allen was to win many of the most prestigious commissions in Liverpool for both architectural and monumental sculpture; his imaginative response to commissions was allied to a professional approach that stood him in good stead with architects and patrons alike. He was one of a new breed of sculptors in Britain who rejected the previous generation's distinction between high art and menial craft, and who learnt how to carve wood and stone working for Farmer & Brindley, a firm of architectural carvers,[5] before going on to more formal instruction.[6]

He made his name in Liverpool as an architectural sculptor with his two panels (begun 1895) for the east front of St George's Hall and shortly afterward was employed by architect James Francis Doyle to execute all the symbolic friezes on Liverpool's Royal Insurance Building (1896–1903). The sculptural decoration of this latter building and the roughly contemporary Pares's Bank in Leicester are both variations on the theme initiated by Allen's former master on the Chartered Accountants building. Both buildings follow the pattern of frieze panels framed between the lower shafts of Ionic half-columns; both sets of panels comprise a central symbolic figure flanked by attendant figures bearing attributes, all faces conforming to Allen's characteristic idealised type. Allen's panels display a sensitivity to their context which would have been nurtured by his training with Farmer & Brindley: the panels are not only decorative in themselves but, with compositions based on horizontal and vertical lines, are also completely in harmony with the rectilinearity of the architectural framework.

The *console figures* and *terms* framing the upper window on Hotel Street similarly derive from the Chartered Accountants building,

though this time from the sculptural decoration by Thornycroft's collaborator, Harry Bates.[7] Whereas, however, Bates's figures have been perceptively described as 'heroic and yet full of humour and variety' with a close kinship to sixteenth-century Genoese models,[8] Allen's are typically prettier, more sweetly decorative and more indebted to contemporary French models.

Allen's assistants on the Pares's Bank building were Joseph Crosland McClure[9] and Joseph Herbert Morcom,[10] both of whom were later to work independently on architectural sculpture commissions in and around Leicester.

Related works: C.J. Allen's figurative friezes for James Francis Doyle's Royal Insurance Building, Liverpool, 1896–1903.[11]

Other works by C.J. Allen for Everard & Pick in Leicestershire: marble altarpiece, *Christ Blessing Little Children*, St Peter's Church, Bardon, signed and dated 1899; bronze relief on the grave monument to Stephen and Harriet Skillington, Welford Road Cemetery, after 1902.

Literature
Liverpool, Walker Art Gallery archives. Letter, dated 6 November 1912, from C.J. Allen to the then director of the Walker Art Gallery, Liverpool, E.R. Dibdin.
General. *Architectural Review*, vol. xiv, no. 85, December 1903, pp.198–202, **198, 199**; Banner, J.W., 1991, pp.104–5; *Builder*: – [i] vol. lxxxi, no. 3059, 21 September 1901, p.252 [ii] vol. lxxxi, no. 3064, 26 October 1901, p.364 [and pls between pp.364/5]; Friedman, T. *et al.*, 1993; Gray, A.S., 1985, p.88; Leicester City Council, 1975, p.42, **42**; Leicester City Council, 1997, 1993 edn, p.**96**; Leicester City Council, 1997, pp.**94, 93, 96**; *L. Daily Post*, 31 August 1920, p.3; Nuttall, G.C., 1905, pp.42–3; Pevsner, N. and Williamson, E., 1992, p.231; Simmons, J., 1974, pp.51–2; *Transactions ...*, vol. ix, 1904–5, p.171.

Notes
[1] As per the measurements given by the sculptor in a note accompanying his letter, dated 6 November 1912, to the then director of the Walker Art Gallery, E.R. Dibdin (WAG archives). [2] Illustrated in *Builder*, 26 October 1901, between pp.364/5. [3] *Ibid.*, p.364. [4] *Ibid.* [5] Allen was an apprentice then an employee (1879–89) of Farmer & Brindley, then Britain's leading firm of architectural stone carvers (Beattie, S., 1983, pp.25–6, 240). [6] While still working at Farmer & Brindley, Allen enrolled in 1882 at the South London Technical Art School where he learnt modelling under W.S. Frith; from SLTAS he went on to the Royal Academy Schools (Beattie, S., 1983, pp.25–6, 240). [7] Friedman, T. *et al.*, 1993, figs 20, 22. [8] Beattie, S., 1983, p.72. [9] *L. Daily Post*, 31 August 1920, p.13. [10] According to an uncredited biographical note in the possession of Dr Alan McWhirr, School of Archaeological Studies, University of Leicester. [11] See Cavanagh, T., 1997, pp.120–2.

St Martins East
No. 3 St Martins East

An 18th-century building restored in 1904 by Everard and Pick as the offices of solicitors W. Cecil and H.B. Harris, now Church House
The frontage has:

Ornamental relief decoration
Designer: unknown

Reliefwork in cast lead, painted grey
Upper (zodiac) frieze: h. 52cm (1'9"); w. 3.25m (10'8")
Middle (allegories) frieze: h. 1.49m (4'11"; w. 3.25m (10'8")
Lower (coat of arms) frieze: h. 97.5cm (3'3"); w. 3.25m (10'8")
Inscriptions in raised capital letters:
– on the middle frieze, on a scroll behind each allegory's head, left: FORTITUDE; middle: JUSTICE; right: TRUTH
– on the lower frieze, on a scroll beneath the coat of arms: IN. DEO. SOLUM. ROBUR
– on the rim of the drainpipe: 1903; on the funnel of the drainpipe: H
Status of building: Grade II
Owner of building: The Diocese of Leicester

Description: A drainpipe on the left of the frontage carries, on the rim of the funnel, the date of Everard and Pick's renovation of the building and on the downpipe, floral

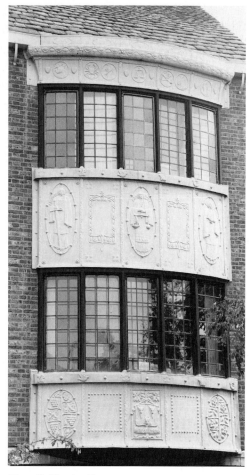

No. 3 St Martins East

decoration. The frontage above and between the bow window zones is completely covered with lead reliefwork. The reliefs are in three horizontal bands, each band marked out into five rectangular fields. Over the upper-floor windows are zodiacal symbols. At the very top are five in oval frames, from left to right: Aries, Gemini, Virgo, Scorpio and Aquarius; beneath this is a convex moulding with a floral

decoration and then, occupying the main horizontal area of the band, the remainder of the zodiacal symbols: in the field on the left, Taurus, in the second from the left, both Cancer and Leo, in the middle, Libra, then Sagittarius and Capricorn, and in the field on the right, Pisces. The band between the upper- and first-floor windows has three full-length female allegorical figures in oval frames representing *Fortitude*, *Justice* and *Truth* – reflecting presumably the moral values espoused by the legal practice for whom Everard and Pick carried out the renovation. The band between the first- and ground-floor windows has a coat of arms in the central field, flanked on the left with a grape-vine and on the right, with roses.

Condition: Good.

History: According to the *Builder*: 'The cast leadwork is from plaster models in low relief, the ground work of panels being tinned ... The cost of the works was 1,540*l* ...'[1]

Literature
Builder, vol. lxxxvi, no. 3193, 16 April 1904, p.414; Pevsner, N. and Williamson, E., 1992, p.232.

Note
[1] *Builder*, vol. lxxxvi, no. 3193, 16 April 1904, p.414.

St Saviours Road

Diamond Jubilee relief bust of Queen Victoria – see Francis Street (p.99)

Shakespeare's Head Public House

Southgates

The Shakespeare's Head Public House, 1967

In niches on either side of the main entrance:
Two Colossal busts of William Shakespeare
Sculptor: unknown

Busts in stone
Each bust: h. 94cm (3'1"); w. 58cm (1'11"); d. 30cm (1')
Status: not listed
Owner of building: RBNB (Barnsley)

Condition: Overall the busts are in fair condition, although the lips on the right-hand

bust are chipped and there is some chipping to the left eyebrow of the left-hand bust, which has been splashed with reddish-pink pigment. The right-hand bust has a splash of black pigment down the right side of the nose.

Literature
Darke, J., 1991, p.178.

Spa Place

Diamond Jubilee relief bust of Queen Victoria – see Francis Street (p.99)

Town Hall Square

Leicester Town Hall, by Francis J. Hames, begun 1874 and officially opened Monday 7 August 1876

1. To the right of the main entrance on the projecting end bay of the central block, below the first floor sash windows, in the outer spandrels of a pair of *œil-de-boeuf* windows:
Reliefs of Night and Day
Sculptor: unknown

Reliefs in Ketton stone
Each relief (approx.): h. 76cm (2'6"); w. 1.44m (4'9")
Inscription on a stone tablet between the *œil-de-boeuf* windows:
: LEICESTER : MUNICIPAL : BUILDINGS : /
: THIS : MEMORIAL : STONE : /
: WAS : LAID : BY : ALDERMAN : WILLIAM :
KEMPSON : / : THE : MAYOR : OF : LEICESTER : / :
ON : THE : 3RD: DAY : OF : AUGUST : A:D : 1874 :
Executed: *c*.1876
Status of building: Grade II*
Owner of building: Leicester City Council

Description: 'Night', in the left-hand spandrel, shows a crescent moon with a face over a nocturnal landscape with sleep-inducing poppies and a flying owl; 'Day', in the right-

Leicester Town Hall, relief: 'Night'

Leicester Town Hall, relief: 'Day'

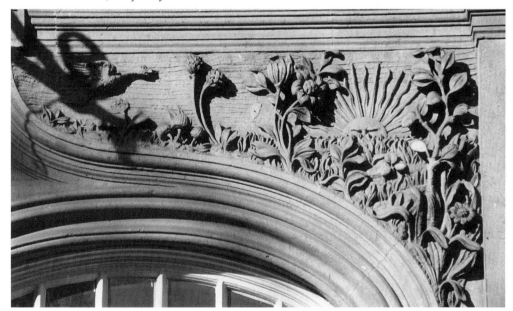

hand spandrel, shows the sun rising over a landscape with mushrooms, clover and sunflowers.
Condition: Fair.

Literature
Banner, J.W., 1994, p.46; Wilshere, J., 1976, pp.14, 14, 15.

2. The centre of the entablature above the relief spandrels is broken by a square framing:

Relief of a Wyvern
Sculptor: unknown

Relief in Ketton stone
Executed: *c.*1876

Condition: Fair.
The wyvern is the heraldic beast on Leicester's crest.

Town Hall Square Fountain
Designer: Francis J. Hames

Fountain in bronze-painted cast iron, Shap granite, and Ross of Mull granite.
Overall h.: 7.16m (23'6")
Lower basin: dia.: 9.14m (30'); d. 76cm (2'6")
Central basin: dia.: 2.74m (9')
Upper basin: dia.: 1.52m (4')
Inscriptions on the inner faces of the arms of the fountain's cruciform base (diagonally aligned to the Town Hall entrance on the south-west side of the square):
– left-hand arm: PRESENTED . TO . THE . BOROUGH . OF . / LEICESTER . BY . ISRAEL . HART . ESQRE· / HIGH . BAILIFF . A.D. 1879.
– right-hand arm: ON . THE . OCCASION . OF . THIS . / LAND . BEING . ENCLOSED . AND . / LAID . OUT . ORNAMENTALLY .[1]
and on the face of the base between these two arms, beneath the Borough coat of arms:
CLEMENT . STRETTON . MAYOR .
Unveiled: Wednesday 24 September 1879, by Sir Israel Hart

Status: Grade II
Owner / custodian: Leicester City Council

Description: Located in Town Hall Square towards the south-eastern (Bishop Street) side, the fountain has three circular basins, diminishing in size towards the top. Encircling the fountain is a rail, supported by eight polished Ross of Mull granite posts. The lowest basin is formed of massive blocks of Shap granite. The fountain proper is of bronze-painted cast iron and stands on a rusticated Ross of Mull granite base, 91cm (36") thick. Crouching on the base, with water gushing from their mouths are four Assyrian winged lions. Alternating with these, around the stem supporting the middle basin, are four Ionic fluted half-columns. The middle basin has outlets shaped like the mouths of flagons, from which water gushes into the spaces between the lions of the level below. The uppermost basin is supported on a circular stem decorated with stubby Ionic pilasters on scroll bases. The water from this basin jets up vertically from a central cluster of bulrushes. Each of the basins has foliated ornamentation. The fountain is in eighteen pieces and weighs nine tons.

Condition: Generally good, although the bronze paint on the lions is worn away in places.

History: On 29 October 1878, Leicester Town Council gratefully accepted on behalf of the Borough the offer of 'a handsome Ornamental Fountain to be placed in the centre of the land fronting the Town Hall Buildings' from Israel Hart, a former Mayor of Leicester.[2] Hart had already engaged architect Francis Hames to prepare some designs for the proposed fountain and, given that Hames had already proved himself with his acclaimed design for the Town Hall, the Corporation Estate Committee – which had been instructed by the Council to consider the layout of the square – proposed that he be given the job of

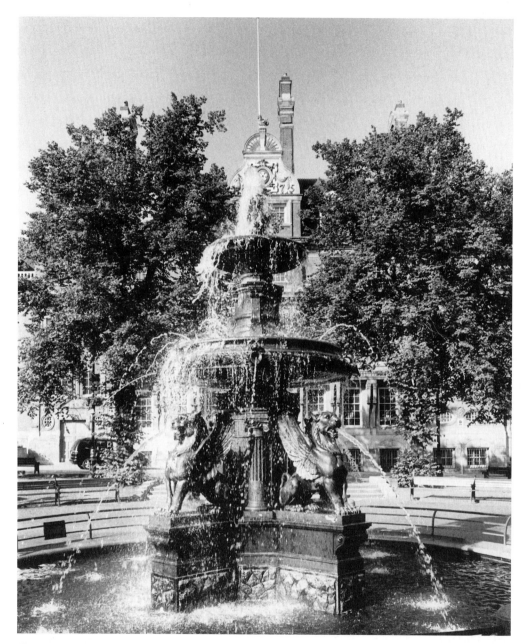

Hames, *Fountain*

designing not just the centrepiece of the square but the entire square itself. At its meeting of 28 January 1879, the Council sanctioned the Committee's proposal and, moreover, approved Hames's drawing for a fountain 'of Cast Iron Bronzed, 18 Feet high and set in a polished Granite basin 30 feet in diameter'.[3]

Before Hart's donation of the fountain there had been much debate as to how the valuable land fronting the Town Hall should be used, some advocating selling it off, some proposing building a civic hall. Hart, however, had been amongst those who wanted it set aside for the use of the citizens of Leicester. As he explained for the benefit of the crowds gathered to watch the unveiling ceremony:

... I hold that we should have in the centre of the town a large open space (applause) ... we can and ought to afford to preserve this small space for the benefit of the townspeople ... It occurred to me that in order to induce the Council to preserve this ground, I might make an offer of some centre-piece which should be an ornament to it ... I desire to thank the members of the Corporation for the kindness they have shown me in permitting me to erect the structure, and the best wish I can utter for it is that it may never want a supply of water (applause). That is also the greatest boon I can ask for the inhabitants of the town (hear, hear) ...

At the select luncheon following the ceremony, he enlarged upon the beneficial effects of town improvements to the very people in a position to do something about them:

... In an industrial town like Leicester [he explained], it was important that they should have breathing spaces adapted to the recreation of the people (applause), and he hoped that they would have many other places of the kind ... It was by improving the

different places in the town that they would improve the character of the population of the town in which they dwelt, and those interested in its welfare should aid in beautifying not only the public but private buildings...[4]

Hart kept the cost of the fountain to himself, although the contemporary press speculated that it could not have been much less than £2,000.[5] Although the name of the foundry was not mentioned, the *Leicester Chronicle* stated that the fountain had been cast in Paris.[6]

In 1919 the fountain narrowly escaped removal from the square to make way for the County's proposed permanent war memorial. The influential Leicester and Leicestershire War Memorial Committee was unanimous in its opinion that the site occupied by the fountain was the one most suitable for the memorial, but public opinion and considerable unfavourable publicity in the local press no doubt fuelled the Council's rejection of the proposal 'by a large majority'.[7]

Related work: ornamental fountain, University Square, Oporto, Portugal.[8]

Literature
LRO. *Council Minutes*, 25 September 1877 – 25 February 1879, pp.429–30, 559, 560. **General.** Banner, J.W., 1991, p.15; Banner, J.W., 1994, pp.46–7, **48**; *Builder*: – [i] vol. xxxvii, no. 1917, 1 November 1879, p.1209 [ii] vol. xxxvii, no. 1918, 8 November 1879, p.1246; *L. Advertiser*, 27 September 1879, p.7; *L. Chronicle*: – [i] 27 September 1879, p.6 [ii] 2 August 1919, p.15 [iii] 23 August 1919, p.11; Leicester City Council, 1997, 1993 edn, p.99; Leicester City Council, 1997, pp.99–100, **100**; *L. Journal*, 26 September 1879, p.6; *L. Mercury*: – [i] 24 September 1879, p.3 [ii] 20 October 1995, p.16; Pevsner, N. and Williamson, E., 1992, p.223; Wilshere, J., 1976, pp.15–16, **16**.

Notes
[1] According to contemporary press reports, the original wording here read: 'on the occasion of this land being dedicated as a place of recreation for the inhabitants of the borough' (*L. Chronicle*, 27 September 1879, p.6; *L. Journal*, 26 September 1879,

p.6). [2] *Council Minutes*, 25 September 1877 – 25 February 1879, pp.429–30. [3] *Ibid.*, p.559. [4] *L. Journal*, 26 September 1879, p.6. [5] *L. Chronicle*, 27 September 1879, p.6; *L. Journal*, 26 September 1879, p.6. [6] *L. Chronicle*, 27 September 1879, p.6. [7] *L. Chronicle*, 13 September 1919, p.2. See also *L. Chronicle*: – [i] 2 August 1919, p.15; and [ii] 23 August 1919, p.11. [8] Some local historians believe the Oporto fountain to be a copy of Leicester's. It is said that Oporto's city fathers were planning to erect a fountain at the time that Leicester's was being cast. They visited several foundries to seek out possible ideas and, seeing and admiring the Leicester fountain in its Parisian foundry, allegedly commissioned the foundry to produce a similar one for them (Colin Crosby, Leicester Blue Badge guide, in *L. Mercury*, 20 October 1995, p.16). It has not been possible to trace the original source of this information.

On the corner of Every Street and Horsefair Street, at the north-east corner of the square:
Leicestershire South African War Memorial
Sculptor: Joseph Crosland McClure
Architect: John Breedon Everard (of Everard and Pick)
Founders (sculpture): Singers
Founders (name plaques): Collins & Co

Memorial with three sculptural groups and three inscription panels in bronze, on pedestals and walls in grey granite
Dimensions:
Left-hand bronze group: h. 1.32m (4'4"); w. 67cm (2'2"); d. 63cm (2'1")
Centre bronze group: h. 1.35m (4'5"); w. 2.2m (7'3"); d. 1.1m (3'7")
Right-hand bronze group: h. 86cm (2'10"); w. 1.33m (4'5"); d. 68cm (2'3")
Outer pedestals: h. 1.5m (4'11"); max. w. 55cm (1'10"); max. d. 1.31m (4'4")
Centre pedestal: h. 1.89m (6'3"); max. w. 1.35m (4'5"); max. d. 90cm (3')
Walls between the pedestals: h. 1.34m (4'5"); w. 1.84m (6'1"); d. 48.5cm (1'7")
Platform in front of the walls and pedestals: h.

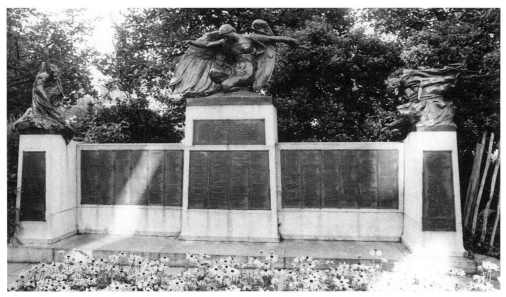

McClure and Everard, *Leicestershire South African War Memorial*

(right) McClure, *Grief*

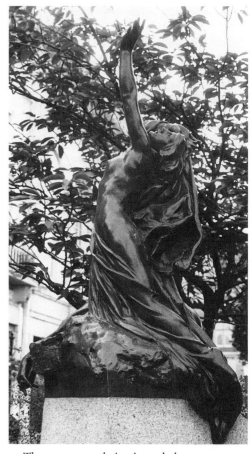

19cm (8"); w. 6.2m (20'4"); d. (to wall): 78.5cm (2'7")

Signed on the right face of the bronze base of the central figure: CROSLAND MᶜCLURE fecit
– the sculptor's initials are incised in a monogram on the bronze bases of the flanking figures, on the left-hand face of the left base and on the right-hand face of the right base.
Signed by the founders on the left-hand face of the bronze base of the central figure:
SINGERS FOUNDERS
Inscriptions cut into the stone of the pedestals:
– on the front face of the central pedestal towards the top:
GLORY TO GOD: HONOUR TO THE DEAD / PEACE AFTER VICTORY
– on the front face of the central pedestal towards the bottom:
TO THE MEMORY OF THE LEICESTERSHIRE MEN / WHO GAVE THEIR LIVES FOR THEIR COUNTRY / SOUTH AFRICA 1899 – 1902

– on the front face of the left pedestal beneath the bronze group: GRIEF
– on the front face of the right pedestal beneath the bronze group: WAR
Exhibited: see p.165
Unveiled and dedicated: Thursday 1 July 1909, by Field Marshal Lord Grenfell, GCB, GCMG, and the Revd John Edward Stocks, Archdeacon of Leicester
Status: Grade II
Owner / custodian: Leicester City Council

Description: The memorial comprises a large central pedestal joined by low walls to smaller flanking pedestals, all raised on a single step, all in granite. On each pedestal is a bronze sculpture. The front face of the central pedestal bears the main inscription plaque; beneath it and on the link walls and side pedestals are the name plaques, all in bronze. McClure described the memorial as follows:

The monument being intended to commemorate those who fell in South Africa, sufficient space on which to inscribe over 300 names determined its shape or plan. The sculptures were thought out as a further tribute to those who sacrificed, and those who risked, their lives for their country. The principal figure is a statue of Peace, with her right hand stretching an olive branch over the world, holding back in her left a sheathed and fastened sword. Peace, as the desired ultimate end of war, rather than Victory, as its immediate conclusion, was chosen as the more suitable motive for a memorial. The

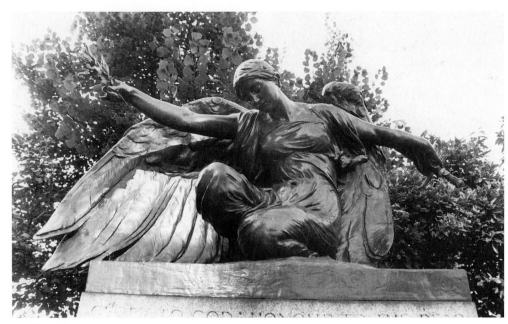

McClure, *Peace*

small groups on either hand are intended to give this idea force. On the side of the sword, the group of figures is intended to recall the horrors of war, the idea having been suggested by a sentence attributed to Henry V, at the siege of Rouen: "War hath three handmaidens: Fire, blood, and famine – and I have chosen the meekest maid of all three." On the right, or olive branch, hand are placed two figures, kneeling among the ruins, abandoned to despair or making a supreme appeal. Phases of the emotion: Grief.[1]

Condition: Good.

History: In the South African, or Boer War, of October 1899 to May 1902, Leicestershire lost over 300 men. A group of leading citizens of the county, led by the Lord Lieutenant, Henry John Brinsley Manners (Marquess of

Granby and, from 1906, 8th Duke of Rutland) agreed that some kind of permanent memorial should be erected, and on 12 January 1903 called a public meeting to discuss the establishment of a subscription to fund the scheme.[2] The meeting being in favour of the proposal, a memorial committee was approved and collectors appointed. It was agreed that a decision on the form of the memorial should be deferred until the likely amount of subscriptions could be estimated confidently.[3] By early April 1903 just over £1,000 had been collected.[4] There was a unanimous feeling amongst the members of the Committee that the memorial should be a commemorative monument rather than a benevolent institution and thus they turned their minds to the question of the sculptor.[5] Their choice, Alfred Gilbert (1854–1934), almost resulted in

complete disaster. Five years later and with £950 of the subscribers' money spent, it became evident that Gilbert was incapable of fulfilling the commission, and the Committee had to cancel the contract, replace the lost subscriptions, and start over again with a new sculptor. To understand how a man who by the 1890s had risen to become the leading British sculptor of his generation should have so signally failed to bring a relatively straightforward commission to completion, it is necessary to review briefly the recent developments in the sculptor's life.

Gilbert's rise to the top of his profession had culminated in January 1892 with a commission from the royal family to design the *Memorial to the Duke of Clarence*. Gilbert's sense of the historic importance of this commission only served to exacerbate his main weakness as a sculptor: a tendency repeatedly to revise his work towards over-elaboration. Having secured royal approval for a relatively simple design he then could not resist piling on more expensive additions and details. At the same time, he evidently found it virtually impossible to reject other commissions.[6] He not only worked extremely long hours, he also tried to maintain an increasingly extravagant social life – and all the while, his domestic situation was deteriorating. The crippling costs of running a vast house and studio in Maida Vale contributed to his financial ruin, and in August 1901 Gilbert was forced to declare himself bankrupt. He moved himself and his family to lodgings in Bruges where, he said, the cost of living was cheaper and his preferred foundry, the Brussels-based Compagnie des Bronzes, was within easy reach. For the next couple of years he was to split his time between the two countries. In 1903, however, matters came to a head. Four years earlier, in a misguided attempt to relieve his financial problems, Gilbert had secretly sold four figurines from the still unfinished *Clarence Memorial* to a dealer as

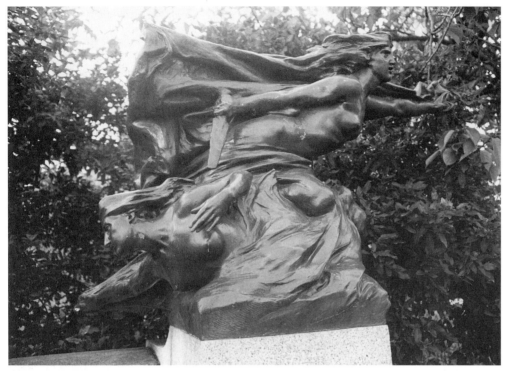

McClure, *War*

independent statuettes,[7] but at Easter 1903, photographs of the statuettes were published in a journal.[8] For the King, frustrated by the delayed completion of the memorial to his beloved son, this was the last straw and he severed all contacts with Gilbert, who, naïvely believing himself to be the injured party, took up permanent residence in Bruges.

Nevertheless, and despite the scandalous nature of his latest circumstances, throughout his troubles Gilbert somehow managed to retain many loyal friends who did all they could to help him. One of his staunchest friends was Violet, Lady Granby[9] and, according to Gilbert's most recent biographer, Richard Dorment, it was she who influenced the decision of the Leicestershire War Memorial Committee to award the commission to Gilbert.[10] She presumably first convinced her husband and then he, in his capacity as Chairman of the Committee, asked the sculptor for an estimate for a 'Monumental Column or Pillar surmounted by a suitable figure in marble and having the names of the men who had fallen carved thereon ...'[11] Gilbert reckoned that such a scheme could be carried out for £1,100. Granby presented the case for employing Gilbert to the meeting of 20 April 1903 and as a result the Committee voted unanimously in favour, subject to the sculptor submitting a suitable design with a formal estimate of the cost.

On 13 May 1903 Gilbert travelled to Leicester and presented two alternative designs, one of *Britannia* and the other of *Victory*. He advised that whichever figure was chosen it should be about 10 feet high and either in bronze or aluminium, at the same time stressing that he favoured the latter because of its lightness.[12] The Committee evidently accepted his advice on the material and selected the figure of *Victory* by a majority of nine to one.[13] Having settled the question of the figure, the Committee then instructed Gilbert to prepare a design for the base upon which the name plaques were to be placed.[14] The site for the memorial was also discussed. Four locations were proposed: two of them – one in Humberstone Gate and the other opposite the Midland Railway Station – were unavailable and were quickly eliminated, but the other two – one in the Municipal (i.e., Town Hall) Square and the other at the London Road entrance to Victoria Park – were available. The latter was chosen by a ten to one majority. Gilbert agreed with the Committee that the site was ideal[15] and on 19 May Victoria Park was approved by the City Council.[16]

At its meeting of 28 July 1903 the Committee drew up a formal contract for Gilbert. It also formed a sub-committee to supervise the inscription and name plaques and made arrangements for local newspapers to publish the lists of the names of the dead so that relatives could submit corrections.[17]

On 26 January 1904, the Committee met to consider Gilbert's pedestal design, but found the sketch rather too vague and wrote to him requesting clarification of the positions of the inscriptions and the overall height. Furthermore, despite the contractual stipulation that the pedestal should be in marble, Gilbert's sketch seemed to suggest that he was thinking in terms of bronze.[18] But the Committee was also in receipt of something altogether more ominous than the customary vagaries of

Gilbert's creative process. Along with the pedestal design was a letter from the sculptor requesting that the second instalment of his fee be paid not to his founders, the Compagnie des Bronzes, as previously agreed, but direct to him. He evidently gave no explanation of his request, but assured the Committee that the model was now approaching completion when the instalment would be due.

In fact, Gilbert was again in severe financial difficulties. His lodgings at Bruges were by no means small, but he needed a much larger space if he were to work on a figure the size of the Leicester 'Victory'. Furthermore, he was trying to establish an art school. To accommodate both projects, he had rented a second building. The first instalment of the Leicester subscribers' money had already been spent on rent for this new building, while students' fees were intended to keep it going. Although Gilbert had, in characteristic fashion, overstretched himself, he was certainly in earnest about both projects: he had placed advertisements for students in a leading art periodical and was evidently working with considerable enthusiasm on the Leicester 'Victory'. Two letters written by his son and secretary, George Gilbert, to M.H. Spielmann, the editor of *The Magazine of Art*, attest both to Gilbert's confidence in his abilities to realise his schemes and to his immediate financial difficulties. On 26 October 1903, Gilbert declared:

> ... 'The School' is no longer a proposition but an actual fact, and as I dictate, I am also directing the erection of a figure of 'Victory' of colossal size, my first work in Bruges, and one which I hope to make justify the position I have taken up ... [19]

More tellingly, on 8 December 1903, in a letter begging a loan from Spielmann, George Gilbert, while confirming the advanced state of the Leicester commission, at the same time distorts the facts of the Leicester committee's contractual obligations:

> ... Now the time has come when he [i.e., Alfred Gilbert] is beginning to be worried for immediate means to carry out the great enterprise he has undertaken. With his characteristic optimism he has gone on ahead despite his difficulties with the result that we have a huge figure of 'Victory' almost completed in clay ...
>
> I know, as his secretary, that he is hard put to [find] immediate means to meet current expenses. He really does not require a large sum, but just sufficient to pay his way, for a while, for he is expecting money due to him for work done, the second instalment of £366, for the payment of which he is dependent upon the vagaries of a Committee. In the meantime Father is in difficulty, and urgently needs £100 ...[20]

It is not known how many members of the Committee were aware of Gilbert's inability to balance his own finances, but Granby, with his court connections, surely must have been. Whatever its reasons, the Committee unanimously refused the sculptor's request.[21]

It was perhaps with some relief that the Committee received, and were able to approve, the sculptor's more detailed pedestal design at its next meeting on 19 February 1904. At the same time, however, Gilbert renewed his earlier plea to have the second instalment diverted to him, explaining that the Compagnie des Bronzes was 'asking a very unreasonable amount' but that he was himself now in a position to carry out the founding. Again the Committee refused and requested the Honorary Secretary (Major W.J. Freer), in the absence of Lord Granby, to advise Gilbert that the second instalment would be forwarded to the founders as soon as the founders' and banker's certificate had been received.[22]

The Committee's failure to agree to Gilbert's proposal evidently precipitated a crisis, as the next minutes are of an emergency meeting on 2 May 1904 at Lord Granby's London residence. Gilbert and Lord Granby had been in correspondence since the last Committee meeting and the situation was felt to be so critical that the Committee was now discussing what other ways might be open to it to obtain a memorial – should the present contract have to be abandoned. Evidently the alternatives were not very attractive as Committee members Sir Thomas Wright and Major Freer were

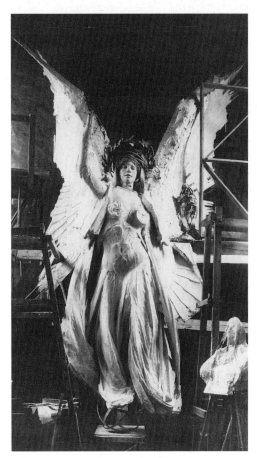

Gilbert, *Leicestershire South African War Memorial*: (?)1st model

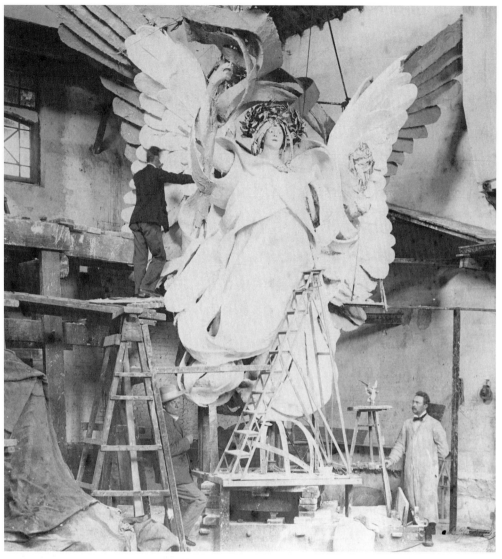

Gilbert, *Leicestershire South African War Memorial: revised model*

Bruges. Gilbert had explained to them that the Compagnie des Bronzes had wanted more money than had originally been agreed to carry out the casting, and that were he to pay what they asked, he would be left with nothing. To add to his troubles he had been forced to re-make his clay model following frost damage. To date, he explained to the delegates, he had spent not only all the first instalment of his fee but had laid out £260 of his own money (presumably omitting to mention that the outlay had been chiefly on his school). The delegates, having inspected Gilbert's facilities and convinced themselves that he was after all experienced enough to supervise and carry out his own casting, and having accepted his promise that he would cast the head and hands himself and that all would be complete 'by September at the latest', had taken him at his word and had modified the contract accordingly.[24]

September 1904 came and went, however, and still there was no sign of the statue. On 10 May 1905 the Committee met to review the situation. Gilbert had sent letters and a report to the Committee excusing his delay as being 'partly caused by his long illness', but that, having recovered, he would have the statue in Leicester 'this year'. He even advised the Committee to go ahead with concreting the proposed site to receive the pedestal.[25] Greatly concerned by now, the Committee wrote to him requesting an explicit set of deadlines for the work. It also determined that no site preparation should take place until the delivery date was more certain. Notwithstanding the Committee's urgent request for clarification, and despite several follow-up letters from Freer, nothing was heard from Gilbert until September when Freer received a letter (presumably from George Gilbert) saying that Gilbert had again been ill but 'promising to send the Report on at once'. Two more months passed before, on 7 November, Freer received a

authorised to go to Bruges to negotiate with Gilbert and, should they deem it appropriate, to write out a cheque for up to '£200 as a further payment on account'.[23]

The Committee re-convened in Leicester on 11 May following the delegates' return from

letter saying virtually the same thing: Gilbert had yet again 'been seriously ill' but that the report would follow within the week.[26]

The next day, 8 November 1905, the now desperate Committee re-convened. Granby had begun to lose patience with Gilbert and had written to him 'in strong terms'. Lady Granby had been over to Bruges to see for herself what progress had been made but even she had not been successful. Yet as frustrated as the Committee must have felt, there was nothing it could do for the moment but wait for the promised report.[27]

When on 14 November Gilbert's report eventually did arrive, Lord Granby found it so unsatisfactory that he immediately wrote back demanding more detail. By the meeting of 2 December, a supplementary report had arrived. The situation was worse than the Committee could have imagined. Gilbert was currently in dispute with his landlord over non-payment of rent and other bills and the Leicester statue, which was now in plaster, had, he informed the Committee, been seized. Even more alarming, Gilbert was now asking the Committee's permission to commence a new statue. After all the years of delays, the Committee could not countenance such a proposal and Freer was asked to write to Gilbert to find out how much he owed the landlord as the Committee might wish to pay off his debts in order to retrieve its statue.

The Leicestershire subscribers were not the only patrons experiencing difficulties with Gilbert. In 1905 one Julia Frankau had agreed terms with Gilbert for a memorial to her recently-deceased husband. As the prescribed deadline came and went, and it was obvious Gilbert was not going to complete, Frankau decided to expose him publicly. She placed advertisements in both the British and European press requesting anyone who had been let down by Gilbert to contact her; more damagingly, in March 1906 she told her story in two long articles in the magazine *Truth*.[28] The Leicestershire Committee could not have failed to have read about and been alarmed by the Frankau affair. Moreover, Gilbert seems not to have responded to Freer's letter.

In May 1906, Freer, having evidently received no reply to his letter, travelled to Bruges with fellow committee-member the Hon. H.R. Scott to find out what, if anything, was happening with their commission. To their astonishment, despite the Committee's instructions, Gilbert had begun another model, this time in papier mâché. The new figure was in armour, the front had been complete when they saw it and, they were quick to assure the other members, it did at least appear 'to be an improvement on the original design'.[29] According to Gilbert, when the Court of Ghent had ordered the original figure and pedestal removed he had, in order to prevent this, destroyed them both[30] – a fact he had omitted to mention in his previous letter. Gilbert undertook to have his new statue and pedestal 'ready by the end of September and the whole memorial complete and delivered by the end of November'. A Mr Humphrey Page of Bruges offered to 'inspect and report' on Gilbert's progress and the Committee arranged to send him a cheque for £60 to pay off Gilbert's debts. So anxious was the Committee to get its statue, it even offered Gilbert a £100 bonus should he meet the November deadline. Understandably, the Committee resolved that no information should be released to the press until the matter was resolved.[31]

Again, Gilbert failed to meet the deadline. Even a desperately-worded letter from the Duchess of Rutland to George Gilbert failed to produce the desired result:

> ... My husband curses the day he gave the Leicester monument to yr father to be done! – He considers now, that yr father has *played him false*!

It probably means that my husband who is so poor that he is having to sell his art treasures – to be able to get along at all – will out of his *own pocket* have to refund all the money already given to yr father – & give it to another sculptor ...[32]

On 5 May 1907, Gilbert finally admitted that he was not going to be able to complete the work by himself and wrote to the Committee proposing that it 'should appoint a capable assistant' – to be approved by him and to work under his direction – who could complete the models from his designs, but that the assistant should be paid by the Committee out of the balance owed to him and that he would himself bear the cost of casting the statue. So certain was he that he was going to complete the work this time that he requested permission to sell reduced versions of the statue in bronze or silver. The Committee found the first of Gilbert's two proposals 'impracticable'. Instead it proposed that should Gilbert have the models of the statue and pedestal ready for casting and delivered to a foundry to be nominated by the Committee by 1 July 1908 and that if he would agree to supervise the casting and erection personally, the Committee would undertake responsibility for all attendant costs. As to Gilbert's proposal to make reduced copies of the statue, the Committee agreed that he could make as many as he liked – just so long, presumably, as it got its memorial.[33]

The Committee did not meet again until 24 January 1908. Humphrey Page had written from Bruges stating that despite repeated efforts it had been quite impossible to get anything out of Gilbert. Committee-member J.A. Corah had himself been to Bruges the previous August to see how matters stood and had concluded 'that there was not the slightest chance of the Committee getting the Statue'. The Chairman (who had by now succeeded to the title of Duke of Rutland) put it to the other members of the

Committee that they had to face the fact: Gilbert was never going to complete the work. There was no other recourse but to cancel the contract and start afresh. At least another £1,000 was needed and he would personally contribute £200. Those present agreed that they had no alternative and resolved to send out a private letter to all Committee members stating the position and asking for donations.[34] The letter cancelling Gilbert's contract was dispatched on 31 January. Somewhat inevitably, Gilbert replied that 'he would at once send full details of the progress and delivery of the work'. [35]

It is not clear just how in touch with reality Gilbert was by this time. He evidently never intended to deceive any of his patrons. Commissions were actually started – often several times, but both the *Frankau Memorial* and the *Leicestershire War Memorial* – as is evident from the surviving photographs – display what Dorment has aptly described as a nightmarish quality. Where the *Frankau Memorial* had become a rather formless mess,[36] Gilbert's models for the *Leicestershire War Memorial* show a quite shocking transition from an unexceptional winged Victory (see fig. on p.161.) to an absurd monstrosity: a rather vacuous face surmounting swathes of meaningless drapery from which sprout a pair of over-sized wings (see fig. on p.162).[37] Notwithstanding his undertaking to the Leicestershire committee to send further details, Gilbert had by 18 March 1908 (and presumably never thereafter) sent nothing. The last we hear of Gilbert's Leicestershire 'Victory' is in September 1908 when Henry Ganz visited Gilbert in Bruges and apparently saw it completed. Gilbert evidently told him that it had been refused by the Committee![38]

By the meeting of 18 March 1908, the Committee had managed to gather together £919. 7s. 7d. Committee-member J.B. Everard (of the architectural practice Everard and Pick) had interviewed sculptor Joseph Crosland McClure of Leicester Art School, and the latter had 'prepared a rough model for the Committee's inspection'. McClure's model evidently consisted of a central figure flanked by terminal lions. The Committee asked him to estimate, on two different scales, the cost of casting the central figure in bronze with the flanking lions in either bronze or granite. Meanwhile Everard was to estimate the cost of all necessary building work. It was also agreed that the new design would be more suitable for the Municipal Square than Victoria Park, and it was decided that a formal petition would be made to the Council once the details of size and cost had been settled with McClure and Everard.[39]

By 9 April 1908 a further private appeal to the principal subscribers had brought the Committee's funds up to £1,039. At the meeting convened on this date McClure submitted his estimates, and Everard his company's drawings. Everard and Pick offered to supervise the building work free of charge and the Committee decided to go for the larger monument at a cost of '£870 including the Plates to receive the names'.[40]

At its meeting on 28 April 1908, Leicester Town Council approved the new site and the Mayor fully appraised its members of the situation with the war memorial scheme, completely exonerating its committee from any blame while praising all those, especially Rutland, who had recouped the loss out of their own pockets. Furthermore, though it was true Leicester had lost a nationally-known sculptor, it could take pride in the fact that the newly-appointed man was local, from the Leicester School of Art, an announcement that was greeted with general approval.[41] Now that the local press blackout had been lifted, the scandal even reached the national press, receiving front page coverage in the *Daily Chronicle*, which paper also reminded its readership of Gilbert's previous broken contract with Frankau.[42] Pointedly headed 'R.A.'s Methods', the article seems finally to have embarrassed the Council of the Royal Academy – which had hitherto resisted expelling Gilbert in the face of pressure from other disgruntled patrons – into forcing Gilbert to resign from the Royal Academy on 24 November 1908.[43]

By 8 August 1908, McClure had secured approval for the plaster of his centre figure of *Peace*, and requested the Committee's permission to substitute, at no extra cost, two allegorical groups, *War* and *Grief*, for the terminal lions, a suggestion with which the Committee was pleased to agree. One slight problem arose regarding the name plates, however. Owing to the regimental headings being so numerous, the cost of the plates had risen from £170 to £270. The full cost of the memorial was now: sculptor £700, name plates £270, granite for base £345, foundations £40, making £1,355 in all. It was agreed that the full list of subscribers should be printed out and further efforts be made to make up the shortfall.[44]

The central figure was ready for casting by 23 January 1909, and this and the unfinished side groups were approved by the Committee, and a cheque for £250, McClure's first instalment, was drawn up. The sculptor reckoned that he would have his part of the memorial ready by 1 June. Everard, who did not envisage any delays on his part either, produced a specimen of Irish granite, which he recommended as a cheaper alternative to the original more expensive granite, representing a saving of about £60. Even with this saving, however, the Committee estimated that the amount in hand, £1,186. 9s. od., was still about £200 short of the amount required and it was agreed that a few more of the original subscribers should be approached.[45]

On 7 May 1909, as the keenly-awaited date of completion drew near, the Committee met to

discuss the unveiling ceremony. Lord Roberts (Imperial Commander-in-Chief during the South African War) had been invited but could not officiate. Lord Grenfell (who had no particular connection with the South African War, but who had been promoted field-marshal in the previous year) accepted. A further £200 was paid to McClure and £100 to Collins and Co. for the bronze name plates.

All the work having been completed and the memorial erected, the unveiling ceremony took place on Thursday 1 July 1909. The following day the *Leicester Daily Post* devoted two entire pages to the 'brilliant spectacle', with photographs not just of the event itself but also of each of the sculptural groups. Additionally, it printed an appreciation of the piece by 'an art critic'. McClure was praised for his 'technical mastery', his 'structural fidelity and refinement in his treatment of the nude', his 'masterly composition', but most of all for his originality in avoiding what the anonymous critic saw as the usual English practice of representing individual, historically-specific 'khaki-clad' soldiers, and instead creating beautiful idealised figures to symbolise the timeless concept of 'Peace prevailing over War and its attributes'. He concluded his long piece with:

... As an acquisition to the beauty of an already beautiful town, the memorial cannot fail to become a cherished possession ... it seems probable that a memorial which endeavours to be a fine emblem of the thoughts and emotions inspired by all warfare will live longer than one which commemorates with exacting particularity any single war ...[46]

Leicester's *South African War Memorial* remained in its original position halfway along the north-western edge of the square facing onto Horsefair Street until the early 1930s, when its relocation to the northern corner, at the point at which Every Street meets Horsefair Street, was necessitated by the Corporation's alteration of the shape of the square.[47]

Related works:

1. Formerly Leicestershire Museums Service – McClure's plaster models for *Peace* (39.A.12), *Grief* (40.A.12) and *War* (41.A.12) (all destroyed).

2. Leicester Cathedral: Leicestershire Regiment South African War Memorial window designed by Clayton and Bell, with marble name tablets to the men of the Regiment who died in the war, unveiled 12 November 1903.[48]

Exhibited (McClure's models):

1910: *War Memorial* (cat. 662) at the Glasgow Institute of the Fine Arts; *Peace. From the Leicester War Memorial* (cat. 1698) at the Royal Academy of Arts.

1911: *Grief – group. From the Leicestershire South African War Memorial* (cat. 1714) and *War – group. From the Leicestershire South African War Memorial* (cat. 1748) at the Royal Academy of Arts.

Literature
LRO. *Estate ... Committee Minutes*, 15 November 1933 – 27 October 1937, pp.55, 68, 113-14, 120, 139; *Leicestershire South African War Memorial Committee Minute Book*.
Royal Academy of Arts archives. Spielmann Papers: letter from Alfred Gilbert to Spielmann, dated 26 October 1902; letter from George Gilbert to Spielmann, dated 8 December 1903.
University of Leicester library. Local History collection – *Council Minutes*: – [i] 1902-3, p.231 [ii] 1907-8, pp.227, 230; *Transactions ... :* – [i] 1904-5, pp.234-5 [ii] 1911-12, p.225.
Windsor, Royal Archives. Letter from the Duchess of Rutland to George Gilbert, dated 22 March 1907.
General. Abdy, J. and Gere, C., 1984, pp.52-3; *Art-Journal*, 1908, p.223; Banner, J.W., 1994, p.47; Cruickshank, I., and Chinnery, A., 1977, fig. **74**; *Daily Chronicle*, 1 May 1908, p.1; Dorment, R., 1985, pp.230-1, 232, 260, 261, 264, 265, **231**; Dorment, R. (ed.), 1986, pp.17, 45, 119, 128, 216, **17**; Ganz, H.F.W., 1934, pp.5, 10, 11, 13; Gildea, J., 1911, pp.119-20, **119**, **120**; Hollins, P. and England, S., 1997, p.**135**; *L. Advertiser*, 3 July 1909, p.11; *L. Chronicle*: – [i] 3 January 1903, p.1 [ii] 17 January

1903, p.5 [iii] 24 January 1903, p.10 [iv] 3 July 1909, p.8; Leicester City Council, 1997, p.101; *L. Daily Post*: – [i] 13 January 1903, p.7 [ii] 14 May 1903, p.3 [iii] 29 April 1908, pp.4, 5 [iv] 26 June 1909, pp.4, 5 [v] 1 July 1909, p.5 [vi] 2 July 1909, pp.6, 7, **6**; *L. Journal*: – [i] 1 May 1908, p.5 [ii] 2 July 1909, p.5; *L. Mercury*: – [i] 2 May 1908, p.5 [ii] 1 July 1909, p.5; Macklin, A.E., 1909, pp.98, 100, **113**; Sharpe, J.M., 1992, pp.6, 19, 27, fig. **2.9**; Tyler-Bennett, D., 1990, p.45.

Notes
[1] As quoted in *L. Daily Post*, 26 June 1909, p.5.
[2] *Ibid.*, 3 January 1903, p.1. [3] *Leicestershire South African War Memorial Committee Minute Book*, meeting of 12 January 1903, and *L. Daily Post*, 13 January 1903, p.7. [4] *Leicestershire South African War Memorial Committee Minute Book*, meeting of 20 April 1903. [5] See *Ibid.* [6] See Dorment, R. (ed.), 1985, p.183. [7] *Ibid.*, pp.198-9, and Dorment, R., 1986, p.155. [8] This was the *Magazine of Art*'s special issue: Joseph Hatton, 'The Life and Work of Alfred Gilbert RA, MVO, LLD', *Easter Art Annual*, 1903. [9] See McAllister, I., 1929, p.167; Bury, A., 1954, pp.35, 54, 60, 96, 97; and Dorment, R., 1985, pp.131, 227, 237. [10] Dorment, R. (ed.), 1985, pp.230, 260; and for Lady Granby's efforts to secure commissions for Gilbert in general, Dorment, R. (ed.), 1986, p.174. [11] *Leicestershire South African War Memorial Committee Minute Book*, meeting of 20 April 1903. [12] Gilbert had already demonstrated the lightness, durability and tensile strength of aluminium in 1893 with his figure of Eros for his *Shaftesbury Memorial*, Piccadilly Circus, becoming thereby the first sculptor to use the material for a large-scale sculpture (Dorment, R., 1985, p.111). [13] *Leicestershire South African War Memorial Committee Minute Book*, meeting of 13 May 1903. [14] According to the *L. Daily Post*, 14 May 1903, p.3, it was intended that the base would be the same height as the figure, 10 feet, making the monument 20 feet high overall. [15] *Leicestershire South African War Memorial Committee Minute Book*, meeting of 13 May 1903. [16] *Council Minutes*, 1902-3, p.231. [17] *Leicestershire South African War Memorial Committee Minute Book*. [18] *Ibid.* [19] Letter to M.H. Spielmann, dictated by Alfred Gilbert to George Gilbert at 44 Rue des Corroyeurs Blancs, Bruges, 26 October 1903 (Royal Academy archives, Spielmann Papers, SP/7/54). [20] Letter to M.H. Spielmann from George Gilbert at Bruges, 8 December 1903 (Royal Academy archives, Spielmann Papers, SP/7/50). [21] *Leicestershire South African War Memorial Committee Minute Book*. [22] *Ibid.*

[23] *Ibid.* [24] *Ibid.* [25] *Ibid.* [26] *Ibid.* In fact during this time Gilbert had been working on – and failing to bring to completion – the *Frankau Memorial*. Far from pleading illness to Mrs Frankau, his letters to this patron promise that her commission is 'progressing rapidly' (Dorment, R., 1985, p.242). [27] *Leicestershire South African War Memorial Committee Minute Book.* [28] Dorment, R. (ed.), 1986, p.45. [29] This, the third attempt at the figure, may be the one photographed in Gilbert's studio (see fig. on p.162). [30] This was not the first time Gilbert had taken such extreme action. On 17 September 1901, on the eve of his departure for Bruges, he had famously destroyed most of his plasters rather than let them fall into the hands of the bailiffs. His reasoning then and presumably in this case was that cheap reproductions could be made in large numbers from any such confiscated plasters (see Dorment, R., 1985, p.219). [31] *Leicestershire South African War Memorial Committee Minute Book.* [32] Windsor, Royal Archives – letter from the Duchess of Rutland to George Gilbert, dated 22 March [1907]. [33] *Leicestershire South African War Memorial Committee Minute Book.* [34] *Ibid.* [35] *Ibid.,* meeting of 18 March 1908. [36] See illustration in Dorment, R., 1985, p.241. [37] *Ibid.,* p.231. [38] Ganz, H.F.W., 1934, p.13. [39] *Leicestershire South African War Memorial Committee Minute Book.* [40] *Ibid.* [41] *L. Daily Post,* 29 April 1908, pp.4, 5. [42] *Daily Chronicle,* 1 May 1908, p.1. [43] Dorment, R., 1985, p.263. [44] *Leicestershire South African War Memorial Committee Minute Book.* [45] *Ibid.* [46] *L. Daily Post,* 2 July 1909, p.6. [47] Joint Meeting of the Estate Committee and Parks Committee of Leicester Corporation, 25 March 1948, in *Estate Committee Minutes 1945–49.* The 25" map for 1930 shows the memorial in its original position; the 1938 25" map shows change to the Horsefair Street edge of the square but with no sign of the memorial; and the 1955 25" map shows the memorial in its present position. It has not been possible to locate any minutes covering the move (e.g., Estate and Highway Committees). In 1934, however, the Estate Committee was discussing the cleaning of the bronze groups. [48] See the 49th Annual Report of the Leicester Architectural Society in *Transactions ...,* 1904–5, pp.234–5.

University of Leicester

That Leicester should have a college was an idea first proposed in the 1880s at the Leicester Literary and Philosophical Society. In 1917–18 the idea was revived but this time with the college serving as a war memorial. In 1919 Thomas Fielding Johnson, a local manufacturer, purchased the former lunatic asylum and several acres of surrounding land which he gave to the town for the purpose of establishing a college and two schools, one for boys and one for girls. Following its conversion, the former asylum opened in 1921 with nine students as the Leicester, Leicestershire and Rutland College. In 1926 it became a university college and in 1957 a university with 1,000 students.[1]

The majority of the sculptures (and a number of the paintings) in the collection of the University of Leicester have been purchased out of the Goddard Fund for the Arts, a fund established by a local couple, Herald and Joan Goddard, with the primary objective of purchasing art works for the University.

Note
[1] Pevsner, N. and Williamson, E., 1992, p.255. For a full history of the University of Leicester, see Burch, B., 1996.

1. Campus
The Attenborough Building (access only by prior arrangement), 1968–70, by Ove Arup Associates

On the first floor of the entrance block:

Relief Sculpture
Sculptor: Derek Carruthers

Sculpture cast in fibreglass resin
h. 4.32m (14'2"); w. 4.32m (14'2"); d. 61cm (2') (all est.)
Inscription on a plaque on the wall to the right of the sculpture:
RELIEF SCULPTURE / DEREK CARRUTHERS 1971 / PURCHASED FROM THE GODDARD FUND FOR THE ARTS 1971
Installed: July–September 1971
Status: not listed
Owner: University of Leicester

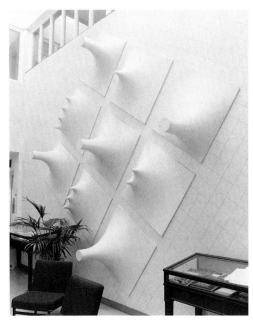

Carruthers, *Relief*

Condition: Generally fair, although the surfaces have numerous scratches and hairline cracks, especially on the lower modules. The circular rims of some of the more protruding forms are chipped (perhaps caused by contact with temporary notice-boards, etc.).

History: The University's Attenborough Building consists of an entrance block linked to an eighteen-storey tower by a covered bridge at first-floor level. Immediately in front of anyone ascending the second flight of stairs from the main entrance was originally a large blank wall. It was with the express purpose of filling this space that in November 1970 the then head of the History of Art Department, Professor Luke Herrmann, approached local artist Derek Carruthers with a proposal from the University that he make a design for a suitable relief sculpture.

Carruthers assessed the possibilities of the

site and duly submitted a drawing to Herrmann, who liked it and approached the then Vice-Chancellor, Dr T. Fraser Noble, for approval.[1] On 24 March 1971, Fraser Noble wrote to Carruthers inviting him to the University to discuss the sculpture. As a result of this meeting, Carruthers produced a one-third scale model.[2] Fraser Noble next invited Herald and Joan Goddard – who had only recently established their purchasing fund – to a meeting with himself and Herrmann to discuss Carruthers's proposal. The Goddards also liked Carruthers's model and so the present relief became the first sculpture to be purchased through the Goddard Fund for the Arts.[3]

Carruthers's casting process was of his own devising. Each of the nine panels of the relief was cast separately. For each panel Carruthers made a wooden frame over which he stretched a thin latex sheet. The sheets were then pulled down by formers 'to create perfect algebraic curves in three dimensions'. Next, the frames were screwed down and the latex sheets coated with layers of plaster of Paris and scrim. Once the plaster mixture had set, the latex sheets and formers were removed and the resulting moulds prepared for casting in fibreglass resin.

Carruthers has described this work as follows:

The nine panels make a square, the axis of which coincides with the top left / bottom right diagonal of the wall itself. This creates a curious anti-clockwise tilt in the equilibrium of this square, which is righted by the offsetting of the larger protrusions which line up with the vertical and horizontal axes of the wall. The smaller protrusions move numerically clockwise.

My original intention was that a coloured gel wheel lighting system (red – orange – yellow – red) be installed to give a different quality and drama in the dark evenings. This was installed but proved disappointing and so was removed.[4]

Literature
PMSA NRP East Midlands Archive. Letter, dated 22 March 1998, from the sculptor to the author.

Notes
[1] Letter from Herrmann to Carruthers dated 25 November 1970. [2] At the time of writing, 1999, still in the sculptor's studio. [3] Information from Herald and Joan Goddard. [4] Letter from the sculptor to the author, dated 22 March 1998.

Note: Percy Brown, *Life* (formerly on the forecourt of the Attenborough Building) is, at the time of writing (autumn 1999), in store awaiting relocation – for an account of the sculpture, see p.323.

The Bennett Building (access only by prior arrangement), 1963–5, by Sir Leslie Martin and Colin St John Wilson in association with Castle and Park

In the foyer:

Orb

Sculptor: David Partridge

Relief in nails, copper discs and wood

h. 91.5cm (3'); w. 1.83m (6')
Inscription on a metal plaque beneath the relief:
ORB DAVID PARTRIDGE
Status: not listed
Owner: University of Leicester

Condition: Generally good, though a few of the nails are missing.

History: *Orb* was purchased by the University of Leicester in 1967 with money provided through the Bain Fund.

Writing in 1965, the art critic Charles S. Spencer described Partridge's nail sculptures as follows:

In all his work one is aware of the overall composition before the jewel-like complexity of the component parts work their fascination. It is the rhythmic, landscape-like shapes which dominate. By landscape, one must not limit meaning to conventional forms; universal or solar conceptions could be appropriate.

Curiously enough the dissections and diversions of the large areas, by rings or rows of nails, or the incorporation of heavier

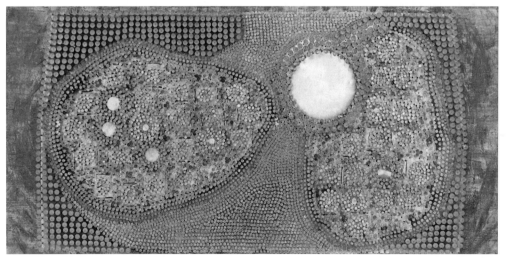

Partridge, *Orb*

metal objects, are, according to Partridge, based on geological studies. As a boy he was fascinated by fossils and the natural structure of plants and rocks. Memories of these studies have seemingly guided him, intuitively, in the development of what he calls his 'vocabulary'.

Generally speaking he makes no preliminary designs. Only when working to an architectural commission does he prepare a sketch or maquette to assist the architect or patron. When working alone, he says, 'I start with one kind of nail without any preconceived ideas. I then go on to the point when I think it is finished'. Whilst, as I have suggested, there is a sub-conscious urge or need to recreate a natural structure, the artist is unaware of this while at work. The mere hammering in of one nail on a board predestines the shape, height, distance of the next.

The complexity of these extraordinary designs almost defies description. It is not enough to state that they are, for the most part, nails hammered in at intervals in straight or curved lines. The infinite variations of texture, density, three-dimensional relationships, solid masses and spatial, pointilliste contrasts, are contrived with brilliant craftsmanship and infinite elegance. Variations are achieved by diverse means; in the first place the nail-heads are different sizes and colours; some are galvanised steel, others copper, or zinc, and when in position groups are polished and lacquered. Then the nails are hammered in at different heights and distances; one section of the panel could be a seemingly solid mass of closely placed heads, to give a powerful, intense, flat plane. Others, with the nails at regular intervals, have a more open, airy feeling of space. In these groupings the nails may vary in height so that an even more complex, mysterious texture is achieved.

Then again, as in mosaic, the placing of the heads at differing angles creates additional relationships of light and reflection, depending on the angle of view. The nails themselves at times make an odd, even eerie, scaly effect, or convey the strength of chain-mail. It does not require much imagination to realise what concentration is required to control all these possible effects at the same time as creating and elaborating the patterns on the working board.[1]

Literature
Spencer, C.S., 1965, pp.20–3.

Note
[1] Spencer, C.S., 1965, pp.21–3.

The Charles Wilson Building (access only by prior arrangement), 1962–7, by Denys Lasdun and Partners

In the foyer:
Relief Construction F3
Sculptor: Anthony Hill

Relief sculpture in plastic and aluminium
Executed: 1965–6
h. 1.07m (3'6"); w. 1.07m (3'6"); d. 9cm (4")
Exhibited: 1983, London, Hayward Gallery (no. 74)
Status: not listed
Owner: Arts Council of Great Britain (on long loan to the University of Leicester)

Condition: Good.
History: *Relief Construction F3* was purchased by the Arts Council of Great Britain from the artist in 1967 and loaned to the University of Leicester in 1980.[1]
Throughout the early 1950s, Hill concentrated on abstract painting, although by the middle of the decade he had reached the conclusion that not only painting but also sculpture had run its course. He considered it an important distinction that the reliefs he

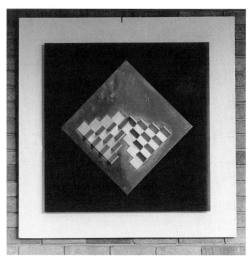

Hill, *Relief Construction F3*

began to make from 1955/6 were not sculptures, but something new: geometrically-controlled abstract constructions. As Hill explained in 1957:

Synthetic materials and other materials like glass and metal in their machine states give the abstract artist a new and important group of media and it is with these materials that "Constructionist" conceptions can be realized and developed. With these new materials comes a new "art object" – the construction ... Constructionist art is purely inventive and concerned with manipulating real entities; it is neither Academic nor Phantasist, Classical or Romantic, it is Realist.[2]

From his earliest experimental reliefs, Hill had restricted himself to using synthetic materials, especially, as in this example, black and white plastic and grey aluminium, eschewing colour for tone and relying on the reflective or transparent properties of the materials to create

instead a sensuous play of light.[3] In the spring of 1956, he began using what was to become one of the most important elements in his work, small sections of angled aluminium. At first he used only 'L' shaped, 90° sections, placed either orthogonally or at 45° to the base plane; from 1962 or early 1963, however, he introduced 120° sections, one face of which was always, as in *Relief Construction F3*, placed parallel to the base plane.[4] The angled sections are combined into two symmetrically-balanced, diagonally-opposed, stepped blocks with ten identical angle sections in each, four in the bottom tier, then three, then two, then one, a sequence for which Hill expressed an especial satisfaction.[5] The lozenge shape of the aluminium base upon which the sections are placed was a new format for Hill, first introduced in this and related reliefs.[6]

Although most of his constructed reliefs have been based on mathematical systems, Hill has insisted that the final judgement has always been a visual one, the mathematical element providing no more than a starting point from which the artist could then move towards his principal objective: the creation of a harmonious work of art.[7]

Literature
Art and Artists, October 1966, p.71; Arts Council of Great Britain, 1983, pp.25, 26, 28, 42, 43, 44, 52.

Notes
[1] Information from the Arts Council of Great Britain. [2] Anthony Hill, as quoted in Arts Council of Great Britain, 1983, p.26. [3] Suzi Gablik in *Art and Artists*, October 1966, p.71; see also Arts Council of Great Britain, 1983, pp.25, 28. [4] Arts Council of Great Britain, 1983, p.42. [5] This sequence is known as the *Divine Tetraktus* (Arts Council of Great Britain, 1983, p.42). [6] *Ibid*, p.43. [7] *Ibid*, p.44.

The Charles Wilson Bookshop

On the exterior wall opposite Victoria Park:
Relief Construction: After-Images
Sculptor: Colin Jones
Fabricators: NIS Sign Group

Sculpture in aluminium and mild steel, finished in low-baked cellulose paint
h. 70cm (2'4"); w. 9.8m (32'2"); max. d. 13.5cm (5")
Inscription on a name plate beneath the sculpture:
AFTER-IMAGES / Colin Jones 1983 / Purchased from the Goddard Fund for the Arts 1983
Unveiled: Tuesday 8 November 1983
Status: not listed
Owner: University of Leicester

Description: Abstract relief of fourteen panels. The two outermost panels slant inwards towards the centre of the relief. Panels 2 to 7 and 8 to 13 form repeat sequences. They are split horizontally, the upper sections slanting inwards towards the left, the lower towards the right. Panels 2 and 8 are split 10/60cm, panels 3 and 9 20/50cm, proceeding at 10cm steps to panels 7 and 13 which are 60/10cm. The end faces of the panels, at right angles to the wall, are coloured. Panel 1 and the lower sections of panels 2 to 7 run from deep to pale blue, while the upper sections (running in the opposite direction from panels 7 to 2) progress from deep to pale orange. Panel 14 and the upper

sections of panels 13 to 8 run from deep to pale pink; while panels 8 to 13 run from deep to pale turquoise.

Condition: Fair, although the sculpture has been damaged on at least two occasions. In March 1984, one of the smaller panels was bent out of alignment and was duly repaired and strengthened by NIS Sign Group, the original fabricators, and in 1999 again one of the smaller panels (perhaps the same as before) came loose, or was prised loose, but this time was refixed by the university.

History: The sculpture is not in its original location, having initially been installed on one of the walls framing a narrow open area that existed between the Charles Wilson Bookshop and the Charles Wilson Café before the construction of the Café Piazza in late 1998. This former space, despite being equipped with tables for *al fresco* snacks and with a pleasant view of Victoria Park at its south end, was considered, in the words of the then Vice-Chancellor of the University, Dr Ken Edwards, to be 'a very dull space' – the windows of the Charles Wilson Café looking out onto nothing more than the long blank brick wall of the bookshop. It was felt, therefore, to be an area in urgent need of the ameliorating effect of a suitable relief sculpture.[1]

It was Herald and Joan Goddard – the

Jones, *Relief Construction: After-Images*

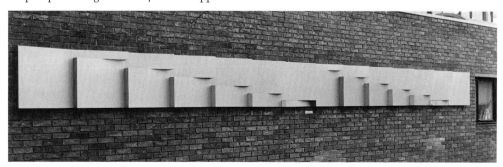

University's principal arts benefactors – who came up with a possible solution. They had recently made acquaintance with a young local sculptor, Colin Jones. In November 1982, following informal discussions with Jones on the subject of his designing a suitable sculpture, the Goddards introduced him to Richard Float, the University's Estates and Services Bursar, to discuss the scheme.[2] By the following March, Jones had completed a maquette which won the approval of Professor Luke Herrmann, then head of the University's History of Art department, and Mr Maurice Shock, then University Vice-Chancellor. The latter invited the sculptor to the University to discuss his ideas and the kind of lighting he thought most appropriate for the site with the University Bursar.[3] Following a meeting of the Sites and Buildings Committee on 26 April 1983, the Bursar wrote to the sculptor advising him of the Committee's approval, subject only to it receiving the sculptor's assurances that the metal and type of paint to be used on the sculpture would be relatively resistant to vandalism and, in the unhappy instance of damage taking place, that the sculpture would be easily reparable. In anticipation of these considerations being satisfactorily resolved, the Bursar suggested the Summer Vacation as the least disruptive period for the sculpture's installation.[4]

The sculptor then obtained an estimate of £1,000 from NIS Sign Group of Leicester to make the sculpture and this was approved by Herald Goddard, along with a fee for the sculptor himself, just over half of which he suggested should be paid to the sculptor immediately to cover his work to date. In addition, Goddard volunteered a generous sum of money to cover any unforeseen additional costs, plus any maintenance or repair that might be needed for the sculpture during the first year after its installation.[5] Towards the end of September 1983, Goddard informed the Vice-

Chancellor that the sculpture was almost finished and asked if a small unveiling ceremony could be arranged. The date was set for 8 November at 5 p.m., the late afternoon timing allowing for a ceremonial switching on of the sculpture's lighting.

Unfortunately it proved rather more difficult than anticipated to obtain ideal light fittings and these were not installed for some considerable time. The delay was due principally to the University's desire to settle for nothing less than the most ideal lighting for the sculpture. The individual panels, half of which are angled towards the left, the other towards the right, are coloured on their raised edges. These coloured edges are graded chromatically. The colours have recently been changed to suit the sculpture's new location, but originally they were red and orange at the Charles Wilson entrance end, lightening gradually to white at the park end, and blue and turquoise at the park end lightening gradually to white at the Charles Wilson entrance. The principal requirement was that the lighting should effectively illuminate the plain aluminium fronts of the panels without throwing the coloured edges into dark shadow. Moreover, there should be no glare to cause discomfort to people entering and leaving the building through the space in front of the sculpture. The problem was solved in December 1985 by the purchase of four directional display lamps, specially fitted with low-glare baffles, the additional cost of which was again financed by the Goddards.[6]

The sculpture was relocated to the wall of the Charles Wilson Bookshop facing Victoria Park in January 1998.

Literature
University of Leicester archives. Miscellaneous correspondence and memoranda relating to the art collection.
General. Strachan, W.J., 1984, p.151, 151.

Notes
[1] Various letters and memoranda, University of

Leicester archives. [2] Information from Herald and Joan Goddard. [3] Various letters and memoranda, University of Leicester archives. [4] Letter from Richard Float, University Bursar, to Colin Jones, 28 April 1983, University of Leicester archives. [5] Letter from Herald Goddard to Richard Float, May 1983, University of Leicester archives. [6] Various letters and memoranda, University of Leicester archives.

The Fielding Johnson Building

In the courtyard (access only by prior arrangement):

Triangulated structure No. 1
(also known as *Triangulated Form*)[1]

Sculptor: Robert Adams

Sculpture in stainless steel on a brick and concrete base
Sculpture: h. 2.6m (8'6"); w. 1.69m (5'7"); d. 1.57m (5'2")
Base: h. 38cm (1'3"); w. 61cm (2'); d. 61cm (2')
Inscription on a name plate set into a paving slab in front of the base:
Triangulated Form, 1960 / by / ROBERT ADAMS / Purchased from the Goddard Fund for the Arts, 1972
Executed: 1960 (Opus 87)[2]
Exhibited: 1960, London, Battersea Park (cat. no. 1); 1969, Blenheim Palace Garden Centre, Woodstock, Oxfordshire; 1971, Northampton, City Art Gallery (cat. no. 28).
Status: not listed
Owner: University of Leicester

History: *Triangulated structure No. 1* was purchased through the Goddard Fund for the Arts in 1972. The decision to purchase this particular piece was made following a visit by Herald and Joan Goddard, accompanied by Luke Herrmann, then Head of the University's History of Art Department, to Adams's studio. The piece was first sited on a lawn at the foot of the north-west side of the University's Attenborough Tower. A photograph reproduced in Alastair Grieve's monograph[3] shows that here, viewed with the sky only

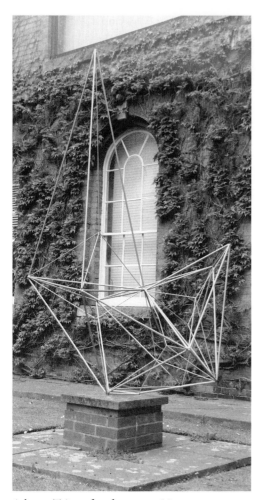

Adams, *Triangulated structure No. 1*

of brickwork and fenestration.

The present sculpture is perhaps one of Adams's most successful essays in his series of triangulated structures, perfectly exemplifying the sculptor's lifelong concern with what Grieve has called 'dynamic balance',[4] here expressed through the poised asymmetry of the sculpture's cellular construction. Adams's earliest, much simpler, triangulated structures, constructed of brass rods, date from *c.*1950–2.[5] As Grieve has proposed, these suggest that Adams was, like his friends and fellow artists Victor Pasmore and Kenneth and Mary Martin, influenced by D'Arcy Thompson's volume on the laws of natural growth, *On Growth and Form*, an edition of which had been published in 1942. Not until 1960 did Adams take up the theme again. Three of the sculptures he then created, *Triangulated Structure No. 1*, *Triangulated Form No. 2* and *Triangulated Form No. 3* (see 'Related Works', below), express not simply a structure that has already developed through cellular replication but, constructed as these three are of triangular cells whose size expands dramatically from the core to the outer limits, a form whose growth is both more vigorous and still in process.[6]

Related works:

1. Maquettes for *Triangulated Structure No. 1*, 1960 – No. 1, steel wire sprayed with aluminium, h. 21cm (8"), Gimpel Fils; No. 2, steel wire, h. 21cm (8"), Private collection; No. 3 (with three legs), steel wire painted grey, h. 21.5cm (9"), St Ives, Wills Lane Gallery; No. 4, steel wire painted grey, h. 23cm (9"), Wilhelmina Barns-Graham; No. 5 (with three legs), steel wire, h. 25.5cm (10"), Gimpel Fils.[7]

2. Other sculptures in the series – *Triangulated Form No. 2*, 1960 (Opus 107), aluminium steel, 1.22m × 59.5cm (4' × 2'), Gimpel Fils; *Triangulated Form No. 3*, 1960 (Opus 107), aluminium steel, 95.5cm × 1.13m (3'2" × 3'9"), Gimpel Fils.[8]

behind it, the delicate triangular webs of the sculpture were seen to their fullest advantage. Sadly, the site proved impractical. Following damage sustained through vandalism, the sculpture was relocated to the more secure courtyard of the University's Fielding Johnson Building. Here, however, the sculpture has to vie with a visually unsympathetic background

Literature
Grieve, A., 1992, pp.82, 87, 190 (no. 292), **58, 82, 190**; London County Council, 1960, n. pag.; Pevsner, N. and Williamson, E., 1992, p.258; Strachan, W.J., 1984, pp.150, **151**.

Notes
[1] According to Alastair Grieve in his *catalogue raisonné* of Adams's work (1992, p.190, no. 292), Adams referred to this piece as *Triangulated structure No. 1*. The name plate for the sculpture at the University of Leicester refers to the piece as *Triangulated Form*, as does Strachan, W.J., 1984, p.150. *Triangulated Form* is the title given by Adams to another, related work of 1952 comprising planes of sheet brass as opposed to webs of steel rods (see Grieve, A., 1992, pp.53, 57). The opus number of *Triangulated Structure No. 1* is due to Adams himself. The subject is even more complicated by the fact that two closely related steel rod sculptures made in the same year as *Triangulated Structure No. 1* are catalogued as *Triangulated Form No. 2* and *Triangulated Form No. 3* (see *ibid.*, p.193, nos. 315 and 317). [2] *Ibid.*, p.190 (no. 292). [3] *Ibid.*, p.82. [4] *Ibid.*, p.88. [5] Nos. 107 and 108 in *ibid.*, pp.160–1. [6] In addition to these three there are two other related sculptures from 1960. *Triangulated Column* and *Triangulated Form: a Maquette* are also constructed of triangular cells, but as the cells are all the same size the suggestion of growth is less dynamic (*Ibid.*, p.87, illustrated pp.86, 196). [7] *Ibid.*, p.190 (nos 293–7). [8] *Ibid.*, p.193 (nos. 315 and 317).

On the lawn in front of the Fielding Johnson Building:

Souls

Sculptor: Helaine Blumenfeld
Foundry: A & A Sculpture Casting Ltd of London

Sculpture in bronze on plinth of concrete faced in granite
Sculpture: h. 2.55m (8'5")
Plinth: h. 44cm (1'5"); w. 3m (9'10"); d. 2.5m (8'3")
Inscription on name plate:
SOULS / HELAINE BLUMENFELD 1990 / DONORS – HELAINE BLUMENFELD LORD SIEFF / EAST MIDLANDS ARTS CHURCH LANGTON FUND BRITISH GAS / CAST BY A AND A SCULPTURE

CASTING LTD
Unveiled: Saturday 22 September 1990 by Dr
Kenneth Edwards, Vice-Chancellor of the
University of Leicester
Status: not listed
Owner: University of Leicester

Condition: Good.

History: Following the removal in 1987 of
Henry Moore's bronze sculpture, *Oval with
Points* (see pp.322–3), the University felt a need
for a new centrepiece for the lawn in front of its
Fielding Johnson Building. In 1989, it
University was fortunate to receive, through the
agency of Professor William Forster of the
University's department of Adult Education, a
gift of a small model for a large-scale sculpture
from the sculptor Helaine Blumenfeld. Forster
and Blumenfeld had known each other from

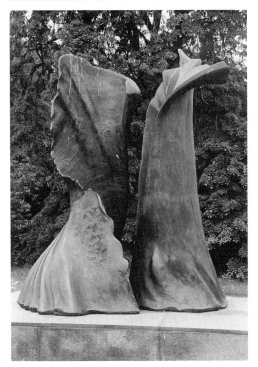

Blumenfeld, *Souls*

their time together on the Arts Council's Visual
Arts Panel. Forster had been impressed with
Blumenfeld's sculpture and so when the site on
the Fielding Johnson lawn became vacant, it
was to her he turned.[1]

On 15 November 1989 Forster advised the
University Bursar that he would be bringing
Blumenfeld's model in for him to see. The
model was approved in principal, subject only
to donations towards the cost of casting the
full-size sculpture in bronze being found.
Fortunately, financial support was secured from
British Gas, Lord Sieff, and East Midlands Arts.

As soon as approval to start was given,
Blumenfeld enlisted the assistance of Derek
Howarth, a specialist in enlarging sculptures.
By February 1990 he had completed the full-
size plaster model. When this was tried out *in
situ*, Blumenfeld realised that the height needed
to be increased so that the sculpture would
harmonise with the wide expanse of lawn of
which it was to be the centre. Both pieces were
therefore cut horizontally and new middle
sections added to make them a third larger. At
the same time the curvature of the tops was
increased.[2] On 23 February the full-size plaster
model was at A&A Sculpture Casting Ltd's
foundry, the intention being that the bronze
casting should be finished and the sculpture
installed on the lawn opposite the Fielding
Johnson Building during the long Summer
Vacation. Blumenfeld chose a golden-brown
patina as being most harmonious with the
greens of the grass, shrubs and trees of the
lawn and surrounding beds.[3] By 27 April 1990
orders had been placed with J.H. Hallam & Son
Ltd for the concrete body of the plinth and
with G. Collin & Son Ltd for the granite
facings; work was in progress by 21 May, the
cost of the plinth being met by the Church
Langton Fund.

Blumenfeld's *Souls* is part of a series
exploring the idea of the myth of the
transmigration of souls; the series is closely tied

into 'what she has always considered sculpture
to be about: an effort to give form to the human
soul'.[4] The formal expression of this idea
derives from the sculptor's intense response to
the ancient olive groves that lie above her house
at Pietrasanta in Tuscany. Walking through the
groves in 1984, the eroded forms of the trees
evoked for her the idea of the human soul
floating in space, moving from body to body
until, tired with life, it

... is given the opportunity to embed itself in
an organic rather than a human form. And
with these olive trees, you really felt you
were looking at souls that had taken on the
attributes of these ancient trees. I went back
down to the house and started working in an
almost obsessive, mad way with clay. I did
hundreds of these groupings of forms and
fired them, and I ended up with what must
have been two or three hundred small
terracotta models. Only then did I begin to
interpret them, and it seemed clear to me the
whole series was called *Souls*.[5]

The first sculpture in the series, *Souls I*, 1984,
was a small-scale group composed of five
moveable pieces. As with this earlier sculpture,
Blumenfeld had intended that the two bronze
pieces of the University's *Souls* should be
capable of being moved so that the spatial
relationships could be varied at the owner's
choosing. The 'changing nature of human
relationships' is a recurrent theme in
Blumenfeld's work as is her interest in the
active involvement of the owner or viewer of
the work.[6] The manœuvrability of the pieces of
the University's sculpture did, however, cause
concern that it might render it especially
vulnerable to vandalism. Consequently, with
the sculptor's approval, the foundry bolted the
pieces to the base on the day of their installation
so that only authorised rearrangements could
be initiated.[7]

Related works include: *Souls I*, 1984, five

parts, green patinated bronze, h. 58cm (1'11"), collection of the artist; *Souls II*, 1985, two parts, white statuary marble, h. 58cm (1'11"); *Souls III*, 1984, three parts, blue patinated bronze, h. 53cm (1'9").

Literature
University of Leicester archives. Miscellaneous correspondence and memoranda relating to the art collection.
General. Beaumont, M.R., 1990; *Arts Review*, 9 September 1988, p.604; Banner, J.W., 1994, p.98; Leicester City Council, 1997, 1993 edn, p.169; Leicester City Council, 1997, p.**165**; *L. Mercury*, 20 September 1990, p.43; Upson, N., 1998, pp.112–13, 125, **122**, **123**.

Notes
[1] Information from the sculptor. [2] *Ibid*. [3] *Ibid*. [4] Upson, N., 1998, p.112. [5] As quoted in *Ibid.*, p.125. [6] Beaumont, M.R., 1990, p.6. Both themes had already been successfully explored by Blumenfeld with a large five-piece granite sculpture, *Figurative Landscape*, 1983, for the Henry S. Reuss Federal Plaza, Milwaukee, which has been regularly rearranged with the assistance of a crane brought to the site by the owner (*Arts Review*, 9 September 1988, p.604). [7] Letter, dated 14 February 1998, from Professor W. Forster to the author; various University of Leicester memoranda.

The Library, 1971–4, by Castle Park Dean and Hook

Inside (access only by prior arrangement):
Single Form
Sculptor: Bertram Eaton

Sculpture in wood
Sculpture: h. 1.9m (6'3"); w. 40.5cm (1'4"); d. 7.5cm (3")
Base: h. 14.5cm (6"); w. 48cm (1'7"); d. 32cm (1'1")
Inscription on a metal plaque fixed to the upper surface of the base:
SINGLE FORM / BERTRAM EATON 1975 / ON PERMANENT LOAN FROM MRS. K. EATON
Status: not listed

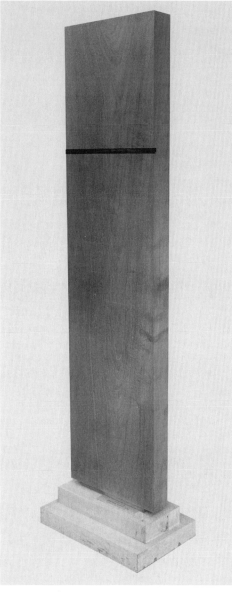

Eaton, *Single Form*

Owner: University of Leicester

Condition: Generally good, although a faint ink stain is noticeable on the front face.
History: *Single Form* was presented on permanent loan to the University of Leicester by the sculptor's widow in 1981.

Porthcressa
Sculptor: Denis Mitchell

Sculpture in bronze, polished
Sculpture: h. 1.93m (6'4"); w. 23.5cm (9"); d. 22.5cm (9")
Socle: h. 9cm (4"); w. 28cm (11"); d. 28cm (11")
Executed: 1967
Status: not listed
Owner: on long loan from the Arts Council of Great Britain

Condition: Good.
History: *Porthcressa* was deposited by the Arts Council on long loan in January 1976. In the catalogue for Denis Mitchell's retrospective exhibition at the Gillian Jason Gallery, London, in 1990, Giles Auty, art critic for *The Spectator*, wrote of the sculptor's work as follows:

... The distinctive characteristics of Denis Mitchell's work seem to me to be a spirit of wisdom and sense of solidity. On the whole the sculptor avoids flights of fancy. Literally and metaphorically his images keep their feet firmly on the ground. However slender his rising forms, a feeling of poise and balance remains. Here the obvious analogy to be made is with ballet where a dancer's whole weight may be centred above nothing more than a single, pointed foot ... This inherent poise, even in many of the smaller pieces, gives them a monumental quality ...
... The artist often names his sculpture after the small villages and hamlets of West Cornwall ... Nor is it the names alone that stir memories. Hints of the man-made as

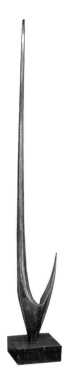

Mitchell, *Porthcressa*

well as the organic abound in Denis
Mitchell's sculptural language: plough,
anchor and anvil, no less than flight, growth
and repose ...[1]

Related works: *Porthcressa* (edition of three
in a smaller size), h. 76.2cm (2'6"), 1961.[2]

Literature
Gillian Jason Gallery, 1990, pp.3–4; Waddington
Galleries, 1961, n. pag.

Notes
[1] Gillian Jason Gallery, 1990, pp.3–4. [2] Shown at
the Waddington Galleries, London, 1961 (no. 18).

On the forecourt in front of the library:
Four-Fold

Sculptor: Stephen Collingbourne

Fountain in BSC stainless steel
h. 1.2m (3'11"); w. 3.4m (11'2"); d. 3.4m (11'2")
Inscription on name plate set into paving on
edge of pool:
4 FOLD / STEPHEN COLLINGBOURNE /
PURCHASED FROM THE / GODDARD FUND FOR
THE ARTS / MADE FROM B.S.C. STAINLESS STEEL
Erected 1977
Status: not listed
Owner: University of Leicester

Condition: There are two very noticeable
dents, one on the upper surface of the north-
west-facing fold, the other on the south west-
facing fold – irreparable, according to the
sculptor. In addition, the north-west-facing fold
has lost the panel from its outer side.
History: Purchased from the Goddard Fund
for the Arts. The sculptor was selected by
Herald and Joan Goddard as a result of seeing
his work in the Royal Academy index of
sculptors. According to the Goddards, *Four-
Fold* was not conceived as a fountain, although
the sculptor was keen to have it sited on water.[1]

Literature
Leicester City Council, 1997, pp.167, **169**; Pevsner,
N. and Williamson, E., 1992, p.258; Strachan, W.J.,
1984, p.151, **151**.

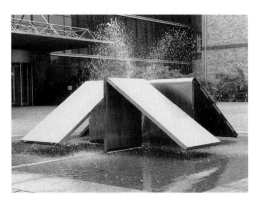

Collingbourne, *Four-Fold*

Note
[1] Information from Herald and Joan Goddard.

*The Rattray Lecture Theatre (access only
by prior arrangement), 1960–2, by Sir
Leslie Martin and Colin St John Wilson*

On the staircase:
Thorn Crucifix
Sculptor: David Partridge

Sculpture in nails, aluminium and blue-painted
wood.
h. 2.42m (8'); w. 98cm (3'3")
Status: not listed
Owner: University of Leicester

Condition: Generally good; three nails
missing from lower area.
History: *Thorn Crucifix* was purchased by
the University of Leicester in March 1967 with
money provided through the Convocation
Appeal Fund. For a contemporary description
and appreciation of Partridge's nail sculptures,
see pp.167–8.

2. Off-campus sites
Labour Market Studies, Nos 7–9 Salisbury Road
In the garden of No. 7:
Diversity in Harmony
Sculptor: Naomi Blake

Sculpture in bronze resin on slate base and
brick plinth
Sculpture: h. 1.5m (4'11"); w. 1.12m (3'8"); d.
39cm (1'3")
Status: not listed
Owner: University of Leicester

Condition: Good.
History: *Diversity in Harmony* was donated
to the University's Scarman Centre for the
Study of Public Order (then located at Nos 6–7
Salisbury Road) by the sculptor in the early

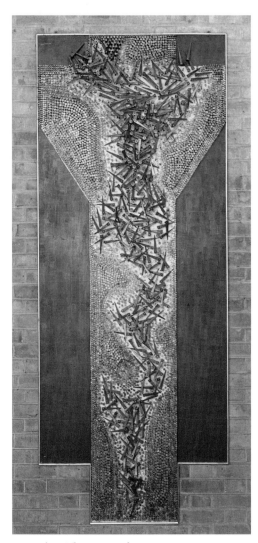

Partridge, *Thorn Crucifix*

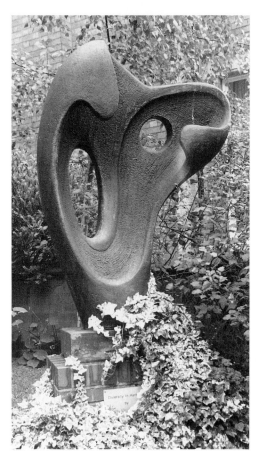

Blake, *Diversity in Harmony*

1990s at the suggestion of a friend of hers, Yvonne Craig, one of the first students to take the Centre's MA in Public Order.

College Hall (access only by prior arrangement), Knighton Road, 1959–61, by (Sir) Leslie Martin and Trevor Dannatt
In the grounds:

Opus 41

Sculptor: Percy Brown

Sculpture in fibreglass on a plinth in *ciment fondu*
Sculpture: h. 1.57m (5'2"); w. 65cm (2'2"); d. 42cm (1'5")
Socle: h. 59cm (1'11"); w. 33cm (1'1"); d. 33cm (1'1")
Inscription on a name plate fixed to the front face of the socle:
Opus 41 / PERCY BROWN 1975 / DONATED BY THE SCULPTOR TO THE UNIVERSITY OF LEICESTER 1984
Executed: 1975
Erected: July 1984
Status: not listed
Owner: University of Leicester

Condition: In 1986 the mild steel mounting rod was damaged and the sculpture put into store at College Hall. It was repaired and was back in position by March 1988, but was damaged again in 1989 and 1993. The nature of the damage in each instance is not clear though a recurrent problem appears to be the strength of the mounting rod.
History: *Opus 41* was donated to the University by the sculptor as a companion piece to his earlier bronze sculpture, *Life*. It was to his long-term friends, Herald and Joan Goddard – who had provided the funds for the earlier purchase – that he made the suggestion and who in turn put the sculptor's proposal to the then Vice-Chancellor, Maurice Shock. As Herald Goddard informed the Vice-Chancellor,

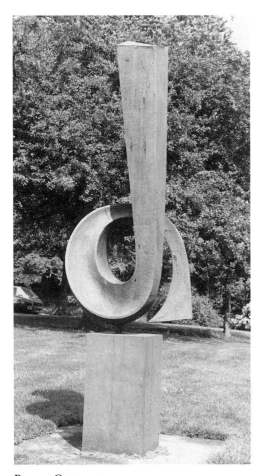

Brown, *Opus 41*

the sculptor's motivation was his affection for Leicester and his delight at being offered the original commission. As an added incentive, Goddard offered to pay for a plinth and the cost of transporting and fixing the piece.[1]

Consideration was given by the University to the most favourable site on campus for the sculpture. Originally the area around the new Computer Bio Centre was considered but it was agreed, in consultation with Percy Brown,

that the sculpture was of an intimate scale more appropriate to a courtyard or garden site. By November 1983, the University had exhausted the possibilities on campus, but at this point Goddard stepped in again and suggested that a garden of one of the halls of residence might be suitable. The Vice-Chancellor agreed and proposed College Hall. Dr Jonathan Young, the Warden of the Hall, expressed his keenness for the proposal as did the sculptor who was content to leave the specific siting to Goddard and the University. Consequently, Goddard and the Vice-Chancellor met with Dr Young at College Hall on 2 March 1984, and the site on the lawn in front of the windows of the Senior Common Room was agreed upon. The sculpture was collected from the sculptor's studio on 13 June 1984. By 18 June it was noted that it had been safely delivered to College Hall and by 3 July the Bursar reported that it had been fixed in position.[2]

Literature
University of Leicester archives. Miscellaneous correspondence and memoranda relating to the art collection.

Notes
[1] Letter, dated 22 November [1982], from Herald Goddard to Maurice Shock, University of Leicester archives. [2] Various letters and memoranda, University of Leicester archives.

University Arboretum, Carisbrooke Road
Spring and Autumn
Sculptor: Anthony Ankers

Sculpture in terracotta on a concrete base
Sculpture: h. 1.81m (5'11"); w. 1.01m (3'4"); d. 1.5m (4'11")
Base: w. 1.1m (3'7"); d. 1.4m (4'7")
Installed: Autumn 1997
Status: not listed
Owner: University of Leicester

Condition: Fair. There is considerable

biological growth on the upper parts of the sculpture and a crack running from the lower edge of the sculpture up to just below the right leg of the standing female figure.

History: Anthony Ankers's *Spring and Autumn* was executed as payment for a part-time MA by research at the University of Leicester, on the agreement of the then Vice Chancellor, Dr Ken Edwards.[1] Having approved Ankers's proposal, subject to his model being acceptable, the University sent him plans of its Arboretum, then in the course of development, so that he could acquaint himself with the proposed location before starting work on the sculpture.

Ankers began by making four 12-inch-high sketch models and a number of drawings and, on 27 January 1995, submitted them to a panel comprising two representatives from the University, plus Douglas Smith (architect in charge of the design of the Arboretum) and Barry Frankland (head gardener at the Arboretum). The panel selected one of the models and instructed Ankers to develop it into a more finished 18-inch-high maquette. The principal concern of the panel was that the finished sculpture should be compact and sufficiently robust to withstand clambering children. At the second attempt, the sculptor came up with an acceptable solution (maquette, h. 18", clay with latex skin; in the possession of the sculptor).

Next Ankers was required to make full-size cut-outs of the sculpture's two figures so that the effect could be judged *in situ*. It was as a result of this exercise that the specific location at the curve of one of the Arboretum's paths was chosen, the idea being that the pathside foliage would obscure the sculpture until within a short distance, thus adding a degree of visual surprise to the first sighting.

Ankers proposed terracotta for the full-scale work, as opposed to the bronze resin or *ciment fondu* that had been suggested by the panel as

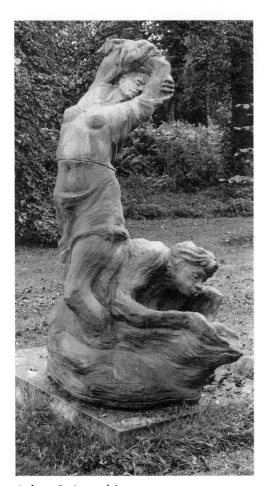

Ankers, *Spring and Autumn*

within the University's price range. The sculptor preferred terracotta for its durability and because he liked the idea of working – for the first time – in a material with such a strong local tradition. The panel, on the other hand, considered *ciment fondu* to be the most feasible, the potential problem with terracotta being, they suspected, finding a specialist capable of firing a sculpture of this size. Ankers, however,

had been thinking about the Hathern terracotta works for some time and, on enquiring, was gratified to find that they still carried out this kind of work.

Meanwhile he was making more detailed studies, using himself and his partner and fellow sculptor, Siân Thomas, as models. Through a colleague at the University art studios, Ankers managed to arrange a meeting with one of the Hathern directors who advised him on the potential problems of executing terracotta sculpture on such a large scale. The director, however, was confident it could be done with the right skills and offered to send along David Brown, one of his specialists, to help Ankers make the moulds should the University give the material its approval which, in the light of Hathern's intervention, it did.

Within about twelve weeks Ankers had completed the full-size clay model. Next, with guidance from Brown, he made 52 plaster piece-moulds of the model. Once set, Ankers transported them to Hathern and started to rebuild them. The small piece-moulds were built up into three separate sections: (i) the upper backward-arching half of the female figure above the rib cage which, because of its weight, had to be fired separately; (ii) the female figure's lower half and the male figure's body which formed a relatively compact group; and (iii) the male head. This last piece, which extended forward of the rest of the group, was to be kept separate only for ease of casting; once that casting accomplished it was to be rejoined to the male body.

Ankers next tried out Hathern's range of terracotta colours, cream, buff and deep orange, ultimately selecting the latter as most suitable for the sculpture's arboreal setting. Casting in terracotta from the three moulds was carried out in early summer 1997. The male head was then rejoined to the body and the two sections left for a couple of months to dry out thoroughly. Once the sections were ready they

were fired in one of Hathern's kilns and delivered to the Arboretum where the lower half was secured to the base and the upper half filled with concrete into which steel rods were partly embedded. The lower half was then also filled with concrete and the upper half lowered onto it, the protruding ends of the steel rods embedding themselves into the still unset concrete of the lower part to form a secure join. Installation was completed in autumn 1997.

Note
[1] The following account is derived from various letters and memoranda in the University of Leicester archives and from conversations with the sculptor.

Victoria Park

The Ethelfloeda Fountain (Memorial Fountain to Edith Gittins) – for the lost fountain, see pp.324–5; for a replica of the fountain's statuette, see pp.129–30.

Welford Place

Statue of John Biggs

John Biggs (1801–71), radical politician, businessman and philanthropist, was the eldest son of a hosiery manufacturer, also called John Biggs, who had established a small business in Leicester. Under John and his younger brother William (1804–81), the business expanded to become one of the largest as well as one of the most enlightened employers in the town. The brothers were Nonconformists, attending the Great Meeting in Bond Street, a focal point of political opposition to the Tory-run Corporation. In 1836, following the 1835 reform of the Corporation, both were elected to the Council. In 1838 John became a founder member of the Leicester Anti-Corn Law Society. He was Mayor of Leicester in 1840, 1847 and 1855 and from 1856–62 Liberal MP for Leicester. He was a keen proponent of civic

improvements, including the new town hall, the enlarged and improved market area and the first municipal cemetery (Welford Road). In 1861, the family business collapsed, due in part, it is thought, to the amount of time he and his brother spent in their political and reforming activities. John Biggs spent his last ten years in retirement, but still living in Leicester. He is buried at Welford Road Cemetery.

Sources: Evans, R.H., 1972–3; Leicester Museums, n.d.

Sculptor: George Anderson Lawson
Contractors for the pedestal: J. Freeman and Sons[1]

Statue in bronze, a replacement of a Sicilian marble original, on a pedestal of Shap Fell granite[2]
Statue: h. 2.13m (7')[3]
Pedestal: h. 2.3m (7'7"); dia. 95cm (3'2")
Base: h. 80cm (2'8"); w. 1.75m (5'9"); d. 1.75m (5'9")
Inscription on the front of the pedestal, in incised, gilded letters:
JOHN BIGGS. / 1801 – 1871.
Signed and dated on the right side of the bronze base of the statue:
GEO. A. LAWSON SC. 1871 /
RENOVATED AND CAST FROM ORIGINAL MARBLE 1930 / BY J.H. MORCOM.
Original (marble) statue unveiled: Tuesday 15 April 1873, by the sculptor, George Anderson Lawson[4]
Replacement (in bronze) erected Wednesday 10 December 1930
Status: Grade II
Owner / custodian: Leicester City Council

Description: Biggs is portrayed standing against a bollard, his right hand extended palm upwards, his left hand tucked inside his coat. Though the statue is now in bronze, the bollard recalls the marble original. It would have been introduced as a structural element, giving additional support to the relatively slender verticals of the legs under the heavy mass of stone representing the body.

The statue is mounted on a red granite pedestal with a polished cylindrical drum and an unpolished octagonal plinth.

Condition: Fair. There is some chipping to the octagonal plinth.

History: Eight days after the death of John Biggs on 4 June 1871 a group of his friends and admirers, including 'some of the leading merchants and manufacturers'[5] of Leicester met at the Town Library to discuss the erection of a memorial to him. The meeting, presided over by the then Mayor, J. Stafford, elected a memorial committee and decided on a tomb monument in Leicester Cemetery (Welford Road), to be funded by subscription at a maximum of two guineas per head.[6]

According to contemporary accounts, Biggs's popularity with the wider public was such that when this rather modest commemoration became known outside the meeting there was an immediate protest – particularly from the working classes – that nothing less than a publicly-sited statue would adequately express the esteem in which Biggs was held by the people of Leicester.[7] The reaction was evidently of a vigour sufficient for the Mayor to call a public meeting at the Town Hall for 23 October 1871 to discuss the matter more openly.[8] A recent historian has plausibly suggested, however, that the reaction was unlikely to have been as spontaneous as reported by the contemporary press. Whilst not denying Biggs's popularity among the working classes, R.H. Evans has pointed out that 'public generosity' is seldom entirely undirected and that memorial committee-member John Burton, an indefatigable campaigner for the embellishment of the town,[9] was undoubtedly instrumental in generating the popular movement for a statue.[10]

The Town Hall meeting voted overwhelmingly in favour of a public statue,[11] despite threats from some Conservatives that they would withdraw their subscriptions. A monument over a grave they considered a fitting tribute to a man whom they respected personally *despite* his Liberal politics, but a statue in the town they felt 'would assume a thoroughly political bearing'. They protested that other equally worthy men had died without memorials being erected to them in the town and that to erect one now to Biggs would be unfair to their memory. It was just such deep political divisions as those that prevailed in Leicester throughout the nineteenth century that at least one contemporary cited as the reason for Leicester's relative paucity of public statuary.[12]

More pragmatic reservations occupied the mind of Mayor Stafford: he doubted that the town would be able to raise the £1,000 he reckoned would be needed to commission a statue and that to fail in such a project, having once begun it, would prove extremely painful to Biggs's family and friends. Although he could not begrudge the 'working classes' their say, he suspected that they would be largely unwilling to contribute – out of the £300 so far subscribed, 'only nine subscriptions of half-a-crown each had come from them'. The reason for that, another speaker reasonably pointed out, was that the working classes had not known where to pay the money: it was therefore proposed that books should be opened at workshops and factories.[13] Stafford was ultimately to be proved wrong for, as Burton would later make plain, working men 'to the number of more than a thousand, contributed to this statue' and, driving the point home, 'their subscriptions decided the question between a statue and a mere monumental erection in the cemetery'.[14]

As soon as the Memorial Committee was confident that there were likely to be adequate funds, it offered the commission for the statue

to the London-based sculptor G.A. Lawson.[15] Lawson accepted the commission and produced a one-third scale model of the statue ('2ft. 4in. in height') which he brought to Leicester for the Committee's approval, offering to carry it out for £500 in either marble or bronze. It was agreed that the final decision on the choice of material should rest with the subscribers but in the meantime a deputation from the Committee arranged to visit Lawson in his London studio to advise him on the 'one or two simple alterations' to the model it felt were necessary to secure a good likeness.[16]

The next meeting of the subscribers was held on 23 April 1872. The Chairman (Alderman Harding) opened proceedings by confirming that the original two guinea limit had been rescinded and that pledged funds now amounted to £603 from about 1,400 subscribers (1,070 of whom he termed 'contributors of small sums'), including £24 10s. 0d. that had been collected by expatriate Leicester men of German Town, Philadelphia, USA, two representatives of whom were present at the meeting. Burton then informed a gratified audience that none of the original subscribers – even those who disapproved of the change from cemetery monument to town statue – had requested the return of their subscriptions.

The statue, he said, was to be seven feet high on an eight-foot-high pedestal, these dimensions 'having regard to the height of the surrounding houses ... which [size], he said, – according to the dictum of eminent sculptors – was the proper size for erection in the town streets'.[17]

Then followed a discussion over whether to commission the statue in marble or bronze. Clearly the great majority of the Committee favoured marble. Joseph Plant, a builder, recommended the use of Sicilian marble for 'its greater durability' and its resistance to pitting by rain or acids. Two other members were nonetheless concerned that marble, whatever its

type, 'would be decomposed by the sulphurous atmosphere of the town' and that it would be more susceptible to accidental damage or vandalism by 'mischievous lads'. Another builder, H.T. Chambers, discounted the idea that Leicester's atmosphere would be injurious to marble, while Burton pointed out that there had been marble statues in Birmingham for 'upwards of thirty years [which] appeared now as good as when first erected'. But the real issue was perhaps the negative associations bronze had acquired for some of the Committee. Chambers said that 'they already had one bronze statue [i.e., the *Duke of Rutland*] which he did not know that anybody was particularly in love with', while F.T. Mott merely added his opinion that 'bronze statues ... always looked black and miserable'. In the end the vote for marble was carried unanimously.

Next came the subject of location. Although Welford Place had already been broadly mooted, Plant spoke out strongly for De Montfort Square. There, he said, the statue would be safer from vandalism, dust and dirt from the road and accidental damage from traffic. Furthermore, the statue would form an appropriate companion to the *Robert Hall Statue* – here he envisaged the beginnings of an outdoor civic pantheon, but was nonetheless unable to resist a party political dig: 'He had no doubt if they were to place the statue there, they would stimulate their Conservative friends to remove the Duke of Rutland from his present water-but [sic] – (laughter) – and place him too in the Square ...'[18]

But as attractive as the idea appeared, as several members of the Committee pointed out, many subscribers had contributed on the understanding that the statue would be erected at Welford Place. Chambers thought it should be erected in Welford Place anyway for, despite the potential hazards, there, 'in a public thoroughfare' the statue would be more 'calculated to improve the taste and the morals

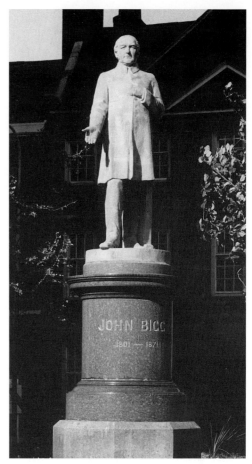

Lawson, *John Biggs*

of the inhabitants'. Thus Welford Place was carried, the specific siting and type of pedestal most suitable to that site to be decided by a sub-committee. The last action of the meeting was to authorise payment of a £100 instalment to Lawson, the sculptor, as agreed in the contract.[19]

The Committee's first choice of site at Welford Place was rejected by the Corporation as being likely to cause congestion at this busy

intersection, and it was not until 28 June 1872 that a compromise solution was agreed – the island in the middle of Welford Place, then used as a cab rank. This location necessitated reducing the size of the rank from three to two horses, but at least it met the Highway Committee's general traffic requirements and, as far as the subscribers were concerned, it not only had the merit of allowing full visibility of the statue from the Belvoir Street and Pocklington's Walk approaches, here it[20] would also be facing the Free Library – an institution Biggs had helped to establish – and Mechanics' Institute, of which he had been president.[21]

Freeman and Sons had completed and delivered the pedestal by October 1872 and in January 1873 formal permission was granted by the Council for its erection.[22] Notwithstanding the apparent unanimity of admiration for Biggs, however, and even before the statue was officially unveiled, the pedestal had had mortar hurled at it – along with that of the Duke of Rutland.[23] Given the disparate nature of the two subjects, it seems less likely that this was a focused expression of political protest than an act of mere vandalism. *John Biggs* and the *Duke of Rutland* were, after all, the only two free-standing statues in Leicester's town centre at the time – that to Robert Hall being, as related above, in a suburban setting and comparatively protected by virtue of its siting 35 feet from the roadway within a fenced square.

At its meeting of 14 March 1873, the Committee approved a payment of £125 for the pedestal and a final payment of £250 to Lawson.[24] The final amount raised by public subscription for the memorial was £800.

On Tuesday 15 April 1873 the unveiling ceremony took place before 'an immense crowd of people'.[25] Tuesday had been specifically chosen by the memorial committee as a day when the maximum number of 'working-people' would be able to attend, it 'being to a considerable extent observed as a holiday in the

town'.[26] As was usual at such events, numerous speeches were delivered, both at the unveiling ceremony at Welford Place and at the public meeting afterwards at the Temperance Hall. The veracity of the statue as a portrait elicited the usual encomiums: John Biggs's brother, William, considered it 'a most striking likeness … executed with the greatest skill',[27] whilst John Burton told of a man who had been in Biggs's service for thirty years whom he had heard 'say that the only defect in the statue was that it did not speak'.[28] Samuel Payne, tailor and draper,[29] giving, according to the *Leicester Advertiser*, 'a working-man's point of view' made a telling assessment of Leicester's meagre record of publicly commemorating its men of distinction whilst at the same time hinting at the political divisions that contributed to its relative failure to do so:

> Mr. S. Payne remembered the time when they had no statue to any of their local men in Leicester. It was true that they had one in the Market-place [i.e., the *Statue of the Duke of Rutland*], but that was of a questionable character. Really and truly as far as the borough of Leicester was concerned they had no public monument – they had no public monument to any benefactor, philanthropist, or politician. They had redeemed their character in that respect...[30]

In contrast, William Barfoot, hosiery manufacturer and future Mayor of Leicester (in 1875) expressed a more conventional view of the civic intention and moral message of this and other commemorative statues:

> This monument, which shows how a people can appreciate the virtues of her best citizens, will now be in the guardianship of all. Let us protect it from the thoughtless who might injure it. These works of art, upon which so much thought has been bestowed, so much energy displayed to

secure their erection – which embellish and adorn our streets and squares – which raise our people in the estimation of surrounding towns – let us guard with jealous care; and if the erection of these monuments should have the effect of stimulating our youth to public action, let us hope that they may imitate the virtues, and follow in the footsteps of those who, forgetting self, have pursued their course with one object – the public good (applause).[31]

The very things that the civic custodians of the statue could not guard it against, however, were those that the Memorial Committee had so ill-advisedly discounted: the extremes of the English climate and the deleterious effects of Leicester's polluted urban atmosphere which, over a relatively few years, had brought the statue to a ruinous condition. By 1928 it had lost a thumb, and at some time before 19 November of that year its nose.[32] The City Surveyor called in local sculptor, Joseph Herbert Morcom, to advise him whether or not the statue could be patched up, but closer examination revealed that the marble was 'in a state of decay, the whole surface having crumbled away'.[33] Consequently, the Surveyor advised the Corporation Estate Committee that repair was not practicable and that the Committee 'may consider it desirable to erect a new Statue'.[34] The Committee obtained Council approval to remove the statue on 29 January 1929 with instructions that it should investigate the cost of replacement in bronze or granite.[35] Morcom was asked to submit tenders for the job. He quoted an approximate figure of £340 for a bronze cast but, not unnaturally given its intractable nature, advised the Corporation against considering granite.[36] There was some considerable delay whilst the Corporation considered what action should be taken and even whether the job was worth the expense. Towards the end of 1929 the opinion of the

Advisory Arts Committee was sought. The Committee reported that it considered it undesirable 'to leave the monument in its present condition' and recommended that 'the missing members of the statue should be repaired by a capable modeller and the whole cast in bronze'.[37] Thus, on 27 May 1930 the Council accepted a provisional tender from Morcom of £370[38] and on 10 December the present bronze cast was erected on the original pedestal.[39]

On 17 September 1950, alterations to the traffic island at Welford Place necessitated the statue's second removal,[40] and it was subsequently stored at the Corporation Depot at Rushey Fields.[41] There then followed some debate as to whether it should be returned to Welford Place or relocated to Victoria Park.[42] A little over a year was to pass before agreement was reached on a third option, the north side of De Montfort Square. The *Biggs Statue* was re-erected on this new site on 25 July 1952.[43] In 1967, the statue was again moved: back to its original site at Welford Place. Finally, on Sunday 8 December 1991, it was shifted fifteen yards from one side of the traffic island to the other so that the road could be widened.[44]

Related work: tomb monument in Welford Road cemetery, signed J. Firn.

Literature

LRO. *Council Minutes*, 26 March 1872 – 10 March 1874, pp.78, 260; *Estate Committee Minutes*: – [i] 16 November 1927 – 21 October 1931, pp.108, 113, 122, 127–8, 140, 145, 147, 203, 222, 234, 281–2, 332 [ii] 25 May 1949 – 23 April 1952, pp.31, 412, 461 [iii] 28 May 1952 – 28 April 1954, p.62; *Highway … Committee Minutes*: – [i] 19 April 1872 – 8 November 1872, pp.63, 105, 121, 137, 155, 449 [ii] 15 November 1872 – 18 July 1873, p.251 [iii] 5 November 1948 – 4 May 1951, p.157; *Museums and Libraries Committee Minutes*, June 1967 – February 1974, p.9.
University of Leicester library, Local History collection. *Council Minutes*: – [i] 1928–9, pp.100–1 [ii] 1929–30, p.246.
General. Banner, J.W., 1991, pp.28–30; Banner, J.[W.], 1994, pp.82–3; Bennett, J.D., 1968, p.38; Burton, D.R., 1993, p.118; Darke, J., 1991, p.177;

Evans, R.H., 1972–3, pp.29–58; Lee, J., 1991, pp.90–1; *L. Advertiser*, 19 April 1873, p.7; *L. & R. Topic*, November 1971, p.**13**; *L. Chronicle*: – [i] 10 June 1871, pp.3, 5, 8 [ii] 14 October 1871, p.8 [iii] 28 October 1871, p.8 [iv] 27 April 1872, p.3 [v] 22 March 1873, p.6 [vi] 19 April 1873, pp.6, 7 [vii] 9 September 1950, p.8, **8** [viii] 2 August 1952, pp.8–9, **8–9**; *L. Daily Post*, 19 April 1873, p.3; *L. Journal*, 18 April 1873, p.6; *L. Mail*, 10 December 1930, p.4, 4; *L. Mercury*: – [i] 2 November 1921, p.9 [ii] 9 November 1921, p.9 [iii] 1 October 1928, p.10, **10** [iv] 9 December 1991, pp.1, 3, **1, 3**; Leicester Museums, n.d.; *Modern Memorials. Leicester...*, 1875, pp.36–43; Pevsner, N. and Williamson, E., 1992, p.235; *Spencers'... Guide to Leicester*, 1878, p.191; *Spencers' New Guide to ... Leicester*, 1888, pp.57–8.

Notes

[1] The Biggs Memorial Committee was engaged in discussions with Freeman and Sons over the cost of various types of pedestal prior to its meeting of 23 April 1872 (*L. Chronicle*, 27 April 1872, p.3.) [2] Banner, J.W., 1991, p.30. [3] Burton informed the subscribers that the statue was to be seven feet in height at the subscribers meeting of 23 April 1872 (*L. Chronicle*, 27 April 1872, p.3). [4] *L. Advertiser*, 19 April 1873, p.7. B/w photograph, c.1900, of original marble statue in Burton, D.R., 1993, p.118. [5] *L. Chronicle*, 19 April 1873, p.6. [6] *Ibid.* [7] *Ibid.*, 14 October 1871, p.8. [8] *Ibid.*, 28 October 1871, p.8. [9] Burton was acknowledged by contemporaries as being a prime mover in every one of the short succession of public memorials erected in Leicester during the 1860s and 1870s (*Modern Memorials*, 1875: 42). In addition to the erection of new memorials he also instigated the renovation in 1872 of the *Duke of Rutland Statue* (see p.144). [10] Evans, R.H., 1972–3, pp.29–30. [11] A competition for the tomb memorial had been won by Samuel Barfield (*L. Chronicle*, 14 October 1871, p.8), though the commission was cancelled following the decision to divert the subscriptions to a public statue. Ultimately a simple monument to John Biggs was erected in Welford Road cemetery and is signed 'J. Firn'. [12] Samuel Payne speaking at the public meeting following the unveiling of Biggs's statue. He referred to ' the party distinction which at one time existed and operated against the erection of such works'. The works he was alluding to were the recently-erected *Statue of Robert Hall* and the present statue to Biggs. [13] *L. Chronicle*, 28 October 1871, p.8. [14] *Modern Memorials*, 1875, p.43. [15] *Ibid.*, p.37. [16] *L. Chronicle*, 27 April 1872, p.3. [17] *Ibid.* [18] *Ibid.* Plant was here referring derisively to the fact that the

Statue of the Duke of Rutland's pedestal was fitted with the outlet for the town's conduit, an arrangement derided at the time by the *Builder* (see p.142). [19] *Ibid.* [20] *Highway … Committee Minutes*, 19 April 1872 – 8 November 1872: meetings of 17 May, 7 June, 14 June, 21 June and 28 June 1872. See also letter from the Memorial Committee to the Corporation Highway and Sewerage Committee, dated 13 June 1872, inserted between pp.121/2 (14 June meeting). The Highway and Sewerage Committee's approval of the site was sanctioned at the Quarterly Council meeting on 2 July 1872 (*Council Minutes*, 26 March 1872 – 10 March 1874, p.82). [21] *L. Advertiser*, 19 April 1873, p.7. [22] *Highway … Committee Minutes*, 19 April 1872 – 8 November 1872, meeting of 18 October 1872; *Council Minutes*, 26 March 1872 – 10 March 1874, meeting of 1 January 1873. [23] *Highway … Committee Minutes*, 15 November 1872 – 18 July 1873, meeting of 4 April. [24] *L. Chronicle*, 22 March 1873, p.6. [25] *L. Advertiser*, 19 April 1873, p.7. [26] *Modern Memorials*, 1875, p.38. [27] *L. Chronicle*, 19 April 1873, p.6. [28] *L. Advertiser*, 19 April 1873, p.7. [29] The only Samuel Payne listed in *Barker & Co's General Topographical and Historical Directory for ... Leicester*, 1875, is Samuel Payne, tailor and draper, 28 New Bond Street. [30] *L. Advertiser*, 19 April 1873, p.7. [31] *Ibid.* [32] *Estate Committee Minutes*, 16 November 1927 – 21 October 1931, p.108, and *L. Mail*, 10 December 1930, p.4. [33] *Council Minutes*, 1928–9, pp.100–1. [34] *Estate Committee Minutes*, 16 November 1927 – 21 October 1931, p.108. [35] *Council Minutes*, 1928–9, p.101. [36] *Estate Committee Minutes*, 16 November 1927 – 21 October 1931, p.140. [37] *Ibid.*, p.234. [38] *Council Minutes*, 1929–30, p.246. [39] *Estate Committee Minutes*, 16 November 1927 – 21 October 1931, p.332, and *L. Mail*, 10 December 1930, p.4. [40] *Estate Committee Minutes*, 28 May 1952 – 28 April 1954, p.187. [41] *L. Chronicle*, 9 September 1950, p.8. [42] *Estate Committee Minutes*, 25 May 1949 – 23 April 1952, p.412. [43] *Ibid.*, 28 May 1952 – 28 April 1954, p.62, and *L. Chronicle*, 2 August 1952, pp.8–9. [44] *L. Mercury*, 9 December 1991, pp.1, 3.

West Bridge

The bridge was built in 1891. Projecting from the corners of the decorative battlements of the four octagonal piers are carvings:

Medieval characters

Sculptor: unknown

Heads in stone
Each head approx. h. 35cm (1'2")
Executed: *c*.1891
Inscription on bronze plaque on north face of south pier at west end (Aldermen's names in Gothic script, all other lettering in Roman capitals):
THIS BRIDGE WAS OPENED IN 1891 / ALD: WILLIAM . KEMPSON . J.P. / MAYOR / ALD: HENRY . THOS . CHAMBERS . J.P. / CHAIRMAN OF THE / FLOOD PREVENTION WORKS COMMITTEE / ALD: JOHN . UNDERWOOD . / CHAIRMAN OF THE HIGHWAY & SEWERAGE COMMITTEE / JOHN STOREY, TOWN CLERK / E G MAWBEY C.E., ENGINEER / S & E BENTLEY & J BUTLER & CO / CONTRACTORS
Status of bridge: Grade II
Owner: Leicester City Council

Description: There are eight heads portraying various medieval types on each octagonal pier; local historians are in general agreement that they are intended to represent Chaucer's Canterbury pilgrims.[1]

Condition: All 32 heads are weathered and some have sustained damage.

Literature
Banner, J.W., 1994, pp.10–11; Darke, J., 1991, p.178.

Note
[1] For example, Banner, J. W., 1994, pp.10–11.

On the north side of West Bridge, overlooking the west side of the Grand Union Canal, mounted on a free-standing wall with a large circular opening:

Mermaids archway

Sculptor: William James Neatby, for Royal Doulton Lambeth Potteries

Relief in terracotta
h. 2.18m (7'2"); w. 6.04m (19'10")
Inscription on a metal plaque on a low wall to the right of the archway:
THE BAS RELIEF PANEL 'MERMAIDS' WAS MADE IN 1900 / AT THE ROYAL DOULTON LAMBETH POTTERIES BY / WILLIAM J NEATBY, WHO WAS HEAD POTTER IN THE / TERRACOTTA

West Bridge, medieval characters

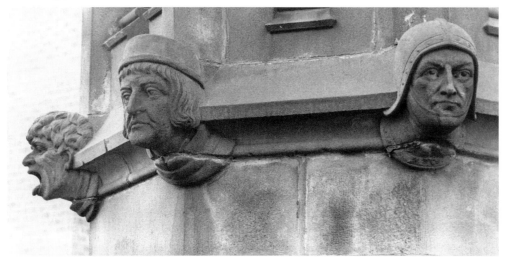

DEPARTMENT THERE FROM 1890 TO / 1907. / FOR MANY YEARS IT STOOD OVER THE MAIN / DOORWAY OF THE LEICESTER WHOLESALE / MARKET ON HALFORD STREET UNTIL THAT BUILDING / WAS DEMOLISHED IN 1972. / IT WAS RE-ERECTED AT ITS PRESENT SITE UPON / THE BASE OF A BRIDGE PIER OF THE OLD GREAT / CENTRAL RAILWAY IN THE SPRING OF 1980.
Executed 1900
Signed and dated at bottom of right-hand spandrel: Doulton WJN April 11th 1900
Exhibited: 1979, London, Victoria and Albert Museum (Architecture and Sculpture section, cat. no. U2)
Status: not listed
Owner: Leicester City Council

Description: A large free-standing wall with a circular hole, into the top half of which has been set the arch from the entrance to the former Leicester Wholesale Market. The spandrels of the arch are decorated with two opposed, symmetrically-designed Art Nouveau-style mermaids. Bubbles issue from their mouths, their hair swirls decoratively up and over their brows, while around their forms are stylized swirls of water. With outstretched hands they guide fishes towards the crown of the arch. Each of the chamfered soffits of the arch voussoirs is decorated with a fish, the whole school swimming anti-clockwise.

Condition: Fair. There are some small chips to the outer edges of the frame and some small losses, filled with a greyish-white material, most noticeably on the back of the left-hand mermaid.

History: The *Mermaid* reliefs, designed by William Neatby, director of Royal Doulton's architectural department, originally decorated the spandrels of the entrance archway to the Wholesale Fish, Fruit and Vegetable Market building, Halford Street. Built in 1900 by Walter Brand, the building was demolished in December 1972/January 1973 following the market's move to larger premises at Freemen's

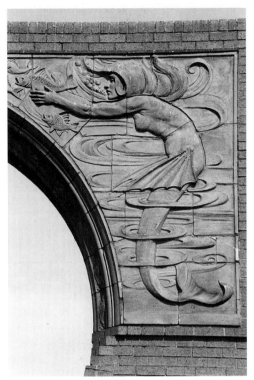

Neatby, *Mermaids archway*

Common.[1] Throughout 1972, pressure groups campaigned without success for the building's preservation 'on the grounds of its architectural splendour'.[2] The Corporation's sole concession was to preserve Neatby's reliefs, one idea being to incorporate it into the design of the multi-storey car park that was to replace the market. This scheme was abandoned, if indeed it was ever seriously considered, and the reliefs remained in store for a number of years, while the Corporation decided where to re-display them.

Then, in 1980, as part of a £15,000 landscaping scheme, the Corporation decided to mount the reliefs on a 20-foot-high, free-

standing, ornamental wall by the renovated West Bridge. Constructed of concrete faced with red brick, the wall is pierced with a 12-foot-wide circular aperture with the reliefs framing the upper half of the circle.[3]

On Tuesday 30 September 1980 a bronze plaque at the foot of the wall was unveiled as part of the official inauguration of this first stage of the West Bridge Road Improvement Scheme.[4]

Photographs of the reliefs in their original and present locations are in Elliott, M., *Leicester: A Pictorial History*, 1983, figs 154, 155.

Related work: According to Atterbury and Irvine the present 'design is very similar to the mermaid panel on the [New] Palace Theatre, [Union Street,] Plymouth', 1898.[5]

Literature
Atterbury, P. and Irvine, L., 1979, pp.30, 84; Banner, J. W., 1991, p.71; Banner, J.W., 1994, p.10; Darke, J., 1991, p.178; Elliott, M., 1983, figs **154**, **155**; Lee, J. and Dean, J., 1995, pp.71, **71**; *L. Chronicle*, 29 December 1972, pp.3, 1; Leicester City Council, 1997, pp.78, **79**; *L. Mercury*: – [i] 4 June 1980, p.18 [ii] 25 September 1980, p.9 [iii] 1 October 1980, p.5 [iv] 22 July 1988, p.8; Pevsner, N. and Williamson, E., 1992, p.228.

Notes
[1] *L. Chronicle*, 29 December 1972, pp.1, 3. [2] *Ibid.*, p.3. [3] *L. Mercury*, 4 June 1980, p.1. [4] *Ibid.*, 25 September 1980, p.9. [5] Atterbury, p.and Irvine, L., 1979, p.84. The New Palace Theatre panel is illustrated in *British Architect*, November 1898, p.382.

2. SUBURBS OF LEICESTER

BEAUMONT LEYS

Beaumont Way

In Beaumont Leys Public Library:
Paging the Oracle
Sculptor: Bill Ming

Sculpture in lime and pine wood, partially stained green
Sculpture: h. 95cm (3'2"); w. 1.54m (5'1"); d. 1.04m (3'5")
Plinth: h. 60cm (2'); w. 1.64m (5'5"); d. 1.14m (3'9")
Signed and dated on the upper surface of the base at rear left: B. MING / '88
Installed: December 1988
Status: not listed
Owner / custodian: Leicester City Council

Description: The sculpture, all in wood, is mounted on a plinth and comprises a boat floating on the wave-like pages of an open book. A canopy over the centre of the boat, supported on two balusters, takes the form of a pitched roof upon which rests another open book. Inside the boat are various carved objects including an egg-timer. The green-stained hull of the boat is carved with reliefs of an *ankh* (an Egyptian hieroglyph symbolising life), an African head in profile with a snake on its brow, a *yin* and *yang* symbol (the negative and positive principles of life in ancient Chinese cosmology), masks of comedy and tragedy from ancient Greek drama, a bird, an eye and a horseshoe. The pages of the open book upon which the boat is sailing are carved with a map of Beaumont Leys, a bird, dividers and a compass.

Condition: Good.

History: *Paging the Oracle*, which cost £2,400, was a joint commission by Leicestershire County Libraries and Information Service, East Midlands Arts and a private sponsor, Herald Goddard, for the newly-opened Beaumont Leys library. In 1988 three local artists were asked to submit maquettes for the commission. Following his selection Bill Ming recalled how surprised he had been to be invited: 'Then I came down to the library and I saw the space there, and the whole feeling of the building, and I thought "This is mine. I want this one."'[1]

Having secured the commission, Ming took his maquette along to a local woodyard to select the wood; on the advice of the owner (with whom he regularly discusses the local woods most appropriate to each commission) he chose lime for the boat and pine for the base. At first Ming had intended to raise the boat on a stilt-like trestle structure, but this was ultimately abandoned and instead he placed the hull directly on the more vivid and apposite motif of the wave-like pages of the open book. The hull of the boat is based on a turtle shell owned by the sculptor; each section of the carapace / hull being carved with cultural, philosophical and religious symbols from across time and around the world. As area librarian Richard Barlow has observed, the theme of the sculpture is ideally suited to its setting: 'The eclecticism of the piece reflects the comprehensive nature of the public library: discovering the symbols is a part of the journey on which the sculpture takes you.'[2]

Literature

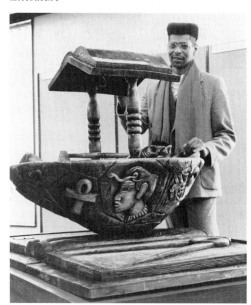

Bill Ming with *Paging the Oracle*

Barlow, R., 1989, pp.20–1; *L. Mercury*: – [i] 30 July 1988, p.6 [ii] 10 December 1988, p.11.

Notes
[1] As quoted in Barlow, R., 1989, p.20. [2] *Ibid.*, p.31.

BELGRAVE

Church Road

Belgrave Hall (1715, by Edmund Cradock), now a Leicester Museum

In the walled garden:
1. To the right of the Hall, against the garden wall:

Fides Christiana or *Religion*

Sculptor: Louis François Roubiliac

Statue in Carrara marble on a pedestal in marble
Statue: h. 2.42m (7'11"); w. 1.22m (4'); d. 64cm (2'1")
Pedestal: h. 99cm (3'3"); w. 91.5cm (3'); d. 86cm (2'10")
Upper step: h. 14cm (6"); w. 1.11m (3'8"); d. 95.5cm (3'2")
Lower step: h. 20cm (8"); w. 1.37m (4'6"); d. 1.22m (4')
Executed: *c.*1761
Inscriptions, all incised:
– across the arms of the cross: ΤΟΥΤΩ ΝΙΚΑ. ['*By this sign shalt thou conquer*']
– on a scroll held in the figure's right hand: ΕΥΑΓΓΕΛΙΟΝ / ΑΙΩΝΙΟΝ ['*The Eternal Gospel*']
– around the base of the statue: Η ΝΙΚΗ Η ΝΙΚΗΣΑΣΑ ΤΟΝ ΚΟΣΜΟΝ Η ΠΙΣΤΙΣ ΗΜΩΝ. ['*The victory which conquered the world is our faith*'][1]
– on the front face of the pedestal: THIS STATUE OF / RELIGION / WAS PRESENTED / TO THE MUSEUM OF THE TOWN OF / LEICESTER / BY / RICHARD WILLIAM PENN EARL OF HOWE / AS A TRIBUTE / OF REGARD AND GOOD WILL TOWARDS / THE METROPOLIS OF HIS NATIVE COUNTY / 1857.

Signed on the rear of the base of the statue towards the right: L. F. Roubiliac. Sc.
Status: Grade II* (upgraded from Grade II on 21 September 1999)
Owner: Leicester City Council

Description: A female figure in heavy, full-length draperies, her head covered with a mantle, her feet sandalled. Standing with her weight on her right foot, her left foot forward, she turns her torso slightly to her left and her head to her right, looking downwards. In her right hand she displays an unrolled scroll bearing an inscription (for which, see above); in her left she holds the shaft of a cross, which bears a further inscription across its horizontal bar. A palm is held against the cross by a crown slotted over the upper arm.

Condition: Poor. The left side of the statue sustained considerable damage at some time before its acquisition by Leicester Museum. A.C. Sewter, writing in 1939, made reference to 'the left hand and the whole of the cross above the shoulder having been at some time broken off, and some small breaks on the crown and palm branch probably caused by the fall of the detached portion'.[2]

The break in the upper part of the shaft of the cross held by the figure has been crudely repaired at a slight angle; the cement used for this repair is now cracked and crumbling. The break in the left wrist is also visible. The stem of the palm frond is missing, as is most of the crown that holds it against the cross above the junction of the arms. The backs of three of the fingers of the figure's left hand (i.e., that holding the cross) are missing and the little finger lost entirely. On the figure's left foot, the big toe and the forward edge of the next toe, both of which once overhung the front of the base, are also missing. In addition, there is some damage to the hem of the figure's robe at the rear. The rear edge of the shaft of the cross closest to the figure is damaged about one third

of the way up. Plug-holes indicate where metal letters forming inscriptions on the figure's scroll, on the horizontal beam of the cross, and around the base have been lost.[3] The engraved replacement inscription is now very weathered as are all of the more exposed surfaces of the statue. The statue is generally grimy, especially the upper portion which has, in addition, extensive areas of green biological growth and lichen, while hollows and undercuttings are filled with grit, cobwebs and wind-blown seeds etc.

History: *Fides Christiana* or *Religion*[4] was commissioned from Roubiliac by Charles Jennens (1700–73) shortly before 1761.[5] Jennens evidently kept the statue at his London house for a short while[6] before removing it to his country estate at Gopsall Hall, Leicestershire, where he had it installed on top of a domed *tempietto* he had erected as a mausoleum commemorating his friend Edward Holdsworth (1684–1746).[7] Jennens died unmarried and bequeathed the estate to his relative, William Penn Assheton Curzon,[8] from whom it passed to Richard Penn, Earl Howe. It was he who in 1857 donated the statue – as indicated by the inscription on the present pedestal[9] – to 'the Museum of the town of Leicester' (i.e., New Walk Museum). The statue was originally installed inside New Walk Museum but, owing to shortage of space, was moved outside in March 1926.[10] Finally, in 1981, it was relocated to the garden of Belgrave Hall following restoration by the Museum.[11]

Remarkably, from the middle of the nineteenth century until 1939, the year an article on the statue was published by A.C. Sewter (then an art assistant at the Leicester Museum), Roubiliac's *Fides Christiana* was considered lost.[12] The inscription recording Earl Howe's donation on the front of the pedestal does not mention the sculptor and although the rear of the statue's base is clearly signed 'L.F. Roubiliac', its position close against a wall after its removal outside (and perhaps also while it

was sited inside the Museum) may have hidden the signature from view. Furthermore, although the pre-1939 Museum records gave the name Roubiliac, they did not give any provenance.[13] Consequently, for nearly one hundred years, the true identity of the present statue remained hidden.

The circumstances of the commission, though well-covered by previous authors, are important for an understanding of the significance of this most important statue, and so will bear repeating in summary form. Holdsworth, to whom the Gopsall *tempietto* was dedicated, had been a tutor at Magdalen College, Oxford, at the time that Jennens had been there as an undergraduate. Holdsworth had been offered a fellowship at Magdalen, a prerequisite of which was that he swear loyalty to King George I. He was, however, a nonjuror, according to whose religious beliefs the new Hanoverian dynasty was not legitimate: it had succeeded to the kingdom by overthrowing the Stuart dynasty in contravention of St Paul's injunction against the opposition of rightful rulers.[14] Consequently, Holdsworth resigned from the university and spent the rest of his life working as a private tutor and as a guide for gentlemen on the Grand Tour.[15] Jennens was also a nonjuror and, like Holdsworth before him, refused to take the oath and was likewise not allowed to take his degree. Jennens, however, had the benefit of a considerable inherited fortune which he used later in life to help people, nonjurors especially, whom he considered deserving.[16]

Jennens inherited Gopsall in 1747, the year after Holdsworth's death, the mausoleum being part of his original plans for the estate.[17] As Bindman has pointed out,[18] the idea of placing a statue of some considerable weight on the top of a small domed *tempietto* is a strange one, but the *tempietto* as built had the whole of its interior taken up by a cenotaph (by Richard Hayward, dated 1764, and now also at Belgrave

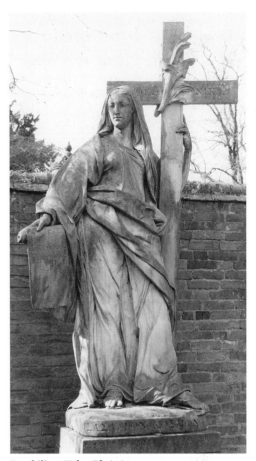

Roubiliac, *Fides Christiana*

Hall; for which, see below). The cenotaph, however, post-dates Roubiliac's death in 1762 and may therefore have been an afterthought, the statue possibly having been commissioned originally for the interior and only mounted on the summit of the dome when it was decided to incorporate a cenotaph. Whatever the case, by the early nineteenth century the temple had become structurally unsound and in 1835 suffered partial collapse.[19] The damage to the statue, though severe, is not as extreme,

however, as one would expect from an actual fall from the summit of the dome and, as Sewter plausibly suggests, may have been incurred during its removal from the dome (i.e., before its eventual collapse).[20]

The question of how Jennens came to select Roubiliac for the statue has been addressed by Emmerson.[21] Apart from the fact that Roubiliac was one of the most successful sculptors of his day, it is probable that the two men were friends. In 1738 Roubiliac had executed a statue of the composer George Friedrich Handel for Vauxhall Gardens (terracotta model at the Fitzwilliam Museum, Cambridge; marble at the Victoria and Albert Museum). Roubiliac and Handel had remained friends, the sculptor eventually being commissioned to design the composer's tomb monument in Westminster Abbey (1759–62). Jennens was himself a friend of Handel's; more importantly in the present context he was also librettist for a number of Handel's oratorios, including *Messiah*. Emmerson has pointed out that Jennens would have almost certainly devised and selected the inscriptions on the mausoleum at Gopsall, and has aptly termed it 'a sort of oratorio in stone'.[22]

Around the frieze of the mausoleum ran an inscription in Greek (lost when the dome collapsed) which, translated, read 'Thanks be to God which giveth us the victory through Our Lord Jesus Christ. A temple of victory'.[23] The first sentence, from 1 Corinthians, 15: 57, was also used by Jennens in the final part of *Messiah*.[24] The combination of the two sentences is a key to the meaning of the mausoleum as a whole, a meaning reinforced by the iconography of Roubiliac's *Fides Christiana* and its three Greek inscriptions. The inscription on the cross, translated as 'By this sign shalt thou conquer', refers to the words heard by Constantine during his vision of the Cross shortly before his victory at the Milvian Bridge: by this victory he became Emperor of Rome, converted to Christianity and made

Christianity the official religion of the empire. The scroll held by the figure has an inscription which translates as 'The Eternal Gospel', while the base inscription translates as 'The victory which conquered the world is our faith' (adapted from 1 John, 5: 4). The inscriptions serve to bring into focus meaning already symbolically figured in the statue: the cross is a symbol of the resurrection made possible through Christ's sacrifice, while the combination of the crown hung over the cross and the palm threaded through it, symbolise the Christian martyr's 'eternal reward in heaven'.[25] Thus the mausoleum and its statue symbolise not just the triumph of Christian faith over death but also, specifically, Holdsworth's spiritual triumph, in so far as he resisted earthly temptation through his refusal to deny his religious beliefs.[26]

As Katherine Esdaile observed, 'works of a definitely religious order are very rare in English art' after the Reformation and until their re-introduction by John Flaxman (1755–1826).[27] Roubiliac had himself already executed a figure of Religion, but only as a supporting figure on his *Monument to Bishop John Hough*, 1744–7, Worcester Cathedral,[28] not as an independent statue. Bindman saw Roubiliac's *Fides Christiana* as belonging more obviously to a French or Italian tradition, plausibly suggesting as antecedents known to Roubiliac, figures of Religion by Robert Le Lorrain at Versailles and by Pierre Legros at Rome.[29] Roubiliac's figure also seems to owe a considerable debt to Michelangelo's *Risen Christ*, 1519–20, S. Maria sopra Minerva, Rome. Yet, as Bindman has noted, despite the inescapable conclusion that *Fides Christiana* fits clearly into a continental, Catholic tradition: 'the uncompromising emphasis on faith as the conqueror of nations expressed in the *Fides Christiana* would have been common ground between High Anglicanism and the new evangelical currents in the Anglican church'.[30]

The statue is of great interest as much on stylistic as on theological grounds. It shows Roubiliac, in what is possibly his last completed work, assimilating into a Baroque mode exemplified by the turning pose and sweeping diagonal folds of the mantle, classical elements, notably the austere dignity of the figure, its serene features and the close-fitting draperies covering the torso, with a conviction unprecedented either in his own or indeed in the work of any other sculptor working in England.[31]

Related works: Monuments to *Elizabeth, Lady Newdigate* († 1765), St Mary's Church, Harefield, North West London, and to *Samuel Phillipps* († 1774), St Botolph, Shepshed, Leicestershire, both by Richard Hayward, the sculptor who executed the cenotaph for the same mausoleum as the present statue (see below). Each of Hayward's monuments is surmounted by a figure of Religion, deriving from that by Roubiliac.[32]

Literature

Bindman, D. and Baker, M., 1995, pp.29, 85, 89, 121–2, 370 n.1, 375 n.73, **28, 121**; Emmerson, R., 1981; Esdaile, K., 1927, p.34; Esdaile, K., 1928, pp.128–30; *Gentleman's Magazine*, April 1791, pp.305–6; Nichols, J., vol. iv, pt ii, 1811, pp.857–8 (and pl. opp.); Oakley, G. and Croman, L., 1996, p.**75**; Pevsner, N. and Williamson, E., 1992, p.269; Sewter, A.C., 1939; Whinney, M., 1988, p.226.

Notes

[1] Greek inscriptions as translated in Sewter, A.C., 1939, p.122. [2] *Ibid.*, p.121, n. 4. [3] John Nichols, writing in 1791, noted that so many of the metal letters had already been lost that the inscriptions had been rendered illegible (*Gentleman's Magazine*, April 1791, p.305). [4] In Dodsley's *London*, 1761, the terracotta model for the present statue is referred to as *Fides Christiana* (Sewter, A.C., 1939, p.123); in the catalogues of the sale following Roubiliac's death in 1762, however, are listed three plaster casts of the statue, there entitled *Religion* (First Day's Sale, 12 May 1762, nos 39, 56; Second Day's Sale, 13 May 1762, no. 60; as published in Bindman, D. and Baker, M., 1995, pp.363, 364). [5] Emmerson, 1981; Bindman, D. and Baker, M., 1995, p.121. [6] The marble statue

and its terracotta model (now lost) were both seen at Jennens's London house at some unspecified date by Thomas Martyn, as he records in his *English Connoisseur* of 1766 (Sewter, A.C., 1939, p.123; see also Bindman, D. and Baker, M., 1995, p.121). [7] Nichols, J., 1811, vol. iv, pt ii, pp.857–8, fig. 12 (opp. p.858); Nichols's entry on Gopsall Hall had appeared in slightly different form as a letter to the *Gentleman's Magazine*, April 1791, p.305. See also in Emmerson, R., 1981, a reproduction of a contemporary painting, *View of Gopsall Hall*, showing at left the *tempietto* standing in the grounds at Gopsall. [8] John Nichols, letter to the *Gentleman's Magazine*, April 1791, p.305. [9] Sewter (1939, p.122) suggests that the pedestal, which came to the Museum with the statue, may have been commissioned by Earl Howe at the time of his donation. [10] Sewter, A.C., 1939, p.122, n. 4; the statue is shown outside the Museum in fig. d, opp. p.121. [11] Emmerson, R., 1981. [12] In 1928, Katherine Esdaile, the pioneering scholar on Roubiliac, wrote: 'The work vanished between 1846 and 1870' (Esdaile, K., 1928, p.129). [13] Sewter, A.C., 1939, p.122. [14] St Paul's injunction to obey 'the powers that be' (St Paul's Epistle to the Romans, 13: 1–7) is the source of the doctrine of the Divine Right of Kings. [15] *DNB*. [16] *Ibid.*; see also Emmerson, R., 1981; Bindman, D. and Baker, M., 1995, pp.121–2. [17] Bindman, D. and Baker, M., 1995, p.122. [18] *Ibid.* [19] Emmerson, R., 1981. An old photograph shows the *tempietto* with everything above the keystones of the arches lost (reproduced in Oakley, G. and Croman, L., 1996, p.75). [20] Sewter, A.C., 1939, p.121. [21] Emmerson, R., 1981. [22] *Ibid.*; also quoted in Bindman, D. and Baker, M., 1995, p.122. [23] As quoted in Emmerson, R., 1981. [24] Bindman, D. and Baker, M., 1995, p.122. [25] Sewter, A.C., 1939, p.122–3. [26] Emmerson, R., 1981. [27] Esdaile, K., 1928, p.128. [28] See Bindman, D. and Baker, M., 1995, p.110, fig. 69. [29] *Ibid.*, p.122. [30] *Ibid.* [31] Sewter, A.C., 1939, p.123. [32] Esdaile, K., 1928, p.177; Pevsner, N. and Williamson, E., 1992, p.376.

2. At the east end of the gardens:
The Holdsworth Cenotaph
Sculptor: Richard Hayward

Cenotaph in Carrara marble[1]
h. including steps and platform (est.). 3.1m (10'2")
base of cenotaph: 1.34m (4'5") × 1.34m (4'5")
Executed: 1764

Inscriptions, incised in capital letters:
– on the left (north) face of the cenotaph (now illegible):[2] E. HOLDSWORTH, NATUS 1684, MORT"S 1746. / INSCRIPTIONEM PRÆSTOLATUS USQUE AD 1764. / MIRARIS FORSAN, LECTOR, NEC IMMERITO, / HUNC OMNI LAUDE DIGNISSIMUM VIRUM / SINE SAXO ET SINE NOMINE CORPUS / JAMDIU JACUISSE! / VERUM ISTE REGULUS, QUI ELOQUIUM POLLICEBATUR / DUM PER PLURES ANNOS / ORATIONIBUS VEL ORATIONCULIS, / ET VERSIBUS SATYRICO-POLITICIS, / SCRIBENDIS, DICENDIS ET AGENDIS, / SUO DENIQUE SUIPSIUS ELOGIO / INANEM SIBI GLORIAM AUCUPATUR, / FAMÆ INTERIM MELIORIS OBLITUS, / AMICIS QUAM DEDERAT FIDEM FEFELLIT.
[translation:[3] *E. Holdsworth, born 1684, died 1746. He did not receive an inscription until 1764. You may perhaps wonder, reader, and with good reason, that this man most worthy of all praise has lain for so long a nameless corpse without a stone. The petty Dr King held out promises of an inscription, but instead gained an empty glory for his own epitaph by writing and making little speeches and verses of political satire: he thus neglected a man more deserving of fame, and betrayed the trust placed in him by his friends.*]
– on the right (south) face of the cenotaph (partly illegible):[4] QUOD GENIUS DIU SOLICITATUS NEGAVIT, / PROMISIT ENIM, NEC TAMEN PRÆSTITIT, / ID DEMUM IMPAR QUIDEM CONATUI, / SED INDIGNATA / PRÆSTAT AMICITIA. / IN MEMORIAM VIRI INTEGERRIMI / EDWARDI HOLDSWORTH. / DE QUO, SI MAGNA LOQUI VIDEAR. / QUOD MARONEM FELICISSIME JUVENIS IMITATUS. / PARI FELICITATE SENIOR ILLUSTRAVIT, DEFENDIT: / QUOD ÆDES MAGDALENIANAS. / QUAS INGENIO, ERUDITIONE, VIRTUTIBUS ALUMNUS ORNAVERAT / DOCTRINA AC PERITIA ARCHITECTONICA. / AB IISDEM ÆDIBUS IMO ET A PATRIA / PER TEMPORUM INIQUITATEM EXTORRIS. / ELEGANTER INSTAURANDAS CURAVIT: / HOC MULTO MAJUS: / QUOD ADOLESCENTES PRO VIRILI SUIS ARTIBUS

IMBUIT ET MORIBUS. / CONTRA DEGENERIS ÆVI VITIA / PRIVATA SIMUL ET PUBLICA / NON MINUS EXEMPLO, QUAM MONITIS MUNIVIT. / ILLUD VERO LONGE MAXIMUM. / QUOD MUNDUM DEO NATUS VICIT: / QUOD, DEI MANDATO OBTEMPERANS. / E GREMIO ALMÆ MATRIS EXIVIT / NESCIUS QUO ESSET ITURUS: / SED ENIM CIVITATEM HABENTEM ΤΟΥΣ ΘΕΜΕΛΙΟΥΣ / CUJUS ARCHITECTUS EST DEUS. / FIDE VERE ABRAMICA. / VERE EVANGELICA. / FRETUS EXPECTAVIT. / HÆC NI FALLOR / QUINQUID CONTRA OBLATRENT PSEUDO-POLITICI. / HÆC CONSENSU BONORUM OMNIUM / OPINIONIBUS QUANTUMVIS DIVERSORUM / SUMMA SAPIENTIA.
[translation:[5] *What Genius refused despite frequent appeals, Friendship, indignant at this promise without fulfilment, now offers, though it be unequal to the task. In memory of a most upright man Edward Holdsworth. If I appear to praise him, it is for the following reasons. As a young man he wrote most felicitous imitations of Virgil, and in riper years with equal success expounded and defended him; as a member he graced Magdalen College with his talent, learning and virtues, and with his knowledge and understanding of architecture. Yet even when, through the wickedness of the times, he had been banished from the college and from his own native land, he made plans for the college to be elegantly restored. By his skills and character he fortified the young no less by example than by his advice against the vices of a degenerate age, both private and public. Most important by far is that the Son of God overcame the world, and obeying the Commandment of God, he left the lap of his Blessed Mother knowing not where he would go: but trusting in the faith of Abraham, the faith of the Gospel, he looked forward to that city with firm foundations whose Architect is God. If I am not mistaken, whatever carping objections false politicians may make, all good men, however varied their opinions, agree that this is the highest wisdom.*]

Status: Grade II* (upgraded from Grade II on 21 September 1999)
Owner: Leicester City Council

Description: The *cenotaph* is located in Belgrave Hall's Monument Garden, a small area surrounded on three sides by conifers, at the far end of the Herbaceous Garden, in a direct line from the Hall. It has voluted corner consoles and a heavy cornice, and is crowned by a large urn. On the (west) face towards the Hall is a relief of a ruined pyramid from which foliage sprouts; Nichols identifies this as Virgil's tomb.[6] On the left (north) face is an inscription on a 'ruined' panel (the first of the two transcribed above); above the panel is a bust portraying, according to Nichols, Virgil,[7] and beneath, a relief depicting antique fragments. On the rear (east) face is a mourning winged Genius leaning on a reversed torch, still flaming. The right (south) face bears the second inscription (as transcribed above).

Condition: All surfaces are weathered, the inscription on the left (north) face being illegible and that on the right (south) illegible in places, particularly the upper lines. On the left face a chunk of the moulding below the fluted frieze is missing towards the rear and the front left corner of the cornice is damaged. The joins where the cenotaph has been re-assembled (having been dismantled at least twice during the course of relocations) are damaged in places. There is much (recent) graffiti, particularly on the far (east) face, out of sight of the Hall.

The sides with the relief of Virgil's Tomb and the 'Quod Genius...' inscription panel seem to have been replaced in wrong positions following one of the relocations. John Nichols, in his article in the *Gentleman's Magazine*[8] describes the Genius relief as being on the south side, Virgil's tomb on the west, the bust of Virgil on the east and the extended inscription beginning 'Quod Genius...' on the north. The engraved illustration in the same author's later

History ... of Leicester[9] supports this arrangement, showing an oblique view of the cenotaph with the Virgil bust on the face on the left (i.e. Nichols's east) and the 'Quod Genius...' inscription on the right (Nichols's north). In the present arrangement, the Virgil bust is to the left of the Virgil tomb, not the inscription. An old photograph[10] shows an oblique view of the cenotaph after its removal to the grounds east of Gopsall Hall but the two sides in view are those with the Genius relief and the Virgil bust (as per both Nichols's description and the present arrangement). It is, therefore, uncertain as to when the mistake was made.

History: As related above (see pp.185–6), the cenotaph, now in the garden of Belgrave Hall, was originally set up in a mausoleum erected in the grounds of Gopsall Hall by Charles Jennens in commemoration of his friend Edward Holdsworth. The dome of the mausoleum was crowned with Roubiliac's *Fides Christiana*, now also in the present garden. It is thought that the statue was executed *c*.1761 (Roubiliac died in 1762) whereas the dedicatory inscription on the cenotaph bears the date 1764, and therefore the cenotaph may have been a late addition to the mausoleum. Richard Hayward, the mason-sculptor responsible for the cenotaph was a friend of Jennens and had previously executed a number of sculptures for Jennens's London home.[11]

The reliefs and inscriptions on the cenotaph elaborate on the themes of Holdsworth's resolve in the face of his own tribulations and more generally of the victory of Christian faith over death. Death is symbolised by the mourning Genius with reversed torch and Christian triumph over death by the foliage growing from a ruined pyramid.[12] The extremely long Latin inscriptions, probably composed by Jennens,[13] lament the previous lack of any memorial (Holdsworth had died in 1746) and extol Holdsworth's virtue in 'a degenerate age'. The bust and pyramid tomb of

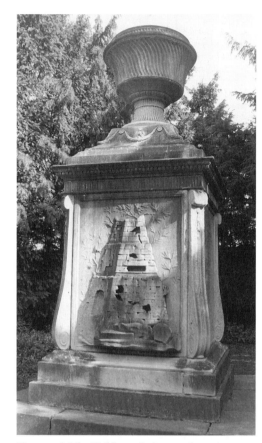

Hayward, *The Holdsworth Cenotaph*

Virgil refer to Holdsworth's fame as the leading Virgil scholar of his age: Joseph Spence had praised Holdsworth for understanding Virgil better than any man he had ever known.[14] Moreover, Holdsworth had bequeathed his papers on Virgil to Jennens.[15]

Following the collapse of the dome of the *tempietto*, the cenotaph was re-erected in the grounds on the east side of the Hall.[16] It remained at Gopsall until 1951 when it was acquired, with other items from the sale of Gopsall Hall, by Leicestershire Museums.[17]

Literature
Bindman, D. and Baker, M., 1995, p.122; Emmerson, R., 1981; *Gentleman's Magazine*, April 1791, pp.305–6; Gunnis, R., [1964] p.194; Nichols, J., vol. iv, pt ii, 1811, p.858 (and pl. opp.); Oakley, G. and Croman, L., 1996, p.75; Pevsner, N. and Williamson, E., 1992, p.269; Sewter, A.C., 1939.

Notes
[1] Nichols (*Gentleman's Magazine*, April 1791, p.305) specifically refers to the marble as being from Luna (i.e., the Latin name for Luni, Tuscany). [2] As transcribed in Nichols, J., 1811, p.858, and Emmerson, R., 1981. [3] As given in Emmerson, R., 1981. [4] Illegible parts as transcribed in Nichols, J., 1811, p.858, and Emmerson, R., 1981. [5] As given in Emmerson, R., 1981. [6] *Gentleman's Magazine*, April 1791, p.305. [7] *Ibid*. Nichols states that the bust is 'taken from the only one known of [Virgil] in the Capitol at Rome'. [8] *Ibid*. [9] Nichols, J., 1811, fig. 11 (opp. p.858). [10] Reproduced in Oakley, G. and Croman, L., 1996, p.75. [11] Gunnis, R., [1964], p.194. [12] Emmerson, R., 1981. [13] Nichols, J., in *Gentleman's Magazine*, April 1791, p.305. [14] *DNB*. [15] Goodwin, G., *DNB* entry on Charles Jennens. [16] Courtney, W.P., *DNB* entry on Edward Holdsworth. [17] Emmerson, R., 1981.

EVINGTON

The Common

In Evington Park; located in the picnic area to the left of the Information Centre:

Steps into Nature

Sculptor: Richard Janes

Sculpture in oak
h. 1.95m (6'5"); w. 1.87m (6'2"); d. 1.4m (4'7")
Unveiled: Saturday 30 September 1995, by Councillor E. Cassidy, Chair of Leicester City Council Public Arts Working Party and Planning Committees
Status: not listed
Owner / custodian: Leicester City Council

Description: Set in the centre of a tree-fringed picnic area, the sculpture is intended for children to clamber over and play on. All the shapes are roughly carved and the whole is fashioned to look like the lower part of a tree trunk. Six block-like steps lead up in a semi-circle, the last doubling as a high-backed throne with arm rests. The arm rests and back are carved to resemble giant leaves. Many of the surfaces are carved with relief representations of animals, including an owl, a caterpillar, a squirrel, a butterfly, a dragonfly and a bird in a nest.

Condition: good.

History: *Steps into Nature* was commissioned by Leicester City Council as part of Richard Janes's residency at Evington Park during summer 1995. Janes took five weeks to create the sculpture, discussing his work and incorporating ideas and suggestions from the Evington Park Users' Group, groups of children from a local play scheme, and individual passers-by.[1] Situated in a park picnic area, the piece, in the words of the sculptor, 'reflects the natural flora and fauna found in the park'[2] and was intended to be used as well as looked at: 'It is an interactive piece. It is carved on all sides and there is a different view from every angle. People who sit on it or climb into it will see aspects which are hidden to those who simply stare at it.'[3]

The sculpture was unveiled as part of a joint ceremony with Kerry Morrison's *Three Orchids* at Abbey Park, Leicester (see p.73). Following the 10.30 a.m. Abbey Park ceremony, officials and guests were conveyed by mini-bus to Evington Park for the 11.15 a.m. unveiling of *Steps into Nature*.[4]

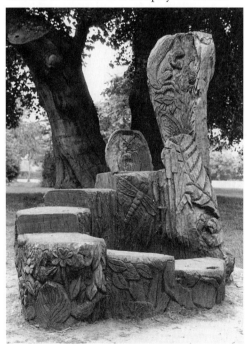

Janes, *Steps into Nature*

Literature
E. Echo, no. 115, October 1995, p.3; *L. Mercury*: – [i] 4 September 1995, p.11 [ii] 28 September 1995, p.5 [iii] 9 October 1995, p.4.

Notes
[1] *L. Mercury*: – [i] 4 September 1995, p.11 [ii] 28 September 1995, p.5. [2] *Ibid.*, 9 October 1995, p.4. [3] *Ibid.*, 4 September 1995, p.11. [4] *Ibid.*, 28 September 1995, p.5.

Uppingham Road

In Humberstone Park, near the Café:

Rose Garden[1]

Sculptor: Kerry Morrison

Sculpture in various woods, including oak, lime and sweet chestnut[2]
Carved roses ranging from h. 3.67m (12') to h. 2.43m (8')
Executed: July–August 1991
Installed: November 1991
Status: not listed
Owner / custodian: Leicester City Council

Description: Twelve giant carved wooden roses, ranging from eight to twelve feet in height. The sculptor described the sculpture during the course of its execution as follows:

> It will be six pairs of roses, each making a sort of an arch that people can walk through ... It's so that people can experience the sculpture, rather than just looking at it ... It's a site specific sculpture – the sculpture is in the site, and the site is in the sculpture.[3]

Each of the roses has been dipped in clear wood preservative.

Condition: The rose stems have splits along the grain and there is biological growth on each of them. The concrete base has started to crumble and one of the paving slabs has been removed. There is also some graffiti.

History: *Rose Garden* was commissioned by Leicester City Council's Arts Development Unit as part of its 1991 Festival of Summer Arts. Morrison was selected to carry out the commission from a number of sculptors who had responded to the Council's advertisement in *Artists Newsletter*, March 1991. Throughout the summer, on weekdays and Saturdays until 31 August, the deadline for its completion, the public was invited to watch Morrison working on her sculpture on site.

The sculptor's daily reports, held in the archives of the Council's Arts and Leisure Department, provide an interesting account of the creation of the sculpture in the park. The majority of passers-by expressed a positive interest, although there were initial problems from stone-throwing youths – as the sculptor pointed out, this was not merely annoying, but extremely hazardous as she was using a chainsaw at the time. However, the youths seemed to lose interest after a few days and the sculptor managed to enjoy the rest of the project. Morrison notes that she completed the first rose at 7 p.m. on Wednesday 24 July.

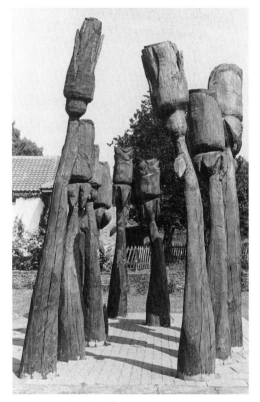

Morrison, *Rose Garden*

Literature
Leicester City Council, Arts and Leisure Dept. *Sculptor's daily reports from Humberstone Park*, 22 July – 1 August 1991.
General. Leicester City Council, *Public Art Trail*, n.d.; *L. Mercury*: – [i] 25 July 1991, p.6 [ii] 9 August 1991, p.10 [iii] 1 June 1995, p.14.

Notes
[1] *Rose Garden* is the title as given in Leicester City Council, *Public Art Trail*, n.d.; the sculpture is also sometimes referred to as *Rose Walk*. [2] *L. Mercury*, 9 August 1991, p.10. [3] *Ibid.*

NETHER HALL

New Romney Crescent

Scraptoft Valley Primary and Infants School, by T.A. Collins, E.D. Smith, and F.W.L. Collington (opened 10 March 1958)

On the west-facing elevation, overlooking the playground:

Folk Dancing

Sculptor: Peter Peri

Relief in yellow concrete
h. 3.9m (12'10"); w. 2.81m (9'3")
Signature and date carved into the brickwork at the lower right of the figures: Peri / 1956
Status: not listed
Owner: Leicester City Council

Description: Six figures modelled as discrete reliefs on the west-facing brick elevation of the school, comprising three boys and three girls dancing in a circle.

Condition: Fair, although the feet of the lowest dancers, just 140cms from the ground, have sustained damage. The left heel of the boy and the sole of the right foot of the girl have been broken off.

History: This and two other reliefs, *Jack and Jill* (formerly on an east-facing elevation; destroyed by vandals, c.1996),[1] and a relief panel

inside the school, variously entitled *Oranges and Lemons* or *Folk Dancing* (see entry below), were commissioned from Peri by the Leicestershire Education Authority in the early stages of the building of the school in late 1954. This was to be the first of many times that Peri would be commissioned to produce sculptures for school buildings in Leicestershire.

Sandra Kenny plausibly suggests that it was the display of Peri's concrete sculptures at the Architectural Association's 'Sculpture in relation to Architecture' exhibition in London earlier that year that had provided Stewart Mason, Leicestershire's then Director of Education, with the immediate stimulus to contact Peri, but that he was certainly aware of Peri's projecting mural group, *Sunbathers*, commissioned for the Festival of Britain in 1951 (he refers to it in his initial letter to the sculptor) and might also have been aware of his free-standing *Old King Cole* and *Boy and Pig* (1946) at Field End Primary School, Eastcote, Middlesex, and his *Footballers* (1949) relief on a block of flats in south Lambeth.[2]

Peri had taken up modelling in concrete for several reasons. Firstly, it was an affordable and (as it was believed at the time) durable alternative to bronze, the medium Peri had favoured in his former home in Berlin. Peri had never been financially secure, but he had managed to get his casting done cheaply in Berlin. In 1933, however, the Nazis came to power in Germany and so Peri, a Jewish Communist, had to flee to England. With his foundry contacts lost, he sought an affordable alternative medium. Concrete was not only relatively cheap, it also had the added advantages of being ideal for architectural sculpture – a category of work completely in harmony with Peri's commitment to art for the people – and, with its rugged texture, suited his direct, realistic style.[3] In 1951, Peri wrote of his work in concrete:

The sculpture which gets stone hard during the process of modelling retains the freshness of conception and is a unique work as a carving.

… figures can be built up in the open air. There is no limitation in the size possible, large or small, figures of less than twelve inches can be modelled by using different aggregates. The proportion of cement, sand and aggregate mixture differs according to the sculpture, whether it is for indoors or the open air, on its size and on the finish which is intended …

There is no time limit to the work on a sculpture, it can be done in a day or worked on for a year. The difference is only that what can be done in minutes in the first week, takes many hours a month later.[4]

Mason arranged to borrow a cement relief panel from the sculptor and returned with it to Leicester to discuss with his architect, T.A. Collins, whether Peri's work might be suitable. On 8 October Mason wrote to Peri offering him the chance of working definitely on two schools then being built – the present one and Scraptoft South Infants School (now Willowbrook Primary School, see pp.326–7) – and possibly on Oadby Primary School (now Langmoor County Primary School, see pp.253–4). As the pieces were going to be site-specific, Mason invited Peri to come up to Leicester to familiarise himself with the school layout.[5]

It was agreed that Peri would receive £150 for his relief, the price to include material costs as well as his fee.[6] The six figures that make up *Folk Dancing* were modelled directly on the wall, the wet concrete being first applied with a small trowel and the finer details afterwards carved into the surface.[7] The themes chosen by Mason, children dancing and nursery rhyme characters, were to be typical of the types he consistently requested for primary schools (see

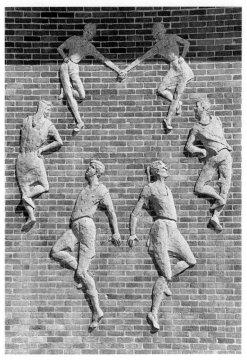

Peri, *Folk Dancing*

pp.253–4), with allegorical or symbolic figures reserved for secondary schools and colleges (see pp.11, 211–12, 308–9).

Related work: *maquette*, h. 94cm (3'1"); w. 72cm (2'4"); d. 4cm (2"); in the collection of the Peri Estate (cat. no. M3).

Literature
The Centre for the Study of Sculpture, Leeds.
Kenny, S., 1980, pp.27, 30–31, 33, 35.
General. Camden Arts Centre, 1987, pp.23, 25–26, 30, 44; Leicestershire Museum and Art Gallery, 1991, p.16; The Minories, 1970, n. pag; Pevsner, N., 1960, p.223.

Notes
[1] Information from the school premises officer, 12 July 1999. [2] Kenny, S., 1980, p.32. [3] Camden Arts Centre, 1987, p.23. [4] Peter Peri, unpublished Mss,

1951, as quoted in Camden Arts Centre, 1987, pp.25–6. [5] Kenny, S., 1980, pp.30–1. [6] *Ibid.*, pp.33, 35. [7] Camden Arts Centre, 1987, pp.25, 30.

Inside the school building:
Folk Dancing ('Oranges and Lemons')
Sculptor: Peter Peri

Relief panel in polychrome concrete
h. 75cm (2'6"); w. 75cm (2'6")
Executed: 1956
Status: not listed
Owner: Leicester City Council

Description: A relief set into a shallow recess in the infants' main foyer and library. This is a variation on the much larger outside relief (see above), but with eight children executing the 'threading the needle' move from an English country dance. The figures are in green and the background, a mosaic-like pattern of orange and terracotta.

Condition: Good, although some small specks of white paint have been accidentally splashed onto the surface by decorators at some time.

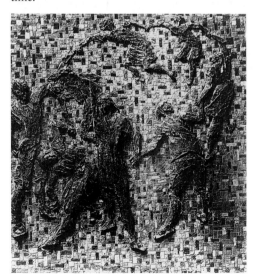

Peri, *Folk Dancing ('Oranges and Lemons')*

NORTH EVINGTON

Bridge Road

In Memorial Gardens:
Bridge Road School War Memorial
Designer: George Mawbey

Memorial in limestone, painted, with relief panel in bronze and name tablets in slate
Memorial: h. 3.25m (10'8"); w. 1.22 m (4'); d. 42cm (1'5")
– relief panel: h. 55cm (1'10"); w. 94cm (3'1")
Inscriptions on the front face of the memorial:
– above the name tablets, either side of a raised block, in relief: 1914 1919
– below this, in relief: IN GLORIOUS MEMORY / OF OLD BOYS OF / BRIDGE ROAD SCHOOL / WHO DIED IN THE / GREAT WAR
[below which are two slate tablets recording the names of the 133 old boys who died in the First World War. Each panel has two columns and the names are listed, forename initials only followed by surnames in alphabetical order – plus six extra names added to the top and bottom of the lefthand tablet. Below the name tablets, incised into the stonework of the upper tier of the plinth:]
At the going down of the Sun and in the morning / We will remember them
Unveiled: Saturday 4 September 1920, by Colonel Sir Charles E. Yate, MP for the Melton Division.
Status: not listed
Owner / custodian: Leicester City Council

Description: The memorial takes the form of an upright, slightly battered, part-painted slab mounted on a two-tiered plinth and base in limestone. Towards the top of the front face (facing Bridge Road) is a panel with a low-relief

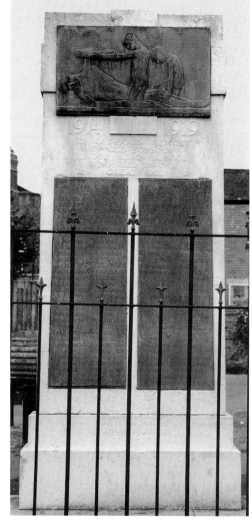

Mawbey, *Bridge Road School War Memorial*

design showing three naked boys, one lying prone on the ground, the other two kneeling. One of the latter holds a laurel wreath over the recumbent figure. Below this are dedicatory inscriptions and two long name tablets.

Condition: Fair. There is some cracking to the slate tablets and the memorial slab itself, and some spalling, especially on the upper inscription. There is some minor graffiti.

History: On the evening of Monday 17 February 1919, the Bridge Road School Old Boys' Association met and unanimously agreed to apply to the Education Committee for approval to erect a memorial to those old boys of the school who had been killed in the Great War.[1] Within a few months, a design by an old boy, George Mawbey, had been selected and a drawing of it published in the *Illustrated Leicester Chronicle*.[2] The memorial was funded by voluntary subscriptions from teachers and students, both past and present.[3]

Literature
L. Advertiser, 11 September 1920, p.8; *L. Chronicle*:– [i] 22 February 1919, p.11 [ii] 19 July 1919, p.11 [iii] 11 September 1920, pp.2, 8–9, **8, 9**; *L. Daily Post*, 6 September 1920, p.1; *L. Mail*, 6 September 1920, p.4; *L. Mercury*, 6 September 1920, p.3; *M.M. Times*, 10 September 1920, p.6; Sharpe, J.M., 1992, pp.37–8, 39–40, fig. **3.3**.

Notes
[1] *L. Chronicle*, 22 February 1919, p.11. [2] *Ibid.*, 19 July 1919, p.11. The caption says the old boy's name is George Noble, a name which the newspaper repeats in its report towards the end of the following year of the unveiling and dedication ceremony (11 September 1920, p.2). All other newspapers, however, refer to him as George Mawbey. [3] *L. Daily Post*, 6 September 1920, p.1.

LOUGHBOROUGH
Civic Parish: Loughborough
Borough Council: Charnwood

Ashby Road

On the south side of Ashby Road, on the grass verge east of the Rutherford Gates entrance to Loughborough University halls of residence:

The Athletes
Sculptor: Julie Doherty

Group in steel
Dimensions (excluding concrete plinths):
Figure 1st left: h. 1.22m (4'); w. 1.02m (3'4"); d. 1.77m (5'10")
Figure 2nd left: h. 2.01m (6'7"); w. 1.02m (3'4"); d. 1.1m (3'7")
Middle figure: h. 2.02m (6'8"); w. 70cm (2'4"); d. 1m (3'3")
Figure 2nd right: h. 2.14m (7'); w. 81cm (2'8"); d. 1.65m (5'5")
Figure 1st right: h. 2.08m (6'10"); w. 89cm (2'11"); d. 1m (3'3")
Inscription on a metal plaque fixed to the steel base plate of the figure on the extreme right:
THE ATHLETES / *1997* / *by;* [sic] *Julie Doherty* / ON LOAN TO THE BOROUGH OF CHARNWOOD / UNDER THE PUBLIC ART PARTNERSHIP / WITH LOUGHBOROUGH / COLLEGE OF ART AND DESIGN.

Unveiled: October 1997, by Councillor June Tyrell, Mayor of Charnwood
Status: not listed
Owner / custodian: Charnwood Borough Council

Description: Five figures made from steel plates, some smooth, some with treads. The left-hand figure crouches, as at the start of the race; the second from the left runs, leaning back, with head back and arms at his sides; the middle figure is in full stride; the figure second from the right has his right arm raised as if finishing the race; and the right-hand figure leans forward as if breasting the finishing tape.

Condition: Good.

History: *The Athletes* was Julie Doherty's Degree Show submission at Loughborough College of Art and Design in June 1997. The group was seen and admired by a representative from Charnwood Borough Council and selected for erection in Loughborough. An

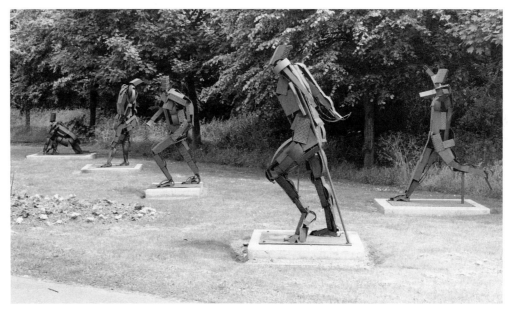

Doherty, *The Athletes*

agreement was struck with the sculptor that the group would initially be acquired on loan, set up in a public place and, if well-received by local people, would then be purchased. Public reaction having been favourable, *The Athletes* was purchased in 1998 for £5,000 as part of Charnwood Borough Council's 'Public Art Initiative' strategy.

Doherty said that she had chosen 'the theme of the athletes after watching the [1996] Olympics'.[1] Councillor Jill Vincent, then Chair of the Charnwood Arts Sub-Committee explained the reason for the Council's selection of *The Athletes* for Loughborough:

> The Athletes was particularly appropriate to Loughborough because it links its sports tradition [the University prides itself in its sporting achievements] with its artistic life [centred on its flourishing art college], both of which justify much celebration.[2]

Literature
Charnwood Borough Council. *Charnwood Borough Council's Public Art Initiative*, strategy document, n.d.; Press cuttings – *L. Mercury*: – [i] 20 January 1998 [ii] [?]January 1998 [article entitled 'On the statue trail ...']; *Lo. Echo*, 31 October 1997.
General. Loughborough College of Art and Design, 1997, p.10, 10.

Notes
[1] Charnwood Borough Council archives. Press cutting – *Lo. Echo*, 31 October 1997. [2] *Ibid.*

Bridge Street

Limehurst High School (access only by prior arrangement)

In a courtyard:
Untitled
Sculptor: William Tucker

Sculpture in galvanised steel
h. 36.5cm (1'2"); w. 1.5m (4'11"); d. 2.59m (8'8")
Executed: 1974

Tucker, *Untitled*

Exhibited: 1980, London, Whitechapel Art Gallery (no. 83)
Status: not listed
Owner: Leicestershire Education Authority

Condition: Fair.
History: *Untitled* was purchased by the Leicestershire Education Authority, with assistance from the Arts Council of Great Britain, in 1974. The work was, until September 1985, located in Brookvale High School, Groby, after which date it was transferred to the present location.[1]

Literature
Arts Council of Great Britain, 1980, p.32.

Note
[1] LEA inventory.

Epinal Way

Mountfields House (East Midlands Arts offices)

Ornamental Gates and Fencing
Designer: Christopher Campbell

Gates in galvanised steel, painted grey-green with inset brass ornaments
Officially opened: Friday 3 April 1998, by

Andy Reed, MP
Status: not listed
Owner: East Midlands Arts

Condition: Good.
History: When East Midlands Arts (EMA) decided to erect some gates and fencing across the entrance to the car park in front of its Loughborough headquarters, Janet Currie suggested that, in keeping with EMA's advice to others, the work should be designed by an artist. She had seen some ornamental work of this nature by sculptor Chris Campbell and so wrote to him inviting him to send in some slides of his work to show her colleagues. This was followed up with a meeting to discuss methods and budgets. Both Campbell and EMA were keen to have local involvement and so EMA approached Mountfields Lodge County Primary School next door. Campbell suggested bringing in a couple of other artists, Usha Mahenthiralingham, whose interests include textiles, drawing and dance, and Charlie Downes, a printmaker. Mahenthiralingham and Downes organised sessions with the pupils, explaining the gates project to them and getting them to think of the kinds of ways fences might be made and how they might be decorated: Mahenthiralingham organised dance and movement sessions exploring these themes and Downes got the pupils to make prints of animals and plants. Campbell discussed the results with his collaborators, and in December 1997, once the work was under way, invited four of the pupils, representative of the years taught at the school, to visit him in his studio. The ideas the children explored in their dance and movement sessions and the prints they made in their classes were used by Campbell as inspiration for the final design with its swaying tree-like uprights, and ornamental branches and leaves. Some of the prints of insects and other small animals created by the children were cast in brass and incorporated into the structure.

EMA, realising the importance of involving not only the local schoolchildren but also its neighbours in the nearby houses, issued invitations to an open evening at its headquarters. At the official opening of the gates on 3 April 1998 all the children were invited to festoon them with special card messages on the theme of 'Opening the gates for the future'.

As EMA explained in its Annual Report for 1997/98:

The gates project fitted in well with East Midlands Arts' own public art policy, which encourages local authorities and other public and private sector organisations to commission artists to come up with more interesting designs that will enhance the local environment and can be enjoyed by everybody.[1]

Related work: Christopher Campbell also designed and executed gates and fencing for Carr Bank Sculpture Park, Mansfield.

Literature
Lo. Echo, 10 April 1998, p.3.

Note
[1] East Midlands Arts, *Annual Report 1997/8*, p.20.

Loughborough University School of Art and Design (access only by prior arrangement)

Originally the school of industrial and fine art within Loughborough College (the precursor to Loughborough University), the school went independent in 1967 under the name Loughborough College of Art and Design. It was incorporated into Loughborough University in 1998.

On the wall to the right of the main entrance to Reception:
Relief
Sculptor: David Tarver

Relief in cast aluminium
h. 2.13m (7'); w. 4.27m (14')
Executed: 1968
Status: not listed
Owner: Loughborough University School of Art and Design

Condition: Good.
History: Tarver was Head of Sculpture at the then Loughborough College of Art and Design from 1957–89. The relief forms, which suggest the influence of Brancusi (see also Tarver's *Swan Sculpture* in Queen's Park, p.219), are organised according to the Golden Section.[1]

Note
[1] Information from the sculptor.

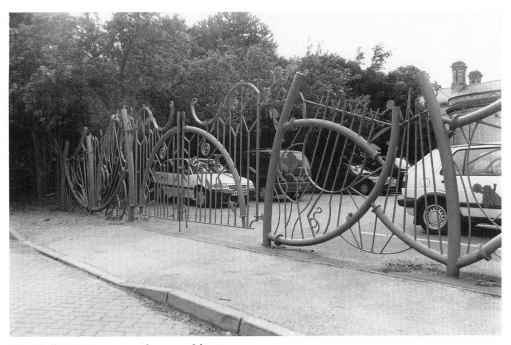

Campbell, *EMA Ornamental gates and fencing*

Tarver, *entrance relief*

On the lawn of the quadrangle behind the main building:

Rainbow Pyramid

Sculptor: John Jackson

Sculpture in wood, steel and concrete
h. 2.55m (8'6")[1]
Executed: 1978
Status: not listed
Owner: Loughborough University School of Art and Design

Description (by the sculptor):

It could be described as a combination of construction and assemblage, the odd rods and planks leaning against the quadrangle wall being part of the whole conception. 'Rainbow' was suggested by the idea of a form rising – as rainbows appear to do – from the ground as if half-buried there.[2]

Condition: Very poor; partly demolished. The quadrangle wall and its rods and planks have disappeared leaving only the 'half-buried' form.

History: *Rainbow Pyramid* was purchased by the Leicestershire Education Authority in 1979 for siting outside Loughborough College of Art and Design library. Ownership was transferred to the College when the latter was granted independent status in 1988. The work was vandalised some time before April 1989.[3]

Literature
Strachan, W.J., 1984, p.152, *152*.

Notes
[1] Original dimensions as given in Strachan, W.J., 1984, p.152. [2] As quoted in *Ibid*. [3] LEA inventory.

Forest Road

In front of Forest Court (Loughborough University student accommodation):

Silver Nut

Sculptor: Friederich Werthmann

Sculpture in welded stainless steel on a concrete base
Sculpture: h. 1.4m (4'7"); w. 1.51m (5'); d. 44cm (1'5")
Base: h. 12.5cm (5"); w. 95.5cm (3'2"); d. 95.5cm (3'2")
Executed: 1964
Exhibited: 1964, London, Hamilton Galleries
Status: not listed
Owner: Loughborough University

Condition: Good.
History: *Silver Nut* was purchased by the

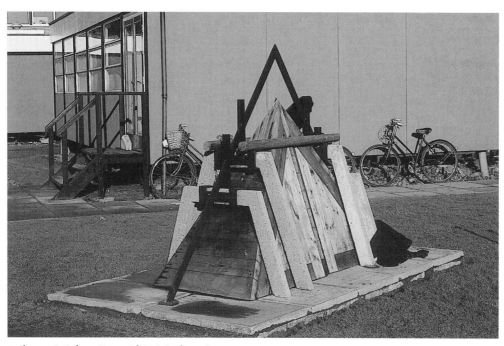

Jackson, *Rainbow Pyramid (original state)*

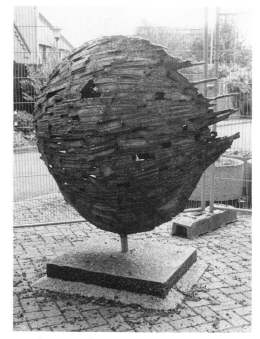

Werthmann, *Silver Nut*

Leicestershire Education Authority in 1965 for £450.[1] Ownership was transferred to Loughborough University following the latter's achievement of independent status in 1966.

Literature
Cantor, L., 1996, p.41; Hamilton Galleries, 1964.

Note
[1] LEA inventory.

Granby Street

On a raised forecourt to the right of the entrance to the Central Library:

The Pinau Statue

Copy after the *Spinario*, an antique Graeco-Roman statue at the Musei Capitolini (Palazzo dei Conservatori), Rome
Statue in bronze on a pedestal in Clipsham stone
Statue: h. 72.5cm (2'5"); w. 47cm (1'7"); d. 60cm (2')
Base of statue: h. 8cm (3"); w. 33.5cm (1'1"); d. 61cm (2')
Pedestal: h. 1.18m (3'11"); w. 59cm (1'11"); d. 89.5cm (2'11")
Inscriptions:
– inscribed into the front face of the pedestal the letters 'E' and 'L' entwined in a circle over the date '1957'
– on a metal plaque on the left-hand face of the pedestal: PINAU / THE BOY WITH THE THORN / HAS STOOD IN THE OLD TOWN OF EPINAL SINCE / THE XVTH CENTURY. SUFFERING MANY VICISSITUDES / AND WITNESS OF MANY WARS, THE STATUE AND ITS / SUCCESSIVE REPLICAS SYMBOLISE THE TOWN'S NAME / IN THE MINDS OF ITS INHABITANTS. / THEIR CHIEF CITIZEN, / CONSEILLER C. GUTHMILLER, / PRESENTED THIS REPLICA TO LOUGHBOROUGH TO / COMMEMORATE THE TWINNING OF THE TWO TOWNS. / THE ORIGINAL ANCIENT STATUE STANDS IN / THE CAPITOL MUSEUM IN ROME.
– on a metal plaque on the right-hand face of

the pedestal, consisting of a line-for-line English / French dual text. On the left-hand half of the plaque: EPINAL / À SA VILLE-SOEUR / TEMOIGNAGE / D'AMITIÉ On the right-hand half: *FROM* EPINAL / TO HER SISTER TOWN / A WITNESS OF / FRIENDSHIP Centred beneath the two texts: 19TH MAY 1957
Unveiled: Sunday 19 May 1957 by Conseiller C. Guthmiller, Mayor of Epinal
Restored statue replaced on its pedestal: Friday 10 February 1984
Status: not listed
Owner / custodian: Charnwood Borough Council

Description: A bronze statue of a nude boy, seated, pulling a thorn from the sole of his left foot. The statue is mounted on a stone pedestal bearing the inscriptions.
Condition: Generally good, although the patination is worn in places.
History: The *Pinau Statue*, Loughborough's first publicly-sited statue, was presented to the town by the citizens of Epinal, in France, to symbolise the twinning of the two towns in June 1956. The gift had been approved by the Epinal town council on 8 October 1956 and is a replica of Epinal's own copy of the celebrated *Spinario* in Rome. It would appear from the minutes of Loughborough's twinning committee that the gift had taken Loughborough unawares. Epinal quite reasonably had expected a reciprocal present – they had evidently suggested a bell for their new town hall – a contingency for which Loughborough had made no provision. The committee decided it would have to wait until after the presentation of the *Pinau* and then, as the Council had no legal right to spend public money on such a gift, launch an appeal inviting those who were interested in the scheme to make voluntary donations.[1]
By 14 January 1957 Loughborough Town Council had decided that the most appropriate

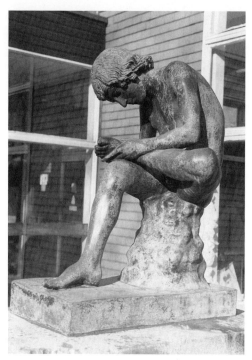

The Pinau Statue

site for the *Pinau* would be the garden at Island House, Granby Street.[2] Here it remained until the mid-1960s when the library extension was built on the site and the *Pinau* was set up on the library forecourt.[3]
In the early hours of Tuesday 23 December 1980, a female student witnessed two men in their twenties remove the statue from its pedestal, bundle it into the back of a car and drive off with it. The ease with which the thieves removed it is explained by the remarkable fact that '[the statue] was only secured [to the pedestal] by its own weight and some mortar'.[4] The theft was both a shock and a major embarrassment to Loughborough Council. Just over two years later, in February 1983 – by which time the Council had

presumably given up all hope of recovering its statue – it was discovered lying in the mud beside the River Ouse at Asselby near Goole, Yorkshire, by a woman out walking her dog. The statue had been severely damaged: it had saw marks on the back of its neck and on its big toe, chisel marks around its genitals, and its right arm was missing. The woman retrieved it and, not realising its provenance, took it to a local valuer. Whilst it was with the valuer, a local newspaper, the *Howdenshire Gazette*, heard about it and published a front page picture story of the woman's discovery.

It was purely by chance that the statue found its way back to Loughborough. A young man, living in Goole and visiting his parents in Loughborough, just happened to bring that particular copy of the newspaper with him. Although he had not realised the significance of the article, his father did and informed Charnwood Borough Council who dispatched their solicitor to retrieve the lost statue.[5] The solicitor convinced the Humberside police of Charnwood's ownership by taking with him a photograph of the statue itself and a tracing of the shape left by its base on Loughborough's vacant pedestal. He then arranged with the police to have the statue lowered on to the tracing where the exact match corroborated Loughborough's claim. Following its return to Loughborough, the Council contacted Loughborough College of Art and Design's then Head of Sculpture, David Tarver, to ask him whether he could restore it.[6]

Tarver confirmed that he could, and travelled to London to make sketches of another copy of the *Spinario* at the British Museum. Working from his sketches and from photographs, he then modelled replicas of the missing right arm and left shoulder and back in clay. From his clay models he then made plaster casts which he sent to Morris Singer, the bronze founders, who cast the replacement parts and welded them to the statue. The more superficial

damage was repaired using Argon arc welding equipment and the whole statue repatinated in the same green as before. Finally the *Pinau* was replaced (more securely) on its pedestal in front of the library.[7]

The *Spinario*, one of the most celebrated statues to have survived from classical antiquity, was first recorded outside the Lateran Palace in Rome between 1165 and 1167. It is thought to have been transferred to the Palazzo dei Conservatori some time after 1471 and remains there to this day. It, with the bronze equestrian statue of *Marcus Aurelius*, was one of the earliest antique statues to be copied. It appeared in a variety of sizes and for a variety of purposes, including fountain centre-pieces and ink-well ornaments; full-size casts were widely taken from the original as royal gifts.[8] The *Spinario* was sufficiently revered in Italy during the early Renaissance for Brunelleschi to incorporate a figure clearly based on it into his panel for the Florentine Baptistery doors competition in 1401–2, knowing that the *cognoscenti* would recognise his reference to classical antiquity and applaud his learning.

Related works: 1. Epinal has two copies: (i) the seventeeth-century bronze which, following bomb damage in the Second World War, was rehoused in Epinal's town hall, and (ii) a new cast which was subsequently set up outside the town hall;[9] 2. At some date after the presentation to Loughborough, Epinal presented a further replica to the German town of Schwäbisch Hall with which both it and Loughborough are also twinned.[10]

Literature
Loughborough Library. Minutes of the General Committee of the Loughborough-Epinal Organization, 26 November 1956 – 5 November 1958.
General. Darke, J., 1991, pp.178–9; Haskell, F. and Penny, N., 1981, pp.308, 309; *Lo. & C. Trader*, 8 February 1984, p.5, 5; *L. & R. Topic*, June 1971, pp.5, 7, 7; *L. Mercury*: – [i] 21 February 1983, p.1 [ii] 24

February 1983, p.5; *Lo. Echo*: – [i] 10 April 1981, p.14 [ii] 25 February 1983, p.1, 1 [iii] 10 February 1984, p.25, 25; *Lo. News*: – [i] 31 December 1980, pp.1, 11, 1 [ii] 23 February 1983, p.1, 1 [iii] 16 March 1983, pp.2, 3; *The Municipal Borough of Loughborough ...*, n.d., pp.36, 37.

Notes
[1] Minutes of the General Committee of the Loughborough-Epinal Organization, meeting of 26 November 1956. The bell, made in John Taylor & Co.'s Loughborough foundry, was presented to the French town in June 1958 (*Ibid.*, Honorary Secretary's Annual Report ... November 5th 1958). [2] *Ibid.*, meeting of 14 January 1957. [3] *Lo. News*, 31 December 1980, p.1. [4] *Ibid.* [5] *Ibid.*, 23 February 1983, p.1. [6] *L. Mercury*, 24 February 1983, p.5. [7] *Lo. and C. Trader*, 8 February 1984, p.5; *Lo. Echo*, 10 February 1984, p.25. [8] Haskell, F. and Penny, N., 1981, p.308. [9] *Lo. News*, 16 March 1983, p.3. The *Lo. News* (23 February 1983, p.1) gives the date of erection of Epinal's first copy as 1604. [10] *Ibid.*, 31 December 1980, p.1.

High Street

Lloyds Bank, No. 37 High Street, c.1900, at the corner with Market Place

The skyline is decorated with an:

Allegorical seated female figure
Sculptor: unknown

Sculpture in terracotta
Status: not listed
Owner: Building in private ownership

Description: The frontage takes the street corner in a curve, originally (before extensions along High Street and Market Place) consisting of a central entrance bay (now just a window bay, a new entrance having been opened up at the far end of the High Street extension) and two bays to each side. The entrance bay is emphasised on the first floor by a large round-headed window framed by blocked columns and on the skyline by an enthroned allegorical female figure. In her left hand she holds a money-bag and in her right a rolled-up deed or

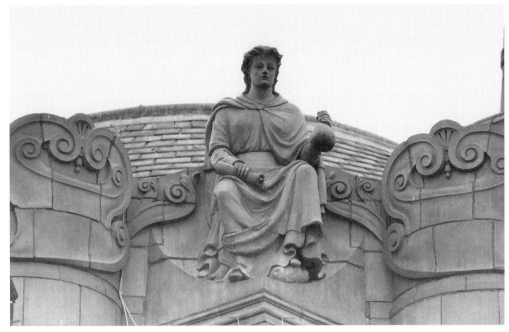

Lloyds Bank: architectural sculpture

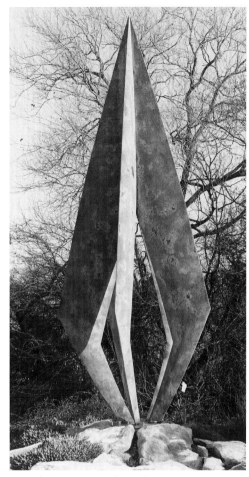

N. and A. Lawson-Baker, *Flame*

bond. To either side, over the flanking bays, the parapet is decorated with fabulous fishes.

Condition: Good.

Holywell Way, off Ashby Road

On the left side of the approach road (Holywell Way) to the Gas Research and Technology Centre:

Flame

Sculptors: Neil and Auriol Lawson-Baker

Sculpture in bronze on a steel armature
h. (est.) 6.7m (22')
Erected: early 1993
Status: not listed
Owner: BG Technology

Description: '[The sculpture] is a 20ft high symbolic sculpture of a flame, constructed from five aerofoil sections, representing the five continents. It is fabricated in patinated bronze with an integral armature in stainless steel.'[1]

Condition: Good.

History: *Flame* was commissioned in 1990 from sculptors Neil and Auriol Lawson-Baker by the then Chairman and Chief Executive of British Gas, Robert Evans. Two casts were made, one for Loughborough and the other for BG plc's headquarters building at Thames Valley Park in Reading. The site for the Loughborough *Flame* was selected on the advice of Leonard Manasseh, the site architect, and was originally intended to be accompanied by five or six other pieces. Ultimately only this and *Double Movement* (see below) were erected.[2]

Related work: another cast is at BG plc's headquarters, Thames Valley Park, Reading, erected late 1992.

Literature
L. Mercury (Loughborough edn), 11 September 1992, p.5.

Notes
[1] Description and explanation supplied by Alan Carr of BG Technology, 30 June 1999. [2] *Ibid.*

By the footpath between the Reception Building and the Holywell Building of the Gas Research and Technology Centre:

Double Movement
Sculptor: Michael Gillespie

Sculpture in bronze with a stone base on a brick pedestal with a slate cornice
Sculpture: h. 80cm (2'8"); w. 1.95m (6'5"); d. 42cm (1'5")
Pedestal (including stone base): h. 1.52m (5')
Erected: Friday 3 December 1993
Status: not listed
Owner: BG Technology

Condition: Good.
History: Gillespie first conceived the idea for *Double Movement* in 1987. For his original version he used an experimental technique employing wire with directly-applied cement and resin, which unfortunately failed to stand up to the years during which it was kept

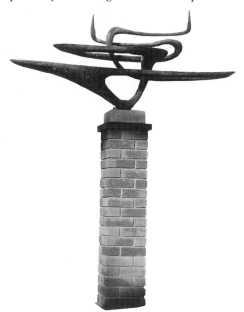

Gillespie, *Double Movement*

outdoors in his garden at Cambridge. In April 1993, Gillespie restored the sculpture for an exhibition at Churchill College. Here it was seen and admired by Leonard Manasseh, the architect responsible for the external design of the Gas Research and Technology Centre at Loughborough. Manasseh had the sculpture cast in bronze and erected in its present location. Gillespie was evidently well satisfied with the chosen site and also with the brick column on which the architect had had the sculpture mounted.[1]

Note
[1] Information supplied by Alan Carr, BG Technology, 23 June 1999.

Loughborough University Precincts

Loughborough University's origins lie in the Loughborough Technical Institute, founded in 1909. During the directorship (1915–50) of Dr Herbert Schofield, this became Loughborough College. Schofield initiated a number of departments which, after his retirement, became independent institutions under a single board of governors. These were the teacher training and physical education departments (retitled the College of Education); the further education department (retitled, in 1966, Loughborough Technical College); and the school of industrial and fine art (retitled, in 1967, Loughborough College of Art and Design). Following the split, the core of the original college was designated Loughborough College of Technology. In 1957 it became the College of Advanced Technology and in 1966 was granted university status.[1] In 1978, the College of Education was reintegrated into the University and finally, in 1998, the art college was reintegrated as Loughborough University School of Art and Design.

The nucleus of the University's sculpture collection was acquired in the 1950s and early 1960s by the Leicestershire Education Authority when Loughborough College of

Advanced Technology and Loughborough College of Education were still under its control. Stewart Mason, the initiator of this programme of acquiring original works of contemporary art for Leicestershire's schools and colleges was, in addition to being Director of Education for Leicestershire, also a member of the governing body of the College of Advanced Technology (and later a member of the University Council).[2]

The following catalogue of sculptures conforms to the sequence established by Loughborough University's 1999 *Campus Sculpture Trail* (see also campus map on p.x).

Notes
[1] Cantor, L., 1996, p.7; Pevsner, N. and Williamson, E., 1992, p.285. [2] Cantor, L., 1996, pp.8–9, 12.

Outside the Physical Education Centre:
UK Swatch Olympic Art Clock
Designer: Ron Arad

Sculpture in stainless steel
h. (est.) 7m (23')
Executed: 1996
Installed: December 1997
Status: not listed
Owner: University of Loughborough

Condition: Good.
History: The *UK Swatch Olympic Art Clock* was donated to Loughborough University by the Swatch watch company. It was one of twelve 'art clock towers' commissioned by the company to celebrate the 1996 centennial Olympic games at Atlanta. Designers of other clock towers included Alessandro Mellini from Italy, Javier Mariscal from Spain, and Jean-Charles Castelbajac from France.

Ron Arad's clock tower stood for the duration of the Atlanta games in front of the Royal Festival Hall, London. Following the games, Swatch wanted to relocate the clock tower permanently to a site associated with sporting endeavour, and chose Loughborough

University because of what it considered to be the excellence of its Department of Physical Education, Sports Science and Recreation Management.[1]

Literature
Loughborough University News, 17 February 1998, p.7.

Note
[1] Fletcher, A.K. and Long, K., 1999; *Loughborough University News*, 17 February 1998, p.7.

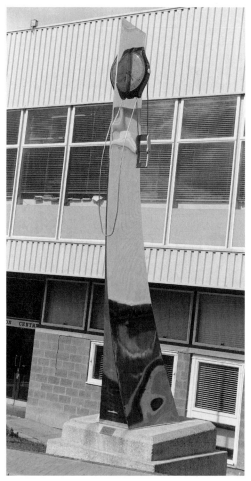

Arad, *Olympic Art Clock*

Outside Martin Hall, facing Epinal Way:
The Spirit of Adventure
Sculptor: Willi Soukop

Sculpture in concrete
Sculpture: h. 1.18m (3'11"); w. 1.64m (5'5"); d. 74cm (2'5")
Plinth: h. 32cm (1'1"); w. 86cm (2'10"); d. 61cm (2')
Inscription on a metal plaque on the west (short) face of the plinth:
THE SPIRIT / OF ADVENTURE / BY W. SOUKOP / PROPERTY OF LOUGHBOROUGH TRAINING COLLEGE
Executed: 1958
Exhibited: 1958, London, Royal Academy of Arts (no. 1414)
Status: not listed
Owner: Loughborough University

 Condition: Good.
 History: *The Spirit of Adventure* was purchased by the Leicestershire Education Authority for £225 in 1958.[1]

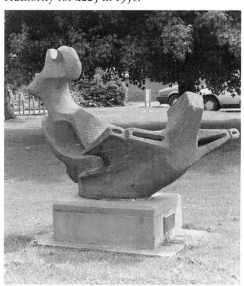

Soukop, *The Spirit of Adventure*

Literature
Cantor, L., 1996, pp.12, 41; Fletcher, A.K. and Long, K., 1999; Levy, M., 1963, p.94.

Note
[1] LEA inventory.

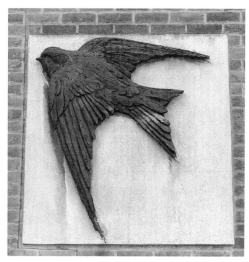

Soukop, *House Martin*

On the exterior wall of Martin Hall, to the right of the main entrance:
Relief of a House Martin
Sculptor: Willi Soukop

Relief in concrete
h. 1.27m (4'2"); w. 1.27m (4'2"); max. d. 12cm (5")
Executed: 1950s
Status of building: not listed
Owner: Loughborough University

 Condition: There is a small area of rather crude repaint on the tail feathers and a loss of about 12cms to the tip of the lower wing.

Literature
Jones, D.K., 1988, p.105.

In the vicinity of the Department of Design and Technology building:

Abstract

Sculptor: Bernard Schottlander

Sculpture in steel, painted, on a concrete base
Each cylindrical element: h. 2.27m (7'5"); dia. 90cm (3')
Executed: *c.*1971
Status: not listed
Owner: Loughborough University

Description: A group of three steel cylinders, painted rose-pink, each leaning at a different angle and fixed to the concrete surface beneath it with four bolts. Although the cylinders appear solid when approached from the north, they are in fact hollow – the south-facing aspects having full-length openings of *c.*30cm width. As the viewer moves around the group, the interiors – one yellow, one green, and one blue (taking an anti-clockwise direction) – are revealed.

Condition: Although the cylinders appear to be structurally sound, the exterior surfaces are scuffed and scratched. In areas of paint loss rust has formed and there is a significant amount of rust around the top edges of the cylinders. Pieces of 'blu-tack' remain where posters were formerly affixed.

History: Schottlander's *Abstract* was purchased by the Leicestershire Education Authority for £375 in 1971 with funds derived from the buildings capital scheme.[1] Although not stated in the LEA inventory, the sculpture must have been purchased for what was then the College of Education (not integrated into the University until 1978), a likelihood supported by the fact that it was purchased with buildings capital funding, which could quite possibly have been generated by the 1969 extension of the nearby Bridgeman Centre (part of the former College of Education).

Literature
Cantor, L., 1996, pp.41, **23**; Fletcher, A.K. and Long, K., 1999.

Note
[1] LEA inventory.

In the foyer of Design and Technology (The Bridgeman Centre; access only by prior arrangement):

Brahman[1]

Sculptor: David Partridge

Relief with wood, nails, and copper and gold paint
h. 1.14m (3'9"); w. 2.05m (6'9")
Status: not listed
Owner: Loughborough University

Condition: Fair – none of the nails are missing, but the wooden support is slightly battered at the edges.

History: *Brahman* was purchased by the Leicestershire Education Authority for £150 in 1969.[2] The purchase was in all likelihood made for the College of Education (of which the Bridgeman Centre was a part), which was not integrated into the University until 1978. Following integration, the LEA would have transferred ownership of the sculpture to

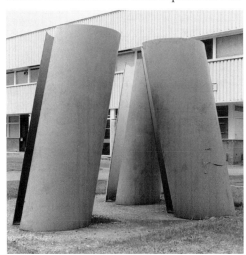

Schottlander, *Abstract*

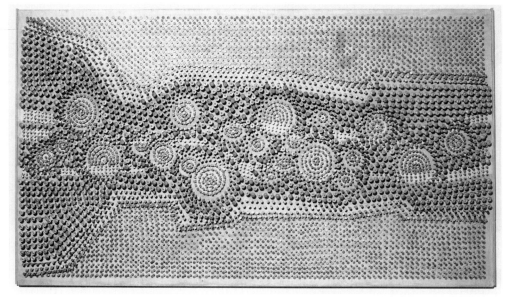

Partridge, *Brahman*

Loughborough University.

For an appreciation of Partridge's nail sculptures by a contemporary art critic, see pp.167–8.

Notes
[1] The LEA inventory gives this title as 'Bramham' – as this word is not known to the present author he assumes this to be a misprint of Brahman. [2] *Ibid.*

Outside the Towers (formerly College of Education Buildings):[1]
Battersea I
Sculptor: Geoffrey Clarke

Sculpture in sandcast pure aluminium
h. 1.06m (3'6"); w. 3.38m (11'1"); d. 78.5cm (2'7")
Executed: 1962
Exhibited: (i) as part of the three-piece *Battersea Group*: 1963, London, Battersea Park (no. 12);[2] (ii) as an independent piece: 1965, London, Redfern Gallery (no. 1);[3] 1967–8, London, Whitechapel Art Gallery (no. 15)
Status: not listed
Owner: Leicestershire Education Authority

Condition: Good.
History: *Battersea I* was purchased by the Leicestershire Education Authority in 1965.[4] It is one of a group of three sculptures collectively titled *Battersea Group* from their first showing at the 1963 'Sculpture in the Open Air exhibition' at Battersea Park, London. G.S. Whittet aptly described *Battersea Group* as a group of

> long-stemmed horizontal structures [that] seem to possess an ambiguity as of ploughshares becoming field guns or the reverse.[5]

The *Battersea Group* sculptures are in aluminium, cast by the sculptor from expanded polystyrene models at the foundry he set up in a converted barn at Stowe Hill, Suffolk, in 1957.

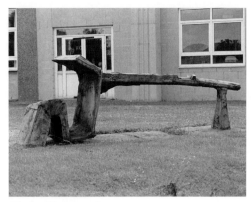
Clarke, *Battersea I*

Up to this time he had worked in iron, but with the establishment of his own foundry he gave up iron altogether. The advantages of aluminium were chiefly that it was cheaper and not susceptible to rust, a major consideration for outdoor sculpture. At first Clarke concentrated on relief sculpture, since he could model his designs in casting sand and open cast them. In 1960, however, he read about a method of casting from expanded polystyrene models, discovered in 1958 by Professor Wittmoser. He realised that this method was the solution to his problem of how to cast free-standing sculptures and immediately adopted it. His first successful use of the method was for his sculpture for Sir Basil Spence's house at Beaulieu; the *Battersea Group* followed not long after.[6]

In 1965 Clarke described his casting process as follows:

> For the most part I use a hot electric wire to cut into the polystyrene. To some extent the material dictates the shapes although I have found there is a natural affinity between my designs and the way polystyrene can be cut. After I have finished the shapes I want, the work is then embedded in casting sand and

molten aluminium is poured through a funnel into the sand mould filled by the polystyrene. The polystyrene evaporates simultaneously as the aluminium fills the mould. Later the set aluminium is ready to be dug out of the sand and thus you have your piece of sculpture in much less time than traditional methods could possibly allow. The advantages of polystyrene are therefore twofold, for me at least. Firstly, it allows me the chance to work directly in a manageable material and, secondly, there is the important factor of speed.[7]

Related works: (i) full-size sculptures: *Battersea II*, 1962, sandcast aluminium, h. 76cm (2'6"); w; 3.2m (10'6"); d. 1.37m (4'6");[8] *Battersea III*, 1962, sandcast aluminium, h. 1.07m (3'6"); w. 3.51m (11'6"); d. 91.4cm (3');[9] (ii) maquettes: *Battersea I*, 1962, brass and resin, h. 3cm (1"); w. 10cm (4"); d. 2.5cm (1"); *Battersea II*, 1962, brass and resin, h. 2.5cm (1"); w. 10cm (4"); d. 5cm (2"); *Battersea III*, 1962, brass and resin, h. 4cm (2"); w. 13cm (5"); d. 4cm (2");[10] *Battersea Series: Angle and Supported Bar*, 1964, cast aluminium, signed and numbered edition of ten;[11] (iii) monotype drawings: *Battersea I*, 1962; *Battersea I (variations)*, 1962;[12] *Battersea Series: Angle and Supported Bar*, 1964.[13]

Literature
Arts Council of Great Britain, 1965, n. pag. (no. 13); *Arts Review*, vol. xvii, no. 4, 6–20 March 1965, p.4; Black, P., 1994, pp.17–20, 21, 62, 64, **62**; Cantor, L., 1996, p.41; Fletcher, A.K. and Long, K., 1999; London County Council, 1963, n. pag. (no. 12); Redfern Gallery, 1965, n. pag. (no. 1); Strachan, W.J., 1974b, pp.42–3, **43**; Strachan, W.J., 1984, p.152, **152**; Taranman, 1975, n. pag. (nos 30, 31, 32); Taranman, 1976, n. pag.; Whitechapel Art Gallery, 1967, p.15, illus. betw. pp.18/19; Whittet, G.S., 1963, pp.48–53, **51**.

Notes
[1] Strachan, W.J., 1984, p.152, locates *Battersea I* at Loughborough College of Art and Technology; the photograph on the same page shows it inside a

building, by a window on an upper floor. It has not been possible to clarify these details. [2] The group is illustrated in Whittet, G.S., 1963, p.51. [3] The photograph captioned 'Battersea I' in the 1965 Redfern Gallery catalogue shows a different, though obviously related piece; the given measurements are, however, exactly the same as those given for the Loughborough *Battersea I* in the catalogue for the 1963 'Sculpture in the Open Air' exhibition at Battersea Park, namely h. 3'6"; l. 11'6"; d. 3'; the present author assumes that even though a different piece was illustrated it was the Loughborough *Battersea I* that was shown at the Redfern Gallery in 1965. [4] LEA inventory. [5] Whittet, G.S., 1963, pp.48–53. [6] Black, P., 1994, pp.16–18. [7] Geoffrey Clarke in interview with Stuart Penrose (*Arts Review*, vol. xvii, no. 4, 6–20 March 1965, p.4). [8] Shown at 1965, Tate Gallery, no. 24 (illus.). [9] Shown at 1965, Arts Council of Great Britain, no. 13. [10] Shown at 1994–5, Ipswich Borough Council Museums and Galleries touring exhibition, nos 52, 53, 54. Illustrated in Black, P., 1994, p.63. [11] Shown at 1975, London, Taranman, no. 40. [12] *Ibid.*, nos 30, 31 (illus.), 33, 34. [13] *Ibid.*, no. 35.

Next to the James France Building and Brockington Wildlife Park:

Truth, Labour and Knowledge

Sculptor: Emlyn Budds

Sculpture in Ancaster blue-vein weatherbed stone and bronze
h. 3.65m (12"); base 1.2 × 1.2m (3'11" × 3'11")
Inscription on the front relief, on the left page of the open book, in incised script:
In spite of knowledge / Yet still be believing / Though no god above / Yet god within
Unveiled: Wednesday 10 February 1999, by Sir Dennis Rooke, Chancellor of Loughborough University
Status: not listed
Owner: Loughborough University

Description of the four bronze reliefs on the chamfered upper part of the pedestal: The relief on the front face is modelled in the shape of an open book with a tasselled bookmark dangling over the left-hand page (which also bears the

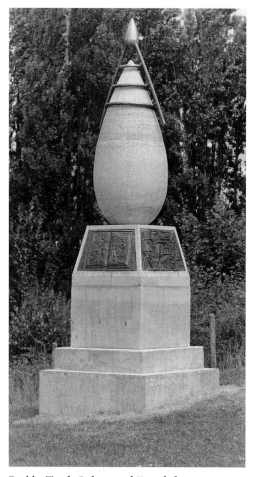

Budds, *Truth, Labour and Knowledge*

above inscription). Images on the pages include Donatello's *David*, an Ionic capital, a treble clef, a Greek letter (sigma), Chinese calligraphy, electrical components, a standard diagram of mass on a spring, a model of an atom and a magnetic field; the right-hand relief has images related to metalwork such as a vice, a pair of dividers, etc.; the rear relief is a decorative geometric pattern of concentric circles broken

by squares; and the left-hand relief has a hammer flanked by various cogs and wheels.
Condition: Good.

History: *Truth, Labour and Knowledge* was commissioned by Loughborough University to celebrate its achievements in the fields of science and engineering and to commemorate the integration of Loughborough College of Art and Design into the University in 1998 as Loughborough University School of Art and Design. Budds's design was selected in a competition of second and third year students of the College of Art and Design's fine art department. It was funded by the Loughborough College Past Students' Charitable Trust.[1]

Literature
Fletcher, A.K. and Long, K., 1999; *L. Mercury*, 11 February 1999, p.2; *Lo. Echo*, 12 February 1999, p.14; *Loughborough University News Release No 99/9*.

Note
[1] *L. Mercury*, 11 February 1999, p.2.

The Brockington Building, 1960, by T.A. Collins

On the exterior brick wall of the projecting wing to the left of the entrance:

Three figurative reliefs

Sculptor: unknown

Reliefs in concrete
Each relief: h. 90cm (3'); w. 90cm (3')
Executed: *c.*1960
Status of building: not listed
Owner of building: Loughborough University

Description: Each relief has two scenes, one above the other. The top relief depicts figures running and swimming; the middle relief depicts figures engaged in debate and study; the lowest, woodwork and metalwork.
Condition: Good.

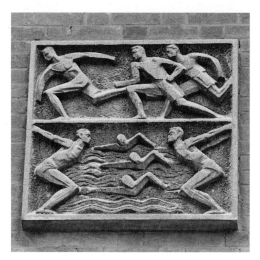

Brockington Building: uppermost relief panel

In an ornamental pool between the Chemistry Building and the Lecture Theatres:

Fountain / Fountain Construction

Sculptor: Austin Wright

Sculpture in aluminium
h. (est.) 3m (10')
Executed: 1968
Erected: 1970-1
Status: not listed
Owner: Loughborough University

Condition: As far as is discernible from the pool side, *Fountain* appears to be in fair condition.

Literature
Cantor, L., 1996, p.41; Fletcher, A.K. and Long, K., 1999; Hamilton, J., 1994, p.108 (no. S274a), 108; Pevsner, N. and Williamson, E., 1992, p.289.

Wright, *Fountain Construction*

In Cedar Court, between the Edward Herbert Building, the Herbert Manzoni Building and Administration I:

The Watchers

Sculptor: Lynn Chadwick

Sculpture in bronze
h. 2.35m (7'9"); w. 3.4m (11'2"); d. 74cm (2'5")
Inscription on a name plate at the foot of the central figure:

THE WATCHERS / by / LYNN CHADWICK / 1966 [i.e. the date of acquisition]
Executed: 1960
Erected on the present site: July 1966
Exhibited: 3–28 January 1961, New York, Knoedler Galleries
Status: not listed
Owner: Loughborough University

Condition: Fair.
History: *The Watchers* cost £3,500. Stewart Mason, then Leicestershire Director of Education, purchased the sculpture for Loughborough University of Technology campus to commemorate three men who in their lifetimes had been responsible for establishing local technical education: Herbert Schofield, first principal of Loughborough College (1915–50), Sir Robert Martin, Leicestershire County Council chairman (1924–60), and Sir William Brockington, Mason's predecessor as Director of Education (1903–47). Interviewed shortly after the erection of the sculpture on the campus, Mason acclaimed the sculptor, Lynn Chadwick, as 'one of the greatest English sculptors of the middle generation'. In explanation of the sculpture's appropriateness as a commemoration of the three men, he added: 'We wanted in some way to mark the work done by these three men. Although Mr. Chadwick had not had them in mind when he did the original work, we thought that a bronze casting of "The Watchers" would be ideal.'[1]

Although it is indeed cast in bronze, *The Watchers* reveals in the angular, faceted planes of its three figures, its origins in a quite different method of creating sculpture devised by Chadwick in the early 1950s. Chadwick's method is to create an armature of welded iron rods thereby forming a web of irregular geometric units, expressing the planes and contours of the figure. The core of the armature is then packed with expanded polystyrene and

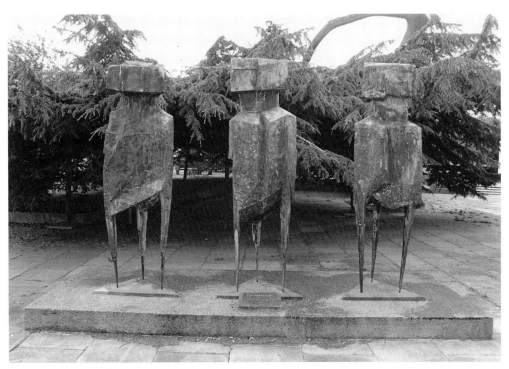

Chadwick, *The Watchers*

the interstices of the web filled with Stolit, a cement-like compound of gypsum and iron powder. Once dry, the compound becomes extremely hard and can be worked and chased. In his earliest pieces using this method, Chadwick allowed the armature to be covered but found that the forms lacked sufficient articulation; his solution, therefore, was to let the armature show. The method is laborious and has the obvious disadvantage that copies in the same material have to be started afresh. Thus, from 1956, Chadwick began to cast some pieces in bronze editions of three or more.[2]

Chadwick first came to international prominence when four sculptures and four drawings of his were included in the British section of the XXVI Venice Biennale in 1952.

Herbert Read, in his frequently-quoted introduction to the catalogue, set the seal on how the work of this group of sculptors, and particularly that of Chadwick, would be seen in a post-war period trying to come to terms with the holocaust, the atom bomb and the Cold War:

> These new images belong to the iconography of despair, or of defiance; and the more innocent the artist, the more effectively he transmits the collective guilt. Here are images of flight, of ragged claws 'scuttling across the floors of silent seas', of excoriated flesh, frustrated sex, the geometry of fear.[3]

Although created somewhat later, in 1960, *The Watchers*, with their brutal, angular forms and brooding presence, would seem to partake of Read's 'geometry of fear'. The very title has been interpreted as having resonances of Cold War spies or agents for some Orwellian Big Brother. And yet, Chadwick denied that Read's phrase applied to his own work. He insisted that his primary concern was with the solving of a set of formal problems, the look of his sculptures being determined by his technique:

> I think really that particular thing evolved from the way I work. My limited technique made me work in straight line [*sic*]. I made angular things and the straight lines may have expressed (fear). Because of the attitude of my work, it may have seemed (so) to other people. But it wasn't at all intentional ... I think that my personal idiom came through my technique, really, and because I worked in this way these images came this way and I couldn't have done it any other way ... I couldn't have carved this in wood because it would have come out quite differently ... Everything is because of, shall we say, the limitations of my technique.[4]

Read later (in 1958) revised his interpretation of Chadwick's work.[5] The sculptor, according to this reading, was tapping into the Jungian collective unconscious, harnessing 'a demonic force' and channelling it into works which, because they derive from archetypal forms, have the potential to be 'symbolic icons' invested with universal significance.[6] But whatever this significance may be, it is not something that can be defined; in fact, it is this mysterious, ultimately elusive quality that gives Chadwick's work its power. Chadwick himself had earlier clearly stated the importance of this aspect of his work:

> It seems to me that art must be the manifestation of some vital force coming from the dark, caught by the imagination and translated by the artist's ability and skill into painting, poetry, sometimes music. But,

whatever the final shape, the force behind it is, as the man said of peace, indivisible. When we philosophise upon this force, we lose sight of it. The intellect alone is still too clumsy to grasp it. The wood is lost in the trees. The intellectual, in his sincere desire to understand by reason, is leary of art which eludes all definitions.[7]

The Watchers then, no less than any other of Chadwick's works, eludes any narrow, fixed interpretation. The title also, is not essentially ominous: it could just as easily imply a group beneficently watching over the progress of others. It is perhaps this very ambiguity that made it possible for Stewart Mason to purchase the piece purely from the happy coincidence of his wanting to commemorate three educationalists whose achievement he greatly admired just at the time that there was available a three-piece group by a man he considered to be one of the greatest English sculptors of his time.

Related works: The present sculpture is one of an edition of three[8], the other two being at Nordjyllands Kunstmuseum, Aalborg, Denmark; and the Alton Estate, London Borough of Wandsworth, sited 1963 (Grade II listed).

Literature
Artscanada, vol. xxiv, October 1967, supp. no. 113, p.10; Cantor, L., 1996, pp.12, 41, **22**; Farr, D. and Chadwick, E., 1990, pp.12, 152 (no. 325), **152**; Fletcher, A.K. and Long, K., 1999; Garlake, M., 1998, pp.230, **231**; Knoedler Galleries, 1961; Koster, N. and Levine, P., 1988, pp.64, 77, 78, 83, 95, **84–5**; *L. & R. Topic*, June 1971, p.**6**; *Lo. Monitor*, 22 July 1966, p.1, 1; Lucie-Smith, E., 1997, pp.56, 145, **49**; Nairne, S. and Serota, N., 1981, p.167; Pevsner, N. and Williamson, E., 1992, pp.289, **74**; Strachan, W.J., 1974a, p.282; Strachan, W.J., 1984, pp.153, **153**; *Studio International*, vol. 174, no. 891, July/August 1967, p.**61**; Whitechapel Art Gallery, 1967, p.**15**, illus. betw. pp.18/19.

Notes
[1] *Lo. Monitor*, 22 July 1966, p.1. [2] Farr, D. and Chadwick, E., 1990, p.10; Koster, N. and Levine, P.,

1988, pp.63–4. [3] As quoted in Farr, D. and Chadwick, E., 1990, p.8. [4] As quoted in Koster, N. and Levine, P., 1988, p.54. [5] In Read, H., *Lynn Chadwick*, Bodensee-Verlag, Amriswil, Switzerland, 1958, 2nd edn 1960. [6] Farr, D. and Chadwick, E., 1990, pp.8–9. [7] From 'The Sculptor and his Public', 1954'; as quoted in Koster, N. and Levine, P., 1988, pp.53–4. [8] Farr, D. and Chadwick, E., 1990, p.152. *Studio International*, July/August 1967, p.61, mistakenly states that it is an edition of four.

The Herbert Manzoni Building (access only by prior arrangement)

In a stairwell, suspended by three chains from the ceiling:

Venus Probe II
Sculptor: Gerald Gladstone

Sculpture in welded steel

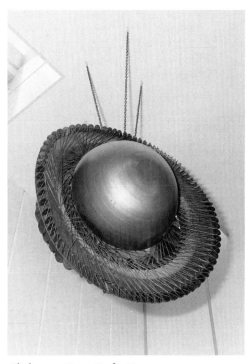

Gladstone, *Venus Probe II*

Dia: 1.24m (4'1"); depth: 71cm (2'4")
Inscription on a plaque fixed to the staircase wall:
VENUS PROBE II / by / GERALD GLADSTONE / 1964 [*sic*]
Executed: 1963[1]
Exhibited: 1967–8, London, Whitechapel Art Gallery (no. 21)
Status: not listed
Owner: Loughborough University

Condition: Fair. Although apparently undamaged, the sculpture is dust-covered, with some areas of rust.

Literature
Cantor, L., 1996, p.41; Whitechapel Art Gallery, 1967, p.16.

Note
[1] Whitechapel Art Gallery, 1967, p.16.

By a cedar tree near Administration Building I, across from the Edward Herbert and Herbert Manzoni buildings:

Per Saeculi Quartum (Through a Quarter of a Century)
Sculptor: Michael Dan Archer

Sculpture in bronze and Cadeby limestone
h. 1.9m (6'3"); w. 1.24m (4'1"); d. 1.66m (5'5")
Inscription on a metal plaque fixed to a low brick wall to the right of the sculpture:
Per Saeculi Quartum / Stone and Bronze / 1991 / Michael Archer / Commissioned by Loughborough University / with assistance from East Midlands Arts / and Brush Electrical Machinery / in celebration of the 25th Anniversary / of the granting of the Royal Charter / to Loughborough University.
Unveiled: Friday 20 December 1991, by Sir Dennis Rooke, Chancellor of Loughborough University.[1]
Status: not listed
Owner: Loughborough University

Condition: Good.

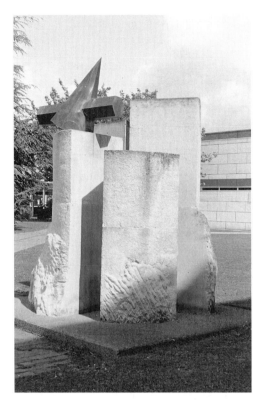

Archer, *Per Saeculi Quartum*

History: *Per Saeculi Quartum* was commissioned to celebrate the 25th anniversary in 1991 of the establishment of the University. It replaced a sculpture by Ralph Brown, *Man and Child*, 1959, destroyed by vandals (see pp.327–8). An open competition, advertised in *Artists Monthly* (September 1990), received over 120 enquiries.

Archer explained his winning sculpture as follows:

The stone base, in four sections, represents a hundred years (as a circle), each segment representing 25 years. The bronze sits on the second segment, representing the fact that the university is moving into its second 25 years, with all the intentions and possibilities for the future implicit in this.[2]

Per Saeculi Quartum was cast at a small engineering foundry in Huddersfield, which has since closed down.[3]

Literature
Loughborough University archives. Advertisement published in *Artists Monthly*, September 1990; Loughborough University press release, 18 February 1991.
General. Cantor, L., 1996, pp.12, 40; Fletcher, A.K. and Long, K., 1999; *L. Mercury*: – [i] 21 February 1991, p.5 [ii] 27 December 1991, p.45; *L. Mercury (Loughborough edn)*, 14 February 1992, p.1; *Lo. Echo*, 3 January 1992, p.12, **12**.

Notes
[1] Information from Loughborough University Registrar's Office. [2] Loughborough University press release, dated 18 February 1991. [3] Letter, dated 27 September 1998, from the sculptor to the author. Unfortunately, the sculptor was unable to recall the name of the foundry.

Administration Building II

In the Council Chamber ante-room (viewing by prior appointment through the Registrar's Office only):

Triptych
Sculptor: George Pickard

Relief in stainless steel
h. 61cm (2'); w. 1.65m (5'5")
Inscription on a plaque fixed to the wall beneath the relief:
In memory of / Professor J.G. PHILLIPS, F.R.S. / Fourth Vice-Chancellor / presented by / Herald and Joan Goddard / February 1988
Status: not listed
Owner: Loughborough University

Condition: Fair; the relief is, however, slightly warped.

Literature
Cantor, L., 1996, p.41; Pitches, G., 1994, p.11.

Outside Telford Hall:
The Wall
Sculptor: Donald Brook

Sculpture in fibreglass and reinforced concrete
Sculpture: h. (est.) 3.66m (12'); w. 94cm (3'1"); d. 17cm (7")
Plinth: h. 87cm (2'10"); w. 89cm (2'11"); d. 31cm (1')
Signed and dated: BROOK 61

Pickard, *Triptych*

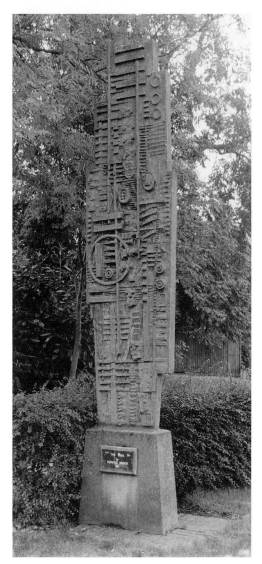

Brook, *The Wall*

Status: not listed
Owner: Loughborough University

Description: The surfaces of the sculpture are moulded with reliefs of cog-wheels and other mechanical elements and tools (e.g., a series of five adjustable spanners on the front face near the bottom).

Condition: The surface appears at one time to have been coated with a light, cream-coloured substance – now mostly lost. Numerous longitudinal cracks – apparently deep – are visible on all faces.

Literature
Cantor, L., 1996, pp.12, 40, **22**; Fletcher, A.K. and Long, K., 1999

At the south-western end of the campus, in the vicinity of Burleigh Court:

Revolution

Sculptor: Paul Wager

Sculpture in welded steel

Wager, *Revolution*

h. 2.25m (7'5"); w. 4.15m (13'8"); d. 1.14m (3'9")
Executed: 1990
Exhibited: Chelsea Harbour Sculpture 96 (RBS exhibition) (no. 4)
Status: not listed
Owner: On loan from the sculptor to Loughborough University

Condition: There are some areas of rust.
History: Loaned by the sculptor to the University for an indefinite period towards the end of 1995.

Literature
Cantor, L., 1996, pp.13, 40; Fletcher, A.K. and Long, K., 1999

At the south-western end of the campus, in front of the Mathematics Building:

La Retraite

Sculptor: Paul Wager

Sculpture in welded steel

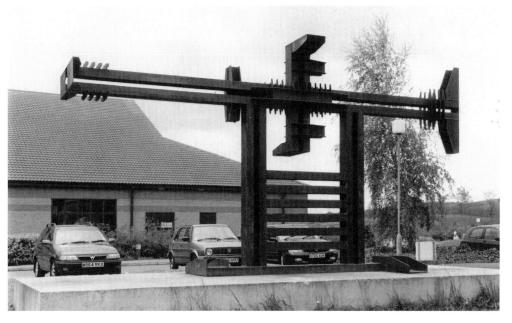

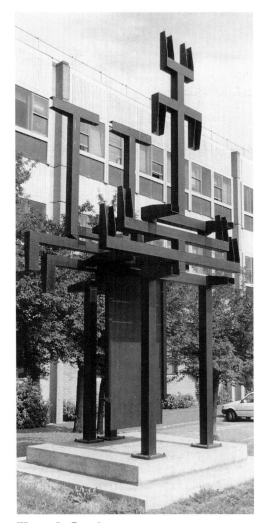

Wager, *La Retraite*

h. (est.) 4.57m (15'); w. 1.89m (6'3"); d. 1.77m (5'10")
Executed: 1986
Status: not listed
Owner: On loan from the sculptor to Loughborough University

Condition: Good.
History: Loaned by the sculptor to the University for an indefinite period towards the end of 1995.

Literature
Cantor, L., 1996, pp.13, 40; Fletcher, A.K. and Long, K., 1999.

At the south-western end of the campus, on a grassy knoll south of the Physics Building:
Strike
Sculptor: Paul Wager

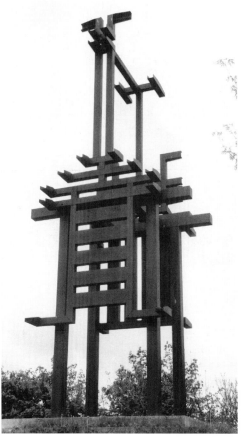

Wager, *Strike*

Sculpture in welded steel
h. (est.) 6.1m (20'); w. 2.55m (8'5"); d. 2.21m (7'3")
Executed: 1990
Status: not listed
Owner: On loan from the sculptor to Loughborough University

Condition: Fair; however, there are some small areas of rust.
History: Loaned by the sculptor to the University for an indefinite period towards the end of 1995.

Literature
Cantor, L., 1996, pp.13, 40; Fletcher, A.K. and Long, K., 1999.

Outside Faraday Hall:
Standing Stones
Sculptor: Margaret Traherne

Sculpture in moulded concrete
Whole group: h. 2.17m (7'1"); w. 4.83m (15'10"); d. 1.07m (3'6")
Status: not listed
Owner: Loughborough University

Description: A group of six standing slabs of moulded concrete, four pieces attached to the exterior wall of Faraday Hall, two free-standing. The first, third, fourth and sixth slabs from the left are pierced with rectilinear apertures.
Condition: The slab on the extreme right is cracked right across near ground level. The front face of the slab second from the left is defaced with three smears of pink pigment. Further damage is likely to occur as the area is used for parking metal goods trolleys.

Literature
Cantor, L., 1996, pp.12, 40, **22**; Fletcher, A.K. and Long, K., 1999.

Outside Royce Hall:
Standing Figure
Sculptor: Bryan Kneale

Sculpture in welded steel, painted
h. 2.61m (8'7"); w. 78cm (2'7"); d. 70cm (2'4")

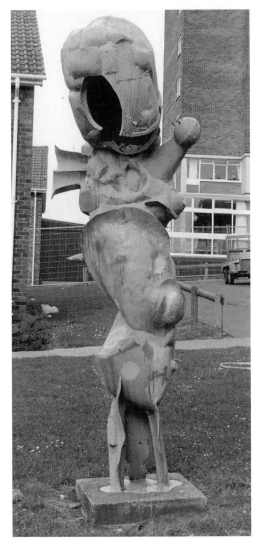

Kneale, *Standing Figure*

Executed: 1961
Status: not listed
Owner: Loughborough University

Description: Grotesque, 'sci-fi' type standing figure of steel, painted grey. The head is formed of an upturned, open-lidded dustbin. A section is cut out where the face would be, giving the impression of a helmet. The figure is mounted on a low concrete plinth.

Condition: Some of the original paint is blistered and cracked. Vandals have splashed and sprayed light green, orange, dark red and light blue paint all over. A letter 'G' has been sprayed on in light blue paint at about the level of the left 'hip'.

History: *Standing Figure* was acquired by the Leicestershire Education Authority in 1963.[1]

Literature
Cantor, L., 1996, pp.12, 40, **22**; Fletcher, A.K. and Long, K., 1999; *L. & R. Topic*, June 1971, p.**7**; Levy, M., 1963, p.**93**; Pevsner, N. and Williamson, E., 1992, p.291; Spencer, C.S., 1966b, p.**66**; Strachan, W.J., 1984, p.154, **154**.

Note
[1] LEA inventory.

Rutherford Hall

On the exterior (west-facing) wall:
The Spirit of Technology
(also known as *Technology* and *Projecting Figure*)

Sculptor: Peter Peri

Projecting figure in concrete on a mild steel armature
h. (est.) 3.04m (10')
Executed: *c*.1961[1]
Status: not listed
Owner: Loughborough University

Description: A male figure, naked but for a suggestion of drapery across the genital area,

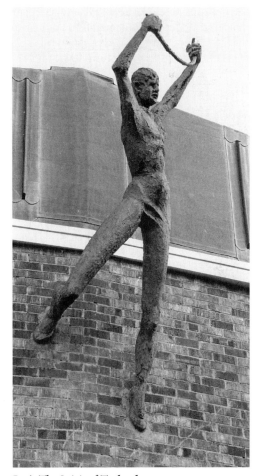

Peri, *The Spirit of Technology*

stands diagonally against the vertical surface of the exterior wall of Rutherford Hall. Suspended between his hands, which are raised above his head, is a loop of metal, the remains of an aerial-like component.

Condition: The surface appears to be crumbling; in addition there are deep cracks to the figure's left forearm, left ankle, and right shoulder. The semi-circular length of metal rod

suspended between the figure's hands is all that remains of an aerial-like component, this being the lower segment of the outer of two concentric circles joined by three radial spokes of metal and intersected at right angles by three rods of varying lengths.[2]

History: Peter Peri's *The Spirit of Technology* was commissioned in 1958 by Harry S. Fairhurst and Son, the architects of the halls of residence of Loughborough College of Advanced Technology (as the present University was then known). In a letter of October 1958 the architects informed Peri that they intended to commission a major sculpture for each of the halls they were then building and invited him to submit a design for one of his projecting figures[3] (the like of which they would have seen on other educational institutions around Leicestershire, see pp.308–9, 326–7).

Peri agreed and evidently submitted a design which was approved for, on 17 February 1960, the architects wrote to William Moss and Sons, the Loughborough firm contracted to build the halls, advising them of the commission and how they were to work with the sculptor. The letter reads:

Will you kindly accept an estimate dated 2nd January 1960 from Mr Peter Peri for a piece of projecting sculpture on Dining Hall Group No. 2, of which a copy is enclosed.

The sculpture will be constructed in reinforced concrete, cantilevered out from some starter bars in the gable wall which you will be inserting to details.

The cost is £500 nett, and appropriate adjustments will be made according with the terms of the contract on settlement. You will notice that the estimate covers for all the reinforcement and for the cement that will be used, and also, of course, for all work; it will be necessary for you to provide scaffolding and appropriate aggregate, which should be dealt with also on the terms of the contract.

It would be advisable for you to let Mr Peri know when the wall is likely to be ready for him. (The brickwork should be built and the gable end of the roof completed.) He will then be able to plan his operations for the summer. It is expected that he will take about two months, and may be working during any of the hours of daylight.[4]

As noted above, *The Spirit of Technology* is one of a number of projecting figures Peri executed in the 1950s and 1960s, several of which were for schools and colleges in Leicestershire. The sculptor wrote of the effect he was trying to create as follows:

I am fascinated by horizontal and diagonal sculptures which jut out of walls, first of all because you can see the figure from above. If you have a figure on the ground, you have to go round it, but here you see it from above, and this is a view everybody loves. You know, if you live in a flat, you like to look down on the people in the street. You get the same feeling here, and another thing is, you see the shadows going round the figure like a sun-dial. And this makes the sculpture more alive. The figure protruding from the wall gives the architecture a very dramatic extension in a new dimension. This is the result of working in concrete and trying out all its possibilities. It would be impossible in stone.[5]

Literature
The Centre for the Study of Sculpture, Leeds. Kenny, S., 1980, pp.39–40, fig. 25.
General. Cantor, L., 1996, p.40; Camden Arts Centre, 1987, pp.37, 44; Fletcher, A.K. and Long, K., 1999; *L. and R. Topic*, June 1971, p.5; Leicestershire Museum and Art Gallery, 1991, p.16; The Minories, 1970, n. pag.; Pevsner, N. and Williamson, E., 1992, p.291.

Notes
[1] The date is generally given as 1957 (Colchester, The Minories, 1970, n. pag.; Camden Arts Centre, 1987, p.44, etc). The sculpture must have been executed at the time of the erection of the building,

however, in 1961–2. [2] See illustration in *L. and R. Topic*, June 1971, p.5. [3] Kenny, S., 1980, p.39. [4] Letter reproduced as fig. 25 in Kenny, S., 1980. [5] Peter Peri, from an interview published in *The Leopardess*, 1962; as quoted in Camden Arts Centre, 1987, p.37.

Outside the Rutherford / Cayley Dining Hall:
Mineral Tree

Sculptor: Michael Piper

Sculpture in welded steel, copper and [now missing] glass
Sculpture h. (est.) 6.9m (22'8")
Plinth: h. 39cm (1'3"); w. 79cm (2'7"); d. 86cm (2'10")
Executed: 1962
Inscription on a plaque on the south face of the plinth:
THE MINERAL TREE / by / MICHAEL PIPER / 1962
Status: not listed
Owner: Loughborough University

Description: A tall, elliptical composition of three narrow sail-like forms, the two towards the rear growing from the root, that at the front suspended; the whole supported by an armature of rods.

Condition: A glass element, once contained by the metal structure, is now missing. The metal structure is rusting in places.

Literature
Cantor, L., 1996, p.40; Fletcher, A.K. and Long, K., 1999; *L. & R. Topic*, June 1971, p.7; Pevsner, N. and Williamson, E., 1992, p.291.

Opposite the north frontage of Administration Building I:
Pulse

Sculptor: Paul Wager

Sculpture in welded steel, painted black
h. (est.) 4.57m (15')
Executed: 1992 or 1993[1]
Status: not listed

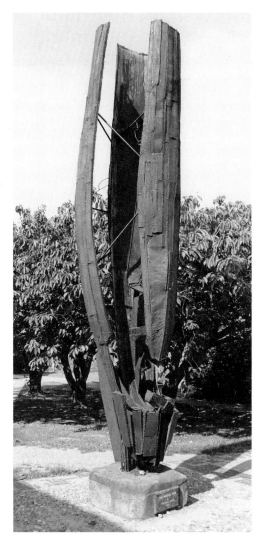

Piper, *Mineral Tree*

Owner: On loan from the sculptor to Loughborough University

Condition: Good.

History: *Pulse* was loaned by the sculptor to the University for an indefinite period towards the end of 1995.

This, according to the Hartlepool-born sculptor, deals, like much of his work, with:

... themes and images of a vanishing society

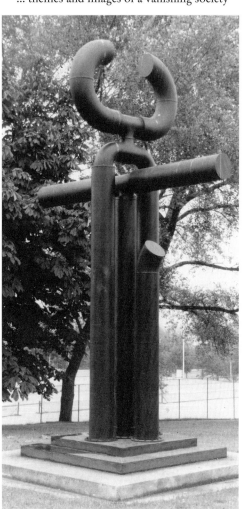

Wager, *Pulse*

which was formerly built around heavy industry and politics. A large fragment of my work pays homage to these dying industries and communities. I attempt to relay a potent authority which is evident in my larger steel sculptures. I also through my work outline an evidence of environmental despoliation and pollution, an ambivalent relationship with remnants of irresponsible industrialists and their decaying industries. I draw off information and examine industrial and mechanical form from this urban landscape and further address the related macho-masculinity detail associated with this northern culture. I enjoy and reflect images which are of a brutal, polluted and dying environment which relate to a bleak authoritarianism ... The political edge of my work is ... very important and is reflected in the interests and themes I have mentioned [above]. The structure of power is of great importance to the concept base of my sculpture, the power of administrations and authority within society; propaganda and the information media greatly concern [me and affect] my social-political views, which [in turn] directly influence my sculptural practice.[2]

Literature
Cantor, L., 1996, pp.13, 40, **23**; Fletcher, A.K. and Long, K., 1999.

Notes
[1] Cantor, L., 1996, p.40, gives 1992; Fletcher, A. and Long, K., 1999, n. pag., gives 1993. [2] Information from the sculptor.

Hazlerigg Hall

On the roof:
Herbert Schofield Weather-Vane

Herbert Schofield (1883–1963), was first principal of Loughborough College, 1915–50
Designer: Ernest G. Fowler

Original executed: 1938; replica made: 1960s
Status: not listed
Owner: Loughborough University

Description: Situated on the top of the tower of Hazlerigg Hall, the weather-vane has a 'characteristic' scene from the life of Dr Herbert Schofield, enacted by figures in cut-out metal on the wind direction bar. Schofield is in the centre of the bar, over the pivot. Immediately identifiable to those who knew him by his familiar wide-brimmed hat, he is frantically running, case in hand, towards an ocean liner at the far end of the bar. Behind him is a group of students, a solid mass standing and waving goodbye, while two have separated from the group overcome with emotion: the one at the front kneels with both arms raised towards Schofield, while the other at the back, turns away to sob into a handkerchief. This light-hearted scene refers to the frequent transatlantic trips Schofield made both for business and to attend international Rotary meetings in the USA.[1]

Literature
Lee, J. and Dean, J., 1995, p.14, **14**.

Note
[1] Lee, J. and Dean, J., 1995, p.14.

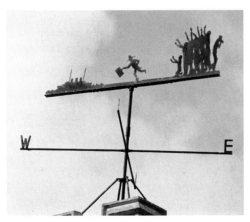
Fowler, *Herbert Schofield Weather-Vane*

Market Place

At the south-west end of the Market Place outside Loughborough Town Hall:
The Sock

Sculptor: Shona Kinloch
Founder: Powderhall Bronze Foundry, Edinburgh

Sculpture in bronze
h. 1.83m (6'); w. 72cm (2'4"); d. 1.58m (5'2")
Unveiled: Saturday 11 April 1998, by Dean Ward, Loughborough's Olympic bobsleigh bronze medallist
Status: not listed
Owner / custodian: Charnwood Borough Council

Description: Stocky male figure seated on a bollard, naked except for a sycamore leaf over his genitals and a sock on his left foot which he extends before him, looking down admiringly at it. The sock is symbolic of hosiery manufacture, an important element in Loughborough's commercial history. According to the sculptor, the 'sock pattern echoes the zig-zag of the new bollards in the Market Place, while the surrounding Art Deco buildings (e.g. the Curzon Cinema) inspired his art deco hair cut'.[1] On the figure's right arm is an incised tattoo of a heart above the word 'Loughborough' set within a scroll motif. The bollard on which he sits is decorated with incised images from the history of the town: a railway track and train, representing Thomas Cook's first tourist excursion from Leicester to Loughborough in 1842, a canal and barge representing the introduction of the Soar Navigation and Leicester Navigation in the eighteenth century, factories and sheep for the woollen industry, one of local agriculturalist Robert Bakewell's longhorn cattle, bells to represent the town's bell-founding industry, and the towers, etc., of Loughborough

University. The sculptor has also commemorated the year in which she began the piece with an image of the Hale Bop comet.

Condition: Within a short time of the unveiling the green patination had been worn away completely from the extended left leg up to the knee and from the right knee and the back of the right hand resting on it. Scratch marks, some of it graffiti, cover much of the surface.

History: *The Sock* was commissioned by Charnwood Borough Council 'to provide an attractive feature and focus of public interest' for the £300,000 pedestrianization scheme for Market Place and Market Street, Loughborough.[2]

From this budget the Borough Council set aside £23,000[3] for a sculpture that would reflect 'all the history of Loughborough'.[4] In November 1996, the design brief was advertised in *Artists Newsletter* with a December deadline for the reception of preliminary designs. To assist potential entrants, important events in the town's history were listed along with an explanation of the way in which it was intended to use the Market Place. From the designs submitted, six, from five artists, were short-listed,[5] the aim being that the short list should represent the widest range of different styles and genres: figurative, animal, abstract, static, dynamic, etc.[6] Each of the five selected artists was given £500 to cover the cost of producing his or her entry for the next stage.[7]

The Council appointed a ten-person selection panel carefully chosen to represent a balance of specialist and non-specialist opinions. The specialists, whose job it was to assess both the physical durability of each proposed structure and the type of sculpture most likely to retain its appeal over the years, included representatives from East Midlands Arts, Charnwood Arts, and Loughborough College of Art and Design, plus a sculptor experienced in the demands of public sculpture,

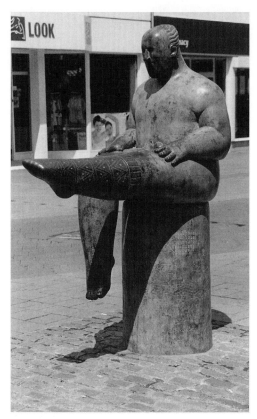

Kinloch, *The Sock*

while the non-specialists, who, it was hoped, would reflect the wider public's taste, included several Charnwood Borough councillors.[8]

The short-listed artists next submitted maquettes, drawings and written explanations of their ideas. An exhibition of the designs was advertised in the local press and shown in the Town Hall over three days in early March 1997. Forms were available at the exhibition for people to express their views and preferences.[9] It is estimated by the Council that some 400 people visited the show.

Having looked at the submissions, the panel interviewed all the artists and saw photographic examples of some of their previous commissions. None of the short-listed designs had won an overall majority in the public vote, but three had gained significantly larger percentages: *The Bell*, by David Annand, had gained 28%, *Loughborough Market* (a representation of sheep in the market place) by Marjan Wouda 22%, and *The Sock*, 18%. The panel 'greatly appreciated' *The Bell*, a sculpture comprising bronze figures of youths dancing on a bell-shaped brick base, but felt that there were certain inherent problems: firstly the brick base looked as if it would be difficult to construct and maintain, secondly the sculpture failed to engage sufficiently with the brief's historical emphasis, and thirdly the image of the high-spirited young lads would, it was feared, 'set the wrong atmosphere in our drive to reduce rowdiness in the Market Place'.[10] *Loughborough Market* was similarly appreciated by the panel, but was excluded on the technical ground that the featured basket motif would collect water and rubbish and on the iconographical ground that the pastoral emphasis did not reflect contemporary Loughborough. The two abstract pieces, *The Needle*, by Nick Aikman and *The Helter Skelter*, by John Thomson, had received the lowest public votes and, though considered by the panel to be imaginative responses to the brief, were felt to be 'out of scale with the site'.[11]

On 10 March 1997, the selection panel voted for Shona Kinloch's design by a narrow majority.[12] Its supporters considered it the best design from the point of view both of artistic quality and technical merit. It seemed to be relatively weather- and vandal-proof and some members of the panel appreciated what they saw as its gentle sense of humour. Most importantly, it 'was also the one that best met the brief, representing not only the hosiery industry, which has employed so many Loughborough people down the ages, but also

including other images of Loughborough'.[13]

In May 1997, Charnwood Borough Council's Public Services Committee approved the panel's choice and subsequently, in a full Council meeting, the committee's approval was ratified.[14] On 1 August 1997, the Council and sculptor signed the contract for the commission.[15]

The choice had, however, met with considerable opposition within the panel and the outvoted panellists immediately made public their disapproval, the most vocal dissenter being independent Councillor Wendy Greene. As she later explained to a national newspaper: 'People think [*The Sock* is] ugly, it's not relevant to the town, and some people object because it has no clothes on … I'm not against nudes personally … but the people don't want their money spent in this way.'[16]

Knowing, presumably, what 'the people' did want their money spent on, Councillor Greene suggested instead a statue of 'someone like Robert Bakewell or William [*sic*] Fearon'.[17] Moreover, she accused the Labour leaders of Charnwood Borough Council of deliberately delaying publication of the report on the selection of *The Sock* until after the General Election (1 May 1997) because they knew that the issue of the statue would sway the voters of Loughborough against them, an accusation that Council leader Mike Jones condemned as 'despicable'. Among the main parties, opinions were split broadly along party political lines, with Labour councillors insisting the choice was fairly made (even if some did not themselves much like that choice) and Conservative councillors urging reconsideration in the light of, as one put it, 'adverse and justifiable criticism'.[18]

The Sock was not without its vocal supporters, however. One correspondent to the local press praised it as 'solid, modern [and] human' and, above all, democratic: '"The Sock" celebrates the ordinary people of our hosiery

industry'.[19] On the other hand, the chairman of John Taylor and Co. (Bellfounders) Ltd thought *The Sock* ghastly, putting the case (not surprisingly) for *The Bell*.[20] And later in the year, in the wake of the death of Diana, Princess of Wales, a Conservative Councillor made the perhaps inevitable plea that a statue of Diana should be erected instead.[21] While the controversy raged in Loughborough, Kinloch worked on *The Sock* in her studio in Glasgow.

She explained her sculpture as follows:

The work was inspired by the fact that the woollen industry contributed greatly to Loughborough's prosperity.

The zig-zag design on the sock was inspired by the see-through bits on the new art deco bollards in the Market Place and is reflected in his hair too.

The whole thing is cast in bronze and stands about 6ft high, just the right height to sit on his knee, swing on his leg or just put an arm around him.[22]

To Charnwood Borough Council it was 'a celebration of our town's industry, its history, its art and it is a bold statement of confidence in our future!'[23]

The Council responded to the interest that had surrounded the sculpture from the time of its controversial selection – it had even received coverage in the national press[24] – by mounting a small exhibition of related material in the Town Hall to coincide with the unveiling ceremony and by creating a website giving a detailed chronology of the scheme, an account of the selection of the sculpture, a brief photographic narrative of the creative process, and photographs of the installation of the piece.

Notwithstanding initial resistance to the statue, and in the usual way of such things, by the first anniversary of its installation there seems to have been a growing acceptance of *The Sock* as part of Loughborough's urban landscape. A reporter from the *Leicester Mercury* conducted a series of interviews with passing members of the public and although, inevitably perhaps, it was the younger people who were more positive in their enjoyment of it, even some of the older interviewees admitted that their initial antipathy had mellowed into an, albeit grudging, liking for the sculpture.[25] Certainly Kinloch's hope that the children of Loughborough would enjoy swinging on the extended leg has been realised, as was evidenced after only a few months by the total erosion of the green patination from that part of the figure.

Literature

Charnwood Borough Council. Information leaflets – *How 'The Sock' was Sewn!*; *The Sock*; *'The Sock' Arrives!*; *Shona Kinloch*; press cuttings: *Daily Mail*, 14 February 1998; *Sunday Times*, [?] March 1998. **General**. *Artists Newsletter*, November 1996; *Guardian*, 14 February 1998, p.10, **10**; *Independent*, 22 April 1998, pp.1, 15, 16, **15**; *L. Mercury*: – [i] 11 September 1997, p.2, **2** [ii] 13 February 1998, p.2, **2** [iii] 9 April 1998, pp.1, 3, **1, 3** [iv] 28 April 1998, p.6; *L. Mercury (Loughborough edn)*: – [i] 6 April 1998, p.4 [ii] 14 April 1999, p.5; *Leicester University Bulletin*, April 1998, p.31, **31**; *Lo. Echo*: – [i] 18 April 1997, p.8 [ii] 2 May 1997, p.5 [iii] 27 February 1998, pp.2, 21, **21** [iv] 3 April 1998, p.1 [v] 10 April 1998, pp.1, 9, **1**; Wheeler, P., 1998.

Notes

[1] *The Sock*, Charnwood Borough Council leaflet, 1998. [2] *'The Sock' Arrives!*, Charnwood Borough Council leaflet, 1998; see also *Leicester Mercury*, 13 February 1998, p.2. [3] *Lo. Echo*, 2 May 1997, p.5. [4] Charnwood Borough Council website: charnwoodbc.gov.uk/html – The Sock Story (p.2). [5] *How 'The Sock' was Sewn!*, Charnwood Borough Council leaflet, 1998. Marjan Wouda submitted two entries, both representing the market place, one of sheep and the other of a market stall with poultry (information from Martin Tinknell, Charnwood Borough Council). [6] *Ibid.* [7] *Ibid.* [8] *Ibid.*; Wheeler, P., 1998. [9] *How 'The Sock' was Sewn!*, Charnwood Borough Council leaflet, 1998. [10] *Ibid.*, 1998. [11] *Ibid.* [12] Charnwood Borough Council website: charnwoodbc.gov.uk/html – The Sock Timetable; Wheeler, P., 1998. [13] *'The Sock' Arrives!*, Charnwood Borough Council leaflet, 1998. [14] *L. Mercury*, 11 September 1997, p.2. [15] Charnwood Borough Council website: charnwoodbc.gov.uk/html – The Sock Timetable. [16] *The Guardian*, 14 February 1998, p.10. [17] *Lo. Echo*, 18 April 1997, p.8. [18] *Ibid.*, 2 May 1997, p.5. [19] Helen Burrows; letter to *L. Echo*, 2 May 1997, p.6. [20] *Lo. Echo*, 18 April 1997, p.8. [21] *L. Mercury*, 11 September 1997, p.2. [22] *Ibid.*, 13 February 1998, p.2. [23] *'The Sock' Arrives!*, Charnwood Borough Council leaflet, 1998. [24] See, for example, *The Guardian*, 14 February 1998, p.10, and *The Independent*, 22 April 1998, pp.1, 15 and 16. [25] *L. Mercury (Loughborough edn)*, 14 April 1999, p.5.

In the centre of the Market Place:

The Fearon Drinking Fountain

Archdeacon Henry Fearon (1802–85) was born in Crayfield, Sussex, and educated at Winchester where in 1821 he gained an open scholarship to Emmanuel College, Cambridge (BA 1824, MA 1827; Fellow until 1848). He was ordained as a priest in 1826, but continued to teach Classics and Divinity at Cambridge, and did not accept his first living – Loughborough All Saints Church – until February 1848 (instituted as Rector in May of that year). He was Archdeacon of Leicester 1863–84.

Source: Humphreys, W., 1985.

Designer: James Forsyth
Contractor: William H. Hull

Fountain in ashlar, Aberdeen granite and cast-iron
h. (est.) 4.57m (15')
Inscriptions:
(i) Running round the fountain at tap height, in incised Roman capital letters:
[north-east face] "OUR COMMON MERCIES [north-west face] LOUDLY CALL [south-west face] FOR PRAISE TO GOD [south-east face] WHO GIVES THEM ALL"
(ii) On a metal plaque on the north-west face:
THE FEARON FOUNTAIN / PRESENTED TO THE TOWN BY / ARCHDEACON FEARON / TO MARK THE PROVISION OF LOUGHBOROUGH'S / FIRST PUBLIC WATER SUPPLY IN 1870. / RENOVATED AS PART OF THE / MARKET PLACE ENHANCEMENT / 1981
(iii) On the north-east face at bottom right: 1981

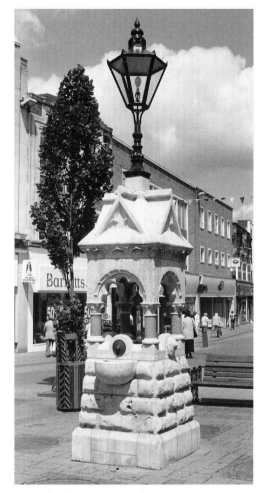

Forsyth, *The Fearon Drinking Fountain*

Inaugurated: Wednesday 31 August 1870
Status: Grade II
Owner / custodian: Charnwood Borough
Council

Description: The drinking fountain is a
square-based canopied structure on a rusticated
pedestal raised on a plinth (this latter dated

1981), with polished marble basins to north-east
and south-west and lion-head spouts to north-
west and south-east. The canopy has a bracketed
cornice and traceried gables (the south-west one
carrying a coat of arms). This is supported on
cusped, round-headed arches raised on columns
with stubby polished granite shafts and stone
capitals decorated with stylised foliage.

Condition: The stone parts are much eroded,
particularly the lion heads, the features of
which have virtually dissolved. The fountain
was restored in 1981 as part of Charnwood
Borough Council's reconstruction and
enhancement of the Market Place. The
stonework was restored by David Tarver, then
Head of Sculpture at Loughborough College of
Art and Design, and a new lamp was made
(using photographs of the original as guides) by
Peter Beacham, also of the College.[1]

History: When Fearon arrived in
Loughborough in 1846 he found a town with
appalling sanitary problems and no guaranteed
supply of fresh water. He therefore gathered
together a group of like-minded townsfolk and,
after many years of campaigning in the face of
an electorate which strongly resisted the
imposition of rate increases for measures which
were essentially for the provision of fresh water
for the poorer (unenfranchised) classes,
eventually saw his campaign achieve success.
There was still no drinking fountain in the
centre of the town, however, and this Fearon
supplied at his own expense. At the
inauguration ceremony Fearon began by
extolling the benefits of pure water before
addressing himself to the local board of health:

> To your custody, as trustees of the town, I
> now hand over [, he said,] the little gift
> which it is the greatest pleasure to me to
> offer, and in exercising the last act of
> ownership [he offered] their respected
> chairman the first drink of water. The rev.
> gentleman then filled a silver goblet with

water from the fountain, and handed it to
Mr. Middleton, who having drank, it was
passed round to the members of the Board,
who all tasted the water ...[2]

Literature
Archdeacon Fearon's Fountain (re-inauguration
leaflet), 1981; Humphrey, W., 1985, pp.7–10; *L.
Chronicle*, 3 September 1870, p.6; *Lo. Advertiser*, 1
September 1870, [p.4].

Notes
[1] D.L. Harris, in *Archdeacon Fearon's Fountain* (re-
inauguration leaflet), 1981. [2] *Lo. Advertiser*, 1
September 1870, [p.4].

*No. 14 Market Place (now a branch of
Etam, Ladies Retail Fashion Wear), on the
north-west side of the square, close to the
High Street end*

The upper part of the frontage has:
Three lunette reliefs
Modeller: George Harry Cox

Reliefs in terracotta
Each relief: h. 98cm (3'3"); w. 2.2m (7'3")
Status: not listed
Owner: unknown

Description: Three semi-circular reliefs of
nude children in woodland settings, the left
and right ones identical. The flanking reliefs

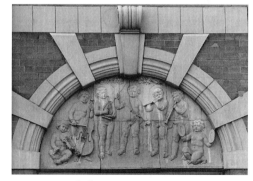

Cox, *Etam relief*

depict eight children dancing; the central one, six children playing musical instruments, with a seventh child in the centre conducting with a baton. To the left are a violinist, a cellist, and a lyrist, and to the right a flautist, a recorder-player, and a cymbalist.

Condition: Good.

History: Although it has not been possible to trace any documentary evidence for the authorship of these reliefs, the figure style and facial types of the children are identical to those by George Harry Cox on the National Westminster Bank at Shepshed (see pp.270–2).

Mount Grace Road

Stonebow Washlands Community Wildlife Area

Next to one of the paths crossing the area, close to the Blackbrook, a sculpture on the East Midlands Shape 21st Birthday Sculpture Trail:

The Kingfisher

Sculptors: Martin Heron and members of the Albert Street Centre

Sculpture in lime
h. 2.15m (7'1"); w. 58cm (1'11"); d. 58cm (1'11")
Unveiled: Sunday 27 June 1999, by the Mayor of Loughborough.
Status: not listed
Owner / custodian: East Midlands Shape / Charnwood Borough Council

Description: A totem-like sculpture, its top comprises a kingfisher, carved fully in the round, plunging into the water to catch a fish in its bill. The main body of the wood is carved in relief to represent an underwater scene of fishes and water plants.

Condition: There are deep splits along the grain and the surfaces are discoloured with green biological growth. As a general policy for all sculptures on the trail it has been decided by

East Midlands Shape that natural disintegration should not be inhibited and that any biological accretions should be allowed to grow.[1]

History: As with all sculptures on the East Midlands Shape 21st Birthday Sculpture Trail, *The Kingfisher* was designed and executed by

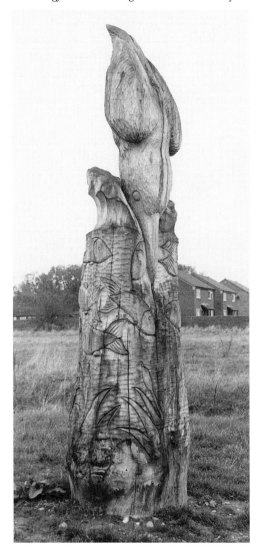

Heron and others, *The Kingfisher*

disabled people from a local group – in this case the Albert Street Centre – under the supervision of professional sculptor Martin Heron.

EMA approached Charnwood Borough Council and the two organisations agreed that the ideal location for the Charnwood sculpture (there is to be one sculpture in each of Leicestershire's district council areas) would be the newly-developed Stonebow Washlands Community Wildlife Area. The subject of the sculpture was carefully chosen by the group 'to reflect the feelings of local people towards their natural environment and wildlife'.[2] The sculpture was unveiled as the main attraction of Charnwood's contribution to County Biodiversity Day, a day of events and activities across Leicestershire and Rutland aimed at promoting the continuing importance of the conservation of natural habitats and the species which inhabit them.

Related works: Other sculptures in the East Midlands Shape 21st Birthday Sculpture Trail are: *Untitled*, National Forest Visitor Centre (see pp.246–8); *The Aviary Tower*, Bouskell Park, Blaby (see pp.14–15); and *The Bird Totems*, Thornton Reservoir (see pp.279–80). At the time of writing (summer 1999), further sculptures are planned for Melton, Harborough, Hinckley and Bosworth, and Oadby and Wigston.

Literature
PMSA NRP East Midlands Archive. Copies of various related documents supplied by Simon Jones, Charnwood Wildlife Project.
General. East Midlands Shape, *Leicestershire Sculpture Trail. Map and Guide*, 1999.

Notes
[1] As stated in the report on the pilot sculpture set up at the National Forest Visitors' Centre. See p.247.
[2] 'Kingfisher Makes Home at Stonebow', Charnwood Wildlife Project press release, June 1999.

Queens Park

Swan sculpture, gazebo and maze
Designer / sculptor: David Tarver

Swan in Clipsham stone on a concrete plinth
under a gazebo in iron
Sculpture and base: h. 57cm (1'11"); w. 1.04m
(3'5"); d. 60cm (2')
Plinth: h. 56cm (1'10"); dia. 1.81m (5'11")
Signed with a monogram and dated at the right-
hand end of the base: D.T. / 1992
Inscription on a tablet set into the ornamental
paving surrounding the gazebo:
(i) running along the left margin, from bottom
to top: *designed by*
(ii) running along the right margin, from top to
bottom: *by david tarver*
(iii) running horizontally across the tablet:
Charnwood Borough Council /
LOUGHBOROUGH / CHARTER / CENTENARY /
1888–1988
Status: not listed
Owner / custodian: Charnwood Borough
Council

Description: The sculpture comprises a
carved swan with three cygnets and a frog, on
an integral circular base raised on a circular
plinth. It stands under an openwork metal
gazebo at the centre of an ornamental pavement
decorated with a maze pattern.
Condition: The circular plinth is, as was
intended, used as a seat. Consequently the stone
of the sculpture, although undamaged, is grimy
and appears rather worn from years of
children's clambering feet and touching hands.
Pigment has been crudely applied to the swan's
eyes and bill.
History: In 1988 Charnwood Borough
Council held a competition for an artwork to
mark the centenary of Loughborough's charter.
The budget was about £16,000 and the
competition was open to all people living in the

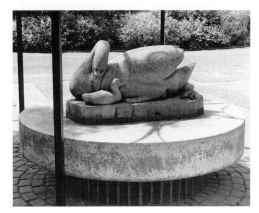

Tarver, *Swan*

Borough. About 50 people, representing a
cross-section of professional artists as well as
amateurs of all ages, responded to the
competition advertisement, and all their
designs, both drawings and maquettes, were
shown at an exhibition in Loughborough Town
Hall. The public, having been invited to vote,
clearly favoured the design submitted by David
Tarver: fortunately this was also the selection
panel's favourite, and Tarver was duly informed
that his design had been selected.[1] To Tarver's
frustration, however, various problems
prevented Charnwood from approving
commencement of the work until 1992.
The pavement as executed is a simplification
of the original design: the maze was originally
intended to incorporate low hedges; this,
however, proved impractical and so the
sculptor's idea had to be reduced to a coloured
design on the pavement. Tarver chose swans as
the theme of his sculpture because of the
proximity of the park ponds, while the circular
seat / base was intended to allude to a millstone,
a reference to the former presence of a water
mill near the site. On another level, according
to the sculptor, the circular seat / base refers to
Brancusi's *Table of Silence*, 1937–8, at Tirgu Jiu

Public Park in Romania. Tarver designed and
executed the entire installation, including the
centenary inscription set into the pavement.[2]

Literature
Charnwood Borough Council. Monuments, Public
Sculptures and Public Art Records, No. 4, *Swan
Gazebo*.

Notes
[1] Information from Martin Tinknell, Loughborough
Borough Council. [2] Information from David
Tarver, 18 June 1999.

Radmoor Road

Loughborough College (access only by prior arrangement)

Originally the further education department of
the precursor to Loughborough University, at
that time also called (confusingly)
Loughborough College. The further education
department was one of those initiated during
the directorship of Dr Herbert Schofield. After
Schofield's retirement in 1950, the department
became an independent institution and in 1966
was retitled Loughborough Technical College.[1]
This, in turn, was shortened to its present name,
Loughborough College, in 1988.

Note
[1] Pevsner, N. and Williamson, E., 1992, pp.285, 292.

1. On the lawn south-east of 'A' Block:
Ganglion
Sculptor: William Pye

Sculpture in polished stainless steel
h. 3.19m (10'6"); w. 1.22m (4'); d. 1.22m (4')
Executed: 1969
Exhibited: 1971, London, Redfern Gallery;[1]
1978–9, Yorkshire Sculpture Park (no. 7); 1980,
Aberystwyth Arts Centre (no. 40)
Status: not listed
Owner: Loughborough College

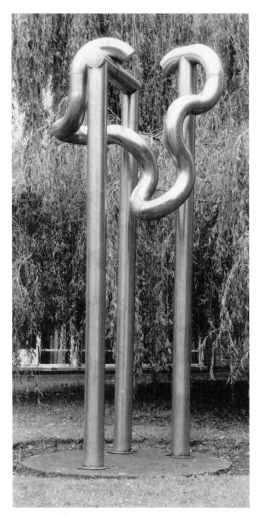

Pye, *Ganglion*

Condition: Fair. The sculpture was evidently repaired by Loughborough College of Art and Design following damage incurred by a dumper-truck reversing into it.[2]

History: *Ganglion* was purchased by the Leicestershire Education Authority in 1972 specifically for Loughborough (Technical)

College. The £500 cost of the sculpture was met by funds obtained through the LEA's buildings capital scheme.[3]

Ganglion is one of a series of sculptures Pye executed in the late 1960s and early 1970s, the basic material for which was industrial steel tubing (see also *Broken Curve*, 1966, Countesthorpe College, p.34). Pye was intrigued with the idea of creating sculptures expressive of emotion and sensuousness simply through the manipulation of prefabricated units of steel tubing, the original purpose of which had been purely functional. As Pye explained in 1973:

> Something ... which I find very exciting is the manipulation of intractible materials – making them do emotional and sensual things. The idea of turning them into something which is languid or alert, simply by welding them together and evolving the abstract language of sculpture from them is absorbing ...[4]

In *Ganglion* the organic nature of the serpentine element is emphasised by the rigid architectonic elements – a lintel and posts – that support it: one end of the serpentine element is apparently heaving itself over a tubular steel lintel, while the other is cupped in what is in effect nothing more than a standard birdsmouth joint. Pye's description of this basic unit highlights his sensitivity to the potential expressiveness of such ostensibly neutral elements: 'The sensation of the "Birdsmouth Joint" (trade term), is real and specific, the horizontal seating itself into the body of the vertical, the vertical biting or containing the horizontal.'[5]

The energetic convolutions of the serpentine element are themselves made up of a number of standard curved sections, for the most part with the weld cleaned off flush with the surrounding surface so as to render it almost invisible. An aspect of this series of great importance to the

sculptor is the reflective surface of the polished steel:

> A valuable quality in sculpture is its apparent responsiveness to the environment. In a very real sense a reflective steel sculpture responds to its situation. In a wood it will be a speckled green sculpture, whereas in an urban setting that same piece may starkly reflect only sky and grey buildings. This varying character gives the object a certain organic quality, a coming alive, that I require of the work.[6]

In 1971, Bernard Denvir wrote:

> *Ganglion* ... will probably continue to represent the apex of one line of [Pye's] development. Commencing as 'a gray mass of nerve tissue existing outside the brain and spinal cord' the word ganglion ended up by meaning (according to the 1967 edition of the *Random House Dictionary of the English Language*) 'a center of intellectual or industrial force, activity, etc'. This specifies perfectly the nature and quality of what Pye has been seeking to achieve in this configuration of an organic, python-like shape twisting itself around the terminals of three stainless steel columns. He has reduced the inanimate vocabulary of technology and the neutral shapes of engineering into a supple and evocative language of formal poetry.[7]

Related work: *Ganglion Maquette*, 1971, nickel-plated steel, shown at Aberystwyth Arts Centre, 1980 (no. 17).[8]

Literature
Whitechapel Art Gallery archives. Press cutting: *Tribune*, 3 October 1980.
General. Aberystwyth Arts Centre, 1980, n. pag. (nos 17, 40); Arts Council of Great Britain, 1980, p.20; Denvir, B., 1971, pp.76, 84, **89**; Denvir, B., 1973, p.**22**; Redfern Gallery, 1969c, n. pag.; Strachan, W.J., 1984, p.153, **153**; Yorkshire Sculpture Park, 1979, n. pag. (no. 7).

Notes
[1] Group exhibition, referred to in Denvir, B., 1971, p.76. [2] Information from David Morris, Head of Sculpture, Loughborough University School of Art and Design. [3] LEA inventory. [4] Denvir, B., 1973, p.22. [5] Redfern Gallery, 1969c, n. pag. [6] *Ibid.* [7] Denvir, B., 1971, p.84,. [8] Dimensions given in Aberystwyth Arts Centre, 1980, as 9" × 9" × 2'2".

Sculpture

Sculptor: Nicholas Glenton[1]

Sculpture in steel, silver hammerite paint and wood
h. 79.5cm (2'7"); w. 1.7m (5'7"); d. 1.36m (4'6")
Status: not listed
Owner: Loughborough College

Condition: There are some spots of rust on the steel elements, and some of the wood elements have small splits and patches of green biological growth.

Note
[1] Information from David Morris, Head of Sculpture, Loughborough University School of Art and Design.

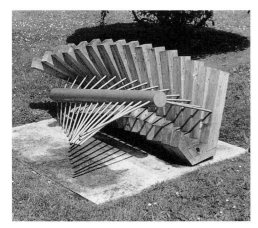

Glenton, *Sculpture*

Totem

Sculptor: Ian Davidson[1]

Sculpture in painted wood, steel and slate
h. 2.84m (9'4"); w. 1.3m (4'3"); d. 58cm (1'11")
Status: not listed
Owner: Loughborough College

Description: The wooden upright of *Totem*

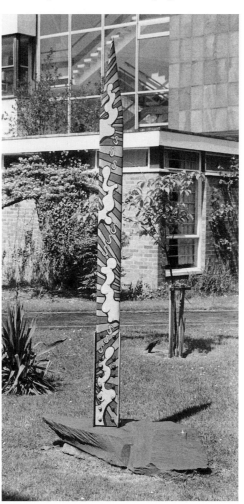

Davidson, *Totem*

is brightly painted in red, yellow, blue, orange, black and white; the steel bracket securing it to the slate base is painted yellow.

Condition: The paint is peeling on both the wood and steel parts; and where the surface is exposed on the latter, rust has formed.

Note
[1] Information from David Morris, Head of Sculpture, Loughborough University School of Art and Design.

2. In a niche in the main corridor of the Administration Block ('A' Block):

Praze

Sculptor: Denis Mitchell

Sculpture in steel
h. 1.63m (5'4")
Executed: 1964
Status: not listed
Owner: Loughborough College

Condition: good.
History: Leicestershire Education Authority purchased *Praze* in 1966 for £300 as part of its initial stocking programme for the College.[1]

Literature
L. Chronicle, 19 January 1968, p.**22**; Whitechapel Art Gallery, 1967, p.17, illus. betw. pp.18/19.

Note
[1] LEA inventory.

3. In 'C' Block quad:

Steel Myth

Sculptor: Antanas Brazdys

Sculpture in welded steel on a base in wood
Sculpture: h. 2.9m (9'6"); w. 90cm (3'); d. 51cm (1'8")
Base: h. 10.5cm (4"); w. 94cm (3'1"); d. 81.5cm (2'8")
Executed: 1965
Exhibited: 1965–6, London, Hamilton Galleries

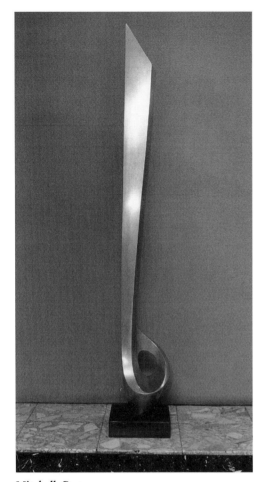

Mitchell, *Praze*

(no. 7); 1967–8, London, Whitechapel Art Gallery (no. 7)[1]
Status: not listed
Owner: Loughborough College

Condition: Although there appear to be no losses, the surface is extremely corroded.

History: *Steel Myth* was purchased by the Leicestershire Education Authority for £375 in

1966 as part of its initial stocking programme for Loughborough Technical College.[2]

The present sculpture is identical to a piece entitled *Motherless* in an article on Brazdys by Charles S. Spencer in *Studio International*, January 1966 (illustrated on p.25). Of this piece, Spencer says:

> Here again references to the human body can be detected, but it is a more skeletal

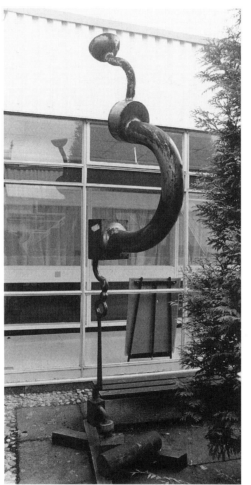

Brazdys, *Steel Myth*

design, concerned with the mechanics of the body rather than sensuous relationships. Thus one is reminded of bone structure, of joints and levers. The imagery is a combination of human and machine, the reduction of organic form to mechanical precision.[3]

Literature
Hamilton Galleries, 1965; Jones, D., 1988, p.86; Spencer, C., 1966a, pp.24, **25**; *Studio International*, vol. 175, no. 897, February 1968, p.**88**; Whitechapel Art Gallery, 1967, p.15.

Notes
[1] *Steel Myth* can be seen in the foreground of a general view of the exhibition in a photograph published in *Studio International*, vol. 175, no. 897, February 1968, p.88. [2] LEA inventory. [3] Spencer, C., 1966a, p.24.

Vertical Forms

Sculptor: Ezra Orion

Sculpture in steel, painted
h. 2.34m (7'8"); w. 49cm (1'7"); d. 42cm (1'5")
Status: not listed
Owner: Loughborough College

Description: Abstract sculpture comprising a cluster of vertical forms painted red, pale blue, grey and white.

Condition: Although there appear to be no losses, the surface is in poor condition; the paint is blistered and worn away in places, with rust where the metal is exposed.

History: *Vertical Forms* was purchased by the Leicestershire Education Authority for £40 in 1966 as part of its initial stocking programme for Loughborough Technical College.[1]

Note
[1] LEA inventory.

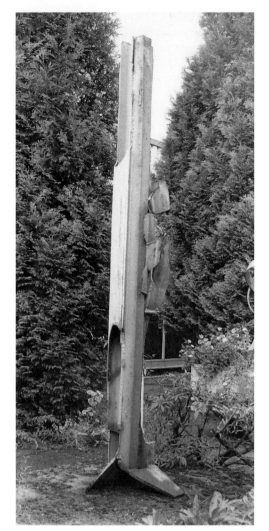

Orion, *Vertical Forms*

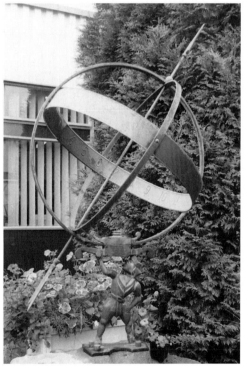

Adamek, *Loughborough College 25th Anniversary Sculpture*

Sculpture for the 25th Anniversary of Loughborough Technical College

Sculptor: Jan Adamek

Sculpture in metal on a stone plinth
Sculpture: h. 1.58m (5'2"); w. 89cm (2'11"); d. 84cm (2'9")
Plinth: h. 50cm (1'8"); w. 1.07m (3'6"); d. 83cm (2'9")
Inscriptions on a block held up by the figure (immediately beneath the astrolabe):
– front face: UNVEILED BY / LORD BULLOCK OF LEAFIELD / TO COMMEMORATE THE / 25TH ANNIVERSARY OF THIS COLLEGE / JUNE 1977
– rear face: LOUGHBOROUGH TECHNICAL / COLLEGE / 1952 – 1977
Signed on the curved section of the front face of the metal base: MADE BY J. ADAMEK
Status: not listed
Owner: Loughborough College

Description: A male figure, legs astride, holds above his head an astrolabe, the inside of the horizontal band of which is inscribed with the numbers 4, 5, 6, 7, 8, 9, 10, 11, 12, 1, 2, 3, 4, 5, 6, 7, 8. The metal base beneath the figure's feet is bolted to a rough stone plinth.

Condition: There appear to be no losses, although the original patination has mostly worn away. There is some rust around the bolts. Originally sited in the main foyer, the sculpture was evidently vandalised before its removal to its present location in a locked quadrangle.

Related works: (i) a reduced version now stands in Loughborough College reception area; (ii) a miniature version has been, on at least one occasion, presented to a member of staff on his retirement.

Royal National Institute for the Blind Vocational College (access only by prior arrangement), 1989, by Barbara Syme of McNeish Design Partnership (Motherwell)

From its inception the college was keen to establish a partnership with the local college of art that would result in the creation of artworks specifically aimed at visually-impaired people, for display in and around the building. David Tarver, then Head of Sculpture at Loughborough College of Art and Design, was approached and a fountain commissioned from him as the college was being erected. The architects also incorporated into the design of the interior corridors display niches and shallow indents, the latter specifically for a projected series of bas-reliefs by visually-impaired people. The College of Art and Design's commitment to the partnership was evidenced at the official opening of the college

when a number of art students presented work for display in the college.

The sculptural works in the grounds are as follows:

In front of the main entrance:
Sculpture (untitled)
Sculptor: Heather Ling[1]

Sculpture in limestone
h. 84cm (2'9"); w. 2m (6'7"); d. 66cm (2'2")
Status: not listed
Owner: RNIB Vocational College

Condition: The sculpture has suffered what appears to be recent damage, the upper right-hand part having lost a large chunk, with numerous cracks on the immediately surrounding surfaces.

Note
[1] Name of sculptor supplied by David Tarver, 5 July 1999.

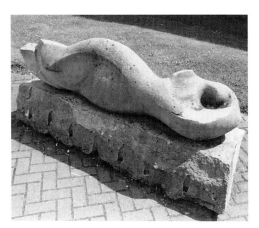

Ling, *Sculpture*

On a grassy slope to the right of the building:
Sculpture (untitled)
Sculptor: Cath Wilson

Sculpture in granite and wood
h. 1.98m (6'6"); w. 92cm (3'); d. 83cm (2'9")
Installed: 1991
Status: not listed
Owner: RNIB Vocational College

Description: The sculpture comprises three upright sections of timber with apertures encasing a large chunk of granite.
Condition: Good.

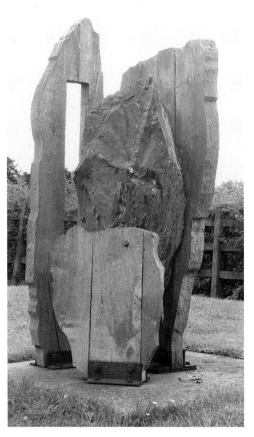

Wilson, *Sculpture*

In the courtyard:
Fountain (untitled)
Sculptor: David Tarver

Fountain in white Mansfield sandstone
h. (est.) 1.52m (5')
Installed: November 1991
Status: not listed
Owner: RNIB Vocational College

Description: Fountain in the form of a set of irregularly-stacked slabs of stone, those surfaces receiving water from the spout at the top having hollowed-out bowls and overflow channels.
Condition: Good.
History: According to the sculptor, the idea was that the sound of the water, amplified by the acoustics of the courtyard, should be as important as the visual appearance of the

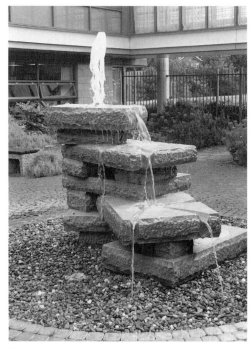

Tarver, *Fountain*

fountain. He also intended that people should be able to approach the fountain and run their hands through the falls and spurts of water.[1]

Literature
L. Mercury (Loughborough edn), 18 November 1991, p.4.

Note
[1] Information from David Tarver, 5 July 1999.

Thorpe Hill

Burleigh Community College (access only by prior arrangement), 1956, by T.A. Collins

1. On the lawn to the right of Gate 1:

Untitled

Sculptor: Garth Evans
Fabricators: Keeps Construction Company Ltd, Birmingham[1]

Sculpture in mild steel, painted grey (originally black)[2]
h. 2.44m (8'); w. 12.05m (39'7"); d. 2.14m (7')
Executed: 1971–2
Status: not listed
Owner: Leicestershire Education Authority

Condition: Fair, but with some scuffing to the paint surface as well as minor paint losses and areas of rust. There is also a small amount of graffiti.

History: Evans's *Untitled* was purchased for the present school in 1973. The £1,000 cost was funded in equal measure by the Leicestershire Education Authority's own buildings capital scheme and the Arts Council of Great Britain.[3] The sculpture had originally been commissioned for the Peter Stuyvesant Foundation City Sculpture Project of 1971–2.

The origins of the project lay in the renewed interest that had arisen during the late 1960s and early 1970s relating to the role of public sculpture in urban settings at a time when the

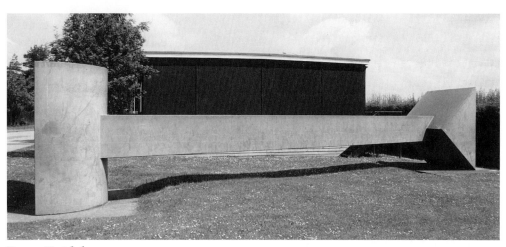

Evans, *Untitled*

majority of the public seemed to be completely bewildered by recent developments in art.[4] A number of exhibitions had been mounted exploring the debate, notably 'New British Sculpture / Bristol', 1968, 'Sculpture in Nottingham', 1969, and the Arts Council's touring exhibitions: 'Sculpture in a City', 1968, and 'New Sculpture 1969'. For the most part, however, these exhibitions had borrowed existing works and thus, it was subsequently felt, had explored in only a limited way the problems raised by, and possibilities open to, contemporary sculpture in urban public contexts. One exhibition which was considered to have more fully addressed such issues in as much as it had consisted entirely of new pieces commissioned for specific sites, was 'Sculpture in Environment', staged in New York in 1967. Importantly, although the exhibition ran for just the month of October, some sculptures had been sufficiently appreciated to have been purchased and retained on the sites for which they were designed.[5]

In the wake of these exhibitions, a series of informal meetings between some of the people

who had been involved in their organisation took place at the Arts Council's offices. Having examined the successes and failures of the earlier examples, the organisers began to formulate plans for an exhibition of major large-scale works which would be created specifically for sites selected by the chosen sculptors in eight city centres throughout England and Wales, and left *in situ* for a term of six months.[6] In addition to the sculptures there was also to be, most importantly, an Arts Council-sponsored touring exhibition of explanatory material which would, after its debut at the Institute of Contemporary Arts in London, show in rotation in each of the participating cities throughout the six-month period the sculptures were on site. The exhibition would introduce the selected artists to a wider public, present a brief visual survey of monuments and sculpture of the past, give details of other urban sculpture projects and suggest some future sculptural possibilities for urban contexts.[7]

The project organisers, Jeremy Rees of the Arnolfini Gallery, Bristol, and Anthony Stokes,

managed to secure financial backing for the commissioning of the sculptures from the Peter Stuyvesant Foundation, and so was born the so-called Peter Stuyvesant Foundation City Sculpture Project.[8] The aim was to site two works in each of the eight participating cities. These eight, which were chosen – with the approval of the relevant local authorities – on a 'population / demographic basis', were Newcastle, Liverpool, Sheffield, Birmingham, Cambridge, Cardiff, Southampton and Plymouth.[9]

The task of looking at photographs of the work of over 100 sculptors was entrusted to Stewart Mason (Director of Leicestershire Education Authority, 1947–71, and subsequently its advisor on arts purchases) and the sculptor Phillip King. From this initial selection a short list of 24 names was drawn up. The short-listed sculptors were invited to submit drawings and/or maquettes (for which they were paid a fee), together with a written report and detailed costings. They were also asked to state their top three preferred cities, following which each was taken to his or her allocated city to select a potential site in consultation with the organisers and the relevant city authorities. Meanwhile, a structural engineer examined the sculptors' proposals and reported back. From the 24 proposals, 17 were selected for full-scale realisation and siting.[10]

Jeremy Rees declared the purpose of the project to be:

... to provide an opportunity for sculptors to produce works related to a specific city environment, which can then be evaluated by a general public over a reasonable period of time and with the benefit of additional documentary exhibition material ... In no sense is the project an attempt to provide definitive works on a few chosen sites, but rather to raise the whole question of the potential of new sculpture in the city environment under conditions which we hope will be more favourable, for both the sculptors and the public, than those previously available.[11]

Garth Evans's untitled sculpture was erected in The Hayes, Cardiff, in 1972. Notwithstanding the site-specific nature of the sculpture it nevertheless still managed to cause bewilderment, if the sampled reactions published in Jeremy Rees's article in *Studio International* are anything to go by.[12] Nor is it clear how edifying the general public found the accompanying exhibition. The sculpture was presumably appreciated by Stewart Mason, however, who must have recommended its purchase by the LEA for the present school.

The sculptor's aims and the final episode in the sculpture's history are recounted in the draft of a booklet produced by the staff of Burleigh Community College in 1988:

The sculptor wanted this to be a relatively indestructible piece embodying qualities of simplicity and purposefulness. He also wanted the work to have the appearance of some form of tool or industrial equipment, and yet be enigmatic. In May 1972 the sculpture was placed on the pavement of The Hayes in Cardiff until it was purchased by Leicestershire and delivered to Burleigh in December 1973.[13]

Related works: In addition to the present sculpture, three others were also purchased by the Leicestershire Education Authority from the Peter Stuyvesant Foundation City Sculpture Project – John Panting's *Flying Cross* (see pp.228–9); Bryan Kneale's *Astonia* (see pp.237–8); and Peter Hide's *Large Compression Pillar* (see pp.310–11).

Literature
Leicestershire Education Authority archives. Jessop, M. and others, draft of a booklet on the artworks at Burleigh Community College, Loughborough, [1988].

General. Arts Council of Great Britain, 1972, n. pag.; Rees, J., 1972, pp.11–15, 21, **21**.
Notes
[1] Arts Council of Great Britain, 1972, n. pag. [2] Grieve, A., 1992, p.132. [3] LEA inventory. [4] The following account of the project is derived from J. Rees, 1972, p.15. [5] Arts Council of Great Britain, 1972, n. pag. [6] Rees, J., 1972, p.12. [7] Arts Council of Great Britain, 1972, n. pag. [8] The Peter Stuyvesant Foundation was at the time a keen promoter of contemporary art, having sponsored a series of annual exhibitions at the Whitechapel Art Gallery, starting in 1964 and including 'The New Generation: 1965' exhibition (see Whitechapel Art Gallery, 1965, pp.5–6). In addition it had formed its own collection of contemporary British painting, shown in its entirety at the Tate Gallery in 1967. [9] London was excluded because it was considered too large for two sculptures to have any significant impact. Nottingham and Bristol were also excluded as they had recently had two similar exhibitions, as referred to above (Rees, J., 1972, p.15). [10] The other selected sculptors were William Pye (Cardiff); Tim Scott and William Turnbull (Liverpool); Barry Flanagan and L. Brower Hatcher (Cambridge); Luise Kimme and William Tucker (Newcastle); Liliane Lijn and John Panting (Plymouth); Nigel Hall, Kenneth Martin and Bernard Schottlander (Sheffield); Peter Hide and Bryan Kneale (Southampton); and Robert Carruthers and Nicholas Monro (Birmingham). For accounts of the Birmingham commissions for this project – Carruthers's *Gate Construction* and Monro's *King Kong* – see Noszlopy, G.T. and Beach, J., 1998, pp.8, 170. [11] Rees, J., 1972, p.15. [12] *Ibid.*, p.21. [13] Jessop, M. and others [1988], n. pag. (LEA archives).

2. In a courtyard:
Boar
Sculptor: Michael Piper

Sculpture in bronze on a plinth in granite rubble
Sculpture: h. 1.03m (3'5"); w. 1.58m (5'2"); d. 32cm (1'1")
Inscription on a metal plaque fixed to the front face of the plinth:

THIS SCULPTURE BY MICHAEL PIPER / CAST IN 1958 IS IN LARGE PART / THE GIFT OF JOHN SHADLOCK MARR / WHO HAS BEEN ASSOCIATED

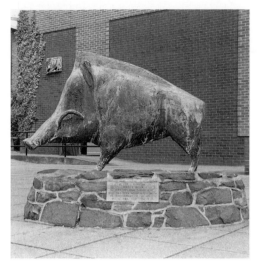

Piper, *Boar*

WITH / THE GOVERNMENT OF THE COLLEGE /
SCHOOL FOR OVER 24 YEARS
Status: not listed
Owner: Burleigh Community College

Condition: Generally fair, though with some
loss of patination.

3. At intervals along the exterior walls of
Gordon Broad block:

Signs of the Zodiac (relief series)
Sculptor: Willi Soukop

Reliefs in polychrome tin-glazed earthenware
Portrait format reliefs: h. 78.75cm (2'7"); w.
56.25cm (1'10"); d. 7.5cm (3")
Landscape format reliefs: h. 56.25cm (1'10"); w.
78.75cm (2'7"); d. 7.5cm (3")
Inscriptions: each relief has a scroll with the
name of the relevant sign inscribed on it, viz:
VIRGO, LIBRA, SCORPIO, SAGITTARIUS,
CAPRICORN, AQUARIUS, TAURUS, GEMINI, ARIES,
CANCER, LEO.
Status: not listed

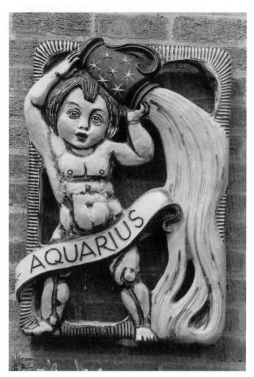

Soukop, *Aquarius*

Owner: Leicestershire Education Authority

Condition: The *Pisces* relief is missing, the
marks still on the wall showing its former
position. All the remaining reliefs are in good
condition.

Related works: Other sets (both complete)
are at The Martin High School, Anstey (see p.1)
and Guthlaxton Community College, Wigston
(see p.284).

Literature
Berger, J. 1957.

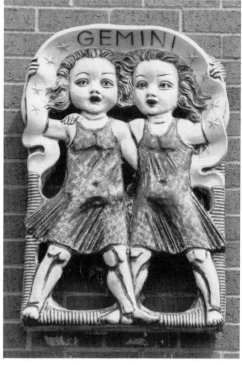

Soukop, *Gemini*

*Garendon High School 1953–5, by T.A.
Collins (access only by prior arrangement)*

On the west elevation of the inner courtyard:

Study and Sport
Sculptor: Robert Clatworthy

Sculpture in concrete, painted yellow
h. 2.64m (8'8"); w. 1.27m (4'2")
Executed: c.1955
Status: not listed
Owner: Leicestershire Education Authority

Description: A relief depicting two boys: the
one on the left stands with a rugby ball under

his arm; the one on the right sits on a stool with a book on his lap.

History: *Study and Sport* was commissioned for Garendon Boys' High School (as it was originally designated) by the Leicestershire Education Authority, as part of a programme to decorate school buildings throughout the County with specially commissioned sculptures. Other sculptors involved in the programme include Peter Peri, Antony Hollaway, Penelope Ellis, Ben Franklin, Ronald Pope and Willi Soukop.[1]

Literature
Pevsner, N. and Williamson, E., 1992, p.293.

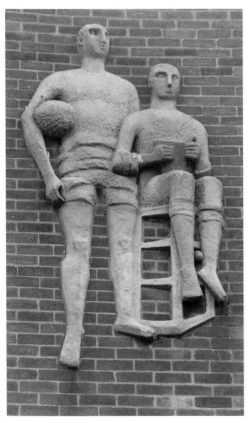

Clatworthy, *Study and Sport*

LUTTERWORTH
Civil Parish: Lutterworth
District Council: Harborough

Bitteswell Road

On the west side of Bitteswell Road, in front of Lutterworth Methodist Church:

Memorial Obelisk to John Wycliffe

Wycliffe (c.1330-84), was Rector of Lutterworth from 1374 until his death (for general biographical details, see p.86).

Designer: unknown
Masons: Garden and Co., Aberdeen[1]

Memorial in granite with panels in marble
h. (est.) 9.14m (30')
Inscriptions, all in incised and gilded Roman capital letters:
(i) On raised marble panels set into the pedestal:
– on the front face: JOHN WYCLIFFE / BORN 1324 / – / DIED 1384 / – / RECTOR OF LUTTERWORTH / FROM 1374 TO 1384 / –
– on the left face: THE / MORNING STAR / OF THE REFORMATION / – / THE FIRST TRANSLATOR / OF THE BIBLE / INTO THE / ENGLISH LANGUAGE / –
– on the right face: SEARCH / THE SCRIPTURES / JOHN. V. 39. / – / THE ENTRANCE / OF THY WORDS GIVETH / LIGHT / PSALM. CXIX. 130. / –
– on the rear face: BE FOLLOWERS OF / THEM WHO THRO' FAITH / AND / PATIENCE INHERIT THE / PROMISES / HEBREWS VI 12. / – / BE THOU FAITHFUL / UNTO DEATH / REV 11. 10. / –
(ii) On the plinth:
– front face: ERECTED IN THE 60TH YEAR / OF THE REIGN OF
– left face: HER MOST GRACIOUS MAJESTY / QUEEN VICTORIA JUNE 1897
Erected: 1897
Status: Grade II
Owner / custodian: Leicestershire County Council

Description: The memorial is in the form of an obelisk mounted on a pedestal and projecting plinth, raised on four steps and a platform.

Condition: Good; restored in April 1999.

History: Lutterworth's *Memorial Obelisk to John Wycliffe* was erected by the Wycliffe Memorial Committee to mark Queen Victoria's Diamond Jubilee. Whether there was an official unveiling ceremony it has not been possible to establish, but the memorial had almost reached completion by 3 July 1897.[2]

In 1999, as a precaution against potential structural damage brought on by the likely increase in traffic using the Bitteswell Road to reach the newly-opened Safeway store opposite, the memorial was resited several feet further away from the roadside with funds supplied by the store.

Related work: Richard Westmacott the Younger, *Wycliffe Memorial* (marble relief), 1837, in St Mary's Church, Lutterworth (Grade I listed).

Literature
Gerrard, D., 1996, p.70, 70; *Kelly's Directory of . . . Leicester and Rutland*, 1922, p.571; *L. Chronicle*: – [i] 19 June 1897, p.8 [ii] 3 July 1897, p.7; *M.H. Advertiser*, 22 June 1897, p.6.

Notes
[1] *L. Chronicle*, 19 June 1897, p.8. [2] Letter from Wycliffe Memorial Committee to Lutterworth Parish Council published in *L. Chronicle*, 3 July 1897, p.7.

Lutterworth Grammar School and Community College (access only by prior arrangement)

In the grounds:

Flying Cross

Sculptor: John Panting

Sculpture in mild steel tubes and aluminium alloy tubes, painted blue; with stainless steel cables.[1]

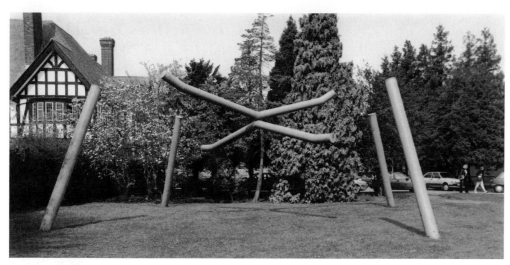

Panting, *Flying Cross*

h. (est.) 5.48m (18'); w. 11m (36'1"); d. 11m (36'1")
Executed: 1971–2
Status: not listed
Owner: Leicestershire Education Authority

Condition: Generally good. There are, however, some scuff marks and scratches on the lower parts of the upright tubes.

History: *Flying Cross* was originally commissioned in 1971 for the Peter Stuyvesant Foundation City Sculpture Project. Seventeen sculptors had been chosen from an original list of over 100 by the appointed selectors Stewart Mason (Director of Leicestershire Education Authority, 1947–71, and subsequently its advisor on arts purchases) and the sculptor Phillip King (for an account of the overall project, see pp.225–6). Each of the successful sculptors was asked to nominate his or her first three choices of city and from his selection Panting was allocated Plymouth. Following a visit to the city he nominated the North Cross Roundabout as the most promising site.[2] Each

of the sculptures was allowed to remain on site for six months throughout the summer of 1972 in the hope that locals would become familiar with it and, with the aid of a concurrent documentary exhibition of explanatory material, perhaps even come to appreciate it. This, sadly, does not seem to have been Panting's experience. As he commented bitterly in his report to the organisers:

> With the exception of the engineers and the site workmen who had a useful basis for coming to terms with the work, public response has been devoid of observation and consisted mainly of hostile reactions. The observations are useful, the abuse I can do without.[3]

In a statement published at the time of the exhibition, Panting explained how the conditions of the original site had informed his sculptural solution:

> Since form and size / scale are interdependent characteristics / constituents

it is difficult to make anything but the vaguest suggestion as to the size and form of a piece likely to work in a large extremely active space. I have attempted to overcome this problem by providing a skeletal structure that functions mainly in terms of its interior spatial relationships. This means that the form itself, the actual configuration, is unlikely to change whatever the size / scale of the final work. It also means that final size is absolutely crucial if the completed piece is to work effectively in terms of its surroundings.[4]

Notwithstanding Panting's efforts to tailor his sculpture for this specific location, Plymouth City Council evidently made no move to retain the piece. In 1973, *Flying Cross* was purchased by the Leicestershire Education Authority for the present school, most likely on the advice of Stewart Mason, the cost being met with funds provided through the LEA's buildings capital scheme and a grant from the Arts Council of Great Britain (the joint sponsors, with the Peter Stuyvesant Foundation, of the City Sculpture Project).[5]

Related works: In addition to *Flying Cross*, three other sculptures were purchased by the Leicestershire Education Authority from the Peter Stuyvesant Foundation City Sculpture Project – Garth Evans's *Untitled* (see pp.225–6); Bryan Kneale's *Astonia* (see pp.237–8); and Peter Hide's *Large Compression Pillar* (see pp.310–11).

Literature
Arts Council of Great Britain, 1972, n. pag.; Arts Council of Great Britain, 1980, p.22, **22**; Rees, J., 1972, pp.11–15, 27, **27**.

Notes
[1] Arts Council of Great Britain, 1972, n. pag.
[2] Rees, J., 1972, p.27. [3] As quoted in Rees, J., 1972, p.27. [4] *Ibid.* [5] LEA inventory.

Two Discs
Sculptor: Brian Wall

Sculpture in welded steel, painted black
h. 2.44m (8'); w. 1.93m (6'4"); d. 1.83m (6')
Executed: 1965
Exhibited: 1967–8, London, Whitechapel Art
Gallery (no. 56)
Status: not listed
Owner: Leicestershire Education Authority

Condition: Fair. The paint surface is,
however, scuffed and chipped in places with
small amounts of rust forming where the metal
has been exposed. The sculpture is currently
painted black although evidently the original
colour was blue.[1]

Wall, *Two Discs*

History: *Two Discs* was purchased by the
Leicestershire Education Authority in 1968
with funds provided by the buildings capital
scheme.[2]

Related work: *Two Discs*, 1965, steel painted
dark green.[3]

Literature
Arts Council of Great Britain, 1980, p.**22**; Spencer,
C.S., 1966c, p.**103**; *Studio International*, vol. 175, no.
897, February 1968, p.89; Whitechapel Art Gallery,
1967, p.18, illus. betw. pp.18/19.

Notes
[1] See Whitechapel Art Gallery, 1967, p.18 (no. 56)
and Spencer, C.S., 1966c, p.103. [2] LEA inventory.
[3] Illustrated in Spencer, C.S., 1966c, p.103.

Church Street
Lutterworth Memorial Gardens

At the extreme western corner:

Memorial to Air Commodore Sir Frank Whittle

Frank Whittle (1907–96), invented the jet
engine. Born in Coventry, the son of an
engineer, he earned a scholarship to Leamington
College. In 1923, he entered the RAF as an
apprentice, but was soon granted a cadetship at
the RAF College at Cranwell, afterwards
becoming a fighter pilot, test pilot and
instructor. In 1929 he formulated the idea of
using a gas turbine for jet propulsion, although
his ideas were dismissed by the Air Ministry as
over-optimistic. He nevertheless filed a
provisional specification at the Patent Office on
16 January 1930, although as it was not covered
by a security classification his idea became
openly available in 1932. Despite his invention
being ignored in Britain, his abilities at least
were ultimately recognised, and he was sent on
a course at the RAF School of Aeronautical
Engineering at Henlow. His success here led to
the Air Ministry arranging for him to go in
1934 to Peterhouse, Cambridge, and two years

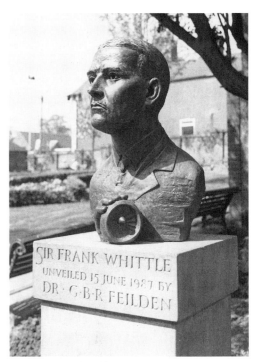

Ford, *Sir Frank Whittle*

later he took first-class honours in the
Mechanical Sciences Tripos. In May 1935, he
co-founded Power Jets, based at the works of
the British Thomson-Houston company at
Rugby. On 12 April 1937, the company
successfully ran the first gas turbine jet engine,
although the Air Ministry still showed no
interest. Ultimately, the Air Ministry awoke to
the potential of Whittle's invention and in 1939
instructed the Gloster aircraft company to build
an experimental aeroplane. Whittle continued
his developmental work on the jet engine firstly
in a former foundry, Ladywood Works in
Lutterworth, and later at Whetstone,
Leicestershire. The Gloster Whittle E28/39
made its first successful flight on 15 May 1941,
but owing to limited financial resources, it was

not until 1944 that the first operational British jet aeroplane, the twin-jet Meteor, made its appearance. Whittle eventually retired from the RAF in 1948 and afterwards served as technical advisor to BOAC, Shell Group and Bristol Siddeley/Rolls Royce successively. He was appointed CBE in 1944, Commander of the US Legion of Merit in 1946, and CB in 1947. In 1976 he moved to the USA with his second wife, an American. He returned on many occasions to receive honours, notably in 1986 to be awarded the Order of Merit.

Source: *The Times*, 10 August 1996, p.21 [obituary]

Sculptor: Ken Ford
Stonemasons for the plinth: Herberts (Masonry Contractors) Ltd

Bust in bronze on a plinth in Stanton Moor Derbyshire grit
Bust: h. 44cm (1'5"); w. 28cm (11"); d. 20.5cm (8")
Plinth: h. 1.21m (4'); w. 35.5cm (1'2"); d. 30.5cm (1')
Inscriptions:
– incised into the front of the plinth cap: SIR FRANK WHITTLE / UNVEILED 15 JUNE 1987 BY / DR. G.B.R FEILDEN
Unveiled: Monday 15 June 1987, by Dr G.B.R. Fielden
Status: not listed
Owner / custodian: Lutterworth Town Council

Description: The memorial is in the form of a bronze bust on a plinth, with the subject's right hand emerging from the top of the plinth, holding a model of a jet engine. His head, with deeply hollowed pupils, is turned to his right. He is represented wearing a jacket with the RAF badge (crown and wings) on the breast, and a shirt and tie.

Condition: Generally good, having been recently restored following damage by vandals. The forward top edge of the plinth is slightly chipped.

History: Ken Ford's *Bust of Sir Frank Whittle* was unveiled as part of the celebrations marking the fiftieth anniversary of the first test run of Whittle's jet engine. Although the sculptor was not by inclination a portraitist, as he explained to the committee representative who offered him the commission, he agreed at the latter's urging to attempt the bust of Whittle. As Whittle was at the time living in the United States, he was not available to pose for the bust and so Ford created the likeness working purely from photographs supplied by the committee.[1]

The day's celebrations started at Lutterworth Town Hall with the arrival of Sir Frank and Lady Whittle, after which a commemorative plaque was unveiled (see 'Related Work', below). The whole company then proceeded to the Memorial Gardens to witness the unveiling of the bust before travelling on to Bitteswell Airfield to view a display of early jet engines. The day's events closed with an RAF flypast.

Related work: Commemorative plaque, Lutterworth Town Hall, cast by R.C. Harrison & Sons, unveiled on the same day as the present work. The plaque is inscribed: THIS PLAQUE COMMEMORATES THE 50TH. ANNIVERSARY OF THE TEST / RUN OF THE FIRST GAS TURBINE ENGINE ON 12TH. APRIL 1937 AT / THE BRITISH THOMSON HOUSTON COMPANY IN RUGBY AND THE / SUBSEQUENT DEVELOPMENT AT LADYWOOD WORKS, LUTTERWORTH, BY / SIR FRANK WHITTLE / O.M., K.B.E., C.B., F.R.S., F.ENG., AIR COMMODORE R.A.F. (RETD). / UNVEILED BY DR. G.B.R. FEILDEN C.B.E. 15TH. JUNE 1987

Literature
Herberts stone masons (publicity brochure); *L. Mercury*, 16 June 1987, p.12; *Sir Frank Whittle, Lutterworth 1987. 50th Anniversary of the First Test Run of a Jet Engine* (unveiling ceremony programme of events).

Note
[1] Information supplied by the sculptor.

Market Square
Lutterworth Market Place Sculpture
Sculptor: Martin Williams

Sculpture in glazed ceramic panels on a concrete core
h. 2.83m (9'4"); dia. 1.39m (4'7")
Inscriptions in gold lustre, running around the circumference of the tower, four lines near the top, four lines near the bottom:
Upper inscription: TERRA MAINNON BRITONIS. / Maino Brito teñ de rege / LVTRESVRDE. Ibi st̄. XIII. / car̄ træ. Ibi fuer̄. IX. car.
Lower inscription: In dn̄io st̄. III. car̄. 7 II. ferui. 7 I. ancilla / 7 VI. uitti cū VII. bord 7 XII. fochi hn̄t. IIII. car̄. / Ibi XII. ac pti. Valuit 7 uat. VII. lib. Radulf' / com̄ tenuit has. III. tras Martin Williams
(the above is the entry for Lutterworth in the Domesday Book – with the artist's name added at the end; the entry translates as follows:
Mainou the Breton holds Lutterworth from the King. 13 c. of land. There were 9 ploughs. In lordship 3 ploughs; 2 male and 1 female slaves. 6 villagers with 7 smallholders and 12 freemen have 4 ploughs. Meadow, 12 acres. The value was and is £7. Earl Ralph held these 3 lands.)[1]
Unveiled: Tuesday 17 June 1997, by the Mayor of Lutterworth
Status: not listed
Owner: Lutterworth Town Council

Description: Located at the northern edge of the Market Place in the centre of a starburst pattern of paving and separated from the Market Place by seven ball-topped bollards painted blue and gold, the sculpture is in the form of a tapering truncated cone mounted on a circular base and surmounted by a green sphere. The surfaces are covered with glazed polychrome ceramic tiles. The sphere is decorated with a pattern of small images in

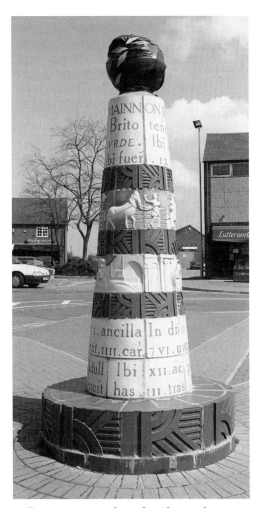

Williams, *Lutterworth Market Place Sculpture*

relief repeated three times; these include an open book, a jet aeroplane, a star, and a bull's head. The cone has eight courses of variously-sized tiles. The top course carries the first four lines of the inscription, taken from the Domesday Book. The second, fourth and sixth courses in green have abstract geometric designs

derived from the patterning of medieval 'ridge and furrow' field systems. The third and fifth courses have figurative friezes. The upper one shows medieval agricultural scenes through the seasons, starting with horse-drawn ploughing, followed by a man with a slingshot scaring birds away from the planted fields, then the wheatsheafs being gathered in, and lastly the wheat being stored. The lower frieze shows urban scenes and people, including a head and shoulders of John Wycliffe, a butcher in his shop with the words 'THE SHAMBLES' underneath (as in the pub sign opposite the sculpture), some vegetables and a rose. The colours on the figurative friezes include blue (the sky), red (the ploughed earth, etc.) and yellow (wheatfields and buildings, etc.). The lowest two courses of tiles continue the Domesday Book inscription, plus the sculptor's name. The wide circular base continues the green ridge-and-furrow design.

Condition: The sculpture has been vandalised: there is a large rectangular hole in the sphere and, on the lower figurative frieze of the cone, the right-hand segment of the rim of the jet engine is broken. The edge of the base is slightly chipped in places.

History: The *Lutterworth Market Place Sculpture* was commissioned as part of a £150,000 town enhancement scheme. For a number of years there had 'been concern that the state of the central market place was detracting from the town's appearance and commercial potential'.[2] In early 1995, a small working party was established comprising members from the Town, District and County Councils and the Lutterworth Chamber of Commerce. An overall development plan was formulated, put on public exhibition in August 1995 and, with a few minor amendments, approved by the respective councils. At the heart of the plans for the Market Place was a proposal for a sculpture to create a central point of interest in this hitherto featureless area. The

partners in the scheme agreed that the sculpture project should be managed by Leicestershire County Council's Department of Planning and Transportation.

From the beginning it was agreed that the sculpture should reflect not only Lutterworth's past but also its aspirations for the future. To create visual unity in its immediate vicinity, themes developed in the sculpture were to be extended into other elements of the enhancement scheme, such as ornamental paving, bollards, seats and planters, and it was decided that the selected artist should be invited to advise the design team for the overall scheme on how this might be done. A sub-group comprising members from all the partners, plus the local Community College and East Midlands Arts, was formed to advise on the preliminary brief (which had been drawn up by Tony Lockley of Leicestershire County Council), to supervise the selection of a suitable design and to see the sculpture through to completion. It was estimated that the sculpture would cost something in the region of £10,000, a sum ultimately made up by contributions from Leicestershire County Council, Harborough District Council and Lutterworth Town Council.

In May 1996 an advertisement was placed in *Artists Newsletter*. From the responses, a short list of five was drawn up: Martin Williams, Robert Koenig, Jane Ackroyd, John Fortnum and a two-person team, Chloe Cookson and Rory McNally. In June a detailed brief was sent to each one. In addition to the requirements referred to above, the brief stressed the necessity of selecting durable, preferably local, materials for the finished piece. A deadline of 19 September 1996 was set for entrants to deliver a two-dimensional sketch, a maquette and a written description of the work to Lutterworth Town Hall. The artists were to arrange their own displays on the tables and screens provided so that the public could see the range of designs and vote for their favourite piece (the artists

were instructed to depart before the public arrived so as to prevent canvassing); in the afternoon and evening the displays were to be put on show at Lutterworth Community College. The displays were to be anonymous (each work being identified by a letter only). Each short-listed artist was to receive £500 and the successful candidate would be required, in addition to carrying out the commission, to undertake a series of workshops – two with pupils at Lutterworth Community College and one at another Lutterworth school – and to address a public meeting to explain his or her sculpture. The completed sculpture was to be in place by March / April 1997.

On 19 September 1996, the five entrants displayed their work and an estimated 250 people visited the exhibitions. The overwhelming majority of those who attended voted for John Fortnum's design, a representation of John Wycliffe. This vote, however, was only intended as a guide to the project sub-group who, calling on their professional expertise and experience, were required to assess the practicalities and potential problems inherent in each design. The sub-group narrowed the choice down to the people's favourite and Martin Williams's design. Both sculptors were asked 'to modify their designs to be more in keeping with the surroundings' and to re-submit them and attend an interview. Following interviews with both sculptors on 29 October 1996, Williams's design was chosen for the commission. Tony Lockley, Leicestershire County Council environment team leader, explained:

> The steering group felt that there was a quality about Martin Williams's work that was very appropriate for a central town location. He has worked in similar situations in both South Wales and London and the information that we have on that work convinced the steering group that he was

capable of providing a very high quality piece of work.[3]

Literature
Leicestershire County Hall. Various documents relating to the *Lutterworth Market Place Sculpture*. **General**. *L. Mercury (Harborough edn)*, 12 November 1996, p.5; *L. Mercury*, 22 October 1997, p.23.

Notes
[1] As translated in *Domesday Book. 22. Leicester*, Chichester, 1979. [2] Leicestershire County Council, *Lutterworth Market Place – Central Sculpture: Application for grant aid*, 17 June 1996. [3] *L. Mercury (Harborough edn)*, 12 November 1996, p.5.

Woodway Road

Lutterworth High School (access only by prior arrangement)

1. In the lobby:
Echo I
Sculptor: David Partridge

Relief in nails, wood and aluminium
h. 1.83m (6'); w. 91.4cm (3')
Executed: 1966
Exhibited: 1967, London, Hamilton Galleries (no. 13)
Status: not listed
Owner: Leicestershire Education Authority

Condition: Fair, although a few of the nails in the lower part of the relief are missing.
History: *Echo I* was purchased by the Leicestershire Education Authority in 1968 with funds made available through the buildings capital scheme.[1]
For an appreciation of Partridge's nail sculptures by a contemporary art critic, see pp.167–8.

Literature
Hamilton Galleries, 1967.

Note
[1] LEA inventory.

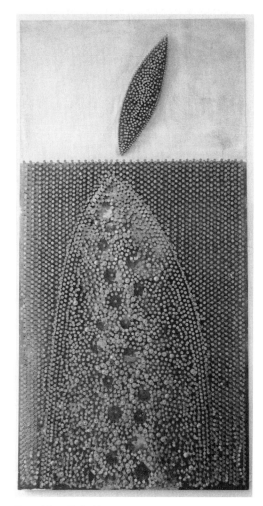

Partridge, *Echo I*

2. In the grounds:
Big Ring
Sculptor: David Annesley

Sculpture in steel, painted blue and white
h. 1.78m (5'10");[1] w. 2.74m (8'10"); d. 46cm (1'6")

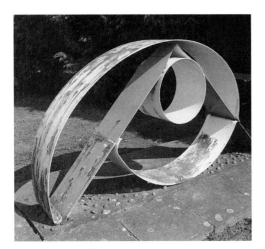

Annesley, *Big Ring (damaged state)*

Executed: 1965
Exhibited: 1966, London, Waddington Gallery;[2] 1966, London, Battersea Park (no. 2); 1967–8, London, Whitechapel Art Gallery (no. 3)
Status: not listed
Owner: Leicestershire Education Authority

Description (original state): Abstract sculpture in painted sheet steel comprising a small inner ring suspended in the angle of an inverted 'V' shape and a big concentric outer ring, in two sections, one over-arching, the other under-arching the 'V', to which both are bolted. The rings are painted white and the inverted 'V' shape blue.
Condition: Poor. There are extensive paint losses, rust having formed where the metal is exposed. The remaining paint is blistered and peeling in places. Most importantly, the over-arching section of the big outer ring has collapsed onto the apex of the inverted 'V' shape following the breakage of the bolts securing one of its ends.
History: *Big Ring* was purchased by the Leicestershire Education Authority in 1966

with funds provided through the buildings capital scheme.[3]

Literature
Art and Artists, April 1966, p.10; Greater London Council, 1966, no. 2 (illus., n. pag.); Rees, J., 1972, p.11; Whitechapel Art Gallery, 1967, p.15, illus. betw. pp.18/19.

Notes
[1] This is the height as given in Whitechapel Art Gallery, 1968 (pl. between pp.18/19). Following the breakage of the bolts holding in place one of the ends of the outer ring's upper segment (see 'Condition'), the height is currently reduced to 40.5cm (4'7").
[2] *Big Ring* (referred to as *Sculpture 1965*) was used to illustrate a brief notice of Annesley's solo exhibition at the Waddington Gallery in *Art and Artists*, April 1966, p.10. [3] LEA inventory. *Big Ring* had been lent to the GLC's Battersea Park open-air exhibition from May to September of that year by the Waddington Galleries, so the latter were presumably the vendors.

Process through a Curve
Sculptor: Neville Boden

Sculpture in steel, painted purple
h. 84.5cm (2'9"); dia. 1.35cm (4'5")

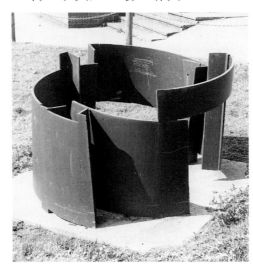

Boden, *Process through a Curve*

Executed: *c.*1974
Status: not listed
Owner: Leicestershire Education Authority

Condition: Fair. The paint surface is scuffed and scratched with some small losses; the inside of the drum has some scratched graffiti.
History: *Process Through a Curve* was purchased by the Leicestershire Education Authority in 1974 with funds provided through the buildings capital scheme.[1]

Note
[1] LEA inventory.

The Park
Bosworth Hall Hotel

Originally built, before 1692, as the private residence of Sir Beaumont Dixie, second baronet of Bosworth Park. It was extensively altered between *c.*1837 and 1850 by the eighth baronet and, from 1885 onwards, by Charles Tollemache Scott.[1]
Status: Grade II*
Owner: Britannia Hotels

On the front face of the Water Tower (*c.*1885), in a shell-headed niche over the entrance archway:

Diane de Gabies, or Diana Robing
Sculptor: unknown

Copy in (?)artificial stone after an antique statue in marble
h. (est.) 1.52m (5')
Status of building: Grade II
Owner: Britannia Hotels

Description: The statue is located on the

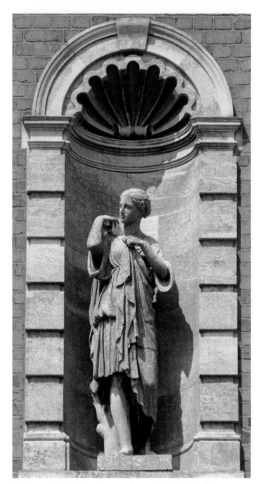

Diane de Gabies (copy after original in the Louvre)

front face of the second storey of the Water Tower in a shell-headed niche framed by pilasters supporting an open-topped pediment. It represents Diana (Roman) or Artemis (Greek) looking to her right as she walks forward slowly, her right foot forward, her left heel raised. She wears sandals and a knee-length dress and is in the act of securing a second piece of drapery at her right shoulder.

Condition: Good.

History: This is a copy after the marble statue in the Louvre, Paris, known variously as *Diane de Gabies*, *Diana Robing* or *Diana Succinct*. The Louvre statue is a Graeco-Roman copy of an original believed to have been made by Praxiteles (mid fourth century BC) for the temple of Artemis Brauronia on the Acropolis, Athens.[2] According to Margarete Bieber:

> Actual dresses were dedicated to this Artemis [i.e., Diana], who was a special protectress of women, particularly of mothers. The temporary arrangement of both dresses is meant to show how the goddess accepts and uses the garments offered by her votaries.[3]

The title by which the Louvre statue is more generally known, *Diane de Gabies*, refers to the fact that it was excavated at Gabii, just outside Rome, on land belonging to Prince Borghese, in 1792. It was purchased by Napoleon Bonaparte (brother-in-law to Prince Camillo Borghese) in 1807 and by 1820 it had entered the collections of the Louvre. The statue's fame increased throughout the nineteenth century, an early plaster cast being acquired for the entrance hall of the Athenaeum, London, on the advice of Sir Thomas Lawrence. Replicas were manufactured in a variety of materials, including bronze, basalt stoneware (W.T. Copeland), terracotta (J.M. Blashfield), and plaster (Brucciani).[4] Neither the date nor the provenance of the present example are known.

Literature
Foss, P.J., 1983, p.154; Haskell, F. and Penny, N., 1981, pp.198–99, **199**.

Notes
[1] Pevsner, N. and Williamson, E., 1992, p.303. [2] Haskell, F. and Penny, N., 1981, p.198. [3] As quoted in *ibid.*, pp.198–9. [4] *Ibid.*, p.198.

In the grounds east of the vinery, in 'The Wilderness':

Monument to Smut (a dog)
Sculptor: unknown

Monument in Portland stone
Pedestal: h. 1m (3'3")
Inscriptions in Roman capital letters on the north face of the pedestal:
Upper inscription: FORGET ME NOT / [space] / MY LITTLE SWEET COMPANION, GENTLE FRIEND, / O THINK NOT LYING IN THY LONELY GRAVE / MY THOUGHTS CAN WANDER OR FORGET THE SPOT / WHERE LIES THE LAST THAT EARTH CAN GIVE OF THEE, / THE DEAREST TRUEST FRIEND I EVER KNEW / FORGET ME NOT I SEEM TO HEAR THEE SAY / FORGET THEE! NEVER! NEVER WHILE MEMORY LIVES / CAN THIS SAD HEART DO AUGHT BUT DREAM OF THEE / AND TEND WITH GENTLE LOVE THY LAST REPOSE. / BENEATH THIS SOIL, SLOW CRUMBLING TO DECAY / SLEEPS BUT THE SHELL OF ONE THAT WAS SO DEAR – / SWEET LITTLE SPIRIT DOST THOU HOVER ROUND / WITH THE OLD FAITHFUL LOVE OF FORMER DAYS. / DEATH HAS NOT SEVERED THEE BUT ONLY DRAWN / ACROSS LIFE'S DREARY STAGE THE VEIL WHICH HIDES / THAT NEVER-DYING LIFE THAT SHONE SO CLEAR – / IMMORTAL IN THY SPIRIT AWAIT ME WHERE / WHEN I HAVE SOUGHT MY LAST ETERNAL REST / I CAN REJOIN THEE NE'ER TO PART AGAIN / [space] / FLORENCE DIXIE
Lower inscription: TO SMUT / A BLACK AND TAN / OLD ENGLISH TERRIER / THE PROPERTY OF / LADY FLORENCE DIXIE. / KILLED ON THE LINE THURSDAY MAY 11TH 1876 / NEAR WROXHALL STATION ISLE OF WIGHT / BEING RUN OVER BY A TRAIN WHILE TRYING / TO TRACE HIS MISTRESS WHO HAD BEEN / ON THE SAME SPOT WITH HIM THE DAY / BEFORE SHE LEFT ENGLAND WHICH / DAY WAS FIVE DAYS PREVIOUS TO / THAT OF HIS DEATH. / HERE LIES AN OLD AND FAITHFUL / FRIEND NEVER FORGOTTEN
Erected: after 1876
Status: Grade II

Owner: Britannia Hotels

Description: Located in a somewhat overgrown area of woodland, the monument is in the form of a marble pedestal ornamented with carved doves drinking from bowls. Originally there was one dove and a large bowl surmounting the pedestal, with a dove and a smaller bowl supported on a scroll at each corner of the plinth course of the pedestal. The top dove and bowl are missing as is the dove that once decorated the north-west corner of the plinth course.

Condition: Poor. The carved dove and bowl from the top of the pedestal were stolen relatively recently, that on the north-west corner of the plinth course having been missing for some time.[1] The whole pedestal is covered in green biological growth.

History: The *Monument to Smut* was erected, as described in its inscription, by Lady Florence Dixie (1857–1905). Described in the *DNB* as an authoress, traveller, champion of women's rights and later in life a campaigner against blood sports, she had married Sir Alexander Beaumont Dixie, the then owner of Bosworth Hall, in 1875.

Literature
Foss, P.J., 1983, pp.168–9, **168**; Pevsner, N. and Williamson, E., 1992, p.304.

Note
[1] A photograph in Foss, P.J., 1983, p.168, shows the upper dove and bowl still present, but the lower one missing.

In a field about one kilometre south of Market Bosworth, now privately owned but formerly part of the Southwood of Bosworth Park:

The Hercules Monument

Sculptor: unknown

Statue in stone on a stone pillar
Height overall (est.): 3.4m (12′5″)
Executed: 18th century

Status: Grade II
Owner: unknown

Description: The monument comprises a tall base constructed of large rough-hewn blocks, the lowest four courses being without mortar, the whole structure tapering towards the summit. Surmounting this base is a plinth supporting a stone statue of Hercules leaning against a tree trunk over which is draped the skin of the Nemean lion. An old photograph[1] shows the figure before the loss of its left arm. The arm is raised, apparently in the act of lifting one end of the lion-skin, as if donning it as a cloak.

Hercules (Gk Herakles) was an ancient Greek hero, the son of the mortal Alcmena and the supreme ruler of the gods of Olympus, Jupiter (Gk Zeus). Following a fit of madness, during which he slew his own children, Hercules visited the Delphic oracle to discover how he might atone for his crime. The oracle ordered him to serve King Eurystheus for a period of twelve years and to undertake any task he might nominate. These tasks became known as the twelve labours of Hercules and the first was the slaying of the Nemean lion. The lion, which had been terrorising the people of Nemea, was eventually strangled by Hercules after proving invulnerable to his weapons. Having killed the lion, Hercules flayed it and used its pelt as a cloak. Along with the club, the skin of the Nemean lion is one of the most common attributes of Hercules.[2]

Condition: Poor. The statue is covered in lichen and is extremely weathered, the facial features being hardly discernible. There is damage to the edge of the lion skin hanging down Hercules's back, and his left forearm is missing.

History: The statue of Hercules is, according to Pevsner, from an eighteenth-century monument.[3] It was set up as the central feature of a star-shaped pattern of walkways in what was then called the 'Southwood' of Bosworth

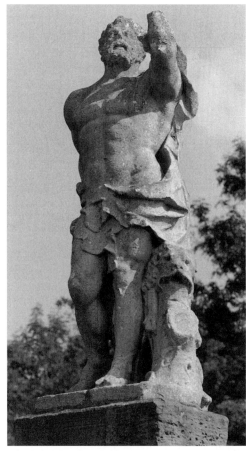

The Hercules Monument

Park by either Sir Wolstan Dixie, the fourth baronet (1700-67), or his namesake, the fifth baronet (1738–1806).[4]

Literature
Foss, P.J., 1983, p.153, **152**; *H. Times*, 10 April 1997, p.17; Pevsner, N. and Williamson, E., 1992, p.304.

Notes
[1] Foss, P.J., 1983, p.152. [2] Hall, J., 1979, p.148. [3] Pevsner, N. and Williamson, E., 1992, p.304. [4] Foss, P.J., 1983, p.153.

Burnmill Road

The Robert Smyth School (access only by prior arrangement)

Beside the playing fields, outside the Design Department:

Astonia

Sculptor: Bryan Kneale
Fabricators: Henry Hartley & Co. Ltd, London[1]

Sculpture in shot blasted steel,[2] painted grey h. 7.9m (25'11");[3] w. 7.1m (23'4"); d. 4.84m (15'11")
Executed: 1971–2
Status: not listed
Owner: Leicestershire Education Authority

Condition: Fair, though some of the paint surface is scuffed.

History: *Astonia* was originally commissioned in 1971 for the Peter Stuyvesant Foundation City Sculpture Project. Seventeen sculptors had been chosen from an original list of over 100 by the appointed selectors Stewart Mason (Director of Leicestershire Education Authority, 1947–71, and subsequently its advisor on arts purchases) and the sculptor Phillip King (for an account of the overall project, see pp.225–6). Each of the successful sculptors was asked to nominate his or her first three choices of city and, from his list, Kneale was allocated Southampton. Following a visit to the city he selected the forecourt of Southampton City Art Gallery as his specific site.[4] *Astonia*, in common with each of the other commissioned sculptures, was allowed to remain on site for six months, from late May to November 1972, in the hope that local people would become familiar with it and perhaps even come to appreciate it. There was, in addition, an Arts Council-sponsored touring exhibition of explanatory material which showed at Southampton City Art Gallery from 8–24 November 1972.[5]

Speaking of his approach to sculpture, both in general and in relation to this commission, Kneale said:

> I have always varied the scale of my sculpture considerably. Changes of scale, weight and material are part of the vocabulary of sculpture, and there are times when thousandths of an inch are as critical as feet or yards might be on another occasion. But the decisions taken relate. Inevitably one's personal approach and concept of sculpture remain unchanged no matter in what circumstances the sculpture is conceived.

> The opportunity to work on a massive scale is pretty infrequent but the chance when it comes – when it has a reason – has great point.

> To be put at risk in this way enables a variety of ideas to be tested and there is no substitute for the experience.

> I chose the site at Southampton for a specific reason: it seemed that in this large rather gloomy forecourt – a box with one side missing and open to the sky – a sculpture could survive on its own terms and be in fact a necessary and logical structure to be placed there.

> I was very conscious of the space and decided to make a piece which would, as far as I was able, use the space as something very much to do with [the] actual forms I made.

> The site did not dictate the form the sculpture took, but it did allow certain things to happen which in working in a studio situation could well not have occurred ...

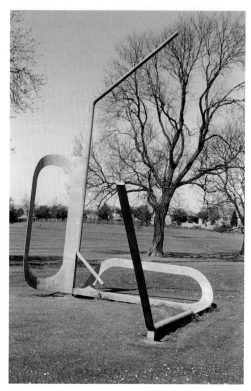

Kneale, *Astonia*

> I was strongly aware of the space available ...

> ... [the] sculpture could be seen from some considerable distance, under differing weather – sunlight, rain – the movement of shadows; the whole atmosphere and quality gained by the fact that the site is on the top of a hill.

> The opportunities gained by placing work outside are of course balanced by the demands made upon the work. It must justify its existence. If the object is to work it has to have sufficient interest not only to the visually trained but also to those who might never have seen a piece of contemporary

sculpture. In other words it must be self-sufficient.

I was interested in taking part in this project for quite another reason ... It seems to me that unless sculptors are given the opportunity to exhibit and work in a public arena the whole concept of art becomes relegated to a purely minority occupation – accessible to fewer and fewer people. In turn solely dependent on the incestuous cycle of art schools and art teaching.[6]

Although Kneale had clearly given much thought to the suitability of the design of his sculpture in relation to its location, Southampton City Council evidently had no wish to retain it and in 1973, *Astonia* was purchased by the Leicestershire Education Authority for the present school, most likely on the advice of Stewart Mason. The cost was met with funds provided through the Leicestershire Education Authority's buildings capital scheme.[7] *Astonia* is known affectionately at the school as the 'broken spectacles / scissors'.[8]

Related works: Three other sculptures were, in addition to the present one, also purchased by the Leicestershire Education Authority from the Peter Stuyvesant Foundation City Sculpture Project – Garth Evans's *Untitled* (see pp.225–6); John Panting's *Flying Cross* (see pp.228–9); and Peter Hide's *Large Compression Pillar* (see pp.310–11).

Literature
Arts Council of Great Britain, 1972, n. pag.; Rees, J., 1972, pp.11–15, 32, **32**.

Notes
[1] Arts Council of Great Britain, 1972, n. pag.; Rees, J., 1972, p.32. [2] Arts Council of Great Britain, 1972, n. pag. [3] Height as given in *ibid*. [4] Rees, J., 1972, p.32. [5] Arts Council of Great Britain, 1972, n. pag. [6] Rees, J., 1972, p.32. [7] LEA inventory. The inventory makes no mention of any contribution from the Arts Council of Great Britain, although given that the Council co-funded the LEA's contemporaneous purchases of the Garth Evans and John Panting sculptures – originally commissioned

for the same project – for Loughborough and Lutterworth, it seems probable that it may have assisted the LEA with the equally large sum involved here. [8] According to Alan Treherne, Head of Art, The Robert Smyth School.

St Mary's Place

Sainsbury's Supermarket, opened in November 1993

On the exterior wall, by the exit:
Relief of Farming Life
Sculptor: Richard Kindersley

Relief in carved brick
h. 1.2m (3'11"); w. 11.48m (37'8")
Inscriptions:
– carved into the brick across the upper part of the relief: SITE OF THE CATTLE MARKET / 1903 – 1992
– printed on a small metal plaque fixed at lower left hand corner of the relief: THIS MURAL,

COMMISSIONED BY SAINSBURY'S / DEPICTS SCENES FROM THE FARMING LIFE / ASSOCIATED WITH THE CATTLE MARKET WHICH / STOOD ON THIS SPOT. IT WAS DESIGNED AND / SCULPTURED BY RICHARD KINDERSLEY. / OCTOBER 1993
Status: not listed
Owner: Sainsbury Plc

Description: Carved into the exterior wall to the right of the exit in St Mary's Place, the relief has representative images signifying the agricultural life of the local area centred on the cattle market formerly occupying this site (1902–92). From left to right, images include the sun, a fieldmouse, wheat, a cockerel, the head of a ram, a pig, an auctioneer with mallet raised, a sheepdog, milk churns, a tractor wheel and a cow. The carving is lightly coloured with a brick dye.[1]

Condition: Good.

Note
[1] Information from the sculptor.

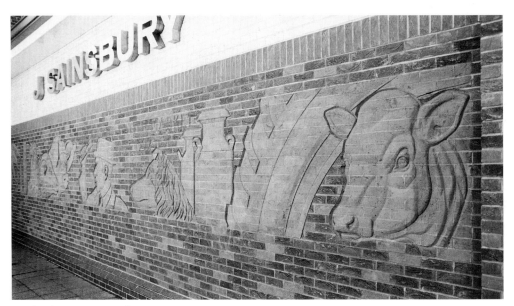
Kindersley, *Farming Life*

The Square

Market Harborough War Memorial
Architect: Walter Talbot Brown
Sculptor: unknown
Contractors: W. Allsop and Sons[1]

Memorial in Clipsham stone
Overall h. 9.45cm (31")
Base: 5.28m (17'4") × 5.28m (17'4")
Inscriptions:
– on the front (north) face of the uppermost tier
of the pedestal in raised capital letters:
TO THE GLORY OF GOD / IN GRATEFUL
REMEMBRANCE / OF ALL IN THE PARISHES / OF
MARKET HARBOROUGH / GREAT & LITTLE
BOWDEN / WHO SERVED IN THE GREAT WAR 1914
– 1918 / THIS CROSS IS ERECTED AS / AN
ENDURING MEMORIAL / OF THE FALLEN. / THEIR
NAME LIVETH.
[on four bronze plaques on the tier below this,
facing north, south, east and west, the names of
the 254 men of Market Harborough who died
in the First World War. The names, in raised
capital letters, are in alphabetical order – with
later additions – surnames followed by initials
only].
– on the octagonal tabernacle, incised into the
stone beneath the relevant statue:
[north-east] JUSTICE [north] TEMPERANCE
[north-west] FORTITUDE
[west] PRUDENCE [south-west] HOPE [south]
CHARITY [south-east] FAITH [east] OBEDIENCE
Unveiled and dedicated: Sunday 25 September
1921, by Major-General Sir Reginald Hoskins
KCB, CMG, DSO, General Officer
Commanding the North Midland Area, and the
Rt Revd Dr Frank Theodore Woods, Bishop of
Peterborough
Status: Grade II
Owner / custodian: Harborough District
Council

Description: The memorial is set within a
knot garden in the middle of The Square. The
pedestal is in three tiers, with name plaques on
the middle tier and the main inscription carved
into the uppermost tier (facing north). From
this level rises a tapering octagonal shaft
surmounted by an octagonal tabernacle and
cross. Beneath the tabernacle is an encirclement
of cherub heads alternated with acanthus leaf
decorations. On each of the eight faces of the
tabernacle is a niche in which stands a carved
female figure personifying a virtue. These are
the three theological virtues (Faith, Hope and
Charity) and the four cardinal virtues (Justice,
Temperance, Fortitude and Prudence), plus
Obedience. Each virtue is identified by an
inscription and one or more of its traditional
attributes. Though the stone is weathered, some
of the attributes are still clearly visible: Faith
carries a bible and chalice, Justice carries scales
and a sword, Prudence is represented pouring
liquid from one vessel into another (i.e.,
diluting wine with water) and Obedience is
shown with her yoke resting on her right
shoulder.[2]

Condition: Generally fair. The surrounding
knot garden is well-maintained, but the
memorial itself is now somewhat weathered.
Biological growth has formed on all stone
surfaces since the last cleaning programme
(c.1993). The inscriptions are losing definition
as are the figures of the virtues around the
tabernacle beneath the cross.

History: At the first meeting of the Market
Harborough War Memorial Committee,
appointed at a town meeting on 12 December
1918, it was agreed that three recommendations
be put up for public approval: the erection of a
monument in the form of a memorial cross; the
provision of a fund from which grants could be
made for the education or care of the children
of those who had died in the war; and the
erection of a new wing of the cottage hospital
giving facilities for 'x-ray electrical treatment
and massage'.[3] A public meeting on 18 March

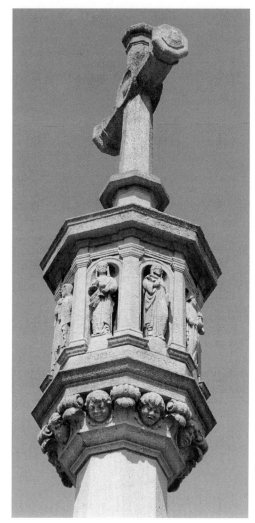

*Market Harborough War Memorial, tabernacle
statues: Faith and Obedience*

1919 voted to go ahead with the launch of a
public subscription to fund the first and last of
these proposals, the estimated cost of the two
schemes being £5,000. Throughout the latter
half of the year appeals were published free of

charge each week in the *Market Harborough Advertiser* (initially on the front page) along with the names of those who had already subscribed and the amount each had given. Originally the Committee, on the advice of Talbot Brown, the chosen architect, decided that the names of the dead would appear on rolls of honour in the vestibule of the cottage hospital but not on the memorial cross in The Square. The corresponding design for the memorial cross was exhibited in Market Harborough Post Office window and immediately met with fierce opposition. In response, the Committee drew up a full justification of their decision, with an explanation from the architect, and had it published in the *Market Harborough Advertiser* for 9 December 1919. The architect explained:

> This problem (that is, the recording of the names on the memorial) is difficult of solution, and even with most competent handling the result is alike unsightly and inartistic. True, in some instances – as in Village Crosses where the names are few – it may be possible to carve them on the base, but where they run into fifty or more (in this case more than two hundred and fifty) it becomes impossible to do so without detriment to the design of the memorial.[4]

There was clearly a difference of opinion as to the purpose of the memorial cross. Many of the townspeople quite understandably saw it as a commemoration of Market Harborough's dead, whereas the Committee saw that function performed by the roll of honour in the hospital thereby freeing up the memorial cross to serve 'a wider purpose'. However, in the face of a petition of protest signed by about 1,500 people,[5] the Committee capitulated in mid-December, though not without a final word of explanation from the Committee Chairman:

> The chief thought [with regard to the monument in The Square] was one of gratitude for victory, a victory which was achieved, under God, by the united sacrifices of all, by the dead, by the men who returned, and by the women. In this achievement our town bore its bitter share. And while recording our gratitude the monument should remind us, and those after us, that the future no less than the past, must stand upon the sacrificial spirit, of which the cross at the summit is the symbol.[6]

This, however, did nothing to mollify at least one of the chief objectors to the decision, George Roe, who in his letter to the *Market Harborough Advertiser* at the end of December 1919, insisted that there had been no misunderstanding over the purpose of the monument: the subscribers were wholly in the right, whereas the Committee had made the mistake of listening to the architect: 'The architect, in his desire for artistic effect, put the monument before the Roll of Honour, whereas we, the petitioners, put the Roll of Honour before the monument, and rightly so.'[7]

Disputes of a similar nature were no doubt enacted across the country and help to explain why First World War memorials were for the most part aesthetically unadventurous: subscribers quite understandably saw the memorial's principal function as being to provide a dignified and respectful setting for the commemoration of the specific individuals who had died fighting for their country, not as an opportunity for architects and sculptors to exercise their creative talents.

With the dispute thus resolved, work on the construction of the memorial began. By April 1920, the tender of local stonemasons William Allsop and Sons, had been accepted and they were busy selecting the blocks of stone.[8] In March 1921, the Committee published the provisional list of names to be inscribed on the monument, asking for corrections and any additions.[9] On 25 September 1921, the *Market Harborough War Memorial* was unveiled and the ceremony recorded on a still-surviving newsreel film, made by a man from the cinematic firm of Cardeaux of Coventry.[10]

Literature
L. Chronicle: – [i] 22 February 1919, p.10 [ii] 15 March 1924, p.1; *L. Daily Post*: – [i] 18 February 1920, p.6 [ii] 20 February 1920, p.8; *L. Mail*: – [i] 2 June 1921, p.6 [ii] 26 September 1921, p.4; *L. Mercury*, 26 September 1921, p.10; *M.H. Advertiser*: – [i] 2 September 1919, p.1 [ii] 9 December 1919, pp.5, 6 [iii] 16 December 1919, pp.5, 8 [iv] 23 December 1919, p.8 [v] 30 December 1919, p.5 [vi] 10 February 1920, p.6 [vii] 13 April 1920, p.7 [viii] 29 March 1921, p.8 [ix] 3 May 1921, pp.5, 7 [x] 13 September 1921, p.6 [xi] 27 September 1921, pp.5, 8; Mastoris, S., 1989, pp.**138, 139**; Sharpe, J.M., 1992, p.49.

Notes
[1] *M.H. Advertiser*, 27 September 1921, p.8. [2] The yoke carried by Obedience refers to the passage in Matthew, 11: 29–30. 'My yoke is good to bear' (Hall, J., 1979, p.227). [3] *L. Chronicle*, 22 February 1919, p.10; *MH Advertiser*, 2 September 1919, p.1. [4] *MH Advertiser*, 9 December 1919, p.6. [5] *Ibid.*, 16 December 1919, p.5. [6] *Ibid.*, 23 December 1919, p.8. [7] *Ibid.*, 30 December 1919, p.5. See also Roe's strongly worded letter to the editor in *ibid.*, 9 December 1919, p.5. [8] *Ibid.*, 13 April 1920, p.7. [9] *Ibid.*, 29 March 1921, p.8. [10] Mastoris, S., 1989, p.138.

MELTON MOWBRAY
Civil Parish: Melton Mowbray
Borough Council: Melton

Asfordby Road

Melton Mowbray College of Further Education

In the courtyard in front of the main entrance:
Sculpture for Osaka
Sculptor: Antanas Brazdys

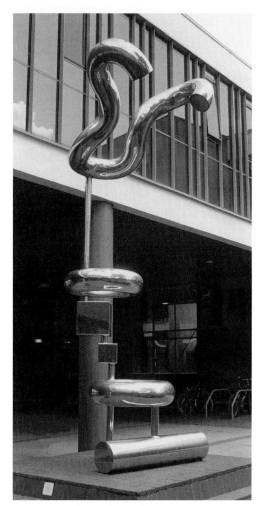

Brazdys, *Sculpture for Osaka*

Sculpture in chromium-plated stainless steel
h. 4.87m (16'); w. 3.04m (10'); d. 3.04m (10')[1]
Executed: 1970
Exhibited: (i) *Maquette for Osaka*, stainless steel: 1971, London, Annely Juda Fine Art (no. 2); (ii) sculpture: 1970, Osaka, Japan, World Fair, British Pavilion; 1972, Royal Academy of

Arts (no. 5)
Status: not listed
Owner: Leicestershire Education Authority

Condition: The sculpture appears to be in generally good condition, but with a small amount of scuffing and graffiti.
History: The sculpture takes its name from the fact that it was shown in Osaka, Japan, in the British Pavilion at the 1970 World Fair.[2]

Literature
Whitechapel Art Gallery archives. Press cutting: *Tribune*, 3 October 1980.
General. Arts Council of Great Britain, 1980, p.**19**; Royal Academy of Arts, 1972, n. pag. (no. 5); Strachan, W.J., 1984, p.154, **154**.

Notes
[1] Dimensions as recorded in Royal Academy of Arts, 1972, n. pag. (no. 5). [2] Strachan, W.J., 1984, p.154.

Burton Road

King Edward VII Upper School (access only by prior arrangement)

Mounted on an exterior wall:
Tree of Knowledge
Sculptor: Antony Hollaway

Sculpture in mild steel with an applied ceramic background
h. 3.2m (10'6"); w. 1.01m (3'4")
Status: not listed
Owner: Leicestershire Education Authority

Condition: All surfaces are rusted.[1]
History: *Tree of Knowledge* was purchased for King Edward VII Upper School by the Leicestershire Education Authority with funds provided through the buildings capital scheme.[2]

Notes
[1] A course of action recommended to the author by the sculptor (13 August 1999) would be to remove the rust by abrasion and to apply three coats of matt hammerite every three years. [2] LEA inventory.

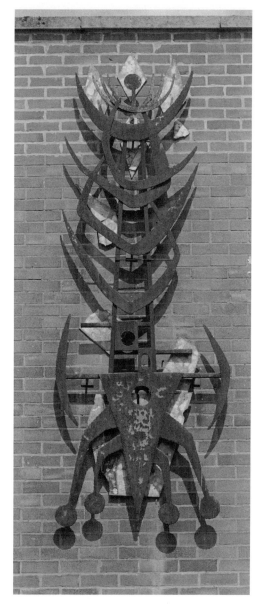

Hollaway, *Tree of Knowledge*

Sarson High School (access only by prior arrangement)

1. In the school grounds:

Euterpe
Sculptor: Willi Soukop

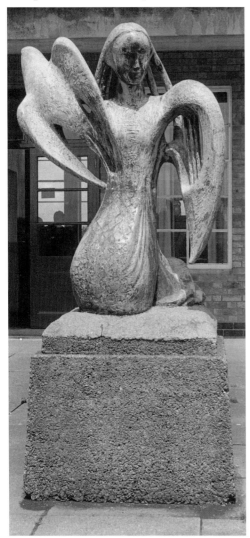

Soukop, *Euterpe*

Sculpture in bronze on a plinth in concrete
Sculpture: h. 1.23m (4'1"); w. 93cm (3'1"); d. 63cm (2'1")
Plinth: h. 73cm (2'5"); w. 86cm (2'10"); d. 86cm (2'10")
Executed: 1949
Status: not listed
Owner: Leicestershire Education Authority

Description: Semi-abstract mermaid-like female figure in green-patinated bronze, with a lyre and a bird. In Greek mythology, Euterpe was the Muse of music and lyric poetry.

Condition: Good.

History: *Euterpe* was purchased by the Leicestershire Education Authority in 1952 with funds made available through the buildings capital scheme.[1]

Note
[1] LEA inventory.

2. In the entrance hall:

The Hunt of a Tana
Sculptor: Zadok Ben-David

Sculpture in metal, cement and pigment
h. 2.66m (8'9"); w. 1.91m (6'3"); d. 25cm (10")
Executed: 1984–5
Exhibited: 1987, London, Benjamin Rhodes Gallery (no. 8)
Status: not listed
Owner: Leicestershire Education Authority

Condition: Generally good, although the cement surface, which has been left intentionally rough, has a tendency to crumble when touched. Consequently the metal armature is exposed in two short patches on the outside edge of the little finger and in one small patch on the back of the hand.

History: *The Hunt of a Tana* was donated to the school privately in 1987.

Literature
Benjamin Rhodes Gallery, 1987.

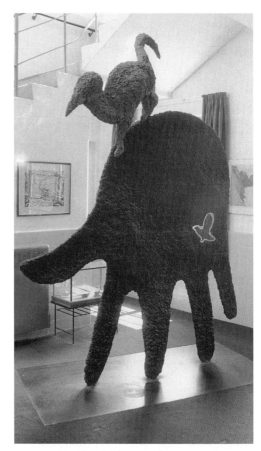

Ben-David, *The Hunt of a Tana*

Burton Street

In the Parish Church of St Mary

Inside, at the east end of the south aisle:

Melton Mowbray War Memorial
Designers: Bodley and Hare[1]

Monument in Caen stone and Clunch stone
h. 2.45m (8'1"); w. 2.02m (6'8")
Unveiled and dedicated: Sunday 13 June 1920, by Earl Beatty, Admiral of the Fleet, and the

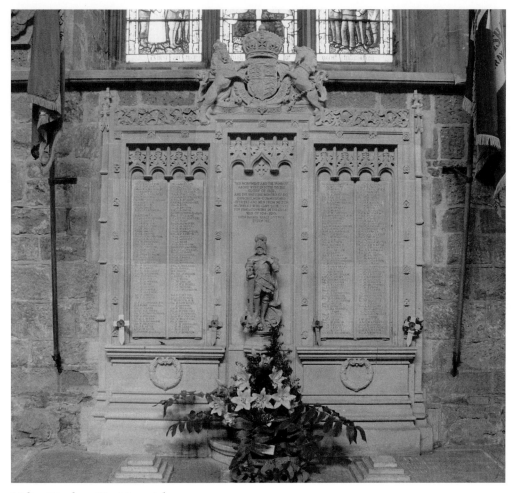

Melton Mowbray War Memorial

Revd Richard Blakeney, Vicar of Melton Mowbray
Status of church: Grade I
Owner / custodian: The Parish Church of St Mary, Melton Mowbray

Description: A wall monument surmounted by the Royal Coat of Arms and fronted by a small, centrally-placed figure of St George. Behind the figure is the dedicatory inscription tablet and to either side tablets with the names of the over 220 men from Melton who died in the First World War. The coat of arms and the figure of St George, together with the upper parts of the tablets, are executed in Caen stone, while the lower parts are in Clunch stone. The

stained glass window above the wall monument, designed by Burlison and Grylls, of London, is also part of the memorial.[2]

Condition: The figure of St George has numerous small chips out of it and there is a visible repair to the upper part of the right, sword-bearing arm – the arm having been broken off in an attack by an unknown person in October 1920.[3] Otherwise the memorial is in fair condition.

History: According to the *Melton Mowbray Times* the decision to erect Melton Mowbray's memorial to its dead of the First World War was taken at a meeting held on 17 March 1919, the church being chosen as it was felt 'by many of the parishioners that there is no place in which a memorial to those who have given their lives for us could be more fitting than in our beautiful and ancient parish church'.[4]

The vicar and churchwardens formed the nucleus of the committee organised to supervise the public subscription, the original estimate of £500 rising to £600 in the face of 'increased expense of labour and the soaring prices of everything'. The unveiling and dedication ceremony took place in front of a capacity congregation with a surpliced choir led by (Sir) Malcolm Sargent (parish organist, 1914–23).

Literature
L. Chronicle: – [i] 19 June 1920, p.2 [ii] 23 October 1920, pp.8–9, **8–9**; *L. Daily Post*, 14 June 1920, p.1; *L. Mail*, 14 June 1920, p.4; *L, R & S Mercury*, 18 June 1920, p.6; *M.M. Times*: – [i] 14 November 1919, p.8 [ii] 24 December 1919, p.2 [iii] 18 June 1920, p.2 [iv] 15 October 1920, p.8.

Notes
[1] *M.M. Times*, 18 June 1920, p.2, gives the designers of the memorial as 'Bodley and Hose' and the related stained glass window above it as 'Burlison and Guills', both of London. The 1920 Post Office commercial directory for London lists only Bodley & Hare and Burlison & Grylls – so presumably the *M.M.Times*'s versions are typographical errors. [2] *Ibid.* [3] *L. Chronicle*, 23 October 1920, pp.8–9. [4] *M.M. Times*, 18 June 1920, p.2.

Enterprise Glade (off Bath Lane)

The Heart of the National Forest Visitor Centre

1. In a woodland setting:

A Flame for Dunblane

Sculptor: Walter Bailey

Sculpture in yew
Dimensions: overall h. 3.13m (10'3")
Flame (trunk): h. 2.75m (9'); w. 1.2m (3'11"); d. 34cm (1'2")
Base (root plate): h. 38cm (1'3"); w. 2.6m (8'6"); d. 2.08m (6'10")
Unveiled and dedicated: Sunday 5 April 1998, by George Robertson, Secretary of State for Defence and MP for Dunblane, and the Rt Revd W.J. Down, assistant Bishop of Leicester
Status: not listed
Owner / custodian: The Heart of the National Forest Foundation

Description: Fashioned from a single yew, the trunk has been shaped to represent a flame, while the spreading root plate of the tree serves as the base of the sculpture. The front has in fact four more flame shapes deeply carved within the outer flame, making five in all, to symbolise the average age of the children killed at Dunblane, while the rear has 17 deep channels radiating starburst-like from the centre to symbolise the number of people here commemorated. The sculpture, approached by a short gravel path, is set on a raised bed bounded by a low log palisade. Around this have been planted 17 hazels and 17 oaks. The soil between the trees is a bed for snowdrops, anemones and bluebells, selected because they flower in March, the month the tragedy took place.

Condition: Good.

History: *A Flame for Dunblane* was commissioned to commemorate the 16 children and one teacher murdered on 13 March 1996 at Dunblane Primary School, Scotland. In the wake of the tragedy, the National Association for Primary Education (NAPE) began to consider what would be the most appropriate form of memorial. It was agreed early on that the memorial should incorporate the planting of flowers and trees as symbols of regeneration and new life.[1] Meanwhile, unsolicited donations from individuals and primary school communities throughout the United Kingdom began to pour in, providing the necessary financial means to give substance to NAPE's idea. NAPE discussed the idea with the parents and teachers of the Dunblane school and both groups agreed that the best location would be one where the greatest numbers of the general public would be able to appreciate the memorial in sympathetic surroundings.[2]

After considering numerous alternatives, it was unanimously decided that the memorial should be a national one, sited in a geographically central location and that a symbolic sculpture should form the centre-piece. NAPE approached the National Forest Company and a suitable site was found at the Heart of the National Forest Visitor Centre at Moira in Leicestershire.[3]

An advertisement was placed in *Artists Newsletter*, May 1997, asking for artists to submit applications to design the memorial. A total of 58 artists responded and from these a short list of three was selected in October 1997 by a panel consisting of representatives from NAPE, the National Forest, East Midlands Arts, Leicestershire County Council Arts and North West Leicestershire Arts.[4] The three short-listed artists were Vivien Mousdell of Whitby, Malcolm Robertson of Glenrothes, and Walter Bailey of Brighton.[5]

From these three, the panel selected Walter

Bailey. In his application for the commission he had written:

I was deeply moved to see that NAPE and the National Forest have collaborated to commission a sculpture to commemorate the lives of the children and teacher who died in the Dunblane tragedy. As the father of three children, I can, to a certain extent, understand the depth of grief and loss in the community of Dunblane. I also understand that the commissioned artist must treat their subject with great sensitivity, and that the sculpture must reflect the needs of the community.

My work is made predominantly in wood in a woodland context and I have particular interest in carving the human form in a way that focuses attention on the open heart and reflects our interconnectedness. I feel that my work may suit the needs of this commission and I would very much like to be given the opportunity to develop designs.[6]

Bailey's empathy with the grief of the bereaved parents had, in fact, been intensified by an earlier near tragedy in his own family when, in March 1995, his son Sol had almost died as a result of Guillain-Barré syndrome. While being nonetheless sensitive to the greater agony of parents whose children's lives had been taken violently, he later explained:

I drew on our son's near death experience for the design of "A Flame for Dunblane", to celebrate the lives of the children of Dunblane, moving the focal point away from that terrible day, remembering the joys of times shared in innocence.[7]

As a first step, Bailey went to Dunblane with representatives from NAPE and the National Forest to meet the teachers and parents at the primary school. All were supportive of the idea of the memorial, many expressing their wish to

attend the unveiling ceremony, scheduled for spring 1998.[8] Once Bailey's design for a sculpture in yew had been accepted, he went in search of a suitable piece of wood. Yew had been his first choice for the sculpture because, as he explained: 'Yew is the most durable of native woods with a rich orange / red colour. With these qualities it was an obvious choice for "A Flame for Dunblane".'[9]

Bailey spent three months searching for his yew tree. In December 1997, just as he was beginning to despair of finding a piece large enough for the form he wanted to carve, he was told of a tree that had been felled by the freak gale of October 1987, located in an ancient yew wood near Kingly Vale, just outside Chichester in Sussex. Bailey estimated that the tree could have been up to 500 years old 'with enough girth to carve the flame and a strong-looking root plate [for the base]'.[10] With the help of a bulldozer and tractor the yew was moved out of the wood and manœuvred onto a low loader on which it was transported to a field near the sculptor's home. There it was set down on its root plate for Bailey to start carving directly with a chainsaw. From time to time his three children, Sol, Gala and Freya, assisted him by removing flints entangled in the root plate.

On the challenges inherent in working on such a piece of wood, Bailey commented:

... if a tree is growing for 500 years you're sure to find holes and faults. You have to be willing to work with these, being guided by them and not resisting, facing up to them. I'm often surprised by the results, these problems shift the carving to a new level, creating unexpected and pleasing qualities that a solid tree would not have. On completion the wood has been left with marks of the chainsaw intact. Energising the surface and revealing the long journey towards completion.[11]

At the unveiling ceremony, the bereaved

Bailey, *A Flame for Dunblane*

parents and invited speakers were unanimous in their insistence on the dual – celebratory as well as commemorative – nature of the memorial. George Robertson, MP for Dunblane, explained:

The desire was to create a special memorial

among trees as a living and growing celebration of the lives so tragically cut short ... These trees will be rooted deep in the soil of Leicestershire, but still, for generations to come, they will instinctively reach for the light above them. They will become an ageless anchorpoint for our thoughts and our memories of those who have gone.[12]

David Scott, whose daughter Hannah was one of those killed, spoke for the parents: 'When NAPE contacted us it was apparent that this would be a living memorial to celebrate the lives of the children and their teacher. That is very important to us.'[13]

As was stated in the official programme, the naming and dedication ceremony was an inauguration rather than a completion:

Today's naming ceremony marks the beginning of the memorial. Over the next months native wildflowers and bulbs including snowdrops[14] will be planted by local schoolchildren. Over the years these and the young trees you see breaking into bud today will grow up round the central sculpture, which will itself alter and mature in its own unique way, fulfilling NAPE's vision of a living commemoration.[15]

After completing *Flame for Dunblane*, Bailey realised he had sufficient wood left to fashion some miniature variations of the main sculpture. On the third anniversary of the killings, the sculptor and Chris Black, the Chair of NAPE, travelled to Dunblane and presented the sculptures to the bereaved families, each making their own choice.[16]

Literature
The National Forest archives. *The NAPE Memorial for Dunblane* (information sheet); *The NAPE Memorial for Dunblane* (naming and dedication ceremony programme); *Notes on the Dunblane Memorial Commission by Walter Bailey*; press cutting – *Artists Newsletter*, May 1997.
General. *Artists Newsletter*, June 1998, p.49, **49**;

Child Education, vol. 75, no. 6, June 1998, p.6, **6**;
Guardian, 6 April 1998, p.**9**; *Independent*, 6 April
1998, p.**4**; *L. Mercury*: – [i] 6 April 1998, pp.3, 28, **1**
[ii] 27 April 1998, p.6; *National Forest News*, Spring
1998, pp.1, 4, 5, **1**, **4**, **5**; *NAPE Newsbrief No. 32*, July
1999.

Notes
[1] *L. Mercury*, 6 April 1998, p.3. [2] *The NAPE
Memorial for Dunblane* (information sheet, The
National Forest archives). [3] *Ibid*. See also *L.
Mercury*, 6 April 1998, p.3. [4] Information from Sue
Anderson, National Forest Community Liaison
Officer. [5] *The NAPE Memorial for Dunblane*
(information sheet, The National Forest archives).
[6] *Ibid*. [7] *Notes on the Dunblane Memorial
Commission by Walter Bailey* (The National Forest
archives). [8] *The NAPE Memorial for Dunblane*
(information sheet, The National Forest archives).
[9] *Notes on the Dunblane Memorial Commission by
Walter Bailey* (The National Forest archives). [10]
Ibid. [11] *Ibid*. [12] *National Forest News*, Spring
1998, p.4. [13] *Ibid*., pp.4–5. [14] A snowdrop was the
symbol chosen by the anti-handgun campaign
launched as a response to the Dunblane tragedy.
[15] *The NAPE memorial for Dunblane* (naming and
dedication ceremony programme). [16] *NAPE
Newsbrief No. 32*, July 1999.

Heron and others, *Untitled*

2. On the shore of the lake, near the Visitor
Centre:

Untitled (also known as 'Forest Family')

Sculptors: Martin Heron and members of Headstart, Moira; the New Opportunities Workshop, Coalville; Coalville Resource Centre; and The Bridge Club, Coalville

Four-piece group in lime, sycamore and poplar
Overall dimensions (est.): h. 3.66m (12'); w. 3m
(9'10"); d. 1.5m (4'11")
Unveiled: Tuesday 3 November 1998, by the
Director of East Midlands Shape, the Co-
ordinator of Mantle Community Arts, and
three members of the participating groups
Status: not listed
Owner / custodians: East Midlands Shape,
Mantle Community Arts and The Heart of the
National Forest Foundation

Description: Four-figure group. On the left
a standing female figure reaches up releasing a
flight of birds from her hands; in the
foreground a male figure lies on his side on a
bed; to the right stands a small boy and a young
girl with her hair in bunches. The pieces are
simply carved, with tool marks deliberately left
unsmoothed. As Martin Heron explained, 'The
sculpture is a family group. There is a sleeping
figure which represents a miner. Taking into
account the past use of the site and the fact that
this is still seen very much as a mining area, we
thought this would be very appropriate.'[1] The
female figure with the birds, known as 'Mother
Nature',[2] signifies 'regeneration, hope and the
rejuvenation of the natural environment'.[3] The
two children 'represent a new generation – the
future'.[4]

The project co-ordinators summed up the
piece as follows:

The sculpture has a sense of calm and is both
strong in terms of its physical size and the
marks that have been chiselled and carved on
to it, all of the pieces have a consistency
within them in the way they have evolved.
The sculpture stands alone as both a work of
art and the result of a project and learning
process.[5]

Condition: Good.
History: The *Sculpture for the National
Forest* is the first in a projected sculpture trail
comprising works created by a professional
artist working with disabled people. The trail
was the brainchild of East Midlands Shape, a
charity founded in 1978 with a mission to work

'towards increasing equality of access to the arts for disabled people and other disenfranchised groups'.[6] East Midlands Shape began operating in Leicestershire in April 1997 and, as a first step, sought out organisations already in the county with whom it might work in partnership. Mantle Community Arts, a Coalville-based organisation which, since its foundation in 1985, had been involved in projects 'to generate interest, awareness and opportunities for all people to take part in arts activities throughout North West Leicestershire' had meanwhile identified Shape as an organisation with which it would like to work. The two organisations met and, having decided on a joint venture, it was agreed that Shape's idea of marking its 21st anniversary in 1999 with a sculpture trail both created by, and fully accessible to, disabled people, and furthermore promoted to 'reflect positive images of disability', would be an extremely worthwhile project. It was also agreed that the success of the overall project would be more assured if they first learnt from experience with a smaller project – a one-off pilot sculpture.[7]

The project co-ordinators felt that if the pilot were to succeed in its aim and generate future funding and participation, it was essential that a high profile site be secured for the sculpture. To this end they contacted the National Forest – an organisation then in the process of developing its new Visitor Centre at Moira – to see if it would be interested in providing a site and contributing some partnership funding. The National Forest responded enthusiastically, suggesting a number of potential sites. It was decided, however, to leave that specific selection to whichever sculptor they eventually awarded with the commission. The co-ordinators next developed a detailed brief, which they advertised in *Artists Newsletter*, a periodical aimed at professional artists, and *In Shape*, East Midlands Shape's quarterly newsletter. They also circulated it via the East Midlands Arts Board's mailing list and to other arts and disability organisations. Artists were required to submit details of their professional experience – particularly where it involved working with disabled people – and to state the reasons why they wanted to work on the project and how they envisaged it developing. As the co-ordinators sifted through the replies, it became clear that Martin Heron was by far the most suitable candidate, a conviction confirmed by the selection panel's later interview with him. His appointment was confirmed (and a contract signed shortly afterwards in August 1998).

Meanwhile, the project co-ordinators had successfully covered the £6,434 they had estimated was necessary to fund the overall project, with contributions from the National Lottery Charities Board (via East Midlands Shape), the National Forest, and Leicestershire County Council (with an Arts Development grant). They had also managed to interest a number of local groups for disabled people in participating in the project: Moira-based Headstart – a group for people with head injuries, and three Coalville-based groups for people with learning disabilities: the New Opportunities Workshop, Coalville Resource Centre, and The Bridge Club.

A preliminary meeting was arranged between Heron and each group to formulate ideas, with those members who wanted to draw their ideas being encouraged to make sketches so that Heron could appraise them all together. The meeting was also an opportunity for Heron to assess the levels of experience and ability within each group. It had at first been assumed that each group would work on its part of the sculpture at its own centre, but it became clear that, given the size of the projected work, it would be better to work on-site at the National Forest Visitor Centre. Luckily the National Forest was able to make available its partly finished art studios. It had already been agreed that an important aspect of the sculpture would be that its material should be in harmony with the surroundings. Local wood therefore was the obvious choice and the co-ordinators managed to secure some pieces of sycamore free of charge from local suppliers. Heron had by now decided to use this particular wood in response to the concerns of many of the members of the groups that the chosen wood should be soft and relatively easily carved.

Work began in July 1998 and continued through until September, each group being allocated six half-day workshops, some members of the groups enjoying the project so much that they returned in their spare time. It was clear to Heron and the co-ordinators that group members were benefitting from the experience not only through the acquisition and development of new technical skills, but also by being part of a team, helping to make decisions within that team and, as one of the members said, by working together to make something that was to be permanently sited and would be seen by many people for years to come.

Press releases and radio interviews were arranged to give a high profile to the completion of the sculpture, though the unveiling ceremony was invitation only, and included Heron, the participating groups and their friends and family, other artists, arts workers, local disabled people, local council officials, East Midlands Shape, Mantle Community Arts, National Forest staff and local press.

As for future maintenance of the sculpture, it was decided that 'it should be allowed to naturally disintegrate and any additions to it, for example fungi, should be left to grow'.[8] A similar policy has been adopted for all the sculptures on the trail.

Related works: Other sculptures in the East Midlands Shape 21st Birthday Sculpture Trail are: *The Aviary Tower*, Bouskell Park, Blaby (see pp.14–15); *The Bird Totems*, Thornton

Reservoir (see pp.279–80) and *The Kingfisher*, Stonebow Washlands Community Wildlife Area, Loughborough (see p.218). At the time of writing (summer 1999), further sculptures are planned for Melton, Harborough, Hinckley and Bosworth, and Oadby and Wigston.

Literature
NW Leics. District Council archives. *Public Art in North West Leicestershire. A sculpture for the National Forest* (report).
General. *C. Times*, 30 October 1998, p.13; East Midlands Shape, *Leicestershire Sculpture Trail. Map and Guide*, 1999.

Notes
[1] *Public Art in North West Leicestershire. A sculpture for the National Forest* (report): press cutting – *Coalville and Ashby Echo* (undated).
[2] Information from Lucy Banwell, East Midlands Shape sculpture trail co-ordinator. [3] *Public Art in North West Leicestershire. A sculpture for the National Forest* (report): press cutting – *Coalville and Ashby Echo* (undated). [4] *Ibid.* [5] *Public Art in North West Leicestershire. A sculpture for the National Forest* (report). [6] *Ibid.* [7] *Ibid.* [8] *Ibid.*

Furnace Lane (off Bath Lane)

At the junction of Furnace Lane and Bath Lane

On open ground to the left:
Sculpture (title unknown)
Sculptor: unknown

Sculpture in wood and metal
h. 2.24m (7'4"); w. 3.42m (11'3"); d. 2.5m (8'3")
Executed: early 1990s
Status: not listed
Owner / custodian: North West Leicestershire District Council

Condition: The wood has weathered, there are areas of damp and there is some damage to the ends of the beams resting on the ground (presumably sustained by buffeting from mowers cutting the surrounding grass). Also

Sculpture at Furnace Lane

the metal bolts that secure the wood to the metal spine have rusted.

History: The present sculpture was commissioned by North West Leicestershire District Council in the early 1990s as part of the refurbishment of the area around Furnace Lane, concentrated on a triangle of land (a neglected public garden) and the open ground on the opposite side of the road. The Council arranged with Loughborough College of Art and Design to hold a competition among the sculpture students to commission a sculpture to create a point of visual interest on the triangle of land. The Council's selection panel looked at about 24 ideas from the College, eventually deciding on the present sculpture. Its theme is regeneration, the two counterpointed spirals, one appearing to descend into the ground, the other rising up from it, being intended to symbolise the dying of the older industries that formerly dominated the area and their replacement by new industries and the National Forest.[1]

Related work: *Maquette* at North West Leicestershire District Council, Community Services (Leisure) Department.

Literature
C. Times, 10 October 1997, p.23.

Note
[1] Information from Matt Corrigan, formerly of North West Leicestershire District Council, and one of the selection panel for the present sculpture. It has not been possible to obtain any further information regarding this piece either from North West Leicestershire District Council's Community Services Department – who were unable to locate any relevant documentation – or from Loughborough University School of Art and Design's Sculpture Department. Thus the name of the sculptor and the specific date of the commission remain unknown.

On open ground on the opposite side of Furnace Lane from the above sculpture:

Moira Furnace Museum sign,
a pit wheel mounted on a free-standing wall. Set into the wall are two relief panels: *The Holer* and *Mining Past and Present*
Designer of relief panels: Judith Reid

Relief panels in terracotta
Left-hand relief: h. 52cm (1'9"); w. 66.5cm (2'2")
Right-hand relief: h. 51cm (1'8"); w. 65cm (1'2")
Executed: 1992
Inscriptions on plaques on the rear of the wall:
– behind the left-hand relief panel: THE PLAQUES ON THIS MONUMENT WERE DESIGNED / BY JUDITH REID DIP. RSA. / – / THE HOLER / THIS PICTURE DEPICTS THE WORK OF / A HOLER WHO WOULD DRIVE WEDGES INTO THE / BOTTOM OF THE COALFACE TO CHIP OFF BLOCKS OF / COAL. THIS WAS VERY HARD AND DANGEROUS WORK / LYING ON HIS SIDE. HE HAD TO KNOCK IN "SPRAGS" / AS WELL, TO PREVENT THE RIDGE ROOF FALLING ON / TOP OF HIM. BY HIS SIDE IS A SNAP BOX AND A / SHUKIE LAMP. / BRICKWORK WAS UNDERTAKEN BY CRAFT APPRENTICES / FROM DAVID WILSON HOMES LTD. IBSTOCK / LEICESTERSHIRE. / THE PLAQUES WERE CARVED BY HAND BY / BUTTERLEY CRAFTSMEN.
– behind the right-hand relief panel: MINING

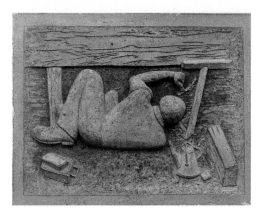

Reid, *The Holer*

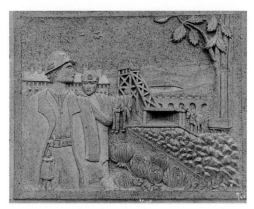

Reid, *Mining Past and Present*

PAST AND PRESENT / THIS PLAQUE SHOWS THE / UNDERGROUND ROADS AND THE COMPANION-SHIP OF / THE PIT PONIES. THE HAND ON THE SHOULDER / SHOWS THE COMRADESHIP OF THE YOUNG AND THE / EXPERIENCED MINERS, WHILST THE DOWNCAST / GLANCES ARE CAUSED BY RECESSION AND PIT / CLOSURES. / THE CHRYSANTHEMUMS SHOW HOW THE MEN COULD / WORK IN DIFFICULT CONDITIONS YET COME ABOVE / GROUND AND GROW FLOWERS WITH SUCH CARE. / IN THE BACKGROUND ARE THE TERRACED HOUSES / TO THE RAWDON, DONISTHORPE, MARQUIS / HEAD STOCKS AND BARRETTS MILL WHERE / THE PIT PONIES FOOD WAS PREPARED. / THE FIVE ARCHES IN MOIRA REPRESENTING / INDUSTRY LINKED WITH THE CANAL AND / RAILWAY AND THE SUBSIDING LANDSCAPE COMMON / AFTER SO MUCH MINING. / ALSO THE FAMILIAR SILVER BIRCH TREES THAT / NOW COVER THE OLD MINE SITES / [then in the bottom right-hand corner, the initials] KJP
The Holer is signed: S. MILLWARD
Mining Past and Present is signed: S. MILLWARD BEM
Status: not listed
Owner / custodian: North West Leicestershire District Council

Condition: The reliefs are in good condition but all the coping bricks of the wall have crumbled badly.
History: The monument, erected in 1992, was commissioned by North West Leicestershire District Council as part of the refurbishment of the immediate area and to serve as a much-needed signpost to Moira Furnace Museum.[1] The pit wheel which surmounts the monument was salvaged from Donisthorpe Pit.

Note
[1] Information from Matt Corrigan, formerly North West Leicestershire District Council.

MOUNTSORREL
Civil Parish: Mountsorrel
Borough Council: Charnwood

Leicester Road

At the corner with The Green, in Castle Park:
Knight
Sculptor: Mike Grevatte

Free-standing relief in Portland stone on a pedestal of local pink granite rubble.

Sculpture: h. 1.89m (6'3"); w. 89cm (2'11"); d. 58cm (1'11")
Pedestal: h. 59cm (1'11"); w. 92.5cm (3'1"); d. 59cm (1'11")
Executed: 1993
Status: not listed
Owner: Leicestershire County Council

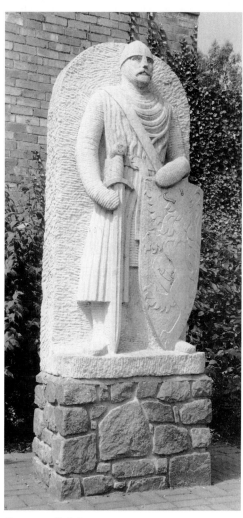

Grevatte, *Knight*

Description: *Knight* stands in front of the rear wall of a paved area with seats, close to the entrance to Castle Park. It is a high-relief standing figure of a twelfth-century knight. He holds in his right hand a long sword, tip touching the ground, while his left hand rests on the upper edge of a shield bearing a device of a lion rampant.

Condition: There is a considerable amount of felt-tip graffiti on the knight's shield, sword pommel and cloak.

History: *Knight* was commissioned along with the same sculptor's *Swan* as part of the Mountsorrel Improvement Scheme, an environmental conservation and improvement scheme run jointly by a team from Leicestershire County Council and Charnwood Borough Council operating in consultation with Mountsorrel Parish Council. In 1993 Charnwood Borough Council issued a brief outlining the requirements of the commission. Several artists responded to the brief and, following a public exhibition of their submitted designs in Mountsorrel, Grevatte's were selected. The figure of the knight is a reference to Mountsorrel Castle (destroyed 1217). The combined budget for the *Knight* and *Swan* sculptures was £20,000.[1]

The Parish Council hopes to complete *Knight* by commissioning from Grevatte a relief of the castle to go on the pedestal and by adding a much-needed explanatory plaque.[2] In 1994 the gardens in which the sculpture stands were awarded the Charnwood Design Award for Landscaping by the *Loughborough Mail*.

Literature
Charnwood Borough Council. Monuments, Public Sculptures and Public Art Records, No. 7, *Knight*.

Notes
[1] Information from Martin Tincknell, Charnwood Borough Council. [2] Information from Mrs J. Broughton, Clerk to Mountsorrel Parish Council.

Loughborough Road

In an open public space with a low wall and seating at the corner of Crown Lane:

Swan

Sculptor: Mike Grevatte

Sculpture in Portland stone on a pedestal of local pink granite rubble
Sculpture: h. 1.2m (3'11"); w. 1.56m (5'2"); d. 91cm (3')
Pedestal: h. 84cm (2'9"); w. 1.56m (5'2"); d. 91cm (3')
Executed: 1993
Signed on the rear of the sculpture (amongst the stylised waves): M. GREVATTE
Status: not listed
Owner / custodian: Mountsorrel Parish Council

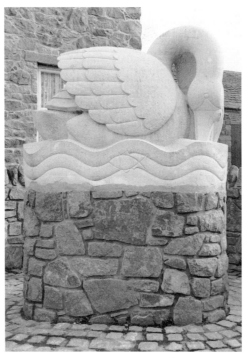

Grevatte, *Swan*

Description: The sculpture is in the form of a mute swan with its head bowed and its bill touching the water, the latter indicated by conventionalised wavy lines and fish.

Condition: Good.

History: *Swan* was commissioned along with the same sculptor's *Knight* as part of the Mountsorrel Improvement Scheme (for details of which, see the previous entry). The subject is a reference to the nearby river.

Related work: *Swan*, elm, h. 1.52m (5') (approx.), 1984, exhibited in the same year at the International Garden Festival, Liverpool.

Literature
Charnwood Borough Council. Monuments, Public Sculptures and Public Art Records, No. 6, *Swan*. **General**. *Festival Sculpture*, 1984, n. pag.; *L. Mercury*, 6 April 1984, p.15.

Market Place

At the corner of Market Place and Sileby Road:

The New Mountsorrel Cross

Sculptor: Mike Grevatte

Village sign in Ancaster limestone on Derbyshire grit base
h. (est.) 5.5m (18')
Unveiled: Saturday 3 December 1994 by Ray Woodward, then Chairman of Mountsorrel Parish Council
Dedicated (with the Peace Garden): Monday 8 May 1995
Status: not listed
Owner / custodian: Mountsorrel Parish Council

Description: The *New Mountsorrel Cross* is loosely based on the old village cross (see 'Related Work' below). It comprises a carved head-piece crowning a tall tapered shaft with chamfered corners and carved base, all in Ancaster limestone, and is mounted on three steps in reclaimed sandstone (Derbyshire grit).

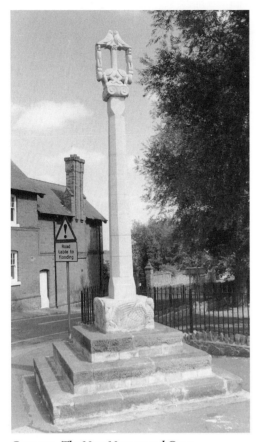

Grevatte, *The New Mountsorrel Cross*

Condition: Good.

History: *The Mountsorrel Cross* was commissioned by the Parish Council as a replacement for the old village cross. This had been removed at the end of the eighteenth century by local landowner Sir John Danvers and re-erected in a field on his estate at Swithland (afterwards the property of the Earl of Lanesborough). In return, Danvers erected on the site of the old cross Mountsorrel's present Butter Cross.[1] Some years ago, the parish council reached agreement with the then

Earl of Lanesborough to have the old cross returned to Mountsorrel, but he died before anything could be done. His successors to the property considered the old cross too fragile to travel and in any case unsuitable for the busy roadside site upon which Mountsorrel Parish Council had hoped to re-erect it. The Parish Council therefore decided to commission a new cross and to erect it in front of their projected Peace Garden. It was intended that the Peace Garden should be the site of a commemorative stone to the dead of the two world wars and that from henceforth Remembrance Day services should be held there, the village war memorial – overlooking the village from the summit of Castle Hill – being on too steep a site to be negotiated by many of the elderly veterans.[2] The plan was to have the cross unveiled in December 1994 to mark the 100th anniversary of the Parish Council's administration and the cross and Peace Garden dedicated on 8 May 1995 to celebrate the 50th anniversary of VE (Victory in Europe) Day.

The Parish Council managed to secure a grant towards the £16,000 cost[3] of the sculpture from Charnwood Borough Council and approached sculptor Mike Grevatte. He had not only recently completed the *Swan* and *Knight* sculptures (see previous two entries) for Mountsorrel but had also lived in the village for a number of years and therefore would, it was felt, have a stronger feel for the subject. Although the brief required him to base his design on the old cross in a general way, he was not required to adhere closely to it. He submitted a number of designs and the Parish Council selected the present one.

In order not to miss the Parish Council's 100th anniversary, the *Mountsorrel Cross* was unveiled on Saturday 3 December 1994 with an incomplete top. It was, however, finished in time for the dedication of the *Cross and Peace Garden* on 8 May 1995.[4]

Related work: As noted above, the present

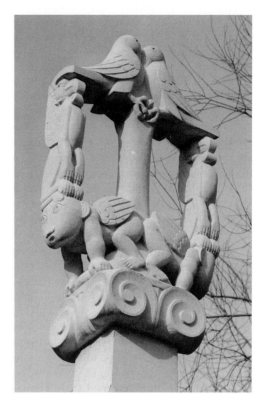

The New Mountsorrel Cross (detail)

cross is based on the village's original medieval market cross, now standing in a field at Swithland. The DCMS list describes the original cross as follows:

> Base consists of five round steps with a square socket stone carved with bats with their wings extended at the corners. Tall monolithic shaft carved with heads and devices. Topstone formed of openwork of upright flat hexagonal shape with wide side and central bar, perhaps representing a weaver's shuttle. The stone is carved with little people and grotesque heads. The top has a broken off Gothic crocket.

Literature
Charnwood Borough Council. Monuments, Public Sculptures and Public Art Records, No. 5, *New Mountsorrel Cross*.
General. *L. Mercury*, 11 February 1995, p.13.

Notes
[1] *Kelly's Directory of ... Leicester and Rutland*, 1922, p.597. [2] The *Mountsorrel War Memorial* was designed by Shirley Harrison and unveiled and dedicated on 15 August 1926. As an architectural structure it is outside the scope of the present volume. [3] Cost as reported in *L. Mercury*, 11 February 1995, p.13. [4] Information from Mrs J. Broughton, Clerk to Mountsorrel Parish Council.

MUSTON Civil Parish: Bottesford
Borough Council: Melton

Church Lane

In St John the Baptist parish churchyard, north of the west end of the church:

Muston War Memorial

Sculptor: William Silver Frith

Memorial in Ketton stone
h. 2.62m (8'7")
Inscriptions on the hexagonal pedestal in incised Roman capitals:
– front (north-west) face: ERECTED TO THE / GLORY OF GOD / AND IN MEMORY / OF THOSE MEN / CONNECTED WITH / THIS PARISH WHO / LOST THEIR LIVES / IN THE WAR / 1914 1918
[on the remaining five faces, the names of the eleven men who died in the First World War, with ranks, regiments and dates of death; also on the face to the right of the front face, added underneath the First World War names, the dates 1939 – 1945 and two names]
Unveiled and dedicated: Saturday 20 September 1919, by the Rt Revd Dr Norman Lang, Bishop of Leicester
Status: not listed
Owner / custodian: Bottesford Parish Council

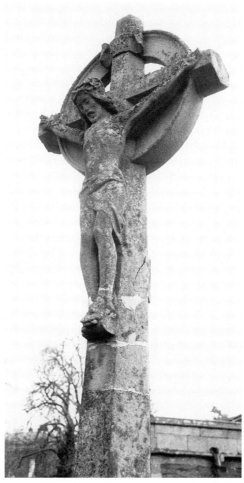

Frith, *Muston War Memorial (before restoration)*

Description: The memorial is in the form of a ringed cross bearing a figure of Christ crucified beneath a scroll inscribed 'INRI'. The tapered hexagonal shaft of the cross is mounted on a hexagonal pedestal bearing the inscription and names, raised on three hexagonal steps.
Condition: The stone is much weathered and a repaired break can be clearly seen on the shaft

of the cross and across the ankles of the Christ figure; also the thumb of the right hand is lost. There is lichen and other biological growth, especially on the pedestal and steps. The memorial was restored by Leicestershire County Council in 1998.

History: On 21 March 1919, Muston Parish Council met and agreed that the village memorial to the dead of the Great War should be 'a cross with a figure of our Lord in the Churchyard', that it should be funded by public subscription and that the committee of 16 parishioners then appointed should supervise the scheme.[1] The Committee managed to secure the services of London sculptor W.S. Frith to carve the memorial, for which it paid him £100 in October 1919.[2] According to a contemporary newspaper, Frith's memorial 'is an exact replica of the old Churchyard Cross'.[3]

Literature
LRO. *Muston Parish Record File*: papers, mainly accounts relating to war memorial; *Notes on History of Muston ...* (unpublished notebook), pp.26–32.
General. *L. Mail*, 22 September 1919, p.4; *L. Mercury*, 22 September 1919, p.5; *M.M. Times*, 26 September 1919, p.3; Sharpe, J.M., 1992, pp.7, 11–12, 20, 25, 40, 48, figs. **1.6, 4.4, 4.5**.

Notes
[1] Undated handwritten note among papers relating to war memorial, in Muston Parish Record File. [2] Receipt, dated 8 October 1919, signed by W.S. Frith, in Muston Parish Record File. [3] *L. Mercury*, 22 September 1919, p.5.

Kenilworth Drive

Langmoor County Primary School (access only by prior arrangement), 1953–5, by T.A. Collins

1. On the wall to the right of the entrance to Reception:

Children playing (three panels)

Sculptor: Peter Peri

Relief panels in concrete
Each relief: h. 77.5cm (2'7"); w. 1.23m (4'1")
Executed: 1955
Status: not listed
Owner: Leicestershire Education Authority

Description: Each relief is situated below a window and is framed by a downward continuation of the concrete frame of the window. The relief on the left depicts five girls playing netball, that in the middle two boys and two girls folk dancing, and that on the right five boys playing football. The background in each relief has been painted white.

Condition: The backgrounds have been painted white (not by Peri), in order, apparently, to make the figures read more clearly. All three reliefs have thin cracks running across them, while the left-hand and right-hand reliefs each have small losses to the background area. The left-hand relief is missing a piece of concrete at bottom left about 4cm high × 9cm wide: here the chicken wire armature is exposed and rusty. Further to the centre of the relief there is a small loose area. The right-hand relief has a small area at bottom right where the concrete is loose, cracked and swelling out due to the expansion of the rusted wire armature.

History: The three reliefs were commissioned from Peri by Stewart Mason, Leicestershire's then Director of Education, at the time of the school's construction in 1955 with funds provided through the buildings capital scheme. Mason had first contacted Peri towards the end of 1954, offering him the opportunity to execute some of the concrete sculptures for which he was becoming known, for Scraptoft Valley Primary School (see pp.190–2) and Willowbrook Primary School (see pp.326–7), then being built. In a letter of 8 October 1954, confirming the commission, Mason also referred to discussions he had been having with the County Architect, T.A. Collins, about a set of concrete reliefs for Oadby Primary School (i.e., what is now Langmoor), also being built at that time. Mason had already settled on what was to be a typical theme for primary school sculptures commissioned from Peri – children playing games – and enclosed some photos from which he hoped Peri could work out some ideas.[1]

By February 1955, Peri had sketched out his first designs for the Oadby reliefs and submitted them to Mason. In a letter dated 4 February 1955 from Collins (who was to work closely with Peri on these commissions), the sculptor was informed that Mason had asked for a few amendments.[2] Mason's close attention to detail was to be a fairly typical element in their working relationship and there is no reason to suppose that Peri did not carry out the requests (for a specific example of such an alteration to Peri's original design see pp.9–10).

Peri normally applied his relief sculptures directly to the wall, but in this case they are on panels screwed to the wall beneath the windows. As was his normal practice for reliefs, however, he first stretched some wire mesh over the surface of each panel to act as a base for the wet concrete, and modelled the figures *in situ*.[3]

Literature
The Centre for the Study of Sculpture, Leeds.
Kenny, S., 1980, pp.19, 26, 30-1, 33; László, H., 1990, p.90.
General. Camden Arts Centre, 1987, p.44; Leicestershire Museum and Art Gallery, 1991, p.16.

Notes
[1] Extracts from Mason's letter to Peri dated 8 October 1954 are quoted in Kenny, S., 1980, p.32. [2] *Ibid.*, p.33. [3] László, H., 1990, p.90.

Peri, *Children Playing (netball)*

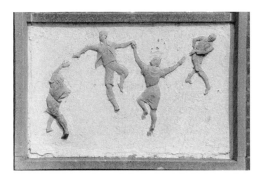

Peri, *Children Playing (folk dancing)*

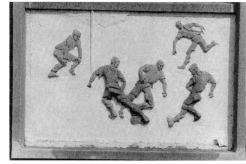

Peri, *Children Playing (football)*

2. On the south-east facing exterior walls either side of the assembly hall windows:

Jack and *Jill*
Sculptor: Peter Peri

Two cut-out reliefs in concrete
Each relief: h. 66.5cm (2'2")
Status: not listed
Owner: Leicestershire Education Authority

Description: Cypresses have been planted directly in front of each relief making it difficult to give anything more than a vague indication of their general appearance. They are mounted slightly away from the wall and the silhouette of each relief is shaped to the contour of the figures. On the left is *Jack*, a boy with a dog, and on the right, *Jill*, a girl with a goose.

Condition: Both reliefs appear to be intact. However, as stated above, a detailed assessment is not possible owing to the cypresses. From the glimpse affordable through the less densely massed branches on the right of the right-hand cypress it can be seen that the *Jill* is discoloured at the edges, possibly due to rust from an exposed armature.

Literature
The Minories, 1970, n. pag.

3. In the entrance hall:
Ursa Major
Sculptor: Alan Durst

Sculpture in Cumberland alabaster on a concrete and brick plinth
Sculpture: h. 47cm (1'7"); w. 82cm (2'8"); d. 37cm (1'3")
Plinth: h. 75cm (2'6"); w. 90cm (3'); d. 45cm (1'6")
Exhibited: 1981, London, Whitechapel Art Gallery (no. 137)
Status: not listed
Owner: Leicestershire Education Authority

Description: The sculpture is of a bear in simplified form on all fours, head down between its paws.

Condition: Generally good, though with some faintly scratched graffiti on the side towards the wall.

History: At a meeting of the Parent Teacher Association of Gartree County School, Oadby, in mid-1955, Stewart Mason, the then Director of Education for Leicestershire, outlined a proposal to provide a piece of sculpture, Alan Durst's *Ursa Major*, for the entrance hall of Oadby (now Langmoor County) Primary School, then in the final stages of construction (it was officially opened in November 1955). The Honorary Secretary of the Association subsequently wrote a letter to the parents advising them of Mason's proposal and appealing to their sense of local pride with the information that 'all the new County Schools have acquired fine pieces of sculpture and there is abundant evidence that this new departure has proved to be both popular and beneficial'.[1]

The school had already been provided with sculptures for its exterior walls (see above two entries), funded through the buildings capital scheme. This, however, would have been

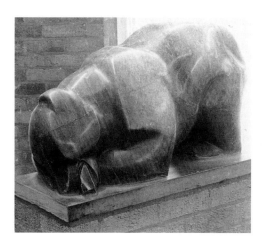

Durst, *Ursa Major*

considered extra and thus the writer advised the parents that:

> ... a scheme of this nature should not be a charge on national or local taxes and its fulfilment must therefore depend upon local effort, by parents, teachers and friends of the school. The Parent Teacher Committee therefore recommends that an effort should be made in Oadby to raise, by voluntary subscription and school efforts, sufficient funds to purchase this work of Art.[2]

Ursa Major was purchased in 1955.[3] It was set up in the entrance hall as planned, and mounted upon a hollow plinth containing a time capsule in which the school stored miscellaneous items of contemporary interest. As was hoped, the sculpture, known at the school as *The Langmoor Bear*, continues to be much appreciated by the children, many of whom are said by the staff to run their hands over its broad forms as they pass.

Literature
PMSA NRP East Midlands Archive. Letter, dated 10 June 1955, from the Honorary Secretary of Gartree County School PTA to the parents (photocopy supplied by Langmoor County Primary School). **General**. Pevsner, N. and Williamson, E., 1992, p.338; Spalding, F., 1986, pp.96, **97**.

Notes
[1] Letter, dated 10 June 1955, from the Honorary Secretary of Gartree County School PTA to the parents (photocopy supplied by Langmoor County Primary School). [2] *Ibid*. [3] LEA inventory.

Ridgeway

Beauchamp Community College (access only by prior arrangement)

1. Outside the Day Nursery:
M'Fazi
Sculptor: Neville Boden

Sculpture in aluminium, painted[1]

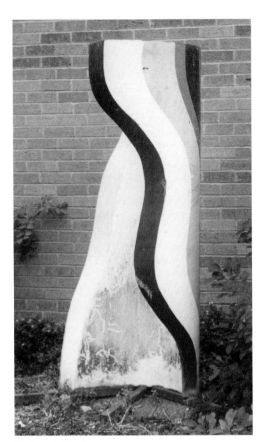

Boden, *M'Fazi*

h. 1.82m (6'); dia. 81cm (2'8")
Executed: 1967[2]
Status: not listed
Owner: Leicestershire Education Authority

Condition: Poor. The paint is grimy, scuffed and peeling, the exposed metal has rusted and the original base is missing.

History: *M'Fazi* was purchased by the Leicestershire Education Authority in 1971. Originally intended for Richard Hill Church of England Primary School, Thurcaston, its purchase was made possible with funds provided through the buildings capital scheme. At some later (unrecorded) date the sculpture was evidently transferred to the present school.

Notes
[1] LEA inventory. [2] Information from Zuleika Dobson.

2. In the entrance hall to the Art and Design Block:
Flag Tree
Sculptor: David Hall

Sculpture in steel
Sculpture: h. 1.85m (6'1"); w. 1.26m (4'2"); d. 89cm (2'11")
Base: h. 11.5cm (5"); w. 70cm (2'4"); d. 63.5cm (2'1")
Executed: 1962

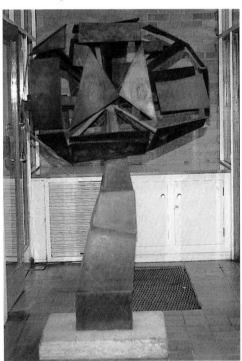

Hall, *Flag Tree*

Status: not listed
Owner: Leicestershire Education Authority

Condition: The sculpture appears to be structurally sound, but all surfaces are rusted.

History: *Flag Tree* was purchased by the Leicestershire Education Authority in 1964 with funds provided through the initial stocking scheme.[1]

Note
[1] LEA inventory.

Gartree High School (access only by prior arrangement)

In Year Six courtyard:
Days of Creation
Sculptor: Antony Hollaway

Seven relief panels in concrete
Dimensions of panels:
– top row left panel: h. 44.5cm (1'6"); w. 23cm (9"); centre panel: h. 44.5cm (1'6"); w. 22.5cm (9"); right panel: h. 52cm (1'9"); w. 24.25cm (10")
– middle row left panel: h. 29.25cm (1'); w. 57cm (1'11"); right panel: h. 52cm (1'9"); w. 56.5cm (1'10")
– bottom row left panel: h. 29.25cm (1'); w. 91.5cm (3'); right panel: h. 52cm (1'9"); w. 57cm (1'11")
Executed: c.1963
Status: not listed
Owner: Leicestershire Education Authority

Description: The seven relief panels are built into a dividing wall 6 ft 10 in high in the courtyard, the backs visible on the opposite face of the wall. The reliefs represent in simplified diagrammatic form the Biblical creation of the world as described in Genesis: I.

The first day – the creation of day and night – is represented by a sun and star in the largest of the reliefs, just to the right of the centre of

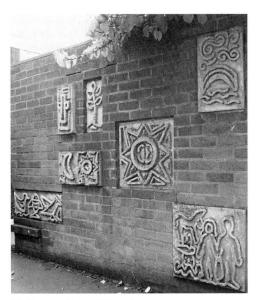

Hollaway, *Days of Creation*

the group; the second day – the division of the waters above and below the firmament – is represented by clouds, rainbow and sea in the relief at top right; the third day – the creation of the dry land and vegetation – by a plant form on the relief at top centre; the fourth day – the creation of the sun, moon and stars – by a moon and sun on the relief at middle left; the fifth day – the creation of birds and fishes – by a representative of each on the relief at bottom left; the sixth day – the creation of animals and man and woman – by a quadruped and Adam and Eve on the relief at bottom right. The seventh day – the day on which God rested from his work – by a cross motif on the relief at top left.

Condition: All reliefs appear to be undamaged except for that on the extreme left of the upper row, which has some loss to the modelling in the upper left-hand corner. The three reliefs on the right of the group, under the

overhanging branches of the shrub planted to the right, are stained with green biological growth.

History: *Days of Creation* was commissioned in *c.*1963 by Stewart Mason, then Director of Leicestershire Education Authority, specifically for the present site.[1] The reliefs were cast by the sculptor from rigid polyurethane foam moulds in white cement, Mountsorrel sand and a white aggregate.[2] The theme – the Biblical account of the creation of heaven and earth – was chosen because the room opposite, with its windows looking out onto the relief, was originally intended for private devotional use.

Notes
[1] LEA inventory. Date as remembered by the sculptor. [2] Information from the sculptor.

QUORN (QUORNDON)
Civil Parish: Quorn
Borough Council: Charnwood

Barrow Road

Opposite the roundabout at the junction with Farley Way:

Trilobite

Sculptor: Sara Spencer

Sculpture in Millstone grit
h. 1.04m (3'5"); w. 60cm (2'); 48cm (1'7")
Sited: December 1999
Status: not listed
Owner / custodian: Quorn Parish Council

Condition: Good
History: *Trilobite* is one of a group of five sculptures commissioned by Quorn Parish Council from second-year sculpture students at Loughborough University School of Art and Design. The commission followed the donation to the parish of stone from the base of the old

chimney of Wright's Mill at Quorn, by Michael Wright, Chairman and Managing Director of M. Wright & Sons Ltd. Quorn Parish Council contacted the staff of the sculpture department of the College asking whether any of their students would be interested in using the stone to create sculptures for various public sites throughout Quorn. Those interested were invited to give a presentation to an interview panel comprising four members of the parish council. The five students who, in the opinion of the panel, were most suitable, were subsequently offered the commission at £200 each. They were then taken on a tour of the village, given some brief local histories and commissioned each to create a sculpture which related to the locale.

The theme of the present sculpture refers to the fossil finds for which the area is locally known.

Related work: Sara Spencer, *Trilobite II* (Fossil sculpture trail), Barrow-upon-Soar (see p.9).

High Street

The public gardens, known locally as the High Street Land, in front of the churchyard.

1. Among the silver birch trees to the right of the path:

Karka and Gurga[1]

Sculptor: Amerjit Kaur Kalwan

Two-piece group in Ancaster limestone on separate concrete bases
Left-hand piece: h. 1.47m (4'10"); w. 55cm (1'10"); d. 43cm (1'5")
Right-hand piece: h. 1.35m (4'5"); w. 55cm (1'10"); d. 43cm (1'5")
Each base: h. 14cm (6"); w. 92cm (3'); d. 61cm (2')
Inscription on a metal plaque fixed to the upper surface of the base of the left-hand sculpture:

'KURKA' AND 'GHUGA' [*sic*] / INTERPRETATIONS
OF LETTERS / FROM PUNJABI SCRIPT / BY /
AMERJIT KALWAN / 1997
Sited: April 1998
Status: not listed
Owner / custodian: Quorn Parish Council

Description: Two sculptures conceived as a
pair, on separate bases among some silver birch
trees. The piece on the left with the flame-
shaped or hood-like top is *Gurga*, based on the
eighth character of the Punjabi alphabet, and
that on the right is *Karka*, based on the sixth
character of the Punjabi alphabet.[2]

Condition: Good.

History: *Karka and Gurga* was purchased
through the Public Art Partnership scheme
initiated by Charnwood Borough Council and
Loughborough University School of Art and
Design. The scheme's aim was to encourage
Charnwood parish councils to borrow
sculptures created by students of the college for
a period of a year, with a view to purchasing
them at the end of that time should local
reaction prove favourable – or, more
realistically, provided public reaction did not
prove unfavourable. Representatives from
Quorn Parish Council visited the College and
selected two sculptures, *Karka and Gurga* and
Fire (see below, p.259). In April 1998, they were
sited prominently within the village. There
having been no negative feedback, *Karka and
Gurga* was purchased by the Parish Council for
£3,000, the final instalment of which was paid in
April 1999.[3]

Of this work, the sculptor said:

... I felt that these two particular letters, their
shape and form, were sympathetic to the
stone I had to work with ... the forms within
the stone are what dictates my carving,
working with the stone's mass, texture and
even the colours within it. My inspiration
comes from the varied and diverse culture of
India, both ancient and modern, from

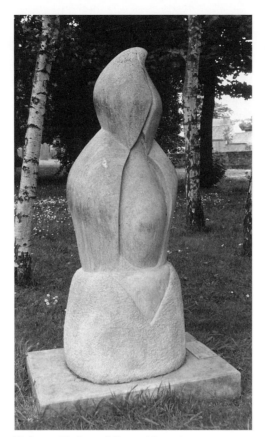

Kalwan, *Karka and Gurga (Gurga)*

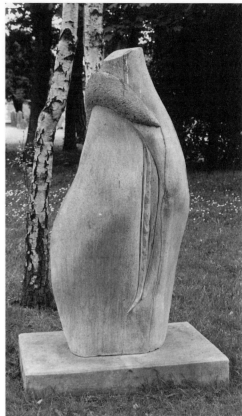

Kalwan, *Karka and Gurga (Karka)*

statues, writings, films and textiles,
combining all with traditional methods of
carving to produce my work.[4]

Literature
PMSA NRP East Midlands Archive. Letter from the
sculptor to the author (n.d., received July 1999).

Notes
[1] Spelling as given to the author by the sculptor.
[2] Information from the sculptor. [3] Information
from Kathryn Paterson, Clerk to Quorn Parish
Council. [4] From a typed statement from the
sculptor to the author, July 1999.

2. On the lawn to the left of the path, near the
left-hand shrubberies:

Saddlestone

Sculptor: Rachel Alen

Sculpture in Millstone grit on a concrete base
Sculpture: h. 84cm (2'9"); w. 1.05m (3'6"); d.
69cm (2'3")
Base: h. 14cm (6"); w. 1.22m (4'); d. 85cm
(2'10")
Sited: early 1999
Status: not listed

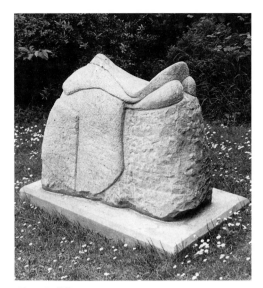

Alen, *Saddlestone*

Owner / custodian: Quorn Parish Council

Description: Sculpture in the form of a saddle on a horse's back.

Condition: Good.

History: *Saddlestone* was one of five sculptures commissioned by Quorn Parish Council from second-year sculpture students of Loughborough University School of Art and Design (for full details, see the entry for *Trilobite*, above, p.256).

The theme of Rachel Alen's *Saddlestone* is the Quorn Hunt.

3. On the lawn to the left of the path, towards the trees:

Roots
Sculptor: Kevin Chadwick

Sculpture in Millstone grit on a concrete base
Sculpture: h. 1m (3'4"); w. 82cm (2'8"); 49cm (1'7")

Base: h. 12cm (5"); w. 1.07m (3'6"); 62cm (2'1")
Sited: Early 1999
Status: not listed
Owner: Quorn Parish Council

Description: An abstract sculpture carved with forms based on tree roots.

Condition: Good. However, water collects in two pools formed by fairly deep hollows in the upper part of the sculpture.

History: *Roots* was commissioned, along with four other sculptures, by the Parish Council from second-year sculpture students of Loughborough University School of Art and Design (for full details, see the entry for *Trilobite*, above, p.256).

It was originally sited at the corner of Leicester Road and Wood Lane, on a triangular plot of grass. Of all the five commissioned sculptures, *Roots* was the only one to be unfavourably received by residents of the immediate vicinity – some of whom disliked its siting while others found the carved shapes unpleasantly suggestive of 'entrails – or even a pile of dog dirt'. Whilst not rejecting altogether the idea of having a sculpture on that site, the protestors wanted 'the parish council to first

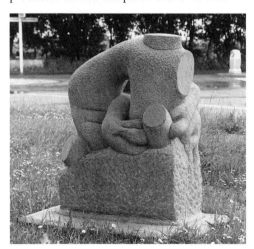

Chadwick, *Roots*

consult with villagers and then replace [*Roots*] with a design more in keeping with village traditions'.[1]

Roots was relocated to the High Street Land in late summer 1999.[2]

Literature
Lo. Echo, 5 February 1999, p.4.

Notes
[1] *Lo. Echo*, 5 February 1999, p.4. [2] Information from Kathryn Paterson, Clerk to Quorn Parish Council.

4. On the lawn to the left of the path, beneath the trees:

Leaning
Sculptor: Alyn Mulholland

Sculpture in Millstone grit on a concrete base
Sculpture: h. 98cm (3'3"); w. 56cm (1'10"); d.

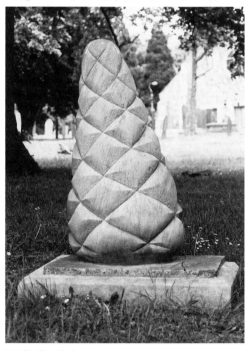

Mulholland, *Leaning*

46cm (1'6")
Base: h. 14cm (6"); w. 91cm (3'); d. 71cm (2'4")
Sited: early 1999
Status: not listed
Owner / custodian: Quorn Parish Council

Description: Sculpture in the form of a giant pine cone.

Condition: Good.

History: *Leaning* is another of the five sculptures commissioned by Quorn Parish Council from second-year sculpture students of Loughborough University School of Art and Design (for full details, see the entry for *Trilobite*, above, p.256).

The sculpture was inspired by the tall pine trees growing nearby.

In front of Quorn Court on a small gravelled plot opposite the High Street Land:

Fire: 'Dissipated Energy', 'Centre of Attention' and 'Anxious Achiever'

Sculptor: Lorraine Young

Three-piece sculpture in Ancaster limestone
h. 83cm (2'9"); w. 1.63m (5'4"); d. 29cm (1')
Inscription on a metal plaque fixed to the upper surface of the base:
'FIRE' / REPRESENTATIONS OF THE / FIRE SIGNS OF THE ZODIAC / BY / LORRAINE YOUNG / 1997
Sited: April 1998
Status: not listed
Owner / custodian: Quorn Parish Council

Description: Carved from a single piece of Ancaster limestone split into three, the sculpture has the collective title 'Fire', while each of the three parts is also named individually, as above. They are based on the fire signs of the Zodiac.

Condition: Generally good, although the rough-hewn upper edges of the sculpture have suffered some small losses – there being some

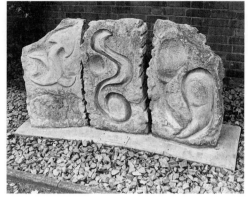

Young, *Fire …*

very small fragments from the sculpture lying on the surrounding ground.

History: *Fire* was purchased through the Public Art Partnership scheme initiated by Charnwood Borough Council and Loughborough University School of Art and Design (for details of which scheme, see the entry on *Karka and Gurga*, above, pp.256–7). In April 1998, *Fire* was sited in its present position in High Street. There having been no unfavourable reaction, the sculpture was purchased by the Parish Council for £750, the final instalment of which was paid in April 1999.[1]

The sculptor says of *Fire*:

Predominantly my work is based upon the unseen forces that affect nature; the changing seasons, and planetary motion. These particular pieces relate to abstracted astrological symbols, each incorporating specific characteristics individual to each sign; my point of reference being the effect that planetary motion has on our day-to-day lives, and on our personalities and or, mood swings. Most, if not all people know under which sign they are born, giving the viewer recognition and inclusion.[2]

Related works: The present sculpture is one of four sets of three treating all twelve signs of the zodiac; the other three sets are in private collections.

Literature
PMSA NRP East Midlands Archive. Letter, dated July 1999, from the sculptor to the author.

Notes
[1] Information from Kathryn Paterson, Clerk to Quorn Parish Council. [2] From a typed statement from the sculptor to the author, July 1999.

On the peak of the gable of the former Old Bull's Head inn:

Bull's Head

Sculptor: unknown

Sculpture in stone and metal

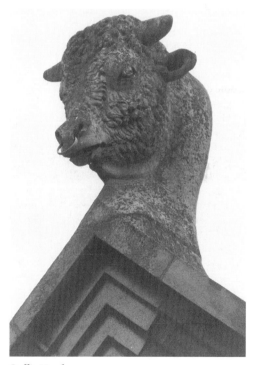

Bull's Head

Status: not listed
Owner: unknown

Description: A bull's head in stone with a metal ring through its nose.

Condition: Good, as far as can be seen from street level.

Loughborough Road

Rawlins Community College (access only by prior arrangement)

On the lawn of the old vicarage to the left of the College Reception building:

Fifty-Fifty

Sculptor: Bernard Schottlander

Sculpture in steel, painted red
h. 1.47m (4'10"); w. 2.6m (8'6"); d. 57cm (1'11")
Executed: 1966/7
Exhibited: 1967–8, London, Whitechapel Art Gallery (no. 51); 1968, Arts Council of Great Britain (touring exhibition) (no. 3)
Status: not listed
Owner: Leicestershire Education Authority

Condition: Poor. The paint surface is blistered and peeling with numerous losses.

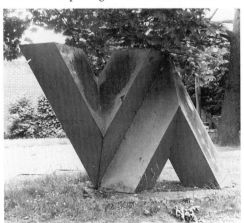

Schottlander, *Fifty-Fifty*

Where the metal is exposed, rust has formed. The flat tops of the arms of the upright V-shaped element are particularly corroded, the inner of the two having a rather large hole in it.

History: *Fifty-Fifty* was purchased by the Leicestershire Education Authority on 1 September 1967 with funds provided through the buildings capital scheme.[1]

Literature
Arts Council of Great Britain, 1968, n. pag.; Whitechapel Art Gallery, 1967, p.18, illus. betw. pp.18/19.

Note
[1] LEA inventory.

Meeting Street

In the memorial gardens at the corner of Meeting Street and Leicester Road:

Quorn War Memorial

Architects: Pick Everard & Keay
Sculptor and stonemasons: Joseph Herbert Morcom and the Plasmatic Company
Builder: William Henry Fewkes

Memorial in Portland stone and Swithland slate
h. 4.1m (13'6")
Inscriptions:
(i) front face
– carved into the stonework below the bas relief: Sᵀ GEORGE & MERRY ENGLAND
– carved into the slate panel: PASS NOT THIS STONE / IN SORROW BUT IN PRIDE / AND MAY YOU LIVE / AS NOBLY AS THEY DIED [beneath which is a carved floral motif, then] IN MEMORY OF / THE MEN OF QUORN / WHO FELL IN THE / GREAT WAR 1914–19 [beneath which is a list of 30 names in full, in alphabetical order, A – G]
(ii) rear face, carved into the slate panel: 1914–1919 [beneath which is a list of 46 names in full, in alphabetical order, H – W]
(iii) left face, carved into the slate panel:

1939–1945 / [space] / IN / HONOURED MEMORY / OF THOSE WHO GAVE / THEIR LIVES IN THE / CAUSE OF FREEDOM [beneath which is a list of 19 names, then, in flowing script] *We will remember them*
Unveiled and dedicated: Sunday 24 July 1921, by Lieutenant-Colonel W.S.N. Toller and the Revd H.H. Rumsey, Vicar of Quorn
Status: Grade II
Owner / custodian: Quorn Parish Council

Description: War memorial comprising a double platform, square plinth course, battered pedestal with panels in Swithland slate, one each on the front, rear and left-hand faces, and a square, pedimented block crowning all, with a bas-relief on its front face. The relief, of St George and the dragon, was described by a contemporary local newspaper as 'a symbolical tablet of St George and the Dragon overcome, depicting the Allies' victory'.[1]

Condition: The pediments and corners of the upper block are rather blackened and the pedestal is stained with green biological growth. The bas-relief is now very weathered, the carving becoming indistinct.

History: The people of Quorn inaugurated and dedicated a temporary war memorial on the site of the present memorial as early as 22 December 1917.[2] On 30 January 1919, however, the parish council called a public meeting to discuss options for a permanent memorial.[3] A generous offer from three local men to purchase a memorial social club for the village provided that the village paid for furnishings and equipment did not find favour and the offer was ultimately withdrawn.[4] It was evident that the parishioners wanted a purely commemorative monument set in a memorial garden and at some time during the course of the year the Quorn War Memorial Committee (drawn from the ranks of the parish council) requested the Leicester firm of architects Pick Everard and Keay to prepare some designs.[5]

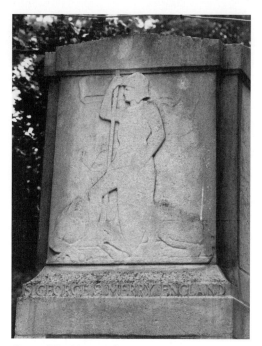

Quorn War Memorial

Having firmly established that a monument – not an institution – was wanted, the committee began collecting subscriptions. By March 1920, it had decided that the inscribed names of the dead should be listed in straight alphabetical order (i.e., without regiments and not in rank order), and by June was in discussion with William Keay over the cost of the preferred design, to be erected in a specially designed setting in the Spinney at the entrance to Quorn House Park. Keay recommended that the committee let him use J.H. Morcom's firm, the Plasmatic Company, to execute the work and advised the committee chairman, Sydney Wright, that Morcom had estimated a cost of between £500 and £600 for the monument alone, plus a further £400 for the setting (with gates and ornamental fence and piers), bringing the total to about £1,000.[6] At this point the committee realised that it would not be able to collect sufficient funds for a scheme on this scale and resolved to cut costs dramatically by re-utilising the existing temporary war memorial site. Wright wrote to Keay on 12 July 1920 approving one of the designs for the monument and instructed him to proceed 'as quickly as possible'.[7]

Unfortunately for the committee, however, the Plasmatic Company was in great demand for war memorial work just at this time and in October 1920, in answer to Wright's urgent enquiries, Keay had to advise him that the Quorn memorial would not be available before 'the early part of next year'.[8] Not until December 1920 was the architect able to provide Wright with Morcom's firm estimate of £500 'for providing Portland Stone, working same ... and fixing complete on site'.[9] The estimate was accepted and Keay instructed Morcom 'to push on with all speed'.[10] By early March 1921, William Fewkes, a local builder, had begun work on the foundations,[11] and by Friday 24 May, Morcom was in a position to ask Keay whether the site would be ready to receive the completed memorial on the following Thursday. Keay replied that it had been ready for some weeks.[12]

The memorial was duly erected, but then on 14 July 1921 Keay wrote to Morcom requesting that as a matter of extreme urgency he correct six errors (which, he stressed, he realised were not Morcom's fault) on the name tablets – before the unveiling and dedication ceremony in ten days time. This Morcom evidently did.[13]

The final payments were £480 for the Plasmatic Company (Morcom had given the committee £20 discount for prompt payment), £38 2s. 6d. to Fewkes for the concrete foundations, and £25 to Pick Everard and Keay for the design,[14] making a total cost for the memorial of £543 2s. 6d. In addition, some further £150 was spent on the laying out of the plot with lawn, flower beds, and a backing of trees[15] – this last being Keay's recommendation as the most appropriate setting for the memorial.[16] In July 1923, as a final touch, the committee ordered four cast bronze flower troughs (no longer in evidence) from Dryad Metal Works, Leicester for £52 12s. 0d.[17]

Literature
LRO. Pick Everard Keay and Gimson, business records: Quorn War Memorial, correspondence, etc., 1919–23.
Quorn Parish Council archives. Quorn Parish Council minutes, 6 November 1917 – 7 October 1924 (as transcribed by Dr Joan Skinner).
General. *L. Advertiser*, 30 July 1921, p.5; *Lo. Echo:* – [i] 16 July 1920, p.8 [ii] 29 July 1921, p.5; Sharpe, J.M., 1992, pp.7, 26, 27, 38, figs. **2.10, 3.16**.

Notes
[1] *L. Advertiser*, 30 July 1921, p.5. [2] Quorn Parish Council minutes (information supplied by Dr Joan Skinner), meetings of 6 November and 4 December 1917. [3] *Ibid.*, meeting of 21 January 1919. [4] *Ibid.*, meetings of 4 February and 4 March 1919. [5] Letter dated 31 September 1919 from William Keay of Pick Everard and Keay to Sydney Wright, Chairman of the Quorn War Memorial Committee (LRO, business records relating to Pick, Everard, Keay and Gimson). [6] Letters dated 11 March, 13 March and 9 June 1920 between Keay and Wright (LRO, *ibid.*). Quorn Parish Council minutes (information supplied by Dr Joan Skinner), meeting of 1 June 1920. [7] *Lo. Echo*, 16 July 1920, p.8; letter dated 12 July 1920, from Wright to Keay (LRO, business records relating to Pick, Everard, Keay and Gimson). [8] Letter dated 13 October 1920, from Keay to Wright (LRO, *ibid.*). [9] Estimate from the Plasmatic Company to Pick Everard and Keay, dated 1 December 1920 (LRO, *ibid.*). [10] Letter dated 2 December 1920, from Keay to the Plasmatic Company (LRO, *ibid.*). [11] Letter dated 4 March 1921, from Keay to Wright (LRO, *ibid.*). [12] Note dated 24 May 1921, from Morcom to Keay; letter dated 25 May 1921 from Keay to Morcom (LRO, *ibid.*). [13] Letter dated 14 July 1921 from Keay to Morcom (LRO, *ibid.*). [14] Letter dated 22 June 1921 from Keay to Wright (LRO, *ibid.*). [15] *Lo. Echo*, 29 July 1921, p.5. [16] Letter dated 10 June 1921 from Keay to George White, Quorn Parish clerk (LRO, business records relating to Pick, Everard, Keay and Gimson). [17] Dryad Metal Works estimate dated 9 July 1923 (LRO, *ibid.*).

Station Road

In Stafford Orchard, on the bank overlooking the river:

Arc II

Sculptor: Michael Thacker

Sculpture in Millstone grit on a concrete base
Sculpture: h. 37cm (1'3"); w. 82cm (2'8"); d. 52cm (1'9")
Base: h. 13cm (5"); w. 1.17m (3'10"); d. 82cm (2'8")
Sited: early 1999
Status: not listed
Owner / custodian: Quorn Parish Council

Condition: Good.
History: *Arc II* was one of five sculptures commissioned by Quorn Parish Council from second-year sculpture students of Loughborough University School of Art and Design (for full details, see the entry for *Trilobite*, above, p.256).
Thacker derived the form of *Arc II* from the vertebrae of a large mammal, his reference being

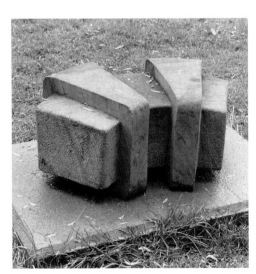

Thacker, *Arc II*

to the fossil finds for which the area is locally known.[1]

Thacker said of his work:

The starting point for my work involves simple architectural forms, such as, pediments and archways. Also utilizing a range of organic forms and developing these into pieces of work, using these diverse sources of inspiration as contrasting parts of my work.[2]

Related work: Michael Thacker, *Broken Arc* (Fossil sculpture trail), Barrow-upon-Soar (see p.9).

Literature
Loughborough University School of Art and Design, 1999, p.51.

Notes
[1] Information from Kathryn Paterson, Clerk to Quorn Parish Council. [2] Loughborough University School of Art and Design, 1999, p.51.

RATBY
Civil Parish: Ratby
Borough Council: Hinckley and Bosworth

Main Street

On the west side of Main Street in front of Ratby County Primary School:

Ratby War Memorial

Designer and maker: Shirley Ward

Memorial in Carrara marble
Figure of angel: h. (est.) 1.3m (4'3")
Pedestal: h. 3m (9'10"); w. 50cm (1'8"); d. 50cm (1'8")
Inscriptions, incised and blackened, on the pedestal:
– on the front face of the dado: 1914 – 1918 / IN MEMORY OF THE MEN / OF RATBY WHO GAVE THEIR / LIVES IN THE GREAT WAR / – / THEIR NAMES LIVETH FOR EVER [then follows a list of

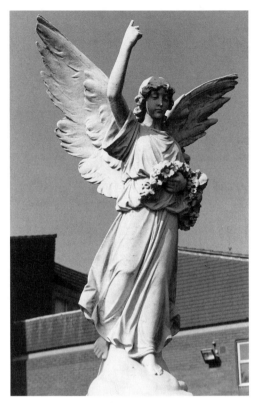

Ratby War Memorial

32 names with initials only of forenames, plus ranks, in two columns of 14, with one name added at the top and three at the bottom]
– on the front face of the plinth: "GREATER LOVE HATH NO MAN". / UNVEILED BY FIELD MARSHAL EARL HAIG. C.C.B., O.M., C.C.V.O. / NOV 13TH 1920.
– on the left face of the dado: 1939 – 1945 [then follows a list of 12 names with initials only of forenames, plus ranks]
Signed on the left-hand face of the base towards the front, in lead letters:
S. WARD / LESTER [*sic*]

Unveiled and dedicated: Saturday 13 November 1920, by Field Marshal Earl Haig and the Revd H.D. Hanford, Vicar of Ratby
Status: not listed
Owner / custodian: Ratby Parish Council

Description: The war memorial is enclosed by a metal railing within a space bordered by a low wall of granite rubble, open to the front. All in white marble, the memorial comprises a tall pedestal on two steps, surmounted by a figure of a winged angel with its right arm upraised, pointing heavenwards. Over the angel's left arm is a garland. The *Leicester Daily Post* explained the figure as being 'symbolical of peace after victory'.[1]

Condition: The overall condition is fair, although the last two joints of the index finger of the angel's right hand (pointing heavenwards) are missing.

History: At a public meeting in the Council Schools, Ratby, on 3 March 1920, a design for a memorial in Carrara marble by Shirley Ward, a Leicester-based monumental mason, was approved at an estimated cost of £500, the sum to be raised through public subscription and fund-raising events.[2]

Literature
L. Advertiser, 20 November 1920, p.8; *L. Chronicle*, 20 November 1920, pp.8–9; *L. Daily Post*: – [i] 6 March 1920, p.7 [ii] 31 July 1920, p.6 [iii] 15 November 1920, p.5; *L. Mail*: – [i] 13 November 1920, p.1 [ii] 15 November 1920, p.2; *L. Mercury*: – [i] 30 October 1920, p.7 [ii] 13 November 1920, pp.1, 5; Sharpe, J.M., 1992, pp.12, 27, 41, fig.**3.6**.

Notes
[1] *L. Daily Post*, 15 November 1920, p.5. [2] *Ibid.*, 6 March 1920, p.7.

Taverner Drive

On a plot of open land:
Ratby Wildlife Totem Pole
Sculptor: Paul Wood

Sculpture in oak, partly coloured
h. (est.) 3.66m (12')
Erected: Sunday 14 June 1998
Status: not listed
Owner: Ratby Parish Council

Description: The sculpture is in the form of a Native American totem pole. At the top is a crow with flapping wings looking down at a fox creeping up towards it. Other carvings include an owl, a ladybird and at the bottom, plants and fish. The crow's body is stained black, its bill yellow.

Condition: The raised wing and head of the bird at the top of the totem pole were broken off and taken by vandals in June 1999. Replacements for the stolen parts were fitted by the sculptor in autumn 1999.

History: The *Ratby Wildlife Totem Pole* was commissioned by the Ratby Community Orchard team in 1998 'to celebrate the [Ratby] Orchard project and to provide an unusual feature' that would signpost its new pond.[1] The timber was donated by the Woodland Trust from an oak felled in Martinshaw Woods during a thinning programme and the sculptor's fee was obtained through a grant from Rural Action. During their search for a sculptor who specialised in wood carving, the project team heard of the work of Paul Wood and, having seen examples of it and decided it was exactly what they wanted, offered him the commission.

Wood worked on the commission for a period of five days. In order to raise local awareness and to give local children a sense of involvement in the project, the Parish Council arranged for the sculptor to work for the first two days in Ratby Primary School. The children were asked to draw examples of native

Wood, *Ratby Wildlife Totem Pole*

British wildlife, some of which were incorporated by Wood onto the *Totem Pole* whilst the children watched. The oak was then relocated to the site at Taverner Drive and over the next three days the sculptor completed all but the lowest three feet of carving (with

assistance from local residents). The totem pole was then manœuvred into position and erected with the help of a JCB lent for the purpose by a local firm. Once the pole was installed, Wood completed his work on the lowest three feet.[2]

Literature
PMSA NRP East Midlands Archive. Photocopies of publicity material, Project Grant Report, etc., for the Ratby Wildlife Totem Pole.
General. *L. Mercury*, 16 June 1998, p.21.

Notes
[1] From a publicity handout advertising the Totem Pole Weekend, 13–14 June 1998. [2] Information from Iris Hannaford, Ratby Community Orchard Project.

RATCLIFFE-ON-THE-WREAKE Civil Parish: Cossington
Borough Council: Charnwood

Fosse Way

Ratcliffe College (access only by prior arrangement) was begun by A.W.N. Pugin in 1843

Of his quadrangular layout, Pugin managed only to complete the east range. In 1854–8 Charles Hansom built the north and south ranges and in 1866–72 E.W. and C. Pugin completed the layout with the west range.

Literature
Pevsner, N. and Williamson, E., 1992, pp.359–61.

Exterior sculpture:
1. East range.
Above the oriel window of the entrance tower, set within a niche:

Virgin and Child
Sculptor: George Myers

Sculpture and niche in stone
Niche (est.): h. 2.59m (8'6"); w. 1.8m (5'11")

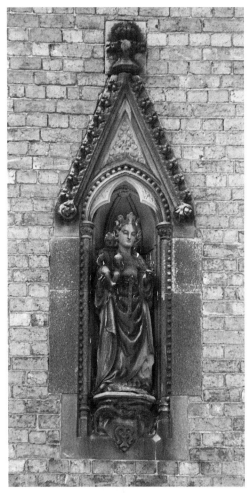

Myers, *Virgin and Child*

Executed: *c.*1843
Status of building: Grade II
Owners: Trustees of Ratcliffe College

Description: The *Virgin and Child* is set within a Gothic-style niche.[1] The Virgin is a standing figure, wearing a crown and supporting the Christchild on her right arm. He

has a globe in his left hand and makes the sign of benediction with his right. The Virgin's crown signifies that she is the Queen of Heaven, while the Christchild's globe coupled with his act of making the sign of benediction are the traditional indicators of Christ as Salvator Mundi, or the Saviour of the World.

Condition: The stone is blackened but there are no evident losses or damage.

Related works: Another version of Myer's *Virgin and Child* is in St David's Roman Catholic Church, Pantasaph, North Wales (exhibited at the Great Exhibition of 1851);[2] with a copy in the Pugin Chantry, St Augustine's, Ramsgate, Kent.[3]

Literature
Atterbury, P. and Wainwright, C. (eds), 1994, pp.241, **78**; *The Crystal Palace Exhibition. Illustrated Catalogue …* , 1970, p.**320**.

Notes
[1] For a good photograph of the *Virgin and Child* on the entrance tower, see Leetham, C.R., 1950 (frontispiece). [2] Illustrated in *The Crystal Palace Exhibition. Illustrated Catalogue …* , 1970, p.320. [3] Illustrated in Atterbury, P. and Wainwright, C. (eds), 1994, p.78.

To the right of the main entrance doorway, set within a niche:

Crucifixion
Sculptor: George Myers

Crucifixion and niche in stone
Niche: h. 1.7m (5'7"); w. 83cm (2'9")
Executed: *c.*1843
Status of building: Grade II
Owners: Trustees of Ratcliffe College

Description: Set within a niche, a relief representing Christ on the Cross flanked by the standing figures of the Virgin Mary and St John the Evangelist.[1]

Condition: The stone is blackened, but there are no losses or damage evident.

Literature
Pevsner, N. and Williamson, E., 1992, p.359.

Note
[1] For a good photograph of the *Crucifixion* on the entrance tower, see Leetham, C.R., 1950 (frontispiece).

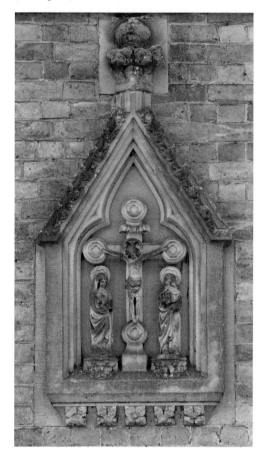

Myers, *Crucifixion*

Jones, *Antonio Rosmini Serbati and Schoolboys*

2. The Chapel, 1958–62, by Sandy and Norris. On the exterior, south-facing wall:

Relief of Antonio Rosmini Serbati and Schoolboys
Sculptor: Jonah Jones[1]

Relief in limestone
h. 2.48m (8'2"); w. 1.68m (5'6"); d. 7.5cm (3")
Inscription, incised across the bottom of the relief:
CARITAS EST VIA AD VERITATEM ['Charity is the path to truth']
Status of building: Grade II
Owners: Trustees of Ratcliffe College

Description: A relief shaped to the contours of a group of schoolboys standing around the figure of Antonio Rosmini. A boy at the right holds a rugby ball, while two in the centre foreground hold, respectively, a dove and a violin.

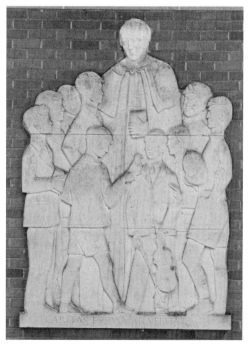

Condition: The relief is in good condition, but with some black encrustation.

Literature
PMSA NRP East Midlands Archive. Letter, dated 27 October 1999, from Brother Anthony Primavesi, Ratcliffe College, to the author.

Note
[1] According to Brother Anthony Primavesi, Ratcliffe College, in a letter dated 27 October 1999 to the author.

Note: In the Chapel (outside the scope of the present volume, see p.xxviii) are statues of saints. According to Pevsner, the best, 'with subtle classical references', is *St Joseph*, 1945, by Father Francis O' Malley. The slate reliefs of the *Stations of the Cross* and the hanging *Crucifix* (along with the stained glass windows) are all by Jonah Jones.[1]

Note
[1] Pevsner, N. and Williamson, E., 1992, p.361.

3. The Square. On the first-floor exterior wall over the arcade of the west cloister (added 1936 by Mr Wort of Cardiff)[1]:

Relief of the Virgin Mary and Eve
Sculptor: Father Francis O'Malley[2]

Relief in stone
h. 84cm (2'9"); w. 90cm (3')
Inscription, incised across the bottom of the relief:
QVOD. LIGAVIT. EVA. HOC. SOLVIT. MARIA ['What Eve left, Mary absolved']
Status of building: Grade II
Owners: Trustees of Ratcliffe College

Description: A relief of the Virgin Mary trampling a serpent, leaning forward to bless an apple proffered by Eve kneeling on the ground beneath a tree. The theme refers to the idea of the Virgin Mary as the second Eve, the one predestined – in so far as she was the mother of Jesus Christ – to redeem mankind from Eve's

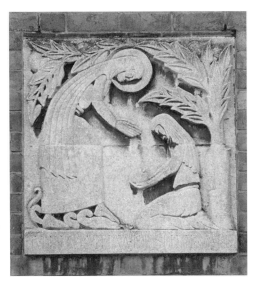

O'Malley, *Virgin Mary and Eve*

incarnate to redeem mankind, was seen by the Roman Catholic Church as 'the second Eve'. The serpent upon which Mary treads is therefore the serpent of the Garden of Eden and the apple is the fruit of the tree of knowledge.

Condition: Fair, but with some black encrustation in channels and hollows, etc.

Note: Father O'Malley, a follower of Eric Gill, also executed the coat of arms on the same wall.

Literature
PMSA NRP East Midlands Archive. Letter, dated 27 October 1999, from Brother Anthony Primavesi, Ratcliffe College, to the author.
General. Leetham, C.R., 1950, p.86.

Notes
[1] Pevsner, N. and Williamson, E., 1992, p.360.
[2] According to Brother Anthony Primavesi, Ratcliffe College, in a letter dated 27 October 1999 to the author.

Interior sculptures, the east cloister:
Our Lady Immaculate
Sculptor: Eric Gill

Statue in Bath stone with added red pigment
Statue and base: h. 1.38m (4'6"); w. 47cm (1'7"); d. 23.5cm (9")
Plinth: h. 74cm (2'5"); w. 48cm (1'7"); d. 23cm (9")
Inscription on base: MARIA / SINE LABE ORI- / GINALI CONCEPTA / O. P.N. ['ora pro nobis'] ['Mary, conceived without original sin, pray for us']
Executed: 20-3 January 1936
Status: not listed
Owners: Trustees of Ratcliffe College

Description: The sculpture is located in a niche facing along the cloister, between the main entrance and reception. The Virgin is represented standing on a dragon (i.e. Satan), its head overhanging the base towards the left. Gill has used red pigment to colour the letters of the Latin inscription and the Virgin's crucifix brooch.

Condition: Fair. However, there is a hairline crack (or a break that has been repaired) from the top of the head, running diagonally across the face, down the left side of the jaw and around the left shoulder. The bottom of the integral base is chipped.

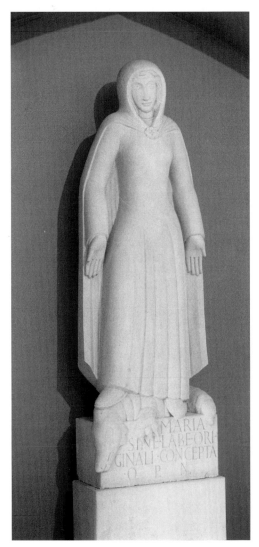

Gill, *Our Lady Immaculate*

original sin as recounted in the Old Testament book of Genesis (Chapters 2 and 3). God, having created the first man, Adam, placed him in the Garden of Eden, explaining that he could eat freely of all the fruit in the garden, except, on pain of death, that of 'the tree of the knowledge of good and evil'; and so that Adam should not be alone, God created Eve to be his wife. Also in the Garden, however, was the serpent (i.e., Satan) who persuaded Eve that if she and Adam were to eat the forbidden fruit they would themselves be like gods. Eve ate the fruit and passed it to Adam who also ate and immediately the two became ashamed of their nakedness. As punishment for their disobedience, Adam and Eve were expelled from the Garden of Eden and lost their immortality, Eve being condemned to painful childbirth and Adam to toil in the fields until he died. Thus Eve not only precipitated the Fall, she was also the first mother. The Virgin Mary, as the mother of Jesus Christ who became

History: According to Judith Collins, *Our Lady Immaculate* (to whom Ratcliffe College is dedicated) and its companion, *Christ the Sacred Heart* (recently sold by the College, see p.329), were commissioned by Father O'Malley of Ratcliffe College in February 1935.[1] C.R. Leetham, President of Ratcliffe College and writer of the College's history (1950) states, however, that the statues were commissioned through 'the piety of the School and the enthusiasm of Fr. Horgan'. He also writes of the present statue that: 'There was a great outcry for and against, and many of the unsophisticated continue to regret the homely statue of Our Lady that now adorns the Study.'[2]

On 14 March 1935, Gill visited the college to discuss the statues and their siting and on 15 and 16 August he made drawings, the statue of *Our Lady Immaculate* being revised on 29 and 30 October (three pencil drawings for the *Christ* and ten for the *Our Lady* are in the collection of the University of Texas, Austin). The two statues were carved by Gill in a matter of days in January 1936 and sent to the college within the same month. They were blessed by the Bishop of Nottingham on 13 February.[3]

Literature
Collins, J., 1998, pp.200-1; Leetham, C.R., 1950, p.87; Peace, D., 1994, p.152; Pevsner, N. and Williamson, E., 1992, p.360.

Notes
[1] Collins, J., 1998, pp.200-1. [2] Leetham, C.R., 1950, p.87. [3] Collins, J., 1998, pp.200-1.

Statue of Antonio Rosmini Serbati

Antonio Rosmini Serbati (1797–1855), philosopher and founder of the Institute of Charity, was born at Rovereto in the Austrian Tyrol. On completion of his studies at the University of Padua, he returned to his home town to prepare for Holy orders. He was ordained priest at Chioggia on 21 April 1821

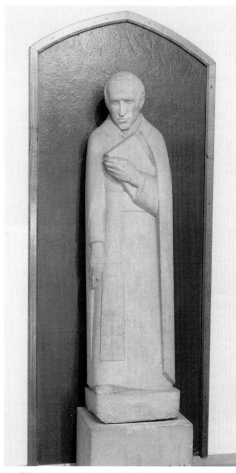

Duffy, *Antonio Rosmini Serbati*

and received his Doctorate in Theology and Canon Law from Padua in the following year. In 1823 he went to Rome and was encouraged by Pope Pius VII to undertake the reform of philosophy. He returned to Rovereto and devoted the next three years to the study of philosophy. The principles he evolved in these years formed the basis of the rules of the Institute of Charity (Rosminians) which he founded in 1828. Missionaries from the institute arrived in England in 1831 and in 1843 began to build a novitiate (which was moved to Rugby in 1852) and lay college, the present Ratcliffe College.

Sources: *Catholic Encyclopedia*, 1999; Livingstone, E.A, (ed.), 1977; Pevsner, N. and Williamson, E., 1992.

Sculptor: Brother Aloysius Duffy

Statue in limestone
Statue and base: h. 1.55m (5'1"); w. 39cm (1'3"); d. 31.5cm (1'1")
Plinth: h. 53.5cm (1'9"); w. 47cm (1'7"); d. 39.25cm (1'4")
Inscription in incised reddened letters on the front face of the plinth:
A. ROSMINI / 1797 – 1855
Status: not listed
Owners: Trustees of Ratcliffe College

Description: Located at the south end of the east passage of the cloisters, Rosmini is represented wearing the typical dress of the Italian clergy of the time. He looks contemplatively down to his right, a large book held in his left hand.

Condition: Fair, though there are some small scratches and minor chipping to the forward parts of the statue.

History: The statue was probably executed at some time during the 1950s.[1]

Literature
PMSA NRP East Midlands Archive. Letter, dated 27 October 1999, from Brother Anthony Primavesi, Ratcliffe College, to the author.
General. Pevsner, N. and Williamson, E., 1992, p.360.

Note
[1] According to Brother Anthony Primavesi, Ratcliffe College, in a letter dated 27 October 1999 to the author.

Bust of Father Joseph Hirst
Sculptor: William Henry Tyler

Bust in white marble
h. 76cm (2'6"); w. 55.5cm (1'10"); d. 33cm
(1'1")
Status: not listed
Owners: Trustees of Ratcliffe College

Description: Located at the south end of the east passage of the cloisters, Father Hirst (d.1895), President of Ratcliffe College 1885–95, is portrayed with his head tilted slightly upwards to his right. The base is carved to represent two large books.
Condition: A large chip is missing from the

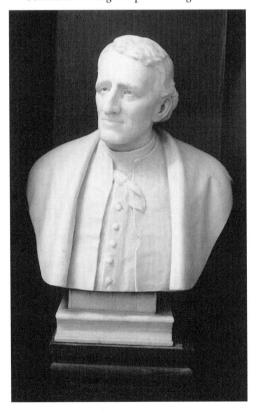

Tyler, *Father Joseph Hirst*

left edge of the waistcoat.
History: The *Bust of Father Joseph Hirst* was commissioned from William Tyler, an Old Ratcliffian, by the Ratcliffe Association. Evidently the commission provoked 'violent arguments' within the College between those who disapproved of such forms of aggrandisement – 'the anti-Busters' – and those who were for it – 'the Busters'. The bust was funded by voluntary subscription by an impressively disparate group of friends and admirers which included Dr Creighton, the then Bishop of London, Lord Gerard, Lord Percy, Professor Hiendl, Lord Arundell, Duchess Sforza, Sir Talbot Baker, and General Jee. The principal memorial to Hirst within the College is the gallery in the library, completed in 1901, 'the expense being defrayed by his brother Edward, who lost his life with all his family in the wreck of the *Stella* on the Casquets in 1899'.[1]

Literature
Leetham, C.R., 1950, p.71.

Note
[1] Leetham, C.R., 1950, p.71.

Note: The Refectory, 1911, designed by Arthur Young and built by Frank J. Bradford of Leicester has carved half-figures of angels on the responds of the vault ribs and, on the end wall, a large marble Christ on the Cross.

ROTHLEY Civil Parish: Rothley
Borough Council: Charnwood

Westfield Lane
Rothley Court Hotel

On the lawn opposite Reception:
Rothley Anti-Slavery Memorial
Designer: unknown

Memorial in limestone, granite and concrete
h. 2.37m (7'9")
Inscriptions in incised capital letters on metal plaques fixed to the pedestal:
– on the front (west) face: THIS MEMORIAL WAS ERECTED / IN DECEMBER 1959 BY / T. CLIVE WORMLEIGHTON / OF MALLORY PARK LEICESTERSHIRE / TO COMMEMORATE THE CENTENARY / OF THE DEATH OF / LORD MACAULEY OF ROTHLEY / WHO WAS BORN HERE IN ROTHLEY / TEMPLE ON OCT. 25 1800. AND DIED / ON DEC. 28 1859. ALSO TO / COMMEMORATE THE CONVERSION / TO ROTHLEY COURT HOTEL / IN THE SAME YEAR.
– on the left (north) face: THIS MEMORIAL / COMMEMORATES THE SITE / ON THE LAWNS OF / ROTHLEY TEMPLE, WHERE / SIR WILLIAM WILBERFORCE BART. / AND THOMAS BABINGTON, / DRAFTED THE ACT OF / PARLIAMENT FOR THE / ABOLITION OF SLAVERY / THROUGHOUT THE BRITISH EMPIRE.
Erected: December 1959
Status: not listed
Owner: Rothley Court Hotel

Description: The *Rothley Anti-Slavery Memorial* takes the form of a pedestal bearing inscription plaques, crowned by a pyramidal cap and mounted on a concrete platform raised on a battered base of rubble masonry.
Condition: The mortar of the granite base is crumbling and the concrete platform between this and the pedestal is cracked from front to back towards the left. The pedestal is weathered and cracked and its plinth course is overgrown with moss.
As indicated on the inscription plaques, the memorial actually provides a triple commemoration, the centenary of the death of Thomas Babington, Lord Macauley of Rothley, the conversion of his house to Rothley Court Hotel and the site on the lawns where William Wilberforce is supposed to have drafted the act of Parliament for the abolition of slavery

throughout the British Empire. Wilberforce had evidently been staying at the house as a guest of Lord Macauley, himself a fervent opponent of slavery.[1]

Literature
Lee, J. and Dean, J., 1995, p.18, **18**.

Note
[1] Lee, J. and Dean, J., 1995, p.18.

Measham Road, between Oakthorpe and Donisthorpe

The Fisherman
Sculptor: Simon Todd

Sculpture in beechwood
h. 1.75m (5'9"); w. 70cm (2'4"); d. 73cm (2'5")
Unveiled: early 1994
Status: not listed
Owner / custodian: Leicestershire County Council

Description: Standing figure of a stockily-built man, barefoot, clasping a large fish to himself.

Condition: Fair, although the surfaces are covered in green biological growth, and fungi are growing from various parts. There are also deep cracks along the grain.

History: Saltersford Valley Picnic Area, located halfway between the villages of Oakthorpe and Donisthorpe on the Measham Road, was until the early 1990s a stretch of derelict land over former mineworks, partially flooded owing to subsidence. When Leicestershire County Council drew up plans

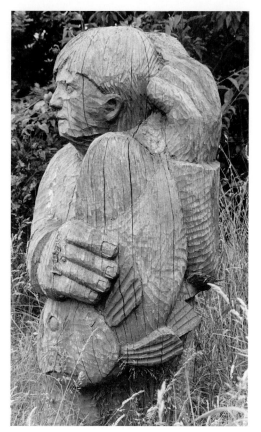

Todd, *The Fisherman*

to re-develop the site as a picnic area, it was agreed that a sculpture or two might provide attractive points of visual interest. Funding was generated mainly from within the Council but with an additional contribution from the Countryside Commission a total of £13,000 was procured for the scheme.[1] Before taking the scheme any further it was imperative to gain the approval and support of the local people. In July 1992, landscape architect Fenella Bellinger, then working for Leicestershire County Council, gave a presentation to Oakthorpe and

Donisthorpe Parish Council, outlining the Council's proposals and introducing some of the ways sculpture had been used in other similar locations.[2] The response being favourable among the adult community, the active involvement of local children was sought with invitations being sent out to the pupils of two local primary schools to make drawings showing what they thought the sculptures should be. In August 1993, these ideas were incorporated into a brief and three professional sculptors were invited to enter a limited competition to produce drawings and maquettes. Each sculptor was paid £400, and on 27 and 28 August their designs were shown at an exhibition in Donisthorpe community centre so that local people could vote for their favourite.[3]

Simon Todd's designs were the clear winners and his appointment was subsequently confirmed by the County Council. He executed the work in Donisthorpe in an outbuilding loaned to him for the purpose by a local woman, Mrs Marjorie Curtois.[4] *The Fisherman* was completed in February 1994[5] and unveiled with its companion piece, *The Fish*, at the official opening of the Saltersford Valley Picnic Area.

Literature
Leicestershire County Council archives. Various memoranda, reports, etc.
General. *C. Times*, 10 October 1997, p.**22**; *L. Mercury (NW Leics edn)*, 31 January 1994, p.5.

Notes
[1] Leicestershire County Council – various memoranda, reports, etc.; and *L. Mercury (NW Leics edn)*, 31 January 1994, p.5. [2] Information from Fenella Bellinger, Leicestershire County Council. [3] According to a letter, dated 28 September 1993, from Fenella Bellinger, Leicestershire County Council, to a Mrs C. Thompson. [4] *L. Mercury (NW Leics edn)*, 31 January 1994, p.5. [5] *Ibid.*

The Fish
Sculptor: Simon Todd

Sculpture in beechwood
h. 90cm (3'); w. 2.73m (9'); d. 92cm (3')
Unveiled: early 1994
Status: not listed
Owner / custodian: Leicestershire County Council

Description: The sculpture serves as a bench and is in the form of two large fish lying side-by-side, nose-to-tail.

Condition: Fair, although the surfaces are covered in green biological growth and grass and fungi are growing in various places. There are also deep cracks along the grain.

History: *The Fish* was completed by January 1994[1] and unveiled with its companion piece, *The Fisherman*, at the official opening of the Saltersford Valley Picnic Area.

For an account of the overall scheme, see the preceding entry.

Literature
Leicestershire County Council archives. Various memoranda, reports, etc.
General. *L. Mercury (NW Leics edn)*, 31 January 1994, p.5.

Note
[1] *L. Mercury (NW Leics edn)*, 31 January 1994, p.5.

Todd, *The Fish*

SCRAPTOFT Valley Primary School – see Leicester City – suburbs: Nether Hall (pp.190–2)

SHEPSHED Civil Parish: Shepshed
Borough Council: Charnwood

The Bull Ring
National Westminster Bank; built for the Nottingham and Nottinghamshire Banking Company by A.E. King, 1903–4

The Nottingham and Nottinghamshire Banking Company opened for business in their new building on the Bull Ring, Shepshed, on Monday 3 October 1904. The bank continued under that name until 1920 when it amalgamated with the London County Westminster & Parr's Bank Ltd.
The frontage and interior have elaborate sculptural decorations:

Frontage: Four Seasons frieze and pediment sculpture

Modeller: George Harry Cox[1]
Makers: Hathern Brick Company

Frieze in terracotta
Owner of building: National Westminster Bank
Status of building: Grade II

Description: The *Four Seasons frieze* is located between the upper-floor windows and the main cornice, and runs the whole length of the frontage between the projecting end wings. The four seasons are represented in the form of putti performing the labours and enjoying the activities appropriate to each season. On the left is spring: one putto operates a horse-drawn plough while a second goads on the horse with a rod and two more follow in their train scattering seeds; another approaches carrying a spade and water jug. A tree acts as a break between this and the next scene, summer. Here the putti take

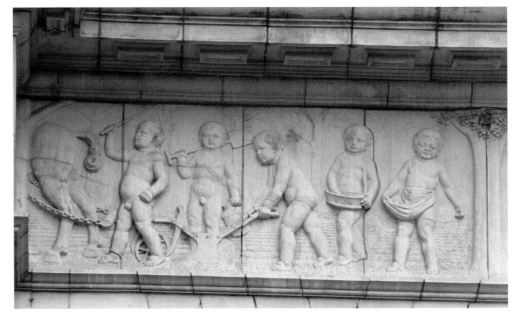

Cox, *The Four Seasons frieze (spring)*

National Westminster Bank: pediment over main entrance

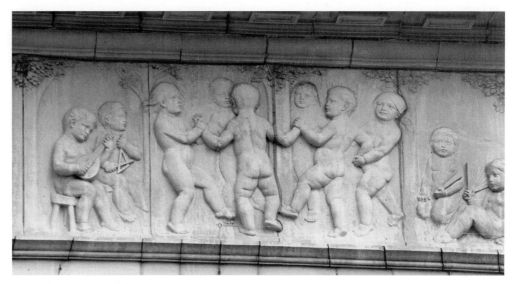

Cox, *The Four Seasons frieze (summer)*

a rest from their labours: six dance in a ring to music provided by two on the left playing a mandolin and triangle. Two putti seated on the right hold fans, one looks towards the viewer, his fan folded, while the other leans against a tree waving his fan to cool himself. On the other side of the tree it is autumn. Here the putti harvest fruit in an orchard. Beyond the last tree it is winter, and the putti warm themselves around a roaring fire: one carries in some more wood, one stokes the fire, one warms his hands and another warms his feet. Some are now clothed. One, a little girl in a dress, huddles against the cold and blows on her clasped hands.

The main entrance on the right-hand, turreted wing, has an open-topped pediment on pilasters with volute-capitals. The open top of the pediment is filled with a classical head and the tympanum beneath with a garlanded, be-ribboned escutcheon in relief. Below this is a frieze with two more escutcheons decorated with heads either side of a voluted extension to the keystone of the doorway below. Both the central volute and the volute-capitals of the

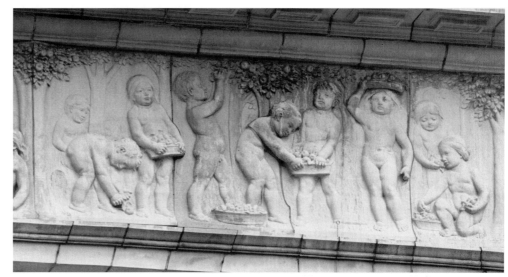

Cox, *The Four Seasons frieze (autumn)*

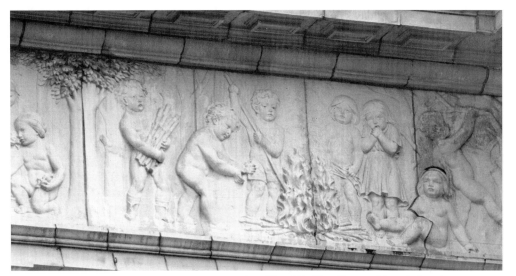

flanking pilasters are decorated with garlands of fruit.

Condition: Good.

Note
[1] Information from Mrs Cecilia Slack, Shepshed.

Interior: sculptural decoration
Modeller: unknown[1]

Sculptural decoration in plaster

Description: The coved ceiling is decorated with a very elaborate plasterwork relief design of dancers, birds and flowers, with three-dimensional figures of Mercury at the corners, above the scagliola columns.

Condition: Good.

Literature
Pevsner, N. and Williamson, E., 1992, p.377.

Note
[1] According to Mrs Cecilia Slack, John Page, working for Johnson's Plasterers, Loughborough, did the plasterwork, although it has not been possible to confirm whether Page actually modelled the figures and reliefs.

Cox, *The Four Seasons frieze (winter)*

(right) Schottlander, *3B Series No. 3*

(below) *National Westminster Bank: Mercury (interior sculpture)*

1. Outside the swimming pool:
3B Series No. 3
Sculptor: Bernard Schottlander

Sculpture in mild steel, galvanised and painted black
h. 2.74m (9'); w. 2.39m (7'10"); d. 65cm (2'2")
Executed: 1967–8
Exhibited: 1969, Nottingham, Midland Group Gallery
Status: not listed
Owner: Leicestershire Education Authority

Condition: Fair. The sculpture has been repainted at some time (the losses and irregularities of the previous coat being visible beneath the present coat). There are numerous scratches and scuff-marks, but there is little evidence of rust.

History: *3B Series No. 3* was purchased by the Leicestershire Education Authority in 1970 with funds provided through the buildings capital scheme.[1] It was evidently selected by the then headmaster, George Mallory, he 'having seen it on display in Nottingham'. Mallory nicknamed the piece 'Two Draws' owing to its double cross shape, a cross being the symbol for a drawn match on a football pool coupon.[2]

Literature
Arts Council of Great Britain, 1980, p.**16**; *L. & R. Topic*, June 1971, p.6, 6; *Studio International*, vol. 178, no. 913, July/August 1969, p.36.

Notes
[1] LEA inventory. [2] *L. & R. Topic*, June 1971, p.5.

2. In an inner courtyard:
Poet in the Wood
Sculptor: Michael Piper

Sculpture in steel and copper
h. 1.99m (6'6"); w. 1.3m (4'3"); d. 1.14m (3'9")
Status: not listed
Owner: Leicestershire Education Authority

Description: The sculpture is in the form of an attenuated male nude standing amongst a group of wiry trees, in the branches of which are two birds.

Condition: Three holes in the base indicate where tree stems have been lost; a tree in the front row has been bent back flush with the base and another has lost its top; other tree stems may be bent. The sculpture is recorded as having been vandalised as early as 1969.[1]

Note
[1] LEA inventory.

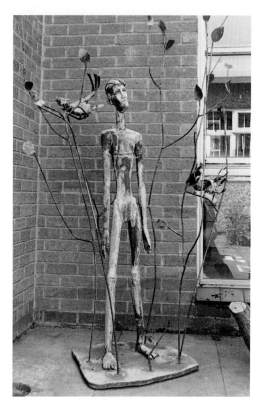

Piper, *Poet in the Wood*

SNIBSTON Discovery Park – *see* Coalville (pp.23–4)

SOUTH WIGSTON – *see* Wigston

Stapleford Park (now Stapleford Park Country House Hotel)

Status: Grade I
Owner: Peter de Savary

The original building was acquired from the Earl of Lancaster by Robert Sherard in 1402. The latter's grandson, Thomas Sherard, added a north wing in *c.*1500. This was restored in 1633 by Lord William (grandson of Thomas) and his wife, Lady Abigail Sherard, with an attention to detail that Pevsner has observed, displays a 'surprisingly early respect for genuine Gothic features'.[1] An inscription referring to this restoration runs across the upper part of the east front. Notwithstanding the credit assumed here solely by William, however, it is generally believed that it was Abigail – a lady, as Nichols describes her, 'of great taste' – who initiated and supervised the restoration.[2] This part of the house, centred on what Pevsner has therefore appropriately designated 'Lady Abigail's Range', is decorated with a remarkable collection of sculpture. On a two-storey extruded corner bay linking Lady Abigail's Range to the (later) main house are two relief panels of knights fighting. On the east front of Lady Abigail's Range are three dormer-head niches and twelve first-floor niches, each filled with a statue and, below the lower string course, five relief panels of religious subjects. Round the corner, on the north end of Lady Abigail's Range are eight more relief panels and finally, beyond a two-storey link, on the north face of the eastward projection of the late nineteenth century service range, a group of six more relief panels, all of religious subjects.[3]

The six statues to the right of the central window and the three in the dormer head

niches are believed to have been made for the original house in *c*.1500; the six to the left of the central window were added by Lady Abigail in 1633. The reliefs of religious subjects are possibly from a church, most likely from the south aisle of the medieval Stapleford church,[4] rebuilt by Lady Abigail *c*.1650.[5] Their provenance in Stapleford church is suggested by the coat of arms of Sherard impaled with Helwell on one of the religious panels, that of *St George and the Dragon*. Thomas Sherard had married Margaret, daughter and sole heir of John Helwell,[6] so this would suggest a date of *c*.1500 for the religious reliefs.

The house was the country seat of the Sherard family until 1894 when it was purchased by the wealthy brewer, John Gretton. It was he who had the above-mentioned service range built by J.T. Micklethwaite. In 1986, John Gretton's great-grandson, the 3rd Lord Gretton, sold the house to Bob Payton, an American restaurant entrepreneur,[7] who had the house converted to a country house hotel by Stamford architect Robert Weighton. Finally, in 1997, it was purchased for The Carnegie Club by its Chairman, Peter de Savary, and continues to function as a country house hotel, open both to members and non-members.

Inscriptions on the east front of Lady Abigail's Range:
– in raised Roman capital letters, above the upper string course: WILLIAM LORD SHERARD BARON OF LETRYM REPAYRED THIS BUYLDING ANNO DOMINI 1633
– in raised Gothic letters, in small recessed panels either side of the niche canopies of the third to fifth statues right of the central window: TS ANᵒ DNI Mᵒ Dᵒ [i.e., Thomas Sherard Anno Domini 1500]
– in incised letters, below the lower string course, towards the right: AND / BOB PAYTON ESQ. / DID HIS BIT / ANNO DOMINI 1988

Notes
[1] Pevsner, N. and Williamson, E., 1992, p.387.
[2] Nichols, J., 1795, vol. ii, pt. i, p.334; Hussey, C., 1924, pp.290, 292, 293; Pevsner, N. and Williamson, E., 1992, p.387. [3] Engravings of the east and north elevations showing the positions of the sculptures are in Nichols, J., 1795, vol. ii, pt. i, pls lvii, lx.
[4] Pevsner, N. and Williamson, E., 1992, p.388. The old church was demolished in 1783 (Nichols, J., 1795, vol. ii, pt. i, p.340). [5] Nichols, J., 1795, vol. ii, pt. i, p.339. [6] *Ibid.*, p.333. [7] Worsley, G., 1988, p.160.

1. *Three dormer head niche statues*
Sculptor(s): unknown

Statues in limestone
h. (est.) 92cm (3')
Executed: *c*.1500

Description: The statue on the left is of an enthroned king with an orb in his right hand and a sword in his left; that in the centre is a standing figure with a sword in his left hand; and that on the right is another standing figure with the remains of a halberd in his left hand.

Condition: All three figures appear to be extremely weathered, the attributes originally held by each being for the most part lost.[1]

Note
[1] See Nichols, J., 1795, vol. ii, pt. i, pl. lviii (figs 13, 14, 15).

2. *Twelve first floor niche statues*
Sculptor(s): unknown

Statues in limestone
h. 92cm (3')
Executed: six left-hand statues: *c*.1633; six right-hand statues: *c*.1500

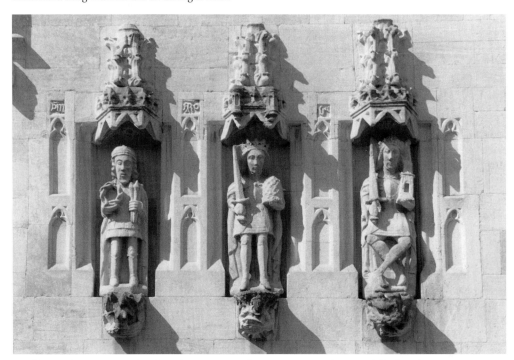

1st-floor niche statues, Lady Abigail's Range, east front (extreme right), Stapleford Park

Inscriptions on banners beneath the six statues to the left of the central window: SCHIRARD LO: OF CHETLETON; KING WILLIAM. THE CONQUEROR; GYLBERT DE CLARE EARLE. OF GLOCESTER; BARTRAM LORD VERDON; WALTER. DE LACY BARON. CI TRIM & EARLE. OF ULSTER;[1] IAMES LE BRABANZON Y. GREAT. WARRIOR [the six statues to the right of the central window have no inscriptions]

Description: The statues are set within niches whose canopies are decorated with the Sherard family plumes. The left-hand six, of *c*.1633, are the Sherard family's assumed ancestors, as the banner inscriptions and coats of arms beneath their niches indicate.

The identities of the six right-hand statues, of *c*.1500, are unknown but each have attributes and, beneath their niches, corbels carved with peculiar devices. On the left is a seated king with a chalice in his left hand; in 1795, John Nichols's engraver, James Basire, saw this not as a chalice, but as an owl.[2] In 1965 the attribute was described as the Holy Grail.[3] Whether Basire was mistaken or the owl was so weathered by 1965 that it was quite plausibly identified as the Holy Grail it has not yet been possible to determine. On the corbel beneath this niche is an angel bearing a shield with a chevron (perhaps the Sherard coat of arms). Next is a standing figure, perhaps a knight, with a curved sword or scimitar. Then follows a king, seated with his left ankle resting on his right knee. He holds an unidentifiable object in his right hand and a similarly unidentifiable animal lies prone beneath his right foot.[4]

The last group of three to the right of the window (see illus. on p.274) comprises, on the left, a standing pilgrim or knight holding a crown of thorns and three nails, with a corbel beneath his niche carved with a mermaid and a ship; in the centre, a standing king holding a sword in his right hand and, in his left, what Nichols and Basire saw as a helmet adorned with the Sherard family plumes and what a

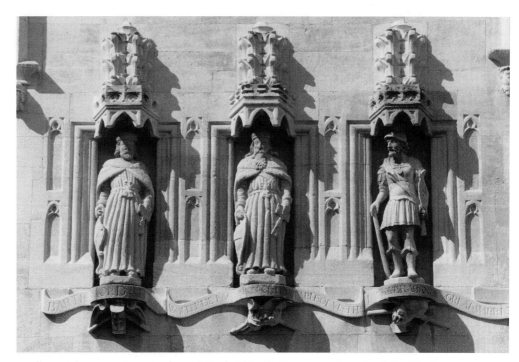

1st-floor niche statues (ancestor figures), Lady Abigail's Range, east front, Stapleford Park

more recent writer saw as a papal tiara,[5] with, on the corbel beneath the niche, an angelic lutenist; and on the right, a cross-legged king with a sword in his right hand and a tabernacle or model of a church in his left – on his corbel is a bird of some sort.

Condition: All twelve statues have been cleaned and appear to be heavily restored. The most recent conservation campaign, supervised by architect Robert Weighton in 1988, was limited, in line with current thinking, to cleaning and only as much structural intervention as was necessary to secure those parts that had become loose. If, as appears likely, heavy restoration has taken place at some time, it was most probably during John Gretton's 1894–8 building programme.[6]

The surfaces on a number of the statues are spalling, with those of the right-hand six figures (i.e., the oldest) appearing the most weathered. Some of the statues have what appear to be deep cracks (whether these are the ones fixed in the 1988 campaign it has not been possible to ascertain): *James Le Brabanzon* is cracked across the torso; the seated king with the chalice is cracked across the neck and shoulders; and the knight with the curved sword has a diagonal crack running from his left shoulder across his chest to his right armpit.

Notes
[1] Basire's engraving in Nichols, J., 1795, vol. ii, pt. i, pl. lviii (fig. 5) gives this banner inscription as: WALTER DE LACY BARON LE TRIM & ARLE OF ULSTER.
[2] *Ibid.* (fig. 7). [3] *Stapleford Park ...*, 1965, p.6.
[4] The writer of the booklet *Stapleford Park ...* (1965,

p.6) identifies this group of three as knights of the round table: the figure with the (?)Holy Grail being Sir Galahad. As it is still clear today that he is wearing a crown this cannot be correct. The right-hand figure is identified as King Arthur and the object in his right hand, the sword Excalibur rising from the lake – it is difficult, however, to see the shape descending from his right hand as a sword either in the present (restored) figure or in Basire's engraving (Nichols, J., 1795, vol. ii, pt. i, pl. lviii, fig. 9). [5] *Cf.* Nichols, J., 1795, vol. ii, pt. i, , p.337, pl. lviii, fig. 11, and *Stapleford Park ...*, 1965, p.7. [6] As suggested to the author by Robert Weighton.

3. *Relief panels of religious subjects and tournament scenes*

Sculptor(s): unknown

Relief panels in limestone
Executed: *c.*1500
(a) The small linking bay in the angle of the main house and Lady Abigail's wing:
– east front: *Two knights fighting with two-handed swords*
– north front: *Two knights jousting, that on the left wearing the Sherard crest*
(b) Lady Abigail's Range, east front, below the lower string course:
– one panel above the left-hand ground-floor window: *The Nativity with the Magi and Shepherds*
– three panels below the central first-floor window: *The Annunciation; The Murder of Thomas à Becket; The Visitation*
– one panel above the right-hand ground-floor window: *David and the Ark of the Covenant.*
(c) Lady Abigail's Range, north end:
– the uppermost panel: *an angel bearing the Sherard coat-of-arms;*
– below this, above the top window: *The Assumption of the Virgin*
– three panels above the first-floor window: *Decollation of St John the Baptist; St Michael weighing a soul; St Martin dividing his cloak*
– three panels above the ground-floor windows: *St George fighting the Dragon; the Princess in*

Relief of knights fighting, linking bay, Lady Abigail's Range, Stapleford Park

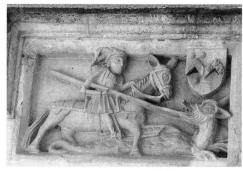

Relief: St George fighting the dragon, Lady Abigail's Range, north end, Stapleford Park

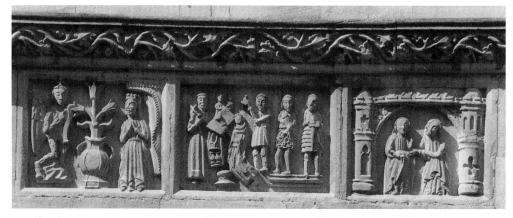

Reliefs: The Annunciation, The Murder of Thomas à Becket, The Visitation, Lady Abigail's Range, east front, Stapleford Park

the desert; the King and Queen of Silene praying for their daughter
(d) North front of the two-storey extension to the service range:
– above the right-hand ground-floor windows (close to the angle with the service wing), six panels of The Creation: firstly *St Peter at the Gates of Heaven*, then five panels representing respectively the creation of *Angels; the Sun, Moon and Stars; Birds; Animals*; and *Adam and Eve*

Descriptions: Linking bay. The relief panel of *Two knights fighting with two-handed swords* (see illus. above left): the knights fight within a circular barrier with towers to left and right. At the top left of the panel is a tumbler about to turn a cartwheel and at the bottom left a tabor player. At the top of the left-hand tower is a queen with two children watching the combat while at the top of the right-hand tower is another woman with two children praying (presumably for the right-hand fighter). At the extreme right two youths wrestle. The relief

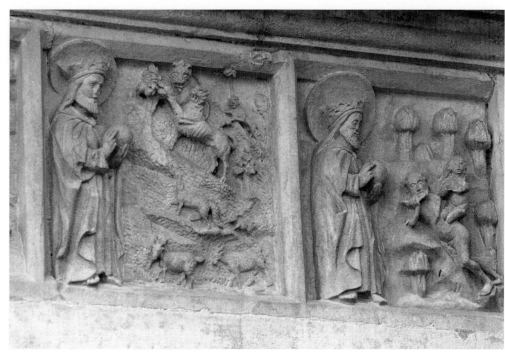

Reliefs: Creation of the animals, and Creation of Eve, service range extension, north front, Stapleford Park

panel of *Two knights jousting*: behind each of the riders is a squire with a lance, the left-hand squire stands within a tent and the right-hand squire within a tower. The left-hand squire, like his knight, wears the Sherard family plumes.

Lady Abigail's Range, east front. *The Annunciation* panel (see illus. on p.276) represents the moment when the angel Gabriel, here dressed in feathers and bearing a scroll, informs the Virgin Mary that she is to bear a son and shall call him Jesus (Luke 1: 26–38). According to Nichols, the scroll was originally inscribed with the words 'Ave, gratia plena; Dominus tecum' ('Greetings most favoured one! The Lord is with you' – Luke 1: 28).[1] *The Murder of Thomas à Becket*: Becket (?1118–70) was Archbishop of Canterbury from 1162. His

disagreement with King Henry II provoked the latter into wishing his death, words which three knights overheard, took literally and acted upon. They are shown stealing up behind Becket while he is at prayer in Canterbury Cathedral, with daggers and swords drawn. *The Visitation* shows the visit, shortly after the Annunciation, of the Virgin Mary to her cousin Elizabeth who was at the time pregnant with John the Baptist (Luke 1: 36–56).

The Nativity shows the simultaneous arrival of the shepherds and the magi at the stable in Bethlehem. *David and the Ark of the Covenant* appears to represent the Israelites bearing the Ark (the chest that held the Jews' sacred relics) into Jerusalem. David was supposed to have danced naked before it; here, admittedly he is

clothed (Basire shows him in a rather strange spotted tunic)[2] but he does appear to be dancing to the sounds of two musicians at left.

Lady Abigail's Range, north end. The uppermost relief shows an angel bearing the Sherard family coat of arms. Below that is a relief identified by Nichols – though not without some reservation – as the *Assumption of the Virgin Mary*. The account of the Assumption is found not in the Bible but in apocryphal sources according to which, three days after her death, Mary was lifted up body and soul into heaven by angels. She is usually shown standing on a crescent moon – Mary being associated with the book of Revelation's description of 'a woman clothed with the sun, and the moon under her feet, and upon her head a crown of twelve stars' (Rev. 12: 1). Here, however, the moon under her feet looks rather like a piece of drapery held up by the two angels at her feet and, more disturbingly – in Basire's engraving at least – the crown of twelve stars has metamorphosed into the Sherard plumes. Consequently, Nichols suggests that it may instead represent the 'Assumption of some lady of the Sherard family'.[3]

The panel of the *Decollation of St John the Baptist* (Mark 6: 21–8) represents the moment after the beheading when the executioners are placing the head upon a platter. At top left Herod and Herodias sit at a table and at bottom left Salome drinks from a stemmed cup. The *St Michael* panel shows the Archangel Michael in his guise as weigher of human souls, determining whether they go to heaven or are consigned to hell. At left the Virgin Mary places a rosary over a pan containing a soul whilst at the right demons try to tilt the scales. The *St Martin* panel shows the warrior saint dividing his cloak to give half to a poor man whom he had encountered shivering in the winter cold.

The *St George* panels represent the legend of the saint's slaying of a dragon that had been laying waste to the countryside around the

pagan town of Silene in Libya. Young virgins had been sent out into the wilderness to serve as sacrifices to the dragon in an attempt to appease whichever god had sent it. Just as it came to the turn of the daughter of the king and queen, the Christian knight St George arrived on the scene and slew the dragon. In the panel on the left he is shown thrusting his lance down the dragon's throat, with, on the right of the panel, the coat of arms of the Sherard family impaled with Helwell (see illus. on p.276). In the centre relief panel the princess is shown in the desert surrounded by animals and birds; and in the right panel her parents pray for her from the high towers of their castle. As a result of St George's intervention, the town was converted to Christianity. St George has been patron saint of England since 1222.[4]

North front of the extension to the service range. *The Creation* panels represent, on the left, God standing before the heavenly city, with St Peter, keeper of the keys to heaven and hell, standing within the gates. Then four panels representing successively the creation of angels; the sun, moon and stars; birds; animals; and lastly, the creation of Eve from Adam's rib (see illus. on p.277).

Condition: The two panels of knights fighting on the linking bay appear to be largely unrestored. The tip of the left-hand knight's sword on the panel on the east front is missing. The panel on the north front appears to be more weathered, the surface is spalling in places and there are areas of biological growth in the crevices. On the east front, *The Nativity* and *Ark of the Covenant* panels look heavily restored, but the surfaces appear to be sound. The central trio of panels, however, have some problems with spalling: in the *Annunciation* panel on the Virgin's cloak above her left arm and on the left side of Gabriel's head; in the *Becket* panel on the figures of the two knights at the extreme right; and in the *Visitation* panel on Elizabeth's face. On the north front also the

surfaces of many of the panels are spalling, notably those of *The Assumption*; the *St George* trio (especially the animals in the desert in the central relief and the praying king and queen in the right-hand relief); and the *St Michael* and *St Martin* panels. The surface of the *Decollation of St John* is weathered but appears to be sound. The surfaces of the *Creation* sextet appear to be relatively unweathered, suggesting either heavy restoration or even complete replacement, most likely, as suggested above, in John Gretton's 1894–8 building programme.

Literature
Barron, O., 1908; Hussey, C., 1924; Nichols, J., 1795, vol. ii, pt. i, pp.334, 337–8, pls lvii, lviii, lix, lx; Pevsner, N. and Williamson, E., 1992, pp.387–8; *Stapleford Park ...*, 1965; Worsley, G., 1988.

Notes
[1] Nichols, J., 1795, vol. ii, pt. i, p.337. [2] *Ibid.*, pl. lix, fig. 6. [3] *Ibid.*, p.337, and pl. lix, fig. 8. [4] Hall, J., 1979, p.136.

SYSTON
Civil Parish: Syston
Borough Council: Charnwood

Central Park

Just inside the park entrance:
Syston War Memorial

Architects: Fogg, Son & Holt
Sculptor: Edward O. Griffith
Clocks by: Gent & Co, of Leicester
Bracket lamps by: The Art Metal Works, Leicester

Memorial in Storeton stone on steps and landing of Yorkshire stone
h. 6.86m (22'6")
Inscriptions on bronze plaques in raised letters:
– on the front face of the tower: TO THE / HONOURED / MEMORY / OF THOSE / FROM / THIS PARISH / WHO GAVE / THEIR LIVES / FOR FREEDOM / IN THE / GREAT WAR / 1914–18, /

Griffith, *Lion (Syston War Memorial)*

AND THE / WORLD WAR / 1939–45
[The three remaining faces of the tower bear plaques with the names of the dead in alphabetical order, the upper part of each plaque devoted to Syston's 82 First World War dead and the lower half, beneath a dividing line, to its 45 Second World War dead.]
Unveiled and dedicated: Saturday 17 December 1921, by Henry John Manners, 8th Duke of Rutland, and the Revd T.R.J. Avery, Vicar of Syston
Status: not listed
Owner / custodian: Syston Town Council

Description: A memorial tower with, towards the top, clock faces to front and rear and bronze bracket lamps to the sides. Beneath this level, on all four sides, are carved laurel wreaths above bronze inscription panels. On the summit is a lion *sejant*. The memorial is surrounded by a railed enclosure.

Condition: Fairly good, although the stone is slightly weathered, with minor areas of biological growth and some (old) carved graffiti on the left face. The original First World War lists of names were incised into the stone and framed by carved stone mouldings; these were

replaced after the Second World War with bronze plaques combining lists of the dead of the both wars.

History: The Syston War Memorial Committee's 'Conditions for Competitors' for the design of the memorial to its First World War dead, dated 10 April 1919, is a rare survival in Leicestershire. Its terms are impressively thorough and business-like. The invitation, evidently issued to all interested architects, sculptors and artists, required each competitor to submit an anonymous design, the name and address of the individual or practice to accompany the design in a plain sealed envelope. The envelopes were to be opened by the Committee only after the selection of the winner. The proposed site was given as 'the junction of the Melton, Leicester and Barkby Roads, and High Street, Syston', and was accompanied by a site plan. Towers, clock towers and monuments with suitable figures were suggested, but the ultimate choice of memorial type was left completely to the discretion of the entrants. The total cost was not to exceed £750, and each design was to be accompanied by a written report stating the materials used and the method of construction. The deadline was 1 June 1919 and the winning competitor was to receive a premium of £20. In the event of the winner's design being ultimately used, his fee was set at '£5 per cent of the total cost'.[1]

Sadly, after such a promising start, the competition produced no clear winner and the scheme became bogged down by indecision. After several meetings, it was only by the casting vote of the Chairman that a design for an obelisk was chosen. Selection by such a narrow margin was clearly unsatisfactory and thus it was decided to leave the ultimate choice to the people of Syston who, at a public meeting on 4 February 1920, voted to accept the design for a clock tower 'at an estimated cost of from £725 to £1,000'.[2] Given the upper limit of

£750 set in the terms of the competition, it was presumably the higher cost of the clock tower that determined the Committee's half-hearted selection of a (presumably cheaper) obelisk. The required amount, amassed through a mixture of voluntary subscriptions and fund-raising activities, was eventually reached in May 1922, five months after the memorial's unveiling ceremony.[3]

The *Syston War Memorial* was originally located, as proposed, at the junction of Syston High Street with the Leicester–Melton Road (A46) and Barkby Road (A607). As a result of the considerable increase in traffic, the memorial was relocated to Central Park in the late 1960s.

Literature
LRO. *Designs for war memorials by W.H.H. Aspell of Leicester ...*: includes, *inter alia*, 'Syston War Memorial. Conditions for Competitors' and Aspell's unsuccessful design for Syston.
General. *L. Chronicle*, 24 December 1921, pp.8–9, **8**, **9**; *L. Mail*: – [i] 6 February 1920, p.8 [ii] 21 October 1921, p.5 [iii] 17 December 1921, p.8 [iv] 6 May 1922, p.5; *L. Mercury*: – [i] 17 December 1921, p.7 [ii] 1 October 1998, p.10; *M.M. Times*: – [i] 13 February 1920, p.2 [ii] 23 December 1921, p.5 [iii] 30 December 1921, p.3 [iv] 12 May 1922, p.2; Sharpe, J.M., 1992, pp.28, 32, 45, fig. **3.1**.

Notes
[1] 'Syston War Memorial. Conditions for Competitors', dated 10 April 1919. [2] *L. Mail*, 6 February 1920, p.8. [3] *M.M. Times*, 12 May 1922, p.2.

THORNTON RESERVOIR
Civil Parish: Bagworth
Borough Council: Hinckley and Bosworth

Reservoir Road

On the north shore Thornton Reservoir, in the woodland:

The Bird Totems
(also known as 'A Vision of the Future')

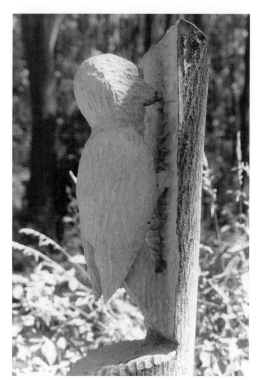

Heron and others, *The Bird Totems (detail)*

Sculptors: Martin Heron and members of Millfield Day Centre, Hinckley

Sculptures in ash
Range of heights from 1.02m (3'4") to 1.84m (6'1")
Status: not listed
Owner / custodian: East Midlands Shape and Severn Trent Water

Description: The sculptures are gathered in a group either side of the woodland path on the north shore of the reservoir and consist of birds carved from the upper parts of sections of tree trunk planted in the ground. Approaching from the west, the first two sculptures encountered

form a kind of gateway to the group and are the only ones conceived as a pair. They are in the form of a pair of Great Crested Grebes looking at each other across the path (as if in their characteristic courtship display). Four other birds – an owl, a woodpecker, a warbler and a blackbird – had been sited by the time of viewing (July 1999); the final sculpture, a heron, was sited in early autumn 1999.

Condition: Good, although some deep splits have occurred in the wood as it has dried out subsequent to its being carved. East Midlands Shape's general policy for the sculpture trail is, however, that natural disintegration should not be inhibited (and also that any biological accretions should be allowed to grow).[1]

History: *The Bird Totems* is part of a county-wide sculpture trail initiated by East Midlands Shape, comprising one sculpture or group of sculptures in each borough or district. Each sculpture or group is conceived and executed by members of local disabled people's groups under the supervision of professional sculptor Martin Heron, Hinckley and Bosworth Borough's sculptural group being created by members of the Millfield Day Centre, Hinckley.

Each sculpture was allocated an estimated budget of £2,887.50, to be obtained through various grants and local budgets. Hinckley and Bosworth Borough Council's Health and Leisure Committee provided £500 (£375 from the Arts budget and £125 from the Local Agenda 21 budget); and Leicestershire County Council's Planning and Transportation Department provided another £500 (£300 from its Landmark North West Countryside Project and £200 from its Environmental Action Programme). Further contributions came from The National Forest (£1,444) and Severn Trent Water (£444).[2]

Before carving started, the volunteers from the Millfield Day Centre were taken to the reservoir and shown the proposed site for the sculpture, at a small clearing on the recently-created woodland path on the far side of the reservoir from the visitor centre. They were told that Severn Trent had felled a line of trees to make the path but had diverted it at this point to avoid felling a tree which was home to a woodpecker: it was this that inspired the group to make a group of sculptures which would be a celebration of birds.[3] The woodpecker sculpture stands under the real woodpecker's tree. The two Great Crested Grebes standing on either side of the path at one end of the group were apparently inspired by Jan Phillips of Severn Trent who in her introductory guided tour of the reservoir and its bird life had mentioned the Grebes' courtship display.

When the location for the sculpture group was first agreed, Severn Trent installed the requisite number of tree trunks on site. Unfortunately the company had not conferred with the Day Centre and, as the staff afterwards explained, the members were not able to work out-of-doors. The problem, however, was happily resolved when the two parties agreed that the already-sited trunks could be used by another group to carve a series of animal sculptures in autumn 1999 or thereabouts.

The Millfield Day Centre members evidently derived a great sense of fulfilment from the project. It is intended that an exhibition in the Thornton Reservoir Visitor Centre will explain the whole Thornton project and include the sculptures.

Related works: Other sculptures in the East Midlands Shape 21st Birthday Sculpture Trail are: *Untitled*, National Forest Visitors Centre (see pp.246–8); *The Aviary Tower*, Bouskell Park, Blaby (see pp.14–15); and *The Kingfisher*, Stonebow Washlands Community Wildlife Area, Loughborough (see p.218). At the time of writing (summer 1999), further sculptures are planned for Melton, Harborough, Hinckley and Bosworth, and Oadby and Wigston.

Literature
PMSA NRP East Midlands Archive. Copies of various related documents supplied by Karen Wilby, Strategic Arts Officer, Hinckley and Bosworth Borough Council.
General. East Midlands Shape, *Leicestershire Sculpture Trail. Map and Guide*, 1999.

Notes
[1] As stated in the report on the pilot sculpture set up at the National Forest Visitors' Centre. See p.247. [2] Hinckley and Bosworth Borough Council, Health and Leisure Committee, District Planning Officer's report, dated 4 February 1999. [3] Information from Lucy Banwell, Project Co-ordinator, East Midlands Shape.

THURMASTON
Civil Parish: Thurmaston
Borough Council: Charnwood

Melton Road

Roundhill Community College (access only by prior arrangement)

On the lawn before Roundhill House (the adult wing):

Armour

Sculptor: Bryan Kneale

Sculpture in steel, painted black
h. 2.35m (7'9"); w. 65cm (2'2"); d. 51cm (1'8")[1]
Executed: 1959[2]
Exhibited: 1960, London, Redfern Gallery (no. 1); 1980, London, Whitechapel Art Gallery (no. 78); 1981–2, London, Whitechapel Art Gallery (no. 72)
Status: not listed
Owner: Leicestershire Education Authority

Condition: Poor. The sculpture was accidentally damaged some years ago and has lost its upper section – the abrupt termination of two vertical, slightly bent metal rods at the top showing where the break occurred. Other

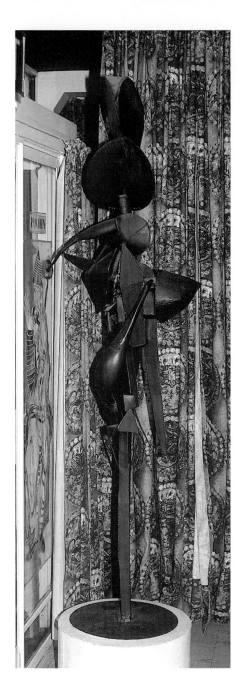

projecting pieces also appear to be bent out of their intended shape. Where the black paint has blistered, exposing the metal, rust has formed.

History: *Armour* was purchased by the Leicestershire Education Authority in 1962, with funds provided through Roundhill Community College's initial stocking allocation.[3] It originally stood in the entrance foyer of the main school but following accidental damage was considered to have too many sharp protrusions for such a location and was resited to the rear of the lawn outside the adult wing.[4]

Literature
Arts Council of Great Britain, 1980, p.32; Nairne, S. and Serota, N., 1981, p.169, **169**; Spencer, C.S., 1966b, p.**66**.

Notes
[1] These are the original dimensions as given in the catalogue of the LEA's 1980 exhibition at the Whitechapel Art Gallery (Arts Council of Great Britain, 1980, p.32). Following accidental damage and the loss of its upper part some years ago, the reduced height, including the base, is 1.86m (6'1"). [2] Arts Council of Great Britain, 1980, p.32. [3] LEA inventory. In 1966, however, *Studio International* published a photograph of *Armour* on the Loughborough Technical College campus (Spencer, C.S., 1966b, p.66). The LEA inventory does not mention this piece as having been at Loughborough and unfortunately in the time allowed for the present survey it has not been possible to investigate this discrepancy further. [4] A photograph of *Armour* is published in Nairne, S. and Serota, N., 1981, p.169. It is not clear whether this is the same as the present sculpture for, even allowing for the present work's incomplete and damaged condition, there appear to be certain differences. The date given for *Armour* in *ibid.* is 1957 (i.e., not 1959, the date given by the LEA for the present piece).

Kneale, *Armour (original state and location)*

Fowler and Smith, *War memorial, St Peter's*

Church Lane

In the churchyard of St Peter's Parish Church (Grade I listed), to the left of the church:

St Peter's Church War Memorial
Architect: Ernest G. Fowler
Sculptor: Anthony Smith

Crucifixion in wood, pedestal in Portland

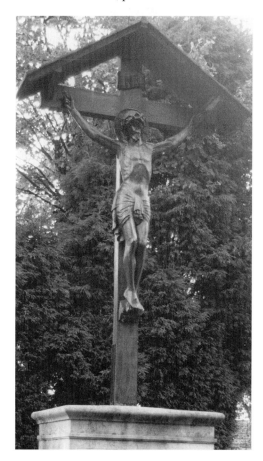

stone, and base in Forest of Dean stone
h. 3.72m (12'3")
Inscriptions:
– around the pedestal frieze, carved into the stone in Roman capital letters [left face:] TO THE MEMORY OF THE [front face:] WHETSTONE MEN WHO GAVE THEIR LIVES [right face:] IN THE WAR [... ?] [rear face:] [... ?]
– on the front face of the pedestal dado, the names of the 18 men who died in the First World War, in two columns of nine, listed in alphabetical order with full forenames followed by surnames.
– on the front riser of the upper step: THEIR NA[ME] L[IVE]TH FOR EVER MORE
– on the front riser of the middle step: R.I.P.
Unveiled and dedicated: Saturday 28 May 1921, by General Lord Horne and Dr Norman Lang, the Bishop of Leicester
Status: not listed separately
Owner / custodian: Whetstone Parish Council

Description: The memorial consists of a wooden figure of Christ on the Cross set under a gable, mounted on a stone pedestal on three steps, the lowest chamfered.
Condition: The wooden figure and gable appear to have been recently treated and the figure is in generally good condition except for the loss of the big toe of the left foot. The stonework is, however, very worn, the inscriptions being largely lost (see losses indicated in square brackets above). The stone surfaces have considerable areas of biological growth.
History: The architect of the present war memorial also designed the village war memorial in the High Street, unveiled just under three months later on Saturday 20 August 1921.

Literature
L. Chronicle, 4 June 1921, pp.8–9; L. Mail, 30 May 1921, p.2; L. Mercury, 30 May 1921, p.9; Sharpe, J.M., 1992, p.25.

WIGSTON
Civil Parish: Wigston
Borough Council: Oadby and Wigston

Bell Street, Wigston Magna

Sainsbury's supermarket, 1977, by Pick Everard

To the left of the entrance:
Sculptural frontage
Designer: George Pickard

Sculptural design in brick
Executed: c.1977
Status: not listed
Owner: Sainsbury Plc

Condition: Good.
History: The sculptor, George Pickard, had worked as an architect for Pick Everard in the 1960s and remained on friendly terms with them thereafter. According to present-day members of the practice, he was therefore in all likelihood given a fairly free hand in his design for the sculptural frontage.[1] The 'peeling' motif derives from the sculptor's interest in 'the peeling and built-in "crumbling" corner façades of the Best Supermarket stores in the USA'.[2] During the 1970s, Pickard produced a number of sculptures in iron and steel relating to this theme.[3]

Pickard, *Sainsbury's, sculptural frontage*

Literature
Pitches, G., 1994, p.9.

Notes
[1] Information from Pick Everard. [2] Pitches, G., 1994, p.9. [3] Examples illustrated in *ibid.*, pls 30, 31.

Launceston Road

Little Hill County Primary School (access only by prior arrangement)

In an inner courtyard:
Counterfeit
Sculptor: Garth Evans

Sculpture in blue-coloured fibreglass and metal
Diam. 1.53m (5'); depth 71.5cm (2'4")
Executed: 1965
Exhibited: 1966, London, Rowan Gallery (no. 2); 1967–8, London, Whitechapel Art Gallery (no. 19); 1968, Coventry, Cathedral ruins (no. 31)
Status: not listed
Owner: Leicestershire Education Authority

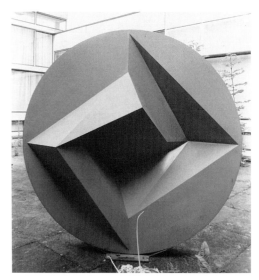

Evans, *Counterfeit*

Condition: There are a number of splits and cracks to the fibreglass, most notably along one side of the rim; also the surface is scuffed in various places. The metal foot is rusted and is no longer secured to the ground (it has three screw holes per side).

History: *Counterfeit* was purchased by the Leicestershire Education Authority in 1966 with funds provided through the buildings capital scheme.[1]

Related work: *Counterfeit* is one of an edition of two.[2]

Literature
Art and Artists, vol. 3, no. 5, August 1968, p.45; Coventry Cathedral, 1968, p.29; Rowan Gallery, 1966, n. pag.; Whitechapel Art Gallery, 1967, p.16, illus. betw. pp.18/19.

Notes
[1] LEA inventory. [2] As noted in Rowan Gallery, 1966 (n. pag.).

St Thomas's Road, South Wigston

South Wigston High School (access only by prior arrangement)

In the quadrangle:
Swan
Sculptor: Joanna Miller

Sculpture in stone
Sculpture: h. 35cm (1'2"); w. 74cm (2'5"); d. 37cm (1'3")
Base: h. 7cm (3"); w. 98cm (3'3"); d. 51cm (1'8")
Executed: 1983
Status: not listed
Owner: Leicestershire Education Authority

Description: The sculpture is of a swan sleeping with its head between its wings.

Condition: Fair, although there is a small chip missing from the edge of the left wing.

History: *Swan* was purchased by the Leicestershire Education Authority from the artist in 1985.[1]

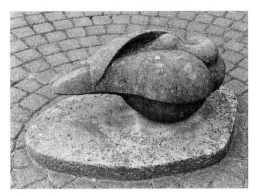

Miller, *Swan*

Note
[1] LEA inventory.

Shenley Road, Wigston

St John Fisher Roman Catholic Primary School – Austin Wright, **Sign of the Blessing** – see Lost Works, pp.329–30

Station Road, Wigston

Abington High School (access only by prior arrangement), 1954, by T.A. Collins

1. On the north-facing elevation:
Sculpture for a Wall
Sculptor: Ronald Pope

Sculpture in Hadene stone on a concrete base
Sculpture: h. 2.18m (7'2"); w. 28cm (11"); d. 28cm (11")
Base: h. 30cm (1'); w. 28cm (11"); d. 30.5cm (1')
Executed: 1955[1]
Status: not listed
Owner: Leicestershire Education Authority

Description: The sculpture is a tall, attenuated semi-abstracted two-figure group. The figures embrace a tree-like form, one standing on the base, the other on the lowest of

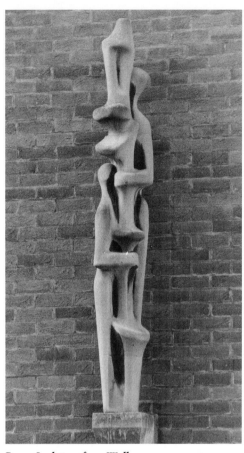

Pope, *Sculpture for a Wall*

the tree's circumferential ridges. The sculpture, made from three blocks of limestone, is fixed to the brick wall with two bolts. The base is 193cm from the ground.

Condition: Good, although the stone is blackened in the undercuttings and hollows, etc.

History: *Sculpture for a Wall* was purchased by the Leicestershire Education Authority for Abington High School at the time of its erection in 1955.[2] It immediately struck a chord

with the host school and even after more than 40 years is seen by the staff as symbolic of the school's aspirations. Abington High School's 1999/2000 prospectus states:

> Our aspirations for our pupils are aptly summarised in our school motto, which is Strive to Succeed, and in the sculpture on the north wall of the school by Reginald [sic] Pope which represents the growth of children, mentally, physically, and spiritually.3

Literature
Pevsner, N. and Williamson, E., 1992, p.423.

Notes
[1] Information from Derby Museum and Art Gallery. [2] LEA inventory. [3] *Abington High School 1999/2000 prospectus*, p.1.

2. In the grounds, on the lawn opposite Reception:
Sculpture (untitled)
Sculptor: Granville Burgess

Sculpture in artificial stone, painted black
h. 2.17m (7'2"); w. 1.06m (3'6"); d. 61cm (2')
Executed: 1960
Status: not listed
Owner: Leicestershire Education Authority

Condition: The coating of black paint has worn away in places.
History: The sculpture appears to have been the result of a fourth-year art project in 1960. The model for the present piece was the best, in the opinion of the then headmaster, Mr Milner, and was selected for scaling-up and siting in the school grounds.

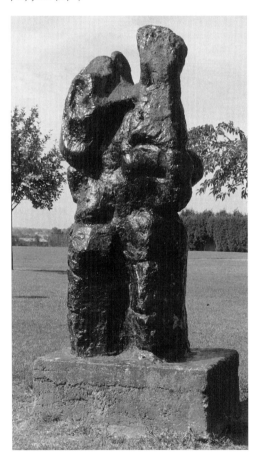

Burgess, *Sculpture*

Guthlaxton Community College (access only by prior arrangement), 1957, by T.A. Collins

1. Mounted on the exterior walls of the school buildings:
Signs of the Zodiac (relief series)
Sculptor: Willi Soukop

Reliefs in polychrome tin-glazed earthenware
Portrait format reliefs: h. 78.75cm (2'7"); w. 56.25cm (1'10")
Landscape format reliefs: h. 56.25cm (1'10"); w. 78.75cm (2'7")

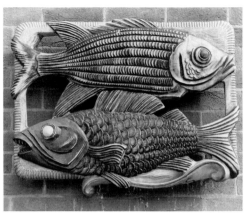

Soukop, *Pisces*

Inscriptions – each relief has a scroll with the name of the relevant sign inscribed on it, viz: ARIES, TAURUS, GEMINI, CANCER, LEO, VIRGO, LIBRA, SCORPIO, SAGITTARIUS, CAPRICORN, AQUARIUS, PISCES.
Executed: c.1957
Status: not listed
Owner: Leicestershire Education Authority

Condition: All but two of the reliefs are in good condition. The horns on the *Taurus* relief are broken and *Aquarius* is splashed with white paint.
History: Although the date is not given in the Leicestershire Education Authority inventory, the present *Signs of the Zodiac* series was in all likelihood purchased for Guthlaxton College at the time of its construction in 1957. The signs have been installed in the correct zodiacal sequence for a viewer moving clockwise around the outside of the building.
Related works: Other sets are at The Martin High School, Anstey (complete; see pp.1–2) and Burleigh Community College, Loughborough (incomplete; see p.227).

Literature
Berger, J., 1957; Jones, D.K., 1988, pl. betw. pp.96/7.

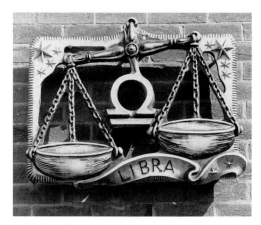

Soukop, *Libra*

Hughes, *Tiger*

h. 2.17m (7'2"); w. 1.7m (5'7"); d. 50cm (1'8")
Inscription on a plaque to the rear of the
sculpture: THE BEAUMANOR CENTAUR /
THE CENTAUR IS MADE FROM STEEL BARS / WITH
CAST BRASS DETAIL AND DESIGNS / CREATED BY
CHILDREN'S WORKSHOPS / HELD AT
BEAUMANOR. / SEE HOW HE REARS UP ON HIS
HIND LEGS / IN FROZEN ANTICIPATION, WAITING
FOR / NIGHTFALL, WHEN HE WILL AGAIN BE ABLE
/ TO HUNT HIS PREY AND PLAY WITH / HIS
FRIENDS.
Executed: 1996
Status: not listed
Owner: Leicestershire Education Authority

Description: Rearing centaur with arms
raised, constructed of metal rods for the body

2. In a locked quadrangle:
Tiger
Sculptor: M. Alwen Hughes

Sculpture in stone
Dimensions (est.) h. 45cm (1'6"); w. 1.4m
(4'7"); d. 25cm (10")
Inscription on a plaque on the ground in front
of the sculpture:
THIS SCULPTURE BY ALWEN HUGHES IS DUE TO /
THE GENEROSITY OF THE FOLLOWING FIRMS /
FREARS LTD A.H. BROUGHTON & CO LTD / HENRY
BATES & CO LTD W. HOLMES & SON LTD / R.
ROWLEY & CO LTD THE WIGSTON LAUNDRY LTD /
ORSON WRIGHT & SON LTD J.W. BLACK & CO LTD
/ AND CONSTONE LTD WHO GAVE THE
MATERIALS
Status: not listed
Owner: Leicestershire Education Authority

Description: Stone sculpture of a big cat,
presumed by the school staff to be a tiger.
Condition: There are numerous cracks and
the surfaces have areas of green biological
growth.
History: *Tiger* was acquired for Guthlaxton
Community College in 1964 with assistance

from various local firms, as indicated on the
sculpture's inscription plaque.[1]

Literature
Pevsner, N. and Williamson, E., 1992, p.423.

Note
[1] LEA inventory. No mention is made in the
inventory of the roles of the firms listed on the
inscription plaque.

WOODHOUSE
Civil Parish: Woodhouse
Borough Council: Charnwood

B591

*Beaumanor Hall (Leicestershire Education
Authority)*

In the gardens:
1. In front of the bay window on the south side
of the house:
Centaur II
Sculptor: Christopher Campbell

Sculpture in steel, painted green, and brass

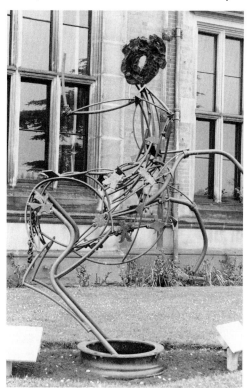

Campbell, *Centaur II*

and a looped chain for the tail, the whole painted green and standing on a circular base. A number of small pieces of cast brass, in the shape of animals, etc., are screwed to the body at various places.

Condition: Generally good, although some of the nuts securing the pieces of brass are rusted.

History: *Centaur II* was purchased by the Leicestershire Education Authority from the artist during his residency in 1996.[1]

Related work: *Centaur*, wood, 2.3m × 1.46m × 80cm (7'6" × 4'9" × 2'8"), purchased by the LEA from the artist in 1984. The sculpture collapsed in 1995.[2]

Notes
[1] LEA inventory. [2] *Ibid.*

2. On the lawn on the south side of the house:
Declaration
Sculptor: Phillip King

Sculpture in (originally dark green) cement with marble chippings
h. 83.8cm (2'9"); w. 2.08m (6'10"); d. 83.8cm (2'9")
Executed: 1961
Exhibited: 1961, Madrid and Bilbao;[1] 1965, London, Whitechapel Art Gallery (no. 11); 1967–8, London, Whitechapel Art Gallery (no. 31); 1980, London, Whitechapel Art Gallery (no. 77)
Status: not listed
Owner: Leicestershire Education Authority

Condition: Fair, although the square slabs have chunks missing from the corners and the colour, originally dark green, is now a drab grey.

History: *Declaration* was purchased by the Leicestershire Education Authority in 1966. Originally sited at Stonehill High School, Birstall, the purchase was made possible through the LEA's buildings capital scheme. At

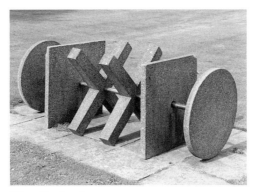

King, *Declaration*

some date during the 1990s the sculpture was transferred to Beaumanor Hall.[2] *Declaration*, created in 1961, is generally accepted as one of King's most important works, representing a turning-point in his career.

During the 1950s King's sculpture was still firmly rooted in the figurative tradition.[3] In 1959 and 1960, however, two experiences followed in succession to help bring about a fundamental change in his work. In 1959 he visited the Documenta II exhibition at Kassel and was struck by two things: the sculptures of Brancusi and the abstract paintings of the leading contemporary Americans, Pollock, Motherwell, Newman and Kline. The Brancusi pieces, with their simplified, harmonious, abstract forms, seemed to King to embody the basic truths of sculpture, an achievement given greater focus by what he saw as the clichéd, self-indulgent expressionism of the contemporary European sculpture with which Brancusi's work was surrounded in the exhibition. In further contrast to the moribund state of European sculpture was the bold optimism of the American abstract painters.[4] In the following year, still considering the implications of what he had seen at Kassel, King visited Greece:

Going to Greece made me consider the possibility of sculpture being natural and therefore of nature. It seemed to me that in Greece the architecture grew so naturally out of the environment, it wasn't something just plonked down like a formula, it had emerged out of the necessity of the people living there. It seemed of nature and not about nature. In a sense that made me feel the possibility of starting on a fresh footing with something outside myself. It gave me roots, I suppose. The type of work I was doing before then was to an extent rootless in that it was all to do with *me*, not with the outside world.[5]

On his return to England, King destroyed all the work then in his studio and started afresh giving his workspace a general clean-up and symbolic coat of white paint.[6] He began a series of drawings, the results of which included two seminal sculptures, *Window Piece* (1960-1, concrete, New Rowan Gallery)[7] and *Declaration*:

I had to get special tools for *Declaration* because it was made of green-coloured concrete and marble chippings. I called it *Declaration* because in a sense it was a manifesto piece for me. I suddenly established new ideas about fundamental forms and sculpture being off the pedestal and extending on the ground and stretching out. I was also interested in repetition and symmetry.[8]

Thus *Declaration* is King's fresh start, the result of his radical reappraisal of what sculpture should be. In *Declaration* he shifted his focus to what he saw as first principles in sculpture: basic geometric forms – square, circle, cross – here symmetrically deployed along a steel bar. Devoid of all allusions to natural forms, *Declaration* is intended to be a self-sufficient piece of sculpture relying purely on its own

sculptural presence for its effect. In his monograph on the sculptor, Tim Hilton wrote: 'This is probably the first time in British sculpture that repetition of non-organic forms had served as a principle of the sculpture's composition. It is an innovation that Brancusi would have recognised.'[9]

Related work: *Declaration* (artist's copy; materials and dimensions as per above), collection of the artist.

Related work exhibited: 1974, Otterloo, Kröller-Müller National Museum (no. 1); 1981, London, Hayward Gallery (no. 2); 1981–2, London, Whitechapel Art Gallery (no. 84); 1997, Florence, Forte di Belvedere.

Literature
Whitechapel Art Gallery archives. Press cutting: *Arts Review*, 23 December 1967.
General. Arts Council of Great Britain, 1980, p.32; Arts Council of Great Britain, 1981, pp.5, 32, 44, 64, **33**; Comune di Firenze, 1997, pp.10, 11, 19, 22, 28, **42**; Hilton, T., 1992, pp.33, 40, 46, 110, **17**; Jones, D., 1988, p.87; King, P., 1968, pp.300-1, 303, **301**; Kröller-Müller National Museum, 1974, pp.17, 34, 35, **14**, **54**; Nairne, S. and Serota, N., 1981, pp.175, **174**; Strachan, W.J., 1984, p.148, **148**; *Studio International*, vol. 175, no. 897, February 1968, pp.88, **86**; *Studio International*, vol. 187, no. 967, June 1974, p.279; Whitechapel Art Gallery, 1965, p.**36**; Whitechapel Art Gallery, 1967, p.16, pl. betw. pp.18/19.

Notes
[1] According to Kröller-Müller National Museum, 1974, p.17, this was a group exhibition of British sculptors 'organised by Kasmin ... King showed "Declaration" in this exhibition, the first on the continent for him'. The sculpture owned by the LEA is the original and the sculptor's is the copy (Hilton, T., 1992, p.110), therefore the present author assumes that all showings pre-dating the LEA's purchase in 1966 were of the original and not of the sculptor's copy. [2] LEA inventory. [3] The sculptor wrote: 'Before 1960 I thought of abstract art as a bit too divorced from life. I was closer to Moore ...' (King, P., 1968, p.300); see also Hilton, T., 1992, p.16.
[4] King, P., 1968, p.300; see also Arts Council of Great Britain, 1981, p.12; Hilton, T., 1992, pp.16, 33.
[5] King, P., 1968, p.300. [6] *Ibid*; see also Hilton, T., 1992, p.33. [7] Illustrated in Hilton, T., 1992, pl. 1.
[8] King, P., 1968, pp.300-1. [9] Hilton, T., 1992, p.33.

3. On the lawn on the west side of the house to the left of a cedar tree:
Elephant
Sculptor: Dawn Beresford
Sculpture in recycled metal
h. 1.64m (5'5"); w. 2.6m (8'6"); d. 98cm (3'3")
Status: not listed
Owner: Leicester Education Authority

Condition: Fair.
History: *Elephant* was purchased by the Leicestershire Education Authority from the artist in 1990 during her term as artist-in-residence at Beaumanor Hall.[1]

Note
[1] LEA inventory.

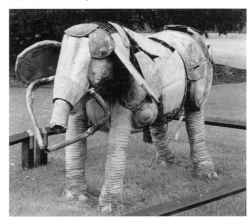

Beresford, *Elephant*

4. On the lawn to the right of the cedar tree:
Rhinoceros
Sculptor: Dawn Beresford
Sculpture in recycled metal
h. 1.35m (4'5"); w. 2.5m (8'3"); d. 70cm (2'4")
Status: not listed
Owner: the artist

Condition: Fair.
History: *Rhinoceros* has been on loan from the artist since 1993.[1]

Note
[1] LEA inventory.

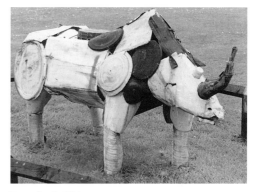

Beresford, *Rhinoceros*

Rutland

BRAUNSTON-IN-RUTLAND
Civil Parish: Braunston-in-Rutland

Cedar Street
All Saints Parish Church (listed Grade II)*

In the churchyard, outside the (liturgical) west end of the church, at the foot of the tower, left of the door:

Pagan Figure[1]

Figure in limestone
h. 1.08m (3'7"); w. 36cm (1'2"); d. 23cm (9")
Status: not separately listed
Owner / custodian: Braunston-in-Rutland Parochial Church Council

Description: The figure is a boldly carved female figure with a grotesque face and prominent breasts.

Condition: The figure suffered damage to the left nipple in May 1999.

The figure is of unknown age and origin. It has been speculatively dated to the Iron Age, to the Celtic period and even to the fourteenth century. The most widely held belief is that it is a pagan fertility symbol or goddess and is related to Irish figures known as Sheela Na-Gigs. The figure was erected in its present position early in the twentieth century following its discovery during the church's restoration: for centuries it had lain face down, serving as the doorstep to the church.[2]

Literature
Gerrard, D., 1996, p.25, **25**; Lee, J. and Dean, J., 1995, p.78, **78**; Pevsner, N. and Williamson, E., 1992, p.456; Waites, B., 1982, p.7.

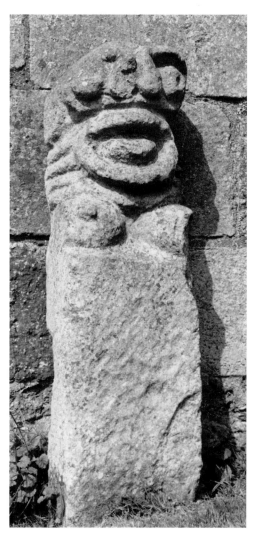

Pagan figure, Braunston-in-Rutland parish churchyard

Notes
[1] Although this figure pre-dates the period covered by the PMSA survey, i.e., from the 1290s (the dates of the *Eleanor Crosses*), the following account has been included in recognition of its national importance.
[2] Gerrard, D., 1996, p.25; Lee, J. and Dean, J., 1995, p.78.

EMPINGHAM
Civil Parish: Empingham

A606
Sykes Lane picnic area

On the north shore of Rutland Water:

The Great Tower
Sculptor: Alexander

Founders: Morris Singer
Sculpture in bronze
h. 9.3m (30'6"); w. 4.3m (14'1"); d. 1.4m (4'7")
Inscription on a nearby plaque, in raised san serif capital letters:
THE GREAT TOWER / BY ALEXANDER 1980 / [*space*] / MANKIND IS CAPABLE OF AN AWARENESS / THAT IS OUTSIDE THE RANGE OF EVERYDAY LIFE. / MY MONUMENTAL SCULPTURES ARE CREATED / TO COMMUNICATE WITH THAT AWARENESS / IN A WAY SIMILAR TO CLASSICAL MUSIC. / JUST AS MOST SYMPHONIES ARE NOT INTENDED / TO BE DESCRIPTIVE SO THESE WORKS DO NOT / REPRESENT FIGURES OR OBJECTS. / ALEXANDER
Signed and dated in flowing script on the east face, towards the bottom, at left: *Alexander / 1980*

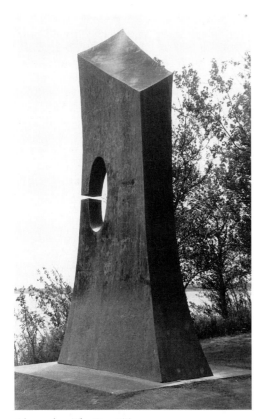

Alexander, *The Great Tower*

Signed by the Foundry to the left of the
sculptor's signature:
Morris / Singer / Founders / London
Executed 1979–80
Unveiled: Thursday 9 October 1980, by Dame
Sylvia Crowe
Status: not listed
Owner: Anglian Water Authority

Condition: The smooth ends of the sculpture
have a small amount of graffiti and there is also
some loss of patination here, presumably where
earlier graffiti has been scrubbed off. The
concrete platform on the side of the sculpture

facing away from the water is badly cracked.

History: In the second half of 1979, the
International Arts Foundation – a charity
funded by bequests and donations with a
mission to help promising artists –
commissioned the sculptor Alexander to
produce a large-scale sculpture for the Anglian
Water Authority's new reservoir, Rutland
Water (officially opened May 1977). The
sculptor's fee and the total cost of producing
the piece, £50,000, was borne by the
Foundation, Anglian Water's agreed
contribution being just £500, the cost of
erecting the piece. The specific site – at the then
rather bleak Sykes Lane picnic site on the
north-west shore of the reservoir – was selected
by the landscape architect who designed
Rutland Water: Dame Sylvia Crowe.

The Water Authority was optimistic that the
sculpture would lend visual interest to the site
and planning permission was granted, but by
early 1980 many of the people of Empingham,
the nearest village, were allegedly 'furious'
about the scheme.[1]

A spokesperson for the Parish Council
objected even to the Water Authority's
relatively small expenditure of £500, suggesting
more practical ways the money could have been
spent. The scheme went ahead however, the
Parish Council's final ineffectual protest being
to boycott the unveiling ceremony.[2] Nor was
Alexander present, he being ill with influenza, a
situation the *Leicester Mercury* made the most
of, with suggestions that the sculptor had been
afraid to face local criticism. Yet for all the
mileage one might have expected the press to
make from ridiculing the piece, it is perhaps
significant that interspersed with the expected
negative reactions from local people were a few
which suggested that some were already
warming to *The Great Tower*, and of course,
most had objected to it without any real idea of
what it would look like. As one man observed:
'It was not the monstrosity I expected after all

the criticism ... We were against Rutland Water
swamping half of Rutland in the first place and
it is a bit bleak now. I think the Tower blends
in well and improves the area.'[3] Another
confessed:

> It gets better every time you see it ... This is
> the third time I have looked at it and each
> time it has taken on a different colour and
> aspect because of the sunlight. It looks
> totally different from different parts of the
> lake. I didn't like it the first time I saw it, but
> I am quite fond of it now ...[4]

The Rutland Times, in its issue for the month
following the unveiling, devoted half of its front
page to a photograph of the new sculpture
along with a plea – following a similar line to
that expressed above – that readers should judge
it for themselves by looking at it not once but
several times and from different viewpoints and
giving consideration to whether its curves and
lines actually enhance the scene.[5]

Dame Sylvia Crowe – who of course would
have been expected to react favourably – gave
one of the most evocative descriptions: 'To me,
it is a wonderful great sail, and it is about to set
sail on the Rutland peninsula. It is here to give
pleasure for years and years to come.'[6]

Cast in London at the Morris Singer
Foundry it was, at the time, 'the largest bronze
sculpture of modern times'.[7] Edward Lucie-
Smith, in his monograph on the artist, wrote:

> *The Great Tower* ... does not echo the forms
> of the landscape directly ...Yet the piece
> seems to be concerned with the idea of
> landscape and the *genius loci* nevertheless. It
> is a piece made for a specific setting: the
> ambitious scale is a function of its position.
> In the eighteenth or nineteenth century, such
> an object would probably have been a
> building – a folly or commemorative
> monument of some kind, perhaps even a
> column or an obelisk. Its task is to animate

and focus what surrounds it. Perhaps the nearest comparison, despite the fact that it is cast in bronze, is with some of the menhirs or standing stones put up in Britain by prehistoric peoples.[8]

Literature
L. Mercury: – [i] 17 January 1980, p.10 [ii] 1 October 1980, p.13 [iii] 9 October 1980, p.19 [iv] 10 October 1980, p.29; Lucie-Smith, E., 1992a, pp.8, 56, 59, 231, 243, **9**, **56**, **57**; Pevsner, N. and Williamson, E., 1992, p.504; R. Times, November 1980, p.1; Strachan, W.J., 1984, p.154, **155**; Waites, B., 1982, p.50.

Notes
[1] L. Mercury, 17 January 1980, p.10. [2] Ibid.: [i] 1 October 1980, p.13 [ii] 9 October 1980, p.19. [3] Mr Les Smith, as quoted in L. Mercury, 10 October 1980, p.29. [4] Mr Lawrie Wickson, as quoted in L. Mercury, 10 October 1980, p.29. [5] R. Times, November 1980, p.1. [6] L. Mercury, 10 October 1980, p.29. [7] Lucie-Smith, E., 1992a, p.8. [8] Ibid, p.56.

Church Road

St Mary's Parish Church (Grade I listed)

In the churchyard, to the east of the church porch:

Ketton War Memorial

**Architect: Sir John Ninian Comper
Sculptor: (?)William D. Gough**

Memorial in Clipsham stone
h. (est.) 4.57m (15')
Inscriptions on the pedestal, in incised and (formerly) blackened Roman capital letters:
– front face: 1914 – 1919 / PRAY FOR THE MEN OF / KETTON WHO GAVE THEIR / LIVES IN THE GREAT WARS / 1939 – 1945 [beneath which, in two columns are the names of the ten men who died in the Second World War, initials only of forenames; on the other three faces of the pedestal the 36 First World War dead are listed,

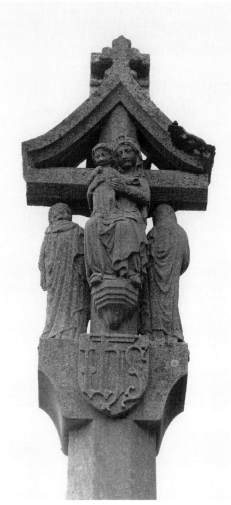

Gough, *Virgin and Child*, from Comper, *Ketton War Memorial* (rear view)

in alphabetical order, initials only of forenames, 12 names per face]
Unveiled and dedicated: 1921
Status: not separately listed
Owner / custodian: unknown

Description: The memorial, wholly in Clipsham stone, has at its summit carved figures around a gable-covered cross. This is supported on a tall tapering octagonal shaft, broached at the foot, rising from a pedestal bearing the inscriptions, on two steps. The carvings represent, at the front, Christ crucified between standing figures of the Virgin Mary and St John the Evangelist and, at the back, the Virgin Mary enthroned with the Christchild standing on her lap. The capital of the shaft has, on the front, a shield with Alpha and Omega (the first and last letters of the Greek alphabet – symbolising Christ as the beginning and end of all things) and, on the back, a shield with the Sacred Monogram – IHS (the abbreviation of Jesus in Greek).

Condition: The carving has lost some definition through weathering and the right hand of the crucified Christ is lost. There is lichen and biological growth on all surfaces.

History: Comper also designed the stained glass in the three-light east window of the chancel (1907); the window at the east end of the south aisle (1917); and the High Altar and the paving of the sanctuary (1925).

The carving of the *Crucifixion* and *Virgin and Child* groups on the present war memorial is very similar to that on Comper's war memorials at Oakham (p.296) and Uppingham (pp.299–300), the sculpture for the former having been executed by William D. Gough, according to a contemporary newspaper.[1]

Literature
Pevsner, N., and Williamson, E., 1992, p.477; Phillips, G., 1920, p.243; Sharpe, J.M., 1992, pp.20, 43, figs. **1.15**, **3.10**.

Note
[1] L., R., and S. Mercury, 7 April 1922, p.6.

OAKHAM Civil Parish: Oakham

Ashwell Road

Oakham School

In the grounds (access only by prior arrangement):

Two Herons

Sculptor and founder: Lloyd Le Blanc

Herons in bronze
Life-size
Executed: 1988
Status: not listed
Owner: Oakham School

Description: The life-size sculptures of herons are on a small island in an ornamental pool within a precinct designed in 1988 by Martin Minshall, Director of Art and Design, Oakham School.
Condition: Good.

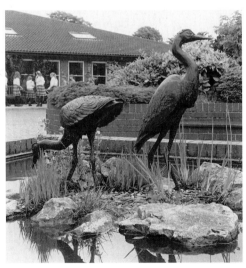

Le Blanc, *Two Herons*

Catmos Street

In front of Oakham Library:

Oakham Town Sign

Designer: Antonia Phillips
Modeller: Martin Minshall
Founders: Le Blanc Fine Art Foundry

Sculptural town sign in bronze, wood and stone
h. 2.99m (9'10")
Inscriptions on metal plaques fixed to the stone base:
– north-east facing plaque: OAKHAM TOWN SIGN / Erected / 1998 / Designed By / ANTONIA PHILLIPS / Oakham School / Modelled By / MARTIN MINSHALL / Head of Design Oakham School / Cast By / LE BLANC / FINE ART FOUNDRY [and at the bottom of the plaque, a cog-wheel motif]
– south-east facing plaque: OAKHAM / TWINNED / WITH / BARMSTEDT / WEST GERMANY / 30th MAY 1987
– south-west facing plaque: The Sign Was Commissioned By / THE / ROTARY CLUB OF / RUTLAND / Following a Competition Held / For Local Students / The Assistance of / The / LEICESTERSHIRE COUNTY COUNCIL / RUTLAND DISTRICT COUNCIL / And In Particular / OAKHAM TOWN COUNCIL / Is Hereby Acknowledged [and at the bottom of the plaque, a cog-wheel motif]
Erected: 1998
Status: not listed
Owner / custodian: Rutland County Council

Description: Town sign with pictorial reliefs in bronze crowning a wooden post mounted on a stone base bearing the metal inscription plaques.
Condition: Good
History: The scheme for a sculptural town sign for Oakham was initiated by The Rotary Club of Rutland in collaboration with the then Rutland District Council. The Council approached Martin Minshall, Director of Art

Phillips and Minshall, *Oakham Town Sign*

and Design at Oakham School, who organised a competition amongst the sixth-form students to create some designs based on the Council's brief. The designs were submitted to the Council, who selected that by Antonia Phillips. The design was then modelled in clay by Minshall and cast by local founders, Le Blanc Fine Art.[1]

Note
[1] Information from Martin Minshall, 9 June 1999.

Chapel Close

Oakham School (access only by prior arrangement)

Oakham School was founded, together with Uppingham School, by Archdeacon Robert Johnson in 1584.[1]

The War Memorial Chapel, by G.E.S. Streatfield, 1924–5, Chapel Close:

West front reliefs

Sculptor: Francis William Sargant

Reliefs in limestone
Tympanum relief: h. 95.5cm (3'2"); w. 1.91m (6'3")
Two upper zone end reliefs: h. 86cm (2'10"); w. 43cm (1'5")
Two upper zone central reliefs: h. 86cm (2'10"); w. 1.61m (5'4")
Two upper zone spandrel reliefs: h. 86cm (2'10"); w. 68cm (2'3")
Four lower zone *Virtue* reliefs: h. 1.27m (4'2"); w. 43cm (1'5")
Inscriptions, all incised:
1. Around the upper mouldings of the tympanum: THIS. CHAPEL. IS. ERECTED. TO. THE. GLORY. OF. GOD. AND. IN. MEMORY. OF / THE. OLD. OAKHAMIANS. WHO. FELL. IN. THE. GREAT. WAR. 1914–19
2. On the *Virtue* reliefs: (extreme left) FORTI- / TVDO (left of entrance) TEMP- / ERANT- / IA (right of entrance) PRV- / DENT- / IA (extreme right) JVSTIT- / IA
Signed and dated on the *Justitia* relief, on the footrest beneath the figure's right foot:
FEC. F. SARGANT 1927
Status: not listed
Owner: Oakham School

Description: The sculptural programme of the south-facing (liturgical west) front of Oakham School Memorial Chapel comprises a tympanum and two zones of reliefs either side

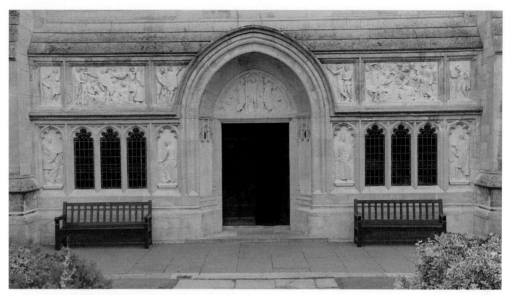

Streatfield, *Oakham School War Memorial Chapel, west front*

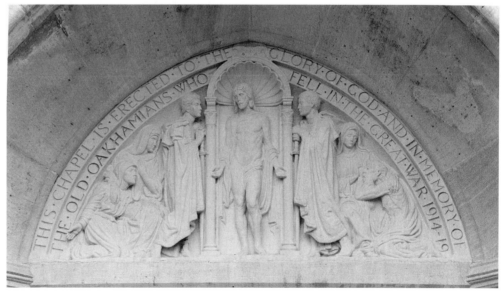

Sargant, *tympanum relief, Oakham School War Memorial Chapel*

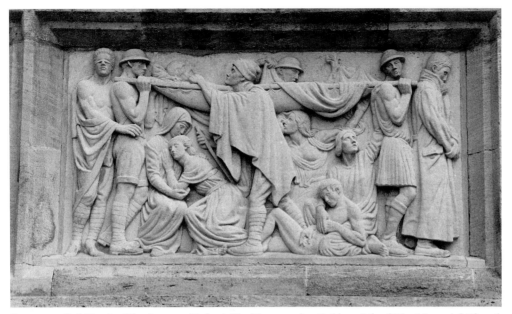

Sargant, *relief, Dead soldier borne to his burial by his comrades, Oakham School War Memorial Chapel*

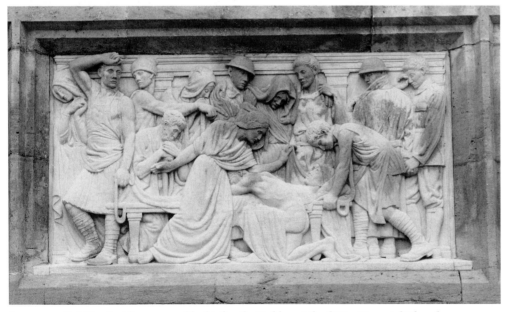

Sargant, *relief, Dead soldier mourned by his family, Oakham School War Memorial Chapel*

of the central arched entrance. The tympanum relief is a symmetrical composition with the risen Christ standing before a shell-headed niche. Flanking the niche are two young men, standing in ankle-length cloaks, bearing reversed swords. To each side of these young men are seated women comforting elderly people who are shown on their knees and apparently grief-stricken: the woman on the left comforts an old woman whose appeal to Christ is met with a compassionate gaze and the display of the stigmata on his hands, the signs of his own sacrifice, while the woman on the right comforts an old man whose drapery has partly fallen away to reveal his emaciated torso. W.L. Sargant explained this panel as 'A symbol of the new life which may rise from the nation's ordeal'.[2] The two long multi-figure reliefs in the upper zone either side of the archway show in two separate tableaux 'a beloved father mortally wounded and borne to his burial by his comrades. In thought he is surrounded by his heart-broken family'. The two smaller panels at the extreme ends of the upper zone represent, on the left, a 'vigorous land-girl [encouraging] her mother' and on the right, 'crippled old age ... supported by a daughter'.[3] The spandrel reliefs show young soldiers holding up lamps of remembrance. Finally, the lower zone has four panels with standing figures of the Cardinal Virtues: Fortitude, Temperance, Prudence and Justice. On the splays to either side of the doorway are the inscribed names of the boys and masters of Oakham School who died in the First World War beneath the school motto, 'Quasi Cursores'.

Condition: Good; cleaned in August 1996 by Lamby Masonry Cleaners, Stamford.

History: The idea of building a memorial chapel to the Old Oakhamians killed in the First World War evolved well before the signing of the armistice on 11 November 1918.[4] By the end of the war 69 former pupils had been killed, many of them junior officers: it was

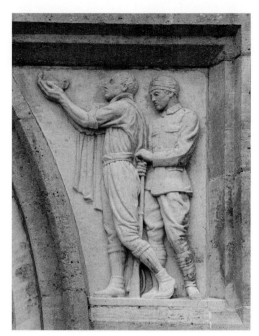

Sargant, *relief, Young soldier holding up a lamp of remembrance, Oakham School War Memorial Chapel*

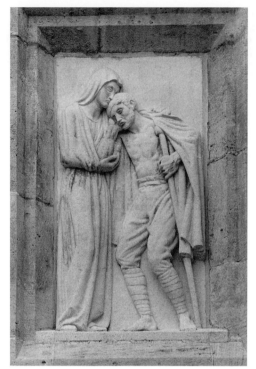

Sargant, *relief, Crippled veteran supported by his daughter, Oakham School War Memorial Chapel*

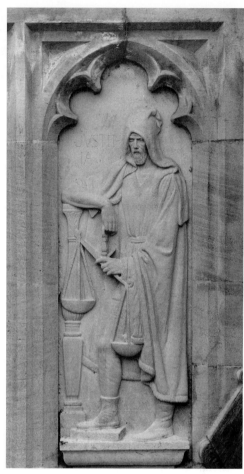

Sargant, *relief, Justice, Oakham School War Memorial Chapel*

from this group, as the then headmaster, W.L. Sargant, observed, that 'death took his heaviest toll'.[5] In November 1918 the first circular inviting subscriptions towards the scheme to build the chapel was issued. In addition, the School Trustees contributed the substantial sum of £4,500. There were at this time only 160 boys in the school and yet the headmaster and his memorial committee decided to commission from architect G.E.S. Streatfield a chapel to seat 300, in anticipation of future growth. With such an ambitious scheme it was evident that it would take quite some time to raise sufficient funds and so, in order not to leave those Old Oakhamians and masters who had died uncommemorated, the headmaster commissioned his brother, F.W. Sargant, to design a pair of oak screens – one screen to be inscribed with their names, the other with sports notices – to flank the main entrance to School House.

By April 1924 sufficient funds had been raised to allow construction to begin. Messrs Bowman, a firm of ecclesiastical builders from Stamford, began work and on Speech Day of that year the Rt Revd Dr Frank Theodore Woods, recently appointed Bishop of Winchester (formerly Bishop of Peterborough), laid the foundation stone in fulfilment of an old promise. On 29 October 1925 the chapel was dedicated by the Rt Revd Dr Cuthbert Bardsley, Woods's successor as Bishop of Peterborough. At this point, the relief sculptures had not even been started.

Fortunately, however, the headmaster had again managed to secure the services of his brother who, in the headmaster's own words, 'gave a very liberal interpretation to a modest commission'.[6] The reliefs were completed and installed in 1927 by which time the whole scheme had cost £16,000.

F.W. Sargant was in fact a professional

sculptor who had spent from 1899 until the outbreak of war in 1914 living and working in Florence. The reliefs, which are of a very high quality, clearly show his familiarity with Florentine quattrocento art, especially the relief sculpture of Donatello and Luca della Robbia. The long multi-figure reliefs, in particular, demonstrate considerable compositional skill and control of spatial relationships.

Literature
Barber, J., 1983, pp.103–4, 116–17, **118**; Page, W., 1935, p.7; Pevsner, N. and Williamson, E., 1992, p.498; Sargant, W.L., 1928, pp.53, 54, 81 (and plates); Sharpe, J.M., 1992, p.7; *The Times*: – [i] 31 October 1925, p.9 [ii] 6 November 1925, p.**18**.

Notes
[1] Pevsner, N. and Williamson, E., 1992, p.497. [2] He does, however, inaccurately describe the tympanum panel as 'youths in scholars' gowns, in adoration of the risen Christ' (Sargant, W.L., 1928, p.81). [3] *Ibid.* [4] The following account derives largely from Barber, J., 1983, pp.116–17, and Sargant, W.L., 1928, pp.53-4. [5] Sargant, W.L., 1928, p.53. [6] *Ibid.*, p.55.

Church Street

All Saints parish church (Grade I listed)

In the churchyard, south side of the church:
Oakham War Memorial

Architect: Sir John Ninian Comper
Sculptor: William D. Gough

Memorial in Clipsham stone
h. 6.7m (22')
Inscriptions, all carved into the stone:
1. On the pedestal within laurel wreaths
– west face: TO / THE MEN OF / OAKHAM / WHO GAVE THEIR / LIVES IN THE / GREAT WAR
– east face: A.D. / 1914 – 1919
– north and south faces: 1939 – 1945 [with the names of the 17 dead of the Second World War, in alphabetical order, initials only and surnames]
2. On the plinth, the names of the 112 dead of

the First World War, in alphabetical order (with two later additions), initials only and surnames
Unveiled and dedicated: Thursday 7 April 1922, by Major-General Sir A.E. Codrington, KCVO, CB, and the Rt Revd Dr Frank Theodore Woods, Bishop of Peterborough
Status: not separately listed
Owner / custodian: Oakham Town Council

Decription: The war memorial comprises a tabernacle with carved representations of The Crucifixion (west face), the Madonna and Child (east face), St Martin dividing his cloak (south face) and St George and the Dragon (north face). The tabernacle crowns a tapering octagonal shaft rising from a square pedestal bearing the main dedicatory inscriptions within carved laurel wreaths, mounted on a star-shaped plinth bearing the names of the 112 dead of the First World War on its 16 faces, raised on three octagonal steps and an octagonal platform.

Condition: Good. Although there is some weathering to the inscriptions, there appear to be no losses.

History: Oakham's memorial to its First World War dead was erected by public subscription, its cost being considerably reduced by John Davenport-Handley-Humphreys, owner of the Clipsham Quarry Company, who donated the stone.[1] A copy of G. Phillips's book, *Rutland and the Great War*, containing the names, biographies and photographs of the dead, which had hitherto hung upon an altar shrine within the parish church, was sealed in a lead casket and placed inside the base of the memorial. During the unveiling and dedication ceremony on 7 April 1922, the memorial was officially handed over to the vicar and churchwarden 'for safe keeping'.[2]

Gough, *St Martin dividing his cloak*, from Comper, *Oakham War Memorial*

Literature
Architects' Journal, 8 September 1920, p.278; *L. Mail*, 7 April 1922, p.5; *L, R & S Mercury*: – [i] 17 December 1920, p.6 [ii] 7 April 1922, p.6; *M.M. Times*, 14 April 1922, p.3; Phillips, G., 1920, p.243; Sharpe, J.M., 1992, pp.20, 43, fig. **1.15**.

Notes
[1] *L, R & S Mercury*, 17 December 1920, p.6.
[2] *Ibid.*, 7 April 1922, p.6.

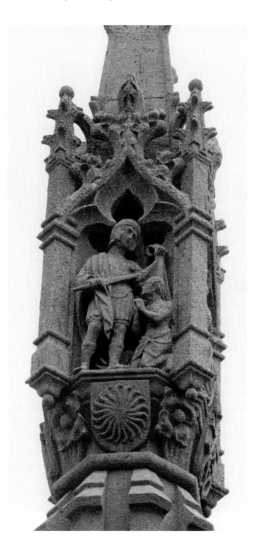

Market Place

Oakham Castle

Of the buildings of the original castle - more correctly a fortified manor house - only the late twelfth-century stone hall, built on an east-west axis, survives. Both the exterior and interior have remains of important *twelfth-century sculpture*.[1]

Sculptors: unknown

Sculpture in Clipsham stone
Executed: late twelfth century (probably 1180s)
Status of building: Grade I
Owner / custodian: Rutland County Council

Description of sculptures:

Exterior: The spaces between the windows of the south front originally accommodated five figurative sculptures; today only three remain, two having been lost by 1847.[2] The sculpture to the left of the doorway represents a man astride a beast, holding its neck and tail. On the gables are two further sculptures, on the west a centaur,[3] and on the east Samson and the Lion.

Interior: The interior is divided into a central nave and side-aisles by arcades of four bays. Each arcade is carried on three circular piers and is finished off with large carved corbels at its meeting with the end walls. Each of the pier capitals is decorated with sculpture: facing the side-aisles, above the capitals, are corbels carved with human heads in the round; facing the central nave, with figures playing musical instruments - the two westernmost piers on each side being human[4] and the two eastern piers, animal.[5] All are now headless but there is a possible survivor, a human head, now in the Rutland County Museum.[6] The animals are identifiable as an ass with a harp-like instrument called a rote (south-east pier) and a goat playing a rebec with a bow (north-east pier). Animal musicians are a feature of the Kentish school, early twelfth-century examples

Oakham Castle, interior, corbel carved with a lion resting its legs on two human heads

being on a capital in the crypt at Canterbury Cathedral. The human figures also resemble earlier Kentish work, specifically some of the apostle figures on the lintel over the west door of Rochester Cathedral.[7] The end wall corbels are decorated with carved beasts in profile, their forelegs and hind-legs resting on human heads,[8] the latter carved with a much greater naturalism than the musicians. Examples of this new naturalism have again been found at Canterbury, in certain fragments of figure carving that may have once decorated the choir screen, erected in 1180. The carving of the Oakham corbels is not as sophisticated and the naturalism not maintained as consistently as it is at Canterbury, reinforcing the suggestion that this is the work of English carvers who had seen the French originals. Above and to left and right of the large corbels, at the junctions of the arcades with the end walls, are hood-mould stops carved as animal and bird heads.[9] Inside is

also a figure of a lion-like beast standing on its hind legs; it is thought that this may have originally formed part of the sculptural programme of the exterior of the building.

History: It has been established with reasonable certainty that the sculptors who carried out the programme of architectural carvings at Oakham Castle were Englishmen who had previously worked at Canterbury Cathedral. The most important carving at Canterbury, in the choir, was carried out by French carvers who brought to England an elaborate, foliated style of capital. English carvers, less skilled in such complex work, were given templates as guides for their work on those capitals in the less important areas of the Cathedral, such as the aisles and upper parts. It is these latter that the capitals at Oakham so closely resemble. The capitals of Canterbury Cathedral were carved by 1178 at the latest and all work on the Cathedral was completed in 1184. Thus, on the basis that the sculptors would most likely have left to seek new work at this time, the Oakham sculptures have been tentatively dated to the 1180s.[10]

Literature
Clough, T.H.McK., 1999, pp.30–7; Emmerson, R., 1981; Page, W. (ed.), 1935, pp.8-10; Pevsner, N. and Williamson, E., 1992, pp.495, 496, figs. 82, 86.

Notes
[1] Although these sculptures pre-date the period covered by the PMSA survey, i.e., from the 1290s (the dates of the *Eleanor Crosses*), the following, albeit brief, account has been included in recognition of their national importance. [2] Emmerson, R., 1981 (reprinted in Clough, T.H.McK., 1999, p.35). [3] Illustrated in *ibid.* (reprinted in Clough, T.H.McK., 1999, p.36). [4] Examples illustrated in *ibid.* (reprinted in Clough, T.H.McK., 1999, pp.31, 33). [5] Page, W., 1935, p.9, n. 55. [6] Emmerson, R., 1981 (reprinted in Clough, T.H.McK., 1999). [7] *Ibid.*, p.32. [8] Example illustrated in *ibid.* (reprinted in Clough, T.H.McK., 1999, p.34). [9] *Ibid.*, p.35. [10] Emmerson, R., 1981 (reprinted in Clough, T.H.McK., 1999, p.37).

Inside the hall, at the east end:

Bust of George Henry Finch, MP

George Henry Finch (1835–1907) was Conservative Member of Parliament for Rutland from 1867 to 1907, was elected to the Privy Council in 1902 and in his later years was Father of the House of Commons.
Sources: *The Rutland Magazine*, 1907–8, vol. iii, no. 19, p.88; *The Rutland Record*, no. 8, 1988, p.273

Sculptor: Frederick William Pomeroy

Bust in white marble on a socle in green marble and pedestal in red marble
Bust: h. 52cm (1'9"); w. 46cm (1'6"); d. 33cm (1'1")
Socle: h. 20.5cm (8")
Pedestal: h. 1.16m (3'10")
Inscriptions:
– on a Ketton stone tablet mounted on the wall behind the bust, in recessed lines in raised Roman capital letters:
AS A MEMORIAL TO THE RIGHT HONOURABLE GEORGE HENRY FINCH, / LORD OF THE MANOR AND CASTLE OF OAKHAM, MEMBER OF PARLIAMENT / FOR THE COUNTY OF RUTLAND FOR MORE THAN THIRTY NINE YEARS AND / "FATHER" OF THE HOUSE OF COMMONS, THE CASTLE OF OAKHAM HAS BEEN / RESTORED AND THIS BUST ERECTED BY HIS GRATEFUL CONSTITUENTS AND / MANY FRIENDS WHO CHERISH HIS MEMORY. / MCMXI
– on the front face of the socle: THE / Rᵀ HON G.H. FINCH. M.P. / BORN 1835. DIED 1907
Signed and dated beneath the right shoulder: F.W. POMEROY / 1912
Unveiled: 1913,[1] by Sir Arthur Fludyer, Bart., Chairman of the George Henry Finch Memorial Committee
Status: not separately listed
Owner: Rutland County Council

Description: Finch is portrayed bare-headed, with beard and moustache, his head directed

Pomeroy, *G.H. Finch*

straight ahead, his incised eyes looking to his right. He wears a jacket, waistcoat, and hunting stock, the latter with a relief of a horse (perhaps intended to represent the ornamental head of a stock pin?).
Condition: Good.
History: Following Finch's death a committee was formed to consider how he might best be commemorated. After some discussion it was decided that Oakham Castle should be restored and a bust of Finch placed inside. A London architect, William Weir, was appointed to supervise the restoration, which was carried out largely by Nichols Bros of

Oakham, and a leading London sculptor, Frederick William Pomeroy, was selected to execute the bust, which was funded by public subscription.

Literature
PMSA NRP East Midlands Archive. *Grantham Journal* [undated cuttings].
General. Page, W. (ed.), 1935, vol. ii, p.9.

Note
[1] From two undated press cuttings supplied by Mrs Finch, a relative of G.H. Finch. The text refers to the unveiling taking place on a Friday afternoon, but gives no date.

Westgate
Somerfield (formerly Gateway) food store

On an exterior wall:

Relief
Sculptor: Martin Minshall

Relief in stoneware ceramic tiles
h. 2.48m (8'2"); w. 3.08m (10'1")
Signed and dated bottom right: M. Minshall 1984
Status: not listed
Owner: Somerfield Stores Ltd

Description: Relief depicting Oakham Market Place and Butter Cross. Minshall based his relief on photographs dating from the 1920s, thereby injecting a certain nostalgic element through the inclusion in the foreground of Oakham people in early twentieth-century costume.
History: The Somerfield building was initiated in the early 1980s by Keymarkets, although before building was completed, Gateway had taken over. The frontages along Westgate and New Street are occupied by, respectively, dummy windows and the main entrance; the splayed corner between them, however, was a blank brick wall. The then Rutland District Council, eager to improve the

look of the frontage, persuaded Gateway to commission some form of decoration for this space. The Council, having approached a number of artists with a brief, finally settled on a series of designs formulated by Martin Minshall, Director of Art and Design at Oakham School. The ultimate choice of design was made by Gateway. As Minshall explained at the time: 'The butter-cross was the original trading centre for old Oakham and Gateway now say they are the trading centre of the new Oakham, so it seemed appropriate.'[1]

Minshall modelled and fired the stoneware tiles in the Art and Design Department at Oakham School.[2] He said of the scene depicted in the relief: 'It's not a hundred per cent architecturally accurate ... but I've tried to get the feel of the scene, as well as the feel of that particular period.'[3]

Literature
PMSA NRP East Midlands Archive. *Stamford Mercury* (undated press cutting supplied by the artist).

Notes
[1] From an undated *Stamford Mercury* press cutting.
[2] Information from Martin Minshall. [3] From an undated *Stamford Mercury* press cutting.

Minshall, *Relief, Somerfield store*

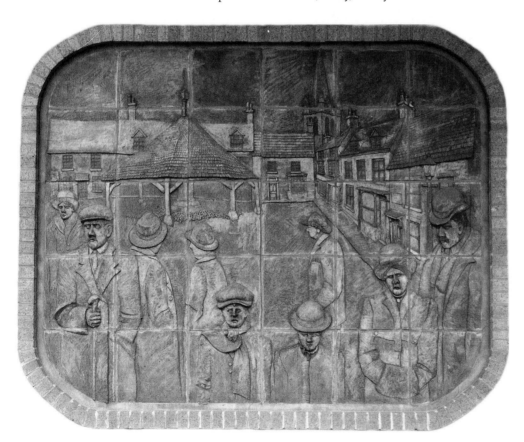

London Road
SS. Peter and Paul Parish Church

In the south-west corner of SS. Peter and Paul parish churchyard, facing west:

Uppingham War Memorial

Architect: Sir John Ninian Comper
Sculptor: William D. Gough (attrib.)
Contractors: H.H. Clarke, of Lyddington[1]

Memorial in Clipsham stone
h. 5.94m (19'6")[2]
Inscriptions:
– on a metal plaque on the front (west) face of the pedestal: IN MEMORY / OF THE MEN OF / UPPINGHAM / WHO GAVE THEIR LIVES / IN THE GREAT WAR / 1914–1919
– on metal plaques on the remaining three faces, the names of the 42 dead, in alphabetical order, forename initials and surnames only.
– inscribed into the stone of the right (south) vertical face of the uppermost octagonal step: WORLD WAR / 1939–1945
– on the vertical face of the next step down, ten names arranged as before
Unveiled and dedicated: Monday 19 July 1920, by Major-General Lord Ranksborough, CB, CVO, Lord Lieutenant of Rutland, and the Venerable E.M. Moore, Rector of Uppingham and former Archdeacon of Oakham
Status: Grade II
Owner / custodian: Uppingham Town Council

Description: The memorial comprises a pillar surmounting a pedestal raised on three hexagonal steps, on a concrete landing set into the grass at the south-western corner of the churchyard, overlooking London Road and opposite Spring Back Way. The pillar is crowned with a tabernacle having a scallop-

Gough, *Virgin and Child,* **from Comper,** *Uppingham War Memorial*

Condition: Overall the stone of the memorial is slightly weathered, with areas of biological growth. The memorial was restored by Uppingham Town Council in March 1994.

History: The *Uppingham War Memorial*, funded by public subscription, cost approximately £500.[3] It was originally erected on the corner of the churchyard wall but was relocated to a plot inside the churchyard and set on a new pedestal and base in 1924/5.[4] Although the sculptor's name is not mentioned in any documents so far found, William D. Gough is recorded in the contemporary local press as having executed the sculpture on Comper's *Oakham War Memorial*.[5] The figure style, drapery carving and compositional formulae in the tabernacle groups on the Oakham and Uppingham memorials are so close – especially in The Crucifixion and Virgin and Child groups which appear in both – as to suggest strongly they were executed by the same sculptor.

Literature
L. Daily Post, 17 November 1919, p.6; *L, R & S Mercury,* 23 July 1920, p.6; Phillips, G., 1920, p.244; Sharpe, J.M., 1992, pp.20, 43, fig. **1.15**.

Notes
[1] Information from Bruce Fruin, Uppingham.
[2] Phillips, G., 1920, p.244. [3] *Ibid.* [4] Information from Uppingham School archives. [5] *L. R, & S. Mercury,* 7 April 1922, p.6.

High Street West

Uppingham School (access only by prior arrangement)

Founded by Archdeacon Robert Johnson in 1584, together with Oakham School.

1. The Victoria Tower of the Classroom (or Victoria) Block, 1894–7, by (Sir) Thomas Graham Jackson. In an aedicule beneath a convex entablature supported on Composite columns, overlooking High Street West:

Statue of the Venerable Robert Johnson, Archdeacon of Leicester

Robert Johnson (1541–1625) was born in Stamford, Lincolnshire, the son of a wealthy dyer, and was educated at King's School, Peterborough, and at Cambridge. Having completed his education, he travelled to France and studied in Paris for a while. At some date before 1571 he was fortunate to secure the post of chaplain to Sir Nicholas Bacon, Queen Elizabeth I's Keeper of the Great Seal. Johnson was installed canon of Peterborough and of Norwich in 1570, and of Windsor in 1572. In 1574 he was instituted Rector of North Luffenham, Rutland. With the considerable wealth he had managed to amass, 'the result partly of his pluralities and partly of the property acquired by his first two marriages'[1]

Frampton, *Archdeacon Robert Johnson*

headed niche on each of its four faces. The niche on the front (west) face contains a carving of Christ on the Cross flanked by the Virgin and St John the Evangelist, while the rear (east) face contains a seated Virgin and Child. The left (north) niche has St Michael, while the right (south) has St George, each shown killing their respective dragons.

(he married three times in all) Johnson founded Uppingham and Oakham schools and hospitals (or, more exactly almshouses) in 1584, the two schools being provided in his will with a certain number of scholarships to Cambridge. In 1591 Johnson was installed Archdeacon of Leicester. He was buried at North Luffenham on 24 July 1625.

Sources: *DNB*; Matthews, B., 1981; *Rutland Record*, No. 8, 1988.

Sculptor: (Sir) George Frampton

Statue in limestone
h. (est.) 2.44m (8')
Status of building: Grade II
Owner: Uppingham School

Description: Johnson stands, his right hand resting on a walking stick with a T-shaped handle, his left hand holding a model of the hospital, or almshouse, he established along with the school. He wears an Elizabethan scholar's cap and ermine-trimmed gown.

Condition: Fair. The figure is slightly weathered and has some black encrustation. The front right-hand corner of the pedestal cornice is lost.

History: Architect T.G. Jackson's building accounts for Uppingham School, dated 6 June 1898, show that the sculptor, George Frampton, was paid £100 for the *Statue of Archdeacon Johnson*. The working relationship between the two men was of some years' standing, Frampton having designed and executed the sculptural frieze for the Music Gallery of Jackson's No. 2 Kensington Court 1883–4.[2] There is also a possible connection at Winchester Cathedral in as much as Jackson had been consulted over structural repairs[3] while Frampton had executed a figure of the *Virgin and Child* for the Cathedral.[4] Furthermore, both were members of the Art Workers' Guild.

Literature
Uppingham School archives – *Uppingham School. Statement of Accounts. Set of Orders. T.G. Jackson R.A. Archt.*

V&A Museum Archive of Art and Design. Sir George Frampton archive – press cuttings, vol. ii: *Building News*, 21 October 1898.
General. *L. Daily Post*, 6 December 1897, p.5; Pevsner, N. and Williamson, E., 1992, p.516.

Notes
[1] *DNB*. [2] *Studio*, vol. i, no. 6, 1893, pp.220–5. [3] Grey, A.S., 1985, p.219. [4] Illustrated in *Art Journal*, 1897, p.323.

2. The Tercentenary Building, 1890, by (Sir) Thomas Graham Jackson. Over the doorway onto the quadrangle:

Relief of a schoolmaster and his class (The School Seal)

Sculptor: unknown

Relief in limestone
h. (est.) 76cm (2'6"); w. (est.) 61cm (2')
Inscription around the almond-shaped frame of the relief, clockwise from the top:
SIG. COM. GUBERN. SCHOLAR. ET. HOSPICIORUM. IN. OKEHAM. ET. UPPINGHAM. IN. COM. RUTL.
– the design is taken from the Common Seal of Uppingham School, dating from 1587, the inscription of which is in abbreviated Latin. In full it reads: 'Sig[illum] Com[mune] Gubern[atorum] Scholar[um] et Hospiciorum in Okeham et Uppingham in Com[itatu] Rutl[andia]', which translates as 'The Common Seal of the Governors of the Schools and Hospitals in Oakham and Uppingham in the County of Rutland'.[1]
Status of building: Grade II
Owner of building: Uppingham School

Description: An elliptical relief representing a stylized classroom in which a schoolmaster sits at his desk facing six standing pupils. The master and pupils are dressed in the fashion of the later sixteenth century.

Condition: Good.

Related work: Another version, partly painted in pale blue and gilded, is located over the doorway of the new library (converted in

c.1950 from the old schoolhouse), facing onto the quad. The inscription on the relief is the same as for the nineteenth-century version. Below it, on another stone set into the wall, is a further inscription in flowing script painted pale blue: *This building is / dedicated / to the sons of / Uppingham / who fell in the War / 1939–1945.*

Literature
Matthews, B., 1984, pp.124, 254–5.

Note
[1] Matthews, B., 1984, pp.254–5.

3. The School Chapel, 1863–5, by G.E. Street, with north extension, 1964–5, by Seely and Paget.[1]

(a) Inside the north-east porch:

Statue of Edward Thring

Edward Thring (1821–87), schoolmaster and educationalist, was born in Somerset. A son of the rector and squire of Alford, Thring was educated at Eton and King's College, Cambridge, becoming a fellow of King's in 1844. In this capacity, he wrote pamphlets against King's time-honoured tradition of allowing degrees without examination; as a result of his campaign the practice was abolished in 1851. Thring was ordained in 1846. His first appointment was at St James, Gloucester, where, as a first manifestation of his lifelong belief in the importance of elementary education, he took a great interest in the efficacy of the local parochial schools. In September 1853 he was elected to the headmastership of Uppingham School at a time when the school was in a run-down state with only 25 pupils, two masters and a negligible reputation. Over the course of his 34–year headmastership he transformed Uppingham into one of the leading public schools in England with excellent educational facilities and accommodation serving the needs of 320 pupils

and 30 masters. He considered this not only the ideal size for the school but also the ideal ratio of pupils to masters, firmly believing that education should be individually tailored to bring out the best in each boy. In 1869 he founded the headmasters' conference and established the first public school mission to the poor of London. He was also the first headmaster to express support for further education for girls. He wrote copiously on the principles of education, his work being influential both in Britain and the USA. Thring died on 22 October 1887, leaving a wife and three sons and two daughters. He is buried in the churchyard of SS Peter and Paul Parish Church, Uppingham.
Source: *DNB*.

Sculptor: (Sir) Thomas Brock

Statue in marble on a pedestal in alabaster
Statue: h. 1.52m (5'); w. 93cm (3'1"); d. 1.13m (3'9")
Pedestal: h. 69cm (2'3"); w. 1.07m (3'6"); d. 1.14m (3'9")
Inscription on the front face of the pedestal:
EDWARD THRING / HEAD MASTER 1853 TO 1887
Signed and dated on the right-hand face of the marble base towards the rear:
T. BROCK. R.A. Sculptor. / LONDON 1892.
Exhibited: 1892, Royal Academy of Arts (cat. 1967)
Unveiled: Tuesday 1 November 1892 by Miss Sarah E. Thring, daughter of Edward Thring.[2]
Status: Not separately listed (Chapel Grade II*)
Owner: Uppingham School

Brock, *Edward Thring*

Description: Thring is represented seated on an ornate chair, dressed in a headmaster's gown. He looks to his left. In his right hand he holds a book, his index finger inserted between the pages. His left arm rests along the arm of the chair, his hand folded over the end. The ornate high-backed chair is decorated on each side with a cherub carved in relief.

Condition: The overall condition is fair. The figure is spattered with small blackish-brown and rust-coloured stains, presumably from the metal struts of the porch roof. There are also accumulations of cobwebs and dirt in most hollows. Along the vertical edge of the gown below knee level a small chip of marble has been lost. The joins of the pedestal are very visible (presumably dating from the time of its removal from the chapel and re-assembly in the porch). Additionally the right-hand face of the pedestal appears roughened and encrusted. The right-hand finial of the chair back is a recent replacement

History: Shortly after Edward Thring's death on 22 October 1887, a meeting was held at Uppingham School to make arrangements for commissioning a monument to his memory. A 'very large and influential committee was appointed'[3] and a subscription list opened. After some discussion it was decided that the school chapel, which was in need of enlargement anyway, to cope with the increased numbers of pupils at the school, should have a galilee, which could also serve as a memorial chapel with a statue to Thring as its centre-piece. The committee selected A.E. Street, the son of G.E. Street, the architect of the original chapel, to design the galilee.[4] The circumstances of Brock's selection are, however, not known. Though he was later to become one of the most successful British sculptors of his generation,[5] he was at the time relatively little known and, according to the anonymous author of a typescript biography in the collection of the National Art Library, going through difficult times with few commissions and a family to support.[6] The Uppingham commission must therefore have been particularly welcome.

The likeness of Thring was probably based, at least in part, on portraits of the headmaster by Charles Rossiter, one of the few surviving documents relating to this commission being a letter from Brock to Mrs Thring, thanking her for her invitation to visit Uppingham to see Mr Rossiter's portraits. Brock writes that he 'cannot get away before the week after next', but as soon as circumstances permit he will confirm arrangements for his visit.[7]

The statue, finished by the summer of 1892 and shown at that year's Royal Academy exhibition, was relatively well-received by the critics. Most enthusiastic was the critic of the *Athenaeum* who remarked: 'The statue of the *Rev. E. Thring* ..., seated in a chair, is very good and sincere'.[8] *The Times*, only a little less positive, found it a 'thoroughly satisfactory piece of work',[9] while the lukewarm *Art Journal* described it as 'conventional, but thoroughly appropriate'[10] The *Saturday Review* critic, though largely approving, nonetheless found fault with certain details: 'Mr. Brock's marble statue of "Edward Thring"... has great merit. The head is a little hard, and the feet needlessly ugly, but the disposition of the drapery is good'.[11]

By the time of the unveiling, £2,022. 8s. 1d. (including interest) had been subscribed. The memorial chapel had cost £875. 7s. 2d., Brock's fee for the statue was £1,000 and a further £120 was spent on 'providing a pedestal, moving and erecting the Statue, Insurance for same, &c'.[12] The Revd H.D. Rawnsley, an Old Uppinghamian, composed a hymn specially for the unveiling ceremony, the opening verse of which likens Thring's moulding of his pupils' characters to the sculptor's art now before them:

> To-day with rev'rent love we meet / Around this sculptur'd stone, / Our Master once again to greet, / And almost hear his tone / He, too, was sculptor: duty's way / The fearless master trod; / He took our boyhood's dullest clay, / And moulded it for God.[13]

Literature
Uppingham School archives. *Edward Thring Memorial Fund. Statement of Accounts and List of Subscriptions*; *Hymn written for the unveiling of the Statue...*; *Order for the Unveiling of the Statue...*
National Art Library (V&A Museum). Letter, dated 12 June 1887 [sic], from Brock to Mrs Thring; typescript biography of Thomas Brock, possibly by a relative, *c*.1930, p.91.
General. *Art Journal*, 1892, pp.242–3; *Athenaeum*, 11 June 1892, p.768; *L. Chronicle*, 5 November 1892, p.3; *L. Daily Post*, 3 November 1892, p.2; Matthews, B., 1984, p.124; Page, W. (ed.), 1908, vol. I, p.297; Pevsner, N. and Williamson, E., 1992, p.516; *Royal Academy Pictures*, 1892, p.152; *Saturday Review*, 23 July 1892, p.103; *The Times*, 28 May 1892, p.17.

Notes
[1] Pevsner, N. and Williamson, E., 1992, p.516. [2] *The [Uppingham] School Magazine*, vol. xxx, no. 242, December 1892, p.333, noted that Miss Thring unveiled the statue 'in the absence of her mother'. The *L. Daily Post*, 3 November 1892, p.2, erroneously reported that it was Mrs Thring herself who performed the ceremony. [3] *The [Uppingham] School Magazine*, vol. xxx, no. 242, December 1892, p.330. The committee included the Archbishop of Canterbury, the Lord Bishops of Carlisle and Oxford, the Earl of Dysart, the Master of Trinity College, Cambridge, the Principal of Hertford College, Oxford, and the headmasters of Eton and Harrow. [4] *L. Daily Post*, 3 November 1892, p.2. [5] The culmination of Brock's career, a commission for which he was knighted, was the *Memorial to Queen Victoria* outside Buckingham Palace, 1906–24 (see Read, B., 1982, pp.371–9). [6] Believed to have been written by a relative of Brock in *c*.1930. [7] The letter, in the collection of the National Art Library, V&A Museum, London, is – most confusingly – dated 12 June 1887, i.e., before Thring's death in October 1887. However, given that the few existing documents explicitly state that the statue was commissioned after Thring's death and given also that in his letter Brock writes of visiting Uppingham to look at painted portraits (and presumably photographs) of Thring – a rather curious measure if Thring were still alive – one can only assume that

Brock accidentally wrote down the wrong year and the date should read 12 June 1888. Such a date would then give a quite plausible seven-month gap between the subject's death and the sculptor being selected and making arrangements to begin his work.

[8] *Athenaeum*, 11 June 1892, p.768. [9] *The Times*, 28 May 1892, p.17. [10] *Art Journal*, 1892, pp.242–3. [11] *Saturday Review*, 23 July 1892, p.103. [12] *Edward Thring Memorial Fund. Statement of Accounts . . .*, October 1892. [13] From an original hymn sheet in the Uppingham School archives.

(b) In the west porch:

Relief Portrait of William Frederick Witts

Sculptor: unknown

Bas relief in marble with alabaster frame
h. 96cm (3'2"); w. 58cm (1'11"); d. 5.5cm (2")
Inscription on the frame, beneath the relief:
TO. WILLIAM: FREDERICK: WITTS: / IN WHOSE NOBLE GIFT THE FOUNDATIONS OF THIS CHAPEL WERE LAID, HIS FRIENDS REMEMBERING IN HIM / THE GRACE OF A PURE AND GENIAL CHARACTER, A FATHERLY TENDERNESS, A CHILDLIKE INNOCENCY. / HAVE RAISED THIS MEMORIAL OF THEIR LOVE. / BORN JULY, 27, 1818: MASTER AND

Relief Portrait of W.F. Witts

FIRST CHAPLAIN AT UPPINGHAM 1861 – 1873: DIED JULY 31, 1884.
Status of building: Grade II*
Owner: Uppingham School

Description: Witts is shown in profile, facing right.
Condition: Good.

4. The Memorial Hall, 1921, by Ernest Newton; completed, 1923–4, by his son W.G. Newton; and divided into two floors, 1969, by Seely and Paget.[1] In the Kendall Room thereby created:

Bust of Queen Victoria

Sculptor: Andrea Carlo Lucchesi

Bust in white marble with tiara in gilt bronze and plinth in grey-green Irish marble
h. (inc. plinth) 65cm (2'2"); w. 50cm (1'8"); d. 35cm (1'2")
Inscription on an ornate plaque on the front face of the plinth:
PRESENTED TO THE SCHOOL BY / WILLINGHAM FRANKLIN RAWNSLEY / O.U. 1855–1864 : MASTER. 1871–1878 / UNVEILED BY / H.R.H. THE DUCHESS OF ALBANY / DEC. 3. 1897. / IN THE 60TH YEAR OF HER MAJESTY'S REIGN / LONGITUDO DIERUM IN DEXTERA ET IN SINISTRA GLORIA.
Signed and dated in script at the rear: *A.C. Lucchesi / /97*
Unveiled: Friday 3 December 1897 by the Duchess of Albany
Status: not listed
Owner: Uppingham School

Description: Queen Victoria is shown in old age, her head tilted to the right, her eyes downcast.
Condition: Fair, although the surface is dulled with grime and there is a small chip from the lace edging to the veil at the left temple.
History: The bust was commissioned from Lucchesi by W.F. Rawnsley, a pupil at the school from 1855 to 1864 and a master from 1871 to 1878. It was presented to the school to

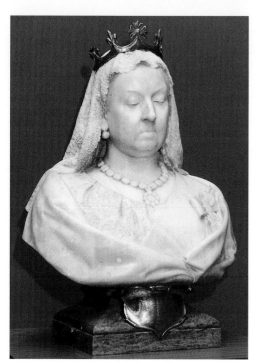

Lucchesi, *Queen Victoria*

mark the opening of the new Victoria Block – so-called because it was opened in the year of Queen Victoria's Diamond Jubilee – and was originally located in one of the new block's classrooms. The Bishop of Peterborough in his speech at the official opening of the block, expressed the wish that the bust – which the Duchess of Albany, the subject's daughter-in-law, was about to unveil – would 'increase that spirit of loyalty and devotion to the throne, which is part of the good, popular, and liberal education given in this school.'[2]

After the unveiling, the sculptor, Andrea Carlo Lucchesi, was introduced to the Duchess who 'remarked upon the fact that he had secured a well-known expression of countenance of her Majesty'.[3] In quite what spirit the words were spoken it is difficult to decide, for one would be hard put to think of a more 'disgruntled' bust of the elderly Queen.[4] The bust remained in the classroom for many years before being relocated to the Theatre (opened in 1972) and most recently to the Kendall Room.

Literature
Uppingham School archives – *Uppingham School. Statement of Accounts. Set of Orders. T.G. Jackson R.A. Archt.*
General. *L. Daily Post*, 6 December 1897, p.5; Matthews, B., 1984, p.124.

Notes
[1] Pevsner, N. and Williamson, E., 1992, pp.516–17.
[2] *L. Daily Post*, 6 December 1897, p.5. [3] *Ibid*.
[4] As accurately described in Matthews, B., 1984, p.124.

Lost and Removed Works

LEICESTERSHIRE

BIRSTALL

Stonehill Avenue

Stonehill High School, 1954–6, by T.A. Collins

Formerly over the school entrance:

Girl Releasing Dove

Sculptor: Ben Franklin

Sculpture in concrete
Dimensions unknown
Executed: 1956
Status: not listed
Owner: Leicestershire Education Authority

History: *Girl Releasing Dove* was commissioned in 1956 by the then Director of Education for Leicestershire, Stewart Mason, with advice from Alec Clifton-Taylor, as part of his programme to decorate school buildings throughout the County with sculptures by living British artists.[1]

By 1981 *Girl Releasing Dove* had begun to deteriorate and small pieces were dropping off. Restoration was investigated but found to be impractical and so ultimately the sculpture was removed.[2] The problem lay in the material itself. The concrete would have been modelled round a metal armature. Once the concrete became cracked, water would have seeped in, causing the armature to rust and expand,

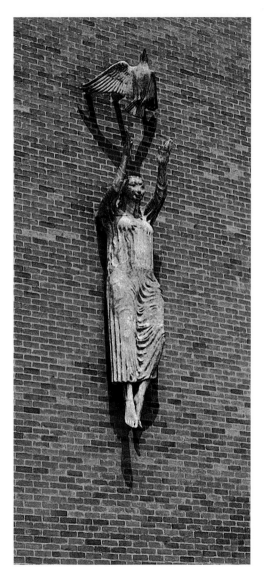

Franklin, *Girl Releasing Dove*

ultimately bursting the concrete coat. Such was the fate of many of the free-standing or boldly projecting concrete sculptures commissioned by the LEA in these years (see below and pp.308, 309, 312, 314, 326–7). Evidently the school retained the head of the girl but the rest had to be scrapped.[3]

Related work: another version of the sculpture was at Hastings High School, Burbage (see p.21–2, 308).

Literature
Pevsner, N. and Williamson, E., 1992, pp.44, 103.

Notes
[1] Pevsner, N. and Williamson, E., 1992, p.40; LEA inventory. [2] LEA inventory. [3] Information from John Siddons, premises officer, Stonehill High School.

BRAUNSTONE

Kingsway North

Winstanley Community College

Formerly in the playground:

Fellowship

Sculptor: Ben Franklin

Sculptural group in concrete
Group: 1.3m × 86cm × 61cm (4'3" × 2'10" × 2')[1]
Plinth: 69cm × 91cm × 65cm (2'3" × 3' × 2'2")
Status: not listed
Owner: Leicestershire Education Authority

History: *Fellowship* was commissioned for the school by the Leicestershire Education Authority in 1962.[2] Although details are sparse,

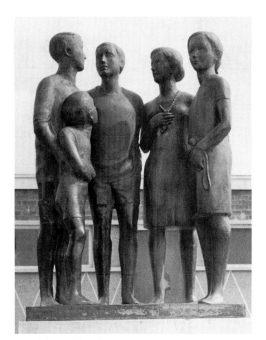

Franklin, *Fellowship*

the following information is recorded in a letter dated 16 January 1984 from the then Principal to Leicestershire's Assistant Director of Education. The sculpture, he writes, was:

... intended to 'represent the spirit of amity and co-operation that links young people in search of knowledge and understanding'. It was presented to the school and sited on the inner court at the time of the school's opening ...[3]

The main reason for the letter was that the sculpture was by this time in a rather poor condition. The first evidence we have of the deterioration of the piece is in an earlier letter from the principal, dated 1 June 1979, in which he states that it had already begun to crumble – though not badly – but that the previous night intruders had entered the school grounds and wrenched part of the sculpture off its plinth. He makes a special plea for the restoration of this 'very excellent work of art' which, he adds, 'we are particularly proud to own'.[4]

It would seem that the repairs were carried out and the sculpture remained in the playground until 1986 when, owing to its worsening condition, it was moved inside. The deterioration continued, however, and the remains of the sculpture were ultimately put in store at the school.

The problem here is that which plagues every outdoor sculpture in concrete on a metal armature. Once the concrete cracks water will seep in, eventually rusting the armature which in turn will expand and cause the already weakened concrete coat to burst. Such has been the case with other of Franklin's school sculptures (see previous and subsequent entries) and also some of Peter Peri's projecting figures (see below and pp.312, 314, 326–7).

Notes
[1] The measurements are as given in the LEA inventory; it is not clear as to which dimension each measurement relates. [2] LEA inventory. [3] *Ibid.*: letter dated 16 January 1984 from the then principal of Winstanley Community College to the Assistant Director, Education Department, Leicestershire County Hall. [4] *Ibid.*: letter dated 1 June 1979 from the then principal of Winstanley Community College to the Director, Education Department, Leicestershire County Hall.

BURBAGE

St Catherine's Close
Hastings High School

Formerly fixed to an exterior wall:
Girl Releasing Dove
Sculptor: Ben Franklin

Sculpture in concrete

2.19m × 48cm (7'2" × 1'7")
Executed: *c*.1956
Status: not listed
Owner: Leicestershire Education Authority

History: *Girl Releasing Dove* was purchased by the Leicestershire Education Authority in 1956.[1] Like its counterpart at Stonehill High School (see p.307) it too began to suffer the kind of deterioration to which concrete is peculiarly susceptible and by 1983 had to be dismantled. Evidently the dove was salvaged and was stored for a time in the school.[2] By 1999, however, even this had been lost.

Literature
Pevsner, N. and Williamson, E., 1992, p.117.

Notes
[1] LEA inventory. [2] Pevsner, N. and Williamson, E., 1960, 1992, p.117.

CASTLE DONINGTON

Mount Pleasant

Formerly in Castle Donington Community College, by T.A. Collins, officially opened 6 October 1958:[1]

Adventures of Learning (also known as *The Boy with the Globe and the Book*)[2]
Sculptor: Peter Peri

Projecting figure sculpture in concrete on a mild steel armature
Dimensions unknown
Signed and dated (on brickwork below figure): Peri / 1957
Status: not listed
Owner: Leicestershire Education Authority

History: Peri's *Adventures of Learning* was commissioned in 1955 by Stewart Mason, Leicestershire's then Director of Education, specifically for Castle Donington Community

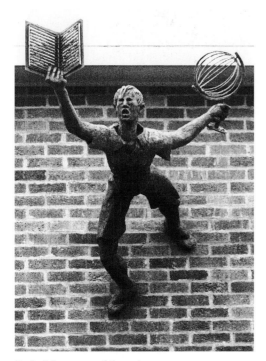

Peri, *Adventures of Learning*

College. Peri's final drawing was approved in June 1955 but not until November of the following year did his model receive the approval of Mason and the school's architect, T.A. Collins.[3] In early 1957 the armature of mild steel rods upon which Peri was to model the sculpture was fixed to the wall of the school close to the main entrance[4] and Peri executed the sculpture in May 1957; as with Peri's other figures of this sort (see pp.11–12, 211–12, 326–7), the work was carried out *in situ*.[5] At some date before 1985 *Adventures of Learning* was removed after deterioration had rendered the work unsafe.[6]

John Berger wrote about the present sculpture in the following appreciative terms in an article in the *New Statesman*:

... if I wanted a single visual symbol for the general promise of the new [Leicestershire] schools that I have described, I would choose Peri's boy at Castle Donington. In one hand he holds out, parallel to the wall but seven feet away from it, an open book made of bars with openings between them; in his other hand is an open globe. His feet are on the wall, standing on it as if it were the ground. His head thrust back looks straight ahead. An image of old Church-school rhetoric? A grotesque gargoyle? Described verbally it could, I suppose, sound like either. But in its concrete form it epitomises an architecture of release. Here is a sculptor who must be used still further for what he can do incomparably well.[7]

Literature
Courtauld Institute, Conway Library – letter, dated 4 February 1958, from Peter Peri to Philip James, Director of Art, Arts Council of Great Britain (letter pasted to reverse of mounted photograph of present sculpture).
The Centre for the Study of Sculpture, Leeds. Kenny, S., 1980, pp.16, 35, 36–7.
General. Berger, J., 1957; Camden Arts Centre, 1987, p.43; The Minories, 1970, n. pag.; Pevsner, N. and Williamson, E., 1992, p.124.

Notes
[1] Kenny, S., 1980, p.37. [2] The latter is the title given in Camden Arts Centre, 1987, p.43. [3] Kenny, S., 1980, p.36. [4] *Ibid.*, pp.36–7. [5] As stated by the sculptor in a letter, dated 4 February 1958, to Philip James, Director of Art, Arts Council of Great Britain (the letter is in the Conway Library photographic collection). [6] LEA inventory. [7] Berger, J., 1957.

COALVILLE

Ashby Road

Formerly in Snibston Discovery Park:
Equinox
Sculptor: Nayan Kulkarni
Sculpture in stainless steel and gypsum

Dimensions unknown
Executed: 1994
Owner: Leicestershire County Council (Museums Arts and Records Service)

History: *Equinox* was removed after being extensively vandalised.[1]

Literature
Snibston Discovery Park archives. *Snibston Discovery Park. Resume ... 1995/96.*
General. *L. Mercury*, 9 December 1991, p.21, **21**.

Note
[1] Information from Steph Mastoris, Snibston Discovery Park.

Belvoir Road and High Street

Formerly at the Belvoir Road and High Street entrances to the Belvoir Shopping Centre:
two abstract sculptures
Designers: Owen Luder and Partners

Sculptures in aluminium
Dimensions unknown
Executed: *c.*1962

History: The two sculptures, designed by the architects of the precinct, were described in a contemporary press report of the official opening of the precinct as:

... contemporary aluminium alloy structures, resembling double-ended rockets on their launching pads ... Costing £1,000 each, the 'towers' will be illuminated. The architect, Mr Owen Luder, said they would mellow to a metallic shade through oxidisation by weathering.[1]

In 1971, a photo article entitled 'What is it?' appeared in a local periodical, the writer seemingly giving voice to the general public's continuing bemusement with the sculptures. In his caption to a photograph of one of the two sculptures he facetiously remarks:

The girl in the UDC offices thought it was a lamp post, but precinct architects Owen Luder & Partners confessed it was their own untitled work of no especial significance, other than to enhance the aesthetic appeal of the environment; a point which is not generally known[2]

By the early 1990s, the sculptures were no longer *in situ*. It has not been possible to establish their fate.

Literature
C. Times, 18 October 1963, p.3; *L. and R. Topic*, June 1971, p.6, **6**.

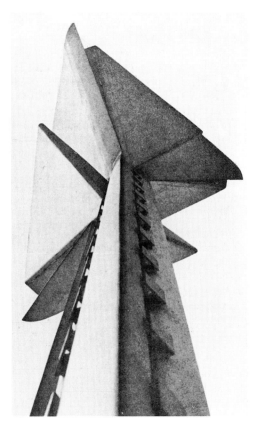

Luder and Partners, *abstract sculpture*

Notes
[1] *C. Times*, 18 October 1963, p.3. [2] *L. and R. Topic*, June 1971, p.6.

Bridge Road

Formerly in Stephenson College (originally Coalville Technical College):

Large Compression Pillar
Sculptor: Peter Hide

Sculpture in pre-cast concrete and cast iron
h. 4.06m (13'4"); w. 1.98m (6'6"); d. 1.98m (6'6")[1]
Executed: 1971–2
Status: not listed
Owner: Leicestershire Education Authority

History: *Large Compression Pillar* was originally commissioned in 1971 for the Peter Stuyvesant Foundation City Sculpture Project. A total of 17 sculptors had been chosen from an original list of over 100 by the appointed selectors Stewart Mason (Director of Leicestershire Education Authority, 1947–71, and subsequently its advisor on arts purchases) and the sculptor Phillip King (for a general account of the project, see pp.225–6). Each of the successful sculptors was asked to nominate his or her first three choices of city and, from his list, Hide was allocated Southampton. Following a visit to the city he selected Guildhall Square as his specific site.[2] *Large Compression Pillar*, in common with the other 16 commissioned sculptures, was allowed to remain on site for six months throughout the summer of 1972 in the hope that local people would become familiar with it and, with the aid of a concurrent documentary exhibition of explanatory material, perhaps even come to appreciate it.

In 1973, following the close of the exhibition, *Large Compression Pillar* was purchased by the Leicestershire Education Authority, most likely on the advice of Stewart

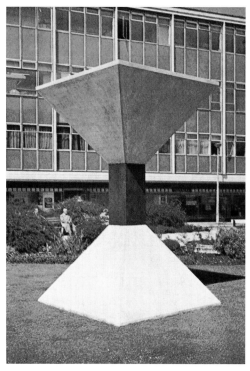

Hide, *Large Compression Pillar*

Mason.[3] By the late 1970s, cracks had appeared in the concrete bottom section (such deterioration being in the nature of the material) and in 1981 the sculpture was dismantled.[4]

Related works: Three other sculptures were also, like *Large Compression Pillar*, purchased by the Leicestershire Education Authority from the Peter Stuyvesant Foundation City Sculpture Project – Garth Evans's *Untitled* (see p.225–6); John Panting's *Flying Cross* (see pp.228–9); and Bryan Kneale's *Astonia* (see pp.237–8).

Literature
Arts Council of Great Britain, 1972, n. pag.; Rees, J., 1972, pp.11–15, 31, **31**.

Notes
[1] Dimensions as in LEA inventory. [2] Rees, J., 1972, p.31. [3] LEA inventory. The inventory makes no mention of any contribution from the Arts Council of Great Britain, although given that the Council co-funded the LEA's contemporaneous purchases of the Garth Evans and John Panting sculptures – originally commissioned for the same project – for Loughborough and Lutterworth, it seems probable that it may have assisted the LEA with the cost here also. [4] *Ibid.*

DESFORD

Leicester Lane
Desford Hall

Built probably in the 1880s as a private residence, and later converted into a convalescent home by the Leicester and County Saturday Hospital Society and officially opened 15 April 1905. Formerly in the entrance hall:

Memorial Portrait Medallion of Sir Edward Wood

Edward Wood (1839–1917), born 16 January 1839 at Derby and educated in Leicester, was a founder of the Leicester boot and shoe manufacturers, Freeman, Hardy and Willis. In 1880 he entered the Council as member for East St Mary's Ward, Leicester, was elected alderman in 1886, and served as Mayor of Leicester in 1888–9, 1895–6, 1901–2 and 1906–7. He was Chairman of the Corporation Gas Committee and Water Committee, and Deputy Chairman of the Derwent Water Board for many years. He was appointed JP in 1889, was presented with the Freedom of the Borough in 1892, and was knighted by King Edward VII in 1906. He was the founder and first president of the Leicester and County Saturday Hospital

Society, 1903 – 1917. Wood died on 22 September 1917 at Shirley Lodge, his house at Knighton, Leicester, and was buried in Welford Road Cemetery.
Sources: Hartopp, H., 1935; Pike, W.T., 1902; Wade-Matthews, M., 1995; *Who Was Who 1916–1928.*

Sculptor: Joseph Herbert Morcom

Memorial tablet in statuary marble, Swithland slate and Derbyshire marble
Dimensions unknown
Unveiled: Saturday 10 April 1920, by Mrs Sydney Gimson, wife of the then President of the Leicester and County Saturday Hospital Society

Description as recorded in the *Leicester Mail*, 12 April 1920, p.5:

> The tribute is in the form of a medallion in statuary marble, set in a panel of Swithland slate which in turn is mounted on Derbyshire marble. The head and shoulders are in beautiful relief. Beneath the striking likeness is the inscription: 'Sir Edward Wood, first president of the Leicester and County Saturday Hospital Society, 1903–1917.' ... It is affixed to the wall of the entrance hall, over the tablet which records the opening of the residence as a convalescent home on April 15, 1905, by Mr. Hy. Broadhurst, M.P., supported by Sir Edward Wood as the founder of the society.[1]

The relief is no longer at this location and the present occupants have no knowledge of it.
Related work: A similar relief by Morcom had been unveiled at Swithland Convalescent Home the previous September (see p.330).

Literature
L. Chronicle, 17 April 1920, p.2; *L. Mail*, 12 April 1920, p.5.

Note
[1] As given in *L. Mail*, 12 April 1920, p.5.

EARL SHILTON

Belle Vue Road
Heathfield High School

Formerly in the grounds:
Flute Player
Sculptor: Michael Piper

Sculpture in metal
Dimensions unknown
Status: not listed
Owner: Leicestershire Education Authority

Condition: Shortly before 9 October 1998, the sculpture was extensively vandalised: the head and arms were broken off and other parts twisted out of shape. It was at first hoped that the sculpture could be restored, but not only did the damage prove to be worse than had at first been thought, it was later discovered that some of the pieces were lost. The LEA came to the conclusion therefore that the sculpture was beyond repair and in its present state, dangerous, and consequently had no alternative but to remove the remains from the site.[1]
History: *The Flute Player* was acquired by the Leicestershire Education Authority in 1960.[2]

Notes
[1] Information from Rachael Green, Leicestershire Education Authority. [2] LEA inventory.

Girl and Boy Reading
Sculptor: Peter Peri

Sculpture in concrete
Dimensions unknown
Executed: 1956
Status: Not listed
Owner: Leicestershire Education Authority

Condition: The sculpture is no longer known at the school, it presumably having

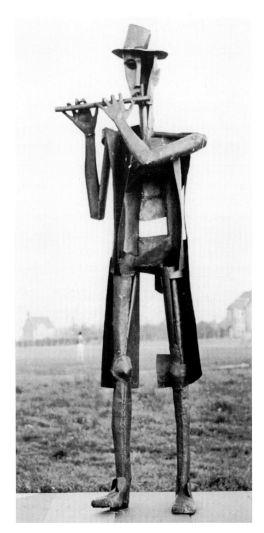

Piper, *Flute Player*

deteriorated and been removed some years ago.

History: *Girl and Boy Reading* was commissioned from Peter Peri by Stewart Mason, Leicestershire's then Director of Education, for the present school at the time of its construction in 1956. Peri had first been contacted by Mason in 1954 (see pp.190–1) and the two men – along with architect T.A. Collins, who was then in the process of building new schools and extending existing ones throughout the county – had since developed a fruitful working arrangement. Peri's sculptures were intended as integral parts of the school buildings for which they were commissioned – he was not merely brought in after the building had been completed and asked to apply sculptural decoration wherever there was an available blank wall – he was generally commissioned at an early stage and, it would seem, had a considerable input into the creation of sympathetic architectural contexts for his sculptures.

In the case of *Girl and Boy Reading*, the three men were in discussion about the placement of the sculpture in the school grounds in early 1956. In a letter from Collins to Peri, dated 20 June 1956, the architect asked the sculptor to confirm his preferred position for the base of the sculpture on an enclosed plan of the school. He also asked Peri to let him know the required height of the wall upon which the figures were to be mounted, its thickness, where he wanted the holding-down bolts placed, how the ends of the wall should be treated, what kind of brickwork he thought best and how the top should be left for him to work upon.[1] Unusually for Peri, he did not execute the figures *in situ*. From Collins's letter it is clear that Peri was to model the figures in his studio and bring them completed to the site for fixing.

The figures were completed and fixed during the summer of 1956, for in September Mason wrote to Peri, praising the result, and advising

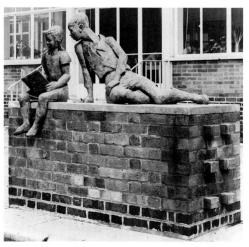

Peri, *Girl and Boy Reading*

the sculptor that payment was forthcoming.[2]

Related works: pen sketches, in the collection of The Centre for the Study of Sculpture, Leeds (cat. nos P56, P65, P66, P163).

Literature
The Centre for the Study of Sculpture, Leeds. Kenny, S., 1980, pp.26, 24–35.

Notes
[1] Kenny, S., 1980, p.34. [2] *Ibid.*, pp.34–5.

Inspan

Sculptor: Wendy Taylor

Sculpture in stainless steel and forged steel
h. 20.5cm (8"); w. 2.74m (9'); d. 61cm (2')
Executed: 1971
Status: not listed
Owner: Leicestershire Education Authority

History: *Inspan* was purchased from the sculptor in the mid-1970s by Leicestershire's then Director of Education, Stewart Mason.[1] Like many of Taylor's works, the present sculpture is designed to invert the viewer's

expectations: a heavy steel tube takes on a lighter-than-air quality and is apparently restrained from floating away only by the heavy-duty steel chain which is wrapped round its middle and bolted securely to the ground.

At some date before 12 October 1998, the sculpture was attacked by vandals. It was subsequently returned to Beaumanor Hall (a Leicestershire Education Authority store) where, at the time of writing (June 1999), it remains. It is intended that the sculpture be repaired and perhaps allocated to another school.

Related work: *Versus*, Thomas Estley Community College, Broughton Astley (see pp.19–20).

Literature
Lucie-Smith, E., 1992b, pp.28, 115, **27**; Strachan, W.J., 1984, p.150, *150*.

Note
[1] Information from the sculptor.

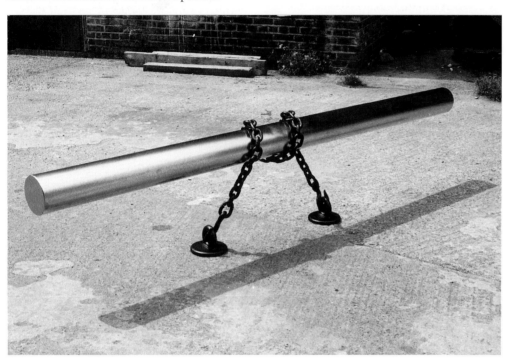

Taylor, *Inspan*

Heath Lane

Formerly in William Bradford Community College:

Agrippa

Sculptor: Tim Scott

Sculpture in polyurethane, fibreglass and glass
h. 1.98m (6'6"); w. 91.4cm (3'); d. 91.4cm (3')
Executed: April 1964 – February 1965
Exhibited: 1965, London, Whitechapel Art Gallery (no. 24); 1967–8, London, Whitechapel Art Gallery (no. 53)
Status: not listed
Owner: Leicestershire Education Authority

History: *Agrippa* was purchased by the Leicestershire Education Authority in 1967 for

Scott, *Agrippa*

Cosby County Primary School, the cost being covered by funds made available through the buildings capital scheme. The sculpture was returned to the LEA float in 1979 and later transferred to Earl Shilton Community College.[1] During refurbishment of the school in the early 1990s, the sculpture was badly damaged and removed shortly afterwards.[2]

Related work: another cast is in the Tate Gallery, London (cat. no. TO1363).

Literature
Whitechapel Art Gallery, 1965, p.61; Whitechapel Art Gallery, 1967, p.18.

Notes
[1] LEA inventory. [2] Information from Rachael Green, Leicestershire Education Authority.

HINCKLEY

London Road

North Warwickshire and Hinckley College (formerly Hinckley College of Further Education).

Reclining Boy and Girl
Sculptor: Peter Peri

Cut-out relief in concrete
Dimensions unknown
Executed: 1959
Owner: Leicestershire Education Authority

History: Peri's *Reclining Boy and Girl*[1] was commissioned for the College by the Leicestershire Education Authority in 1959.[2] It was evidently sited 'round to the left of the [New] Hall Block with concealed lighting under the flagstones in front of it'.[3] At some time during the 1960s or 1970s, the figure of the boy was decapitated by vandals. The then Principal made enquiries about the cost of repairing the piece and was told that it would be 'in the region of £150', i.e., slightly more than

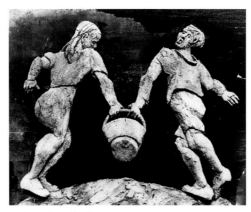
Peri, *Jack and Jill*

the £135 the sculpture had cost in 1959.[4] The ensuing sequence of events is unclear, but presumably the sculpture was removed and may even have been demolished, as by 1982 there was no trace of it.[5]

A further Peter Peri sculpture is also mentioned as having been at Hinckley College of Further Education. A photograph of a cut-out relief in concrete, entitled *Jack and Jill*, representing two children carrying a pail of water between them and captioned as being at the college, is in the Peter Peri archive at The Centre for the Study of Sculpture, Leeds (see fig. above). The present author could find no other reference to this sculpture being at this location, however; furthermore, the photograph appears to show the sculpture whilst still in the sculptor's studio

Literature
The Centre for the Study of Sculpture. László, H., 1990, p.88.
General. Camden Arts Centre, 1987, p.43; Henderson, E., 1981, pp.31, **33**; Leicestershire Museum and Art Gallery, 1991, p.16; The Minories, 1970, n. pag.

Notes
[1] See photograph in Henderson, E., 1981, p.33.
[2] LEA inventory. [3] Henderson, E., 1981, p.31.
[4] *Ibid*. [5] LEA inventory.

LEICESTER (CENTRE)

Abbey Park

Animal sculptures: giraffe, wild boar, horse and goat
Sculptor: Denis O'Connor

Sculptures in wood set into concrete base blocks
Owner / custodian: Leicester City Council

History: Denis O'Connor created his *animal sculptures* group in Abbey Park as part of his seven-week residency in late summer / early autumn 1987.[1] Conceived as an ephemeral piece, Leicester City Council removed and destroyed the group once deterioration had set in.[2]

Literature
L. Mercury, 9 October 1987, pp.30, 35; *L. Trader*, 7 October 1987, p.5.

Notes
[1] *L. Mercury*, 9 October 1987, pp.30, 35
[2] Information from Pete Bryan, former Leicester City Council Public Arts Officer.

Family Group
Sculptor: Denis O'Connor

Sculpture in ash wood
Executed: 1987/8
Owner / custodian: Leicester City Council

History: Formerly on the site now occupied by *Three Orchids*, next to Abbey Park Bowls Club, this work was, like the same sculptor's *animal sculptures* above, intended to have a limited life-span and was removed by Leicester City Council once it had started to deteriorate.[1]

Family Group was created during O'Connor's residency at Abbey Park in 1987/8, during which time he held open workshops and encouraged visiting members of the public to

participate in his work. This was an aspect of the residency that the sculptor welcomed. As he explained: 'This way of working is a stimulus in itself, as many of my work ideas are concerned with breaking down barriers associated with contemporary sculptures.'[2]

The wood used in *Family Group* was from ash trees that had been felled for horticultural reasons.

Literature
Abbey Park sculpture trail, n.d.

Notes
[1] Information from Pete Bryan, former Leicester City Council Public Arts Officer. [2] *Abbey Park sculpture trail*, n.d.

Log Seat Sculpture
Sculptor: Pauline Wittka-Jezewski (*née* Holmes)

Sculpture in wood
Executed: 1990
Owner / custodian: Leicester City Council

Description: The sculpture took the form of logs arranged in ascending tiers around the base and part of the way up the trunk of a tree located between the bowling green and the river.

History: *Log Seat Sculpture* was commissioned by Leicester City Council from sculptor Pauline Wittka-Jezewski in 1990. The sculptor took her idea from the traditional round seats that had been set up around some of the larger trees in the park. Her hope was for 'a functional sculpture to surround the base of a tree that would also serve as a seat'.[1] By 1997, however, vandalism had rendered the structure unstable and the work was consequently removed by Leicester City Council.[2]

Literature
Abbey Park sculpture trail, n.d.; Leicester City Council, 1997, 1993 edn, p.105; *L. Mercury*, 3 September 1990, p.5.

Notes
[1] *Abbey Park sculpture trail*, n.d. [2] Information from Karen Durham, Leicester City Council Public Arts Officer.

Canning Street

A *Statue of St Margaret* was formerly on the exterior of Corah & Sons Ltd's St Margaret Works building.

Castle Gardens

The Tumblers
Sculptor: Albert Pountney
Architects: Frank Chippendale and Partners

Sculpture in artificial stone on a brick plinth
h. of sculpture (approx.): 1.24m (4'1")
Executed: 1953[1]

Description: The sculpture represents two acrobats, or tumblers, one standing upright, the other upside down, each grasping the other's ankles. The heads and hands are realistically modelled while the torsos and limbs are more abstracted. Professor Susan Tebby (a friend and colleague of the late sculptor) has suggested that the realistic modelling of the hands may be 'to emphasise the crucial, physical nature of "holding on" and the aesthetic need to continue the lines of movement', while the realism of the heads provides 'both physical and visual counterbalances in reciprocating motion'.

History: *The Tumblers* was commissioned by Leicester City Council through Stephen George, the then City Architect, for a part of Castle Gardens near Leicester Polytechnic (now De Montfort University) tennis courts, close by the College of Art and Technology and Newarke Bridge. Its acrobatic theme was intended to reflect the proximity of the sports facilities.

The sculpture, of two tumblers on a

Albert Pountney (left) with two student assistants and his sculpture, *The Tumblers*

cushion-shaped integral base, was cast in artificial stone (white concrete with a natural stone aggregate) from a clay original. It was designed as part of an ensemble, its tall brick plinth standing at the junction of two benches set at right angles to each other. The bench ends were shaped like artists' palettes, as was the concrete platform on which the benches and plinth stood. An undated photograph in the possession of Mrs Jane Pountney shows her husband, then Head of the Sculpture School at Leicester College of Art, sitting on one of the benches with two of his students, David Neville and an unidentified young woman, both of whom assisted in the casting of the sculpture.

The sculpture was vandalised shortly after its erection, by someone daubing it with dark paint, as an (undated) photograph from the *Leicester Evening Mail* shows. It was

successfully cleaned and remained relatively undisturbed for almost forty years until 1994/5 when the land was acquired by De Montfort University. A legal requirement of the purchase being that the land be developed, the sculpture was by necessity removed to store. It was by this time, however, in a sadly deteriorated state. A piece of the sculpture was missing and the iron armature inside the casting had started to oxidise and expand, thus causing the concrete to split open. At the time of writing (mid-1999) there is some discussion amongst interested parties as to how it might be possible to restore and resite the whole ensemble of sculpture, plinth and benches.[2]

Notes
[1] Information from Jane Pountney. [2] Information from Susan Tebby.

Granby Street
Britannia Hosiery building

Formerly next to the Temperance Hall; demolished in the 1960s.[1] The frontage had a crow-stepped gable inset with a semi-circular blind arch containing a *relief* and, on its summit, a figure of *Britannia* by an unknown sculptor.

Description: The *relief* depicted a sailing ship with what appears to be, on the left, a cornucopia and, on the right, a bale of cotton beneath a table with a sewing machine. The keystone of the arch was decorated with a crowned head of Neptune. *Britannia* was represented standing, holding her trident in her right hand. Her left hand rested on the upper part of the rim of her shield which was standing on the ground at her left side. By her right side was a lion *couchant* with crossed-paws.

History: It has not as yet been possible to locate any documentary evidence relating to the loss of these sculptures, although there are a number of commonly-held beliefs relating to

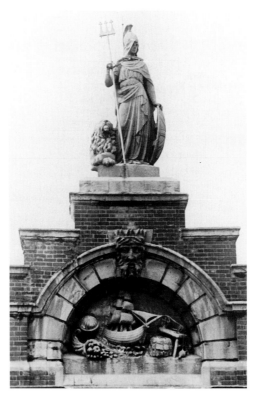

Britannia Hosiery Building: gable with relief and figure of Britannia

them. Some local historians assume that the building and sculptures were lost in a fire; others that the *Britannia* figure fell from the roof. Yet others believe that the *Britannia* was removed and given to Albert Pountney, then Head of Sculpture at Leicester School of Art (though this last version may be a confusion with the Coronation Buildings sculptures, for which see p.317).

Literature
L. Mercury, 28 January 1994, p.10.

Note
[1] *L. Mercury*, 28 January 1994, p.10.

General News Room and Library

At the corner with Belvoir Street, by William Flint, completed in January 1838 and demolished in 1898. The Belvoir Street frontage consisted of four three-quarter Ionic columns and antae. In the upper zone of the five intercolumniations was a series of reliefs:

The Muses between Greek and British Poets
Sculptor: William Pitts

Description: According to the *Gentleman's Magazine* (June 1840, p.661) the reliefs represented 'the Muses between the British and Greek poets, and emblems of the four quarters of the globe'.

History: A leading Leicester historian has described the architect William Flint as 'the best practitioner of his generation in Leicester' and his General News Room and Library as 'perhaps his masterpiece, a distinguished – though belated – product of the Greek Revival'.[1] Unfortunately, the News Room never achieved commercial success. It lost many potential members to the short-lived Athenaeum during the 1840s and, following its opening in 1870, to the Municipal Free Library.[2] Flint's General News Room and Library was ultimately demolished and replaced in 1898 by Goddard and Company's News Room. There is some confusion over the exact date and reason for the demolition. There was at one time a widely-held belief that Flint's building was demolished in 1902 for road-widening. This, however, is contradicted by the date, 1898, on Goddard's replacement building, built on the same site.[3] Perhaps the confusion reflects a certain resistance to the idea that Leicester's finest classical building could have been demolished for any reason less than the necessity of ensuring the free flow of late nineteenth-century Leicester's increasingly heavy road traffic.

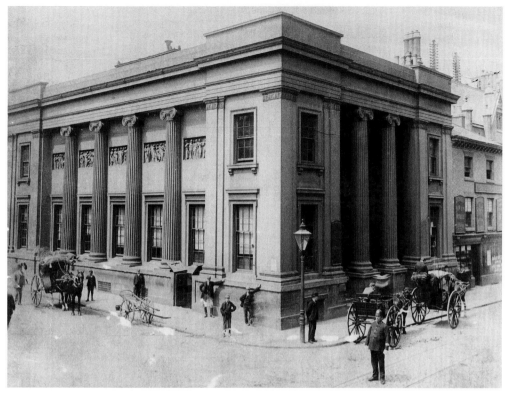

Flint, *General News Room and Library*

Sculptures in terracotta
Executed: *c.*1904

Description: The frontage is three storeys high with a central entrance bay surmounted by a barrel vault and flanked by three bays to each side. An intensively imperialistic and mercantile theme was carried through the whole of the decoration of the frontage. The six cartouches (supplied by the Doulton Factory, Lambeth), are ranged across the lower part of the second storey, three to each side of the central entrance bay. Each cartouche has an oval polychrome Union flag medallion at its centre and is inscribed with the name of a colony and surmounted by an animal symbolising that colony. They are, left to right, a kangaroo for Australia, a camel for Egypt, a bear for Canada, a lion for India, an elephant for Burma, and an ostrich for Africa. In the central bay at the base of the barrel vault are three panels of polychrome tiles. The two outer ones, of sailing ships, are original, the central one, a chequered abstract design, is a later addition. Between the outer two was originally the lower segment of a blind oculus containing one of the two sculptures: a group of three female figures bearing the produce of the Empire. Above the oculus, on the summit of the barrel vault, was an enthroned figure of *Britannia* presiding over all.

History: In the 1970s a fire seriously damaged the upper floors. Of the two sculptural pieces on this part of the building, the *Britannia* was unfortunately destroyed, while the *group of three female figures* in the blind oculus below was salvaged by the demolition contractor who, thinking it might be valuable, contacted Albert Pountney, the then Head of Sculpture at Leicester School of Art. As the owners of the Singer Building did not want to keep the damaged group, Pountney removed it firstly to the sculpture department and then to his studio at Bitteswell, near Lutterworth, hoping to restore it. This did not after all prove possible and so in 1982 he offered

Literature
Architectural Magazine, 1837, vol. vi, p.78; Colvin, H., 1978, p.309; *Gentleman's Magazine,* June 1840, p.661; Gunnis, R., [1964], p.307; Leicester City Council, 1975, p.40; Simmons, J., 1971, pl **6**; Simmons, J., 1974, vol. i, p.153, pl. **21b**; White, W., 1862, p.186.

Notes
[1] Simmons, J., 1974, p.153. [2] *Ibid.* [3] Leicester City Council, 1975, p.40. Howard Colvin (1978, p.309) gives the date of demolition as 1901.

High Street

Coronation Buildings, 1904, by Arthur Wakerley, built for the Singer Sewing Machine Company (and thus more often referred to as the Singer Building) to mark the coronation of King Edward VII.

The decoration of the frontage consists of six cartouches, two pictorial tiles and, formerly, two large pieces of sculpture:

Britannia and a *Group of three female figures*

Sculptor: William James Neatby (attributed)

it to Michael Stratton, then director of the Ironbridge Gorge Museum, Telford, Shropshire.[1]

Although documentary evidence substantiating the authorship of the present sculptures remains to be found, Mr Scott Anderson (Southampton Institute; formerly of Leicester) has suggested, on stylistic and circumstantial evidence, that they, along with the rest of the decoration of the frontage, may be the work of William James Neatby. Neatby had been head of the architectural department at the Doulton Factory, Lambeth, until 1900, though he continued to supply the factory with designs after that date, for example on Wakerley's Turkey Café of 1901 in Granby Street, Leicester. As Mr Anderson observes, the polychrome tiles supplied by the Doulton Factory for the Singer frontage are stylistically compatible with those Neatby designed for the same company for Harrods Meat Hall in 1903, while the capitals of the pilasters on the present frontage are also typical of Neatby's style. More importantly, he also notes a stylistic affinity between the Singer Building figures and Neatby's signed and dated (1900) mermaid reliefs for the Leicester Wholesale Market (see pp.182–3). That, as he admits, raises the only concern in the attribution: Neatby virtually always signed or initialled his work.[2] Although the stylistic and circumstantial links are strong, the attribution must remain tentative pending the discovery of supporting documentary evidence.

Literature
Farquhar, J., 1984, pp.51–2; Lee, J. and Dean, J., 1995, p.72, **72**; *L. Mercury*: – [i] 24 October 1969, p.16 [ii] 8 July 1992, p.6.

Notes
[1] Information from Jane Pountney and the Ironbridge Gorge Museum. [2] Information from Mr Scott Anderson.

Horsefair Street

According to *Spencers' Illustrated Handy Guide to Leicester* (1878):

> The premises of Messrs. Jacobs and Kennard [cabinet makers and furnishing contractors] at the end of Horsefair street, are an example of the application of every modern contrivance on a very large scale, to the production and exhibition of what has become quite an art – the furnishing throughout of the interior of a house. Atlas House, as it is named from the **statue of Atlas** bearing the world on his shoulders, which surmounts it, rises to a height of 90ft, and contains vast and well-filled show rooms.[1]

The building no longer exists and it has not as yet been possible to find any further details relating to it.

Note
[1] *Spencers' .. Guide to Leicester* 1878, p.188.

Infirmary Close

Leicester Royal Infirmary

Formerly in the main entrance:

Charles John Bond Memorial Plaque

Charles Bond (1856–1939), Vice-President of Leicester Royal Infirmary, was born in Leicestershire and educated at Repton School and University College, London where he was awarded gold medals in Anatomy and Physiology. He entered Leicester Royal Infirmary as a pupil in 1875, was appointed house surgeon 1883 and was honorary surgeon from 1886 until he retired in 1913. His publications include *Essays and Addresses ... by a Surgeon* (1930), *Biology and the New Physics* (1936), *The Nature and Meaning of Evil and Suffering as Seen from the Evolutionary Standpoint* (1937), and *Recollections of Student Life and Later Days* (1939).
Sources: Frizelle, E.R. and Martin, J.D., 1971; *Who Was Who 1929–1940*.

Sculptor: Albert Pountney
Inscription: Alec T. White[1]

Memorial plaque in bronze and Hopton Wood stone
Dimensions unknown
Inscription in incised Roman capital letters:
CHARLES JOHN / BOND / C.M.G. F.R.C.S. / HONORARY SURGEON / 1886 – 1913
Status: not listed
Owner: Leicester Royal Infirmary NHS Trust

Description: The memorial takes the form of a bronze medallion with a relief portrait set into the upper half of a rectangular slab of Hopton Wood stone, the lower half bearing the

Poutney, *Bond Memorial Plaque*

inscription. Bond is shown in profile wearing a collar and tie, and a jacket with a waistcoat.

History: The memorial plaque was commissioned from Pountney by the Leicester Infirmary in the early 1950s. It remained *in situ* until rebuilding in the early 1990s necessitated its removal. Since that time it has hung in the Bond Room (no public access) in the Infirmary's Victoria Building.[2]

Notes
[1] Information from Jane Pountney. [2] Information from Susan Tebby.

New Walk

Formerly on the south-east side of New Walk Museum (built by J.A. Hansom as a Nonconformist Proprietary School, 1836) and demolished in 1955:

Memorial to James Francis Hollings

Hollings (1806–62) was born 15 April 1806 in London, moving to Leicester in 1837 to take up the post of master at the recently-opened Proprietary School in New Walk (now the Museum). He was promoted to the headship in 1846, but a year later the school closed. Hollings was President of the Literary and Philosophical Society in 1846–7, 1853–4 and 1858–9, and of the Mechanics' Institute in 1852–62. He was elected councillor for Middle St Margaret's Ward, Leicester, in 1857, Mayor of Leicester in 1859–60 and JP in 1860. He was also editor of the *Leicestershire Mercury* for some years. At the inquest into his death, it was concluded that Hollings 'had caused his [own] death by strangulation while in an unsound state of mind'. He had been married to the sister of John Biggs (see p.177) and, since her death about four months previously, had been living at the Biggs family house. He had evidently been in a severe state of depression since his wife's death. He was found on Monday 15 September 1862 by one of the

servants in his bedroom, having hanged himself from a bedpost with a noose made from a handkerchief. Hollings was buried in Welford Road Cemetery, Leicester.
Sources: Hartopp, H., 1935; *L. Chronicle*, 20 September 1862, p.8; Wade-Matthews, M., 1995.

Architect: John Henry Chamberlain
Sculptor: Samuel Barfield

Memorial in Bolsover stone[1]
h. (est.) 7.62m (25')
Inscriptions on the base:

(i) BORN IN LONDON 1806 / AND EDUCATED AT CHRIST'S HOSPITAL / RESIDED IN LEICESTER FROM 1837 / HEAD MASTER OF THE PROPRIETARY SCHOOL 1846–7 / PRESIDENT OF THE MECHANICS' INSTITUTE 1852–[1862] / AND OF THE LITERARY AND PHILOSOPHICAL SOCIETY / 1846–7, 1853–4, 1858–9. / MAYOR OF THE BOROUGH 1859–60. / DIED 1862.

(ii) ERECTED / BY THOSE WHO KNEW / THE NOBLENESS OF HIS CHARACTER, / THE VIGOUR OF HIS INTELLECT, / AND THE TENDERNESS OF HIS HEART.

(iii) IN MEMORIAM JACOBI FRANCESCI HOLLINGS, HAUD PROCUL / SEPULTI, HOC MONUMENTUM CARISSIMI CAPITIS DESIDERIO / AMICI POSUERE. VI ANIMI, INGENIOQUE VERSATILI INSIGNIS, / LITERARUM THESAURIS NECNON SCIENTIARUM OPIBUS / ERUDITUS, ALIOS LÆTISSIMUS DOCUIT, HUIC MUNICIPIO A / CIVIBUS ET SOCIETATI LITERARIÆ LEICESTRIENSI QUÆ / JUXTA CONVENIRE SOLET NON SEMEL A SODALIBUS EST / PRÆFECTUS. NATUS MDCCCVI. OBIIT MDCCCLXII. / "MULTIS ILLE BONIS FLEBILIS OCCIDIT." ['To the memory of James Francis Hollings, buried not far from this spot, his friends, in grief for the loss of one most dear to them, have erected this monument. Distinguished by the force of his intellect and the versatility of his genius, and learned in the treasures of literature as well as in the resources of science, he most willingly instructed others. He was appointed Mayor of this borough by his fellow citizens; and oftener than once was he elected by his fellow members, President of the

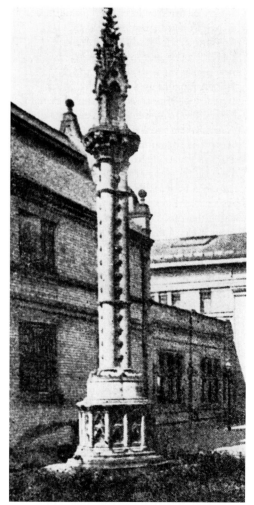

Chamberlain, *Hollings Memorial*

Leicester Literary Society, which is accustomed to meet close by. Born 1806. Died 1862. "He died to be lamented by many good men."'][2]
Erected: August 1864

Description, as recorded in the 'Report for 1864' of the Leicestershire Architectural and Archaeological Society:

It may be described as a Gothic column (rising from a richly decorated base), carrying a canopy which is surmounted by the Cross. The plinth upon which the base rests, is a cross with arms of equal length (13 feet), having the angles partially filled. The base, which rises seven feet from the plinth, is quatrefoil on plan, is richly moulded, and is divided by small columns into twelve parts. It is surmounted by a richly carved moulding breaking round each column, and forming the capital thereto. The panels are enriched with tracery and carving. The shaft which rises from the base, and is twenty-one feet in height, is also quatrefoil on plan, and is enriched in the angles with conventional foliage springing upwards. The shaft is divided into three portions by two ornamental bands, which mark the spots where the stones join, it being impossible to procure a single stone of sufficient size. This shaft or column is surmounted by a deeply and enriched carved capital, from the abacus of which rises the tabernacle supported by four ornamental columns, above which appears a richly crocketed canopy, terminating in a copper gilt foliated cross, which rises five feet from the stone finial. It is feared this attempted description of this very beautiful memorial will convey but a meagre impression of its excellence ...[3]

History: In June 1863 the sub-committee for the subscribers to the Hollings Memorial successfully applied to the Corporation's Museums Committee for permission to erect the memorial outside the New Walk Museum.[4] The final cost of the memorial was about £200.[5]

The memorial stood for just over 90 years although, towards the end of that period, it fell into an increasingly poor state of repair. In November 1954, the then director of the New Walk Museum reported to the Museums and Libraries Committee that he had been informed that the memorial would cost as much to demolish as to repair, namely £75.[6] The memorial was evidently by now proving to be something of an obstruction to traffic arriving at the library and the museum's director was looking into possible alternative sites. The Literary and Philosophical Society (whose members had been largely responsible for erecting the memorial) stressed that they wanted the memorial preserved, but saw no particular problem with it being relocated, as long as the site was sympathetic. The director, however, could find nowhere suitable and in January 1955, the Museums Committee decided that the memorial should stay where it was, instructing the director to take other measures to solve the traffic access problems.[7]

The director next called in a local stonemason to examine the memorial closely. On 15 April 1955, he reported the bad news to the Museums Committee that the memorial was, after all, 'unsafe and unrepairable in its present form'. The stonework was, according to the stonemason, so perished that the only solution was to remove the lantern (i.e., the tabernacle, canopy and cross) and replace it with a new one on a shortened column. The work was now going to cost between £300 and £400. Had the Committee been in any doubt as to whether the repairs were worth doing at that price, the director set their minds straight. As the minutes succinctly put it: 'The Director further states that the memorial is of no great architectural merit and if such repairs were made the memorial would not be the same; he therefore recommends that it be demolished.'[8]

The Committee, seeing no other solution, agreed to the demolition but with the instructions to the director that every precaution be taken to preserve the inscription tablets.[9] It would seem, however, that the tablets were not salvageable as the only remaining part of the memorial in the Leicester City museums collections is a glass jar containing newspapers and coins, etc., that had been deposited within the foundations.[10]

Literature
LRO. *Estate Committee Minutes*, 18 January 1855 – 22 March 1870, n. pag.; *Museums and Libraries Committee Minutes*, 28 May 1954 – 17 July 1959, pp.54, 57, 72, 105; *Special Committees Minutes*, 21 February 1855 – 4 November 1874, p.180; letter, dated 7 January 1981, from R.A. Rutland, Keeper of Antiquities, Newarke Houses Museum, to a member of the public; various photographs.
University of Leicester library, Local History collection. *Leicester Literary and Philosophical Society, Transactions*, 1884, p.260; *Leicestershire Architectural and Archaeological Society, Transactions*, vol. iii, 1874, pp.9–10.
General. Burton, D.R., 1993, p.**123**; Hartopp, H., 1935; *L. Chronicle*: – [i] 20 September 1862, pp.5, 8 [ii] 3 September 1864, p.4 [iii] 10 September 1864, p.8 [iv] 17 September 1864, p.3; *L. Mercury*, 30 November 1921, p.9; Nuttall, G.C., 1905, p.38; *Spencers' ... Guide to Leicester*, 1878, p.41.

Notes
[1] *Leicester Literary and Philosophical Society*, 1884, p.260. [2] As translated by George B. Franklin in a letter to *L. Chronicle* (10 September 1864, p.8). [3] *Leicestershire Architectural and Archaeological Society, Transactions*, 1874, vol. iii, pp.9–10. [4] Museum Committee meeting of 19 June 1863, in *Special Committees Minutes*, 21 February 1855 – 4 November 1874, p.180. [5] *Leicester Literary and Philosophical Society*, 1884, p.260. [6] Meeting of 19 November 1954, in *Museums and Libraries Committee Minutes*, 28 May 1954 – 17 July 1959, p.54. [7] Meeting of 21 January 1955, in *ibid.*, p.72. [8] Meeting of 15 April 1955, in *ibid.*, p.105. [9] *Ibid.* [10] As stated in a letter, dated 7 January 1981, from R.A. Rutland, Keeper of Antiquities, Newarke Houses Museum, in response to an enquiry from a member of the public.

Painter Street

Charles Keene College of Further Education

In the quadrangle, the remains of:

untitled sculpture

Sculptor: Ken Ford

Sculpture in ciment fondu and bronze aggregate
Free-standing element: h. 2.34m (7'8"); max. w. 2.39m (7'10")[1]

Executed: 1960
Status: not listed
Owner: Charles Keene College of Further
Education

Description: Abstract group in five pieces,
comprising four variously sized dish-shaped
reliefs mounted on the long left-hand wall and,
about six feet forward of the wall, between the
third and fourth reliefs from the left, a U-
shaped free-standing relief on a plinth.
According to a contemporary magazine,
Adrem, the sculpture:

... has as its theme the transition of the
inactive into the active which is the basis of
the control over Nature and our re-creation
from its forces, namely engineering.

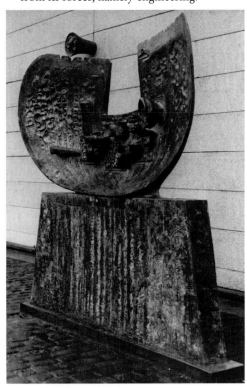

Ford, *untitled sculpture*

The sculpture on the wall and in the
round is, in the words of the sculptor, to be
considered as an entity ... [2]

Condition: Only three of the dish-shaped
wall reliefs have survived. The third dish relief
from the left has been lost and the free-standing
relief and its pedestal were removed
(subsequent fate unknown) when the
quadrangle was converted to a car park.

History: The process of production was
described in *Adrem* as follows:

... The sculpture was modelled in clay and a
plaster waste mould made. This was surfaced
with Ciment Fondu with a powdered metal
aggregate, and Aglite and Fondu were used
for the core to create lightness. A particular
problem was the roundels which had to be
fixed to cladding which would not bear a
great deal of weight.
 The wall was chosen as the site as it
presented a pleasantly severe background for
both close and distant views. It also gave an
opportunity to emphasize the character of
the space enclosed. [3]

Literature
*Adrem. The magazine of the Butterley Company
Limited*, no. 24, Autumn 1963, pp.43–4.

Notes
[1] Dimensions as recorded in *Adrem ...*, no. 24,
Autumn 1963, p.44. [2] *Ibid.*, pp.43–4. [3] *Ibid.*

Town Hall Square

Temporary War Memorial

**Designers: S. Perkins Pick and
Benjamin John Fletcher
Sculptor: Joseph Herbert Morcom
Lettering: Mr Roberts and other masters
and students of Leicester School of Art
Plaster work: A. Crew & Sons
Contractors: Henry Herbert & Sons**

Memorial in brick, cement and plaster
Unveiled: Thursday 28 June 1917, by Henry
John Manners, 8th Duke of Rutland

Description: The temporary war memorial,
in brick with a cement face, took the form of a
screen wall with centre and side panels.
Sculptural relief designs included a pelican
bleeding itself to feed its young – emblematic of
Kipling's line: 'Who dies if England lives?' and
a St George and the Dragon with the motto 'St
George and Merrie England'. Over the lists of
names was the inscription: 'They did not fail us,
We must not fail them' and 'Greater love hath
no man than this that he lay down his life for
his friend'. The lists at the time of the unveiling
comprised the names of 95 men from the Navy
and 2,034 from the Army; space was left for
further names.

History: The temporary war memorial in
Leicester Town Hall Square was proposed by
the then Mayor of Leicester, (Sir) Jonathan
North, and sanctioned by Council on 10
October 1916.[1] His intention was that the
memorial would:

... bring home ... to many people – especially
young people –, who seem to be still
regarding the War with indifference, the
seriousness of the times in which they live.
At the same time those who are mourning
will be to some extent encouraged and
consoled by the knowledge that their grief is
shared by the community, and that the
supreme sacrifice made by their relatives will
be placed on honourable record.[2]

According to F.P. Armitage, it had originally
been hoped that the memorial would be funded
by public subscription but ultimately the cost
was covered by the Mayor's Fund.[3]

At the unveiling and dedication ceremony,
the Mayor further explained: 'In due course a
fitting memorial of a permanent character will
be provided, such as will keep fresh and

fragrant the memory of these noble heroes, and serve as an example and an inspiration to succeeding generations.'

The permanent memorial, the *Leicester Arch of Remembrance*, designed by Sir Edwin Lutyens, was unveiled Saturday 4 July 1925 in Victoria Park.[4] The temporary war memorial was eventually dismantled in late 1926 or early 1927.[5]

Literature
University of Leicester library, Local History collection – *Council Minutes*: – [i] 1915–16, pp.289–90 [ii] 1926–7, pp.56, 57.
General. Armitage, F.P., 1933, pp.180–1, 230–1, pl. opp. 230; *L. Chronicle*: – [i] 30 June 1917, p.2 [ii] 7 July 1917, p.1; *L. Journal*, 6 July 1917, p.2; *L. Mail*, 29 June 1917, p.2.

Notes
[1] *Council Minutes*, 1915–16, p.289. [2] Armitage, F.P., 1933, pp.180–1. [3] *Ibid.*, pp.180, 230. [4] Lutyens's *Leicester Arch of Remembrance*, though an important work is, as an architectural memorial, outside the scope of the present survey. [5] *Council Minutes*, 1926–7, pp.56, 57.

University of Leicester

The centre of the lawn in front of the University's Fielding Johnson building was formerly occupied by two successive bronze sculptures by **Henry Moore**:

1. *Draped Seated Woman*

h. 1.85m (6'1")
Executed: 1957/8
Installed Wednesday 23 September 1970; returned Thursday 21 October 1971

2. *Oval with Points*

h. 3.32m (10'11"); w. 2.74m (9'); d. 1.45m (4'9")
Executed: 1968–70
Installed Thursday 21 October 1971; returned Wednesday 15 April 1987

History: During the summer of 1969, Henry Moore visited the University of Leicester

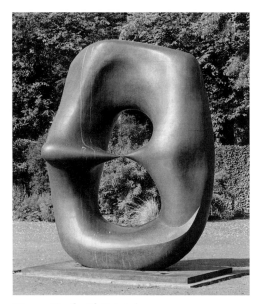

Moore, *Oval with Points*

campus to seek out a suitable site for a piece of sculpture he had decided to loan to the University.[1] Having agreed with the then Vice-Chancellor, T. Fraser Noble, that the lawn in front of the Fielding Johnson Building would be ideal, he informed Noble in November that the most suitable sculpture for this location would be his *Draped Seated Woman*. The sculpture arrived at the University and was duly sited in September 1970. In the following July, Moore visited Leicester to receive an honorary doctorate and informed the Vice-Chancellor that he would need to have the sculpture back for a short while for an important exhibition. He then went to look at the site (with which he expressed evident satisfaction) to gauge which of his other sculptures might make a suitable temporary replacement. At the beginning of October 1971, however, Moore telephoned Noble explaining that he had in fact promised *Draped Seated Woman* to his daughter some

time ago. He had evidently forgotten this and now explained to Noble that the replacement would have to be permanent and that he would like the switch to be made before the onset of bad weather, preferably before the end of the month. Moore had decided that an ideal substitute would be a large abstract bronze, *Oval with Points*, then in Prague and sited, as he explained, on a similar lawn. The changeover from *Draped Seated Woman* to *Oval with Points* was effected on Thursday 21 October 1971.

In late 1976 or early 1977, the University was informed that on 28 January 1977, Henry Moore would be donating the majority of his works, Leicester's *Oval with Points* included, to the newly-formed Henry Moore Foundation Ltd. As the Foundation's solicitors assured the University in their letter of 26 January, the transfer would in no way affect the loan agreement, excepting that from the 28th onwards the sculpture would be the property of the Foundation.

In March of that year, Moore requested the temporary return of *Oval with Points* as he wished to include it in a series of exhibitions to be held on the continent in celebration of his 80th birthday. The sculpture was removed from its plinth on 29 March 1977 and was then absent for a full three-and-a-half years. Widely appreciated by previous staff and students and unanimously acknowledged as the most prestigious piece of contemporary sculpture in Leicestershire, the University keenly felt its absence and was greatly pleased to receive it back on 21 November 1980, even making sure that its triumphal return would receive suitable coverage in the *Leicester Mercury*.

Thus *Oval with Points* again became the focal point of the Fielding Johnson lawn and there it remained undisturbed until 1987. On 16 March of that year the Henry Moore Foundation (Moore having died in 1986) wrote to the University requesting the sculpture's

return for an important commemorative exhibition at Yorkshire Sculpture Park, starting on 6 May. Amidst the ensuing negotiations for the sculpture's removal one letter from the Foundation, dated 27 March 1987, carried the ominous line: 'There is a possibility that we may need <u>Oval with Points</u> back at the Henry Moore Foundation'.[2] The University subsequently enquired whether a replacement could be found, should the Foundation decide that it had to retain *Oval with Points*. On 23 June 1987, the University received the extremely disappointing reply that not only would *Oval with Points* have to be retained but that the Foundation was not in a position to provide a replacement for a number of years: it had decided that its priority was firstly with the placement of sculptures at the Foundation itself and then with the consideration of those institutions that had not hitherto had a Moore sculpture.

Clearly, the University felt somewhat upset about this turn of events for, as far as it was concerned, Moore had intended the loan to be permanent, with the sole stipulation that the sculpture could be recalled temporarily whenever needed for important exhibitions. Unfortunately for the University, there was nothing in writing and despite various attempts to negotiate either the return of *Oval with Points* or its replacement with another Henry Moore bronze, the plinth in the centre of the Fielding Johnson lawn remained empty until Helaine Blumenfeld generously donated her maquette for *Souls* to the University (see pp.171–3).

Literature
Bowness, A. (ed.), 1977, pp.13, 17, 54 (no. 596), **55**, pls **118**, **119**; Leicester City Council, 1997, 1993 edn, p.169; Pevsner, N. and Williamson, E., 1992, p.258; Strachan, W.J., 1984, p.152, **152**.

Notes
[1] The following account is derived from various correspondence and internal memoranda in the University of Leicester Art Collection archives.
[2] Letter, dated 27 March 1987, from Margaret McLeod, Trustee of the Henry Moore Foundation, to R.H. Float, University of Leicester, Estates and Services Bursar.

Sited originally outside the University of Leicester's Attenborough Building and then for a number of years at Knighton Hall (the Vice-Chancellor's residence), the following work is, at the time of writing (autumn 1999), awaiting relocation:

Life

Sculptor: Percy Brown

Sculpture in bronze
h. 1.2m (3'11"); stone base: h. 70cm (2'4")[1]
Inscription on a name plate fixed to the front face of the pedestal:
Life / by / PERCY BROWN / Purchased from the Goddard Fund for the Arts
Executed: 1976
Status: not listed
Owner: University of Leicester

Condition: Good. It has, however, suffered at the hands of vandals on at least two occasions. In June 1979, the supporting rod between the sculpture and its plinth was bent, following which it was equipped with a protective bronze collar and in May 1985, despite this measure, further damage was inflicted and repairs had to be carried out and the sculpture re-fixed on its plinth.[2]
History: *Life* was purchased for £2,000 from the artist by the University of Leicester through the Goddard Fund for the Arts. Percy Brown was at the time Sculpture and Pottery tutor at the Leicester School of Art (now incorporated into De Montfort University) and a long-term friend of Herald and Joan Goddard. The sculpture was sited on the forecourt of the University's Attenborough Building in July 1977.[3] At some later date, it was removed from the forecourt and subsequently spent a number of years on the lawn of Knighton Hall (the Vice-Chancellor's house). Then, towards the end of 1999 it was removed to store to await relocation, possibly on the main campus.

Literature
University of Leicester archives. Miscellaneous correspondence and memoranda relating to the art collections.
General. Charles, B., n.d., b/w plate (n. pag.);

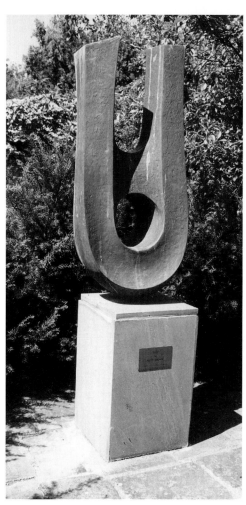

Brown, *Life*

Pevsner, N. and Williamson, E., 1992, p.256; Strachan, 1984, p.151, **151**.

Notes
[1] Strachan, W.J., 1984, p.150. [2] Various letters and memoranda, University of Leicester archives. [3] *Ibid.* For a photograph of the sculpture in its original location outside the Attenborough Building, see Charles, B., n.d., n. pag.

Vaughan Way

Formerly on the exterior of the Davis Manufacturing Company building:
Sculptural relief
Sculptor: Ernest Bottomley

History: Courtaulds, of which the Davis Manufacturing Company was the Leicester subsidiary, commissioned this work for the exterior of their Vaughan Way building. According to the writer of an article in the *Leicester and Rutland Topic* in June 1971, the relief was composed of 'unconventional materials such as laminated wood' and was intended to be 'symbolic of the evolution of the man-made fibre industry'.[1]

Literature
L. and R. Topic, June 1971, p.7, **7**.

Note
[1] Harry Martin, in *L. and R. Topic*, June 1971, p.7.

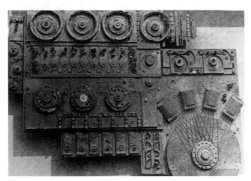
Bottomley, *Davis Manufacturing Company, relief*

Victoria Park

The Ethelfloeda Fountain (Edith Gittins Memorial Drinking Fountain)

Ethelfloeda (or Ethelfleda) (?d. 918) was the eldest daughter of Alfred the Great (849–99), King of Wessex. During Alfred's reign the eastern half of England, which included Leicester, was occupied by pagan Danes. In 918, Ethelfloeda led her army against Leicester, expelling the Danes and re-introducing Christianity to the town.

Edith Gittins (1845–1910) spent the whole of her life in Leicester. She was a water-colour artist, drawing teacher, social reformer, campaigner for women's rights and devout Christian, worshipping at the Great Meeting Chapel, East Bond Street, Leicester. She taught in the Sunday School for forty years and on one night of each week ran a Women's Friendly Meeting. Gittins was a co-founder – with A.H. Paget – of the Leicester branch of the Kyrle Society, formed to bring 'beauty in every form to humble streets and homes'; she founded the Leicester Women's Liberal Association; was a member of the Leicester Women's Suffrage Society, and the Society of Leicester Artists.[1] She is buried in Welford Road Cemetery. It was presumably Ethlefloeda's renown as a militant Christian that led Edith Gittins to erect a fountain in her honour.
Sources: *DNB*; Ellis, I.C., 1935; *L. Mercury*, 3 August 1922, p.1.

Designers: Benjamin John Fletcher and the Birmingham Guild

Fountain with a basin of Hopton Wood stone, on a column and base of Portland stone, surmounted with a statuette in bronze
Unveiled –
(i) In Victoria Park: Thursday 3 August 1922, by Mrs Heath, Mayoress of Leicester[2]

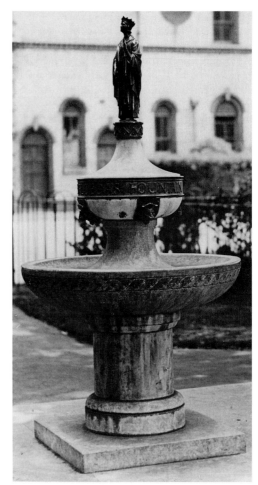
Fletcher, *The Ethelfloeda Fountain*

(ii) In Dolphin Square: Wednesday 20 August 1980, by Herbert Sowden, Lord Mayor of Leicester

Description: The fountain comprised a thick circular column on a square base, both in Portland stone, supporting a bowl of Hopton Wood stone, from the centre of which rose a baluster equipped with lion's head water

outlets. Surmounting the whole was a bronze statuette of Ethelfoeda (the baluster now forms the pedestal to the replacement statuette in Leicester's City Rooms, for which see pp.129–30).

History: The *Ethelfloeda Fountain* was Edith Gittins's gift to her home town. She had made provision in her will for £500 to cover the erection and maintenance of a drinking fountain after the death of her sister, Mary Catherine Gittins, who was until that time to receive income from the amount.[3] Under the terms of her bequest, the fountain was to be

a public drinking fountain to be called 'Ethelfloeda's Fountain,' and to be 'beautiful in material, colour, and workmanship, and always supplied with pure water.' If the offer was accepted she desired the work to be entrusted to Mr. J.B. Fletcher and Mr. Crosland McClure, of the Municipal School of Art. The angle formed by the junction of High-street and Silver-street, was [considered by Miss Gittins] to be a suitable site.[4]

The sister, however, anxious that the erection of the fountain should not be delayed until after her own death, offered the sum to the City Council on 28 September 1920. Notwithstanding the generosity of the gesture, the Mayor expressed some doubt that £500 would be sufficient to fund a fountain 'erected in a prominent position ... of a character worthy of the city' and that extra funds would have to be found to supplement the legacy.[5] Although the offer was ultimately accepted and a vote of thanks to Miss Gittins recorded, the *Leicester Daily Post* considered the Mayor's reaction ungrateful, pointing out that £500 could indeed 'buy a street ornament which, though small, may be made very artistic'.[6]

As stated above, along with the artist who was eventually to design the fountain, Miss Gittins had nominated Crosland McClure. He

had in the year before her death in 1910, provided Leicester with the fine bronze groups for the *South African War Memorial* (see pp.157–66), but by 1920 was working as a barman in a hotel at Kingston, Surrey, having given up sculpture through lack of commissions.[7] Fletcher, however, was still in business, although just at the time the bequest was made available he was on the point of leaving Leicester School of Art, where he had been principal for the previous twenty years, to take up a similar post at Birmingham;[8] nonetheless, he accepted the commission.

By 1920, Edith Gittins's choice of site in the city centre had become heavily congested with traffic, so the Corporation's Victoria Park Sub-Committee, in consultation with Mary Gittins, proposed it be erected instead in Victoria Park, which proposal was approved by the Highway and Sewerage Committee on 3 December 1920.[9] By April 1922, however, the specific location in Victoria Park was causing her concern – evidently it was too close to the 'War Trophies'.[10] Consequently, when, on 5 April 1922, she submitted Fletcher's design to the Corporation Parks Committee for its approval, she also requested that the fountain be erected instead 'on the east side of the [Regent Road] entrance to the Park', a request the Committee evidently had no problems in complying with.[11]

At the unveiling of the *Ethelfloeda Fountain* on 3 August 1922, the Mayoress of Leicester expressed her hope that it would stand 'for all time', to provide refreshment especially for the children who played in the park as well as serving as a permanent memorial to Edith Gittins and her work.[12] In 1978, however, the bronze statuette of *Ethelfloeda* was stolen.[13] A replacement statuette was commissioned and the fountain was relocated to the newly-created Dolphin Square near Leicester's Market Place, where it was unveiled on 20 August 1980.[14] Ten days later the replacement statuette was stolen, but later retrieved.[15] The statuette was replaced

on the fountain, but after being vandalized on at least two more occasions, City Council officials removed it altogether and kept it in store while they decided what to do with it. The fountain was eventually dismantled and a tree surrounded by seating put in its place.[16]

The statuette and upper part of the fountain are now, as stated above, at the City Rooms.

Literature
LRO. *Highway ... Committee Minutes*, 9 April 1919 – 28 October 1921, pp.289, 327; *Parks ... Committee Minutes*, 11 January 1921 – 14 December 1928, pp.79, 93–4.
University of Leicester library, Local History collection – *In Memory of Edith Gittins* (pamphlet, n.d.).
General. Banner, J.W., 1991, p.96; Banner, J.W., 1994, pp.67, 95–6; Ellis, I.C., 1935, pp.147–9, 292; *L. Chronicle*: – [i] 2 October 1920, p.2 [ii] 22 July 1922, p.3 [iii] 24 February 1932, p.1; *L. Daily Post*, 29 September 1920, pp.2, 5; *L. Mail*: – [i] 2 August 1922, p.3 [ii] 3 August 1922, p.6; *L. Mercury*: – [i] 3 August 1922, p.1 [ii] 4 February 1978, p.12 [iii] 21 August 1980, p.5 [iv] 1 September 1980, p.1.

Notes
[1] Ellis, I.C., 1935, pp.147–9. [2] Wife of James Wedgwood Heath, Mayor of Leicester, 1921–2. [3] *L. Mercury*, 3 August 1922, p.1. [4] *L. Daily Post*, 29 September 1920, p.5. [5] *Ibid.*, pp.2, 5. [6] *Ibid.*, p.2. [7] *Ibid.*, 31 August 1920, p.3. [8] *Ibid.*, 25 September 1920, pp.2, 3. [9] *Highway ... Committee Minutes*, 19 April 1919 – 28 October 1921, p.327. [10] As described by the Chairman of the Leicester Corporation Parks Committee in his report of 5 April 1922 (*Parks ... Committee Minutes*, 11 January 1921 – 14 December 1928, p.79). It has not been possible to establish what exactly these 'War Trophies' were. [11] *Parks ... Committee Minutes*, 11 January 1921 – 14 December 1928, p.79. [12] *L. Mercury*, 3 August 1922, p.1. [13] *Ibid.*, 4 February 1978, p.12. [14] *Ibid.*, 21 August 1980, p.5. [15] *Ibid.*: – [i] 1 September 1980, p.1 [ii] 5 September 1980, p.1. [16] Banner, J.W., 1994, p.67.

Wellington Street

Formerly in the forecourt of Leicester Crown Courts, 90 Wellington Street:

Solar-kinetic sculpture

Sculptor: Andrew Stonyer

Sculpture in anodised aluminium and stainless steel
h. 3.66m (12')
Unveiled: May 1981 by Herbert Sowden, Lord Mayor of Leicester[1]
Status: not listed
Owner: Leicester City Council

Description: According to the *Leicester Mercury*, the sculpture was computer-operated and comprised four metal planes – two fixed and two that moved in response to sunlight.[2] Stonyer's own description of the operation of the sculpture is as follows:

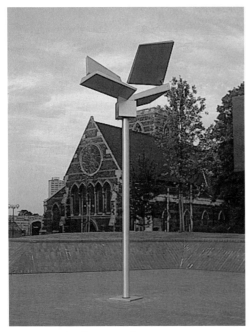

Stonyer, *Solar-kinetic sculpture*

It is a kinetic sculpture that responds to sunlight by the movement of the two upper planes ... On the upper surfaces of the lower fixed planes are photocells which are set at a particular threshold of illumination. When the sunlight rises above this threshold this causes the upper planes to rotate over the photocells, thus placing them completely in shadow ... When the illumination is below the threshold the planes open out ... and endeavour to reflect light into the photocells.[3]

History: In early 1979, Andrew Stonyer, then a postgraduate research student at Leicester Polytechnic, held an exhibition of solar-powered kinetic sculptures at the Polytechnic's Kimberlin Exhibition Hall.[4] Towards the end of the year it was reported in the local press that Leicester City Council was considering erecting a £25,000 kinetic sculpture 'with moving parts propelled in part by the sun's rays, by wind, and by electricity' outside the newly-built Crown Court. The sculptor, although he was not named in the press, was Andrew Stonyer. Though the Council intended to provide the greater part of the cost of the sculpture, it was attempting to secure a grant from the Arts Council of Great Britain and, in addition, hoped that local industry might make a contribution.[5] Almost immediately the scheme was attacked, in this case by the Leicester Ratepayers' Action Group who, with tiresome inevitability, condemned it as a waste of public money. Nonetheless, the Council remained undeterred and on 6 August 1980 Stonyer was at the Council's New Walk Centre offices explaining how his sculpture would work.[6] In November, the local press announced that the Council had now approved the sculpture but that the cost (towards which the Council was still trying to secure outside contributions) would now be nearer £15,500.[7] Local industry was not in the end forthcoming and the sculpture was eventually erected with financial assistance solely from the Arts Council.[8]

In the year following the unveiling, Stonyer moved to Canada to take up a post lecturing and researching at Concordia University, Montreal (1982–9). The sculpture, according to Stonyer, was not thereafter adequately maintained by the Council and its final demise came a mere two years later when one of its planes was ripped off during a gale. At some time after this the sculpture was dismantled; its ultimate fate is not known.[9]

Literature
PMSA NRP East Midlands Archive. Letter, dated 2 November 1999, from Andrew Stonyer to the author. **General**. *L. Mercury*: – [i] 29 November 1978, p.14 [ii] 7 December 1978, p.4 [iii] 23 January 1979, p.8 [iv] 19 December 1979, p.15 [v] 5 August 1980, p.26 [vi] 7 August 1980, p.14 [vii] 26 November 1980, p.29 [viii] 14 May 1981, p.12, **12.**

Notes
[1] *L. Mercury*, 14 May 1981, p.12. [2] *Ibid.*, p.12. [3] Letter, dated 2 November 1999, from Andrew Stonyer to the author. [4] *L. Mercury*, 23 January 1979, p.8. [5] *Ibid.*, 19 December 1979, p.15. [6] *Ibid.*, 5 August 1980, p.26. [7] *Ibid.*, 26 November 1980, p.29. [8] *Ibid.*, 14 May 1981, p.12. [9] Information from Andrew Stonyer (21 September 1999).

LEICESTER (SUBURBS)

Thurnby Lodge

Roborough Green

Willowbrook Primary School (originally called Scraptoft Willowbrook Infants School), completed 1958 by T.A. Collins:

Two Children Calling a Dog

Sculptor: Peter Peri

Projecting figure group in green concrete on a mild steel armature
Dimensions unknown
Executed: 1957[1]

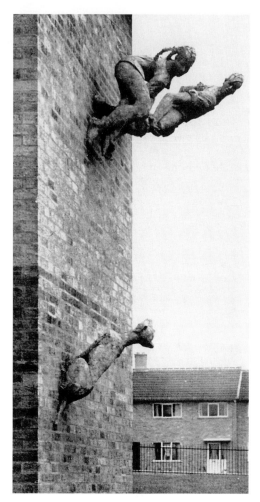

Peri, *Two Children Calling a Dog*

usually needed only an armature to support their weight; in this case, however, the ankles of the standing children – who projected almost at right angles from the vertical surface of the wall – were not able to bear the weight and they had to be supported by wires stretching from their backs to the wall above them.[3]

As with Peri's other sculptures of a similar nature (see pp.11–12, 308–9), *Two Children Calling a Dog* was well-loved by generations of both pupils and staff. By 1996, however, the sculpture had deteriorated to such an extent that the Leicestershire County Council felt that it should be removed for safety reasons.[4] The remains are currently in store.[5]

Related work: pencil sketch, in the collection of The Centre for the Study of Sculpture, Leeds (cat. no. P317).

Literature
The Centre for the Study of Sculpture, Leeds. Kenny, S., 1980, p.32; László, H., 1990, pp.87, 94. **General.** Camden Arts Centre, 1987, p.44; Leicestershire Museum and Art Gallery, 1991, p.16; Pevsner, N.,1960, p.223.

Notes
[1] This is the date given in the LEA inventory. Camden Arts Centre (1987, p.44) and Leicestershire Museum and Art Gallery (1991, p.16), however, give the date as 1956. As Peri's works of this nature were always executed for new school buildings and as the school was completed in 1958, the LEA date seems more likely. [2] Pevsner, N, 1960, p.223. [3] László, H., 1990, p.94. [4] LEA inventory. [5] Information from Rachael Green, Leicestershire Education Authority.

Status: not listed
Owner: Leicestershire Education Authority

History: This group of projecting figures was commissioned by the Leicestershire Education Authority for an outside rear elevation of the then Scraptoft Willowbrook Infants School.[2] Peri's other sculptures of this type

LOUGHBOROUGH

Loughborough University

Formerly near Administration Building I:
Man and Child

Sculptor: Ralph Brown

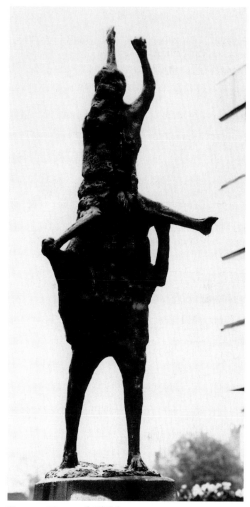

Brown, *Man and Child*

Sculpture in hollow concrete with a bronze metallic finish[1]
h. 1.9m (6'3"); w. 76.2cm (2'6"); d. 1.12m (3'8")
Executed: 1959
Exhibited: 1967–8, London, Whitechapel Art Gallery (no. 9)

History: *Man and Child* was purchased by

the Leicestershire Education Authority for the then Loughborough College of Advanced Technology.[2] When the College became Loughborough University in 1966, the LEA transferred ownership to the new institution. The sculpture was destroyed at some time in the 1980s by vandals.

Literature
Cantor, L., 1996, p.12; Whitechapel Art Gallery, 1967, p.15, illus. betw. pp.18/19.

Notes
[1] As described in Whitechapel Art Gallery, 1967, p.15 (no. 9). [2] It has not been possible to trace any documentation relating to this piece. In the catalogue of Brown's one-man exhibition at the Archer Galleries ('Sculpture and Drawings', 12 April–13 May 1972), however, Loughborough's *Man and Child* is listed as a commission (i.e., as opposed to a purchase).

Formerly near the Towers:
3B Series No. 2
Sculptor: Bernard Schottlander

Sculpture in mild steel, painted
w. 8.1m (26'7")[1]
Executed: 1968

History: W.J. Strachan, in his 1984 survey of open-air sculpture in Britain, publishes a photograph of this work standing in the vicinity of Loughborough University's Towers building, drawing a comparison with what he says is another cast at Bosworth College, Desford (see above pp.39–40).[2] Curiously, neither the Leicestershire Education Authority, who presumably would have purchased the piece before 1978 when the Towers building was still part of its College of Education, nor Ken Long, Art Advisor to Loughborough University at the time of the survey for the present volume, have any records or recollection of *3B Series No. 2* being on the Loughborough site.

Literature
Strachan, W.J., 1984, p.153, **153**.

Notes
[1] Measurement as given in Strachan, W.J., 1984, p.153. [2] *Ibid*. The author makes the comment: 'In the present case, [the sculpture] seems dwarfed by the multi-storeyed building behind. At Desford, it dominates the setting, but seems more satisfactorily integrated'.

Formerly in Loughborough University School of Art and Design:
Angola
Sculptor: Isaac Witkin

Sculpture in steel, painted
Dimensions not known
Executed: 1966
Status: not listed
Owner: Loughborough University School of Art and Design

Condition: By 15 June 1998 (the date of my site visit), the sculpture had been dismantled and some elements lost. The remaining pieces are in store in Loughborough University School of Art and Design Sculpture Department.

History: *Angola* was purchased by the Leicestershire Education Authority in 1969 with funds provided through the buildings capital scheme.[1] Loughborough College of Art and Design was granted independent status in 1988, at which time ownership of the artworks bought by the LEA for the college was transferred.

Following its exhibition in New York in 1967, American art critic Dore Ashton wrote of Witkin and *Angola* in the following terms:

... It seems to me that Witkin is one of the stronger younger members of England's refreshing sculpture florescence. He has a very firm sense of sculptural extension and a good working feeling for his craft. I found his large iron [*sic*] piece called *Angola* one of the soundest extensions of the tradition largely fathered by David Smith that I've seen yet.

Witkin plays simple forms against one

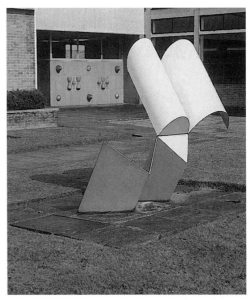

Witkin, *Angola*

another in a complex way. For instance, a flaring projection of curving planes, swinging out freely into space suggests great drum-like volumes, while yet remaining obviously what they are: welded curved sheets of iron. As their anchor, Witkin composes contrasting angular or rather, triangular shapes that sit weightily on the ground. Yet these too are what they are: slender sheets bent suggestively.

This implication of volume, where in fact none exists, is perhaps the strongest lesson David Smith offered the younger generation and Witkin has excelled in carrying it through ...[2]

Literature
Studio International, vol 175, no 896, January 1968, p.41, **41**.

Notes
[1] LEA inventory. [2] *Studio International*, vol 175, no 896, January 1968, p.41.

RATCLIFFE-ON-THE-WREAKE

Fosse Way

Ratcliffe College

Formerly in the south half of the east passage of the Cloisters:

Christ the Sacred Heart
Sculptor: Eric Gill

Statue in Bath stone with added colour
h. 1.4m (4'7")
Inscription on base: MISEREBITUR / SECUNDUM. MULTI- / TUDINEM. MISERA- / TIONUM. SUARUM ['He will have mercy according to the multitude of his mercies'][1]
Executed: 13–20 January 1936 (statue); 24 January 1936 (inscription)
Current location: Collection of Ivor Braka, having been sold at Phillips Fine Art Auctioneers, Bond Street, London, 8 March 1994 (lot 102)[2]

Description: A standing figure of Christ pointing to his heart with his right hand, his left clasping to himself a leafing branch. The branch is symbolic of the cross as the tree of life – the *lignam vitae*.[3] The stigmata on Christ's hands are accentuated with red pigment.

History: For a general account of the commission, see the entry for the companion statue of *Our Lady Immaculate* (pp.266–7).

Related work: Eric Gill, *St Francis*, 1936, sandstone, h. 45.7cm (1'6"), private collection (this figure is virtually a small-scale imitation of the present work).[4]

Literature
Collins, J., 1998, p.22, 200, 200; Peace, D., 1994, p.152.

Notes
[1] Psalm 50 (Vulgate). Translation as rendered in Collins, J., 1998, p.200. [2] Collins, J., 1998, p.200. [3] *Ibid.*, p.22. [4] See *ibid.*, p.206 (no. 266; illus.).

Gill, *Christ the Sacred Heart*

SHEPSHED

Forest Street

Formerly at Shepshed High School:

Leopards
Sculptor: Karin Jonzen

Sculptures in concrete
Dimensions unknown
Status: not listed
Owner: Leicestershire Education Authority

History: Jonzen's group, *Leopards*, was purchased by the Leicestershire Education Authority in 1957.[1] Staff at the school in 1998 recalled that it 'had deteriorated and [the parts] were thrown away ten years ago'.[2] The deterioration was probably caused by moisture seeping in through cracks and rusting the metal armature which would have expanded and burst the concrete body of the sculpture, a problem common to all concrete sculptures in the open-air (see, e.g., pp.307–9).

Literature
Pevsner, N. and Williamson, E., 1992, p.377.

Notes
[1] LEA inventory. [2] Response to East Midlands Regional Archive questionnaire, November 1998.

WIGSTON

Shenley Road

Formerly at St John Fisher Roman Catholic Primary School:

Sign of the Blessing
Sculptor: Austin Wright

Sculpture in aluminium
h. 2.44m (8'); w. 25.4cm (10"); d. 20.3cm (8")
Executed: 1967

Exhibited: 1967–8, London, Whitechapel Art Gallery (no. 59)
Status: not listed
Owner: Leicestershire Education Authority

History: *Sign of the Blessing* was purchased by the Leicestershire Education Authority in 1967 with funds provided through the buildings capital scheme.[1] The sculpture was removed in 1992 after being vandalised.[2]

Literature
Hamilton, J., 1994, p.104 (no. S247), 104; Whitechapel Art Gallery, 1967, p.18.

Notes
[1] LEA inventory. [2] Hamilton, J., 1994, p.104.

WILLESLEY PARK

Willesley Hall, south-west of Ashby-de-la-Zouch, was demolished, except for the façade and stables, in 1953. Most of the former grounds now constitute a golf course.

Near the ninth hole was formerly:

Statue of Diana, Goddess of Hunting

Cast of, or copy after, *Diane Chasseresse*, an antique Graeco-Roman statue in the Louvre, Paris
Medium of copy / cast: unknown

h. of original: 2m (6'7")
Status of copy / cast: not listed

Description: A photograph of the statue appeared in the *Illustrated Leicester Chronicle*, 7 October 1922, pp.8–9.
History: The statue was destroyed in 1983.[1]

Literature
L. Chronicle, 7 October 1922, pp.**8–9**; Haskell, F. and Penny, N., 1981, pp.196–8; Pevsner, N. and Williamson, E., 1992, p.424.

Note
[1] According to information gathered by survey volunteers from officials of the golf club which now owns the land.

WOODHOUSE EAVES

Formerly in Swithland Convalescent Home (by Seale and Riley, 1912; now converted into flats):

Memorial Portrait Medallion of Sir Edward Wood
(for biographical details of Wood, see p.311).

Sculptor: Joseph Herbert Morcom

Memorial tablet in bronze, marble, Swithland slate and Hopton Wood stone
Dimensions unknown
Unveiled: Saturday 20 September 1919, by Mrs A.E. Lennard, the subject's daughter

Description: The *Leicester Mercury* (22 September 1919, p.3) described the memorial as:

... a chaste relief medallion of Sir Edward's head upon marble, surrounded by Swithland slate, with a framework of Hopton Wood stone, with bronze relief. It bears the simple inscription: 'Sir Edward Wood, First President of the Leicester and County Hospital Fund, 1905–1917 [*sic*]. The work has been executed by Mr. J. Morcom, of the Leicester Art School.'[1]

If this description is accurate, the materials are different from those used for an otherwise similar-sounding relief of Edward Wood by the same sculptor, unveiled at Desford Hall Convalescent Home the following April (see p.311)

The present relief is no longer at the former Smithland Convalescent Home[2] and it has not been possible to ascertain what happened to it.

Literature
L. Chronicle, 27 September 1919, p.2; *L. Mail*, 22 September 1919, p.1; *L. Mercury*: – [i] 20 September 1919, p.7 [ii] 22 September 1919, p.3; *M.M. Times*, 26 September 1919, p.3.

Notes
[1] As quoted in *L. Mercury*, 22 September 1919, p.3 – the dates of Wood's term of office as President of the Leicester and County Hospital Fund are in fact 1903–17. [2] Information from Lady Martin via the Clerk to Woodhouse Parish Council (25 November 1999).

Unrealised Work

Town Hall Square

Statue of Simon de Montfort

 The Art-Journal, 1877, p.313, reported a proposal to erect a statue to de Montfort outside the new Town Hall, Leicester. H.H. Armstead had received the commission to execute a sketch model. A contemporary guide-book to Leicester expressed the hope that it would be 'a fine statue' to grace the new building.[1] Evidently the scheme failed to move beyond the planning stage; the reasons for its non-completion are not known.

Literature
Art-Journal, 1877, p.313; *Spencers'... Guide to* Leicester, 1878, p.187.

Note
[1] *Spencers'... Guide to* Leicester, 1878, p.187.

Leicestershire Education Authority

Sculptures not included in the main part of the catalogue

The following list comprises for the most part those sculptures owned by the LEA that are not permanently sited in school grounds or in main circulation areas. The list is arranged in alphabetical order by sculptor; titles are as recorded in the LEA inventory; materials and date of acquisition by the LEA are given where known.

M. Abdulla / M.A. Abdalla[1]
 Shape 1, 1976
 Shape 3, 1976
 Shape 6, 1976
Jane Ackroyd
 Cat, painted steel, 1981
 Crocodile, painted wood, 1981
 Dog, painted steel, 1981
 Humming Bird, wood
 Party Time, painted steel, 1985
 Roly Poly Pig, steel, 1983
 Whirlwind, painted metal, 1984
 Wig Wig, painted steel, 1981
Maurice Agis
 Construction, painted steel, 1966
David Alexander
 Breakopen 6, steel
 Dividing Column 2, steel, 1981
 Dividing Column 5, metal
 Fortress I, 1977
 Helmet Head I, steel, 1977
 Helmet Head III, metal, 1977
 Helmet Head V, metal
 Helmet Head VI, metal, 1975
 Macaroni Macaroni, steel, 1975

1 Both spellings are used in the LEA inventory.

 Maldrini Molaroni, 1975
 Sun Discs, steel, 1974
 Warplane 3, 1976
 Warplane 4, metal, 1976
 Warrior 5, 1978
Anthea Alley
 Circles, aluminium, 1966
Raymond Arnatt
 Cross, resin, 1963
John Ashworth
 Counterpoise 1, steel and glass, 1978
 Counterpoise II, steel, glass and aluminium
Bernard Aylward
 Bird Sculpture, wood, 1964
 Miniature Bird Sculpture, wood
 Untitled, wood
 Sculpture, wood
 Yawn, wood
Michael Ayrton
 Figure in Balance, bronze, steel and wood, 1956
Peter Eugene Ball
 St Colomba, wood, copper and brass, 1989
Nicola Ballance
 Diver, elm, 1991
 Reaching, oak, 1991
Neil Barclay
 The Clown
B. Jane Barnes
 Cuckold's Nest, painted wood, 1982
 Untitled, painted wood, 1982
Neville Barrow
 Eye, metal
Roger Bates
 Pasta, wood and steel, 1982
Richard Perry Bedford
 Cat, stone, c.1958

Dawn Beresford
 Life's Just a Fishious Circle, wood and metal, 1989
 Rhino and Tickbirds, 1989
Oliver Bevan
 Connections, 1970
Arthur E. Birch
 Aftermath Root Thorn, wood, 1977
 Owl, elm, 1977
Ellen Birch
 Abstract, Line, wood, 1977
 Abstract No. 2 Driftwood, wood
Brian Bishop
 Hot Half, mild steel, 1966
 Morning High, welded steel
 Project Ball Design, metal, 1966
John Blatchford
 Pal, mixed media, 1992
Michael Blodget
 Sirens, ciment fondu, 1985
Neville Boden
 Domes, fibreglass
 Endless Column, fibreglass
 Flare, metal, 1970
 Flower Cones, 1973
 Lyre, steel, 1970
 Queen of Spades, steel, 1970
 Small Sculpture, metal, 1972
 Twist, steel, 1970
Sam Boffey
 Fighting Cocks, 1988
Michael Bolus
 Untitled No. 5, painted aluminium, 1967
Derek Boshier
 Hexagon ('Blue Moon'), perspex and glass
Victoria Brailsford
 Sharon, Ancaster stone, 1989

Antanas Brazdys
Alone, black-painted metal, 1973
Untitled, steel, 1969
Paul Bridge
Bird, 1979
Creature, 1979
Expanded Light, metal, 1981
Sitting Girl, 1979
Standing Creature, resin, 1980
Standing Form, resin, 1980
Upright Wing, 1981
John Brown
Headstand, stone, 1986
Laurence Burt
Device for an Astronaut Mark II, welded
 steel, 1964
Figure, metal, 1964
Maquette for a Sentinel, 1965
Metal Relief Seascape, metal
Project for Architecture, 1964
Sculpture 1, plaster, 1964
Sculpture 2, plaster, 1964
Square and Round
Andrew Burton
Bull, reinforced concrete
V. Caloutsis
Forms Suspendue, metal, 1963
Shirley Cameron
Cirace, fibreglass, 1966
Through, fibreglass, 1968
Christopher Campbell
Bird, resin, 1990
Bird in a Bush I, steel, aluminium and brass,
 1992
Camel, wood, 1984
Creature, wood, 1990
Crocodile, wood, 1983
Green Bird, wood, 1988
Head, wood, 1984
Horse's Head, wood, 1986
Ostrich, wood, part-painted, 1983
Sea Serpent, wood, 1985
Tree, wood
Yellow Dog, wood, 1985

Neil Canavan
Magpie I, welded steel, 1987
John Carter
Black Spring, 1974
Great Wheel, wood, 1969
Relief panel, painted metal and wood, 1971
Hilary Cartmel
Lady Mahat II, wood, 1986
Man and Horse, stainless steel, 1991
Musicians, steel, 1989
The Red Hat, stainless steel, 1991
Screen, steel, 1989
Ian Caunce
Seated Figure, steel, 1985
Mark Chapman
Fish, painted steel, 1987
Michael Chilton
Construction, wood and canvas, 1964
Geoffrey Clarke
Channel and Plane, sandcast aluminium,
 1966
Four Slabs and Plane III, sandcast
 aluminium, 1966
Two Slabs and Flat Bar, sandcast aluminium,
 1968
Two Slabs Supporting Bar, sandcast
 aluminium, 1968
John Clinch
Hound Dog, glass reinforced polyester,
 1983
Miss Bina Bhatt, painted fibreglass, 1984
Miss Dean Taylor, fibreglass, 1983
Bill Cockburn
Sculpture, painted steel
Trumpeter, metal
Weight Lifters, 1979
Peter Cockburn
Cidric in Metal, metal, 1978
D'Artagnan, 1978
Mr Holmes, metal, 1980
Peter and Bill Cockburn
Butterfly, metal, 1977
Nathan Cohen
Untitled IIb, painted mahogany, 1986

Stephen Collingbourne
Disc Grid, metal and wood, 1977
U Angle, metal, 1977
Katy Coombs
Moving 1, steel, 1990
Moving 3, steel, 1990
J. Cooper
Blue Box, perspex
Judith Cowan
Sand Boat, sand resin (loan from artist)
John Crossley
Jigo X, painted wood, 1983
B.A. Croxford
Juggler, wood, 1964
Michael Culshaw
The Band, 1990
Lois Davies
Blackbird, metal and painted plaster, 1990
Jupp Dernbach-Mayen
Red Converter
John Donovan
Fish, metal, 1976
Potentate, metal, 1975
Railway Debris, metal, 1979
Geoffrey Doonan
Flat Blade II, 1978
Simon Doughty
Driftwood Yacht Mirror, driftwood, glass,
 tin and paper, 1997
Kenneth Draper
Eclipse
Alfred Dunn
Bubble Sculpture, perspex and wood
Coming Storm, metal, 1970
Detergent Sculpture, fibreglass and perspex,
 1978
Echoes, 1968
Hairy Ball, metal, fibreglass, wood and
 nylon, 1970
Quiet Noises
B.A. Dunstone
Untitled, 1968
Alan Lydiat Durst
Bull, green marble, 1959

Hawk, stone, 1967

Horse, 1959

Georg Ehrlich

Bust of Dr Schofield, bronze, 1958

Garth Evans

Untitled, metal, 1973

Barry Flanagan

Special Commission, 1973

Mark Folds

Albatross, 1991

Ken Ford

Double Image, resin, 1964

Memory Form, resin, 1982

Sculpture, 1964

Sea God, 1964

Joanna Fowler

Simple Supper, painted wood, 1992

Still-Life with Pineapple, painted wood, 1992

Stephen Gilbert

Structure 10c, anodised aluminium, 1967

Graham Gilchrist

Blue Thru', metal, 1969

Kokeda, 1969

Gerald Gladstone

Flower, painted metal, 1964

Sculpture, steel

Cheryl Gould

Tom Fool, bronze, 1992

Lee Grandjean

Cockerel

Shane Green

Personal Uprising, wood, 1988

Shane Green with pupils from The Hall County Primary School, Glenfield

Sculpture, concrete breeze-blocks, 1989

Mike Grevatte

Fish on a Dish, Hornton stone, 1982

Maggi Griffiths

The Seed, 1980

David Hall

The House that Jack Built, welded sheet metal, 1965

Orange, metal, 1969

Span, steel, 1960

Ian Hall

Wood carving, 1963

Nigel Hall

Plateau Marker I, 1974

Kevin Harrison

Cat, wood, linoleum and wax, 1983

Paula Haughney

Donkey, beech, 1987

Rabbit with Passenger, elm, 1988

J. Hilliard

Bound Flow, 1970

Helen Hodgson

Untitled 2, clay, 1990

Antony Hollaway

Astra Domus, perspex, 1967

Driftwood Assemblage, stone, glass and painted wood, 1970

Fountain, metal

Fountain Sails Maquette, 1975

Head of a Warrior, stainless steel and aluminium, 1973

Iron, Stone and Glass, iron, stone and glass, 1972

Maquette for a Fountain, grit-blasted stainless steel, 1973

Maquette for Sculpture, steel, 1971

Multi-Coloured Abacus, perspex, 1972

Perspex Box No. 2, perspex, 1972

Perspex Object, perspex, 1967

Perspex Relief, perspex, 1974

Perspex Screen, perspex, 1967

Brian Hollingworth

The Prince Williams, stoneware, 1983

A. Hoogenboom

Sculpture 75, metal, 1979

Untitled, painted steel, 1974

Knighton Hosking

Sun, Moon, Dial I, resin, 1983

Kate Houghton

Greater Depths, paper and wood, 1984

Christopher Hughes

Recline, red sandstone, 1985

Sitting, red sandstone, 1985

G. Hughes

Divided Object, perspex, 1969

David Hunter

Tree Brain, wood and leather, 1982

Michael Ingram

Column for Xilonen, wood, 1972

Criletic B Fusion ('Zebra Legs'), 1972

Kevel Match, painted wood, 1968

Lail Si, 1973

Pocia Nu, plaster, 1968

Psydiom Watch, wood and metal, 1977

Red Mood, wood, 1972

Summer Jazz, wood, 1972

Verteise Asse, wood, 1972

White Construction, wood, 1972

John Jackson

Black Day - 30th Anniversary, 1980

Untitled, wood, steel and concrete, 1978

Maurice Jadot

Wood relief, c.1966

Anthony Jadunath

Peaceful Animals, pyro-enamel, 1991

Douglas Jeal

Untitled, painted steel, 1966

Margret Joelsdottir

Construction, painted wood, 1971

Selwyn Jones-Hughes

Emperor Fuchsia, plastic and painted board, 1972

Yellow Baby

Karin Jonzen

Bear, stone, 1952

Andrew Kemp

Intolerantia, ceramic sculpture

Nigel Kent

Pyramid I, nail sculpture, 1972

Pyramid II, nail sculpture, 1972

Michael King

Flight of Tern, wood, 1989

Otter, wood, 1988

The Searchers, wood, 1988

Snobs, wood, 1990

Stoat, wood, 1989

Bryan Kneale
 Arthropod, steel, 1963
 Close, bronze, 1982
 Coxcomb, steel, 1965
 Cumae, perspex, aluminium and brass, 1970
 Horse's Head, metal, 1964
 Horse's Head Relief, 1960
 Landraker, painted steel, 1965
 Matrix I, aluminium, 1972
 Thera, oxidised brass, 1982
 Time Balance, steel and wood, 1965
 Tregone, steel, 1963
 Two, steel, 1968
 Zeal, 1968
Justin Knowles
 Dogon, 1970
Robert Koenig
 He Sprints Downfield, yellow pine, 1989
 Three Egyptian Heads, carved and painted oak, 1986
 Untitled, wood, 1987
 Wood panel, wood, 1987
Kuka
 K2D, metal, 1976
 Rockin' and Rollin', metal, 1976
 Untitled, metal
Pamela Leung
 Untitled I, clay, 1987
Kim Lim
 Blue Note, painted steel, c.1966
 Thenganni I, fibreglass, 1972
Margaret Lovell
 Copper Disc, copper, 1963
Jeff Lowe
 Circular Steel Sculpture No. 2, steel, 1978
 Enclosure Act 6, steel
Joy Lucas
 Centrifuge, metal, 1972
Sally Matthews
 Pig, cement, 1988
Iain Machell
 Hands of the Muse No. 1, alabaster, 1984
Penny McIntosh
 Mother and Child Seated, terracotta, 1989

Michael McKinnon
 Coloured Tumble Discs, 1969
 Sifting Pyramid, 1972
 Zig Zag Liquidise, 1972
C. Macklin
 Growth, wood, 1964
H. Mann
 Eclipse, 1967
Imogen Margrie
 Friendly Yet Gross, stoneware, 1992
 I'm Ready When You Are, ceramic sculpture, 1990
D.T. Merriman
 Winter Solstice, 1965
Michael Michaeledes
 Mirror Reliefs, 1974
Joanna Miller
 Cat, limewood, 1984
 Cat, ciment fondu, 1987
 Caterpillar, wood, 1987
 Cockerel, wood, 1984
 Cockerel's Head, elm, 1985
 Crow, wood, 1986
 Dragon, stone, 1986
 Goosey Lucy, wood, 1989
Bill Ming
 Green Glasses, laburnum, 1985
 Horse, walnut, 1984
 Kid Blue, 1988
 A Lesson in Trust, limewood, 1985
 Message in a Bottle, wood, 1989
 Not How!! But Why?, 1992
 A Poem, wood, 1997
 The Sheik Down, 1988
Nadia Ming
 Temple of the Ancients I, wood, slate, copper and paint, 1991
Anthony Morgan
 Between Eight Yellows, 1967
 Between Three Reds, aluminium, 1967
Francis Morland
 Blue Spiral, resin bonded fibreglass
Claire Morris
 Circles, beechwood, 1983

Mother Figure, Portland stone, 1983
Mother Figure, porcelain, 1984
Alison Muir
 The Red Cactus, wood, 1984
Nadia Nagual
 Guardian Angel, wood, bone, stone, shell and metal, 1983
William Newland
 St Christopher, 1960
Victor Newsome
 The Flower, wood and lacquer, 1966
Iain Nutting
 Atlas, welded brass, 1988
 Javelin, welded brass, 1986
 On the Deckchair, welded brass, 1988
Hilary Oliver
 Tethered, wood, slate, copper and perspex, 1990
Ezra Orion
 Active Space 3, 1966
 Active Space 8, welded steel and slate, 1968
 Iron Swing, metal, 1968
 Night, metal, 1966
 Sentinel, metal, 1966
 Space and Iron, painted metal, 1966
 Space and Iron 8, metal, 1968
 Space and Iron 9, metal, 1970
 Storm, metal, 1967
Mary O'Shea
 Green Relief Panel, 1968
 Three Coloured Cones, painted metal, 1968
Ouksuali
 Oiseau, 1985
Sylvia Owens
 See No Evil, Speak No Evil, Hear No Evil, wood and lead, 1997
 Toot Toot, wood and acrylic paint, 1990
Padlat
 Walrus, soapstone, 1982
Jean Parker
 Two-Faced, alabaster, 1987
Phil Parry
 Man Shaving in Lovey Dovey Blow Lamps, wood, 1986

David Partridge
 Cellular II, wood, nails, aluminium and copper, 1967
 Change of Direction, nail sculpture, 1973
 Coloured Configuration, nails, wood and aluminium, 1965
 Configuration Trio, nail sculpture, 1964
 Coral, nail relief, 1968
 Disc II, nail sculpture, 1972
 Disc III, nail sculpture, 1972
 Echo II, nails, wood and aluminium, 1969
 Festival Dances, nail sculpture, 1971
 Hedgehog, nail sculpture, 1969
 Laburnum, nail sculpture, 1970
 Nail Wall Sculpture in Three Pieces, wood, metal and nails, 1988
 Naillie, nail sculpture, 1974
 Observer I, nails, wood and aluminium, 1968
 Observer II, nails, wood and aluminium, 1969
 Palaeozoic, nail sculpture, 1968
 Pink Nail Sculpture, nails and wood, 1970
 Simple?, nail sculpture, 1970
 Taurus, nail sculpture, 1970
 Transfiguration, nail sculpture, 1969
Peter Peri
 Boy and Girl with Dog, cement (maquette), 1957
 Boy at Street Corner, 1958
 Camel, ceramic sculpture
 Despair, bronze, 1964
 Forlorn Lady
 Girl Reading, 1963
 Girl Reading, Boy Looking Over Her Shoulder, plaster and wire
 Man Ploughing, 1957
 Man Wielding a Sledgehammer, plaster, 1956
 Man with a Hammer I, 1958
 Mother and Daughter, cement, 1961
 Old Man Leaning on a Broom, 1956
 Sledgehammer, metal, 1964
 Small Girls
 Street Sweep, 1961

Workman with Sledgehammer, 1957
Maurice Perry
 Cube IV, painted steel, 1978
 Cube VII, metal, 1979
 Cylinder II, metal, 1978
 2 A.M., painted steel, 1976
Richard Perry
 The Ugly Sisters, elm, 1987
 Untitled (Head), wood, 1986
 Young Savage, Ancaster stone, 1986
Roland Piché
 North Devon Landscape, mixed media, 1982
M. Pichy
 Nail Sculpture, 1971
George Pickard
 Moonface, alabaster, 1989
Michael Piper
 Agamemnon, metal
 Boy with Bird, bronze, 1960
 The Don, steel, 1961
Chris Plowman
 Random Cluster, sandcast aluminium, 1989
 Shovelhead, steel, 1992
Nicholas Pope
 A Thin Stone (A Thin Water Sculpture), marble, 1977
Ronald Pope
 Bridge Figure, stone, 1958
J. Portchmouth
 Orang-Utan, plaster, 1964
Barbara Priewska
 Aluminium Relief IV, aluminium, 1965
Alan Reynolds
 Quartet - September '75 II, painted wood, 1978
 Vertical Structure III, 1979
Ron Robertson-Swann
 Sculpture 66, painted steel, 1969
Chris Romer
 Bombay Duck, steel and wood, 1982
Ted Roocroft
 Lamb, concrete and marble, 1987
 Resting Sow, willow and laburnum
 The Seated Cow, concrete, 1987

Young Pig, alabaster, 1988
Gerda Rubinstein
 Bus Stop, ciment fondu and mild steel, 1983
 Cat, bronze, 1981
 Donkey, bronze resin, 1989
 Donkey Ride, bronze resin, 1984
 Elephants, bronze resin
 Flamingos, bronze, 1985
 Friends, ciment fondu, 1990
 Girl Standing, bronze resin, 1986
 The Grass is Greener, bronze resin and wood, 1988
 Is the Grass Greener?, bronze resin, 1986
 Izumi, ciment fondu
 Mother and Son, bronze resin, 1987
 Nadia, resin
 Schoolgirl, ciment fondu and wood, 1990
 Small Owl, bronze, 1985
 Warbler, welded bronze, 1983
Matt Rugg
 Pyramid, painted wood, 1967
Neil Rutherford
 Number III, painted steel, 1966
Christopher Sanderson
 Rome, aluminium, 1967
Michael Sandle
 Relief, painted wood, copper and aluminium, 1964
Jenny Sault
 Untitled, wood
 Untitled outdoor sculpture, plaster and fibreglass
Ellis Schofield
 I am My Father's Ghost, 1978
 Machine, 1978
 War Machine, black-stained wood, 1980
Julian Schwarz
 Pink and Yellow Circle, stained wood, 1982
M. Scott
 Penguin
Tim Scott
 Birds in Arras IV, steel, 1971
 For 'Cello, fibreglass, steel tube and acrylic sheet, 1966

Colin Searls
 Untitled, wood
Mary Shemilt
 Lake Landscape, steel, 1985
 Lizard Landscape, mild steel, 1984
Harry Snook
 Untitled, painted wood, 1982
 Untitled Painted Wood Relief No. 5, painted
 wood, 1980
 Untitled Wood Relief, wood, 1980
 Untitled Wood Relief No. 5, painted wood,
 1980
Christos Solomi
 Standing Figure, white marble, grey marble
 and wood, c.1974
Dean Sorenson
 Aluminium Sheet 2, aluminium, 1975
Willi Soukop
 Boy, bronze
 Boy with Dog, bronze, 1955
 Donkey, 1956
 Donkey Foal, stone, 1954
 Education
 Exotic Bird, wood, 1986
 Frog Girl, bronze, 1956
 Girl's Head, terracotta, 1964[2]
 Goalie, metal, 1956
 Head, 1961
 Horse, sheet bronze
 Meditation, bronze, 1960
 Owl in a Tree, 1990
 Pied Piper, resin and wood, 1990
 Seashell, wood, 1992
 Two Seated Figures, 1965
 Young Faun's Head, terracotta, 1951
Clifford Strong
 Cobra Lily I, forged mild steel and copper

Jill Swan
 Camel, resin, 1985
Peter Tapley
 Maquette, wood, 1984
 Pine-Brown on Black Base, wood, 1981
 Sculpture I, 1979
 Sculpture II, wood, 1979
Wendy Taylor
 Series I, fibreglass and mild steel, 1971
 Series III, fibreglass and mild steel, 1971
 Series V, fibreglass and mild steel, 1971
 Series VI, fibreglass and mild steel, 1971
Rosemary Terry
 Colloquy, burr elm, 1991
James Thrower
 Over Everything Below, steel, 1988
 Race Star, steel
Margaret Traherne
 Blue Table Cross, glass, 1965
 Constellation, stained glass sculpture
 Cross, metal and stained glass
 Glass Construction, glass, 1967
Robin Tucker
 Cat, wood, 1989
William Tucker
 Untitled (Blue Sculpture), painted iron, 1961
George Tuckwell
 Mobile, painted metal
 Mobile II, metal, 1964
Paul Varnom
 The Rocker, elm, 1982
J. Barrington Wards
 Creative, steel, 1972
John Webb
 Release of Merlin, laburnum, 1990
 Satisfaction, wood, 1990
Steven Weids
 Wave Hollow, Ancaster stone, 1992
Friederich Werthmann
 Gordian Knot, stainless steel, 1965

Stanley Whatmore
 Bucket and Spade, wood and steel, 1990
 The Colouring Book Page 1: The Clown,
 steel, 1986
 *The Colouring Book Page 8: Duck à
 l'orange*, mild steel, 1986
 Not to Dot, steel, 1989
 Roger Red Hat, steel, 1989
 Yehudi on a Yamaha, wood and steel, 1990
John Willats
 King of Five Senses, concrete and mosaic,
 1964
 Past and Present, 1959
Isaac Witkin
 Alter-Ego, fibreglass and wood, 1967
Paul Wood
 Eternal Knot, larch, 1984
 Mermaid 2, walnut, 1986
 Mermaid 3, walnut, 1986
 Mithuna, elm and willow, 1984
 *The Pig that Wanted to Learn to Fly but
 Learnt to Swim Instead*, cherry, 1990
 Rasa, walnut and horse chestnut, 1987
 Seed, elm and willow, 1984
 Tree Dancer, dogwood, 1990
 Unicorn, almond, 1985
Derrick Woodham
 Three Painted Metal Boxes, painted mild
 steel, 1967
Austin Wright
 Flower Head, aluminium, 1967
 Heliograph, aluminium, 1967
 Word, aluminium, 1967
Georgina Yates
 Equus, aluminium and slate, 1985
Astrid Zydower
 Girl with Bird, painted metal

2 When this was shown in the 'Growing Up With
Art' exhibition at the Whitechapel Art Gallery (no.
81) it was catalogued as in terracotta on a wooden
base. The LEA inventory records it as being in
bronze.

War Memorials

All known monumental or sculptural First and Second World War memorials in Leicestershire and Rutland were surveyed as part of the PMSA NRP research project in 1998 and 1999 and the information forwarded to the National Inventory of War Memorials for inclusion on its database. Owing to the considerable size of the category as a whole, however, it was not possible to give every memorial surveyed a full catalogue entry in the present volume. A more selective approach had therefore to be adopted and consequently only those memorials with figurative sculpture and, in the case of those inside churches, only those where access was relatively easy, have been included. The following is a list of all those memorials surveyed but not covered by a full catalogue entry.

Leicestershire

Ab Kettleby, parish churchyard, obelisk by Thomas Drake, 1920.

Anstey, memorial garden, cenotaph by Howard Henry Thomson, 1921.

Appleby Magna, cemetery, cross by Henry Charles Mitchell, 1920.

Ashby-de-la-Zouch, Market Street, cross and archway by Thomas Henry Fosbrooke, 1922.

Bardon, parish churchyard, cross by George Nott, 1920.

Barlestone, memorial garden, obelisk, designer unknown, date unknown.

Barwell, Church Lane, Gothic canopied monument by Samuel Henry Langley, 1922.

Billesdon, Market Place, cross, designer unknown, 1921.

Birstall, parish churchyard, cross by Howard Henry Thomson, 1921.

Bradgate Park, *Leicestershire Yeomanry War Memorial* by Stockdale Harrison and Sons, 1927.

Broughton Astley, memorial garden, cross, designer unknown, 1921.

Church Langton, village green, cross, designer unknown, 1921.

Claybrooke Parva, parish churchyard, cross by Fosbrooke and Bedingfield, 1920.

Coalville, Bridge Road School, memorial boulder in granite, 1922.

Coalville, Memorial Square, clock tower by McCarthy, Collings and Co, 1925.

Coleorton, Church Town Road, cross by Robert Bridgeman and Sons, 1922.

Congerstone, village green, cross, designer unknown, 1922.

Cosby, parish churchyard, sundial, designer unknown, c.1920.

Cossington, Main Street, cross, designer unknown, 1920.

Countesthorpe, parish churchyard, cross by George Maile and Son, 1921.

Croft, roadside memorial enclosure, cross, designer unknown, 1921.

Dunton Bassett, Church Lane, cross by Kelly and Co, 1920.

Eastwell, parish church, carved oak tablet by Fox, of Croxton, 1923.

Edmondthorpe, parish churchyard, cross by H.F. Traylen, 1920.

Ellistown, parish church, carved marble and alabaster tablet by J.H. Morcom, 1919.

Fleckney, parish church, carved marble, alabaster and Ketton stone tablet by J.H. Morcom, 1920.

Gaddesby, before the parish churchyard, cross by George Collin, c.1920.

Glenfield, parish churchyard, cross by Amos Hall, 1920.

Great Dalby, village green, cross by The Mountsorrel Granite Co, 1920.

Great Easton, Cross Bank, cross, designer unknown, 1920.

Great Glen, village green, cross by George Maile and Son, 1921.

Grimston, by the village green, cross by Francis W. Reckitt, 1920.

Gumley, common land, cross by J.H. Morcom, 1920.

Hallaton, The Cross, cross, designer unknown, 1921.

Harby, School Lane, cross, designer unknown, 1920.

Hathern, cemetery, cross, designer unknown, 1920.

Higham-on-the-Hill, parish church, carved oak wall tablet, designer unknown, 1920.

Hinckley, parish church, carved, painted and gilded reredos by Temple Lushington Moore, 1920.

Husbands Bosworth, erected on the churchyard wall, cross, designer unknown, 1921.

Ibstock, Central Avenue, architectural monument by T.B. Wain (of Goddard and Wain), 1921.

Kibworth Beauchamp, parish churchyard, cross, designer unknown, 1920.

Kirby Muxloe, Garden of Remembrance with inscribed gates and gateposts and Stone of Remembrance, designer unknown (lettering by J.H. Morcom), c.1924.

Kirby Muxloe, parish church, carved oak wall tablet, designer unknown, 1919.

Knipton, village green memorial garden, cross, designer unknown, c.1920.

Leicester, London Road, Seventh Day Adventist churchyard (formerly Victoria Road Church), cross by Walter Brand, 1920.

Leicester, Victoria Park, *Arch of Remembrance* by Sir Edwin Landseer Lutyens, 1925.

Leicester, Victoria Park, *US Second Airborne Division Memorial*, granite boulder, 1976.

Leicester (suburbs), Welford Road Cemetery, memorial wall and 'Cross of Sacrifice', after a design by Reginald Blomfield, 1923.

Leicester, Aylestone parish churchyard, cross by J.H. Morcom, 1921.

Leicester, Evington, Main Street, cross by Stockdale Harrison and Sons Ltd (carving and lettering by The Plasmatic Co), 1920.

Leicester, Knighton parish church, carved marble wall tablet by B.J. Fletcher, 1920.

Leire, parish churchyard, obelisk, designer unknown, 1921.

Little Bowden, parish churchyard, cross by W. Talbot Brown and Herbert G. Coales, 1920.

Long Whatton, Main Street, cross, designer unknown, 1921.

Loughborough, Queens Park, Carillon tower by Sir Walter Tapper, 1923.

Loughborough, All Saints parish church, carved stone wall tablet by J.H. Morcom, c.1922.

Lubenham, memorial garden, sundial, designer unknown, 1920.

Lutterworth, Church Street memorial garden, cross, designer unknown, 1921.

Market Bosworth, Market Place, cross by Cowdell and Bryan, 1920.

Market Harborough, RC Church of Our Lady of Victories, carved Seaton stone and marble altarpiece by Wall and Co, 1921.

Market Harborough, Welland Park, *Royal British Legion Memorial* by Alfred Herbert, 1996.

Measham, memorial garden, cross by Harry Swanwick, 1921.

Medbourne, Main Street, cross by Thomas Marlow, 1920.

Misterton, parish church, wall memorial with carved soldier and sailor, designer unknown, 1920.

Moira, Bath Lane, collieries war memorial, obelisk, designer unknown, early 1920s.

Mountsorrel, Castle Hill, memorial arch by Shirley Harrison, 1926.

Nanpantan, boulder in Forest Rock, 1922.

Narborough and Littlethorpe, cemetery, cross by Ernest Harry Smith and H. Robinson, 1920.

Nether Broughton, parish churchyard, cross by S. Squires and Son, 1920.

Newbold Verdon, Main Street memorial enclosure, standing stone, 1920s.

Oadby, before the parish churchyard wall, cross by John Cecil Baines, 1921.

Queniborough, built into the parish churchyard wall, cross and memorial walls by Clement Ogden (stonework by J.H. Morcom), 1921.

Ravenstone, parish churchyard, cross by Thomas Henry Fosbrooke (stonework by J.H. Morcom), 1920.

Rothley, Cross Green, obelisk by The Mountsorrel Granite Co, 1921.

Sapcote, Church Street memorial enclosure, cross by John G. Pullen and Sons, 1921.

Scalford, parish churchyard, cenotaph by A. Herbert, 1920.

Seagrave, Green Lane memorial garden, cross, designer unknown, 1921.

Sharnford, parish churchyard, obelisk, designer unknown, 1920.

Shenton, Pump Street memorial enclosure, cross, designer unknown, 1920.

Shepshed, The Paddock, memorial garden, cenotaph with lantern by John Daymond and Son, 1918.

Sileby, Memorial Park, architectural memorial by E.W. Parkinson, 1921.

Snarestone, Main Street, cross by Wells and Co, 1922.

Stoke Golding, cemetery, cross, designer unknown, 1921.

Stoney Stanton, parish churchyard, cross by The Mountsorrel Granite Co, 1921.

Swithland, Main Street, cross, designer unknown, 1921.

Theddingworth, parish churchyard, cross, designer unknown, 1920.

Thorpe Langton, parish churchyard, cross, designer unknown, 1921.

Thrussington, The Green, obelisk, designer unknown, 1920.

Thurmaston, in front of Thurmaston War Memorial Hall, obelisk, designer unknown, c.1920.

Tilton-on-the-Hill, parish churchyard, cross, designer unknown, 1920.[1]

Tur Langton, parish churchyard, cross, designer unknown, 1920.

Twycross, village green, cross, designer unknown, 1919.

Weston-by-Welland, parish church, wall tablet by J.H. Morcom, 1920.

Whetstone, High Street, cross by Ernest G. Fowler, 1921.

1 Note: East Midlands NRP Archive volunteers were unable to locate this memorial in autumn 1999.

Whitwick, parish churchyard, cross by the Revd Thomas William Walters, 1921.

Wigston, in front of St Thomas's Church, *South Wigston and Glen Parva War Memorial*, designer unknown, 1923.

Woodhouse, set into the parish churchyard wall, cross, designer unknown, 1920.

Woodhouse Eaves, in front of the parish church, cross by Howard Henry Thomson, 1920.

Wymondham, parish churchyard, cross by Belton and Goddard, 1919.

Rutland

Ashwell, set into the parish churchyard wall, pedestal and cross, designer unknown, *c*.1920.

Belton-in-Rutland, traffic island at road junction, cross, designer unknown, *c*.1919.

Braunston-in-Rutland, parish churchyard, cross, designer unknown, *c*.1920.

Cottesmore, parish churchyard, cross by Traylen and Son, 1919.

Empingham, cemetery, cross by Traylen and Lenton, 1920.

Hambleton, parish churchyard, cross by George Draycott, 1920.

Manton, parish churchyard, cross, designer unknown, 1920.

Morcott, cemetery, cross, designer unknown, 1919.

Preston, parish churchyard, cross, designer unknown, 1920.

Seaton, parish church, Swithland slate and alabaster wall tablet by J.H. Morcom, 1920.

Glossary

Two books in particular provided indispensible source material for the glossary entries on building stones: Alec Clifton-Taylor and A.S. Ireson, *English Stone Building*, London, 1983, and Alec Clifton-Taylor, *The Pattern of English Building*, 1962, 4th edn 1987.

In the following glossary, italicised words indicate cross-references.

abacus: the flat slab on top of the *capital* of a *column*.

acanthus: an architectural ornament, derived from the Mediterranean plant of the same name, found mainly on *capitals*, *friezes* and *mouldings* of the *Corinthian order*.

accretion: an accumulation of extraneous matter on the surface of a *monument* or *sculpture*, e.g., salts, dirt, pollutants, bird excrement, etc.

aedicule: a statue *niche* framed by *columns* or *pilasters* and crowned with an *entablature* and *pediment*; also a window or door framed in the same manner.

alabaster: a soft translucent stone which is a form of gypsum, occurring white, yellow, red, etc.

allegory: a work of art in which objects and/or figures represent abstract qualities or ideas.

aluminium: a modern, lightweight white metal obtained from bauxite. On exposure to the atmosphere it rapidly develops an inert and protective film of aluminium oxide which protects the surface of the metal from corrosion. **Anodized aluminium** is aluminium which has been given a coating of aluminium oxide by means of chemical or electrolytic action, in order to protect it from corrosive agents.

Ancaster limestone: an *oolitic limestone*, one of the so-called Lincolnshire limestones, from Ancaster in south-west Lincolnshire. There are three varieties, lying in strata one below the other. The uppermost, which is also the hardest, is the Weatherbed: it is very shelly and can be polished to a marble-like smoothness. Below this is the finest grained, the Hardwhite. The lowest and softest is the Freebed, virtually free of shell fragments. The Weatherbed is warm brownish yellow and the Hardwhite and Freebed both creamy white. A high-quality stone, Ancaster limestone has been used extensively as building material for churches both in Lincolnshire and beyond; in Leicestershire it was the chief building stone for Belvoir Castle. It has also been much in demand for sculpture: the exterior carved ornamentation at Wollaton Hall, Nottinghamshire, is of Ancaster limestone.

antae: *piers* or *pilasters* placed at the ends of the short projecting walls of a *portico*, with *capitals* and bases of a different order from that used on the rest of the building. If there are *columns* between the antae they are called *in antis*.

apse: a semi-circular or semi-polygonal termination to a building, usually vaulted; hence **apsidal**.

arcade: a range of *arches* carried on *piers* or *columns*, either *free-standing* or attached to a wall (i.e., 'a blind arcade').

arch: a curved structure, which may be a *monument* itself, e.g., a Triumphal Arch, or an architectural or decorative element within a monumental structure.

architrave: the main beam above a range of *columns*; the lowest member of an *entablature*. Also the *moulding* around a door or window.

archivolt: a continuous *moulding*, or series of mouldings, framing an *arch*.

armature: the skeleton or framework upon which a modelled *sculpture* is built up and which provides an internal support.

artificial stone: a substance, usually cement or reconstituted stones, moulded and then fired rather than carved.

ashlar: masonry cut into squared, smoothed blocks and laid in regular courses.

astragal: a small *classical moulding*, circular in section, often decorated with alternated bead and reel shapes.

atlantes (sing. **atlas**): supports in the form of full- or half-length male figures, sculptured in the round or in *relief*. See also *caryatid*.

attic course / attic storey: the course or storey immediately above the *entablature*, less high than the lower storeys.

attribute: a symbolic object by which an *allegorical* or sacred personage is conventionally identifiable.

baldachin / baldacchino: in monumental architecture, a *canopy* carried on *columns* or *piers*.

baluster: one of a series of short posts carrying a railing or coping, forming a **balustrade**.

barrel vault: a continuous vault of semi-circular section.

basalt: a dark, hard igneous rock, commonly greenish- or brownish-black.

base: the lowest visible course of masonry in a

wall; the lowest section of a *column* or *pier*, between the *shaft* and *pedestal*; the lowest integral part of a *sculpture* (sometimes mounted on a pedestal). Loosely, the lowest portion of any structure.

basement: the lowest storey of a building or architectural *monument*, sometimes partly, sometimes wholly below ground level. If wholly above ground level, the basement storey is of less height than the storey above.

bas-relief. See *relief*.

Bath stone: a honey-coloured *oolitic limestone* from Bath, Avon, ideal for carving.

battered: of a wall, inclined inwards.

bay: a vertical division of a building or architectural *monument*, marked by supporting members such as *pilasters*, *buttresses*, *engaged columns*, etc.

black encrustation: a black crust-like deposit forming on stone where there is atmospheric pollution.

bolection: a curved *moulding* covering the joint between two different surface levels and projecting beyond both surfaces.

bollard: a thick post of stone, wood, or metal, for securing ropes, etc., commonly on a quayside or ship.

Bolsover stone: a fine-grained magnesian, or dolomitic *limestone* from Bolsover Moor, Derbyshire. As with all limestones, this type is relatively soft when quarried but becomes hard on exposure to the air. This makes it ideal for carved work. A serious drawback, however, is 'the general failure of magnesian limestone to withstand the chemicals contained in coal smoke, which eat into the stone below its surface and render some portions spongy or, still worse, convert them into flaky dust'.[1] A weakness vividly demonstrated by the deterioration of the *Hollings Memorial* (see pp.319–20).

[1] Clifton-Taylor, A., 1987, p.95.

brass: an alloy of copper and zinc, yellowish in colour.

Breedon limestone: a Carboniferous *limestone* from Breedon-on-the-Hill, Leicestershire.

broached: when an octagonal spire or shaft rises from a square tower or base it often has **broaches**, that is, half-pyramidal masses of masonry attached to those faces of the spire or shaft which stand above the corners of the tower or base. The broaches smooth the transition from octagon to square.

bronze: an alloy of *copper* and, usually, between 1% and 10% tin. Some modern bronzes also contain zinc and lead.

bronze resin. See **cold-cast bronze**.

bust. See *sculpture*.

buttress: a mass of masonry or brickwork projecting from a wall, or set at an angle against it, to give additional strength.

cable moulding: a *moulding* imitating the twisted strands of a cable.

Caen stone: a pale beige *limestone* from Caen, Normandy.

Calvary. See *cross*.

canopy: a hood or roof-like structure, projecting over a *niche*, or carried on *columns* or *piers* over a *monument* or sculpture, etc.

capital: the head of a *column* or *pillar*.

Carrara marble. See *marble*.

cartouche: an ornamental *panel* in the form of a scroll or sheet of paper with curling edges, often oval and usually bearing an inscription or emblem.

caryatid: a sculptured female figure, used in place of a *column* or *pier* as an architectural support. See also *atlantes*.

cast: to reproduce an object by making a negative mould or moulds of it and then pouring material (e.g., liquid plaster, molten metal) into the moulds. A cast is an object made by casting. An 'after-cast' or 'recast' is a subsequent cast taken from moulds, not of the original object, but of the first, or even later, cast (and often not authorised by the

artist). A metal after-cast is inevitably slightly smaller than its original since metal shrinks on cooling.

cast iron. See *iron*.

castellated: fortified with battlements. By extension, the term is descriptive of something that is ornamented with a battlement-like pattern, e.g., a castellated crown.

Celtic cross. See *cross*.

cenotaph: a *monument* which commemorates a person or persons whose bodies are elsewhere; a form of First World War memorial popularised by Sir Edwin Lutyens' precedent at Whitehall, London.

ciment fondu: a hard and quick-setting aluminous cement, widely used by sculptors.

classical: in its strictest sense, the art and architecture of ancient Greece and Rome, especially that of Greece in the fifth and fourth centuries BC and later Roman work copying it or deriving from it. By extension, any post-antique work that conforms to these models. **Neo-classical** describes work of this sort produced across Europe from the mid-eighteenth to the mid-nineteenth centuries.

Clipsham stone: the hardest of the so-called Lincolnshire *limestones* quarried around Clipsham in north-east Rutland, close to the Lincolnshire border. An *oolitic* limestone, usually pale cream, pale brown or buff-coloured, it contains a large number of shell fragments; it can, however, be rubbed down to produce an extremely smooth surface if necessary. Its characteristic colouring easily harmonises with older stonework and thus it has been used in the twentieth century for the restoration of a number of England's cathedrals, for the colleges of Oxford, and for the post-Second World War restoration of the Houses of Parliament.

Clunch stone: a soft white *limestone* used principally for internal carved work.

Coade stone: an *artificial stone* of extreme durability and, importantly, resistance to frost, manufactured and marketed by Mrs Eleanor Coade (see pp.96, 361). Her firm, operating from Lambeth, was a highly successful supplier of cast sculpture and architectural ornaments from 1769 to 1843.

cold-cast bronze (bronze resin): a synthetic resin that has been coloured by means of a powdered bronze filler to simulate, and so provide a cheaper substitute for, a work in *cast bronze*.

colonnade: a range of *columns* supporting an *entablature*.

colonnette: a small, usually ornamental, *column*.

column: a free-standing *pillar*, circular in section, consisting of a *shaft* and *capital*, sometimes with a *base*. An **engaged column** is one that appears to be partly embedded in a wall – also called an attached, applied, or half-column.

Composite order. See *order*.

concrete: a composition of stone chippings, sand, gravel, pebbles, etc., mixed with cement as a binding agent. Although concrete has great compressive strength it has little tensile strength and thus, when used for any free-standing *sculpture*, must be reinforced with an *armature* of high tensile steel rods.

console: a decorative bracket with a compound curved outline, resembling a figure 'S' and usually taller than its projection.

contrapposto (It. 'set against', 'opposed'): a way of representing the human body so as to suggest flexibility and a potential for movement. The weight is borne on one leg, while the other is relaxed. Consequently the weight-bearing hip is higher than the relaxed hip. This is balanced by the chest and shoulders which are twisted in the opposite direction.

coping: a protective capping or covering to a wall, *parapet*, etc., often sloping to shed water.

copper: a naturally occurring red-coloured metal. Characteristically malleable, it is often used for *repoussé* work. As an alloy, it is the main constituent of *brass* and *bronze*.

Corinthian order. See *order*.

cornice: (i) the overhanging *moulding* which crowns a *façade*; (ii) the uppermost division of an *entablature*; (iii) the uppermost division of a *pedestal*. The sloping mouldings of a *pediment* are called **raking cornices**.

cornucopia (pl. **cornucopiae**): the horn of plenty.

corona: the overhanging vertical-faced member of a *cornice*, above the bed-moulding and below the *cymatium*.

corrosion: a process in which metal is gradually eaten away through chemical reaction with acids, salts, etc.; the process is accelerated when these agents combine with moisture.

Corten steel: a trade term for a type of *steel* which naturally forms a very tough protective, evenly-coloured layer of rust over its surface. Once this has formed the process stops and there is no further oxidization and *corrosion*.

couchant: heraldic term indicating an animal lying on its belly with its head raised.

crazing: a network of minute cracks on a surface or in a coating.

crocket: in *Gothic* architecture, an upward-pointing ornamental spur sculptured into a vegetal form. Found in series on the angles of spires, pinnacles, gables, canopies, etc.

cross: (i) Calvary, Wayside cross. A sculptural representation of the Crucifixion, sometimes with a *canopy*; (ii) Celtic cross. A cross with a tall shaft and a circle centred on the point of intersection of its short arms; (iii) Latin cross. A cross whose shaft is much longer than its three arms.

cupola: a small dome.

cusp: in *Gothic tracery*, a projecting point at the meeting of two *foils*.

cymatium: in a *classical entablature*, the uppermost member of a *cornice*.

dado / die: on a *pedestal*, the middle division above the *plinth* and below the *cornice*.

delamination: the splitting away of the surface layers of stone, etc.

dentils (from Fr. *dentilles*, 'little teeth'): small square blocks used in series on *cornices* of the Ionic, Corinthian and Composite (rarely in the Doric) *orders of architecture*.

Derbyshire marble: generic name for a number of varieties of Carboniferous *limestone*, referred to as *marble* because they are all capable of being highly polished. They are found at the southern end of the Pennine chain in Derbyshire. The best known is *Hopton Wood stone*. There is also Derbydene marble, grey in colour and characterised by its high fossil content; Derbyshire Fossil, grey again but with lighter-coloured fossils; Ashford Black; and Derby Black. Because of their ornamental qualities, many of these 'marbles' have been used extensively for wall cladding and flooring.

Doric order. See *order*.

dormer: vertical-faced structure situated on a sloping roof, sometimes housing a window.

dormer head: gable or pediment above a dormer window.

dressed: of masonry, worked to a desired shape, with the exposed face brought to a finish, whether polished, left matt, or moulded.

drops: pendant architectural ornaments, either cone- or cylinder-shaped. Known in classical architecture as *guttae*.

drum: (i) a cylindrical *pedestal*, supporting a *monument* or *sculpture*; (ii) a vertical wall, circular in plan, supporting a dome; (iii) one of the cylindrical stone blocks making up the *shaft* of a column.

earthenware: descriptive of articles made of baked clay which remain porous unless treated with a glaze.

echinus: the plain convex *moulding* supporting the *abacus* of a *Doric capital*; term used also for the decorated moulding of similar profile on an *Ionic* capital.

écorché (Fr. 'flayed'): a representation of a human figure or animal, with the skin removed to show the musculature.

effigy. See *sculpture*.

egg and tongue: classical moulding of alternated egg and arrow-head shapes (also called **egg and dart**).

Eleanor Crosses: a series of twelve monumental crosses erected between 1291 and *c.*1296 by King Edward I after the death of his queen, Eleanor of Castile, in 1290. The crosses, each containing stone statues of Eleanor, marked the stopping places of her funeral cortège on its journey from Lincoln (she died at nearby Harby) to Westminster Abbey. The sites are Lincoln, Grantham, Stamford, Geddington, Hardingstone, Stony Stratford, Woburn, Dunstable, St Albans, Waltham, Cheapside and Charing. Of these, only the crosses at Geddington and Hardingstone in Northamptonshire and Waltham in Hertfordshire survive. Records of payments (with names of the masons and sculptors) survive for all the crosses except that at Geddington which is consequently believed to be the latest of the series.

engaged column. See *column*.

entablature: in *classical* architecture, the superstructure carried by the *columns*, divided horizontally into the *architrave*, *frieze* and *cornice*.

equestrian statue. See *sculpture*.

erosion: the gradual wearing away of one material by the action of another or by, e.g., water, ice, wind, etc.

façade: the front or face of a building or *monument*.

faience (Fr. name for Faenza in Italy): *earthenware* with a tin glaze.

fasces: originally a bundle of rods tied around an axe, a symbol of a Roman magistrate's authority. In architecture, a decorative motif derived from this.

fascia (pl. **fasciae**): in *classical* architecture, one of the two or three plain, overlapping, horizontal bands on an *architrave* of the *Ionic*, *Corinthian*, and *Composite orders*.

festoon: a sculptured ornament representing a garland of flowers, leaves, fruit, etc., suspended between two points and tied with ribbons. Also called a **swag**.

fibreglass: a material made of resin embedded with fine strands or fibres of glass woven together to give it added strength. As it does not shrink or stretch, has high impact strength and can withstand high temperatures, it has become a popular material for modern *sculpture*.

finial: in architecture, a terminal ornament on a spire, pinnacle, etc.

fluting, **flutes**: concave grooves of semi-circular section, especially those running longitudinally on the *shafts* of *columns*, *pilasters*, etc.

foil: in *Gothic tracery*, an arc- or leaf-shaped decorative form which meets its neighbour at a *cusp*.

foliate: sculptured with leaf ornament or **foliation**.

Forest of Dean stone: a Carboniferous *sandstone* from a number of quarries in Gloucestershire. One of the strongest sandstones, it is characteristically grey in colour, although one variety has a dark bluish tinge. It has been used both for paving and for building.

foundation stone: a stone situated near the base of a building or *monument*, bearing an inscription recording the dedicatory ceremony.

founder's mark: a sign or stamp on a sculpture, denoting the firm/individual responsible for its *casting*.

free-standing: of a *monument* or *sculpture*, standing independently.

freestone: any *limestone* or *sandstone* which is sufficiently homogeneous and fine-grained to be cut or sawn 'freely' in any direction.

frieze: the middle horizontal division of a *classical entablature*, above the *architrave* and below the *cornice*, often decorated with *relief* sculpture. The term is also applied to any band of sculptured decoration.

frontage: the front face of a building.

frontispiece: (i) the main *façade* of a building; or (ii) its decorated entrance *bay*.

gableboard (also called a bargeboard or vergeboard): a board which hangs from the slope of a roof gable, masking the ends of the horizontal roof-timbers; often elaborately carved and ornamented.

galilee: a porch, vestibule or chapel, usually at the west end of a church beyond the entrance to the main body of the church, and originally for penitents. Also called a narthex or paradise.

galvanised steel: *steel* coated with zinc as a protective barrier against atmospheric *corrosion*.

gargoyle: a spout projecting from the gutter of a building or *monument*, usually representing a *grotesque* animal or human figure.

gazebo: a small summer house, or similar structure, usually in a garden or park.

giant order: an *order* whose *columns* or *pilasters* rise through two or more storeys. Also called a colossal order.

gilding, **gilt**: to gild is to cover a surface with a thin layer of gold, or with a gold-coloured pigment; gilding is the golden surface itself.

glass-reinforced concrete: cement which has been mixed with chopped, *c.*50mm-long strands of glass fibre for enhanced strength.

glass-reinforced polyester: a polyester resin strengthened with glass fibres.

glory: light radiating from a sacred personage.

glyptic: of sculpture, carved rather than modelled (cf. *plastic*).

Golden Section, Golden Mean: a proportion long believed to express the essence of visual harmony. Euclid called it 'extreme and mean ratio' and defined it as a straight line bisected such that the lesser is to the greater part as the greater part is to the whole. Its fascination lay in the fact that it cannot be expressed in whole numbers, that is, it is an irrational proportion. There was a revival of interest in the Golden Section in fifteenth-century Italy: for instance, the architect and theorist Leon Battista Alberti appears to have employed it to determine the proportions of his façade for Santa Maria Novella, Florence (1456-70), and the mathematician Luca Pacioli wrote a book on it entitled *Divina Proportione* (1509). There has also been much interest in the Golden Section from twentieth-century abstract artists.

Gothic: descriptive of medieval art and architecture from the end of the Romanesque period to the beginning of the Renaissance. In architecture it is the style typified by the pointed *arch*. In Britain, Gothic architecture is divided into three chronological periods: Early English (mid-twelfth – late-thirteenth century), characterised by lancet windows without *mullions*; Decorated (late-thirteenth – second half of fourteenth century), characterised by a profusion of decoration and *tracery*; and Perpendicular (mid-fourteenth – mid-sixteenth century), characterised by *panel* motifs, an emphasis on rectilinearity and the use of flattened arches.

Gothic Revival: a revival of the forms of Gothic art and architecture, beginning in the mid-eighteenth and lasting throughout the nineteenth centuries.

graffiti: unauthorised lettering, drawing, or scribbling applied to or scratched or carved into the surface of a *monument* or *sculpture*.

granite: an extremely hard crystalline igneous rock consisting of feldspar, mica and quartz. It has a characteristically speckled appearance and may be left either in its rough state or given a high polish. It occurs in a wide variety of colours including black, red, pink, grey-green.

grit, gritstone: name often used for the coarser types of *sandstone*, i.e., Millstone grit.

grotesque: a type of decorative *sculpture* or painting in which human figures and/or animals are fancifully interwoven with plant forms. Popular in ancient Rome, the rooms that were decorated thus were buried for centuries. When excavated they were known in Italian as *grotte* ('caves') and so the style of their decoration became known as grotesque. By extension, this term is now applied to any fanciful decoration which involves distortion of human or animal form.

guilloche: a running pattern formed by two or more bands which interweave like a plait to form circular openings sometimes filled with circular ornaments.

Guiting stone: an *oolitic limestone* from the Cotswolds, Gloucestershire.

guttae: pendent ornaments, generally in the form of truncated cones, sometimes cylinders, found in series on the undersides of the *mutules* and *regulae* of *Doric* entablatures.

Hadene stone: a Carboniferous *limestone* from Derbyshire.

high relief. See *relief*.

hood-mould: a projecting *moulding* placed above a window, doorway, or archway to throw off the rain.

Hopton Wood stone: a *limestone* from Derbyshire, occurring in light cream and grey. In common with other polishable limestones it is sometimes referred to incorrectly as a *marble*.

in situ: (i) of a *monument* or *sculpture*, still in the place for which it was intended; (ii) of an artist's work, executed on site.

intercolumniation: the intervals between the lower parts of the shafts of adjacent *columns*.

Ionic order. See *order*.

iron: a naturally occurring metal, silver-white in its pure state, but more likely to be mixed with carbon and thus appearing dark grey. Very prone to rust (taking on a characteristic reddish-brown colour), it is usually coated with several layers of paint when used for outdoor *sculptures* and *monuments*. As a sculptural material it may be either (i) **cast** – run into a mould in a molten state and allowed to cool and harden; or (ii) **wrought** – heated, made malleable, and hammered or worked into shape before being welded to other pieces.

jamb: one of the vertical sides of a door, window, or archway.

Kerridge sandstone: an even-grained, very hard Carboniferous *sandstone* from Kerridge near Macclesfield, Cheshire, widely used for paving and roofing.

Ketton stone: an *oolitic limestone* from Ketton, south-east Rutland, close to the Northamptonshire border. It is usually creamy yellow in colour and is characterised by the even size of its ooliths and the virtual absence of shells, etc. It was worked as early as the Middle Ages but achieved wider popularity from the sixteenth century onwards. With its even texture and fine grain, it is one of the better *freestones* and has long been highly valued as a medium for carving. Ketton stone was also the main building material employed for the Cambridge colleges (there being no substantial local stone).

keystone: the wedge-shaped stone at the summit of an *arch*, or a similar element crowning a window or doorway.

kinetic sculpture. See *sculpture*.

landscape format: of panels, etc., rectangular, and wider than they are high (cf. *portrait format*).

lantern: a small circular or polygonal windowed turret, surmounting a dome, *cupola* or *canopy*.

larvikite: a dark igneous rock containing a type of feldspar called labradorite; often used as a veneer. Named after Larvik in Norway.

Latin cross. See *cross*.

limestone: a sedimentary rock consisting wholly or chiefly of calcium carbonate formed by fossilised shell fragments and other skeletal remains. Most limestone is left with a matt finish, although certain of the harder types can take a polish after cutting and are commonly referred to as *marble*. Limestone most commonly occurs in white, grey, or tan.

lintel: a horizontal structural member, usually of stone or wood, placed over a doorway or window, to take the weight of the superincumbent masonry.

lost wax (or *cire perdue*): metal *casting* technique used by sculptors, in which a thin layer of wax carrying all the fine modelling and details of the *sculpture* is laid over a fire-proof clay core and then invested within a rigidly-fixed, fire-proof, outer casing. The wax is then melted and drained away ('lost') through vents, and replaced with molten metal. The resulting cast is an extremely faithful replication of the wax original.

lunette: semi-circular surface on, or opening in, a wall, framed by an *arch* or vault.

Mansfield stone: a *sandstone* from Nottinghamshire, occurring pale yellow ('white') or pinkish-brown ('red'). It is fine-grained and therefore cuts well, but it is also relatively soft and prone to weathering.

maquette (Fr. 'model'): in *sculpture*, a small three-dimensional preliminary sketch, usually roughly finished.

marble: in the strictest sense, *limestone* that has been recrystallized under the influence of heat, pressure, and aqueous solutions; in the broadest sense, any stone (particularly limestone that has not undergone such a metamorphosis) that can take a polish. Although true marble occurs in a variety of colours, white has traditionally been most prized by sculptors, the most famous quarries being at **Carrara** in the Apuan Alps, Tuscany, and on the island of Paros (i.e., **Parian** marble) in the Aegean. Also prized is **Pentelic** marble, from Mount Pentelikos on the Greek mainland, characterised by its golden tone (caused by the presence of iron and mica). Other types include: **Grestela** marble, a dark-veined white marble, found in the Carrara quarries; and **Sicilian** marble, a term applied to all marbles from the Apuan Alps that are white with cloudy and irregular bluish-grey veins.

mausoleum: a monumental tomb. The term derives from the Tomb (one of the Seven Wonders of the Ancient World) of King Mausolus at Halicarnassus, *c.*350 BC.

meander pattern: a continuous geometric pattern of alternated vertical and horizontal straight lines joined at right angles.

medallion: in architecture, a circular frame (i.e., shaped like a medallion or large medal).

memorial. See *monument*.

metope: in a *Doric frieze*, one of the rectangular surfaces alternating with *triglyphs*, frequently sculptured.

mild steel: *steel* containing only a small percentage – up to 0.15% by weight – of carbon. Mild steel is noted for its strength and toughness.

Millstone grit: also known as gritstone, it is a Carboniferous *sandstone* occurring in the Southern Pennines, Derbyshire and adjacent parts of Cheshire and Staffordshire. It is brown in colour and is distinguished by the angularity and the often large size of its quartz grains. The two most sought-after gritstones are Darley Dale and Bramley Fell. The name 'Millstone grit' derives from the fact that it is the stone from which millstones were formerly made in the Pennines.

modello (It. 'model'): a small-scale, usually highly-finished, sculptor's (or painter's) model, generally made to show to the intended patron.

monolithic: of a large *sculpture*, *pillar*, *column*, etc., made from a single stone.

monument: a structure with architectural and/or sculptural elements, intended to commemorate a person, event, or action. The term is used interchangeably with *memorial*.

mosaic: a design comprised of small, coloured, pieces of glass, *marble*, stone, tile, etc., cemented to a surface.

moulding: in architecture, a decorative contour designed to enrich a projecting or recessed member.

Mountsorrel granite: a pink or grey *granite* quarried at Mountsorrel, Leicestershire. The stone was seldom used until the late 1820s when a team of granite masons from Aberdeen, Scotland, moved to the area and showed local masons how to work the stone. An extremely durable stone, its greatest use in the nineteenth century was for setts and kerbstones and in this form it was transported by railway and canal around England. Christ Church, Mountsorrel, 1844, by William Moseley, is built entirely in Mountsorrel granite.

mullion: one of the vertical stone or timber members dividing a window into lights.

Muses: ancient Greek goddesses who preside over specific arts and sciences. They are the daughters of Zeus and the Titaness Mnemosyne ('Memory'), are nine in number, and live with Apollo on Mount Parnassus. Each has her own sphere of

influence. Clio is the Muse of history, Euterpe of music and lyric poetry, Thalia of comedy and pastoral poetry, Melpomene of tragedy, Terpsichore of dancing and song, Erato of lyric and love poetry, Urania of astronomy, Calliope of epic poetry, and Polyhymnia of heroic hymns.

mutule: projecting square block above a *triglyph* and on the underside of a *Doric cornice* decorated on its underside with a series of *guttae*.

Neo-classical. See *classical*.

newel-post: the terminal post at the head or foot of a flight of stairs.

niche: a recess in a wall, often semi-circular in plan, usually intended to house a *sculpture*.

obelisk: a monumental tapering shaft of stone, rectangular or square in section, ending pyramidally.

oculus: a circular opening or window. A **blind oculus** is one where the circular surround is applied to a wall where there is no aperture.

ogee: a line with a double curve resembling a letter 'S'; descriptive of a *moulding* with such a shape. An ogee *arch* is one with lower concave and upper convex curves meeting at a point.

oolitic: descriptive of *limestones* whose structure is largely composed of ooliths, small rounded granules of carbonate of lime.

open-work: any kind of decorative work which is pierced through from one side to the other.

order: in classical architecture, an arrangement of *columns* and *entablature* conforming to a certain set of rules. The Greek orders are (i) **Doric**, characterised by stout columns without *bases*, simple cushion-shaped *capitals*, and an entablature with a plain *architrave* and a *frieze* divided into *triglyphs* and *metopes*; (ii) **Ionic**, characterised by slender columns with bases, capitals decorated with *volutes*, and an entablature whose architrave is divided horizontally into

fasciae and whose frieze is continuous; and (iii) **Corinthian**, characterised by relatively slenderer columns, and bell-shaped capitals decorated with *acanthus* leaves. The Romans added **Tuscan**, similar to the Greek Doric, but with a plain frieze and bases to the columns; **Roman Doric**, in which the columns have bases and occasionally *pedestals*, while the *echinus* is sometimes decorated with an *egg and tongue moulding*; and **Composite**, an enriched form of Corinthian with large *volutes* as well as acanthus leaves in the capital.

oriel window: a bay window corbelled out from the wall of an upper storey.

palazzo: in Italian architecture, an imposing civic building or town house.

palmette: an ornament, somewhat resembling the splayed fingers of a hand, derived from a palm leaf.

panel: a distinct part of a surface, either framed, recessed, or projecting, often bearing a sculptured decoration or an inscription.

pantheon: originally, a temple dedicated to all the gods, specifically the Pantheon in Rome, completed *c*.AD 126. By extension, the name came to be used for places where national heroes, etc., were buried or commemorated (e.g., the Panthéon, Paris).

parapet: a wall bordering the edge of a high roof, or bridge, etc.

patina: the surface colouring, and sometimes encrustation, of metal, caused by chemical changes which may be deliberately effected in the foundry or occur naturally through exposure.

pavilion roof: a roof inclined equally on all four sides to form a pyramidal shape.

pedestal: the *base* supporting a *sculpture* or *column*, consisting of a *plinth*, a *dado* (or die) and a *cornice*.

pediment: in *classical* architecture, a low-pitched gable, framed by a *cornice* (the uppermost member of an *entablature*) and

by two *raking cornices*. Originally triangular, pediments may also be segmental. Also, a pediment may be open at the apex (i.e., an open-topped or broken-apex pediment) or open in the middle of the horizontal cornice (an open-bed or broken-bed pediment). The ornamental surface framed by the pediment and sometimes decorated with *sculpture* is called the **tympanum**.

Perpendicular Gothic. See *Gothic*.

personification: a representation of an abstract idea, moral quality, or actual thing, by an imaginary person.

phosphor bronze: a type of *bronze* with *c*.1% phosphorus added, giving enhanced strength.

pier: in architecture, a free-standing support, of rectangular, square or composite section. It may also be embedded in a wall as a *buttress*.

pilaster: a shallow rectangular *pier* projecting less than half its width from a wall.

pilaster strip: a *pilaster* without a *base* or *capital*. Also called a lesene.

pillar: a free-standing vertical support which, unlike a *column*, need not be circular in section.

pits/pitting: small holes and other faults in a metal surface caused either by imperfections in the *casting* process or by *corrosion*.

plaque: a *panel*, usually of metal, fixed to a wall or *pedestal*, bearing sculptured decoration and/or an inscription.

plaster: a range of materials ideal for casting. The type most often used by sculptors is specifically known as **plaster of Paris**, a mixture of dehydrated gypsum and water. It is mixed together as a liquid and may be poured into negative moulds (which themselves may be made of plaster) to make positive casts of a fragile clay model, or as a studio record of a finished work. Plaster of Paris sets in a compact mass of even consistency and, most importantly, can

reproduce fine details from the mould, since it expands slightly in setting. When a sculptor's model is referred to as a plaster, or as a plaster cast, it is usually understood that it is specifically plaster of Paris that is referred to.

plastic: (i) any synthetic substance that can be modelled and will then harden into some permanent form; (ii) a term descriptive of *sculpture* that is modelled rather than carved (cf. *glyptic*).

Plexiglas: proprietary name for a material made from clear acrylic resin, used as a stronger, more durable, substitute for glass.

plinth: (i) the lowest horizontal division of a *pedestal*; (ii) a low plain *base* (also called a *socle*); (iii) the projecting base of a wall.

podium: a raised platform.

pointing machine: a sculptor's device for the exact replication of a statue or full-sized model, or the enlargement of a small-scale model to a full-size *sculpture*. It consists of an upright frame with moveable arms equipped with adjustable measuring rods to enable the sculptor to mark precisely and replicate at the same or other scale, any number of points on the form to be copied.

polychromy: the practice of finishing a *sculpture*, etc., in several colours.

polyester resin: a commercially-produced synthetic material capable of being moulded. Its chief virtues are its tensile strength (which can be enhanced through the addition of glass fibres, i.e., *glass-reinforced polyester*) and its versatility: it can either be allowed to retain its natural transparency through the addition of transparent dyes, or it can be made opaque through the addition of powder fillers (e.g., *cold cast bronze*) or opaque pigments.

portico: a porch consisting of a roof supported by *columns*.

Portland stone: a *limestone* from Dorset, characterised by its bleached white

appearance when exposed to the elements.

portrait format: of panels, etc., rectangular, and higher than they are wide (cf. *landscape format*).

putto (pl. **putti**): a representation of an idealised nude male child.

pylon: strictly, the monumental gateway to an ancient Egyptian temple, consisting of a pair of rectangular, tapered towers connected by a lower architectural member containing the gate; more loosely, a tapering tower resembling one of the towers from such a gateway.

pyramid: a square-based structure with four inward sloping triangular sides meeting at an apex.

rail: a horizontal member in the framework of a door.

raking cornice. See *cornice*.

regula (pl. **regulae**): short band between the *taenia* and *guttae* beneath a *triglyph* on a *Doric entablature*.

relief: a sculptural composition with some or all areas projecting from a flat surface. There are several different types, graded according to the degree of their projection. The most common are (i) **bas-relief**, or low relief, in which the figures project up to less than half their notional depth from the surface; and (ii) **high relief**, in which the main parts of the design are almost detached from the surface. Many reliefs combine these two extremes in one design.

repoussé (Fr. 'pushed back'): *relief* design on metal, produced by hammering from the back.

reredos: strictly, a decorated screen or wall rising behind and above an altar; more loosely, an altarpiece.

return: the continuation of a structure or member in a different direction, usually at a right angle.

rosette: a rose-shaped decorative motif.

rostral column (*columna rostrata*): originally in

ancient Rome, a free-standing *column* erected to celebrate a naval victory, decorated with representations of the prows (*rostra*) of ships.

rostrum: a platform.

rotunda: a circular building, usually domed.

roundel: a circular decorative *panel*. See also *tondo*.

rustication: stonework cut in massive blocks, separated from each other by deep joints. The surfaces are often left rough to suggest strength or impregnability. A rusticated *column* has a *shaft* comprising alternated rough (or textured) and smooth *drums*.

Sacred Monogram: any one of a number of monograms for Christ. It may be a combination of *chi* and *rho*, the first two letters of the Greek word Χριστος (Christ), or *iota* and *chi*, the initial letters of Ιησους Χριστος (Jesus Christ), or *iota*, *eta*, *sigma*, IHS or IHC, the first two letters and last letters of Ιησους (Jesus).

sandstone: a sedimentary rock composed principally of particles of quartz, sometimes with small quantities of mica and feldspar, bound together in a cementing bed of silica, calcite, dolomite, oxide of iron, or clay. The nature of the bed determines the hardness of the stone, silica being the hardest.

scagliola (It., from *scaglia*, 'scales or chips of marble'): imitation *marble*, much used for *columns*, *pilasters* and other interior features.

scroll: a spiral architectural ornament, either one of a series, or acting as a terminal, as in the *volute* of an *Ionic capital*.

sculpture: three-dimensional work of art which may be either representational or abstract, relief or free-standing. Among the many different types are: (i) **bust** – strictly, a representation of the head and shoulders (i.e., not merely the head alone); (ii) **effigy** – representation of a person, the term usually implying that of one who is shown deceased; (iii) **equestrian** – representation of a horse

and rider; (iv) **kinetic** – a sculpture which incorporates actual movement, whether mechanical or random; (v) **relief** – see separate entry; (vi) **statue** – representation of a person in the round, usually life-size or larger; (vii) **statuette** – a small-scale statue, very much less than life-size; (viii) **torso** – representation of the human trunk without head or limbs.

sejant: in heraldry, descriptive of a quadruped sitting with its forelegs upright.

serpentine: a metamorphic rock, consisting chiefly of hydrous magnesium silicate, usually green in colour and sometimes spotted or mottled like a serpent's skin. When polished it is commonly referred to as serpentine marble.

shaft: the trunk of a *column*, between the *base* and the *capital*.

Shap granite: *granite* from Shap Fell, Westmorland. Quarrying did not begin until about 1868 owing to the high cost. The distinguishing characteristic of the stone is the large crystals of red feldspar within the grey, the two colours combining from a distance to produce an overall pink. Shap granite became very fashionable in the last quarter of the nineteenth century.

Sicilian marble. See *marble*.

silicon bronze: alloy of *copper* and *c*.1-3% silicon and often a small amount of manganese, tin, *iron*, or zinc. Originally developed for the chemical industry because of its exceptional resistance to *corrosion*. Its other chief characteristics are strength, hardness, and ease of welding.

slate: a metamorphic rock of sedimentary origin, its chief characteristic is the ease with which it can be split into thin plates.

smalt glass: coloured glass or enamel, generally cut into small cubes or pieces, for use in mosaic work.

socle: a low undecorated *base* or *plinth*.

spalling: in stone or brick, the splitting away in slivers or fragments parallel to the surface.

spandrel: the surface, roughly triangular in shape, formed by the outer curves of two adjoining *arches* and a horizontal line connecting their crowns. Also the surface, half this area, between an arch and a corner.

splay: a sloping surface making an oblique angle with another surface. The term usually refers to the widening of a doorway or window, etc., by slanting its sides.

stainless steel: a chromium-*steel* alloy. The alloy is rendered stainless because its high chromium content – usually between 12-25% – protects its surface with a *corrosion*-resistant chromium oxide film.

statue, statuette. See *sculpture*.

steel: an alloy of *iron* and carbon, the chief advantages over iron being greater hardness and elasticity.

stele, stela (pl. **stelae**): an upright slab of stone, originally used as a grave marker in ancient Greece. It may bear sculptured designs or inscriptions or carry *panels* or *tablets*.

stoneware: a hard, dense, non-porous clay fired at a temperature – 1,200° C to 1,400° C – sufficiently high to vitrify it partly.

stops: projecting stones, sometimes sculptured, at the ends of a *hood-mould*, acting as terminals.

Storeton stone: a pinkish *sandstone* from Storeton, Cheshire.

string course: a continuous horizontal band projecting from or recessed into a *façade*.

swag. See *festoon*.

Swithland slate: Pre-Cambrian *slate* from Leicestershire, formerly quarried on the eastern and southern edges of Charnwood Forest principally at Groby, Woodhouse Eaves and Swithland. The stone is either blue-grey or purple and was used for roofing tiles, *plinths*, doorsteps, window sills, etc., and, most famously, for gravestones. The quarries flourished until the second half of the nineteenth century

when they were put out of business by competition from cheaper, mass-produced Welsh slate. The great advantage of Welsh over Swithland slate was that the former was capable of a thinner cleavage and therefore did not impose so heavy a burden on roofing frameworks, making Welsh slate preferable as a roofing material, the mainstay of the quarries' business.

tabernacle: a *canopied niche* in a wall or *pillar*, usually containing a *statue*.

tablet: a small slab of stone or metal usually bearing a sculptured design or an inscription.

taenia: narrow raised band forming the uppermost member of a *Doric architrave*.

tempietto: a small temple-like structure, especially of an ornamental character, set in a garden.

term: a sculptured human figure, either just the head, or the head and shoulders, or the figure all the way down to the waist, rising from a *pillar*. Also known as a **terminal figure**.

terracotta (It. 'baked earth'): clay that has been fired at a very high temperature and which is usually unglazed. It is notable for its hardness and was much used for architectural ornament in the second half of the nineteenth century.

Thermal window: a semi-circular window divided by *mullions* into three lights. Also known as a Diocletian window.

tondo (pl. **tondi**): a circular *panel*. Also known as a *roundel* or *medallion*.

torus: a bold convex *moulding*, semi-circular in section, especially on the *base* of a *column*.

tracery: ornamental intersecting ribwork, characteristic of *Gothic* architecture, notably in the upper parts of windows, *panels*, and blind *arches*, etc.

triglyph: on a *Doric frieze*, one of the vertically-grooved blocks alternating with the *metopes*.

trophy: representation of a group of arms

and/or armour commonly found on military *monuments* and war *memorials*.

Tuscan order. See *order*.

tympanum. See *pediment*.

urn: vessel of an ovaloid form with a circular base, often used in antiquity to hold the ashes of the dead. Ornamental urns are sometimes used in *monuments*.

verdigris: a green deposit which forms naturally on the surface of copper, *bronze*, and *brass*.

volute: a spiral *scroll*, especially on an *Ionic* or *Composite capital*.

wayside cross. See *cross*.

Weatherbed – see *Ancaster limestone*.

Weldon stone: an *oolitic limestone* deriving from a quarry a little to the east of Corby, Northamptonshire. It is a *freestone*, notably resistant to frost, with a fine, even texture and is usually either pale or warm buff in colour. Two of the three surviving *Eleanor crosses*, those in Northamptonshire, 1291-c.1296, are in Weldon stone and it was also used for nearby Kirby Hall and for most of the original parts of Jesus College, Cambridge.

white encrustation: a white crust-like deposit forming on stone where there is atmospheric pollution.

wrought iron. See *iron*.

York stone, Yorkshire stone: a Carboniferous *sandstone* from quarries to the south of Leeds and Bradford and around Halifax. It is usually light brown in colour, has a fine, even grain and may be highly laminated. This latter quality renders it capable of being split into thin slabs down to an inch thick which are nonetheless strong and durable. It is thus in demand for paving, *coping*, cladding, sills, etc.

Makers' Biographies

A & A Sculpture Casting Ltd
London-based bronze foundry.

Accrite Aluminium
Foundry based in Ellistown, Leicestershire.

Robert Adams (1917–84)
Sculptor, designer and lithographer born 5 October 1917 at Northampton. He attended evening classes at Northampton School of Art, perhaps as early as 1933, but seems to have left the same year and resumed them again only in 1938–44. In the daytime during these years he was earning his living in a variety of fields including engineering. His earliest sculpture, mostly carved and figurative, was influenced by Henry Moore. From the early 1960s, however, under the influence of Brancusi and Gonzalez, he began making abstract sculpture, notably in steel. From 1949–60 he taught at the Central School of Art and Design. Following his first solo exhibition, in 1947 at Gimpel Fils, London, he exhibited widely throughout the 1950s and into the 1960s, and his work was included in several of the International Biennales: for example São Paulo in 1951 and 1957 and Venice in 1952 and 1962. His work featured in 'This is Tomorrow', Whitechapel Art Gallery, 1956, 'British Sculpture in the Sixties', Tate Gallery, 1965, and 'British Sculptors '72', Royal Academy, 1972, and he had a retrospective at the Northampton Art Gallery in 1971. His chief public commissions include *Apocalyptic Figure* for the Festival of Britain, 1951; a concrete wall relief for the Municipal Theatre, Gelsenkirchen, Germany, 1957–9; reliefs for the liners *Canberra* and *Transvaal Castle*, 1961; a roundel in bronzed steel for the BP building, London, 1966; *Vertex No. 1* for Kingswell, Hampstead, 1972; and *Folding Movement*, a bronzed steel wall relief for Williams & Glyn's Bank, London, 1976. He died 5 April 1984 at Great Maplestead, Essex. Examples of his work are in the collections of the Arts Council, British Council, Tate Gallery, and Museum of Modern Art, New York.

Sources: Buckman, D., 1998; Grieve, A., 1992; Nairne, S. and Serota, N. (eds), 1981; Royal Academy of Arts, 1972; Spalding, F., 1990; Strachan, W.J., 1984; *Who Was Who 1981–1990*.

James and Robert Agar (active *c*.1891 – *c*.1932)
Firm based in Syston, Leicestershire, operating as monumental masons, *c*.1891 – *c*.1908, from which latter date until *c*.1932 they are listed as stonemasons.

Sources: *Kelly's Directory of . . . Leicester and Rutland* (edns from 1891–1932).

Alexander (b. 1927)
Artist born in London who prefers to be known only by his surname. He studied at St Martin's School of Art, graduated in 1950 and in the same year had his first solo exhibition, solely of paintings, at the Artists' House, London. He continued to devote himself to painting for about the next 20 years. Then, from the early 1970s, he concentrated on sculpture and holograms, returning to painting only in 1989. Throughout these years he divided his time between Britain and Australia, exhibiting widely. A notable exhibition of his sculptures was staged at the Festival of Perth, Western Australia, in 1982, when five monumental sculptures were sited around the Festival theatres and 42 smaller ones were shown in the city's Lister Gallery. One of the five larger sculptures, *Pallisandro*, marble, was subsequently purchased by the University of Western Australia. Alexander's principal sculptural commissions are: *Jubilee Oracle*, 1979–80, a monumental bronze for the South Bank, London; *Duet in Marble*, 1980–1, for University Hospital, Nottingham; and *Music Sculpture*, 1986–7, stainless steel, made in collaboration with composer Moya Henderson, for Lane Cove Park, Sydney. A touring retrospective exhibition of Alexander's work was shown at the Museum of Contemporary Art, São Paulo, Brazil, and the National Museum of the Fine Arts, Santiago, Chile (both 1989), and at the Modern Museum of Art, Santa Ana, California (1990).

Sources: Buckman, D., 1998; Lucie-Smith, E., 1992a; Strachan, W.J., 1984.

Charles John Allen (1862–1956)
Sculptor born at Greenford, Middlesex. From 1879–89 he was with Farmer & Brindley of Lambeth, firstly as an apprentice and then as a carver in stone and wood. He studied at the South London Technical Art School under William Silver Frith, 1882–7, and subsequently at the Royal Academy Schools, where he won four silver medals. From 1890–4 he was chief modelling assistant to Hamo Thornycroft. He exhibited both at the RA (1890–1922) and abroad. In 1900, at the Paris International Exhibition, he received a gold medal for his bronze group *Love and the Mermaid* (Walker Art Gallery) and his plaster group *Rescued*, the latter of which was subsequently commissioned in bronze by Queen Alexandra. Allen lived for

many years in Liverpool: from 1894 he was instructor in sculpture at the School of Architecture and Applied Art and, from 1905, was Vice-Principal at the School of Art, Mount Street. He retired from his appointments in 1927. His public commissions, most of which are in Liverpool, include two relief panels on St George's Hall (1895–8) and memorials to *Queen Victoria* (unveiled 1906) and *Florence Nightingale* (unveiled 1913). He was, from 1894, a member of the Art Workers' Guild.

Sources: Beattie, S., 1983; Buckman, D., 1998; Cavanagh, T., 1997; Gray, A.S., 1985; Johnson, J. and Greutzner, A., 1976; Walker Art Gallery, 1981; Waters, G.M., 1975.

W. Allsop and Sons (active *c*.1921 – *c*.1941)
Firm of monumental masons at St Mary's Road, Market Harborough. William Allsop had operated independently from *c*.1895 and before that, in partnership, as Allsop and Monk. Allsop and Sons also executed a marble war memorial tablet for Foxton Parish Church.

Sources: *Kelly's Directory of . . . Leicester and Rutland* (edns from 1888–1941); Foxton Parish Record Files (LRO).

Anthony George Michael Ankers (b. 1962)
Sculptor based at Leicester. He gained a First Class Honours Degree in Fine Art (Sculpture) at Leicester Polytechnic in 1985 and a Diploma in the Conservation of Architectural Stonework at Weymouth Technical College, Dorset, in 1989. In June 1994 he was resident sculptor at the Sir Henry Doulton School of Sculpture, Stoke-on-Trent. In 1998 his work was included in a three-person exhibition at Vaughan College, Leicester.

Source: information from the sculptor.

David Annand (b. 1948)
Sculptor based in Kilmany, Fife. He studied at the Duncan Jordonstone College of Art and taught art at a school in Dundee before

becoming a full-time sculptor in 1988. His public sculptures outside Leicestershire include: *Deer Leap*, 1986, Dundee Technology Park (awarded Sir Otto Beit Medal in 1987); '*Nae Day Sae Dark*', 1989, Perth, Scotland; *Royal Stag*, 1993, for Baxters of Speyside (unveiled by HRH Prince Charles); *Helter Skelter*, 1995, Blackpool; '*Y Bwa*', 1995, Wrexham, North Wales; *Three Cranes in Flight*, 1997, British High Commission, Hong Kong; *Kelty Miners' Memorial*, 1997 (unveiled by Mick McGahey and Gordon Brown).

Source: information from the sculptor.

David Annesley (b. 1936)
Sculptor, painter and teacher born in London. From 1947–56 he lived with his family in England, Australia and Southern Rhodesia and in 1956–8 did his National Service in the RAF. In 1958–61 Annesley was at St Martin's School of Art, starting as a painter and then transferring to sculpture (he resumed painting in 1969), working for a time as Anthony Caro's assistant. He spent six months of 1962 working in Majorca. From 1963 he taught at Central School of Art and Design and Croydon College of Art, and from 1964 at St Martin's. In 1966–8 Annesley lived in the USA where he worked with, and was influenced by, the American painter Kenneth Noland. Annesley was a contributor to the influential 'New Generation' exhibition, Whitechapel Art Gallery, 1965; had his first solo exhibition in 1966 at the Waddington Gallery, London; was one of seven sculptors included in the Alistair McAlpine Gift to the Tate Gallery in 1971; and had his work included in the 'British Sculpture in the Twentieth Century' exhibition, Whitechapel Art Gallery, 1981–2. He showed from 1989 with the London Group and from 1991 at the Royal Academy Summer Exhibition. In 1993 his work was included in the first Royal West of England Academy 'Open Sculpture Exhibition' and also in the Royal Society of

British Sculptors exhibition 'Chelsea Harbour Sculpture 93'. In 1990 Annesley was a prize-winner in the BP Sculpture Competition. Examples of his work are in the collections of the Arts Council, British Council, Tate Gallery, and Museum of Modern Art, New York.

Sources: Buckman, D., 1998; Nairne, S. and Serota, N. (eds), 1981; Spalding, F., 1990; Strachan, W.J., 1984; Whitechapel Art Gallery, 1965.

Ron Arad (b. 1951)
Designer born in Israel. After moving to England, he studied architecture in London and then, in 1981, opened the 'One Off' design company and gallery which quickly established itself as London's leading centre for alternative design. Arad's reputation was made with the *Rover Chair*, 1985, a design produced in considerable numbers from recycled Rover car seats. His other work includes the *Well-Tempered Chair* (polished steel) and *Horns Chair* (aluminium) of 1986/7, and *Deep Screen* (steel, glass, silicon and aluminium mesh) of 1987.

Source: Fleming, J. and Honour H.

Michael Dan Archer
Sculptor based in Leicestershire. He spent five years, 1979–84, in Japan and Spain teaching English as a foreign language. Currently (1999) he is an associate lecturer in sculpture at Loughborough University School of Art and Design and a visiting lecturer at Cardiff, Coventry and Derby art colleges. His work has been included in numerous mixed and group exhibitions, including 'New Art', Hiroshima City Gallery, Japan, 1984; the Scottish Sculpture Open exhibition, Kildrummy Castle, Aberdeenshire, 1987; the International Granite Sculpture Symposium, Sardinia, 1989; the Gateshead Garden Festival, 1990; 'Finding Form', Russell-Cotes Gallery, Bournemouth, 1991; 'Sculpture in the Close', Jesus College, Cambridge, 1992 and 1996; the Royal Society of

British Sculptors exhibition at Chelsea Harbour, 1996; and in exhibitions at the Ferrers Centre, Staunton Harold, Leicestershire, 1998 and 1999. In 1990–2 he staged a solo travelling exhibition appearing at Nottingham Castle Museum and Art Gallery, the Glynn Vivian Gallery, Swansea, and the Queen Mary Centre, Basingstoke. In 1993 he had a residency at the Yorkshire Sculpture Park. Other solo exhibitions have been at the Hannah Peschar Gallery, 1994, Dean Clough Art Gallery, Halifax, 1997, and Churchill College, Cambridge, 1998. He has been a member of the RBS since 1994 (council member from 1995).

Source: information from the sculptor.

Henry Hugh Armstead (1828–1905)

Sculptor, silversmith and teacher born 18 June 1828 in London. At the age of eleven he entered the workshop of his father, an heraldic chaser. At thirteen he was sent to the Government School of Design at Somerset House. He next worked at Hunt & Roskell's gold and silverwork factory, while receiving occasional tuition from the sculptor E.H. Baily and attending the Royal Academy Schools in the evenings. He eventually became Hunt & Roskell's chief designer. Armstead's best known piece of silverwork is the *Outram Shield* (now in the Victoria and Albert Museum, London) shown at the RA in 1862. It did not, however, win him the acclaim for which he had hoped and he left Hunt & Roskell to devote himself full time to sculpture. He had already achieved some success in this field, having won Art Union prizes for *Satan Dismayed* and *The Temptation of Eve*. Following a trip to Italy in 1863–4 he was introduced to the architect (Sir) George Gilbert Scott and was commissioned by him to work on the *Albert Memorial*, carving reliefs of painters and musicians of the main European schools for the podium and also modelling bronze figures of *Chemistry*, *Astronomy*, *Medicine* and *Rhetoric*, 1863–72.

Amongst numerous other works he carved for Scott are reredos figures for Westminster Abbey, 1867; the effigy for the *Tomb of Bishop Wilberforce* (died 1873) in Winchester Cathedral; and some of the spandrel reliefs on the Colonial and Home Offices, Whitehall (completed 1875). Armstead also executed commissions to his own designs, including a fountain, 1874–9, for the forecourt of King's College, Cambridge, the *Memorial to G.E. Street*, 1886, in the Law Courts, London, and the *Tomb of Bishop Ollivant* (died 1882) in Llandaff Cathedral. Armstead's marble statue, *Remorse*, was purchased by the Chantrey Bequest and is now in the Tate Gallery. He exhibited at the RA from 1851, taught in the RA Schools from 1875, was elected ARA in the same year and RA in 1879. In 1900 he arranged the British sculpture in the Paris Exhibition. He died at his house in St John's Wood, London, 4 December 1905.

Sources: Beattie, S., 1983; *DNB. Second Supplement*, vol. 1, 1912; Turner, J. (ed.), 1996; Waters, G.M., 1975; *Who Was Who 1897–1915*.

Kevin Atherton (b. 1950)

Sculptor born 25 November 1950 in the Isle of Man. He studied at Douglas School of Art, 1968–9, and Leeds Polytechnic (Fine Art), 1969–72. During the 1970s he taught part time at Middlesex Polytechnic, and at Chelsea, Maidstone, and Winchester schools of art. His commissions include *A Body of Work*, 1983, for Langdon Park School, Poplar; *Three Bronze Deckchairs*, 1984, for the Liverpool International Garden Festival; *Upon Reflection*, 1985, Elthorne Park, London; *Platform Piece*, 1986, Brixton Railway Station, London; *Iron Horses* (12 sculptured horses sited at intervals beside the railway track between Birmingham and Wolverhampton), 1987; *Swing*, 1988, St Chad's Circus, Birmingham; *A Different Ball Game*, 1994, Kings Hill, West Malling, Kent; and *A Private View*, 1995, Taff Viaduct, Cardiff Bay.

Sources: Buckman, D., 1998; *Festival Sculpture*, 1984; Noszlopy, G.T. and Beach, J., 1998; Spalding, F., 1990; Strachan, W.J., 1984.

John Bacon the Elder (1740–99)

Sculptor, born at Southwark on 24 November 1740. From 1755–64 he was apprenticed to Nicholas Crisp, a jeweller and porcelain manufacturer, under whom he gained experience modelling figures. In 1759 Bacon was awarded a premium (the first of eleven he was to receive) by the Society of Arts, for a small figure of *Peace*. He entered the Royal Academy Schools in 1769, the year after the RA's foundation, winning, in that same year, the very first gold medal for sculpture, for a bas-relief of *Aeneas and Anchises*. He exhibited at the RA 1769–99. Between 1765 and 1770 he designed models for Wedgwood and Crown Derby and from 1769 until his death he worked for the Coade Artificial Stone Manufactory at Lambeth (from 1771 he was chief designer). In 1770 his plaster statue of *Mars* secured his election as ARA (he was to be elected RA in 1778). Despite a favourable critical reception on its exhibition at the RA in the following year, the statue failed to attract a purchaser and in 1777 Bacon presented it with a companion statue of *Venus* to the Society of Arts, in recognition of which he was awarded the Society's Gold Medal. Notwithstanding its commercial failure, *Mars* attracted the attention of the Archbishop of York who commissioned Bacon to execute a marble bust of King George III for the Hall of Christ Church, Oxford (RA 1774). The King was sufficiently impressed with the bust to order copies for the University of Göttingen, the Prince of Wales, and the Society of Antiquaries. It was through the King's influence that Bacon received the commission that made his reputation, the *Monument to William Pitt, Earl of Chatham* (c.1778–83) for Westminster Abbey. Bacon was largely self-taught and never made the all-important trip to

Italy, factors which gave his detractors the opportunity to accuse him of having no real understanding of the antique, an accusation he is said to have confounded by carving a colossal head, *Jupiter Tonans* (RA 1777), which he convinced both fellow artists and connoisseurs was a genuine antique. It has been suggested that his detractors were partly motivated by the success of his immensely prolific workshop at Newman Street, London. Bacon's high output was greatly assisted by his invention of an improved pointing machine which allowed his workshop assistants to copy accurately from his models and thus carry out all – barring the finer details of the most important commissions – the actual marble and stone carving. The premises also contained a foundry for bronze commissions. Bacon's most important public commissions include the *Monument to Thomas Guy* (1779) at Guy's Hospital, those to *John Howard* (1795) and *Dr Johnson* (1796) in St Paul's Cathedral and, for Somerset House, the bronze group of *King George III and the River Thames* in the courtyard and the *Fame and Genius of England* on the Strand frontage (1778–9). Bacon was married twice, firstly in 1767 and secondly, following the death of his first wife, in 1782. After his death on 7 August 1799, Bacon's practice was carried on by the second son of his first marriage, John Bacon the Younger.

Sources: Clifford, T., 1985; Cox-Johnson, A., 1961; *DNB*; *Gentleman's Magazine*, September 1799; Graves, A., 1905; Gunnis, R. [1964]; Popp, G. and Valentine, H. (comps), 1996; Whinney, M., 1988.

Samuel Barfield (1830–87)
Architectural sculptor of Leicester and, from 1870, a member of the Leicester School of Art Committee. Barfield enjoyed a long working relationship with Leicester architect Joseph Goddard for whom he executed the carving on his *Memorial to Sir Joseph Paxton*, 1868, at Coventry (for Leicester commissions see relevant catalogue entries). Barfield also worked for Birmingham architect J.H. Chamberlain, for whom he executed in that city the architectural carving on the *Memorial Fountain to Mayor Joseph Chamberlain*, 1880, and the carved lilies-and-lattice decoration of the rose window on the new School of Art, *c.*1885. In Leicester, in addition to work treated in the present catalogue, Barfield signed a Celtic cross-style *Monument to Benjamin Sutton* (d. 1858) in Welford Road Cemetery, Leicester.

Sources: Beaumont, L. de, 1987; Bennett, J.D., 1975; Brandwood, G. and Cherry, M., 1990; *L. Mercury*, 11 July 1994, p.4; *Men of the Period ...*, 1897; Noszlopy, G.T. and Beach, J. 1998; Pevsner, N. and Williamson, E., 1992; personal knowledge.

Stuart Bastick (b. 1965)
Sculptor and painter born at Beverley, East Yorkshire. He studied at Hull College of Art, 1986–7, and Birmingham Institute of Art and Design, 1987–90, finishing with a First Class degree in Fine Art (Sculpture). In 1988 he worked as assistant to Richard Harris, then Sculptor-in-Residence at Grizedale Forest, Cumbria. Bastick has shown in various group exhibitions at, for example, the Cotton Gallery, 1989, and the Concourse Gallery, 1990, both in Birmingham; Myxna Art School, Leningrad, Russia, 1990; and the Gallery in the Forest, Grizedale, 1993. His first solo exhibition, entitled 'The Last Supper Between the Devil and the Deep Blue Sea', was at the Dock Museum, Barrow-in-Furness, 1992, and in 1995 he had an exhibition of paintings (entitled 'Orange') at the Ludus Gallery, Lancaster. He has had residencies at Barrow-in-Furness (1991–2, 'Cumbria Craft Residency') and at Turton, near Bolton, Lancashire (1993, Turton Tower). His sculpture commissions include *Unknown New Cargo*, 1991, Hull Marina (Hull Open Sculpture Competition winner); *The Arrival*, 1993, Grizedale Forest; and *Bath-time Two x Two*, 1995, 'The Washlands', Burton-upon-Trent, Staffordshire.

Source: information from the sculptor.

Bedingfield and Grundy (active *c.*1932 – *c.*1969)
Leicester-based architectural practice.

Sources: *Kelly's Directory of ... Leicester and Rutland* (edns from 1932–69).

Zadok Ben-David (b. 1949)
Sculptor born in Bayhan, Yemen. His family later moved to Israel and from 1971–3 he studied at Bezalel Academy of Art and Design, Jerusalem. He moved to England in 1974 and was assistant to sculptor N.H. Azaz. In 1975 he entered Reading University to study Fine Art and in 1976 took the advanced course in sculpture at St Martin's School of Art and Design. He himself taught sculpture at St Martin's from 1977–82 and then, from 1982–5, at Ravensbourne College of Art and Design, Bromley. He had his first solo exhibition at the Air Gallery, London, in 1980. Other solo exhibitions include Woodlands Art Gallery, London, 1982, and the Benjamin Rhodes Gallery, London, 1987 and 1992. In 1987 he was artist-in-residence at Stoke-on-Trent City Art Gallery and in the following year represented Israel (jointly with Moti Mizrachi) at the Venice Biennale.

Sources: Benjamin Rhodes Gallery, 1987; Buckman, D., 1998; Spalding, F., 1990.

William Henry Bidlake (1861–1938)
Architect, the son of the Wolverhampton-based church architect George Bidlake. He was articled to Sir Robert Edis and Bodley and Garner, and was assistant to (Sir) R. Rowand Anderson. In 1883 Bidlake entered the Royal Academy Schools and in 1885 won the RIBA Pugin Prize. In 1887 he joined John Cotton (also a Pugin Prize winner) in a Birmingham-based partnership which went on to design numerous churches and houses in Birmingham and the West Midlands, specialising in an Arts and Crafts style. Bidlake was also an instructor at Birmingham Central School of Art and was

instrumental in the establishment of the Birmingham College of Art School of Architecture of which he became a Director. In Leicestershire, in addition to the *Houghton-on-the-Hill* war memorials (see p.62), he designed The Knole, Stoneygate, Leicester (1910). He exhibited at the RA in 1909 and 1931. In 1923 he was awarded the Gold Medal of the Birmingham Civic Society. He retired to Bestbeech, West Sussex, and died 6 April 1938 in the house he had built there.

Sources: Gray, A.S., 1985; Service, A., 1977.

John Bingley (*fl*.1773–1802)

London-based sculptor who in *c*.1790 went into partnership with J.C.F. Rossi producing principally works in terracotta. The partnership got into financial difficulties, however, and was dissolved within a few years. As an independent practitioner Bingley designed a number of carved marble chimney-pieces, for patrons such as the Duke of Bridgewater (1796, Cleveland House, London) and Mr Henry Peters (one for his country seat at Betchworth Castle, Surrey, and another for his London house in Park Street, both 1801). Bingley also executed a number of church monuments, including those to *Mary Darker* (died 1773) and *John Darker* (died 1784), Church of St Bartholomew the Less, St Bartholomew's Hospital, London, *James Evelyn* (died 1793), St Nicholas's Church, Godstone, Surrey, and *Captain Willcox* (died 1798), Church of St Mary and St Bega, St Bees, Cumbria.

Sources: Good, M. (compiler), 1995; Gunnis, R., [1964].

Kevin Blackwell

Leicestershire sculptor. He studied at Leicester Polytechnic and Sheffield Polytechnic and took a postgraduate degree at Dundee. His first exhibition was in 1986 in Yorkshire.

Source: *L. Mercury*, 9 July 1993.

Naomi Blake (b. 1924)

Sculptor born in Czechoslovakia and interned during the Second World War in Auschwitz concentration camp. She studied at Hornsey School of Art, 1955–60, and worked in Milan, Rome and Jerusalem, eventually settling in London in the 1970s. She has shown in numerous exhibitions including several from 1962 onwards at the Society of Portrait Sculptors, as well as others at the Woodstock Gallery, 1972; Magdalene Street Gallery, 1976; Alwin Gallery, 1977 and 1979; Embankment Gallery, 1980; Royal West of England Academy, 1989; and Chelmsford Cathedral Festival, 1991. She was elected an associate member of the Royal Society of British Sculptors in 1979. Her publicly-sited sculptures include *View II*, 1977, Fitzroy Square, London; *Image*, 1979, Waterlow Park, Highgate, London; *Refugee*, 1981, Bristol Cathedral Garden; *Mother and Child*, 1984, Norwich Cathedral Precinct; *Sanctuary*, 1985, the churchyard of St Botolph Aldgate, London; and *Renew Our Days*, 1986, forecourt of the Sternberg Centre for Judaism, Finchley, London. Her work is generally abstract but often with a strong figurative element.

Sources: Buckman, D., 1998; National Art Library information file; Spalding, F., 1990; Strachan, W.J., 1984.

Helaine Blumenfeld (b. *c*.1940)

American sculptor, mainly of abstract organic pieces in marble, terracotta and bronze. Since 1969 she has lived at Grantchester, England, and divides her time between there and Pietrasanta, Tuscany, where she lives and works with a community of other sculptors. Having obtained a PhD in philosophy at Columbia University, New York, in 1964, she went to Paris in the following year to study sculpture with Ossip Zadkine. She had her first solo exhibition, consisting of bronzes, at the Palais Palfy, Vienna, in 1966, and since then has

shown around the world, with exhibitions at the Chapman Sculpture Gallery, New York, 1968; the Palais Royale, Gallerie Jacques Casanova, Paris, 1969; Kettle's Yard, Cambridge, England, 1973; the Bonino Gallery, New York, 1976 (retrospective); Zoumboulakis Gallery, Athens, 1979; the Villa Schiff, Montignoso, Italy, 1985; Galerie Kampen, Oslo, Norway, 1986; and Sarina Tang Fine Art, Singapore, 1994. Her major commissions include *Figurative Landscape*, 1983, 5-piece sculpture in Norwegian granite, City Centre, Milwaukee, Wisconsin; *Double Torso*, 1985, bronze, Capital and Counties, Basingstoke, England; *Creation*, 1990, marble, Capital House, Heathrow, England; *Dialogue*, 1991, marble, Paris; and *Flame*, 1993, marble, British Petroleum HQ, Brussels, Belgium. She was from 1981–8 a member of the Arts Council of Great Britain Visual Arts Panel and in 1993 was elected a member of the Royal Society of British Sculptors.

Sources: Dunford, P., 1990; Lucie-Smith, E. and Buckland, D., 1982; Upson, N., 1998.

Neville Boden (1929–96)

Sculptor and teacher born in Alperton, South Africa. He worked as a boilermaker before moving to London in 1958 and studying sculpture at Chelsea School of Art, 1958–63. From 1965–8 he was a Gregory Fellow at Leeds (and his work was featured in 'The Gregory Fellows' exhibition, Leeds City Art Gallery, 1966). He exhibited with the London Group from 1961 (and was president, 1973–9) and with the Artists' International Association in 1963 and 1964; his work was included in 'Chromatic Sculpture' (Arts Council touring exhibition), 1966–7, and in 'Three Decades' (ILEA artists), Royal Academy, 1983; his solo exhibitions include the Whitechapel Art Gallery, London, 1973, and the Camden Arts Centre, London, 1976 and 1986. Boden taught at the London College of Printing, and at Chelsea, Camden,

Central St Martin's and Kingston schools of art. His work is included in the collections of the Arts Council and the Tate Gallery, in the Leeds Sculpture Collections, and in the Bradford and Hull city art galleries. Boden died 24 June 1996 at London having lived for a number of years at La Indiana, Andalusia, Spain.

Sources: Buckman, D, 1998; Camden Arts Centre, 1986; National Art Library information file.

Bodley and Hare (active 1907–40)
Architectural practice based at Gray's Inn Square, London. George Frederick Bodley (1827–1907) was one of the leading architects of nineteenth-century England. Following his death the practice was continued by Cecil Greenwood Hare (1875–1932) as Bodley and Hare, which name it retained until 1940, some years after Hare's death. The last commission in which Bodley was involved was probably St Faith's Church, Brentford, 1906–7. In 1909 Hare designed the reredos for All Saints Church, Swiss Cottage, London, 'in the style of his partner Bodley'.[1] For Holy Angels Church, Hoar Cross, Staffordshire, Hare designed the west narthex, 1906, and the *Monument to F.G. Lindley Meynell* (with a kneeling figure by Bridgeman and Sons), 1910. In 1916 the practice was commissioned by the London *Evening News* to produce a design for street shrines to the dead of the First World War for the poorer areas of London, the cost of each one executed to be financed from a fund established by the newspaper. In 1920 Hare designed the south chapel (a war memorial) and in 1932 the choir stalls for St Peter's Church, Ealing.

Sources: Cherry, D. and Pevsner, N., 1991; Cherry, D. and Pevsner, N., 1998; Felstead, A. *et al.*, 1993; King, A., 1998; Good, M. (compiler), 1995.

Note: [1] Cherry, D. and Pevsner, N., 1998, p.200.

Ernest Bottomley (active 1960s)
Loughborough-based artist.

Antanas Brazdys (b. 1939)
Sculptor in steel, born in Lithuania. At the age of eight he fled with his family to England to escape the Russian occupation. His family later moved to the USA and he studied firstly, 1962–4, at the Art Institute of Chicago and then at the Royal College of Art, London. He then taught at the Royal College and at the Gloucester College of Art. In 1965 he had his first solo exhibition, at the Hamilton Galleries, London, and his work was featured in the influential Arts Council of Great Britain touring exhibition of sculptors from the Royal College, 'Towards Art II'. His awards include the Sainsbury Award for Sculpture, 1963, and the first prize in the *Sunday Times* Sculpture Competition, 1968. His public sculptures include *Ritual*, 1969, Basinghall Street, London, EC2, and several for Harlow New Town, including *Echo*, 1970; *Solo Flight*, 1982; and *High Flying*, 1982.

Sources: Buckman, D., 1998; Royal Academy of Arts, 1972; Spalding, F., 1990; Strachan, W.J., 1984.

Sir Thomas Brock (1847–1922)
Sculptor born 1 March 1847 at Worcester where he attended the Government School of Design. In 1866 he moved to London and became a pupil of John Henry Foley. In 1867 he entered the Royal Academy Schools gaining, in 1869, the RA gold medal in sculpture for his group, *Hercules Strangling Antaeus*, which was exhibited at the RA in 1870. In this same year, 1870, he produced his first portrait statue, *Richard Baxter*, at Kidderminster. When Foley died in 1874, Brock undertook to complete many of his unfinished commissions, thereby succeeding to much of his practice. Brock's numerous public commissions include portrait statues of *Sir Bartle Frere*, 1888, Victoria Embankment Gardens, London, and *Sir J.E. Millais*, 1904, Tate Gallery grounds, London; the *Tomb of Lord Leighton*, 1900, St Paul's Cathedral; and an *Equestrian Statue of the*

Black Prince, 1902, Leeds, but the most prestigious was the *Memorial to Queen Victoria* (with Aston Webb) in front of Buckingham Palace, earning him his knighthood at its unveiling in 1911. Brock exhibited at the RA, 1868–1922, and was elected ARA in 1883 and RA in 1891. He was first president of the Royal Society of British Sculptors at its founding in 1905 and membre d'honneur of the Société des Artistes Français. He was made honorary ARIBA in 1908, honorary DCL at Oxford University in 1909, and honorary RSA in 1916. He died 22 August 1922.

Sources: *DNB*; Beattie, S., 1983; *Who Was Who 1916–1928*.

The Bronze Foundry (established 1979)
Foundry based at New Bradwell, Milton Keynes; since 1992/3 operating as The Mike Davis Foundry. Work outside Leicestershire includes James Butler's *Statue of J.H. Greathead*, 1994, Cornhill, London. Davis, a sculptor in his own right, designed and executed *Thor's Footstool*, stainless steel and granite, 1994, for Christiani and Nielson, Leamington Spa.

Percy Brown (1911–96)
Sculptor and potter born in Wolverhampton. He studied from 1927–32 at Wolverhampton School of Art and from 1932–5 at the Royal College of Art under Richard Garbe. In 1935 Brown was appointed Lecturer in Sculpture at Leicester College of Art, moving in 1946 to Leeds College of Art as Head of the Sculpture and Ceramics Department. In 1950 he went to Hammersmith School of Art, becoming Head in 1956 (retired 1975). Until 1955 his sculpture had consisted principally of architectural commissions and portrait busts; from that date, however, his sculpture became increasingly abstract. He exhibited at the RA from 1934 and had a retrospective exhibition at The Canon Gallery, Chichester, in 1991.

Sources: Buckman, D., 1998; *Crafts*, no. 143, November/December 1996, p.64 (obituary by Charles Bernard); *Percy Brown. Retrospective*, n.d.; Strachan, W.J., 1984; Waters, G.M., 1975.

Ralph Brown (b. 1928)

Sculptor born 24 April 1928 in Leeds. He studied at Leeds College of Art, 1948–51, Hammersmith School of Art, 1951–2, and at the Royal College of Art, 1952–6, where his teachers were Frank Dobson and John Skeaping. In 1954 he was awarded two scholarships, one to study under Zadkine in Paris and another to study in Greece; in 1957 he was sponsored by Henry Moore to study in Italy. Brown was Head of Sculpture, Bournemouth College of Art, 1956–8, and taught at Bristol College of Art and the Royal College, 1958–72. He lived in France, 1973–6. His first solo exhibition was at the Leicester Galleries in 1961 and he had a retrospective at the Henry Moore Centre for the Study of Sculpture, Leeds, in 1988. He also took part in the open-air exhibitions at Battersea Park, 1960 and 1963, and at Coventry Cathedral, 1968, and his work was included in 'British Sculpture in the Sixties', Tate Gallery, 1965, 'British Sculpture '72', Royal Academy, 1972, and in the 1993 Royal Society of British Sculptors exhibition, 'Chelsea Harbour Sculpture 93'. He was elected ARA in 1968 and RA in 1972. His public sculpture commissions include *Swimmers*, Hatfield New Town, and *Sheepshearer*, 1956, and *Meat Porters*, 1960, for Harlow New Town. Examples of his work are in the collections of the Arts Council and the Tate Gallery, in the Leeds Sculpture Collections, the Kröller-Müller Museum, Otterloo, Netherlands, and the Gallery of New South Wales, Sydney, Australia.

Sources: Buckman, D., 1998; Nairne, S. and Serota, N. (eds), 1981; Royal Academy of Arts, 1972; Spalding, F., 1990; Strachan, W.J., 1984; *Who's Who 1999*.

Walter Talbot Brown

Architect based in Wellingborough, Northamptonshire. He co-wrote with architect J.A. Gotch, *Architecture of the Renaissance in England*, Batsford, 1894. His partnership, W. Talbot Brown & Fisher, carried out the restoration of St Peter and St Paul Church, Great Bowden, 1886–7, and St Peter's Church, Belton-in-Rutland, 1897–8. He exhibited at the Royal Academy in 1881 and 1909.

Source: Pevsner, N. and Williamson, E., 1992.

Emlyn Budds

Sculptor. He went first to Norwich School of Art, before taking up degree studies at Loughborough College of Art and Design (1996–9).

Burmantofts Works, Leeds Fireclay Company

The firm began in 1842 as Lassey and Wilcock, coal proprietors and brick makers, at Burmantofts, just outside Leeds. By the early 1870s the firm had become Wilcock and Co., specialising in sanitary tubes and salt-glazed bricks. In 1879 James Holroyd took over as manager and within five years Wilcock and Co. had been transformed from a firm with a solid local reputation to a nationally-known firm making architectural ornamentation in faience and terracotta for some of the country's leading architects, for example Alfred Waterhouse at the Yorkshire College, Leeds, 1877–86 and 1894; at the Victoria Building, Liverpool University, 1887–91; and at King's Weigh House Chapel, Duke Street, London, 1889–91. In 1888 the firm was renamed The Burmantofts Company Ltd. The very next year, however, Burmantofts amalgamated with a number of other firms in the Yorkshire towns of Halifax, Huddersfield and Wortley, together forming the largest clay-working company in Britain. Holroyd was elected to the board of the parent company whilst continuing as manager at the Burmantofts Works. Burmantofts employed a number of first-rate artists as principal designers, including W.J. Neatby (see p.378) and E. Caldwell Spruce (see p.385). In 1906–7, Burmantofts also supplied a range of faience tiles for the entrances of many of the London Underground Railway stations, for example Leicester Square, Russell Square and Piccadilly Circus. Burmantofts Works eventually closed in 1957.

Sources: Bradford Art Galleries and Museums, 1983; Stratton, M., 1993.

James Walter Butler (b. 1931)

Sculptor in bronze, born 25 July 1931 in London. He studied at Maidstone School of Art, 1948–50, and at St Martin's School of Art and the Royal College of Art, 1950–2. He worked as an architectural carver from 1950–60 (interrupted by National Service, 1953–5) and taught sculpture and drawing at the City and Guilds of London Art School, 1960–75. His public commissions include statues of *President Jomo Kenyatta*, 1973, Nairobi; *Field Marshal Alexander*, 1985, Wellington Barracks, London; *Sir John Moore*, 1987, Sir John Moore Barracks, Winchester; *John Wilkes*, 1988, New Fetter Lane, London; *James Henry Greathead*, 1994, Cornhill, London; the *Monument to the Freedom Fighters of Zambia*, 1974, Lusaka; *The Burton Cooper*, 1977, Burton-on-Trent; the *Dolphin Fountain*, 1988, Dolphin Square, London; and *The Stratford Jester*, 1995, Stratford-upon-Avon. Butler exhibited at the RA from 1958 onwards and was elected ARA in 1964 and RA in 1972. In 1980 he was elected a Royal West of England Academician. In 1981 he was made a fellow of the Royal Society of British Sculptors and in 1993 was included in the RBS show 'Chelsea Harbour Sculpture 93'.

Sources: Buckman, D., 1998; Spalding, F., 1990; Strachan, W.J., 1984; *Who's Who 1999*.

Christopher Campbell (b. 1956)

Sculptor born in Blackpool. He studied at Blackpool College of Technology and then

Trent Polytechnic, Nottingham, where he settled. Many of his sculptures are based on animals, his best known perhaps being *Camel*, wood, 1984, for Milton Keynes General Hospital, commissioned by the Milton Keynes Development Corporation. He has work in Sheffield City Art Galleries.

Source: Buckman, D., 1998.

William Douglas Caröe (1857–1938)
Architect born 1 September 1857 at Blundellsands, the son of the Danish Consul in Liverpool. He was articled to the Liverpool architect Edmund Kirby, 1879, then worked in the London office of J.L. Pearson, 1881–5. In 1885 he was appointed as an architect to the Ecclesiastical Commissioners, becoming Senior Architect in 1895. He ran a very successful practice, winning both ecclesiastical and secular commissions. In addition to architectural work, he also designed a number of important church monuments, including those to *Archbishop Temple* in Canterbury Cathedral, *Bishop Owen* in St David's Cathedral, *Bishop Ridding* in Southwell Cathedral, and *Bishop Satterlee and Bishop Harding* in Washington Cathedral, USA. Amongst his work in Leicestershire not included in the catalogue is the reredos, sedilia and piscina, c.1892, for Holy Trinity, Barrow-upon-Soar, the organ chamber, 1897, for St Bartholomew's, Quorn, and woodwork, described by Pevsner as 'excellent', 1890s, for St Peter and St Paul, Syston. Caröe exhibited at the Royal Academy 1884–1935 and was a brother-upholder of the Art Workers' Guild. He died 25 February 1938.

Sources: *DNB 1931–1940*; Gray, A.S., 1985; Pevsner, N. and Williamson, E., 1992; Service, A., 1977.

Derek Carruthers (b. 1935)
Artist and teacher born in Penrith, Cumberland. He studied art at King's College, Newcastle University, 1953–7, his teachers there including Victor Pasmore and Lawrence Gowing. Carruthers went on to teach at Sunderland College of Art, 1957–64, and Trent Polytechnic, 1973–88, taking early retirement in the latter year to devote himself wholly to art. His earlier work, primarily sculpture, was abstract and influenced by Pasmore, although in the later seventies he re-embraced figuration and concentrated more on painting. Examples of his work are in Bradford City Art Gallery and the Abbot Hall Gallery, Kendal.

Sources: information from the sculptor; Buckman, D., 1998; Spalding, F., 1990.

Hilary Cartmel (b. 1958)
Sculptor born at Wendover, Buckinghamshire. She studied at Exeter College of Art, 1976–7, and Trent Polytechnic, 1977–80. She has had residencies at sculpture parks in Germany and in the UK, including Grizedale Forest, various public parks and schools, and at Carlton Hayes Hospital, Narborough, Leicestershire. Her first solo exhibition was at the Air Gallery, London, 1982; others have been at the Centre Gallery, Cheltenham, 1982, and Loughborough Art Centre, 1983. Her public commissions include *Lambis Shell*, 1983, Wesley Green School, Oxford; *Traffic Flow* (wall relief), 1985, Maid Marian underpass, Nottingham; *The John Tradescant Commemorative Sculpture*, 1988, Albert Square, Lambeth, London; *Carmen*, Theatre Square, and *Three Swimmers*, Arnold Leisure Centre, both 1989, Nottingham; *The Herons Dream*, a collaborative work with Christopher Campbell, Michael Johnson and Jonny White, 1991, Waverley Shopping Centre, Edinburgh; *The Filleters' Gate*, 1992, Fish Street, Hull; *Portrait of Rotherham*, 27 screens for Rotherham Transport Interchange, 1995–7; and *A Bird in the Hand*, 1996, Royal Mail Headquarters, Chesterfield.

Sources: sculptor's curriculum vitae, dated 1998; Buckman, D., 1998; Spalding, F., 1990; Strachan, W.J., 1984.

Castle Fine Art Foundry
Fine art bronze foundry based at Oswestry. The foundry cast the figures for Philip Bews's *Time and Tide* outside the Customs and Excise Building, 1993, Liverpool, and Tom Murphy's *Statues of John Moores and Cecil Moores*, 1996, in Church Street, Liverpool.

Source: Cavanagh, T., 1997.

Lynn Russell Chadwick (b.1914)
Sculptor, largely self-taught, born 24 November 1914 in London. His earliest ambition was to be a sculptor but he was persuaded by his family to enter an architect's office. He worked as an architect's draughtsman from 1933 until the Second World War when he became a Fleet Air Arm pilot (1941–4). After the war, whilst working for architect Rodney Thomas, he made his earliest sculptures. Chadwick's first experiments were with mobiles but in the early 1950s he began making sculptures based on humanoid and animal forms. His first solo exhibition was in 1950 at Gimpel Fils, London, and his first in the USA was in 1957 at the Saidenberg Gallery, New York. In 1951 he was commissioned to produce two large sculptures for South Bank restaurants for the Festival of Britain and one large sculpture for the International Open-Air Exhibition of Sculpture at Battersea Park. These, his first large-scale commissions, instilled in him the necessity of learning to weld, which he did at the British Oxygen Company's Welding School at Cricklewood in summer 1950. In 1953 Chadwick gained a national prize in 'The Unknown Political Prisoner' competition. In 1952 he made his first appearance at the Venice Biennale and in his second, in 1956, he won the International Sculpture Prize. In 1959 he won first prize at the Concorso Internazionale del Bronzetto, Padua. He has had numerous solo exhibitions, including a retrospective at the Yorkshire Sculpture Park in 1991–2, and his works are represented in the collections of the

Arts Council and British Council, in the Tate Gallery and the Victoria and Albert Museum, and in many collections around the world. In 1964 he was appointed CBE; in 1986 he was created Officier and then, in 1993, Commandeur, Ordre des Arts et Lettres, France.

Sources: Buckman, D., 1998; Cerrito, J. (ed.), 1996; Farr, D. and Chadwick, E., 1990; Nairne, S. and Serota, N. (eds), 1981; Spalding, F., 1990; Strachan, W.J., 1984; *Who's Who 1999*.

John Henry Chamberlain (1831–83)
Architect and designer of stained glass, metalwork and domestic furniture, born 26 June 1831 in Leicester, the son of the Revd Joseph Chamberlain. He was first articled to Henry Goddard in Leicester but on completion furthered his training in a London practice. About this time Chamberlain became an ardent advocate of the teachings of John Ruskin, duly visiting Venice and other Italian cities before settling in Birmingham in 1856. His first short-lived partnership was with his friend William Harris. He then worked independently for a number of years before going into a more lucrative partnership in 1864 with William Martin who had already secured much work from Birmingham Corporation and other public bodies. The working relationship was ideal in that whereas Martin's strengths were in planning and construction, Chamberlain's was in the actual design of buildings. The practice thereafter produced many buildings for Birmingham, including the College of Arts and Crafts (1881–5), pumping stations for the Corporation Water Works Department, 30 board schools, several churches and numerous private houses. Chamberlain's preferred sculptor was Samuel Barfield who worked for him on a number of independent schemes including Leicester's *Hollings Memorial*, 1864 (see pp.319–20) and Birmingham's *Memorial Fountain to Mayor Joseph Chamberlain* (no

relation), 1880. Chamberlain's work was firmly rooted in a Ruskin-influenced Gothic style; Ruskin in turn expressed his appreciation of Chamberlain's work by selecting the architect as one of the trustees of the St George's Guild. Chamberlain died suddenly of heart disease on 22 October 1883.

Sources: *DNB*; Dixon, R. and Muthesius, S., 1985; Noszlopy, G. and Beach, J., 1998.

Geoffrey Clarke (b. 1924)
Sculptor, etcher, and designer in stained glass and mosaic, born 28 November 1924 in Darley Dale, Derbyshire. He studied at Preston School of Art, 1940–1, and Manchester School of Art, 1941–2. His studies were interrupted by the Second World War (he served in the RAF, 1943–6), after which he spent a year at Lancaster and Morecambe School of Arts and Crafts, finishing off at the Royal College of Art, 1948–52. He later taught at the RCA in the Light Transmission and Projection Department, 1968–73. Clarke won the Silver Medal at the Milan Triennale, 1951, and appeared at the Venice Biennales of 1952 and 1960. His first solo exhibition was at Gimpel Fils in 1952 and a touring retrospective of his works was organised by Ipswich Museums and Galleries, 1994–5. His commissions include an iron sculpture, 1952, for the Time-Life Building, Bond Street, London; the High Altar Cross and candlesticks, Flying Cross and Crown of Thorns, 1953–62, for Coventry Cathedral; *The Spirit of Electricity*, 1958, for Thorn House in London; *Relief ('Bubble Chamber Tracks')*, 1966–8, for the University of Liverpool; ceremonial entrance portals, 1969, for the civic centre at Newcastle upon Tyne; and *Cast Aluminium Relief*, c.1964, for the Nottingham Playhouse. He was elected ARA in 1970 and RA in 1976. Examples of his work are in the collections of the Arts Council, Tate Gallery, Victoria and Albert Museum, and in the Leeds Sculpture Collections.

Sources: Black, P., 1994; Buckman, D., 1998; Cavanagh, T., 1997; Nairne, S. and Serota, N. (eds), 1981; Royal Academy of Arts, 1972; Spalding, F., 1990; Strachan, W.J., 1984; *Who's Who 1999*.

Robert E. Clatworthy (b.1928)
Sculptor born 31 January 1928 at Bridgwater, Somerset. He studied at the West of England College of Art, 1944–6; Chelsea School of Art, 1949–51; and the Slade School of Fine Art, 1951–4. He later taught at the West of England College of Art, 1967–71, and was visiting tutor at the Royal College of Art, 1960–72. He was a member of the Fine Art Panel of the National Council for Diplomas in Art and Design, 1961–71; a governor of St Martin's School of Art, 1970–1; and Head of the Department of Fine Art, Central School of Art and Design, 1971–5. His first solo exhibition was at the Hanover Gallery, London, in 1954, and his work was included in the open air sculpture exhibitions at Holland Park, 1957, and Battersea Park, 1960 and 1963; in 'British Sculpture in the Sixties', Tate Gallery, 1965; and in 'British Sculpture '72', Royal Academy, 1972. Clatworthy's public commissions include *The Bull*, 1961, Alton Housing Estate, Roehampton; *Horse and Rider*, 1984, Finsbury Avenue, London. He was elected ARA in 1968 and RA in 1973. Examples of his work are in the Tate Gallery and the Victoria and Albert Museum.

Sources: Buckman, D., 1998; Nairne, S. and Serota, N. (eds), 1981; Royal Academy of Arts, 1972; Spalding, F., 1990; Strachan, W.J., 1984; *Who's Who 1999*.

John Clinch (b. 1934)
Sculptor born at Folkestone, Kent. He studied fine art at Kingston School of Art, 1951–5, and specialised in sculpture at the Royal College of Art, 1957–61. In 1962 he was awarded the Sir Robert Sainsbury Scholarship. He taught at the University of Calgary, Canada, 1969–70, and from 1970 at Trent Polytechnic. In 1979 he won the Arts Council Major Award and in 1989, the

Welsh Arts Council Travel Award. Clinch has shown in group exhibitions since 1960 and had his first solo exhibition at Graffiti, London, in 1982. In 1984 he was commissioned by the Merseyside Development Corporation to produce a sculpture (*Wish You Were Here*) for Liverpool's International Garden Festival. Other public sculptures by Clinch include *The Great Blondinis*, Swindon city centre, and *People Like Us*, Cardiff Bay. He is an Associate of the Royal Society of British Sculptors and was included in the RBS exhibition 'Chelsea Harbour Sculpture 93'. His sculpture, *Mr "Fats" Waller*, 1981, is in the collection of the Arts Council.

Sources: Buckman, D., 1998; *Chelsea Harbour Sculpture 93*; *Festival Sculpture*, 1984; Spalding, F., 1990.

Coade's of Lambeth, Coade and Sealy (firm *fl.* 1769–1843)

Coade's of Lambeth, a manufactory of artificial stone, was set up by Mrs Eleanor Coade in 1769. One of her advertisements precisely summed up the unique properties that made her product so successful: the stone, it claimed, has 'a property peculiar to itself of resisting the frost and consequently of retaining that sharpness in which it excels every kind of stone sculpture'. This was not an inflated claim, as is attested by the good condition, even after nearly two hundred years, of much of the outdoor sculpture produced by her firm. It was for many years assumed that the Mrs Eleanor Coade referred to as the owner of the firm was the widow of George Coade (d. 1769), a wool merchant of Lyme Regis and Exeter. It has, however, been established by Alison Kelly that the owner was not the widow (1708–96) but the daughter, also called Eleanor (1733–1821). It was known that the daughter never married and the confusion arose from the contemporary use of 'Mrs' as a courtesy title for women in business whether they were married or not.

Eleanor Coade had been born 3 June 1733 in Exeter. Following her father's declaration of bankruptcy in 1759 the family moved to London. Eleanor soon established herself as a businesswoman and in 1769 purchased an artificial stone manufactory at Lambeth from Daniel Pincot, whom she retained for a short while as manager. He was replaced in 1771 by the sculptor John Bacon the Elder who for 28 years until his death in 1799 was to be not merely her manager but also her chief designer and modeller. Apart from the durability and relative cheapness of the artificial stone, the other principal ingredient in the firm's success was that it employed as designers and modellers, in addition to Bacon, some of the finest sculptors of the day including (on an occasional basis) J.C.F. Rossi, John Flaxman and Thomas Banks. In 1799 Eleanor Coade went into partnership with her cousin, John Sealy (1749–1813), and the firm operated thereafter as Coade and Sealy. On the death of Sealy, Coade took on William Croggon (*fl.*1814–35) as manager and he in turn purchased the company on Coade's death in 1821. The firm continued until Croggon's death in 1835, at which point his son Thomas Croggon succeeded him. There was, however, no longer such demand for artificial stone and the moulds were finally sold off in 1843. Coade's output was prolific, ranging from garden ornaments and architectural decoration through statues and monuments to what is perhaps its most ambitious and impressive work, the *Nelson Pediment*, designed for the firm by Benjamin West for the Royal Naval College (formerly Hospital) at Greenwich, 1810–12.

Source: Gunnis, R., [1964]; Kelly, A., 1990; Turner, J. (ed.), 1996.

Stephen Collingbourne (b. 1943)

Sculptor born at Dartington, Devon. From 1960–1 he attended Dartington College of Art

and then, from 1961–4, Bath Academy of Art, Corsham. After teaching at a comprehensive school in Oxford he returned to Dartington College of Art, where he lectured from 1965–70. In 1970 he took a foundry course at the Royal College of Art; in 1972 he worked as an assistant to Robert Adams and in 1972–3 lived in Malaysia. In 1974 he was fellow in sculpture at the University College of Wales and in 1976 was appointed lecturer in sculpture at Edinburgh College of Art. Collingbourne's first solo exhibition was at Dartington Hall in 1968; others followed at the University of Wales, 1974, Oriel Gallery, Cardiff, 1975, and the MacRobert Arts Centre, Stirling University, 1979. His commissions outside Leicestershire include sculptures for Aberystwyth University College, Dyfed, 1977, and Royal Mile, Edinburgh, 1983.

Sources: Buckman, D., 1998; Spalding, F., 1990; Strachan, W.J., 1984.

George Collin and Son (firm active *c.*1904–98)

Leicester firm of stonemasons. George Collin worked independently from *c.*1891 – *c.*1899. He then established his own firm, operating first as 'and sons' and then from *c.*1916 as 'and son'.

Sources: *Kelly's Directory of . . . Leicester and Rutland* (edns from 1891–1941).

Sir John Ninian Comper (1864–1960)

Architect, principally of churches, born 10 June 1864 at Aberdeen, the son of the Revd John Comper (High Church). Following his schooling in Scotland, Comper attended Ruskin's School at Oxford before going on to London where he divided his time between studying at the South Kensington Schools and working at the stained glass works of C.E. Kempe. He was next articled to church architects Bodley and Garner. His independent work falls into two categories. Before *c.*1904 his work, like Bodley's, was scrupulously based on the prevailing style of the fourteenth century

and is typified by St Cyprian, Clarence Gate, London, 1903, which he designed in its entirety. After c.1904, following a trip to the Mediterranean which made him realise the debt owed by Christian art to the classical tradition derived from ancient Greece, he began to add classical, renaissance and baroque details, in a more eclectic style which he called 'Unity by Inclusion', a leading example of which is his church of St Mary, Wellingborough, Northamptonshire, 1904–40. In 1924–8 he designed in a thoroughly Classical style the *Welsh National War Memorial* (sculpture by Bertram Pegram), Cathays Park, Cardiff. Two works in Rutland and Leicestershire not included in the present catalogue are the south-east window of the south transept, 1912, of St Peter and St Paul, Langham, Rutland, and the north-east chapel, 1917, of All Souls, Aylestone Road, Leicester.

Sources: *DNB 1951–1960*; Gray, A.S., 1985; Pevsner, N. and Williamson, E., 1992; Service, A., 1977.

Corinthian Bronze Foundry (c.1925 – c.1971)
Foundry based at Peckham, London, specialising in sand casting.

Sources: James, D., 1970; *Kelly's Post Office London Directory* (edns from 1970–2).

George Harry Cox (active c.1903–c.1916)
Modeller based in Leicester.

Sources: *Kelly's Directory of . . . Leicester and Rutland* (edns from 1903–16).

[Arthur Edward] Seán Crampton (1918–99)
Sculptor and printmaker born 15 March 1918 at Manchester. He first studied silversmithing at the Vittoria Junior School of Art, Birmingham, 1930–3, then attended Birmingham's Central School of Art before going to Paris where he worked in Fernand Léger's studio. Once back in England, Crampton enrolled in the Territorial Army and on the outbreak of the Second World War served in North Africa and

in Italy. In July 1943, Crampton, by this time a Lieutenant, was awarded the Military Cross. Six months later, in January 1944, he stepped on a landmine. The official citation records that the moment Crampton felt his foot touch the igniter, he kept it pressed down, shouted to his men to take cover and, by virtue of allowing his foot to take the full force of the blast, prevented the mine from rising into the air, thereby undoubtedly saving the lives of his men, all of whom escaped without injury. Crampton, however, lost his foot. For this act of selfless bravery he was awarded the George Medal. After a long period of rehabilitation he resumed his career as an artist-craftsman and teacher. From 1946–50 he was Professeur de Sculpture at the Anglo-French Art Centre in St John's Wood, London. Crampton exhibited (albeit infrequently) at the Royal Academy from 1955, had 17 one-man shows in various commercial galleries in the West End and was included in the first Royal West of England Academy Open Sculpture Exhibition in 1993. His commissions include a memorial for his old regiment, the London Irish Rifles, and *The Three Judges*, 1970, for Churchill College, Cambridge. He was a member of the Royal Society of British Sculptors from 1953, FRBS from 1965, President, 1966–71. In 1978 he was elected Master of the Art Workers' Guild. He died at Calne, Wiltshire, 16 July 1999.

Sources: Buckman, D., 1998; *Independent*, 23 July 1999 (obituary); Spalding, F., 1990; Strachan, W.J., 1984; Waters, G., 1975; *Who's Who 1999*.

Hubert Cyril Dalwood (1924–76)
Sculptor, born 2 June 1924 at Bristol. He was an apprentice engineer to the British Aeroplane Company, 1940–4, and served in the Royal Navy, 1944–6. He studied at Bath Academy, 1946–9, under Kenneth Armitage and William Scott. He had his first solo exhibition at Gimpel Fils, London, 1954, and was Gregory Fellow of Sculpture at Leeds University, 1955–8. Between

1956 and 1964 he taught at Leeds, Hornsey, and Maidstone colleges of art and was Head of the Sculpture Department at Hornsey, 1966–73, and Central School of Art, 1974–6. In 1959 Dalwood won the Liverpool John Moores Exhibition sculpture prize and in 1962 was awarded the David E. Bright Prize for younger sculptors at the Venice Biennale. In 1976 he was elected ARA. Many of his sculptures were commissioned by universities including Liverpool (1960), Leeds (1961), Nuffield College, Oxford (1962), Manchester (early 1960s), and Nottingham (1974). He died 2 November 1976. Retrospective memorial exhibitions of his work were mounted at the Hayward Gallery, 1979, and Hebden Bridge Arts Festival, 1996. Examples of his work are held in the collections of the Arts Council and British Council, in the Tate Gallery, London, and in the Museum of Modern Art and Guggenheim Museum, New York.

Sources: Buckman, D., 1998; Nairne, S. and Serota, N. (eds), 1981; Royal Academy of Arts, 1972; Spalding, F., 1990; Strachan, W.J., 1984; *Who Was Who 1971–1980*.

Edward Davis (1813–78)
Sculptor born in Carmarthen, Wales. He trained in the studio of Edward Hodges Baily and attended the Royal Academy Schools in 1833, exhibiting at the RA, 1834–77. He specialised in portrait statues and busts, his statues including those of *Sir William Nott*, 1851, Carmarthen, and *Josiah Wedgwood*, 1863, Stoke-on-Trent, and his busts, those of the *Duchess of Kent*, 1843, Royal Collection, *William Rathbone*, 1857, for St George's Hall, Liverpool, and the painters *Daniel Maclise*, 1870, and *John Constable*, 1874, both commissioned by the RA. He also executed a number of church monuments, including those to *Joseph Walley*, 1851, St Luke's Church, Lancaster, and to *Colonel J. Bugle Delap*, 1853, Church of the Assumption, Lillingstone Lovell,

Buckinghamshire. At the Great Exhibition of 1851 he exhibited, in addition to Leicester's *Duke of Rutland Statue* (see p.141–5), a marble group, *Venus and Cupid* (now Salford Art Gallery). At the International Exhibition of 1862, he exhibited a figure of *Rebecca*. He died 14 August 1878.

Sources: Good, M. (comp.), 1995; Gunnis, R., [1964].

Kenneth Draper (b. 1944)

Sculptor and painter born at Killamarsh, near Sheffield, Yorkshire. He studied at Chesterfield College of Art, 1959–62, Kingston School of Art, 1962–5 (painting until 1964, then sculpture), and the Royal College of Art, 1965–8. In 1965 he was awarded the Young Contemporaries Prize for Sculpture and in 1971 the Mark Rothko Memorial Award (travel bursary to the USA). He had his first solo exhibition at the Redfern Gallery, London, 1969, a retrospective was held at the Warwick Arts Trust in 1981, and he had a solo exhibition in the USA in 1991, at the Glen Green Gallery, Santa Fe. Among the group exhibitions in which his work was featured are 'British Sculptors '72', Royal Academy, 1972, and the 'Silver Jubilee Contemporary British Sculpture' exhibition, Battersea Park, 1977. From 1976 he taught at Goldsmiths' School of Art and, from 1977, at Camberwell School of Arts and Crafts. His public commissions include sculpture, 1972–3, for the John Dalton Building, Manchester Polytechnic, and *Oriental Gateway*, 1977–8, Bradford University. He was elected ARA in 1990 and RA in 1991. Examples of his work are in the Arts Council collection, the Fitzwilliam Museum, Cambridge, the National Museum of Wales, Cardiff, the Cartwright Museum and Art Gallery, Bradford, and the Mappin Art Gallery, Sheffield.

Sources: Buckman, D., 1998; The Minories, 1982; Nairne, S. and Serota, N. (eds), 1981; Royal Academy of Arts, 1972; Spalding, F., 1990; Strachan, W.J., 1984.

Judith Holmes Drewry

Leicestershire-based sculptor, principally of portraits. She studied at Norwich Art School before attending San Francisco Art Institute on an English Speaking Union exchange scholarship to the USA. Apart from her work in Leicestershire, Drewry's public commissions include a sculpture, 1989, for the Woolwich Building Society head offices, London; a *Memorial to the Home Guard*, 1996, Lyndhurst, Surrey; and sculpture features for the Hampton Court Flower Show, 1997, and Chelsea Flower Show, 1998. She casts all her own sculptures at Le Blanc Fine Art, the foundry she runs in collaboration with her husband and fellow sculptor, Lloyd Le Blanc.

Sources: information from Le Blanc Fine Art; *L. Mercury*, 22 April 1994, p.18.

Gary Drostle – see 'Wallscapes'

Dryad Metal Works (active c.1925–1970s)

Firm of art metalworkers owned by Harry Hardy Peach, based originally at St Nicholas Street, Leicester.

Sources: *Kelly's Directory of . . . Leicester and Rutland* (edns from 1925–71).

Samuel Dunckley (d. 1714)

Mason based in Warwick, where he was employed in the rebuilding of St Mary's Church following the fire of 1694. He is solely credited with the design, building and carving of the portal of the church's Beauchamp Chapel in what Colvin has described as 'an elaborate and remarkably convincing Gothic style'.

Source: Colvin, H., 1978.

Alfred Dunn (b. 1927)

Sculptor, printmaker and teacher born in Wombwell, Yorkshire. He studied at Barnsley and Leeds schools of art and then, 1959–61, at the Royal College of Art, later becoming senior tutor there. He had his first solo exhibition at the Redfern Gallery, 1965, since which time he has shown both in England and on the continent (Germany and Italy). His *Together*, 1974, painted mild steel, was purchased for the Yorkshire Sculpture Park.

Sources: Buckman, D., 1998; Spalding, F., 1990; Strachan, W.J., 1984.

Alan [Lydiat] Durst (1883–1970)

Sculptor born 27 June 1883 at Alverstoke, Hampshire. He served in the Royal Marines, 1902–13. In 1913 he enrolled at Central School of Art and Design, but at the outbreak of the First World War he returned to the Royal Marines, 1914–18, resuming his studies at the end of the war. On leaving art school, Durst became Curator of the G.F. Watts Museum, Compton, 1919–20. He left to take up sculpture full time, later teaching wood carving at the Royal College of Art, 1925–40 and 1945–8. He exhibited with the Seven and Five Society, 1923–4, and had his first solo exhibition at the Leicester Galleries, London, in 1930. In 1938 he published his book, *Wood Carving*. He exhibited at the Royal Academy, 1938–70. Durst's public commissions include Masks of *Comedy* and of *Tragedy*, 1931, for the frontage of the Royal Academy of Dramatic Art, London, *Christ in Majesty*, gilded wood, 1960, for St Mary the Great, Cambridge, and statues for the west front of Peterborough Cathedral. He was elected ARA in 1953.

Sources: Buckman, D., 1998; Good, M. (comp.), 1995; Nairne, S. and Serota, N. (eds), 1981; Popp, G. and Valentine, H. (comps), 1996; Spalding, F., 1990; Waters, G., 1975; *Who Was Who 1961–1970*.

Bertram Eaton (1912–77)

Self-taught sculptor born 15 April 1912 in Northampton. After school he worked in a succession of office jobs before being taken on, at the age of 21, by a leather manufacturer on the outskirts of Northampton, in the Nene Valley. He stayed with the firm until his

retirement in 1977. By the late 1930s he had become interested in modern sculpture. At the outbreak of the Second World War he registered as a conscientious objector and it was during this period that he carved his first sculpture, a female torso in oak in the style of Maillol, using his wife, whom he had married in 1938, as a model. He persevered in the difficult job of teaching himself to carve and in the late 1940s became friends with Robert Adams. In 1948, Eaton's wife took some of his pieces to the Leicester Galleries in London and had a couple of them accepted. By the time of his first (and only) solo exhibition in London, at the Galerie Apollinaire, in 1950, his work was almost completely abstract. In 1952 and 1954 he showed with the London Group, and in the latter year he showed one sculpture, *Space Form Composition*, with the short-lived Groupe Espace in its exhibition in the foyer of the Royal Festival Hall. He thereafter showed at the Royal Scottish Academy, at various London galleries and annually in the exhibitions of the Northampton Town and County Art Society (President 1968–9). In 1975 he had his second solo exhibition, at the Central Art Gallery, Northampton. By this time his work had reached its final phase, consisting of severely rectilinear sculptures in a variety of woods, the importance of the distinctive characteristics of each wood being conveyed in the titles, e.g., *Applewood sculpture*, *Mahogany and ebony sculpture*, etc. In 1980 a touring exhibition of Eaton's work was organised by East Midlands Arts.

Source: *Bertram Eaton. A Northamptonshire sculptor* (exhib. cat.), 1980.

Georg Ehrlich (1897–1966)

Sculptor, painter and etcher born 22 February 1897 in Vienna. He studied art at the Kunstgewerbeschule, Vienna, 1912–15, after which he served in the Austrian Army until the end of the First World War. From 1919–21 he lived in Munich, having an exhibition of his prints there in 1920 at the Hans Goltz Gallery. He began to exhibit widely, moving next to Berlin and then in 1923 back to Vienna where, in about 1926 he began to sculpt. The rise of Nazism meant that Ehrlich, a Jew, could no longer safely remain in Austria, and in 1937 he moved to England, in the same year winning a Gold Medal at the Exposition Internationale des Arts et Techniques in Paris. From the year after he arrived until 1960 he had numerous solo exhibitions in London. In 1948 he was artist-in-residence at the Columbus Gallery of Fine Arts, Ohio. From 1950–1 he taught at Hammersmith School of Art. In 1951 two of his sculptures were included in the Festival of Britain and in 1958 he showed at the Venice Biennale. In 1960 his *Head of a Horse* was purchased by the Chantrey Bequest, in 1961 he was awarded the Sculpture Prize of the City of Vienna, and in the following year, 1962, he was elected ARA. He showed at the RA from 1940–67. His public sculptures include his *'Pax' Memorial*, Coventry; *The Young Lovers*, 1973, St Paul's Cathedral churchyard, London, and *The Bombed Child*, Rathaus, Lünen, Germany. He died 1 July 1966. Examples of his work are in the Tate Gallery, the British Museum, the Victoria and Albert Museum, Wakefield City Art Gallery; Tel Aviv Museum of Art, Israel; and the Metropolitan Museum of Art, New York.

Sources: Buckman, D., 1998; Spalding, F., 1990; Strachan, W.J., 1984; Waters, G., 1975; *Who Was Who 1961–1970*.

Penelope Ellis (b.1935)

Sculptor born in London. She studied at the Slade School of Fine Art, 1953–6, and was awarded a British Institute in Paris Scholarship,1956–7, to continue her studies in art. From 1957–8 she was at the Institute of Education, London University, and went on to teach art and design at secondary school level in Bristol, 1958–97. In 1958 she exhibited with the 'Young Contemporaries', and in 1962, 1963 and 1964 with the Women's International Art Club. In 1963 Ellis was the sculptor-member of the British team in the Manifestation Biennale et Internationale des Jeune Artistes at the Troisième Biennale de Paris. The team's entry in the 'Travaux d'Equipe' section won first prize for foreign entries and in 1964 was exhibited at the Institute of Contemporary Art, London, and the Bristol Building and Design Centre. In about 1969 Ellis showed a kinetic piece, *Spinning Colour*, at a mixed exhibition on the theme of colour at the Graves Art Gallery, Sheffield.

Source: information from the sculptor.

Garth Evans (b.1934)

Sculptor and teacher born at Cheadle, Cheshire. He studied at Manchester School of Art, 1955–7, and Slade School of Fine Art, 1957–60. In 1960 (and 1965) he showed at the John Moores Exhibition, Liverpool, and in 1962 he had his first solo exhibition at the Rowan Gallery (and many thereafter). His work was included in the 'British Sculpture '72' exhibition at the Royal Academy, 1972, and the 'Silver Jubilee Contemporary British Sculpture' exhibition at Battersea Park, 1977. He taught at Camberwell School of Arts and Crafts, and was visiting lecturer at St Martin's School of Art, the Royal College of Art and Slade School of Fine Art. In 1973 he was visiting professor at Minneapolis College of Art and Design. Evans's awards include a Gulbenkian Purchase Award, 1964; an Arts Council Sabbatical Award, 1966; a British Steel Corporation Fellowship, 1969; and a Bradford Print Biennale Prize, 1972. He lived and worked in the USA from the early 1980s. Examples of his work are in the Arts Council collection and in the Tate Gallery, Victoria and Albert Museum, Bristol City Art Gallery, Portsmouth City Art Gallery, Metropolitan Museum of Art, New York, and

the Power Gallery of Contemporary Art, Sydney, Australia.

Sources: Buckman, D., 1998; Nairne, S. and Serota, N. (eds), 1981; Royal Academy of Arts, 1972; Spalding, F., 1990; Strachan, W.J., 1984.

John Breedon Everard (1844–1923)
Architect, civil engineer and President of the Leicester and Leicestershire Society of Architects, born in Groby, Leicestershire. He was articled to John Brown, a mining engineer, for four years in 1862 and after completion, in 1866, became assistant to W.H. Barlow (MICE) of Westminster. He returned to Leicester and began in independent practice in 1868, later entering into partnership with S. Perkins Pick (see below). In 1888 he was elected a Fellow of the Royal Institute of British Architects. Everard's principal architectural works, all in Leicestershire, include the Leicester Cattle Market, 1871; the Church of St John the Baptist, Hugglescote, 1878–9, 1887–8, which has been described as 'easily the best C19 [Leicestershire] church outside Leicester';[1] St Peter, Bardon, 1898–9; and, for himself, 'Woodville', a large house in Knighton Park Road, Leicester, 1883. He retired in 1911 and died at 'Woodville' on 12 September 1923.

Sources: *Builder*, vol. 125, no. 4207, 21 September 1923, p.436 (obituary); Felstead, A., *et al*, 1993; Pevsner, N. and Williamson, E, 1992; *RIBA Journal*, vol. 30, no. 20, 20 October 1923, p.653 (obituary).

Note: [1] Pevsner, N. and Williamson, E., 1992, p.181.

Everard and Pick (active from *c*.1891)
John Breedon Everard (see above) and Samuel Perkins Pick (1859–1919) established their Leicester-based architectural and civil engineering practice, Everard and Pick, in 1888. In 1905, Everard's son Bernard joined and the practice became Everard, Son and Pick . By 1918 J.B. Everard had retired and William Keay (d. 1952) became a partner, the practice being re-designated Pick Everard and Keay. This in turn became Pick Everard Keay and Gimson in 1923, a name it retained until 1991, from which date it has operated as Pick Everard. The practice exhibited at the Royal Academy in 1901, 1904, 1915, 1916 and 1917. Everard and Pick built the original Leicester College of Art and Technology (now the Hawthorn Building, De Montfort University), 1896–7 (additions 1909, 1928 and 1937), and also Pares's Bank, Leicester, 1900–1.

Sources: information from Pick Everard; Beaumont, L. de, 1987; *Kelly's Directory of … Leicester and Rutland* (various edns); *L. Chronicle*, 31 May 1919, p.2 (obituary of Pick).

Farmer and Brindley (*fl*. mid-1850s – 1929)
A firm of decorative craftsmen and church furnishers providing architectural sculpture under contract, based at Westminster Bridge Road, London. William Farmer was the director of the firm and William Brindley the chief executant. Many of the workers for the firm, including Charles John Allen and Harry Bates, trained at the South London Technical Art School. The firm provided decorative sculpture for many of the most important architects up until the First World War, their major contracts including work on Sir George Gilbert Scott's *Albert Memorial*, London, and Alfred Waterhouse's Natural History Museum, London, and Town Hall, Manchester. Scott said of Brindley that he was 'the best carver I have met and the one who best understands my views'. After Farmer's death, the firm continued to flourish under Brindley, but was eventually amalgamated with another firm in 1929. No records appear to survive from the firm's heyday.

Sources: Beattie, S., 1983; Read, B., 1982.

Michael Farrell
A sculptor, he graduated from Birmingham Polytechnic with a degree in fine art.

Source: *L. Mercury (NW Leics edn)*, 15 December 1992, p.5.

Steve Field (b.1954)
Artist working in a variety of media, born in Saltash, Cornwall. He studied at Sheffield University and then Wolverhampton Polytechnic where he was a joint research fellow and gained a master's degree in fine art. He was a member of the West Midlands Public Art Collective, 1985–8, and won a Royal Society of Arts 'Art for Architecture' Award in 1992. He is a member of Art for Architecture (a4a), an informal collaborative association of artists, designers and craftsmen. He has made a number of designs for execution by sculptor John McKenna (founder of a4a), including the two relief roundels at Fosse Park, Leicestershire (see p.50), *The Glassblower*, 1995, Stourbridge Railway Station, Worcestershire, and four bronze relief panels for St John's Retail Park, Wolverhampton.

Source: Art for Architecture website: a4a.clara.net/a4a.htm; Buckman, D., 1998.

John Firn (active *c*.1861 – *c*.1877)
Leicester-based monumental mason, stonemason and builder. In addition to items covered in the present volume, he rebuilt the tower, spire and north aisle of St Mary's, Stoughton, Leicestershire, 1861–2, and executed the tomb of John Biggs (died 1871) in Welford Road Cemetery (signed).

Sources: Pevsner, N. and Williamson, E., 1992; various Leicester trade directories; personal information.

Arthur Fleischmann (1896–1990)
Sculptor born in Bratislava, Slovakia (then part of Hungary). He studied medicine in Budapest and Prague, eventually qualifying as a doctor. However, he became interested in art and won a scholarship to the Master School of Sculpture at Vienna, also studying in France and Italy. He taught art in Vienna, 1935–7, and also held classes for the Czech army. He lived for a number of years in successive countries (South

Africa, Bali and Australia) before settling in London in 1948. He exhibited from this date at the Royal Academy, the National Society of Painters, Sculptors and Gravers, and the Royal Society of British Artists. Fleischmann did many portrait busts including four successive popes from life, a record accomplished by no other artist. His work, though originally figurative, became increasingly abstract from the 1960s and he became a pioneer in the use of perspex for sculpture. A devout Roman Catholic, he has work in many churches. Examples of his work are also in public galleries in Leeds and Blackburn in the UK as well as in Bratislava and Sydney.

Sources: Buckman, D., 1998; Spalding, F., 1990.

Benjamin John Fletcher (1868–1951)
Artist, craftsman and teacher. He worked for the Coalbrookdale Company, Shropshire, from the age of about eleven and from 1885–8 attended part-time classes at Coalbrookdale School of Art. Here he was influenced by the principal Augustus Spencer's ideas about linking art to manufacturing. When in 1888 Spencer left to become Principal of Leicester School of Art, he employed Fletcher as a teacher and as his deputy. Fletcher succeeded Spencer as Principal (1900–20), his ideas during his principalship strongly influenced by the Arts and Crafts movement. He and his students produced much work for Dryad Metal Works, his friend Harry Peach's firm (formed in partnership with William Pick in 1912). In 1920 Fletcher left Leicester to take up the post of Principal at Birmingham School of Art.

Sources: *L. Advertiser*, 2 May 1914, p.[?]; *L. Mercury*, 3 August 1922, p.1; *L. Daily Post*, 25 September 1920, pp.2, 3.

Ron Florenz
Sculptor based in Nottingham. In summer 1980 he had a solo exhibition and held a public

demonstration of portraiture at Hinckley Public Library.

Fogg, Son & Holt
Firm of architects, based in Liverpool.

Ken Ford (b. 1930)
Sculptor born at Birstall, Leicestershire. He studied at Leicester College of Art, 1946–9, and the Royal College of Art, 1949–53, gaining a Rome Scholarship, 1955–7. He was Head of Sculpture at Leicester Polytechnic, 1967–88. From 1998 he has been a visiting lecturer at the Elizabeth Frink School of Sculpture, Stoke-on-Trent. His public commissions outside Leicestershire include *Into our First World*, 1993, Surrey Heath House, Camberley, Surrey.

Sources: information from the sculptor; *L. Mercury*, 13 October 1992, p.4.

James Forsyth (1826–1910)
London-based architectural and ecclesiastical sculptor. His most notable architectural commissions are the *Perseus Fountain*, c.1860, Witley Court, Great Witley, Worcestershire, and the *Market Place Fountain*, 1867, Dudley, Staffordshire. His ecclesiastical commissions include an *Ascension* relief, date unknown, for Trinity Hall Chapel, Cambridge, and an alabaster relief of *Christ Appearing to his Disciples*, 1860, for the pulpit of St Dionysius Parish Church, Market Harborough, Leicestershire (removed to Harborough Museum, 1975). He executed a number of monuments, including those to *Bishop Parry*, 1881, and to the *Hon. James Beaney*, 1893, both Canterbury Cathedral, to *Bishop Fraser* (died 1885), Manchester Cathedral, and to *Bishop Pelham*, 1896, Norwich Cathedral. He also carried out much work to others' designs, especially the architect William Eden Nesfield, for whom he executed the stone reredos, organ case, table tomb, etc., 1868, at St Mary's, Kings Walden, Hertfordshire, and the *Village Cross*,

1861–70, West Derby, Liverpool. For William Slater he executed a font, c.1862, at Lichfield Cathedral; for R.H. Carpenter relief figures for the reredos, 1884, in the choir at Sherborne Abbey; for B. Ingelow the pulpit, 1899, for the crossing, also at Sherborne Abbey; and for Oldrid Scott the recumbent marble effigy for the *Monument to Bishop T. Leigh Claughton*, 1895, St Alban's Cathedral. Forsyth exhibited between 1880 and 1889 at the Royal Academy and at the Glasgow Institute of the Fine Arts. He was the father of another sculptor, James Nesfield Forsyth.

Sources: Good, M. (comp.), 1995; Johnson, J. and Greutzner, A., 1976; personal knowledge.

Sir George James Frampton (1860–1928)
Sculptor and craftsman, born 16 June 1860 in London. He worked first in an architect's office, then for a firm of architectural stone carvers, before training at the Lambeth School of Art under William Silver Frith and, in 1881–7, at the Royal Academy Schools. His group, *An Act of Mercy*, exhibited at the RA in 1887, won the Gold Medal and Travelling Scholarship and in 1888–90 he was in Paris, studying sculpture under Antonin Mercié. Frampton's *Angel of Death* gained a gold medal at the Salon of 1889. In the 1890s he became interested in the Arts and Crafts movement and wrote influential articles on enamelling, woodcarving, and polychromy, etc., as well as actually producing works in those media. His *Mysteriarch* of 1893, which shows the influence of French symbolism, was awarded the médaille d'honneur at the Paris International Exhibition 1900. Frampton was a member of the Art Workers' Guild from 1887 and Master in 1902. He was elected ARA in 1894 and RA in 1902 (exhibiting there regularly 1884–1928). In 1908 he was knighted. From 1911–12 he was President of the Royal Society of British Sculptors, having been a founder member. Such recognition brought increasing numbers of

public commissions, including many for monuments to Queen Victoria (firstly at Calcutta, 1897; then variants at Winnipeg; St Helens, Lancashire; Leeds, etc.). One of his most splendid private commissions is the set of silver-gilt figure panels of Arthurian heroines for the door of the Great Hall for Lord Astor's London house, 1895–6. Perhaps his most famous work, however, is his bronze *Peter Pan*, Kensington Gardens, 1910 (with a replica at Sefton Park, Liverpool, unveiled 1928). He died 21 May 1928 in London.

Sources: *DNB 1922–1930*; Beattie, S., 1983.

Ben Franklin (1918–86)
Artist and teacher born at Petworth, Sussex. He worked as a lithographic artist, 1933–9, for the last three years of which he studied part-time at Croydon School of Art. During the Second World War he served in the Devonshire Regiment, completing his course at Croydon following demobilisation. From 1947–50 he studied sculpture at Goldsmiths' School of Art and in 1951 worked as an assistant to Frank Dobson on work for the Festival of Britain. Franklin showed at the Royal Academy 1951, 1952 and 1954. He was Head of Sculpture at the West Surrey College of Art and Design, Farnham, 1969–81, and had a retrospective at the James Hockey Gallery in Farnham in 1988.

Sources: Buckman, D., 1998; Spalding, F., 1990.

John Freeman and Sons
Granite merchants and quarry owners based in Penryn, Cornwall, active from the second half of the nineteenth into the twentieth century.

Sources: *Kelly's Directory ... of Cornwall* (various edns).

William Silver Frith (1850–1924)
Sculptor and teacher. He studied at Lambeth School of Art from 1870 and from 1872 also at the Royal Academy Schools. By 1879 he was assistant to the modelling master, Jules Dalou,

and in that year moved with him to the newly-established South London Technical Art School. In the following year he succeeded Dalou and from then until his retirement in 1895 exerted a strong influence over a whole generation of young sculptors, including Frampton, Pomeroy and C.J. Allen, imbuing them with Dalou's more vivacious approach to drawing and modelling. Most of Frith's work as a sculptor was for architects, notably Aston Webb; for example Frith worked on the Victoria Law Courts, Birmingham (figure of *Justice* on the central gable and the spandrel figures of *Truth*, *Patience* and *Plenty*, the latter to designs by Walter Crane, 1887–91); on 13–15 Moorgate, City of London (the niche figures and reliefs, c.1893); on the Cromwell Road façade of the Victoria and Albert Museum (figures of *Grinling Gibbons* and *John Bacon the Elder*, 1899–1909); and at Imperial College, South Kensington (allegorical figures flanking the entrance, c.1906). His other works include the high-relief carvings on the *Royal Engineers South African War Memorial*, 1905, Chatham, Kent; bronze standard lamps, 1908, outside Lord Astor's home at 2 Temple Place, London; spandrel reliefs, c.1908, on the bridge over King Charles Street, Whitehall, London; and the *King Edward VII Memorial*, 1911, Whitechapel. From 1886 he was a member of the Arts Workers' Guild and, in 1905, a founder member of the Royal Society of British Sculptors. He exhibited at the Royal Academy 1884–1912.

Sources: Beattie, S., 1983; *Builder*, 29 August 1924, p.310 [obituary]; Gildea, J., 1911; Gray, A.S., 1985; Stratton, M., 1993.

Steve Geliot
Sculptor and teacher born at Chislehurst, Kent, currently (1999) living at Brighton, Sussex. He studied at Brighton College of Art and Chelsea School of Art. He then went on to teach at Brighton and also at West Surrey College of Art and Design, Farnham. In 1986 he took part

in the Camden Annual at the Camden Arts Centre, London, winning first prize. He has had solo exhibitions at the Camden Arts Theatre, 1987, and the Sue Williams Gallery, London, 1990. His public commissions include *Environment*, Wigmore Park, Luton, 1991; *Fencing and Gateways*, Oldham Park, 1992; *Trefoil*, Norbury Park, Surrey, 1992; *Environmental Works*, Brighton Seafront, 1993; *Courtyard Environment*, Taunton and Somerset NHS Trust Hospital, 1994; and a sequence of six works for Car Dyke, North Kesteven, Lincolnshire.

Source: Axis – Visual Arts Information Service, East Midlands Arts.

Sir Alfred Gilbert (1854–1934)
Sculptor born 12 August 1854 in London, the elder son of a musician. Gilbert had hoped to become a surgeon, but was distracted by the more congenial prospects of a career in art, and managed to get into the Royal Academy Schools in 1873. He also received in 1874 some instruction from Joseph Edgar Boehm who recommended he should study in Paris. This he did, followed by six years working in Italy, where he executed his earliest ideal bronzes and learnt the lost-wax casting process, which he was instrumental in re-introducing to England with a series of bronzes in which the sensitive control of modelling obtainable through this process helped make him the most influential British sculptor of his generation. His *Icarus* of 1884, commissioned by Lord Leighton (PRA), secured Gilbert's election as ARA in 1887. He was a member of the Art Workers' Guild from 1888 and, in 1892, was elected RA. He won important commissions from the Royal Family, including the prestigious *Tomb of the Duke of Clarence* for Windsor. In 1897 he was appointed MVO and in 1900 was nominated Professor of Sculpture at the RA Schools. In 1901, however, he became bankrupt and, amidst a scandal over his unauthorised sale of figures

from the unfinished royal tomb, fled to Bruges, returning only in 1926 after George V had personally requested that he finish the tomb. On his return he was awarded the gold medal of the Royal Society of British Sculptors and, in 1932, was knighted. He was, both before and after his exile, a regular exhibitor at the RA (1882–1907 and 1933–5). He died 4 November 1934 in London. Examples of his work are held in numerous public collections, including the Tate Gallery, Victoria and Albert Museum, Leeds City Art Gallery, Walker Art Gallery, Liverpool, and National Museum of Wales, Cardiff.

Sources: Beattie, S., 1983; *DNB 1931–1940*; Dorment, R., 1985; Dorment, R. (ed.), 1986; *Who Was Who 1929–1940*.

(Arthur) Eric (Rowton) Gill (1882–1940)
Sculptor, draughtsman, engraver, letter-carver, typographer and author born 22 February 1882 at Brighton, the son of a minister. In 1897 the family moved to Chichester and Gill attended the art school there for two years. In 1900 he was apprenticed in London to the architect W.D. Caröe but found contemporary notions of architecture not to his taste. In the evenings he took lessons in masonry and lettering, the latter under Edward Johnston at Central School of Art and Design. In 1903 Gill left the architect's office and worked as a letter-cutter. In 1904 he married and by 1907 was living in Ditchling, Sussex. About this time he began engraving and in 1909 made his first stone figure, not following the traditional method of first producing a clay model for replication in stone, but carving directly from the stone. By now Gill had acquired influential friends, including Roger Fry and Augustus John, the latter of whom helped him set up his first solo exhibition in 1911 at the Chenil Gallery, Chelsea. Always of a deeply religious mind, in 1913 Gill converted to Roman Catholicism (becoming in 1918 a Dominican tertiary) and in

the same year was commissioned to carve the Stations of the Cross for Westminster Cathedral (completed 1918). Following the First World War, he was commissioned to execute war memorials at Bisham, South Harting, and Trumpington. He also continued working on religious commissions including another set of Stations of the Cross, 1921–4, for St Cuthbert's Church, Bradford. In 1924 Gill moved to Capel-y-ffin, Wales, for four years. In this period he executed *Mankind*, a colossal torso in Hoptonwood stone later acquired by the Tate Gallery, and designed his 'Perpetua' and 'Gill Sans' typefaces. In 1928 he moved to Pigotts, near High Wycombe, and over the next three years published *Art-Nonsense* (1929), his first full-length book; some of his finest illustrations; and, in 1929–32, his sculptures for the exterior of Broadcasting House. From 1935–8 he was engaged on his large relief, *The Creation of Adam*, for the League of Nations Palace at Geneva. In 1935 he was elected honorary ARIBA and in 1937 he was made an honorary associate of the RBS and was elected ARA (thereafter exhibiting at the RA 1938–41). In 1938 he collaborated with a professional architect to build an octagonal church planned round a central altar at Gorleston-on-Sea, Norfolk. He was busy to the very end of his life. He died of a lung infection on 17 November 1940, the year his *Autobiography* was published. Retrospectives include Kettle's Yard, Cambridge, 1979, and the Barbican Art Gallery, 1992–3 (and tour).

Sources: Collins, J., 1992; Collins, J., 1998; *DNB 1931–1940*; Nairne, S. and Serota, N. (eds), 1981; Spalding, F., 1990; Strachan, W.J., 1984; *Who Was Who 1929–1940*.

Michael Gillespie (b. 1929)
Sculptor and teacher. He studied at Hammersmith College of Art and later taught at Hertfordshire College of Art and Cambridgeshire College of Art and Technology. A major influence on his work

was Jacob Epstein from whom he learnt bronze casting; he also carried out some casting for Epstein and for Elizabeth Frink. Gillespie exhibited at the Royal Academy in 1962 and 1963 and had a solo exhibition at the Gilbert-Parr Gallery, London, 1979. In 1969, with John W. Mills, he published the manual, *Studio Bronze Casting*.

Sources: Buckman, D., 1998; National Art Library information file.

Gerald Gladstone (b. 1929)
Sculptor, painter and draughtsman born in Toronto, Canada, of English-born parents. Largely self-taught as an artist, he started drawing at the age of eleven. After leaving school he had a number of jobs, mostly in advertising. He made his first piece of sculpture in 1956 as a result of seeing a solo exhibition of work by Gordon Rayner at the Art Gallery of Toronto. Drawn to working in steel, Gladstone studied welding, and in 1957 he too had a solo exhibition at the Art Gallery of Toronto. Furthermore, the Gallery purchased one of his sculptures, *Female Galaxy*. More solo exhibitions followed, as well as two important commissions in 1959 in the city of Toronto: *Fountain* (a construction) for the Federal Government's William Lyon MacKenzie Building, and *Pylon*, a construction in bronze and concrete for the East York Public Library. In 1961 Gladstone was awarded a Canada Council grant. This funded a visit to England of several months, during which time he produced paintings and sculptures, studied at the Royal College of Art and in 1962 had his first London exhibition, at the Molton Gallery. Gladstone returned to Canada and continued working and exhibiting to considerable critical acclaim. In 1964, three of his sculptures were selected for the Second Canadian Sculpture Exhibition (sponsored by the National Gallery of Canada). In the same year he had his second solo show in London, at the Hamilton Galleries, his first in

New York City, at the Graham Gallery, and was the subject of a CBC TV documentary, *The Creative Welder*. He continued to show internationally and to receive commissions, including *Solar Cone*, for Winnipeg Air Terminal Building, a fountain for the Toronto Telegram Newspaper Building, and a couple of pieces for the Canadian Pavilion at Expo 67. Examples of Gladstone's work are in the National Gallery of Canada; Montreal Museum of Fine Arts; the Victoria and Albert Museum, London; and in private collections in Canada, USA and Britain.

Sources: *Apollo*, February 1964, pp.147–8; *Connoisseur*, February 1964, p.127; MacDonald, C.S. (comp.), 1977; Spencer, C.S., 1962.

Joseph Goddard (1840–1900)

Leicester-based Gothic Revival architect, the son of architect Henry Goddard (1792–1868). Joseph was articled to his father in 1856, aged 16. In 1862 he became a partner and the firm was henceforth known as Goddard and Son, soon becoming the leading Leicestershire church architects, a position the firm held until the end of the century: during the 1860s Goddard and Son restored 23 churches in the county and built one new church, St Andrews, Tur Langton, 1865–6 (from about this time onwards, Joseph was effectively in control of the practice and the design here is generally attributed to him). In 1874 A.H. Paget (1848–1909) joined the practice and in *c*.1890 so did Joseph's son, Henry Langton Goddard (1866–1944) at which point the practice became known as Goddard, Paget & Goddard and from 1897, Goddard & Co. The practice exists to this day, now based in London, as the Goddard and Manton Partnership. The buildings for which Joseph Goddard is best known in Leicester are the *Haymarket Clock Tower*, 1868 (see pp.112–18) and the Leicestershire Banking Company Headquarters (now HSBC), Granby Street, 1872–4 (see pp.105–6). He also designed

numerous houses and schools throughout the county. By the early 1890s his son, Henry Langton, had effectively taken over and a renaissance-influenced style prevailed.

Sources: Brandwood, G. and Cherry, M., 1990; Gill, R., 1989.

John Alfred Gotch (1852–1942)

Architect and author born 28 September 1852 at Kettering, Northamptonshire. He studied at the University of Zurich and King's College, London, after which he was articled to architect and surveyor R.W. Johnson of Melton Mowbray and Kettering. After Johnson's death in 1879 his Kettering practice was taken over by Gotch and Charles Saunders, a partnership which lasted 55 years (the partnership exhibited at the Royal Academy 1890–1928). In 1882 Gotch became surveyor to Kettering Urban District Council. In 1886–7 he was President of the Architectural Association and in 1923–5 President of the Royal Institute of British Architects (as well as being a member of the RIBA council for forty years). For some years he was a member of the Royal Fine Art Commission, an honorary corresponding member of the American Institute of Architects, and first President of the Northamptonshire Association of Architects. He was also a member of Northamptonshire County Council. In addition to being a practising architect, Gotch was an eminent architectural historian, notably of early Renaissance architecture, particularly that of Northamptonshire. He died at Weekley Rise, near Kettering, 17 January 1942.

Sources: *Builder*, 23 January 1942, p.78 (obituary); Gray, A.S., 1985; *Royal Institute of British Architects Journal*, February 1942, pp.66–7 (obituary).

Joseph Gott (1785–1860)

Sculptor, born in London and baptised at St Martin-in-the-Fields 11 December 1785.[1] He first served as an apprentice in the studio of

John Flaxman and then, in 1805, entered the Royal Academy Schools where he won a Silver Medal in 1806 and a Gold in 1807. In 1808 he was awarded the Greater Silver Palette by the Society of Arts for *Samson*, a sculpture in plaster, and in 1819 a second Gold Medal from the RA for his *Jacob Wrestling with the Angel*. Gott enjoyed the patronage of individuals both highly influential – e.g., Sir Thomas Lawrence – and wealthy – e.g., Benjamin Gott (no relation) of Armley House, Leeds. It was the latter who paid for Gott to go to Rome in 1824. He was to remain there for the rest of his life, continuing to send work to the Royal Academy (1820–48) and to produce works for Armley House. In 1821 and 1822 he showed at the British Institution and in 1855 sent a sculpture, *Ruth Gleaning*, to the Universal Exhibition, Paris. Examples of his work are in the John Soane Museum, London, and the Leeds Sculpture Collections. His monuments include *Thomas Lloyd*, 1828, Leeds Parish Church, and *Benjamin Gott*, 1840, Armley, Yorkshire. He died 8 January 1860 in Rome and was buried in the Protestant Cemetery.

Sources: Gunnis, R. [1964]; Temple Newsham House, 1972.

Note [1] Information from Dr Terry Friedman.

William D. Gough (active *c*.1915 – *c*.1937)

Architectural sculptor based in London. He practised alone until *c*.1933 after which he continued as W.D. and J.H. Gough, taking on monumental as well as architectural sculpture. He carried out much work for the architect Ninian Comper; in addition to those works covered in the present volume, in 1915 he carved figures for Comper's reredos in St Michael's Church, Stanton, Gloucestershire.

Sources: Good, M. (comp.), 1995; *Post Office London Directory* (edns from 1916–37).

Mike Grevatte (b. 1943)

Sculptor born in Northern Rhodesia. He

studied at Leicester Polytechnic, 1969–72, receiving a Diploma in Art and Design (Fine Art). From 1974–5, he worked as a conservator at Leicester City Museum and from 1982–3 was artist-in-residence at Nottingham City Hospital. In 1984 his *Swan* in elmwood was selected for the International Garden Festival at Liverpool.

Sources: *Festival Sculpture* (Liverpool), 1984; *L. Mercury*, 6 April 1984, p.15.

Edward O. Griffith (active 1888–1921)
A Liverpool sculptor, he exhibited at the Walker Art Gallery five times from 1888 to 1912. He executed all the sculptural work on (Sir) Henry Tanner's New Post Office in Victoria Street, Liverpool, and worked with William Birnie Rhind on Matear and Simon's New Cotton Exchange in Old Hall Street, Liverpool. He also executed all the stone carving in the church of the Holy Trinity, Southport.

Sources: Cavanagh, T., 1997; Johnson, J. and Greutzner, A., 1976.

David Hall (b. 1937)
Sculptor and teacher born at Leicester. He studied at Leicester College of Art, 1954–60, and the Royal College of Art, 1960–4 (under Bernard Meadows). In 1964 he won the Young Contemporaries Kasmin Prize and in 1965, at the IV Biennale de Paris, the Prix des Jeunes Artistes and Prix de la Ville de Paris. His work was included in the 1966 Battersea Park open-air exhibition and the 1968 Arts Council touring exhibition, 'Art in a City'.

Sources: Art Council of Great Britain, 1968; Buckman, D., 1998.

Francis J. Hames (*fl.*1871–9; d. 1922)
An architect, he designed Leicester's Town Hall, 1873–6 (designs shown at the Royal Academy, London, 1874) and the Fountain in Town Hall Square (see pp.155–7). He also designed a 'simple Domestic-Revival-style

building (the earliest in Leicester, 1871–3)' in Silver Street, Leicester.[1] As Pevsner has noted, very little else is known about his career. Hames died at his home in London.

Sources: *L. Chronicle*, 3 June 1922, p.3 (obituary); Pevsner, N. and Williamson, E., 1992; Wilshere, J., 1976.

Note [1] Pevsner, N. and Williamson, E., 1992,p.230.

Cecil G. Hare – see Bodley and Hare

Stockdale Harrison & Sons Ltd (practice active *c.*1904 – *c.*1954)
Leicester-based architectural practice founded by Stockdale Harrison (1846–1914). He is listed working independently from *c.*1875. The practice was continued after his death by his sons, James Stockdale Harrison (1874–1952) and Shirley Harrison (1876–1961). In addition to the works covered in the present volume, Stockdale Harrison was responsible for the former Abbey Sewage Pumping Station (now a museum), Leicester, 1889–91, St Thomas's Church, South Wigston, 1892–3, Vaughan College, Leicester, 1906, St Guthlac's Church, South Knighton, 1912 (Stockdale Harrison's last work) and a considerable amount of better-quality domestic architecture in Leicester. The practice's most important commission outside Leicestershire was the Usher Hall, Edinburgh, 1910–14.

Sources: *Kelly's Directory of . . . Leicester and Rutland* (edns from 1875–1954); Pevsner, N. and Williamson, E., 1992.

Richard Hayward (1728–1800)
Mason-sculptor, born in Bulkington, Warwickshire. He was first apprenticed to Christopher Horsenaile (died 1742) in London, transferring on the death of his master to Henry Cheere, with whom he stayed until 1749. Very large payments from Cheere in the latter part of his apprenticeship indicate his importance in the workshop and suggest that he may have

been solely responsible for some of the work put out under Cheere's name during this period. He may have continued working for Cheere following the completion of his apprenticeship, as his datable works do not appear before the 1760s. In 1752 he was appointed Renter Warden of the Masons' Company and in 1753 went to Rome where he stayed for about a year. One of his earliest patrons was Charles Jennens of Gopsall, Leicestershire (see pp.187–9), in whose London home in 1761, according to Dodsley (*London*, 1761, vol. v, p.96) were works by Hayward including 'a Bacchanalian Boy, Bust of Aratus, and a Vestal'. Hayward received many commissions for carved marble chimney-pieces, including those at Kedlestone, 1760; Woburn Abbey, 1771; and, from 1778 onwards, several at Somerset House. In 1772 and again in 1774 he was at Blenheim providing terms for the gallery and an ornamental fountain for the grounds. Hayward also has the distinction of having executed the earliest surviving public statue in the USA (*Statue of Lord Botetourt*, 1773, Williamsburg, Virginia). He also enjoyed a highly successful practice as a maker of church monuments, his commissions including six for Westminster Abbey. In 1789, he presented a carved marble font to the church at his birthplace, Bulkington. Hayward, who exhibited at the Society of Arts, 1761–6, died at his lodgings in Halfmoon Street, London, on 11 September 1800.

Sources: *Gentleman's Magazine*, September 1800, p.909; Gunnis, R., [1964]; Webb, M.I., 1958; Whinney, M., 1988.

Dame (Jocelyn) Barbara Hepworth (1903–75)
Sculptor, born 10 January 1903 at Wakefield, Yorkshire, the daughter of a civil engineer. She entered Leeds School of Art in 1919, transferring to the Royal College of Art in 1920. In 1924 she won a scholarship for one year's study abroad and went to Italy with

sculptor John Skeaping, whom she married in 1925 (marriage dissolved 1933). They stayed in Rome until 1926. In Italy Hepworth learned to carve stone, a skill not taught at the Royal College, as it was at this time considered stonemason's work. She had her first major exhibition in 1928 at the Beaux Arts Gallery, Hampstead (with Skeaping), her work there consisting of stone carvings of figures and animals. During the early 1930s she simplified her forms to the point of complete abstraction, a process encouraged by her association with Ben Nicholson, who was to become her second husband in 1938[1] (marriage dissolved 1951). The couple visited Paris and were in touch with the international avant-garde, notably Picasso, Brancusi, Braque and Mondrian, both becoming members of the Paris-based Abstraction-Création group. They were also members of the English Seven and Five Society and Unit One. In 1939 they moved to St Ives, where Hepworth stayed for the rest of her life, allowing the Cornish landscape to influence her abstract forms. She had numerous retrospective exhibitions, including the Venice Biennale in 1950, the Whitechapel Art Gallery in 1954 and 1962, the São Paulo Biennale in 1959, where she was awarded the Grand Prix, and the Tate Gallery in 1968. Her most prestigious commission was *Single Form* (unveiled 1964) for the UN building in New York. She was appointed CBE in 1958 and DBE in 1965. She received honorary degrees from several British universities and, in 1973, honorary membership of the American Academy of Arts and Letters. She died in a fire in her studio at St Ives 20 May 1975. Trewyn studio, as it is called, was presented to the nation by her executors in 1980 together with a representative collection of her work.

Sources: Buckman, D., 1998; *DNB 1971–1980*; Gale, M. and Stephens, C., 1999; Nairne, S. and Serota, N. (eds), 1981; Strachan, W.J., 1984; Turner, J. (ed.), 1996.

Note [1] Date as given by Alan Bowness (*DNB*) and Penelope Curtis (1998, p.11). There seems to be much confusion about the date of this second marriage. G.S. Whittet, writing in Cerrito, J. (ed.), 1996, p.500, gives the date as 1932. Curtis at first agreed with Whittet (in Turner, J. [ed.] 1996, vol. 14, p.401); then, in Gaze, D. (ed.), 1997, p.670, gave the date as 1936, but most recently, as indicated above, settled on 1938, in line with Bowness.

Henry Herbert and Sons (active *c*.1899 – *c*.1969)
Leicester-based firm of builders.

Sources: *Kelly's Directory of . . . Leicester and Rutland* (edns from 1899–1969).

Alfred Herbert, Herberts (Masonry Contractors) Ltd
Market Harborough-based firm of stonemasons owned by Alfred Herbert, grandson of Alfred Herbert of Melton Mowbray (active *c*.1916– 41). The earlier Alfred's firm was carried on by his son, A.T. Herbert, who ran it from Syston, reforming it in 1960 as a limited company, A.T. Herberts Ltd, with himself and his two sons, Alfred and Peter, as directors. In the mid-1970s the firm moved to Market Harborough and in about 1984 Alfred bought out his brother Peter, thereby becoming sole owner. The firm has carried out numerous works of restoration in and around Leicestershire (see e.g., pp.88, 118). One of its principal commissions of original work is the *Statue of St Thomas More* in Ancaster stone for the west front of St Thomas More Church, Knighton, Leicester.

Sources: information from Alfred Herbert; *Herberts stone masons* (publicity brochure); *Kelly's Directory of . . . Leicester and Rutland* (edns from 1922–41).

Martin James Heron (b. 1965)
Sculptor, born 7 February 1965 at Cookstown, Northern Ireland, currently (1999) based in Derbyshire. He studied at John Moores University, Liverpool (Foundation, 1985–6; BA [Hons] Fine Art, 1986–9) and has had solo exhibitions at the Groundwork Trust, Blackburn (1995), the Tyrone Guthrie Centre, Newliss, Co. Monaghan, Republic of Ireland (1996) and the Lawrence Batley Theatre, Huddersfield (1998). His public commissions include *Head to Head – between you and me*, carved wood, 1995, Rossendale Borough Council; *Triangle / Circle / Square*, mixed media, 1996, Tyrone Guthrie Centre; and *Totem*, carved wood, 1998, Blackmoor Special School, Blackburn.

Source: information from the sculptor.

Mark Hessey (active *c*.1870–85)
Sculptor based in York.

Source: *Steven's Directory of York*, 1885.

Peter Hide (b. 1944)
Sculptor and teacher born at Carshalton, Surrey. He studied at Croydon College of Art, 1961–4, and St Martin's School of Art, 1964–7, later teaching at Norwich School of Art, 1968–74, and St Martin's School of Art, 1971–8. In 1977 he was appointed Professor of Sculpture at the University of Alberta, Canada. Hide exhibited at the Stockwell Depot from 1968 and his work was included in the group's travelling exhibition to Oslo and Gothenburg in 1970. Other group and mixed exhibitions include 'Prospect 68', Düsseldorf, Germany, 1968; 'The Conditions of Sculpture', Hayward Gallery, 1972; and the 'Silver Jubilee Contemporary British Sculpture' exhibition, Battersea Park, 1977. In 1986 he had a ten-year retrospective exhibition at Edmonton Art Gallery, Canada, and in 1990 a solo exhibition at the André Emmerich Gallery, New York. Hide is an abstract sculptor, concerned principally with structure and working mostly in steel, either solely or in combinations calculated to emphasise the physical properties of the material. Examples of his work are in the collection of the Arts Council of Great Britain, the Tate Gallery, the City of Barcelona

Museum of Modern Art, and in various North American collections.

Sources: Buckman, D., 1998; Hayward Gallery, 1972.

Anthony Hill (b. 1930)
Constructionist artist born 23 April 1930 in London. He studied at St Martin's School of Art, 1947–9, and Central School of Art and Design, 1949–51. At the latter school he met firstly Victor Pasmore and Robert Adams and then in 1950 Kenneth and Mary Martin and Adrian Heath; Hill joined these artists in a group primarily devoted to constructed abstract art. In the same year he made the first of many visits to Paris, contact with Picabia, Kupka and Vantongerloo exerting a great influence on his adoption of complete abstraction. He showed his first work in public at 'Aspects of British Art', ICA, 1950–1. In 1955–6 he made his last paintings and thenceforward committed himself full-time to constructed reliefs. He showed his first constructed relief (in plastic) in the 'Nine Abstract Artists' exhibition, Redfern Gallery, 1955, and had his first solo exhibition of reliefs in 1958 at the Institute of Contemporary Arts. He took part in 'This is Tomorrow', Whitechapel Art Gallery, 1956, and 'Construction: England 1950–1960', Drian Gallery, 1961. In 1960 Max Bill invited him to participate in 'Konkrete Kunst' at Zurich and from this time onwards he exhibited internationally. He taught part-time at the Polytechnic of Central London and Chelsea School of Art and, from 1971–3, had a Leverhulme Fellowship in the mathematics department, University College, London. From 1973 he began producing a different kind of work, comprising collages and later on reliefs, which he signed at first Rem Doxford and then REDO (examples shown at the Angela Flowers Gallery, 1983). His chief public commission was a large mural-relief for the headquarters of the International Union of Architects' Congress, South Bank, 1961. A major retrospective was held at the Hayward Gallery, 1983.

Sources: Arts Council of Great Britain, 1983; Buckman, D., 1998; Nairne, S. and Serota, N. (eds), 1981.

Antony Hollaway (b. 1928)
Sculptor, stained-glass designer, painter, writer, and teacher born 8 March 1928 at Kinson, Dorset. He studied art at Bournemouth College of Art, 1948–53, took an art teacher's diploma at Southampton University, 1953, and was at the Royal College of Art, 1953–7. Throughout the 1960s he was a visiting lecturer at Central School of Art and Design, Hornsey College of Art, Guildford School of Art, and Kingston College of Art. He taught full-time at Kingston Polytechnic, 1970–3 (lecturer, Foundation Studies); at Epsom School of Art and Design, 1973–9 (senior lecturer, Foundation Studies, 1973–6; Head of Three-Dimensional Design, 1976–9); and Trent Polytechnic, Nottingham, 1979–89 (Head of Three-Dimensional Design, 1979–88; Head of Design, 1988–9). Hollaway took early retirement in 1989 to concentrate on stained-glass design. His commissioned work outside Leicestershire includes a concrete relief sculpture for the University of Manchester, 1963–5; a mural for City University, London, 1970; a mosaic for Lloyds Bank Head Office, Cornhill, London, 1970; and stained glass windows for numerous churches and most notably Manchester Cathedral, 1971–2, 1976, 1980, 1991 and 1995. He was elected: a member of the Architectural Association in 1959; a member of the National Society for Art Education and a fellow of the Society of Designer Craftsmen in 1968; a fellow of the British Society of Master Glass Painters in 1974; a fellow of the Royal Society of Arts and of the Society of Industrial Artists and Designers in 1983; and chairman of the Eastern Region Royal Society of Arts in 1989. From 1993–5 he was a member of the council of the Royal Society of Arts. His work has been included in numerous group exhibitions in Britain and overseas.

Source: information from the sculptor.

John Hoskin (1921–90)
Sculptor in metal, born at Cheltenham, Gloucestershire. He left school at 14 and worked as an architectural draughtsman until the Second World War when he served in the Army. After the war he returned to his previous work but by 1950 had begun painting and making sculptures, and by 1953 had committed himself to sculpture. He worked for a while as an assistant to Lynn Chadwick before being appointed Head of the Sculpture School (part-time) at Bath Academy, 1957–68. From 1954 he showed with the London Group. His first solo exhibition was at Lords Gallery in 1957, and his work was featured in a number of mixed exhibitions including Coventry Cathedral's open-air 'Exhibition of British Sculpture', 1968. From 1968–71 he was sculptor-in-residence at Lancaster University and from 1978–88,[1] Professor of Fine Art at Leicester Polytechnic. His publicly-sited sculptures include *Exalted Christ*, 1958–9, a reredos in mild steel for St Stephen's Church, Southmead, Bristol; a cross and reredos, 1960, for Nuffield College Chapel, Oxford; *Red Strike*, 1966, for the University of Kent campus; and *Kendal Sculpture*, 1972, for the Provincial Insurance Company, Kendal. A retrospective exhibition was held at the Storey Gallery, Lancaster, 1994, and a photographic archive of Hoskin's work is in the The Centre for the Study of Sculpture, Leeds.

Sources: 'Notes (possibly compiled by John Hoskin)' in the John Hoskin archive, The Centre for the Study of Sculpture, Leeds; Buckman, D., 1998; *The Guardian*, 13 April 1990 (obituary); Spalding, F., 1990; Strachan, W.J., 1984.

Note: [1] Dates as given by Susan Tetby, a former colleague of Hoskin.

(Mrs) M. Alwen Hughes
Sculptor based at Maida Vale, London, in the late 1950s when she exhibited several ciment fondu animal sculptures at the Royal Academy (1957, 1958 and 1959).

Samuel Hull (active 1850s)
Leicester-based stonemason.

John Jackson (b. 1938)
Sculptor and teacher born in London. He studied at Walthamstow School of Art, Hornsey College of Art and Central School of Art and Design. He was head of sculpture at Batley School of Art and also taught at Maidstone College of Art, West Ham College, Loughton College of Further Education, Homerton College, Cambridge, and Cambridge School of Art. He was visiting artist at the University of Wisconsin, 1969–70 and 1976, and subsequently at Maidstone College of Art, the Universities of North Michigan, Mississippi, and South Dakota, USA, and Chesterfield School of Art. He has shown with the London Group and his work has been included in various mixed exhibitions such as the Leeds and Essex University Arts Festivals, 1966; 'East Anglian Artists Today', Royal Institute Galleries, 1969; and East Anglian Sculptors Exhibition, Ipswich Civic Centre, 1976. He has had solo exhibitions at Kettle's Yard, Cambridge, and The Minories, Colchester. His publicly-sited sculptures include *The Entrance*, 1977, Wardown Park Recreation Centre, Luton, and *Bedford*, 1982, Sandy Upper School, Bedford.

Sources: Buckman, D., 1998; Strachan, W.J., 1984.

Colin Edward Lawley Jones (b. 1934)
Constructivist sculptor and designer born in Worcester. He studied at Malvern School of Art, 1955–7, and Goldsmiths' School of Art, 1957–60 (where he was taught by Kenneth Martin). At Stafford College of Art, he was a lecturer, 1961–4, and, at Leicester Polytechnic, he was senior lecturer in the School of Fine Art, 1964–83, and Head of the Drawing Centre, 1983–9. In later years he was visiting lecturer at Cranfield Institute of Technology, Gwent College of Higher Education, Peterborough Regional College, the University of East London, De Montfort University, the University of Leicester, and Ulster University. His work has been shown in a number of exhibitions including, 'The Geometric Environment', AIA Gallery, 1962; 'Construction England' (Arts Council touring exhibition), 1963; 'Relief Structures', Institute of Contemporary Art, 1966; 'Systems' (Arts Council touring exhibition), 1972; Düsseldorf International Art Fair, 1974 and 1975; 'Sequences' (tour), West Germany, 1976; 'Constructivism Today', Gardner Centre, Sussex University, 1978; 'Diverse Approaches to a Structured Art', Saarbrucken (and German tour), 1986; and 'Creativity and Cognition' (exhibition and conference), Loughborough University, 1993. In 1964 Jones won a prize in the Leeds Sculpture Competition at the Merrion Centre. His commissions include *Neon Light Sculpture*, Phoenix Arts Centre, Leicester (with Arts Council grant), 1980–1, and *Neon Sculpture*, Sharespace Shopping Arcade, Nottingham, 1984–5.

Sources: information from the sculptor; Buckman, D., 1998; *L. Mercury*, 11 November 1983; Spalding, F., 1990; Strachan, W.J., 1984.

Karin Jonzen (1914–98)
Sculptor and teacher, born Karin Löwenadler of Swedish parents on 22 December 1914 in London. In 1944 she married artist and dealer Basil Jonzen (died 1969) and then in 1972 the Swedish poet Ake Sucksdorff. As a child her comic drawings impressed her father sufficiently for him to send her to the Slade School of Fine Art (1933–6), hoping she might become a *Punch* cartoonist. She aspired to a more serious line of work, however, and spent much time studying in the British Museum and National Gallery; furthermore she won both the painting and sculpture prizes and in 1936 was awarded a scholarship for a fourth year which she spent at the City and Guilds School, Kennington. In 1939 she was at the Royal Academy, Stockholm, and in the same year won the Prix de Rome, although the Second World War – in which she served as an ambulance driver – prevented her from going to Italy. She was invalided out with rheumatic fever and during her recuperation became convinced that modernism – which she believed 'did violence to the human form' – was not the correct way forward; from this time she was to adopt a more classical style. Jonzen was elected a fellow of the Royal Society of British Artists in 1948. She had a solo exhibition at the Fieldbourne Galleries, 1974, exhibited at the Royal Academy from 1944, and also showed in various group and mixed exhibitions. She died 29 January 1998. Examples of her work are in the National Portrait Gallery; the Victoria and Albert Museum; and the Bradford, Brighton, Glasgow and Southend art galleries. Her public commissions include *The Gardener*, 1971, Brewer's Hall garden, by London Wall; *Beyond Tomorrow*, 1972, Guildhall Piazza; and *Bust of Samuel Pepys*, 1983, Seething Lane Gardens, all bronze and in London.

Sources: Buckman, D., 1998; *The Independent*, 2 February 1998, p.16 (obituary); Spalding, F., 1990; *The Times*, 31 January 1998, p.25 (obituary); Waters, G.M., 1975; *Who's Who 1998*.

Amerjit Kaur Kalwan
Loughborough-based sculptor. She spent her foundation year (1993) at Stourbridge College of Art and Design before going on to Loughborough College of Art and Design where she achieved a BA (Hons) in sculpture (1997).

William Keay – see Everard and Pick.

Richard Kindersley (b. 1939)
Sculptor and letterer born 14 May 1939 in London. He studied at Cambridge School of Art and in the studio of his father, David Kindersley. He set up his own studio in London in 1966. His commissions include sculptural work for Exeter University, British Telecom, Lloyds Register of Shipping, and Christies' Fine Art, as well as numerous lettering schemes, including an inscription on permanent display at the Gallery of the 20th Century, Victoria and Albert Museum, intended to serve as a demonstration of modern craft skills. In 1998 he was commissioned to produce a major piece of public art for London's Jubilee Line extension. Kindersley has had exhibitions at the Mall Gallery, London; Winchester Art Gallery; Bath City Art Gallery; and the Scottish Gallery, Edinburgh.

Source: information from the sculptor.

A.E. King (active c.1899 – c.1928)
Loughborough-based architect, operating alone from c.1899 and then from c.1912 – c.1928 as A.E. King & Co.

Sources: *Kelly's Directory of . . . Leicester and Rutland* (edns from 1899 -1928).

Phillip King (b. 1934)
Sculptor born 1 May 1934 in Kheredine, Tunisia; he moved to England with his family in 1946. After studying modern languages at Cambridge University, 1954–7, he entered St Martin's School of Art, training as a sculptor under Anthony Caro, 1957–8. In 1959–60 he worked as an assistant to Henry Moore, and briefly to Eduardo Paolozzi. He taught at St Martin's, 1959–80, during which time he was also visiting lecturer at Bennington College, Vermont, 1964, Slade School of Fine Art, London, 1967–70, and Hochschule der Künste, Berlin, 1979–80. From 1980–92 he was Professor of Sculpture at the Royal College of

Art. Having worked initially in clay and plaster, from 1960 King began producing work in fibreglass and metal, and then, from the late 1960s, in metal, wood and slate. His first solo exhibition was in 1957 at Heffer's Gallery, Cambridge, his first London solo exhibition at the Rowan Gallery, 1964, and his work was included in the influential 'New Generation' exhibition, Whitechapel Art Gallery, 1965. He has had retrospectives at the Whitechapel Art Gallery, 1968; Hayward Gallery, 1981; the Yorkshire Sculpture Park, 1992; and the Forte di Belvedere, Florence, 1997. His commissions include *Diamond Sculpture* and *Steps Sculpture*, both 1974–5, for C. & J. Clarke, Street, Somerset; *Cross-bend*, 1978–80, for the European Patent Office, Munich; and *Clarion*, 1981, for Romulus Construction Ltd, London. He was awarded the CBE in 1974 and was elected ARA in 1977, RA in 1991, and PRA in 1999.

Sources: Buckman, D., 1998; Cerrito, J. (ed.), 1996; Hilton, T., 1992; Nairne, S. and Serota, N. (eds), 1981; Royal Academy of Arts, 1972; Spalding, F., 1990; Strachan, W.J., 1984; Whitechapel Art Gallery, 1965; *Who's Who 1999*.

Shona Kinloch (b. 1962)
Figurative sculptor, born in Glasgow. She studied sculpture at Glasgow School of Art, gaining a BA (Hons) in Fine Art (Sculpture), 1980–4, going on to take postgraduate studies, 1984–5. As a postgraduate student 'she became interested in the formal implications of anatomical exaggeration.'[1] She cites as her influences Maillol, Frank Dobson and Marino Marini. Public commissions include *Seven Glasgow Dogs*, Glasgow Garden Festival, 1988 (subsequently sold as individual pieces, three of them to the Kelvingrove Museum, Glasgow); *As the Crow Flies* for the 'Milestones for Scotland' programme, Woodlands, Glasgow, 1990; 'Chookie Burdies', Garenthill Lighting Project, Glasgow, 1993; *Fission*, Scottish Nuclear headquarters, East Kilbride, 1993;

sculptures for Kilmarnock town centre regeneration programme (*Four Twins*, Foregate Square, 1994, *Kilmarnock Swimmers* and *The Binmen*, both King Street, 1994, and *Twa Dogs*, The Cross, 1995); and *The Square Stars*, Hamilton Town Square, 1998. In 1992 Kinloch was awarded the Saltire Society Art in Architecture Award.

Sources: information from the sculptor; Buckman, D., 1998; *Shona Kinloch* (Charnwood Borough Council leaflet), 1998.

Note: [1] *Shona Kinloch* (Charnwood Borough Council leaflet), 1998.

(Robert) Bryan (Charles) Kneale (b. 1930)
Sculptor, painter and teacher born 19 June 1930 in Douglas, Isle of Man. He studied at Douglas School of Art, 1947, and then at the Royal Academy Schools, 1948–52, winning the Rome Prize in painting. He was in Italy, 1949–51, where he was greatly influenced by the Futurists and the metaphysical painters. In c.1959 his increasing preoccupation with form engendered his move from painting to sculpture, at first using solely welded steel but later incorporating other materials. His work is abstract but is largely based on organic forms, both anthropomorphic and vegetal. Kneale's first of many solo shows was in 1954 (paintings only) at the Redfern Gallery (where he first exhibited sculptures in 1960) and he had retrospectives at the Whitechapel Art Gallery, 1966, and at the Royal West of England Academy, 1995. Among the mixed exhibitions he took part in were the John Moores Exhibition, Liverpool, 1961; 'Battersea Park Sculpture', 1963 and 1966; and 'British Sculpture in the Sixties', Tate Gallery, 1965. He also helped organise the exhibitions, 'Sculpture 72', Royal Academy, 1972, and the 'Silver Jubilee Contemporary British Sculpture' exhibition, Battersea Park, 1977 (in both of which he also showed). He taught at the Royal Academy Schools from 1964 (Master of Sculpture, 1982–5; Professor of Sculpture,

1985–90; Trustee from 1995) and at the Royal College of Art (Senior Tutor, 1980–5; Head of Sculpture Dept, 1985–90; Professor of Drawing, 1990 until his retirement in 1995). He was elected ARA in 1970 and RA in 1974 (having shown at the RA since 1953). His work is in collections worldwide including the Arts Council, the Contemporary Art Society, the Tate Gallery, London, and the Museum of Modern Art, New York.

Sources: Buckman, D., 1998; Nairne, S. and Serota, N. (eds), 1981; Royal Academy of Arts, 1972; Spalding, F., 1990; Strachan, W.J., 1984; *Who's Who 1999*.

George Anderson Lawson (1832–1904)
Sculptor born in Edinburgh who trained under A.H. Ritchie and in the schools of the Royal Scottish Academy. He spent some time in Rome, where he admired John Gibson's work, and returned to England, making his home firstly in Liverpool where, in 1861, he was commissioned by Liverpool Corporation to execute a *Statue of the Duke of Wellington* to surmount a 110-foot-high Doric column designed by his architect brother, Andrew Lawson. In 1866 he moved to London and in 1868 had his first popular success at the Royal Academy with his statuette, *Dominie Sampson* (he showed at the RA from 1862–93). In *c*.1888 he executed architectural sculpture for the City Chambers, Glasgow. He also executed a bronze panel, *Painting, Sculpture and Architecture*, to go over the entrance to Aberdeen Art Gallery and a *Statue of Joseph Pease*, 1875, for Darlington, County Durham. He died at Richmond, Surrey.

Sources: Cavanagh, T., 1997; *DNB. Second Supplement*, vol 2, 1912; Gosse, E., 1883; McEwan, P.J.M., 1994.

Neil Lawson-Baker and Auriol Pace
London-based sculptors.

Lloyd Le Blanc, Le Blanc Fine Arts
American-born sculptor and bronze founder based in Saxby, Leicestershire. After completion of his studies at Yale University in 1967, he worked in his own studios in New England, moving to England briefly to take up the post of lecturer in sculpture at Falmouth College of Art in 1969. From 1970–3 he had a studio and foundry in California and then in 1973 moved to Leicestershire on a permanent basis. His work is naturalistic and comprises mostly animals, birds and water features. He has exhibited in London, Hong Kong, Dubai and Australia. His commissions include a sculpture for the Valley Life Insurance Building, Arizona, USA, 1987, and sculptures for the Donnarneade and Port Leach shopping centres, Ireland, 1994, along with numerous private commissions. He runs the Le Blanc Fine Arts foundry at Saxby in collaboration with his sculptor wife Judith Holmes Drewry, casting not just their own work but also that of other sculptors.

Sources: information from the sculptor / founder; *L. Mercury*, 22 April 1994, p.18.

Andrea Carlo Lucchesi (1860–1925)
Sculptor born 19 October 1860 in the City of London, the son of an Italian sculptor's moulder and an English woman. He attended West London School of Art and then, in *c*.1886, the Royal Academy Schools.[1] He also worked as assistant to sculptors H.H. Armstead and Edward Onslow Ford and for two commercial silversmiths, Garrard's and Elkington's. In 1895 his *Destiny* won a gold medal at Dresden and in 1900 a life-size plaster model of *Destiny* and another entitled *A Vanishing Dream*, won gold medals at the Paris International Exhibition. He was best known for portrait busts, e.g., *Sir John Franklin*, 1898, bronze, National Portrait Gallery, and mildly erotic female nudes, e.g., *The Myrtle's Altar*, bronze, RA 1899 (reductions at Birmingham and Preston). In 1903 his *Memorial to Edward Onslow Ford* (designed in collaboration with architect John W. Simpson) was unveiled in Abbey Road, London. Lucchesi also did a bronze tablet to *John Wareing Bardsley, Bishop of Carlisle*, 1906, for Carlisle Cathedral. He was a member of the Art Workers' Guild and exhibited at the Royal Academy from 1881–1925.

Sources: Beattie, S., 1983; Gray, A.S., 1985; Nairne, S. and Serota, N. (eds), 1981; *Who Was Who 1916–1928*.

Note [1] Sources differ: Nairne and Serota (1981, p.257) gives 1881–6 for Lucchesi's entire period at the West London School of Art and Royal Academy Schools; while Beattie (1983, p.246) and Gray (1985, p.237) give 1886 and 1887 respectively for his entry to the Royal Academy Schools.

Joseph Crosland McClure (exhibited 1900–14)
Sculptor and teacher. He taught modelling, firstly at Liverpool School of Art, moving to Leicester by 1905 and taking up a similar post at Leicester School of Art. He is recorded as living in London by 1913. His work was shown in temporary exhibitions, at the Glasgow Institute of Fine Arts (seven times), the Walker Art Gallery, Liverpool (eleven times), and the Royal Academy, London (eighteen times). Commissions not described in the present volume include stone figures of *Truth* and *Wisdom*, 1906, for H.H. Thomson's St Alban's church, Leicester; two sculptural groups: *The Music of the Woods and the Sea* and *Municipal Beneficence and the Soul of Music*, 1910–14, for Stockdale Harrison's Usher Hall, Edinburgh; and a *Statue of King Edward VII* in coronation robes (for which the king granted McClure a sitting) for Madras. Examples of McClure's work are also in Leicester Museum and Art Gallery (*Portrait Bust of Mrs Mary Stanion*) and the Walker Art Gallery (*Sunrise, Morning and Evening*).

Sources: *Architects' Journal*, 8 September 1920, pp.261–2; Gifford, J. *et al.*, 1984; Johnson, J. and Greutzner, A., 1976; *L. Chronicle*, 4 September 1920, p.2; *L. Daily Post*, 31 August 1920, p.3; *L. Mail*, 30 August 1920, p.2; *The Studio*: [i] vol. xxiv, no. 104, November 1901, p.137 [ii] vol. xxxiv, no. 146, May 1905, p.351; *Transactions ...*, 1911–12, x, p.14.

John McKenna (b. 1964)
Sculptor born in Manchester, currently (1999) based in Worcester, a member of the Royal Society of British Sculptors. He studied art and design in London and in 1987 was awarded a three-year bursary to study under the patronage of Dame Elizabeth Frink at the Sir Henry Doulton School of Sculpture, Staffordshire. In 1993 he founded Art for Architecture (a4a), an informal association of artists, designers and craftsmen in a variety of media who collaborate on public art commissions. McKenna's a4a commissions include a polychrome brick relief for Bilston Job Centre, Staffordshire; the *Droitwich Saltworkers Fountain*, Droitwich, Worcestershire; *Phantom Coach and Horses*, stainless steel relief for Canley Railway Station, Coventry; *Children at Play*, 23 mild steel panels for a housing estate, Wednesfield, Staffordshire; *The Commuter*, 1996, Snow Hill Railway Station, Birmingham; *Sculptural Steel Gates*, 1998, Coombes Croft Library, Haringey, London; and *The Glassblower* (with Steve Field), 1995, Stourbridge Railway Station, Worcestershire.

Source: John McKenna. Art for Architecture website: a4a.clara.net/a4a.htm

Ailsa Magnus (b. 1967)
Sculptor born on 3 March 1967 in Cupar, Fife. She studied at Edinburgh College of Art (1985–9, BA Hons in Sculpture) and Grays School of Art, Aberdeen (1989–90, Postgraduate Diploma). Her work has appeared in several group exhibitions, including 'The New Generation', Compass Gallery, Glasgow, 1990; 'Scottish Sculpture Open 6', Kildrummy Castle, Aberdeenshire, 1991; 'Art Cuisine', Milton Keynes Exhibition Gallery, 1991; Scottish Society of Artists Annual, RSA Edinburgh, 1993; European Sculpture Symposium exhibitions in 1993 and 1994 at Foundation Helen-Arts, Bornem, Belgium, and

Gallery Konschthaus, Bien Engel, Luxembourg, respectively; and 'Two Natures' (two-person exhibition), Pier Arts Centre, Stromness, Orkney, 1994. She was artist-in-residence for Clerk Green Renewal Area, Batley, West Yorkshire, May 1995 – March 1998, producing for the Beaumont Street Play Area, Batley, a carved brick relief of three trees. Her other commissions include carved brick wall reliefs for Chinese Ethnic Housing in Hull, 1996, and for Henshaw's, Conyngham Hall Arts and Crafts Centre, Harrogate, 1998. Magnus is an Ordinary Member of the Scottish Society of Artists.

Sources: information from the sculptor; Axis – Visual Arts Information Service, East Midlands Arts.

M.B. Fine Arts Foundry
Foundry established in 1985 by Martin Bellwood at Longford, Clunderwen, Carmarthenshire, Wales.

Meridian Sculpture Foundry (active c.1966–98)
London-based foundry. Work outside Leicestershire includes James Butler's *Statue of Field Marshall Alexander*, 1985, Wellington Barracks, London.

Source: James, D., 1970.

Bill Ming (b. 1944)
Sculptor and teacher born in Bermuda, settling in England in 1971 and currently (1999) living and working at Newark, Nottinghamshire. He studied at Mansfield College of Art, 1975–6, and gained a degree in sculpture and creative writing from Maidstone College of Art, 1979. In 1992–3 he was the first Henry Moore Sculpture Fellow at John Moores University, Liverpool. He has organised sculpture workshops in England, Wales and Bermuda, has been a part-time lecturer at Leicester Polytechnic and Loughborough College of Art and Design, and in 1998 ran workshops in the

'Soweto Schools Project', South Africa. Ming's solo exhibitions include the Africa Centre, Covent Garden, London, 1984; City Museum and Art Gallery, Birmingham, 1987; Mappin Gallery, Sheffield, 1989; 'Two Rock Passage to Liverpool', Bluecoat Gallery, Liverpool, 1993; 'Home Comin'', National Gallery of Bermuda, 1994; 'Stories from da Wood', Parts I and II, Islington Arts Factory, London, and Angel Row Gallery, Nottingham, 1996; and 'Da Spoken Word', Hourglass Studio Gallery, Hebden Bridge, West Yorkshire, 1999. He has also featured in various group exhibitions including 'The Cutting Edge', Manchester City Art Gallery, 1989; 'The Caribbean Connection', Islington Arts Factory, 1995; and 'Reclaiming the Crown', New York, USA, 1997–8. His commissions include *Appletongate Mural*, 1986, Newark-on-Trent; *Craft Box*, 1995, Angel Row Gallery, Nottingham; *Bobo Birds*, 1997, Belle Vue Primary School, Wordsley, Staffordshire; and *Discovery Table* (for the National Trust), 1999, Belton House, Lincolnshire. Ming works mainly in wood and draws his inspiration from his multi-cultural heritage (he is of African, Native American and Scottish ancestry).

Sources: information from the sculptor; Barlow, R., 1989; Buckman, D., 1998.

Martin Minshall
Sculptor, designer and teacher. He studied at Stourbridge College of Art and Design, graduating with a BA (Hons) in Glass and Ceramics, and at Birmingham University School of Art Education where he gained a PGCE. He is currently (1999) Director of Art and Design at Oakham School, Rutland.

Denis Mitchell (1912–93)
Sculptor, painter and teacher born on 30 June 1912 at Wealdstone in Middlesex, but raised at Mumbles, near Swansea. From 1930–9 he attended evening classes at Swansea School of Art, afterwards moving to St Ives, Cornwall,

where he at first worked in a number of jobs whilst pursuing painting in his spare time. He was in 1949 a founder member of the Penwith Society of Arts (Chairman, 1955–7). From 1949–59 he worked for Barbara Hepworth, eventually becoming her chief assistant. During this time he began sculpting, at first in wood, then from 1959 in bronze. In 1957 he founded Porthia Textile Prints. He taught part-time at Redruth Art School and Penzance Grammar School from 1960. In 1966 he won an Arts Council Award and in 1967 gave up teaching to concentrate on sculpture full-time. In 1968 he was awarded a Foreign Office commission, producing *Zelah 1*, a bronze sculpture for the University of the Andes, Bogota, Colombia. In 1969 he moved to Newlyn, Cornwall, and in 1970 went on a lecture tour of Colombia. From 1973 he was a member of the board of governors of Plymouth College of Art and Design and from 1977, of Falmouth School of Art. He had his first solo exhibition in 1957 at the AIA Galleries, London, his first overseas exhibition in 1962 at the Devorah Sherman Gallery, Chicago, and retrospectives at the Glynn Vivian Art Gallery, Swansea, 1979, Gillian Jason Gallery, London, 1990, Penwith Galleries, St Ives, 1992, and Flowers East, London, 1993. A two-man show of Mitchell and his friend Tom Early was held at the Penwith Galleries in 1996. Examples of his work are in the Tate Gallery, Walker Art Gallery, Liverpool, Fitzwilliam Museum, Cambridge, and National Gallery of New South Wales, Australia.

Sources: Buckman, D., 1998; Gillian Jason Gallery, 1990; Spalding, F., 1990; Strachan, W.J., 1984.

Henry Spencer Moore (1898–1986)
Sculptor and graphic artist born 30 July 1898 at Castleford, Yorkshire, the son of a miner. He studied at Leeds School of Art, 1919–21, and the Royal College of Art, 1921–4. In 1925 he went to France and Italy on a travelling scholarship and on his return taught at the RCA, before moving to Chelsea School of Art where he remained until 1939 at which point he resigned to concentrate on sculpture full-time. He was from early on concerned with direct carving and the appropriate use of materials. Much of his work was based on the human figure and even when wholly abstract still retained a strong feeling for natural form: his ideal was not so much the creation of beauty in the traditional sense, as of energy and vitality. His earliest influences were not the sculptures of classical Greece and the Renaissance, but those of ancient Egypt, archaic Greece and particularly, of pre-Columbian America. He achieved recognition early on: in 1928 he had his first solo exhibition at the Warren Gallery, London, and his first public commission, the *West Wind* relief on the London Underground headquarters near St James's Park. He then participated in a number of the most forward-looking group exhibitions such as those of the Seven and Five Society, Unit One, and the International Surrealist Exhibitions held in London in 1936 and in Paris in 1938. During the Second World War, as an official war artist, he made a celebrated series of drawings of Londoners sheltering from air raids in underground stations (published as *The Shelter Sketch-Books*). From early on his work had been bought by private collectors and before long by galleries throughout the world. His large-scale bronzes are to be found in public places in many cities around the world, including London, Washington, New York, Amsterdam, Vienna, Zurich, Singapore, and Hong Kong. He was made a Companion of Honour in 1955 and was appointed a Member of the Order of Merit in 1963. In 1977 he set up The Henry Moore Foundation, a charity whose aim is 'to advance the education of the public by the promotion of their appreciation of the fine arts and in particular the works of Henry Moore'. In 1982 The Henry Moore Sculpture Gallery and Centre for the Study of Sculpture was opened in Leeds. A memorial exhibition was held at the Royal Academy in 1988.

Sources: Buckman, D., 1998; *DNB 1986–1990*; *Who Was Who 1981–1990*; The Henry Moore Foundation website: henry-moore-fdn.co.uk.

Joseph Herbert Morcom (1871–1942)
Sculptor born outside Minera, near Wrexham, in North Wales. His father, captain of the local lead mine, died in 1880 and, as soon as he was old enough, Morcom was sent to work for a local firm of stonemasons. He eventually secured a job in Liverpool with Norbury, Paterson & Co. Whilst with them, in the early 1890s, he enrolled at the Liverpool School of Architecture and Applied Art. Morcom was also taken on as an assistant in the private sculptural practice of C.J. Allen (see pp.153, 352), then head of the School's sculpture department. By 1904 Morcom had been appointed assistant modelling master at the school. In the following year he was elected a member of the Liverpool Academy and was awarded a 'National Medal for Success in Art' by the Board of Education, South Kensington. In the 1909 Eisteddfod he won first prize in the sculpture section. In May 1910 he was appointed modelling master at Leicester School of Art. At Leicester he also worked as an architectural sculptor and in 1914 bought up Pearson and Shipley, a firm of Stonemasons and Monumental Sculptors, based in The Newarke. Morcom called his new firm The Plasmatic Company (see p.381). In addition to his work for the firm, he worked independently as a sculptor and continued at the School of Art. Morcom married in 1915 and his final home was at Kirby Muxloe, in a house designed for him by Ralph Bedingfield and decorated with carved stonework executed by The Plasmatic Company. Morcom exhibited at the Walker Art Gallery, Liverpool, the Royal Cambrian Academy, the Royal Academy, London, and, as a member of the Leicester Society of Artists,

regularly at the New Walk Art Gallery, Leicester. Many of his smaller works and models are now in the collection of the Wrexham Maelor Museum Service, Wrexham, Clwyd. A *Statuette of Andromeda* in bronzed plaster is in Leicester Museum and Art Gallery.

Sources: *L. Mercury*, 4 December 1981, p.18; *The Studio*: [i] vol. xxxiv, no. 146, May 1905, p.351 [ii] vol. xxxvi, no. 152, November 1905, pp.169, **166**, **169** [iii] vol. xxxix, no. 163, October 1906, pp.68, **67**, **68** [iv] vol. xlii, no. 177, December 1907, pp.231, **228**; information from Dr Alan McWhirr.

Morris and Sons (active first quarter of twentieth century)
Northamptonshire-based firm of stonemasons established by Henry Morris, who is first listed working independently as a monumental mason at Rushden. By c.1906 he had set up in practice with his sons in Kettering, firstly as monumental masons and then, from c.1910, as stonemasons.

Sources: *Kelly's Directory ... of Northamptonshire* (various edns from 1898–1924).

Morris Singer
Foundry established by John Webb Singer (1819–1904), who began as a watchmaker and jeweller, setting up Frome Art Metalworks in 1848, specialising in church furnishings. By 1888 he had extended his premises on the outskirts of Frome, Somerset, to incorporate a foundry equipped both for lost wax and sand casting. The foundry, originally called Singer & Sons, went on to become one of the leading fine art bronze foundries in Britain.

Sources: Beattie, S., 1983; James, D., 1984.

George Myers (1804–75)
Builder, sculptor and furniture maker, working principally for A.W.N Pugin. Myers may have met Pugin as early as 1827, but the working relationship between the two men can only be dated with certainty to 1838. Myers, as head of

a Lambeth-based workshop, is believed to have built 36 churches to Pugin's designs. He also personally executed numerous pieces of furniture, decorative carving in wood and stone, and figure sculpture. His main sculptural works for Pugin include the altar and reredos, 1849, St Marie's, Sheffield; the octagonal pulpit and Petre Chantry, including the *Tomb of the Hon. Edward Robert Petre*, St George's Cathedral, Southwark, 1849; the *Tomb of Bishop Thomas Walsh*, 1851, St Chad's Cathedral, Birmingham; the *Tomb of John, Lord Rolle*, 1852, in Holy Trinity Church, Bicton, Devon; the reredos at St Anne's Roman Catholic Cathedral, Leeds; and the Easter Sepulchre at St Giles, Cheadle. A considerable selection of Myers's work was included in 'The Mediaeval Court', Pugin's display at the Great Exhibition of 1851, earning Myers a prize medal in Class XXVII for works in Caen stone.

Sources: Atterbury, P. and Wainwright, C. (eds), 1994; Stanton, P., 1971.

William James Neatby (1860–1910)
Art Nouveau-style designer, born in Yorkshire. At about fifteen Neatby was articled to a local firm of architects, subsequently working in the profession for two years. In about 1883, however, he changed his career path and joined Burmantofts Potteries, Leeds, as designer and painter of glazed ceramic building ware. In 1889 he moved to Doultons of Lambeth as head of the architectural department, staying until 1900. Thereafter he set up with the architect E. Hollyer Evans. In addition to ceramics (the new firm, Neatby, Evans & Co, continued to undertake commissions from Doultons, as well as manufacturing Neatby's own designs), Neatby also designed stained glass for ecclesiastical and domestic purposes, ornamental metalwork and furniture. He was at times executant as well as designer of architectural statuary and was an accomplished wood carver. His major commissions include

the interior decoration of the Restaurant Frascati, Masonic Hall, Oxford Street, London (demolished), incorporating stained glass windows and painted murals; 28 painted ceramic panels for the Winter Gardens Ballroom, Blackpool (completed 1897); the glazed terracotta frontage for the Edward Everard printing works, Bristol (completed 1901); and the interior ceramic decoration of the meat hall of Harrods, Knightsbridge (commission obtained through Doultons; completed 1902). He was a member of the Royal Society of Miniature Painters and exhibited as a painter at the Royal Academy in 1906 (two pictures) and 1909 (one).

Sources: Barnard, J., 1970a; Barnard, J., 1970b; Bradford Art Galleries and Museums, 1983; Fleming, J. and Honour, H., 1989; Gray, A.S., 1985; Vallance, A.,1903.

Denis O'Connor (b. 1959)
Sculptor and teacher born in Dublin. He studied at Limerick School of Art and then Birmingham Polytechnic. He has held many residencies particularly in the Midlands. He has received awards from West Midlands Arts and East Midlands Arts, both 1986; the Arts Council of Ireland, 1987; and Nottinghamshire County Council, 1988. He has shown in mixed exhibitions at the Ikon Gallery, 1983 (and onwards); Castle Museum, Nottingham, 1985; National Garden Festival, Stoke-on-Trent, 1986; and Loseby Gallery, Leicester, 1987. His solo exhibitions include the Herbert Art Gallery, Coventry, and Castle Museum, Nottingham, both 1985, and Derby Museum and Art Gallery (with a residency), 1991. His teaching includes St Martin's School of Art, 1986–8 (visiting tutor) and Derby School of Art and Design, 1988–90 (part-time).

Source: Buckman, D., 1998.

Ezra Orion (b. 1934)
Sculptor born at Kibbutz Beit Alpha, Israel. He studied at Bezalel School of Art, Jerusalem,

1952, at St Martin's School of Art, London, 1964, and at the Royal College of Art, London, 1965–7. His solo exhibitions include Mishkan Le-Omanut, Ein Harod, and the Museum of Modern Art, Haifa, both Israel, 1963, and the Mercury Gallery, London, 1965. In 1968 he designed and constructed the 'Sculpture Field' near the Sdeh Boker College in the Negev Desert, Israel. His work was included in the Museum of Modern Art's 'Art Israel' exhibition at the Jewish Museum, New York. Examples of Orion's sculpture are in the Museum of Modern Art, New York, and the Israel Museum, Jerusalem.

Source: National Art Library information file.

John Panting (1940–74)
Sculptor and teacher born in New Zealand. He studied sculpture at Canterbury University School of Art, 1959–62, and in 1963 won a New Zealand Arts Council Award. He then moved to England and studied at the Royal College of Art, 1964–7, subsequently teaching both there and at Central School of Art and Design, 1967–74 (Head of Sculpture in the latter school, 1972–4). His work featured in several mixed exhibitions in Britain and overseas, including 'Towards Art II' (Arts Council touring exhibition of sculptors from the Royal College), 1965; 'Art 2 '71', Basel, Switzerland, 1971; and 'British Sculpture '72', Royal Academy, 1972. He had solo exhibitions in 1967 and 1968 at Galerie Swart, Amsterdam, and in 1971 at the Royal West of England Academy, Bristol. His chief commission was part of the Peter Stuyvesant Sculpture Project, 1972 (see pp.228–9). Panting was killed in a motorcycle accident in July 1974 and a memorial retrospective exhibition was held the following year at the Serpentine Gallery. His *Untitled No. VI*, mild steel, 1973, was purchased for permanent siting at the Highland Sculpture Park, near Carrbridge, Scotland.

Sources: Buckman, D., 1998; Nairne, S. and Serota, N. (eds), 1981; Royal Academy of Arts, 1972; Spalding, F., 1990; Strachan, W.J., 1984; *Studio International*, vol. 188, no. 969, September 1974 (obituary).

David Partridge (b. 1919)
Sculptor, painter, printmaker and teacher born in Akron, Ohio, USA. He lived in England until he was 16 at which time he moved to Canada and, in 1944, became a Canadian citizen. He studied at the University of Toronto, 1938–41, then served in the Royal Canadian Air Force for four years before going to Queen's University, Kingston, Ontario. He studied painting, firstly in Canada, then at the Art Students' League of New York, before being awarded a British Council Scholarship to the Slade School of Fine Art, London, 1950–1, after which he went on to Atelier 17, Paris. From 1958–61 he was back in Canada teaching. In 1958, he began producing the works for which he is best known, his nail sculptures (or 'nailies' as he calls them), inspired as the sculptor readily admits by the works of Zoltan Kemeny. In 1962 one of Partridge's nail sculptures won for him the Montreal Spring Show Purchase Prize. From 1962–74 he lived in London, during which period he had numerous exhibitions and, in 1965, was commissioned to produce a ceiling sculpture for the roof restaurant at the Royal Garden Hotel. He then returned to Canada and exhibited widely there too, his commissions including murals for Toronto City Hall. Examples of his work are in the Tate Gallery, the Victoria and Albert Museum, and in the National Gallery in Ottawa. His nail reliefs were evidently influenced by fossil formations, the natural structure of plants and rocks, and his experience as an aircraft pilot.

Sources: Buckman, D., 1998; Hamilton Galleries, 1967; Spencer, C.S., 1965.

Peter (Laszlo) Peri (1899–1967)
Sculptor, draughtsman and printmaker born

Laszlo Weisz on 13 June 1899 at Budapest, Hungary. The family, which was Jewish, changed its name to Peri, a Hungarian name, when the sculptor was in his teens. Peri first worked as a stonemason, studying art in the evenings. In the years after the First World War he produced drawings in an Expressionist style and was associated with the left-wing avant-garde journal, 'MA'. His political activities precipitated his departure from Hungary and he stayed briefly in Vienna and Paris before settling in Berlin in 1920. He became associated with a group of exiled left-wing Hungarian artists, one of whom was Moholy-Nagy with whom he had an exhibition in 1922 (at this time Peri's sculpture was constructivist, influenced by Kandinsky). Whilst in Berlin Peri also studied architecture. By 1927 his political convictions – he wanted to reflect life around him in a way that could be understood by ordinary people – drew him back to realism. About this time he started making small figures in bronze. By the early 1930s he and his second wife (whom he had married in 1932 following his separation from his first whom he had married in c.1919) were deeply involved in anti-Nazi activities. When the Nazis came to power in 1933 the Peris fled to England, virtually penniless. Peri now joined the anti-fascist Artists International Association (AIA). No longer able to afford bronze he resorted to the cheapest viable alternative he could find, concrete. In 1938 he had an exhibition sponsored by the Cement and Concrete Association, 'London Life in Concrete' which although critically well-received achieved few sales. In 1939 Peri was granted British citizenship. Any possibility of immediate progress in England, however, was delayed by the Second World War in which Peri served in the Air-Raid Rescue Service. About this time he took up etching, producing two series, *Gulliver's Travels* and *Pilgrim's Progress*. After the war Peri pioneered the use of polyester

resin for sculpture. Thenceforward he was to earn a living from commissions for public sculptures in this new material as well as concrete. Increasing knowledge of developments within Russia led to his disenchantment with communism and, discerning that the Society of Friends was closest to his ideals, he became a Quaker. Following his arrival in England, Peri had taken part in numerous group exhibitions and had had many of his own, the first being at Foyles Art Gallery in 1936. A retrospective was held at Leicester Museum and Art Gallery in 1991. Peri died on 19 January 1967. Examples of his work are at the Tate Gallery (sculpture and drawings), British Museum (etchings), Derby Museum and Art Gallery (sculpture) and in several collections overseas.

Sources: Buckman, D., 1998; *L. Mercury*, 16 August 1991, p.48; Leicestershire Museum and Art Gallery, 1991; Spalding, F., 1990; *The Times*, 25 January 1967, p.12.

John Birnie Philip (1824–75)
Sculptor, born in London on 23 November 1824. At 17 he entered the Government School of Design at Somerset House. His first employment was as ornamental sculptor under A.W.N. Pugin at the Houses of Parliament. His longest working relationship, however, was with Sir G.G. Scott, much of his work being for churches the architect was either building or restoring. For Scott, Philip executed reredoses for Tamworth Parish Church, 1853, Ely Cathedral, 1857, and St George's Chapel, Windsor, 1863; the tympanum relief of *St Michael and Satan* and the colossal statues of the *Four Evangelists*, 1858, at St Michael's, Cornhill, London; the royal figures and *St George* (the latter to the design of J.R. Clayton) on the *Westminster Scholars' Crimea Memorial*, 1859–61, at Broad Sanctuary, London; the reredos and choirscreen at Lichfield Cathedral, 1864; and some of the spandrel reliefs on the

exterior of Scott's Government Offices, Whitehall, 1862–73. His best known work for Scott is on the Albert Memorial, 1863–76, notably the marble podium friezes representing 87 great architects and sculptors (1864–72), but also the bronze figures of *Geometry*, *Geology*, *Physiology*, and *Philosophy* on the canopy over the central figure, and the eight angels around the base of the cross crowning the summit. Philip also ran a successful studio executing funerary monuments, including those to *Queen Katherine Parr*, 1859, Sudeley Castle chapel, Gloucestershire, the *Revd W.H. Mill*, 1860, Ely Cathedral, and *Lord and Lady Herbert of Lea*, 1864, Wilton Church, Wiltshire. In 1869 he returned to the Houses of Parliament to execute for architect E.M. Barry, a series of eight statues of British monarchs for the Royal Gallery. Philip's statues as an independent sculptor include *Richard Oastler*, 1866, Bradford; *Lord Elgin*, 1869, and *Colonel Baird*, 1870, both Calcutta; and *Colonel Edward Akroyd*, 1875, Halifax. Philip exhibited at the Royal Academy from 1858 to 1875, dying of bronchitis in the latter year at his studio, Merton Villa, Chelsea, on 2 March.

Sources: *Art Journal*, 1875; *DNB*; Graves, A., 1905–6; Gunnis, R., [1964]; *MEB*; Read, B., 1982.

Pick Everard and Keay – see Everard and Pick

S. Perkins Pick – see Everard and Pick

George Pickard (1929–93)
Sculptor, architect, painter and teacher born at Syston, Leicestershire, living from 1980 at nearby Rearsby. He studied at Leicester School of Architecture, 1945–52, becoming an Associate of the Royal Institute of British Architects in 1953. In 1952–4 he did his National Service in the Royal Artillery as regimental artist designing camouflage. He practised as an architect from 1957–66, developing an interest in interior design and

sculptural components in building, having by 1964 already built a metal sculpture workshop for himself. In 1966 he was appointed Senior Lecturer in Interior Design at Leicester Polytechnic and was granted a year's sabbatical in 1986 to study advanced design and methods in flat-glass with specific application to sculpture, travelling extensively in Britain and Germany to gain a thorough knowledge of glass and glass bonding. He resigned from teaching in 1988 to concentrate on sculpture, developing his skills in bronze and aluminium casting at the Charles Keene Foundry in 1991 and thereafter producing some 20 pieces in these metals. He had been a founder member of the Architect Sculptors Group in 1972, and in the same year had had exhibitions at the RIBA Headquarters and the Yehudi Menuhin School. In the years that followed he exhibited in Leicester, Northampton, Birmingham and London. His sculptures have been bought by numerous private patrons and, in addition to the commissions detailed in the present catalogue, he also designed a mosaic roundel, 1978, by the entrance to the Leicester Royal Infirmary; stained glass windows for the United Reformed Church, Groby, Leicestershire; and *Abstract*, 1990, a coloured steel sculpture for Walker's Crisps, Beaumont Leys, Leicestershire.

Sources: Buckman, D., 1998; Pitches, G., 1994.

Michael Piper (b. 1921)
Sculptor born in Nottingham. He studied under Frank Dobson at the Royal College of Art, 1949–52. His commissions include a large *Horse and Rider* in stone for Clarendon School, Oxhey (Hertfordshire County Council).

William Pitts (1790–1840)
Sculptor and silver-chaser born in Leicester and apprenticed to his father, also a silver-chaser. In 1812 he won the Isis Gold Medal of the Society of Arts for modelling two warriors. He first came to notice for chasing most of Thomas

Stothard's *Wellington Shield* and then the whole of John Flaxman's *Shield of Achilles*, some years later modelling in imitation of these, shields of *Hercules* and of *Aeneas* (left incomplete at his death). In 1829 he was commissioned to carve reliefs for Buckingham Palace: *Eloquence* for the picture gallery, *Pleasure* for the blue drawing room, *Harmony* for the music room, *Peace and War* for the guard room and, in 1831, twelve relief panels of children for the white drawing room. Even though the results had been approved, the Palace delayed payment for so long it almost ruined him financially. Pitt's other commissions included reliefs of *Proserpine* and *The Nuptials of Pirithous and Hippodamia*, 1829, for Mr Simons of Regents Park; *St Martin and the Beggar*, a carving dated 1831 for the pediment of the vestry room of St Martin-in-the-Fields; three bas-reliefs for Sir W.A. Cooper, of Isleworth House; and *The Triumph of Innocence, Flora with the Seasons*, and *The Pledges of Virtue* for George Harrison, of Carlton Gardens. In 1839 he was an unsuccessful entrant in the competition for the *Nelson Column*, Trafalgar Square. He also did portrait busts and church monuments, amongst which are those to *David Ricardo* (died 1823), St Nicholas Churchyard, Hardenhuish, Wiltshire, and to the *2nd Lord Boston* (died 1835), St Mary's Church, Whiston, Northamptonshire. He was, in addition, an accomplished (and ambidextrous) draughtsman, painter and designer of china. He showed at the Royal Academy, 1823–40, and the British Institution, 1824–34. Pitts suffered from depression, allegedly brought on by professional disappointments, and ended his own life on 16 April 1840 with an overdose of laudanum, leaving behind him a poverty-stricken wife and five children. His obituarist in the *Gentleman's Magazine* said of him: 'In subjects of pure classical taste, he stood unrivalled, and his talents were highly appreciated by the late celebrated Flaxman, by Sir Richard Westmacott, R.A. and by Sir Francis Chantrey, R.A.'

Sources: *DNB*; *Gentleman's Magazine*, June 1840 (obituary); Good, M. (comp.), 1995; Gunnis, R., [1964].

The Plasmatic Co. (active c.1916 – c.1941)
Firm of craftsmen in stone, marble, wood, cement and plaster, based at The Newarke, Leicester. The Art Director was Joseph Herbert Morcom. To manage the masonry side of the business, Morcom brought in a former fellow student from Liverpool, George Quayle. Throughout the early 1920s the firm secured much work in the region fulfilling the heavy demand for war memorials. The masonry side of the firm folded in about 1930, although Morcom continued independently as an architectural sculptor.

Sources: information from Dr Alan McWhirr; *Kelly's Directory of . . . Leicester and Rutland* (edns from 1916–41).

Frederick William Pomeroy (1856–1924)
Sculptor born 9 October 1856 in London. He was first apprenticed to a firm of architectural carvers, meanwhile attending the South London Technical Art School part-time where he learnt modelling from Jules Dalou and W.S. Frith. He was at the Royal Academy Schools, 1881–5, winning the gold medal and travelling studentship in 1885. He travelled to France and Italy, studying in Paris under Emmanuel Frémiet and Antonin Mercié. In 1887 he collaborated with Frith on the *Victoria Fountain* in Glasgow. He exhibited at the RA 1885–1925, with the Arts and Crafts Society from 1888, and was a medallist at the Paris International and Chicago exhibitions of 1900. He worked on a number of buildings, notably those by architect E.W. Mountford, including Paisley Town Hall, 1890; Sheffield Town Hall, 1890–4; Liverpool College of Technology (and Museum extension), completed 1902; and the Central Criminal Court, Old Bailey, London, completed 1907 (Pomeroy is responsible for the famous gilt bronze *Justice* surmounting the dome). Pomeroy's portrait statues include *Dean Hook*, 1900, Leeds City Square; *W.E. Gladstone*, 1900, Houses of Parliament; and *Monsignor Nugent*, 1906, Liverpool. His most famous ideal sculpture is probably *Perseus* (shown at the Royal Academy in 1898; life-size bronze in the National Museum of Wales, Cardiff; numerous reductions). He was a Member of the Art Workers' Guild from 1887 (Master in 1908) and was elected ARA in 1906 and RA in 1917. He was also, in 1911, a founding member of the Society of Portrait Sculptors. He died 26 May 1924.

Sources: Beattie, S., 1983; Cavanagh, T., 1997; Gray, A.S., 1985; Nairne, S. and Serota, N. (eds), 1981; Popp, G. and Valentine, H. (comps), 1996; *Who Was Who 1916–1928*.

Ronald Pope (1920–97)
Sculptor, painter and teacher born in Westbury-on-Severn, Gloucestershire. He took an engineering course at Derby College of Technology, gaining his degree in 1941 and going on to work for a time in the tool design office at Rolls-Royce. He then studied at Derby College of Art, 1943–5, and at the Slade School of Fine Art, 1945–8 (transferring from painting to sculpture in his second year), where he was taught by A.H. Gerrard, Randolph Schwabe, and F.E. McWilliam and won a prize for carving in stone. In 1946–8 he was also studying ceramics at Woolwich Polytechnic under Heber Mathews. Pope took part-time posts teaching sculpture and ceramics at Lonsdale College of Higher Education, Derby, and the University of Nottingham, allowing himself sufficient time to pursue his own work. Amongst his more notable public commissions are a wall relief, *Family of Man*, for the entrance to Derby Museum and Art Gallery, and *Walking Figures*,

a wall relief in welded aluminium for Spondon County Secondary School, Derbyshire, both 1964; a figure of *St Catherine*, 1965, on St Catherine's Church, Sheffield (for architect Sir Basil Spence); and *Five Bishops*, 1974, a wall sculpture in welded phosphor bronze for Hertford Civic Centre. He had an exhibition at the Alwin Gallery, 1984, and others at the Yew Tree Gallery, Ingleby, and the Ninety-Three Gallery, Derby. The Derby Museum and Art Gallery mounted a retrospective in 1998 and has a selection of his work in its permanent collection.

Sources: Buckman, D., 1998; Derby Museum and Art Gallery (typed hand-out for 1998 solo exh.); Strachan, W.J., 1984.

Albert Pountney (1915–92)

Sculptor and teacher born 19 August 1915 at Wolverhampton, Staffordshire. He studied at Wolverhampton School of Art, 1931–5, under R.J. Emerson, and the Royal College of Art, 1935–8, winning the Prix de Rome to study at the British School in Rome, 1938–9. After the Second World War he was appointed Head of Sculpture firstly at Hull College of Art, 1945–7, then at Leicester School of Art, a post he retained until 1963 when he was appointed Head of the Faculty of Fine Art in the newly-created Leicester Polytechnic, eventually retiring in 1979. Pountney was a fellow of the Royal Society of British Sculptors and a member of the Society of Rome Scholars. He showed at the Royal Academy, 1943–8. Although he did a number of commissioned portrait busts, most of his work was for public buildings: in addition to those sculptures included in the catalogue, he was also responsible for a stylised coat of arms for the Council Chamber, Leicestershire County Hall.

Sources: Buckman, D., 1998; *The Guardian* (obituary) [undated press cutting]; Leicester City Council, 1993; *L. Mercury*, 19 September 1992, p.15; Waters, G.M., 1975.

Powderhall Bronze Foundry

Fine Art bronze foundry established in Edinburgh in 1989. At the time of writing (1999), it is the only fine art casting service in Scotland. It specialises in lost wax casting techniques combined with modern materials such as silicon rubber moulds. The foundry also provides a maintenance programme for sculpture cast in the foundry. In this latter capacity, one of the foundry's leading clients is the Scottish National Gallery of Modern Art. Public sculptures cast by the foundry include Shona Kinloch's *Fission*, East Kilbride; David Annand's *Royal Stag*, for Baxters of Speyside Ltd; and Alexander Stoddart's *Bust of Henry Moore*, for the Scottish National Gallery of Modern Art.

Source: Powderhall Bronze Foundry.

William Pye (b. 1938)

Sculptor and teacher born William Burns Pye on 16 July 1938 in London. He studied at Wimbledon School of Art, 1958–61, and the Royal College of Art, 1961–5. He then taught at Central School of Art and Design, 1965–70, and Goldsmiths' School of Art, 1970–7, and was visiting professor at California State University, 1975–6. His first solo exhibition was at the Redfern Gallery, London, in 1966, and his first in the USA was at the Bertha Schaefer Gallery, New York, in 1970. His work was included in Coventry Cathedral's open-air 'Exhibition of British Sculpture', 1968; in the Middelheim Biennale, 1969; in 'British Sculptors '72' at the Royal Academy; and the Open Air Sculpture Exhibition at Holland Park, London, both 1972; and in the 'Silver Jubilee Contemporary British Sculpture' exhibition, Battersea Park, London, 1977. A retrospective of his work was held in Hong Kong in 1987. In 1990 he formed the William Pye Partnership. His public sculptures include *Zemran*, 1971, South Bank, London; *Peace Sculpture*, 1985, University of Aston, Birmingham; *Slipstream and Jetstream*,

1987–8, Gatwick Airport passenger terminals (ABSA Award for best commission of new art and the Art and Work Award for best commission in 1988); *Downpour (water sculpture)*, 1995, British Embassy, Muskat, Oman; *Derby Cascade*, 1995, Market Square, Derby; and *Water Pyramid*, 1995, Le Colisée, Paris. In 1971 he made the films *Reflections* and *From Scrap to Sculpture* (the latter documenting the making of *Zemran*). His awards include the 'Structure 66' prize, Welsh Arts Council, 1966; Prix de Sculpture, Budapest International Sculpture Exhibition, 1981; and the Royal UENO Award, Japan, 1989. He was made a Fellow of the Royal Society of British Sculptors in 1992 and an Honorary Fellow of the Royal Institute of British Architects in 1993.

Sources: Buckman, D., 1998; Nairne, S. and Serota, N. (eds), 1981; Noszlopy, G. and Beach, J., 1998; Royal Academy of Arts, 1972; Spalding, F., 1990; Strachan, W.J., 1984; *Who's Who 1999*.

Peter Randall-Page (b. 1954)

Sculptor, draughtsman and teacher born in Essex, but brought up in Sussex. He studied at Bath Academy of Art, 1973–7, and after graduating worked for sculptor Barry Flanagan, 1977–8, and then, in 1979, with Robert Baker on conservation work at Wells Cathedral. In 1980 he won the Winston Churchill Memorial Trust Travelling Scholarship to study marble carving at Carrara. On his return he became a visiting lecturer at Brighton Polytechnic, 1982–9, after which he moved to Drewsteignton, Devon, and set up a workshop with associates to carry out large commissions. He had his first solo exhibition at the Gardner Centre Gallery, University of Sussex, in 1980, and his first solo exhibition in London at the Anne Berthoud Gallery in 1985. His work was also included in various mixed exhibitions including 'Summer Show 3', Serpentine Gallery, 1982; 'Sculptors and Modellers', Tate Gallery, 1984; 'Feeling through Form', Barbican Art

Centre, London, 1986; the Seventh International Small Sculpture Exhibition of Budapest, Hungary, 1987; and 'Chelsea Harbour Sculpture 93', 1993. In 1992 a major retrospective was held at Leeds City Art Gallery and Yorkshire Sculpture Park (and tour). His public commissions include *Nocturne II*, 1979, and *Untitled*, 1980, both for Milton Keynes; *Cuilfail Spiral*, 1982, on the A26 roundabout at the north end of the Cuilfail tunnel, Lewes; and *... and Wilderness is Paradise Enough*, 1986, St George's Hospital, London.

Sources: Buckman, D., 1998; *Chelsea Harbour Sculpture 93*, 1993; Strachan, W.J., 1984.

Jim Robison (b. 1939)
Sculptor and potter born in Independence, Missouri, USA. He first trained as a jet engine mechanic in the USAF, serving in West Germany for three years. On his return he attended Graceland College, Iowa, 1961–5, and Eastern Michigan University, 1968–70, studying liberal arts and taking up ceramics. Having taught for a while at Ann Arbor, Michigan, he moved to England in 1971 firstly establishing a studio at Leeds and then, in 1975, setting up Booth House Gallery and his own workshop at Holmfirth, Yorkshire. He was a member of the Yorkshire Arts Association's visual arts panel and is a member of the Craftsmen Potters' Association. Robison has executed a number of murals on public buildings in, for example, Cambridge, Chepstow, Pontefract, and Wilmslow. He has exhibited both in Britain and on the continent, including the White Rose Gallery, Bradford, 1976, Leeds City Art Gallery, 1979, and the Yorkshire Sculpture Park, 1980.

Source: Buckman, D., 1998.

John Charles Felix Rossi (1762–1839)
Sculptor born at Nottingham but brought up in Mountsorrel, Leicestershire, the son of a quack-doctor from Siena. Rossi first studied under,

then worked for, the sculptor Locatelli. In 1781 he entered the Royal Academy Schools, winning a silver medal the same year and a gold medal in 1784; he exhibited at the RA 1782–1834. In 1785 he won the travelling scholarship and went to Rome, staying until 1788. On his return he worked at the Derby China Works and shortly afterwards for Coade's of Lambeth, the manufacturers of decorative sculpture in durable artificial stone. Later Rossi was to develop an artificial stone of his own composition (he executed much work in artificial stone at Buckingham Palace, 1827–9). In 1798 he was elected ARA and in 1802 RA. His practice flourished and he received a number of prestigious commissions, none more so than those for national monuments in St Paul's Cathedral. In the 1810s his career faltered and he even considered taking up the offer of a commission in Haiti, but he stayed in England and in 1819 won a commission to execute the terracotta caryatids for the Church of St Pancras, London. Throughout his career he worked successfully as a portraitist and held the post of sculptor to both George IV and William IV. Despite achieving recognition, he died in fairly straitened circumstances – his large family (sixteen children from two marriages) absorbing so much of his income that, according to his obituary in the *Art-Union*, he 'bequeathed to his family nothing but his fame'.

Sources: *Art-Union*, 1839 (obituary); *DNB*; *Gentleman's Magazine*, May 1839 (obituary); Gunnis, R., [1964].

Louis François Roubiliac (1702–62)
Sculptor born 31 August 1702 to wealthy parents at Lyons and possibly apprenticed to Balthazar Permoser who was then sculptor to the Elector of Saxony at Dresden. Roubiliac was at the Académie Royale, Paris, in the late 1720s and may have been assistant to Nicholas Coustou, one of the two Recteurs; in 1730 he

won the second prize for sculpture. Roubiliac moved to England most likely in 1730 and was employed first by Benjamin (or Thomas) Carter and then by Sir Henry Cheere. In 1745 he was appointed lecturer in sculpture at St Martin's Lane Academy and in 1752 made the all-important trip to Italy. In 1759 he was elected to the committee of the Society for the Encouragement of Arts and Sciences (now the Royal Society of Arts). Roubiliac had received his first independent commission – the *Statue of G.F. Handel* for Vauxhall Gardens – in 1738 (terracotta, Fitzwilliam Museum, Cambridge; marble, Victoria and Albert Museum). With his fee, he was able to set up his own studio in St Martin's Lane, London, where he quickly established a reputation for portrait busts, some of them, notably his *Alexander Pope*, being repeated many times. Other outstanding examples are *William Hogarth*, terracotta, c.1740 (National Portrait Gallery); *Sir Andrew Fontaine*, marble, 1747 (Wilton House, Wiltshire); and Roubiliac's late self-portrait in terracotta (National Portrait Gallery). The more prestigious field of church monuments was, however, more difficult to enter, his first major commission being the *Monument to Bishop Hough*, 1744–7, in Worcester Cathedral, and his first London commission being the *Monument to the Duke of Argyll and Greenwich*, 1745–9, for Westminster Abbey. He was thereafter in constant demand, creating some of the most brilliantly carved, imaginatively-conceived and theatrically dramatic monuments ever to appear in Britain, notable amongst them being the pendant tombs of the *Duke* and *Duchess of Montagu*, 1749–54 and 1752–4 respectively, for Warkton, Northamptonshire and, again for Westminster Abbey, *General William Hargrave*, c.1752–1757, and *Joseph and Elizabeth Nightingale*, 1758–61. In Rupert Gunnis's estimation, 'Roubiliac was probably the greatest sculptor to work in England during the eighteenth century'.

Sources: Bindman, D. and Baker, M., 1995; Gunnis, R., [1964].

Thomas Sabin (d. 1702)
Mason-sculptor of Ashby-de-la-Zouch.

Source: Gunnis, R. [1964].

Francis William Sargant (1870–1960)
Sculptor born 10 January 1870 in London, the younger brother of the painter Mary Sargant-Florence. He was educated at Rugby and New College, Oxford, and then studied art at the Slade School of Fine Art, London, 1895–6, and at Florence and Munich, 1899–1903, winning a gold medal for a work exhibited at Munich in 1904. Whilst retaining an address in London, Sargant spent most of his life in Italy, living and working in Florence from 1899–1914 and 1918–37. One of his principal commissions was a *Memorial to Florence Nightingale*, 1913, for the church of Santa Croce, Florence. On 1 January 1920, Sargant was awarded an OBE 'for services in connection with the [First World] War' in his capacity as Commandant of the British Red Cross Unit No. 2, Italy. Later the same year the Italian authorities appointed him Cavaliere Corona d'Italia. He showed at the Royal Academy, London, from 1919–59, his major work of these years undoubtedly being his series of reliefs for Oakham School War Memorial Chapel (see pp.293–6). He died at Cambridge 11 January 1960. His work was strongly influenced by the sculpture of the Italian Renaissance and though most of it was in stone or marble Sargant was dismissive of the claims of the direct carving faction, fervently believing that better results could be achieved through the traditional method in which a clay or plaster model is copied in stone or marble by means of a pointing machine. Examples of his work are in the Tate Gallery and in Leeds Sculpture Collections.

Sources: information from Central Chancery of the Orders of Knighthood; Buckman, D., 1998; *The Times*, 13 January 1960 (obituary); Waters, G.M., 1975.

George H. Saul (exhibited 1876–87)
Sculptor. In 1876, 1879 and 1887 he exhibited at the Royal Academy of Arts (the catalogue giving his address as Florence) and in 1880 and 1883 at the Grosvenor Gallery, London. He executed the *Monument to Mrs Townley*, 1881, in St Peter's Church, Burnley, Lancashire.

Sources: Graves, A., 1905–6, 1970; Johnson, J. and Greutzner, A., 1976; Newall, C., 1995; Pevsner, N., 1969.

Bernard Schottlander (1924–99)
Sculptor in metal, born 18 September 1924 of Jewish parents in Mainz, Germany. His family fled Germany in 1939, he and his parents and brother becoming separated, with them ending up in Switzerland and he in England. He stayed, was adopted by a refugee organisation, and was naturalised in 1946. From 1941–4 he worked as a welder and plater whilst attending evening classes in sculpture at Leeds College of Art. After war service, 1944–8, he studied at the Anglo-French Art Centre, St John's Wood, 1948–9, and then, 1949–51, took an industrial design course at Central School of Arts and Crafts. From 1951 Schottlander worked as an industrial designer and metalwork maker in his own workshop. From 1963, however, he practised sculpture full-time, teaching at St Martin's School of Art, 1965–7. His first solo exhibition was at the Architectural Association in 1964 and he had an open-air exhibition at Guinness's Brewery in 1972. His work was also included in a number of mixed shows, including the Arts Council's touring exhibition, 'Sculpture in a City', and Coventry Cathedral's open air 'Exhibition of British Sculpture', both 1968. In the mid-1970s, Schottlander began to move away from the geometric forms hitherto characteristic of his sculpture towards more organically-based forms. His most important public sculptures are a memorial to the Jewish athletes killed by terrorists at the 1972 Munich Olympic Games, now in Tel Aviv, Israel, and *South of the River*, 1975, outside Ernst and Young's offices, Lambeth Palace Road. He died 28 September 1999 at Oxford.

Sources: Buckman, D., 1998; *The Independent*, 14 October 1999, p.6 (obituary); Strachan, W.J., 1984.

Sir George Gilbert Scott (1811–78)
Gothic Revival architect born at Gawcott, Buckinghamshire. Scott's father, the curate of Gawcott, recognised his son's interest in architecture – the boy spent much time drawing churches – and articled him in 1827 to architect James Edmeston. On completion in 1831, Scott worked for several other architects before establishing his own practice in 1835, later taking his clerk-of-works, W.B. Moffat, into partnership (terminated 1845). The practice specialised in workhouses, all in a quasi-Elizabethan style, but it was at this time that Scott built his first churches, though not yet in the Gothic style for which he was to become best known. Neither his evangelical upbringing nor the architectural predilections of the architects for whom he had worked had encouraged an interest in Gothic, and it was only when he began to read Pugin and later met him (through Pugin's chief builder, George Myers) that his interest developed. Scott's first essay in Gothic principles was the *Martyrs' Memorial*, 1841–2, at Oxford, won in competition, and his first building in the Gothic style was the church of St Giles, Camberwell, 1841–4. Then began his series of restorations, starting with Chesterfield Church, his first work for a cathedral being the chapter house at Ely (1847). In 1844 Scott's reputation extended beyond Britain when he won the open competition for St Nicholas, Hamburg, with a design based on his researches into fourteenth-century German Gothic architecture. In 1856 he entered the competition to design the War

and Foreign Offices – a competition which became a centre of conflict between advocates of the Gothic and the Classical schools of architecture. Scott was eventually appointed to build the Foreign Office but only after he had been forced to change his design from Gothic to Italian Renaissance (completed 1873). In 1864, however, his Italian Gothic design for the Albert Memorial was accepted and in 1868 he designed, also in the Gothic style, his best known building, St Pancras station and hotel (completed 1874). By this time he had been recognised as one of the leading practitioners in his field: he had been architect to the Dean and Chapter of Westminster Abbey since 1849; in 1855 he had been elected ARA and in 1861 RA (exhibiting regularly at the RA, 1847–78); in 1859 the RIBA had awarded him its Royal Gold Medal and in 1873 elected him President; from 1868 he was Professor of Architecture at the Royal Academy; and finally, in 1872, he was knighted (essentially for the Albert Memorial). He died of a heart attack, following a short illness, on 27 March 1878, and was buried in Westminster Abbey.

Sources: Curl, J.S., 1999; *DNB*.

Tim Scott (b. 1937)
Sculptor and teacher born in Richmond, Surrey, working principally in fibreglass, steel, glass, and perspex. He studied at Tunbridge Wells School of Art, 1954, the Architectural Association, 1954–9, and part-time at St Martin's School of Art, 1955–9. From 1959–61 he lived in Paris and worked at the Atelier Le Corbusier-Wegenscky. His interest in Le Corbusier led to a thesis on the architect's Villa Savoye; he also admired Brancusi. In 1961 he showed at the Institute of Contemporary Art in the exhibition '26 Young Sculptors'. In the following year he began teaching at St Martin's (and several other art schools), becoming head of the sculpture department in 1980. In 1965 he showed in 'The New Generation' exhibition at

the Whitechapel Art Gallery and in the same year was awarded a Peter Stuyvesant Foundation Bursary. In 1978–9, he was sculptor-in-residence at the North London Polytechnic. His first solo exhibition was at the Waddington Galleries, London, in 1966; he also exhibited widely abroad. He had retrospectives at the Whitechapel Art Gallery, 1967, the Museum of Modern Art, Oxford, 1969, and the Kunsthalle, Bielefeld, 1979. He was commissioned to produce a sculpture for the Peter Stuyvesant Sculpture Project, Liverpool, 1972, and his *Khajuraho 2*, 1980, was purchased for the North London Polytechnic. The Tate Gallery has examples of his work and his *Cathedral*, c.1978, is in the Highland Sculpture Park, near Carrbridge, Scotland.

Sources: Buckman, D., 1998; Nairne, S. and Serota, N. (eds), 1981; Spalding, F., 1990; Strachan, W.J., 1984; Whitechapel Art Gallery, 1965.

Simonet et fils (active 1850s)
Bronze founders based in Paris

Singers (foundry) – see Morris Singer

Anthony Smith (active *c*.1904 – *c*.1941)
Sculptor working throughout his career from Colton Street, Leicester.

Sources: *Kelly's Directory of . . . Leicester and Rutland* (edns from 1904–41).

Willi Soukop (1907–95)
Sculptor born 5 January 1907 in Vienna. Wilhelm Joseph Soukop, as he was originally known, was the son of a Moravian shoemaker whose horrific experiences in the First World War led to some kind of mental breakdown and his disappearance immediately following the war's end. From an early age Willi had to work in a factory, attending evening classes at the arts and crafts school in Vienna before managing to get into the Academy of Fine Arts (1928–34). In 1934 he met an English woman who invited

him to England. He settled into a studio at Dartington Hall, Devon, and, 1935–45, taught part-time at Dartington Art School (apart from nine months in 1940 when, because of his Austrian citizenship, he was interned in Canada) and at Blundell's School, also in Devon. In 1945 he married and moved to London, teaching at Bromley (1945–6), Guildford (1945–7) and Chelsea (1947–72) schools of art. He was a member of the Faculty of Sculpture at the British School in Rome, 1952–75, and Master of Sculpture at the Royal Academy schools, 1969–82. He exhibited at the Royal Academy from 1935 onwards; his *Owl*, shown in 1963, was bought by the Tate Gallery under the terms of the Chantrey Bequest. His work was included in the 1949 and 1950 open-air sculpture exhibitions at Battersea Park, and he had a solo exhibition at the Yehudi Menuhin School, Cobham, 1979, and a major retrospective at the Belgrave Gallery, 1991. In 1981, problems with his eyesight were finally diagnosed as cataracts and glaucoma; after being partially cured, he involved himself in working on sculptures for the blind. He was elected to the Royal Society of British Artists in 1950, made a Fellow of the Royal Society of British Sculptors in 1956, ARA in 1963 and RA in 1969. He died 8 February 1995.

Sources: Buckman, D., 1998; Nairne, S. and Serota, N. (eds), 1981; Spalding, F., 1990; Strachan, W.J., 1984; *The Times*, 9 February 1995, p.21 (obituary).

E. Caldwell Spruce
Principal modeller for Burmantofts (see p.358)throughout the 1880s and 1890s. Among the many commissions he carried out for the company are four relief panels for the exterior of the Midland Hotel, Manchester, and a relief of *St George and the Dragon* for the Church of St George the Martyr, Southwark. He exhibited at the Royal Academy 1906–15.

Source: information from Scott Anderson; Bradford Art Galleries and Museums, 1983.

Andrew Stonyer (b. 1944)
Sculptor and teacher. He first studied art at Northampton School of Art, 1961–3, then took sculpture at Loughborough College of Art and Design, 1963–7, and architecture at the Architectural Association's School of Architecture. Following this he went to Ankara, Turkey, for two years. In 1975–8 he completed a doctoral thesis entitled, 'The Development of Kinetic Sculpture by the Utilisation of Solar Energy'. From 1982 he was in Canada lecturing and researching at Concordia University, Montreal, as well as carrying out sculpture commissions. In 1989, Stonyer returned to England to take up the post of Head of Fine Art at Falmouth School of Art and Design. From 1993 he was reader in fine art and design at Cheltenham and Gloucester College of Higher Education. He has had solo exhibitions at the Architectural Association, 1971, and Leicester Polytechnic, 1978. From 1991, while in Cornwall, he exhibited as an associate member of the Newlyn Society of Artists at the Newlyn Orion Gallery. His work was also included in the 'Falmouth Connections' exhibition at the Falmouth Art Gallery, 1994.

Source: Buckman, D., 1998.

David Tarver
Sculptor, letterer and teacher. He studied at Oxford School of Art, 1948–52, and the Royal College of Art, 1954–7, and was Head of the Sculpture Department at Loughborough College of Art and Design, 1957–89. From 1989 onwards he has practised as a freelance sculptor concentrating on architectural sculpture and lettering in stone and wood. His lettering commissions in Leicestershire (not in the catalogue) include inscriptions for: the foundation stone, Welsh slate, John Storer House, Loughborough, 1966; the new Oak Screen in Kegworth Church; a Swithland slate plaque for the Robert Herrick Garden,

Beaumanor Hall, 1983; a Welsh slate dedication stone for the RNIB Training College, Loughborough, 1991; and a commemorative Welsh slate slab in the Loughborough Carillon, 1994.

Source: information from the sculptor.

Wendy Ann Taylor (b. 1945)
Sculptor, printmaker, draughtsman and teacher born at Stamford, Lincolnshire, but living for many years in London. She studied at St Martin's School of Art, 1961–7, winning, in 1964, the Walter Neurath Award. She also won the Sainsbury Award in 1966, and then in 1977, both an Arts Council Award and a gold medal in the Listowel Graphics Exhibition, County Kerry, Eire. Taylor had the first of many solo exhibitions in 1966, at the Axiom Gallery, and her work has also appeared frequently in group exhibitions. She taught at Ealing School of Art, 1967–75, and the Royal College of Art, 1972–3. She was awarded the CBE in 1988. Taylor's commissioned work includes *Timepiece*, 1972–3, Tower Hotel, St Katherine Docks, London; *Octo*, 1979–80, and *Essence*, 1982, both Milton Keynes; *Compass Bowl*, 1980, and the *Roundacre Improvement Scheme*, 1985–8, both Basildon, Essex; *Pharos*, 1986, *The Whirlies*, 1988, and *Phoenix*, 1989–90, all for the East Kilbride Development Corporation, Scotland; *Globe Sundial*, 1987, Swansea Maritime Quarter, South Wales; *Spirit of Enterprise*, 1987, Docklands, London; and *Anchorage*, 1991, Salford Quays, Manchester. Examples of her work are in the Victoria and Albert Museum, and Geffrye Museum, London, and also at the Ipswich Museum, Dudley Museum, Leicester Museum, and Ulster Museum. Overseas her work is in the City of Christchurch Art Gallery, New Zealand, and the Lunds Museum, Göteborg, Sweden.

Sources: Buckman, D., 1998; Lucie-Smith, E., 1992b; Nairne, S. and Serota, N. (eds), 1981; Spalding, F., 1990; Strachan, W.J., 1984; *Who's Who 1999*.

Robert John Royden Thomas (1926–99)
Sculptor and teacher, born 1 August 1926 at Cwm-parc, Glamorgan, South Wales, the son of a miner. During the Second World War he worked as an electrician in the mines, afterwards studying at Cardiff College of Art, 1947–9, and at the Royal College of Art, 1949–52, under Frank Dobson. He exhibited at the Royal Academy from 1955 onwards. During the 1960s he taught part-time at Ealing School of Art, returning to Wales in 1971. In 1963 he was awarded the Sir Otto Beit Medal of the Royal Society of British Sculptors (for Coalville's *Mother and Child*, see pp.30–1) and in 1966 the RBS silver medal. He was President of the Society of Portrait Sculptors, 1972–7, and was RBS Vice-President, 1979–84. A greater part of his commissions were portraits of eminent Welsh men and women. His busts include *Lord Edmund Davies* (judge), *Sir Geraint Evans* and *Dame Gwyneth Jones* (opera singers) and *Gwyn Thomas* (writer). His statue of *Aneurin Bevan*, 1987, stands in Queen Street, Cardiff. His most famous statue in Wales is, however, his life-size bronze of *Diana, Princess of Wales*, 1987, in St David's Hall, Cardiff – according to Thomas's obituarist, it was 'the only sculpture for which she posed and with which she was said to have been delighted'. Thomas also did the bronze *Captain Cat* (from Dylan Thomas's 'Under Milk Wood'), unveiled in 1990 at Swansea Marina. At the time of his death he had just completed a statue of *Isambard Kingdom Brunel* for Neyland, Pembrokeshire.

Sources: Buckman, D., 1998; *Independent*, 21 May 1999, p.6 (obituary).

Thrall and Vann (firm active 1870s)
Leicester-based firm of monumental and stonemasons owned by William Thrall and King Vann. The firm continued as Thrall and Payne from c.1881.

Sources: *Barker & Co's ... Directory for the Counties*

of Leicester, Rutland. &c..., 1875; *Kelly's Directory of ... Leicester and Rutland*, 1881.

Simon Todd (b. 1962)

Sculptor and teacher born 10 October 1962, based at Uppingham, Rutland. He studied fine art at Winchester School of Art and on completion of the course opened his own gallery in Uppingham High Street. His commissions include bronze busts of *John Lennon, Albert Einstein, Ludwig van Beethoven*, and *Gustav Mahler* for a firm of Uppingham solicitors; and sculptures in wood for the North Kesteven Arts programme, Lincolnshire: *Kingfisher*, 1990, South Kyme; *Bust of King George III*, 1991, Dunston; *Fox and Pheasant*, 1993, Haverholme; and *Sleeping Shepherd*, 1997, Rauceby. He also executed gargoyles for Lyddington Church, Leicestershire.

Sources: information from the sculptor; *L. Mercury*, 29 January 1991, p.10; *In View. Public Sculpture around North Kesteven* (Sleaford Tourist Information leaflet), n.d.

Margaret Traherne

Painter, sculptor and designer in stained glass. She studied at the Royal College of Art and later at the Central School of Art and Design. Her public commissions include stained-glass windows for Coventry Cathedral, the Roman Catholic Cathedral at Liverpool and Manchester Cathedral. From the 1960s her work has been included in a number of group exhibitions in London, Oxford and Edinburgh. She had a solo exhibition at the Bear Lane Gallery, Oxford.

Source: Spalding, F., 1990.

William Tucker (b. 1935)

Sculptor and teacher born in Cairo, Egypt. His family moved to England in 1937 and he studied history at Oxford University, 1955–8, before going on to do sculpture at Central School of Art and Design and St Martin's School of Art, 1959–60, in which latter school he was a pupil of Anthony Caro; his greatest influence, however, was Brancusi. Tucker's work, which is abstract, is generally in steel, fibreglass, plastics and wood. In 1961–2 he taught at Goldsmiths' School of Art and St Martin's; in 1976 he taught in Canada at the University of Western Ontario; and in 1978 he taught in the USA at Columbia University, New York, and the New York School of Painting and Sculpture. He had his first solo exhibition in 1963 at the Rowan Gallery and his work was included in 'The New Generation: 1965' exhibition at the Whitechapel Art Gallery. Also in 1965 he was awarded the Peter Stuyvesant Foundation travel bursary and in 1968–70 was Gregory Fellow in Sculpture at Leeds University. His commissions include sculpture for Newcastle upon Tyne for the Peter Stuyvesant Sculpture Project, 1972, and another for the Livingstone Development Corporation, Lanark, 1976. He selected works for 'The Conditions of Sculpture' exhibition at the Hayward Gallery, 1975, and in 1974 published his acclaimed book, *The Language of Sculpture*. He later went to live in New York and had solo shows at the David McKee Gallery and the Neuberger Gallery, both in 1985. Examples of his work are in the Arts Council collection and in the Tate Gallery.

Sources: Buckman, D., 1998; Nairne, S. and Serota, N. (eds), 1981; Royal Academy of Arts, 1972; Spalding, F., 1990; Strachan, W.J., 1984; Whitechapel Art Gallery, 1965.

Rob Turner – see 'Wallscapes'

William Henry Tyler (active 1878–93)

Sculptor, principally of portrait busts. He showed at the Royal Academy, 1878–93, at the Grosvenor Gallery, 1879–90, and also at the New Gallery and the Royal Society of British Artists. His *Miniature Bust of Princess Mary*, marble, is at Osborne House.

Ambrose Louis Vago

London-based architectural sculptor operating independently until 1895 and then from 1896–1902 as Vago and Co.

Sources: *Post Office London Trades Directory* (edns to 1902).

Paul Wager (b. 1949)

Sculptor born in Hartlepool, 17 February 1949. He studied at Sunderland and Newcastle polytechnics and then at the Royal College of Art. For a time he worked as an assistant to Lynn Chadwick. He has taught at Cheltenham and Winchester schools of art and at the Central School of Art and Design, London. He currently (1999) teaches sculpture at Loughborough University School of Art and Design.

Sources: information from the sculptor; Cantor, L., 1996.

Brian Wall (b. 1931)

Sculptor and teacher, born in London. He worked from 1945–50 as a glassblower, then while serving in the Royal Air Force, studied at Luton College of Art, 1951–2. For several years he divided his time between London and Paris. His interest in the work of Ben Nicholson took him to St Ives in 1954; he showed paintings at the Castle Inn there and, from 1954–8, worked as an assistant to Barbara Hepworth. His first sculptures were in wood but he later moved to abstract welded steel constructions. He returned to London in 1960 and taught at Ealing College of Art, 1961–2, Central School of Art and Design, 1962–72 (Head of Sculpture from 1964), and was visiting professor at the University of California, Berkeley, USA, 1969–73. His first solo exhibition was at the School of Architecture, London, 1957, and his work was included in the 'British Sculpture in the Sixties' exhibition, Tate Gallery, 1965; the open-air sculpture exhibition, Battersea Park, 1966; 'British Sculpture out of the Sixties',

Institute of Contemporary Art, 1970; and 'British Sculptors '72', Royal Academy, 1972. His commissions include sculptures for Thornaby-on-Tees Town Centre, 1968, and the University of Houston, Texas, 1978. Examples of his work are in the Arts Council collection and at the Tate Gallery, Whitworth Art Gallery, Manchester, the Art Gallery of New South Wales, Sydney, Australia, and the Art Museum, University of California.

Sources: Buckman, D., 1998; Nairne, S. and Serota, N. (eds), 1981; Royal Academy of Arts, 1972; Spalding, F., 1990.

Wallscapes (founded 1987)
London-based public arts team specialising in mosaics and murals. The company was founded by Gary Drostle and Ruth Priestly in 1987, although Priestly left in 1990 and was replaced by Rob Turner. Drostle was born in 1961 in Woolwich, London, and studied until 1984 at Camberwell, St Martin's, and Hornsey colleges of art, and also for a short while at the School of Marble Sculpture, Carrara. He specialises in hand-cut mosaic work and is a member of the Association for the Study and Preservation of Roman Mosaics and L'Association Internationale pour l'Étude de la Mosaïque Antique. Turner studied painting at St Martins School of Art until 1984. He has since then had a number of solo exhibitions, as well as having the making of two of his mosaics at Luton featured in 'Metroland', a Carlton Television documentary series. Wallscapes' clients have included the London boroughs of Croydon, Greenwich, Haringey, Islington, Lewisham, and Sutton; Hertfordshire County Council; Slough and Wellingborough borough councils; Sevenoaks and Stratford-upon-Avon district councils; and Gloucester City Council. Wallscapes is a member of the Guild of Master Craftsmen and the National Artists Association.

Source: information from Wallscapes.

Shirley Ward (firm active c.1916–1960)
Monumental mason, his firm, based at St Augustine Street, Leicester, was styled 'S. Ward & Co.' from c.1916 – c.1922, and 'Shirley Ward' from then until 1960.

Sources: *Kelly's Directory of . . . Leicester and Rutland* (edns from 1916–60).

Friedrich Werthmann (b. 1927)
Sculptor, born in Wuppertal, Germany. A self-taught sculptor, he began working in wood and stone, making firstly figurative (1948–52), then abstract (1952–6) works. In 1956–7 he made 'diastructures' in fortified cement and from 1957 worked in steel. His first solo exhibition was in 1956 at the Galerie l'Entracte, Lausanne, and his first solo exhibition in England was in 1964 at the Hamilton Galleries, London. In addition, he has had one-man shows in Bonn, Wuppertal, Duisberg, Düsseldorf, Basel, Zurich, Nice, Lyon and Milan. He was awarded the German Youth Prize and Düsseldorf City Prize in 1959.

Sources: Annely Juda Fine Art (exhib. cat.), 1974; Hamilton Galleries (exhib. cat.), 1964; Hamilton Galleries (exhib. cat.), 1966.

Father Aelred Whitacre, OP (active 1930s)
Dominican priest and sculptor. He was at St Peter's Roman Catholic Church, Hinckley, until 1931, during which time he carved two reliefs for the exterior of the priory (see pp.60–2). He then left to join the Dominican Order (Ordo Praedicatorum) at a foundation at Edinburgh. He exhibited a statuette in Hopton Wood stone, *Rosa Mystica*, at the Royal Academy in 1934. He also carved a facsimile of the original south porch *Annunciation* relief for the Dominican Priory, Woodchester, Gloucestershire.

Sources: information from Pat Reid, St Peter's Roman Catholic Church, Hinckley; Good, M. (comp.), 1995.

Edward John Williams (1886–1948)
Architect based in Leicester. After studying at Leicester School of Art he was articled to Stockdale Harrison & Sons. From 1921–30 he was a partner in the Harding and Williams practice in Leicester and from 1930 until his death was in practice independently. He was elected FRIBA in 1925 and from 1937–9 was President of the Leicester and Leicestershire Society of Architects.

Sources: *Builder*, vol. 174, no. 5480, 27 February 1948, p.260 (obituary); RIBA biographical file.

Martin Williams (b. 1954)
London-born sculptor who moved with his family to Swansea where he was educated at Penlan Comprehensive. He completed a foundation course at Swansea College of Art, 1972–3, before taking a BA in Three-Dimensional Design (Sculptural Ceramics) at Staffordshire University, 1973–6. From 1976–7 he was at the Institute of Education, University of London, where he achieved an Art Teacher's Certificate. In 1978 he established his own studio at Swansea. His sculpture commissions outside Leicestershire include *The Bay Panels*, 1992, 12 reliefs for a pedestrian route at Cardiff Bay; *Woolwich Arsenal Workers*, 1993, a large ceramic relief at Woolwich Arsenal Station, London; four stoneware reliefs, 1994, for the entrances to Canal Park, Cardiff; and a stoneware relief and two monochrome images on steel, 1995, for Evanstown Community Centre.

Source: information from the sculptor.

Sir William Wilson (1641–1710)
Sculptor and architect, baptised 16 May 1641 at St Nicholas Church, Leicester, the son of a baker. He is believed to have served an apprenticeship with a statuary mason and shortly before 1669 carved the *Statue of King Charles II* for the west front of Lichfield Cathedral (taken down in 1877 and installed in

the north-west tower). In 1670 he executed carvings for the entrance porch of Sudbury Hall, Derbyshire, then being rebuilt; in c.1671 he executed the Wilbraham family monuments in Weston Church, Staffordshire, and in 1679 an *Equestrian Statue of William, Duke of Newcastle* for the north-east front of Nottingham Castle. In 1677 he had been commissioned by Jane Pudsey, of Langley Hall, Warwickshire, to make a monument to her recently deceased husband. The exceptionally wealthy and influential widow evidently fell in love with him, secured a knighthood for him (on 8 March 1681/2), was possibly instrumental in arranging his admittance to the Fellowship of the Freemasons (two days later) and shortly thereafter married him. Between 1693 and 1697 Wilson was engaged on the building of Sir John Moore's School, Appleby Parva (see pp.2–4) and from 1698, on the rebuilding of St Mary's Church, Warwick. His other sculptural commissions include allegorical statues, 1697, over the porch of Castle Bromwich Hall, Warwickshire; the *Monument to Sir Thomas Gresley* (died 1699) in St George and St Mary's Parish Church, Church Gresley, Derbyshire; and a *Statue of Edward VI*, 1707, destroyed 1833, for Birmingham Grammar School. Wilson died on 3 June 1710 and is commemorated by a tablet in the vestry in Sutton Coldfield Church. In his will he left a donation to the poor of St Nicholas Parish, Leicester.

Sources: Colvin, H., 1978; Gunnis, R., [1964].

Isaac Witkin (b. 1936)
Sculptor and teacher born in Johannesburg, South Africa, where he worked as a sculptor's apprentice. He moved to England in 1956 and, from 1957–60, studied at St Martin's School of Art under Anthony Caro (working for him part-time in 1960). From 1961–4 he was assistant to Henry Moore. Witkin's work is mainly in steel but he has also used painted wood and fibreglass. He had his first solo

exhibition in 1963 at the Rowan Gallery, London. In 1965 he had his first solo exhibition in the USA at the Robert Elkon Gallery, New York, won joint first prize at the Paris Biennale, and was included in 'The New Generation: 1965' exhibition at the Whitechapel Art Gallery. His work was also included in the 'British Sculpture out of the Sixties' exhibition, Institute of Contemporary Art, 1970, 'The Condition of Sculpture' Hayward Gallery, 1975, and 'Chelsea Harbour Sculpture 93'. He taught at St Martin's, 1963–4 and 1966–7, between which periods (1965–6) he taught at Bennington College, Vermont, USA, being appointed artist-in-residence there in 1967. From 1975 he taught at Parsons School of Design, New York. Examples of his work are at the Tate Gallery and in the collection of the Arts Council.

Sources: Buckman, D., 1998; Nairne, S. and Serota, N. (eds), 1981; Spalding, F., 1990; Strachan, W.J., 1984; Whitechapel Art Gallery, 1965.

Pauline Wittka-Jezewski (*née* Holmes) (b. 1967)
Sculptor and teacher born 7 August 1967. After taking a foundation course at Mid-Cheshire College of Art and Design, Northwich, 1985–6, she went on to Nottingham Trent University, graduating in 1989 with a degree in Fine Art (specialising in sculpture). In 1999 she gained a PGCE in Further Education and Training and has had practical teaching experience at various colleges and universities throughout the Midlands. Her principal sculpture commissions outside Leicestershire are *Mobile Sculpture*, 1988, Victoria Shopping Centre, Nottingham; *Tale of the Whale*, 1990, Market Square, Nottingham; a font, 1991, for St Nicholas's Church, Nottingham; and *Helical Spire*, 1997, for Jersey Airport, Channel Islands. In 1997 she collaborated with architects Ruddle Wilkinson to design a 100-foot-high tower for the NEC, Birmingham. She has been sculptor-in-

residence at Abbey Park, Leicester (1990), at Rossendale Borough Council's Irwell Way Sculpture Trail (1993), and Snibston Discovery Park, Coalville, Leicestershire (1994). She has shown in several group exhibitions, her first being at the Whitworth Art Gallery, Manchester (1989), and has had several solo exhibitions, the first of which was at Nottingham Castle Museum (1992). Solo exhibitions since then include the Dean Clough Art Gallery, Halifax (1994), the Contact Gallery, Norwich (1995), and the West End Centre, Hampshire (1999). She is a member of the Royal Society of British Sculptors and the Contemporary Glass Society and is currently chairperson of the Nottingham City Artists Studios, Nottingham.

Source: information from the sculptor.

Austin Wright (1911–97)
Sculptor and teacher, born 4 June 1911 to Quaker parents, living firstly and briefly in Chester, then Cardiff and moving to Yorkshire in 1937. Wright took a degree in modern languages at New College, Oxford, and trained as a teacher. He had by this time become interested in modern art and before long was teaching art alongside languages. In 1947, he was appointed teacher of drawing and sculpture at York Art School. He stayed for eight years, eventually leaving in 1955 to devote himself full-time to drawing and sculpture; in these early years his choice of materials – wood, lead and concrete – was determined principally by their relative cheapness. In 1957 he won the Ricardo da Silvera Acquisition Prize at the São Paulo Biennale and from 1961–4 was Gregory Fellow in Sculpture at Leeds University – this appointment with its guaranteed income allowing him to work in his preferred material, aluminium. Although he had his first solo exhibition in London at Rowland, Browse and Delbanco in 1956, most of his other exhibitions and all of his major retrospectives have been in

the north: Wakefield City Art Gallery, 1960; Newcastle upon Tyne Polytechnic, 1974; Yorkshire Sculpture Park, 1981 (his 70th birthday); Ferens Art Gallery, Hull, 1988; and York City Art Gallery, 1994. He has had a number of commissions for public sculptures, but many unfortunately have been vandalised, notably his remarkable eight-foot-high *Two Rings*, aluminium, installed 1977, mutilated 1989, Roppa Bank, near Helmsley, Yorkshire. One of the few that has survived is his *Wall Relief*, 1981, aluminium and steel, University of Northumbria. His sculpture, however abstract, rarely departs from its firm basis in organic sources, notably bone structures and plant growth. Examples of his work are in the Fitzwilliam Museum, Cambridge, Ferens Art Gallery, Hull, the Leeds Sculpture Collections, and the National Museum of Wales, Cardiff.

Sources: Buckman, D., 1998; *The Guardian*, 25 February 1997, p.13 (obituary); Hamilton, J., 1994; *The Independent*, 26 February 1997, p.18 (obituary); Spalding, F., 1990; Strachan, W.J., 1984.

Allan Gairdner Wyon (1882–1962)
Sculptor and medallist, born in London, the son of Allan Wyon, Chief Engraver of Her Majesty's Seals. He studied at the Royal Academy Schools under Hamo Thornycroft, became a member of the Art Workers' Guild (Hon. Sec. 1924–30) and was elected a member of the Royal Society of Miniature Painters, Sculptors and Gravers in 1922 and a fellow of the Royal Society of British Sculptors in 1926. He exhibited at the Royal Academy, 1908–56, and the Royal Society of Artists, 1916–32, as well as at the Royal Hibernian Academy, the Royal Glasgow Institute of the Fine Arts and the Paris Salon. He completed the carving of *The East Wind*, late 1920s, for the head offices of the London Underground Railway, at 55 Broadway, London. Much of Wyon's sculpture is on religious themes and he was in Holy Orders from 1933, serving as vicar of Newlyn, Cornwall, 1936–55. He spent his final years living at Great Shelford, near Cambridge, and died 26 February 1962 at King's Lynn,

Norfolk. Examples of his work are in Leicester Museum and Art Gallery; Glasgow Art Gallery; and Auckland Art Gallery, New Zealand. Among his commissions are a figure of St Michael for the *Shrewsbury War Memorial*; the *Richard Corfield Memorial*, Marlborough College; the *Combined Memorial to William Pitt the Younger and Elder*, Hayes, Kent; and busts of *Geoffrey Chaucer*, *John Milton*, *Isaac Newton*, etc., for Nottingham University.

Sources: Buckman, D., 1998; Waters, G.M., 1975; *Who Was Who 1961–1970*.

Lorraine Young
Loughborough-based sculptor. She spent her foundation year (1993) at Hugh Baird College, Merseyside, before going on to Loughborough College of Art and Design where she achieved a BA (Hons) in sculpture (1997).

Bibliography

Note: Sources for artists' biographies are separately listed on pp.397–8, and for the Introduction on pp.398–9.

Published sources

Abdy, J. and Gere, C., *The Souls*, London, 1984.

Aberystwyth Arts Centre, *William Pye. Sculpture for Public Places* (exhib. cat.), Aberystwyth, 1980.

Annely Juda Fine Art, *Antanas Brazdys. Sculpture* (exhib. cat.), London, 1971.

Anon., 'The Architecture of our Provincial Towns. vii. Leicester', *Builder*, vol. lxxii, no. 2835, 5 June 1897, pp.497–505.

Armitage, F.P., *Leicester 1914–1918. The war-time story of a Midland town*, Leicester, 1933.

Arnason, H.H., *The Sculptures of Houdon*, London, 1975.

Arts Council of Great Britain, *Towards Art II. Sculptors from the Royal College of Art* (touring exhib. cat.), London, 1965.

——, *Sculpture in a City* (touring exhib. cat.), London, 1968.

——, *City Sculpture* (touring exhib. cat.), London, 1972.

——, *New Work 2. John Ashworth, Nicholas Monro, Peter Startup, Victor Newsome, Malcolm Hughes, Bryan Kneale, Gerald Newman, Trevor Halliday* (Hayward Gallery exhib. cat.), London, 1975.

——, *Bryan Kneale. Sculpture. Work in Progress* (Serpentine Gallery exhib. cat.), London, 1978.

——, *Growing Up With Art. The Leicestershire Collection for Schools and Colleges* (Whitechapel Art Gallery exhib. cat.), London, 1980.

——, *Phillip King* (Hayward Gallery exhib. cat.), London, 1981.

——, *Anthony Hill. A Retrospective Exhibition* (Hayward Gallery exhib. cat.), London, 1983.

Ashby-de-la-Zouch Civic Society, *A Guide to the Ancient Town of Ashby-de-la-Zouch*, Ashby-de-la-Zouch, n.d.

Atterbury, P. and Irvine, L., *The Doulton Story. A catalogue of the Exhibition held at the Victoria and Albert Museum ...* , London, 1979.

Atterbury, P. and Wainwright, C. (eds), *Pugin. A Gothic Passion*, New Haven and London, 1994.

Baker, A.K., 'Cheney of Gaddesby', *Leicestershire Historian*, no. 35, 1999, pp.11–13.

Baker, D. and Duckworth, S., *Coalville: a Trip Through Time*, Coalville, 1994.

Banner, J.W., *Discovering Leicester: the researches of a Leicester City Guide*, Leicester, 1991.

——, *Out and About in Leicester*, Leicester, 1994.

Barber, J., *The Story of Oakham School*, Wymondham, 1983.

S. Barker & Co's General Topographical and Historical Directory, for the Counties of Leicester, Rutland, &c, 1875.

Barlow, R., 'Every Sculpture Tells a Story', *Steppin Out*, February 1989, pp.20–1.

Barron, O., 'Stapleford Park, Leicestershire, the seat of Mr John Gretton', *Country Life*, vol. xxiii, no. 581, 22 February 1908, pp.270–5.

Beattie, S., *The New Sculpture*, New Haven and London, 1983.

Beaumont, L. de, *The History of the Leicester School of Art 1869 – 1939*, unpublished MPhil thesis, Leicester Polytechnic, 1987.

Beaumont, M.R., 'Helaine Blumenfeld', *Art Line International Art News*, October 1990 (Special Supplement).

Beavin, H.A., *The Book of Hinckley*, Buckingham, 1983.

Benjamin Rhodes Gallery, *Zadok Ben-David* (exhib. cat.), London, 1987.

Bennett, J.D., *Discovering Statues in Central and Northern England*, Shire Publications, Tring, Herts, 1968.

——, *Who was Who in Leicestershire*, Loughborough, 1975.

Bennett, R.H., *A Short History of Barrow-upon-Soar*, Loughborough, 1938.

Berger, J., 'Artists and Schools', *New Statesman*, 27 July 1957, p.209.

Bindman, D. and Baker, M., *Roubiliac and the Eighteenth-Century Monument. Sculpture as Theatre*, New Haven and London, 1995.

Black, P., *Geoffrey Clarke, Symbols for Man. Sculpture and Graphic Work 1949–94* (touring exhib. cat.), Ipswich and London, 1994.

Boorman, D., *At the Going Down of the Sun. British First World War Memorials*, York, 1988.

Bowness, A. (ed.), *Henry Moore: sculpture and drawings. Volume 4. Sculpture 1964–73*, London, 1977.

Bradford Art Galleries and Museums, *Burmantofts Pottery* (exhib. cat.), Bradford, 1983.

Brandwood, G. and Cherry, M., *Men of Property. The Goddards and Six Generations of Architecture*, Leicester, 1990.

Braund, J. and Evans, J., *Old Aylestone*, Leicester, 1983.

Briggs, N., *John Johnson 1732–1814. Georgian Architect and County*

Surveyor of Essex (Essex Record Office Publications), Chelmsford, 1991.

Broadfield, A., *Leicester As It Was*, n.p., 1978.

Burch, B., *The University of Leicester. A History, 1921–1996*, Leicester, 1996.

Burton, D.R., *Leicester in Old Photographs*, Stroud, 1993.

——, *Leicester. A Second Selection in old photographs*, Stroud, 1994.

Camden Arts Centre, *Survey '68: Abstract Sculpture* (exhib. cat.), London, 1968.

——, *Fighting Spirits: Peter Peri and Cliff Rowe* (exhib. cat.), London, 1987.

Cantor, L., *The Treasures of Loughborough University*, Loughborough, 1996.

The Catholic Encyclopedia, vol. xiii, 1912, Online Edn 1999.

Cavanagh, T., *Public Sculpture of Liverpool*, Liverpool, 1997.

Cave, K. (ed.), *The Diary of Joseph Farington*, New Haven and London, 1984, vol. xiv.

Charles, B., *Percy Brown. Retrospective*, n.p., n.d.

City of Coventry Leisure Services, *Helaine Blumenfeld* (exhib. cat.), Coventry, 1985.

Clark, Revd F.G., *A Brief History of Gaddesby Church*, n.p., n.d.

Clifton-Taylor, A., *The Pattern of English Building*, London and Boston, 1962, 4th edn 1987.

Clifton-Taylor, A. and Ireson, A.S., *English Stone Building*, London, 1983.

Clough, T.H.McK., *Oakham Castle. A Guide and History*, Oakham, 1999.

Coade's Gallery, or, Exhibition in Artificial Stone, Westminster-Bridge-Road ... of Statues, Vases, Bustos, Pedestals, and Stoves ..., Lambeth, 1799.

Collins, J., *Eric Gill: Sculpture* (Barbican Art Gallery exhib. cat.), London, 1992.

——, *Eric Gill. The Sculpture*, London, 1998.

Colvin, H., *A Biographical Dictionary of British Architects 1600–1840*, London, 1978.

Coutts-Smith, K., 'William Pye', *Sculpture International*, vol. 3, no. 2/3, Summer 1970, pp.15–21.

Coventry Cathedral, *Exhibition of British Sculpture* (exhib. cat.), 1968.

Cox, O. and Millett, F., 'Mural Techniques Today', *Architectural Review*, vol. 130, no. 773, July 1961, pp.89–100.

Crofts, J. and Moreton, N., *Enderby, Narborough and Littlethorpe*, Stroud, 1998.

Cruickshank, I., and Chinnery, A., *Victorian and Edwardian Leicestershire from old photographs*, London, 1977.

The Crystal Palace Exhibition. Illustrated Catalogue, London 1851. An unabridged republication of The Art-Journal special issue, New York, 1970.

Darke, J., *The Monument Guide to England and Wales*, London, 1991.

Denvir, B., 'London Letter', *Art International*, vol. 15, May 1971, pp.76, 84

——, 'William Pye. Metaphors of the Machine', *Art International*, vol. 17, December 1973, pp.20–2.

Derby Museum and Art Gallery, *Ronald Pope. Sculptor and Artist 1920–1997* (exhib. cat.), [1998].

Dorment, R., *Alfred Gilbert*, New Haven and London, 1985.

—— (ed.), *Alfred Gilbert: Sculptor and Goldsmith* (Royal Academy exhib. cat.), London, 1986.

Dove, C., and Gill, R., *Leicester in Camera*, Buckingham, 1986.

Dunmore, R., *This Noble Foundation. A History of the Sir John Moore School at Appleby Magna in Leicestershire*, Ashby-de-la-Zouch, 1992.

Elliott, M., *Victorian Leicester*, London and Chichester, 1979.

——, *Leicester. A Pictorial History*, Chichester, 1983.

Ellis, I.C., *Records of Nineteenth Century Leicester* (privately published), 1935

Emmerson, R., *Roubiliac's Statue 'Religion'* (Leicestershire Museums, Art Galleries and Records Service leaflet), 1981.

——, *Twelfth Century Sculpture at Oakham Castle* (Leicestershire Museums, Art Galleries and Records Service leaflet), 1981.

Esdaile, K., *English Monumental Sculpture Since the Renaissance*, London, 1927.

——, *The Life and Works of Louis François Roubiliac*, London, 1928.

Evans, R.H., 'The Biggs Family of Leicester', in *The Leicestershire Archaeological and Historical Society. Transactions*, vol. xlviii, 1972–3, pp.29–58.

Examples of Modern Architecture. Series No. 6. J. Stockdale Harrison. Shirley Harrison, Cheltenham and London, n.d.

Farquhar, J., *Arthur Wakerley 1862–1931*, n.p. (Sedgebrook Press), 1984.

Farr, D., and Chadwick, E., *Lynn Chadwick: Sculptor*, Oxford, 1990.

Festival Sculpture (International Garden Festival, Liverpool), Liverpool, 1984.

Firenze, Comune di, *Phillip King* (exhib. cat.), Firenze, 1997.

Fletcher, A.K. and Long, K., *Campus Sculpture Trail* (Loughborough University), 1999.

Foss, P.J., *The History of Market Bosworth*, Wymondham, 1983.

Freebody, N.K., *The History of the Collegiate Girls' School Leicester 1867–1967*, Leicester, 1967.

Freeman, J.M., *W.D. Caröe RStO FSA: his architectural achievement*, Manchester and New York, 1990.

Friedman, T., Linstrum, D., Read, B., Rooke, D. and Upton, H., *The Alliance of Sculpture and Architecture. Hamo Thornycroft, John Belcher and the Institute of Chartered Accountants Building*, Leeds, 1993.

Frizelle, E.R. and Martin, J.D., *The Leicester Royal Infirmary 1771 – 1971*, Leicester, 1971.

Gale, M. and Stephens, C., *Barbara Hepworth. Works in the Tate Gallery Collection and the Barbara Hepworth Museum St Ives*, London, 1999.

Ganz, H.F.W., *Alfred Gilbert at his Work*, London, 1934.

Garlake, M., *New Art, New World. British art in postwar society*, New Haven and London, 1998.

Gerrard, D., *Leicestershire & Rutland Past. A Guide to Historic Places and People*, Stroud, 1996.

Gildea, J., *For Remembrance and in Honour of those who lost their lives in the South African War 1899 – 1902*, London, 1911.

Gill, R., *The Book of Leicester*, Buckingham, 1985.

——, 'The man who built Leicester's Clock Tower', *Leicestershire & Rutland Heritage*, no. 2, 1989, pp.34–5.

——, *A Walk through Victorian Leicester*, Leicester, 1994.

Gillian Jason Gallery, *Denis Mitchell. A Retrospective. Sculptures 1951 – 1990* (exhib. cat.), London, 1990.

Good, M. (comp.), *A Compendium of Pevsner's Buildings of England on Compact Disc*, Oxford, 1995.

Gould, F.J., *The History of the Leicester Secular Society*, Leicester, 1900.

Granger, F., 'New Buildings in Leicester', *The Architects' Journal*, vol. lxiii, no. 1638, 9 June 1926, pp.779–90, 799.

Graves, A., *The Royal Academy of Arts: a Complete Dictionary of Contributors and their works from its Foundation in 1769 to 1904*, London 1905–6 (8 vols), reprinted 1970 (4 vols).

Gray, A. S., *Edwardian Architecture*, London, 1985.

Great Exhibition of the Works of Industry of all Nations, 1851. Official Descriptive and Illustrated Catalogue. By Authority of the Royal Commission, 3 vols, London, 1851.

Greater London Council, *Sculpture in the Open Air (An exhibition of contemporary British Sculpture. Battersea Park …)*, London, 1966.

Grieve, A., *The Sculpture of Robert Adams*, London, 1992.

Gunnis, R., *Dictionary of British Sculptors 1660–1851*, London, 1951 [1964].

Hall, J., *Dictionary of Subjects and Symbols in Art*, London, 1974, revised edn 1979.

Hamilton, J., *The Sculpture of Austin Wright*, London, 1994.

Hamilton, J. and Warner, M., *Peter Randall-Page. Sculpture and Drawings 1977–1992*, Leeds, 1992.

Hamilton Galleries, *Werthmann* (exhib. cat.), London, 1964.

——, *Antanas Brazdys* (exhib. cat.), London, 1965.

——, *David Partridge* (exhib. cat.), London, 1967.

Hartopp, H., *Roll of the Mayors of the Borough and Lord Mayors of the City of Leicester 1209 to 1935*, Leicester, 1935.

Haskell, F., and Penny, N., *Taste and the Antique. The Lure of Classical Sculpture 1500–1900*, New Haven and London, 1981.

Henderson, E., *Milestones of Hinckley 1640–1981*, [Hinckley], 1981.

Hickman, T., *Around Rutland*, Stroud, 1996.

Hillier, K., *The Book of Ashby-de-la-Zouch*, Buckingham, 1984.

Hilton, T., *The Sculpture of Phillip King*, London, 1992.

The Hinckley Times, *Images of Hinckley and District*, Derby, 1996.

Hodin, J.P., *Barbara Hepworth*, London, 1961.

—— ——, 'Geoffrey Clarke. Maker of Art', *The Studio*, vol. 165, no. 841, May 1963, pp.210–15.

Hollins, P. and England, S., *Memory Lane Leicester*, Derby, 1997.

The Hotel that never was (Leicester City Council pamphlet), n.d.

Humphrey, W., *Henry Fearon – a Maker of Modern Loughborough*, Loughborough, 1985.

Hussey, C., 'Stapleford Park, Leicestershire, the seat of Lieut.-Col. John Gretton, M.P.', *Country Life*, vol. lvi, no. 1442, 23 August 1924, pp.288–96.

James, D., 'Foundries', *Arts Review*, vol. 23, no. 3, 13 February 1970, pp.70–1, 87.

Jones, D. K., *Stewart Mason: The Art of Education*, London, 1988.

Kelly, A., *Mrs Coade's Stone*, Upton-upon-Severn, 1990.

Kelly's Directory of the Counties of Leicester and Rutland, London (various edns).

Kenny, S., *Peter Peri's Sculpture for Schools: its commissioning and execution, with special emphasis upon work carried out in Leicestershire* (unpublished BA thesis), 1980.

King, P., 'British Artists at Venice 2: Phillip King talks about his sculpture', *Studio International*, June 1968, pp.300–5.

Knoedler Galleries, *Lynn Chadwick* (exhib. cat.), New York, 1961.

Koster, N. and Levine, P., *Lynn Chadwick: the sculptor and his world: the artist and his work*, Leiden, 1988.

Kröller-Müller National Museum, *Phillip King* (exhib. cat.), Otterloo, 1974.

Lacey, A.J., Smith, S., Jowett, D. and Smith, C., *A History of Shepshed (Regis)*, Shepshed 1965, 2nd edn 1969.

László, H., *The Realistic Sculpture of Laszlo Peter Peri* (unpublished thesis; English translation 1993 by C. Rozsnyai), 1990.

Lee, J., *Who's Buried Where in Leicestershire*, Leicester, 1991.

Lee, J. and Dean, J., *Curiosities of Leicestershire and Rutland*, Seaford, 1995.

Leetham, C.R., *Ratcliffe College 1847–1947*, [Ratcliffe-on-the-Wreake], 1950.

Leicester City Council, *Leicester's Architectural Heritage*, Leicester, 1975.

Leicester City Council, *The Quality of Leicester* (text by Michael Taylor), Leicester 1993, 2nd edn 1997.

Leicester Mercury, *Images of Leicester*, Derby, 1995.

Leicestershire Museum and Art Gallery, *Peter Peri 1899–1967. A Retrospective Exhibition of Sculpture, Prints and Drawings* (exhib. cat.), Leicester, 1991.

Leicester Museums, *John Biggs 1801– 1871* (leaflet), n.d.

Levine, P., and Koster, N., *Lynn Chadwick: The Sculptor and His World*, Leiden, 1988.

Levy, M., 'Pioneering patronage for schools. British Art in Leicestershire', *The Studio*, vol. clxvi, no. 845, September 1963, pp.92–7.

Livingstone, E.A. (ed.), *The Concise Oxford Dictionary of the Christian Church*, Oxford, 1977.

Local Chronology of the Borough of Leicester (Gamble), Leicester, 1926.

London County Council, *Sculpture in the Open Air. Battersea Park. London. 1960* (exhib. cat.), London, 1960.

——, *Sculpture in the Open Air. Battersea Park. London* (exhib. cat.), London, 1963.

Loughborough College of Art and Design, *New Identities* (exhib. cat.), Loughborough, 1997.

Loughborough in Black and White. Volume 3. A collection of old postcards of Loughborough University and the Old College, Loughborough, 1997.

Loughborough University School of Art and Design, *Sculpture 1999* (exhib. cat.), Loughborough, 1999.

Lucie-Smith, E., *Alexander*, London, 1992a.

——, *Wendy Taylor*, London, 1992b.

——, *Chadwick*, Stroud, 1997.

Lucie-Smith, E. (text) and Buckland, D. (photographs), *The Sculpture of Helaine Blumenfeld*, London, 1982.

McKinley, R.A. (ed.), *A History of the County of Leicester. Vol. IV. The City of Leicester* (The Victoria History of the Counties of England), London, 1958.

Macklin, A.E., 'Alfred Gilbert at Bruges', *The Studio*, vol. xlviii, no. 200, November 1909, pp.98, 100, 113.

McNaughton, J.D., *Around Old Burbage*, Burbage, 1980.

Mastoris, S., *Around Market Harborough in Old Photographs*, Gloucester, 1989.

Matthews. B., 'Archdeacon Robert Johnson: Puritan Divine', *Rutland Record*, 1981, no. 2, pp.53–7.

——, *By God's Grace ... A History of Uppingham School*, Maidstone, 1984.

Meadows, S.R., *Swithland*, Leicester, 1965.

Men of the Period selected from centres of Commerce and Industry ... (The Biographical Publishing Company), London, 1897.

The Minories, *Peri's People* (exhib. cat.), Colchester, 1970.

——, *Kenneth Draper. Sculpture, Paintings and Drawings 1962–82* (exhib. cat.), Colchester, 1982.

The Municipal Borough of Loughborough. The Official Guide, Cheltenham and London, n.d.

Nairne, S. and Serota, N. (eds), *British Sculpture in the Twentieth Century*, London, 1981.

Nichols, J., *The History and Antiquities of the County of Leicester* (4 vols)
– vol. 1, pt ii, London 1815 (reprint Wakefield 1971).
– vol. 2, pt i, London 1795 (reprint Wakefield 1971).
– vol. 4, pt. i, London 1810 (reprint Wakefield 1971).
– vol. 4, pt ii, London 1811 (reprint Wakefield 1971).

Noszlopy, G.T. and Beach, J., *Public Sculpture of Birmingham*, Liverpool, 1998.

Nuttall, G.C., *Guide to Leicester and Neighbourhood*, Leicester, 1905.

Oakley, G. and Croman, L., *The Bosworth and Gopsall Estates. Village Life in the Early 20th Century*, n.p., 1996.

O'Hana Gallery, *Georg Ehrlich* (exhib. cat.), London, 1955.

Orna, B., 'Antony Hollaway. Artist for architecture. An interview with Bernard Orna', *The Studio*, vol 167, no 850, February 1964, pp.58–63.

Page, W. (ed.), *The Victoria History of the County of Rutland*, London
– vol. 1, London 1908, reprinted Folkestone 1975.
– vol. 2, London 1935, reprinted Folkestone 1975.

Peace, D., *Eric Gill. The Inscriptions*, London, 1994.

Penrose, S., 'Profile. Geoffrey Clarke', *The Arts Review*, vol. xvii, no. 4, 6–20 March 1965, p.4.

Pevsner, N., *Leicestershire and Rutland* (The Buildings of England), London 1960.

Pevsner, N. and Williamson, E., *Leicestershire and Rutland* (The Buildings of England), London 1960, 2nd revised edn 1984, reprinted with corrections 1992.

Phillips, G., *Rutland and the Great War*, Salford, 1920.

Pike, W.T., *A Dictionary of Edwardian Biography. Leicestershire and Rutland*, Brighton, 1902.

Pitches, G., *George Pickard 1929–1993. Monograph*, Leicester, 1994.

Read, B., *Victorian Sculpture*, New Haven and London, 1982.

Read, H., *Modern Sculpture: A Concise History*, London, 1964.

Read, R., *Modern Leicester: jottings of personal experience and research*,

with an original history of Corporation undertakings . . ., London and Leicester, 1881.

Redfern Gallery, *Kneale* (exhib. cat.), London, 1960.

——, *Geoffrey Clarke. Recent Sculptures 1965* (exhib. cat.), London, 1965.

——, *Alfred Dunn* (exhib. cat.), London, 1966a.

——, *Summer Exhibition 1966* (exhib. cat.), London, 1966b.

——, *Bryan Kneale* (exhib. cat.), London, 1967.

——, *Kenneth Draper* (exhib. cat.), London, 1969a.

——, *Alfred Dunn. New Works 1969* (exhib. cat.), London, 1969b.

——, *William Pye. New Sculpture* (exhib. cat.), London, 1969c.

——, *Bryan Kneale. New Sculpture* (exhib. cat.), London, 1970.

Rees, J., 'Public Sculpture', *Studio International*, vol. 184, no. 946, July/August 1972, pp.10–32.

Robertson, B., 'Bryan Kneale's new work', *Studio International*, vol. 174, no. 893, October 1967, pp.150–3.

Rowan Gallery, *Garth Evans* (exhib. cat.), London, 1966.

Royal Academy of Arts, *British Sculptors '72* (exhib. cat.), London, 1972.

Rutland Local History Society, *The Villages of Rutland*
– vol. 1, pt 1, Oakham, 1979.
– vol. 1, pt 2, Stamford, n.d.

Sadler, A., 'Victorian Commemorative Plaques', *Leicestershire Historian*, no. 35, 1999, pp.1–2.

Saint John the Baptist Church of England Schools. Official Opening of the New Infant and Junior Schools, East Avenue, Clarendon Park Road, Leicester, on Saint John the Baptist's Day Monday, the 24th June, 1974, Leicester, n. pag.

Sargant, W.L., *The Book of Oakham School*, Cambridge, 1928.

Scott, W., *The Story of Ashby-de-la-Zouch*, Ashby-de-la-Zouch, 1907.

Sewter, A.C., 'A Statue by Roubiliac', *The Burlington Magazine*, vol. lxxv, no. 438, September 1939, pp.121–3.

Sharpe, J., *The War Memorials of Leicestershire and Rutland* (unpublished MA thesis, De Montford University), Leicester, 1992.

Shaw, F., *Barwell and Earl Shilton in old picture postcards*, Zaltbommel, Netherlands, 1987.

Simmons, J., 'Notes on a Leicester Architect. John Johnson (1732–1814)', in *Transactions of the Leicestershire Archaeological Society*, vol. xxv, 1949, pp.144–58.

——, *The City of Leicester. A Guide to Places of Interest*, Leicester 1951, 3rd edn 1960.

——, *Parish and Empire*, London, 1952.

——, 'Mid-Victorian Leicester', in *The Leicestershire Archaeological and Historical Society. Transactions*, vol. xli, 1965–6, pp.41–56.

——, *Life in Victorian Leicester*, Leicester, 1971.

——, *Leicester Past and Present*, i: *Ancient Borough to 1860*, London, 1974.

——, *Leicester Past and Present*, ii: *Modern City 1860–1974*, London, 1974.

Smith, E.D., *The Story of Gaddesby Parish Church*, Leicester, 1968.

Spalding, F., *British Art since 1900*, London, 1986.

Spencer, C.S., 'David Partridge's nail mosaics', *Studio International*, vol. 170, no. 867, July 1965, pp.20–3.

——, 'Brazdys: sculptural analysis of reality', *Studio International*, vol. 171, no. 873, January 1966a, pp.22–5.

——, 'Bryan Kneale: sculptor of Interior Form', *Studio International*, vol. 171, no. 874, February 1966b, pp.66–7.

——, 'Brian Wall: sculptor of simplicity', *Studio International*, vol. 171, no. 875, March 1966c, pp.103–5.

Spencers' Illustrated Handy Guide to Leicester (includes *Supplement to Spencers' New Guide and Handbook to the Town of Leicester, bringing the information down to the year, 1878*), Leicester, 1878.

Spencers' New Guide to the Town of Leicester, its History, Antiquities, etc, with numerous illustrations, Leicester, 1888.

Stapleford Park, near Melton Mowbray, Burton-on-Trent and Derby, 1965.

Stevenson, J., *Leicester Through the Ages*, Newton Linford, 1995.

Strachan, W.J., 'The Sculptor and his Drawings: 5. Lynn Chadwick', *The Connoisseur*, vol. 186, no. 750, August 1974a, pp.280–5.

——, 'The Sculptor and his Drawings: 6. Geoffrey Clarke', *The Connoisseur*, vol. 187, no. 751, September 1974b, pp.40–7.

——, *Open Air Sculpture in Britain*, London, 1984.

Stratton, M., *The Terracotta Revival*, London, 1993.

Stretton, J., *The Counties of England Past and Present. Leicestershire and Rutland*, Peterborough, 1997.

Taranman [Gallery], *Geoffrey Clarke* (exhib. cat.), London, 1975.

——, *Geoffrey Clarke. Early Engraved Work and Iron Sculpture* (exhib. cat.), London, 1976.

Tate Gallery, *British Sculpture in the Sixties* (exhib. cat.), London, 1965.

——, *Barbara Hepworth* (exhib. cat.), London, 1968.

——, *Barbara Hepworth. A Guide to the Tate Gallery Collection at London and St Ives, Cornwall*, London, 1982

Temple Newsham House, *Joseph Gott 1786 – 1860. Sculptor* (exhib. cat.), Leeds, 1972.

Thawley, J., *A Certain Hospital Forever. A recent history of Wyggeston's Hospital*, Leicester, 1997.

Tyler-Bennett, D., 'The Dark Lady, a Lord and a King: The statues of Leicester', in *The Leicester Topic*, vol. xxvi, no. 301, March 1990, pp.44–5.

Upson, N., *Mythologies. The Sculpture of Helaine Blumenfeld*, New York and London, 1998.

Waddington Galleries, *Denis Mitchell. Sculpture* (exhib. cat.), London, 1961.

Wade-Matthews, M., *Grave Matters. A walk through Welford Road Cemetery Leicester*, Wymeswold 1992, 2nd edn 1995.

Waites, B., *Exploring Rutland*, n.p., 1982.

W[arren], R.H., *The Hall Family*, Bristol, 1910.

Warwick Arts Trust, *Kenneth Draper. Sculpture and Drawings 1962–81* (exhib. cat.), London, 1981.

Wheeler, K., *Leicester's High Cross*, Leicester, 1978.

Wheeler, P., 'Saga of a Sock', *Sculpture '98* (Royal Society of British Sculptors), Summer 1998, p.7.

Whinney, M., *Sculpture in Britain 1530 to 1830*, London, 1988.

White, W., *History, Gazetteer, and Directory of the Counties of Leicester and Rutland …*, Sheffield and London,1862.

Whitechapel Art Gallery, *The New Generation: 1965* (exhib. cat.), London, 1965.

——, *Bryan Kneale. Sculpture: 1959–1966* (exhib. cat.), London, 1966.

——, *British Sculpture and Painting from the collection of the Leicestershire Education Authority* (exhib. cat.), London, 1967.

Whittet, G.S., 'Battersea Power Sculpture', *The Studio*, vol. 166, no. 844, August 1963, pp.48–53.

Whittick, A., *War Memorials* (Country Life Ltd), London, 1946.

Wilford, B. and J., *Bygone Barrow-upon-Soar*, Barrow-upon-Soar, 1981.

Williams, D.R., *Cinema in Leicester 1896–1931*, Loughborough, 1993.

Williams, Revd E., *William Carey's Cottage, Harvey Lane, Leicester. A House of Memories*, n.d.

Wilshere, J.E.O., *Leicester Clock Tower 1868–1968*, Leicester [1968].

——, *Leicester Clock Tower. A short history of the Site and construction of the Tower*, Leicester, revised edn 1974

——, *The Town Halls of Leicester*, Leicester, 1976.

Worsley, G., 'Stapleford Park, Leicestershire', *Country Life*, vol. clxxxii, no. 25, 23 June 1988, pp.160–3.

Wren Society, *The Eleventh Volume of the Wren Society 1934*, Oxford, 1934.

Yorkshire Sculpture Park, *William Pye* (exhib. cat.), 1979.

Zientek, M. and J., 'War Memorials in the County', *Village Voice. The quarterly magazine of the Leicestershire Rural Community Council*, Spring 1993, pp.6–7.

Archival sources

1. Leicestershire Education Authority archives

Jessop, M. and others, draft of a booklet on the artworks at Burleigh Community College, Loughborough, [1988].

2. Leicestershire Record Office:

(i) Leicester Corporation Minute Books:

Council Minutes (Minutes of the Council or Common Hall)
– 2 May 1850 – 25 March 1852 (CM 1/6)
– 1 January 1866 – 11 May 1869 (CM 1/11)
– 29 June 1869 – 20 February 1872 (CM 1/12)
– 26 March 1872 – 10 March 1874 (CM 1/13)
– 31 March 1874 – 4 January 1876 (CM 1/14)
– 25 September 1877 – 25 February 1879 (CM 1/16)

Estate Committee Minutes
– 26 May 1845 – 13 December 1854 (CM 12/2)
– 18 January 1855 – 22 March 1870 (CM 12/3)
– 30 November 1870 – 28 June 1875 (CM 12/4)
– 19 July 1875 – 20 October 1881 (CM 12/5)
– 9 February 1921 – 28 May 1924 (CM 12/14)
– 16 November 1927 – 21 October 1931 (CM 12/16)
– 15 November 1933 – 27 October 1937 (CM 12/18)
– 1945 – 1949 (DE 3277/81)
– 25 May 1949 – 23 April 1952 (DE 3277/82)
– 28 May 1952 – 28 April 1954 (DE 3277/83)
– 2 June 1969 – 1 May 1972 (DE 3277/91)

Highway and Public Works Committee Minutes
– 5 November 1948 – 4 May 1951 (DE 3277/132)

Highway and Sewerage Committee Minutes
– 16 August 1867 – 25 June 1868 (CM 22/25)
– 19 April – 8 November 1872 (CM 22/31)
– 15 November 1872 – 18 July 1873 (CM 22/32)
– 19 April 1919 – 28 October 1921 (CM 22/61)

Museums and Libraries Committee Minutes
– 28 May 1954 – 17 July 1959 (DE 3277/171)
– June 1967 – February 1974 (DE 3277/174)

Parks and Recreation Grounds Committee Minutes
– 11 January 1921 – 14 December 1928 (CM 28/6)
– 2 January 1929 – 3 October 1934 (CM 28/7)

Special Committees Minutes
– 21 February 1855 – 4 November 1874 (CM 46/3)
– May 1970 – February 1974 (DE 3277/264)

(iia) Parish Record Files (church):
Muston – papers, mainly accounts relating to war memorial (DE 830/48); *Notes on History of Muston...*, pp.26–32 (DE 830/49)
Quorn – papers relating to placing of war memorial in parish church, 1919 (DE 725/41)

(iib) Parish Record Files (Council)
Hinckley – Hinckley War Memorial Committee and War Records and Relief Committee Minute Book (DE 1961/3)

(iii) Miscellaneous
Archdeacon Fearon's Fountain (re-inauguration leaflet), 1981
City Rooms: *Hotel and Assembly Rooms, Leicester, letter and subscription list, 1800* (10D372/486, 487); *letter, John Johnson to Sir Edmund Cradock Hartopp, Bt., 1799* (10D72/470)
Designs for war memorials by W.H.H. Aspell of Leicester including unsuccessful design for Syston ... 1919 (DE 4756/131)
The East-Gates Improvement and the Haymarket Memorial Clock Tower, Leicester. A Sketch. Dedicated, with great respect, to the eight hundred and ninety-three subscribers to the East-Gates Improvement, and to the Haymarket Memorial Structure, Leicester, 1871 (Pamphlets, vol. 24, and L914.2)
Four Benefactors of Leicester and their Memorial. A Lecture delivered before the Leicester Literary and Philosophical Society, by John Barclay, M.D., F.R.C.S. Reprinted from the Leicester Advertiser, April 18 and 25, 1868 (Pamphlets, vol. 51)
Gaddesby Historical Society, *A General Introduction to St Luke's, Gaddesby* (unpublished pamphlet), 1978 (L726)
Hinckley and District War Memorial Committee and War Records and Relief Committee Minute Book (DE 1961/3)
Hinckley War Memorial, correspondence relating to (part of bundle of items interleaved in Hinckley Sunday School Union Minute Book, *c.*1919–20) (H/SSU/142/2/1)
Hollings Memorial: letter, dated 7 January 1981, from R.A. Rutland, Keeper of Antiquities, Newarke House Museum, plus various photographs, relating to the above (DE 3736)
Leicestershire South African War Memorial Committee Minute Book (DE 171)
Modern Memorials. Leicester. The East Gates Improvement. The Memorial Clock Tower. The Robert Hall Statue. The Rutland Statue Renovation. The John Biggs Statue, Leicester, 1875
Order of Proceedings at the Unveiling of a Memorial to Cardinal Wolsey, October 24th, 1934 (L920 WOL)
Pick, Everard, Keay and Gimson, business records: Quorn War

Memorial, correspondence, etc., 1919–23 (8D62, Box 56, item 5)
Wolsey Ltd photograph album, n.d., n. pag. (DE 3375/182)

National Art Library (Victoria and Albert Museum)
Letter, dated 12 June 1887 [*sic*], from Thomas Brock to Mrs Thring, making arrangements to visit Uppingham (86.WW.1)
Typescript biography of Thomas Brock (uncredited), *c.*1930 (86.ZZ.110)

Royal Academy of Arts archives
Spielmann Papers:
Letter from Alfred Gilbert to Spielmann, dated 26 October 1902 (SP/7/54)
Letter from George Gilbert to Spielmann, dated 8 December 1903 (SP/7/50)

University of Leicester Local History Collection
Council Minutes. Minutes of the Proceedings of the [Leicester City] Council (942 *LEI*/13 *LEI*):
– 10 November 1902 – 27 October 1902
– 9 November 1907 – 27 October 1908
– 9 November 1922 – 30 October 1923
– 9 November 1928 – 30 October 1929
– 6 November 1929 – 28 October 1930
– 10 November 1930 – 28 October 1931
The East-Gates Improvement and the Haymarket Memorial Clock Tower, Leicester. A Sketch. Dedicated, with great respect, to the eight hundred and ninety-three subscribers to the East-Gates Improvement, and to the Haymarket Memorial Structure, Leicester, 1871 (942 LEI/14 EAS)
In Memory of Edith Gittins, n.d. (942 LEI/15/GIT)

Windsor, Royal Archives
Letter from the Duchess of Rutland to George Gilbert, dated 22 March 1907 (RA Add. X/212)

Sources for artists' biographies

Annely Juda Fine Art, *Friederich Werthmann* (exhib. cat.), London, 1974.
Barnard, J., 'The Master of Harrods Meat Hall W.J. Neatby', *Apollo*, vol. xci, no. 97 (ns), March 1970a, pp.232–4.
——, 'Some Work by W.J. Neatby (1860–1910)', *The Connoisseur*, vol. clxxv, November 1970b, pp.165–71.
Bertram Eaton. A Northamptonshire sculptor (EMA touring exhib. cat.), 1980.
Buckman, D., *Dictionary of Artists in Britain since 1945*, Bristol, 1998.

Camden Arts Centre, *Neville Boden* (exhib. cat.), London, 1986.

Cerrito, J. (ed.), *Contemporary Artists*, Detroit, 1996.

Chelsea Harbour Sculpture 93 (RBS exhib. cat.), London, 1993.

Cherry, D. and Pevsner, N., *London 3: North West* (Buildings of England), London, 1991.

——, *London 4: North* (Buildings of England), London, 1998.

Clifford, T., 'John Bacon and the Manufacturers', *Apollo*, vol. cxxii, no. 284, October 1985, pp.288–304.

Collis, L., 'One-Woman Show [Helaine Blumenfeld]', *Art and Artists*, September 1982, pp.30–2.

Cox-Johnson, A., *John Bacon R.A. 1740–1799*, London, 1961.

Curl, J.S., *A Dictionary of Architecture*, Oxford, 1999.

Curtis, P., *Barbara Hepworth* (St Ives Artists), London, 1998.

Dictionary of National Biography, 63 vols, London, 1885–1900.

—— *Supplement*, 3 vols, London, 1901.

—— *Second Supplement*, 3 vols, London, 1912.

—— *Supplement 1901–1911*, London, 1912.

—— *1922–1930*, London, 1937.

—— *1931–1940*, London, 1949.

—— *1951–1960*, London, 1971.

—— *1961–1970*, Oxford, 1981.

—— *1971–1980*, Oxford, 1986.

—— *1986–1990*, Oxford, 1996.

Dixon, R. and Muthesius, S., *Victorian Architecture*, London 1978, 2nd edn 1985.

Dunford, P., *A Biographical Dictionary of Women Artists in Europe and America since 1850*, Hemel Hempstead, 1982.

Felstead, A., Franklin, J. and Pinfield, L., *Directory of British Architects 1834–1900*, London, 1993.

Fleming, J. and Honour, H., *The Penguin Dictionary of Decorative Arts*, London 1977, 2nd edn 1989.

Gaze, D. (ed.), *Dictionary of Women Artists*, London and Chicago, 1997.

Gifford, J., McWilliam, C., Walker, D. and Wilson, C., *Edinburgh* (The Buildings of Scotland), Harmondsworth, 1984.

Gosse, E., 'Living English Sculptors', *The Century Magazine*, vol. xxvi (new series vol. iv), no. 2, June 1883, pp.181–3.

Hamilton Galleries, *Friederich Werthmann* (exhib. cat.), London, 1966.

Hayward Gallery, *The Conditions of Sculpture* (exhib. cat.), London, 1972.

James, D., *A Century of Statues: a History of the Morris Singer Foundry*, Frome, 1984.

Johnson, J. and Greutzner, A., *The Dictionary of British Artists 1880–1940*, Woodbridge, 1976.

King, A., *Memorials of the Great War in Britain. The Symbolism and Politics of Remembrance*, Oxford and New York, 1998.

Lucie-Smith, E., *Four Women Artists working in Britain* (Sainsbury Centre, University of East Anglia, exhib. cat.), 1982.

MacDonald, C.S. (comp.), *A Dictionary of Canadian Artists*, vol. 2 (G to Jackson), Ottawa 1968, 3rd edn 1977.

McEwan, P.J.M., *Dictionary of Scottish Art and Architecture*, Woodbridge, Suffolk, 1994.

Modern English Biography, vols 1–3, London 1892–1901, 1965 edn.

——, vols 4–6, London 1908–21, 1965 edn.

Newall, C., *The Grosvenor Gallery Exhibitions: change and continuity in the Victorian art world*, Cambridge, 1995.

Pevsner, N., *North Lancashire* (Buildings of England), Harmondsworth, 1969.

Popp, G. and Valentine, H. (comps), *Royal Academy of Arts. Directory of Membership from the Foundation in 1768 to 1995 including Honorary Members*, London, 1996.

Service, A., *Edwardian Architecture*, London, 1977.

Spalding, F., *20th Century Painters and Sculptors*, Woodbridge, 1990.

Spencer, C.S., 'Gerald Gladstone: spacist sculptor', *The Studio*, vol. clxiii, no. 830, June 1962, pp.214–15, 235.

Stanton, P., *Pugin*, London, 1971.

Turner, J. (ed.), *The Dictionary of Art* (Macmillan), London, 1996.

Vallance, A., 'Mr W.J. Neatby and his Work', *The Studio*, vol. xxix, no. 124, July 1903, pp.113–17.

Walker Art Gallery, *The Art Sheds 1894–1905* (exhib. cat.), Liverpool, 1981.

Waters, G.M., *Dictionary of British Artists working 1900–1950*, Eastbourne, 1975.

Webb, M.I., 'Henry Cheere, Sculptor and Businessman ...', *Burlington Magazine*, vol. c, no. 665, August 1958, pp.274–9.

Who's Who 1998, London, 1998.

—— *1999*, London, 1999.

Who Was Who 1897–1915, London, 1929.

—— *1916–1928*, London, 4th edn 1967.

—— *1929–1940*, London, 2nd edn 1967.

—— *1961–1970*, London, 1972.

—— *1971–1980*, London, 1981.

—— *1981–1990*, London, 1991.

Sources for Introduction

Barclay, J., 'Modern Leicester, Part II', lecture delivered to the Leicester Literary and Philosophical Society, 22 February 1864.

Borg, A., *War Memorials from Antiquity to the Present*, London, Leo Cooper, 1991.

Borsay, P., '"All the town's a stage": urban ritual and ceremony 1660–1800', *The Transformation of English Provincial Towns*, P. Clarke (ed.), London, Hutchinson University Library, 1984.

——, *The English Urban Renaissance: Culture and Society in the Provincial Town, 1660–1770*, (Oxford Studies in Social History, Gen. Ed. K. Thomas) Oxford, Oxford University Press, 1989.

Bray, W., *Sketch of a tour into Derbyshire and Yorkshire including part of Buckingham, Warwick, Leicester...*

Burgess, F., *English Churchyard Memorials*, 1963, 1979.

Cantor, L., *The Historic Country Houses of Leicestershire and Rutland*, Leicester, Kairos Press, 1998.

Cantor, L. and Squires, A., *The Historic Parks and Gardens of Leicestershire and Rutland*, Leicester, Kairos Press, 1997.

Chinnery, G.A., 'Eighteenth-Century Leicester', *The Growth of Leicester*, ed. A.E. Brown, Leicester, Leicester University Press, 1972.

Clarke, D.T. –D. and Simmons, J., 'Old Leicester An Illustrated Record of Change in the City', *The Leicestershire Archaeological and Historical Society Transactions*, vol. xxxvi, 1960.

Curtis, J., *Topographical History of the County of Leicester*, Leicester 1831.

Davies, D., *Stewart Mason: The Art of Education*, London, Lawrence and Wishart, 1983.

Davies, J.C., 'The "tulip slates" of south Leicestershire and north-west Northamptonshire', *The Leicestershire Historian*, 4: 1, 1993.

Defoe, D., *A Tour through the Whole Island of Great Britain*, London, J.M. Dent and Sons, 1962.

Ellis, C.D.B., *History of Leicester 55 B.C. – A.D. 1900*, Leicester, City of Leicester Publicity Department, 1948.

Ellis, R. Jnr., *Modern Leicester*, 1881.

Evans, R.H., 'The local government of Leicester in the nineteenth century', *The Growth of Leicester*, ed. A.E. Brown, Leicester, Leicester University Press, 1972.

Everitt, A.M., 'Leicester and its Markets: the seventeenth century', *The Growth of Leicester*, ed. A.E. Brown, Leicester, Leicester University Press, 1972.

Fraser, D., *Urban Politics in Victorian England: The structure of politics in Victorian cities*, Leicester, Leicester University Press, 1976.

Fussell, P., *The Great War and Modern Memory*, Oxford, Oxford University Press, 1977.

Lancaster, B., *Radical Cooperation and Socialism: Leicester working class politics 1860–1906*, Leicester, Leicester University Press, 1987.

Mander, J., *Leicester Schools 1944–1947*, Leicester, Leicester City Council, 1980.

Mason, S.C., *In our Experience*, (Education Today Series) London, Longman, 1970.

Moriarty, C., 'Private Grief and Public Remembrance: British First World War Memorials', Evans, M. and Lunn, K. (eds) *War and Memory in the Twentieth Century*, Oxford and New York, Berg, 1997.

Nash, L. and Reeder, D. (eds) *Leicester in the Twentieth Century*, Stroud, Alan Sutton Publishers and Leicester City Council, 1993.

Newman, A. and Lidiker, P., *Portrait of a community: a history of the Leicester Hebrew Congregation*, Leicester, Lithigo Press, 1998.

Pritchard, R.M., *Housing and the Spatial Structure of the City: residential mobility and the housing market in an English city since the Industrial Revolution*, Cambridge, Cambridge University Press, 1976.

Reeder, D., *Landowners and Landholdings in Leicestershire and Rutland 1873–1941*, Leicester, University of Leicester Centre for Urban History, 1994.

Rimington, G.T., *The Comprehensive School Issue in Leicester 1943–1974, and other essays*, Peterborough, IOTA Press, 1984.

Saint, A., *Towards a Social Architecture: the role of school-building in Post-War England*, New Haven and London, Yale University Press, 1987.

Simmons, J., 'The Power of the Railway', *The Victorian City Images and Realities*, vol. II, *Shapes on the Ground/A change of Accent*, eds H.J. Dyos and M. Wolff, London, Routledge & Kegan Paul, 1973.

Simon, B., 'Education in Leicestershire', *Leicester and its region*, ed. N. Pye, Leicester, Leicester University Press, 1972.

Strachan, A.J., 'Patterns of population change', *Leicester and its Regions*, ed. N.J. Pye, Leicester, Leicester University Press, 1972.

Temple Patterson, A., *Radical Leicester a History, 1780–1850*, Leicester, Pitman Press for University College Leicester, 1954.

Winter, J., *Sites of Memory, Sites of Mourning: the Great War in European Cultural History*, Cambridge, Cambridge University Press, 1995.

Index

Notes Titles of works are in italics. References to illustrations are in bold. Monuments and sculptures are indexed in two ways: (i) by title, followed by location, then maker / makers' surname in brackets, and (ii) by maker, followed by title. In addition, schools, buildings, and other specific locations are indexed.